MATISSE
PICASSO

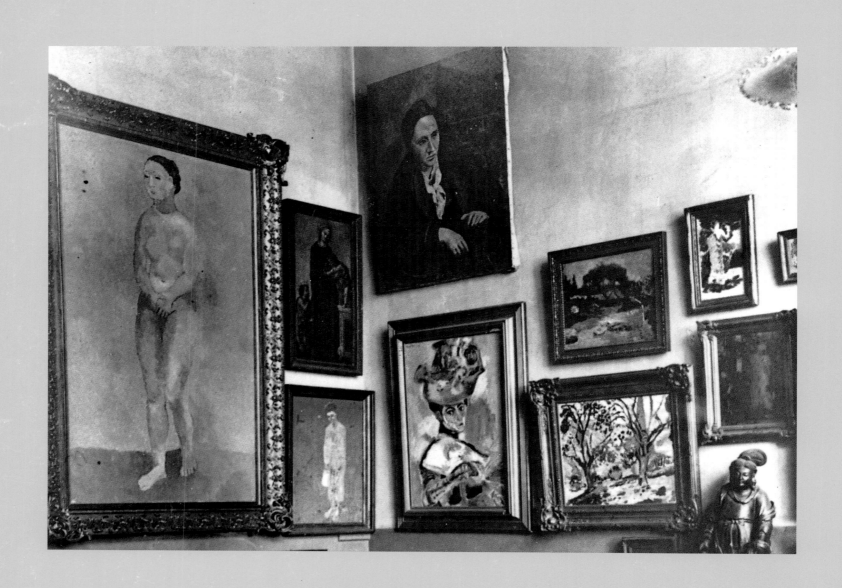

MATISSE
PICASSO

Elizabeth Cowling Anne Baldassari John Elderfield

John Golding Isabelle Monod-Fontaine Kirk Varnedoe

Tate Publishing

Réunion des Musées Nationaux

The Museum of Modern Art

The exhibition at Tate Modern is sponsored by

ΞⱮ ERNST & YOUNG

Published to accompany the exhibition at
Tate Modern, London
11 May – 18 August 2002

Les Galeries Nationales du Grand Palais, Paris
25 September 2002 – 6 January 2003
(French edition available)

The Museum of Modern Art, New York
13 February – 19 May 2003

Published in 2002 by Tate Publishing,
a division of Tate Enterprises Ltd,
Millbank, London SW1P 4RG
Texts by Elizabeth Cowling and John Golding © Tate 2002
Texts by Anne Baldassari and Isabelle Monod-Fontaine © Editions
de la Réunion des Musées Nationaux 2002
Texts by John Elderfield and Kirk Varnedoe © The Museum of
Modern Art, New York 2002
All works by Henri Matisse © Succession H. Matisse, 2002
All works by Pablo Picasso © Succession Picasso, 2002

ISBN 1 85437 376 5 (paperback)
ISBN 1 85437 392 7 (hardback)

A catalogue record for this publication is available
from the British Library

Book design: Steven Schoenfelder, New York
Printed and bound in Italy by Conti Tipocolor
Chapters 5, 7, 8, 11, 19–22, 25, 27 and 31 translated from the
French by Georges Collins

Cover:
Henri Matisse, *Vegetation (Végétaux)* c.1951 (no.163)
and Pablo Picasso, *Large Still Life on a Pedestal Table
(Grande Nature morte au guéridon)* 1931 (no.162)
Back cover:
Pablo Picasso, *Acrobat (L'Acrobate)* 1930 (no.167)
and Henri Matisse, *Flowing Hair (La Chevelure)* 1952 (no.164)
Frontispiece:
The apartment of Leo and Gertrude Stein at no.27 rue de Fleurus,
Paris, c.1907 (left: Picasso's *Nude with Clasped Hands* of 1906,
top: Picasso's *Portrait of Gertrude Stein* of 1905–6 (no.58),
centre: Matisse's *The Woman with the Hat* of 1905,
to its right: Matisse's *The Olive Trees* of 1906)

Contents

Sponsor's Foreword

Ernst & Young is delighted to be sponsoring *Matisse Picasso*.

We began our support of the arts in 1994 when we sponsored *Picasso: Sculptor/Painter* at the Tate Gallery. It seems fitting, therefore, that we now continue with *Matisse Picasso* at Tate Modern. In the UK, this is our seventh sponsorship, and our fourth with Tate.

Matisse and Picasso were the twin giants of modern art. Their reputations were built on their ability to set new standards. They were leaders and visionaries. At Ernst & Young we pursue the same principles of leadership, vision and innovation for our clients. Like these artists, we aim to be leading edge.

As one of the world's largest business advisors, we also welcome the opportunity to contribute to cultural life. Sponsorship gives us the ability to do so.

We hope that you will enjoy this exhibition and that this book will provide a reminder for years to come.

Nick Land
Chairman

Foreword

It has been a genuine pleasure for us to collaborate on this historic exhibition which explores the relationship between Matisse and Picasso, and we are delighted that it will be seen in three cities: London, Paris and New York. As a result of this close collaboration we have been able to include many seldom lent works from our own collections: from the Musée Picasso and from the Centre Pompidou/Musée National d'Art Moderne, Paris, from The Museum of Modern Art, New York and from Tate, London.

Matisse Picasso is an ambitious project which seeks to explore the creative dialogue of the two most significant artists of the twentieth century and to show how close they were, contrary to widely held opinion, and how complex their relationship could be. The nature of their relationship fascinated their contemporaries and has been subjected to constant critical re-evaluation, an early instance being their first joint exhibition in the Galerie Paul Guillaume in Paris in 1918, with catalogue essays by Guillaume Apollinaire. The present exhibition takes a global view and opens in 1906 when Matisse and Picasso first began to meet regularly. It proceeds to explore the history of their fluctuating interaction over almost half a century by means of thirty-four pairs or larger groups of works on the same themes, arranged in broadly chronological sequence. Picasso's continuing dialogue with Matisse's work after the latter's death in 1954 forms a moving and also a thrilling climax to the show. While not seeking to be exhaustive, the selection highlights both familiar and hitherto wholly overlooked aspects of their multi-faceted exchange.

The original idea for the exhibition was proposed by Elizabeth Cowling and John Golding for Tate Modern, London, and was subsequently enthusiastically adopted by us all. The exhibition has been selected by a team of six curators, two representing each city: Elizabeth Cowling and John Golding for London, Anne Baldassari and Isabelle Monod-Fontaine for Paris and John Elderfield and Kirk Varnedoe for New York. We are deeply grateful to them for their enthusiasm and dedication and for all the time they have devoted to the project: selecting the works, tracking down their current location and negotiating the loans. We should also like to thank each of them for the illuminating essays they have written for this catalogue which explain the reasoning behind the individual groupings. A substantial chronology complements these essays and brings together essential information and documents, including the artists' largely unpublished correspondence.

We are most grateful to the families of Matisse and Picasso who joined in the organisation with great generosity. We particularly want to thank Claude Duthuit and Claude Ruiz-Picasso who represent them. Their support from the earliest days of the project has encouraged and helped us to assemble this exceptionally stimulating and beautiful exhibition offering many new insights on both Matisse and Picasso.

Loans of specific works were essential in order to make the comparisons and pairings. From the very first visits to collectors to explain the project and our needs, we found that belief in the nature of the exhibition was so great that most were prepared to lend important and often very popular works in their own collections for the whole period. Inevitably there will be a few variations in the contents in each museum as not all lenders could agree to be parted from works for the full length of the tour. This is particularly true of the works on paper, but the majority of the exhibition will remain the same throughout.

Our debt to all lenders is enormous and we trust that they will find that their faith in the project is justified when they see the exhibition. We offer them all our deep thanks for their great generosity.

It is hard for us adequately to thank all those staff of Tate Modern, of the Réunion des Musées Nationaux, of the Centre Pompidou/Musée National d'Art Moderne and of The Museum of Modern Art whose collective efforts have supported the curators throughout and who have helped to realise this outstanding exhibition. The project has been managed by three teams working in collaboration: Ruth Rattenbury for Tate Modern in London, assisted by Sophie Clark; Bénédicte Boissonnas for the Réunion des Musées Nationaux in Paris, assisted by Vincent David, who were also appointed to represent the Musée Picasso and the Centre Pompidou/Musée National d'Art Moderne; Jennifer Russell of The Museum of Modern Art in New York assisted by Maria DeMarco Beardsley and Claudia Schmuckli. We have relied heavily on the total dedication of everyone throughout.

This impressive, beautiful and fully illustrated catalogue was designed in New York by Steven Schoenfelder. The English edition has been published in England, edited by Sarah Derry. We offer both them and their assistants our deep thanks. The French edition will differ slightly in content and will be edited and published in France.

As always we are dependent on the generosity of our sponsors whose faith in the project has made everything possible. We should like to offer our sincere thanks to Ernst & Young who have so generously supported the exhibition in London at Tate Modern. In Paris the exhibition at the Galeries Nationales du Grand Palais has been made possible by the very generous support of LVMH/Moët Hennessy, Louis Vuitton and Christian Dior and to them too we offer our great gratitude. The Museum of Modern Art is most grateful for the outstanding generosity of Merrill Lynch, which has sponsored the exhibition and publication in New York.

Jean-Jacques Aillagon

Président du Centre Pompidou/Musée National d'Art Moderne, Paris

Glenn Lowry

Director of The Museum of Modern Art, New York

Francine Mariani-Ducray

Directrice des Musées de France. Président de la Réunion des Musées Nationaux, Paris

Nicholas Serota

Director of Tate, London

Curators' Acknowledgements

An exhibition of this scale and ambition could never have been realised without the assistance, advice and support of a great number of individuals and institutions. We are deeply grateful to all of them for the generosity and good will with which they have responded to our numerous and onerous requests.

Our first debt of gratitude is to the museums, foundations and private collectors who have consented to be parted from works of such exceptional importance and value, and to the directors, trustees and curators who have demonstrated such faith in our project. We thank most warmly all those listed on page 391, as well as the private collectors who have preferred to remain anonymous.

No exhibition on this theme would have been possible without the collaboration of the heirs of Matisse and Picasso. At an early stage, we approached Claude Duthuit and Claude Ruiz-Picasso, as the representatives of the two families, and were greatly heartened by their enthusiastic response to the concept of the show. Their support encouraged us to believe that it would indeed be possible to mount an exhibition worthy of a subject of this historical importance, and they have continued to aid and advise us unstintingly ever since. We are deeply grateful to them and to the other members of their families. In the Matisse family, in addition to thanking Claude and Barbara Duthuit, we should particularly like to express our gratitude to Georges Matisse, the late Maria-Gaetana Matisse, Paul Matisse, Pierre-Noël Matisse and Jacqueline Matisse-Monnier. In the Picasso family, as well as thanking Claude Ruiz-Picasso, we should particularly like to express our gratitude to Catherine Hutin-Blay, Christine Picasso, Bernard Ruiz-Picasso, Marina Ruiz-Picasso, Paloma Ruiz-Picasso, Diana Widmaier-Picasso, Maya Widmaier-Picasso and Olivier Widmaier-Picasso.

We have been extremely fortunate in the friendship and support of many people, who have been instrumental in helping us trace and secure crucial loans and have provided us with essential advice and information. Without their help this exhibition would be much less rich and beautiful and the catalogue much less substantial. We are particularly indebted to the following for their invaluable cooperation not only in seeking and securing loans but also in helping with material for the catalogue: William Acquavella, Dawn Ades, Isabelle Alonso, Jean-Pierre Angremy, Irina Antonova, Brigitte Baer, Laure Beaumont-Maillet, John Berggruen, Olivier Berggruen, Marie-Laure Bernadac, Irène Bizot, Yve-Alain Bois, Bruno Blaselle, Doreen Bolger, Richard Brettell, Francis Briest, Janet Briner, Doris Brynner, Wendy Bryson, Richard Calvocoressi, Kimberley Camp, Sara Campbell, Alessandra Carnielli, Camilla Cazalet, Eric de Chassey, Jean-Paul Claverie, Ivan Conquéré de Monbrison, the late Judith Cousins, Pierre Daix, the late Gilbert de Botton, Janet de Botton, Marie-Noëlle Delorme, Anne d'Harnoncourt, 9

Giuseppe Donegà, Roland Doschka, Sasha Dugdale, Anne Duruflé, Bernd Dütting, Teri Edelstein, Barbara Epstein, Hélène Fauré, Evelyne Ferlay, Jay Fisher, Michael FitzGerald, Jack Flam, Dominique Fourcade, Hunan Freimanova, Jay Gates, Sherri Geldin, Thomas Gibson, Françoise Gilot, Christopher Green, Wanda de Guébriant, Agnes Gund, Colette Haufrecht, Allis Helleland, Alan Hobart, Cornelia Homburg, David Jaffé, Philip and Helen Jessup, Paul and Ellen Josefowitz, Stella Kattan, Richard Kendall, James and Clare Kirkman, Albert Kostenevich, Marie-Josée Kravis, Diana Kunkel, Jeremy Lang, Rémi Labrusse, Emma Laurent, William S. Lieberman, Françoise Lemelle, Robert R. Littman, Manuel Lopez Bolinches, Daniella Luxembourg, Edouard Malingue, Marta-Volga de Minteguiaga, James Mayor, Marilyn McCully, Kasper Monran, Helly Nahmad, David Nash, Christine Nelson, Lars Nittve, Josep Palau I. Fabre, Robert Parks, Antony Penrose, Meg J. Perlman, Christine Pinault, Mikhail Piotrovsky, Joachim Pissarro, Sandra Poole, Marla Prather, Noëlle Prejger, Michael Raeburn, Eliza Rathbone, Peter Read, John Richardson, Elizabeth Rohatyn, Elaine Rosenberg, Pierre Rosenberg, Robert Rosenblum, Jacob Rothschild, William Rubin, Angelica Zander Rudenstine, John Russell, Sophie Scheidecker, Angela Schneider, Pierre Schneider, Daniel Schulman, Edouard Sebline, Robert B. Silvers, Ann Simpson, Hilary and John Spurling, Leo Steinberg, Dennis Stevenson, Michel Strauss, Charles F. Stuckey, Jaume Sunyer, Michael Taylor, Jennifer Tonkovich, Olga Uhrova, Brian Urquhart, Gertje Utley, Sylvie Vautier, Nicholas Watkins, Sarah Whitfield, Patricia Willis.

The directors of the four museums which we represent were extremely supportive from the first: Alfred Pacquement and his predecessor Werner Spies of the Centre Pompidou/ Musée National d'Art Moderne, Paris, Gérard Régnier of the Musée Picasso, Paris, Glenn Lowry of The Museum of Modern Art, New York, and Nicholas Serota of Tate, London. We have often benefited from their counsel and their knowledge and thank them most warmly for their full and constant cooperation.

In each of the three cities a team of people has worked with exceptional dedication and professionalism to ensure the successful realisation of the exhibition and the catalogue. It has been a complicated and taxing operation for all of them and we are extremely grateful to them for collaborating so whole-heartedly with us. We should particularly like to thank the following:

In London:

Dennis Ahern, Holly Allen, Elisabeth Andersson, Nicola Bion, Simon Bolitho, Jane Burton, Sophie Clark, Celia Clear, Catherine Clement, Phil Coles, Abbie Coppard, Deborah Denner, Sarah Derry, John Duffet, Stephen Dunn, Suzanne Freeman, Matthew Gale, Colin Grant, Penny Hamilton, Tim Holton, John Johnson, Sioban Ketelaar, Ann Katrin Köster, Catherine Macduff, Odile Matteoda-Witte, Jerry Mawdsley, Elizabeth McDonald, Stephen Mellor, John Miller, Philip Miles, Phil Monk, Nick Morse, Lynn Murfitt, Lars Nittve, Ruth Rattenbury, Katherine Rose, Mary Scott, Julie Simek, Patricia Smithen, Gill Smithson, Gabriella Svenningsen, Nadine Thompson, Sheena Wagstaff, Dave Willett, Calvin Winner.

In Paris:

At the Centre Georges Pompidou, Musée National d'Art Moderne/Centre de Création Indus-trielle: Agnès de la Beaumelle, François Belfort, Jean-Pierre Biron, Laurence Camous, Cathe-rine Duruel, Emmanuel Fessy, Jacques Hourrière, Claude Laugier, Brigitte Léal, Nathalie Leleu, Olga Makhroff, Bruno Maquart, Christiane Rojouan, Martine Silie, Brigitte Vincens, Anne-Marie Zuchelli.

At the Musée Picasso: Véronique Balu, Claire Bergeaud, Franck Besson, Hubert Boisselier, Jean-Pierre Chauvet, Patrick Destin, Fabien Docaigne, Dominique Dupuis-Labbé, Marie-Chris-tine Enschaïen, Thomas Eschbach, Pierrot Eugène, Sylvie Fresnault, Vidal Garrido, Laurence Madeline, Paule Mazouet, Yann Pelé de St-Maurice, Mélanie Petetin, Jean-René Quentric, Dominique Rossi, Hélène Seckel-Klein, Jeanne-Yvette Sudour, Marie-Liesse Sztuka, Vérane Tasseau, Patrice Triboux.

At the Réunion des Musées Nationaux: Juliette Armand, Hélène Bartissol, Thomas Bigeon, Béatrice de Boisséson, Bénédicte Boissonnas, Bernadette Caille, Evelyne David, Vincent David, Pascale Desriac, Philippe Durey, Fabien Escalona, Béatrice Foulon, Anne Giani, David Guillet, Sybille Heftler, Marie-José Lecoeur, Jean Naudin, Laetitia Noppe, Alain Madeleine-Per-drillat, Michel Richard, Francine Robinson, Gilles Romillat, Cécile Vignot.

with the additional help of: Jean-François Bodin, Georges Collins, Béatrice Hatala, Bernard Lagacé, Hélène Lebreton, Marc Vallet.

In New York:

Esperanza Altamar, Anny Aviram, Ramona Bannayan, Jamie Bennett, Karl Buchberg, Daniela Carboneri, Mikki Carpenter, James Coddington, Kathy Curry, Sharon Dec, Maria DeMarco-Beardsley, Gary Garrels, Maria del Carmen González, James Gundell, Madeleine Hensler, Ruth Kaplan, Katherine Krupp, Kynaston McShine, Michael Maegraith, Michael Margitich, K Mita, Kim Mitchell, Jerome Neuner, Pete Omlor, Susan Palamara, Avril Peck, Peter Perez, Elizabeth Peterson, Diana Pulling, Ed Pusz, Jennifer Roberts, Cora Rosevear, Susanna Rubin, Jennifer Russell, Claudia Schmuckli, Deborah Schwartz, Ethel Shein, Rebecca Stokes, Deborah Wye.

Elizabeth Cowling
*Senior Lecturer, Department of
Fine Art, University of Edinburgh*

John Golding
Painter and art historian

Anne Baldassari
Curator, Musée Picasso, Paris

Isabelle Monod-Fontaine
*Deputy Director, Musée National
d'Art Moderne, Paris*

John Elderfield
*Chief Curator at Large, The Museum
of Modern Art, New York*

Kirk Varnedoe
*Formerly Chief Curator of Painting and
Sculpture, The Museum of Modern Art,
New York and now Professor of the History
of Art, School of Historical Studies,
Institute for Advanced Study, Princeton*

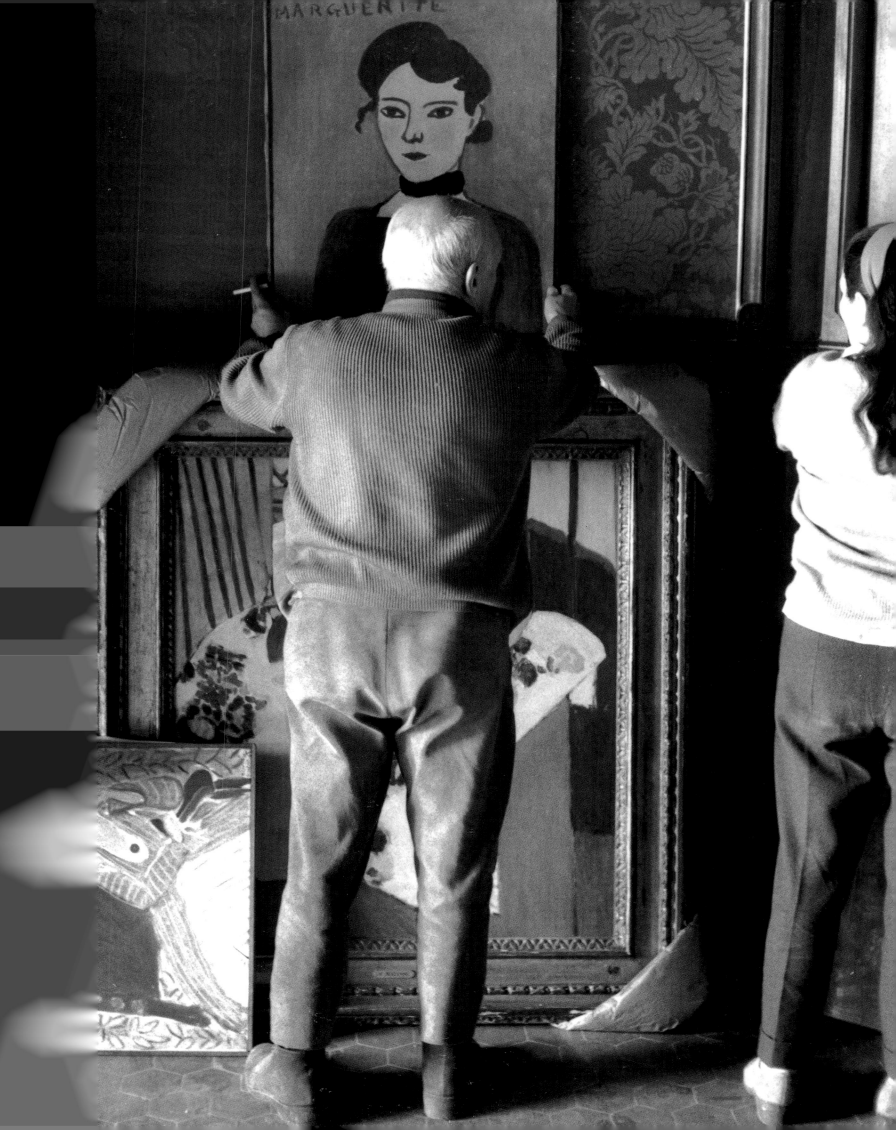

Introduction

John Golding

*You have got to be able to picture side by side
everything Matisse and I were doing at that time.
No one has ever looked at Matisse's painting more
carefully than I; and no one has looked at mine
more carefully than he.*

<div align="right">

PICASSO, IN OLD AGE[1]

</div>

This exhibition tells one of the most compelling
and rewarding stories in the entire history of art.

It was in March of 1906 that three members of
the Stein family, then living in Paris, took Matisse
to Picasso's studio, presumably to see the portrait
of Gertrude Stein on which Picasso was at work.[2]
Contrary to Gertrude's later assertion that 'hitherto
Matisse had never heard of Picasso and Picasso
had never met Matisse',[3] the two men were already
aware of each other's work and may even have
encountered each other. Paintings by both artists
could be seen at the gallery of Berthe Weill and,
more prestigiously, at Vollard's. But in Picasso's
mind the momentous meeting became associated
with his visit to the Salon des Indépendants of
1906 which opened on 20 March. Matisse was rep-
resented there by a single work, *Le Bonheur de
vivre* (fig.2). Simultaneously the Galerie Druet
mounted a substantial one-man show of Matisse's
work. Matisse was now confirmed as 'chef d'école'
of the Fauve movement which represented all that
was most advanced and audacious in young French
painting. *Le Bonheur de vivre* was to reverberate in
Picasso's imagination throughout his life.

Picasso, twelve years younger than Matisse,

was in a very different position. In Spain he had
been accepted as a child prodigy. Since establish-
ing himself in Paris in 1904 he had remarkably
quickly attracted the attention of critics, writers
and of a few dealers, but most of his closest
friends were like himself expatriate Spaniards; he
still spoke indifferent French. As personalities the
two men were diametrically opposed. 'As different
as the north pole is from the south pole',[4] Matisse
himself once said. Although in previous years
Matisse had experienced self doubts and hardship
at many levels, by the time of his meeting with
Picasso he had acquired great presence and
showed, superficially at least, great self-assurance.
The Steins, for instance, saw him as erudite,
affable, but slightly remote; he was invariably
impeccably turned out. The image of Matisse as
an anti-bohemian would cling to him for the rest of
his life. Matisse had studied for the law and his
subsequent evolution as a painter had been meas-
ured, even carefully calculated – he spelled himself
out shrewdly.

Picasso's career had already about it a touch
of the meteoric. Matisse's charm, when he cared
to exert it, was formidable but cultivated. Picasso's
charisma was from the start magical and unforced.
He could be capable of unkindness, even of cruelty,
but such was his magnetism that those whom he
had hurt or wounded almost invariably were irre-
sistibly attracted back to him. He was elemental.
Like nature itself he was unpredictable and he
ignored all conventions: a born bohemian. Initially
the two men circled each other warily. But from
the start each seems to have recognised instinc-
tively that the other was to be his only true rival.
Gertrude Stein was to write: 'They were friends but
enemies',[5] but this was not altogether true; as so
often in Stein's writing she falls prey to the striking
aphorism or phrase. Both artists were later to talk
of their early encounters with a certain nostalgia.
In later years Matisse was to remember this as a
time of intellectual generosity:[6] 'Our disputes were
friendly'.[7] They began to meet with regularity. They
visited each other's studios frequently, undoubt-

fig.1 David Douglas Duncan
*Pablo Picasso and Jacqueline Roque
with three paintings by Matisse,
'Portrait of Marguerite', 'Still Life with
Basket of Oranges' and 'Seated Girl
in a Persian Dress', Vauvenargues,
Spring 1959*

fig.2 Henri Matisse
Le Bonheur de vivre 1905–6
Oil on canvas 174 x 238 cm
The Barnes Foundation,
Merion Station, Pennsylvania

13

edly in a spirit of competitiveness but also out of intense curiosity. On Saturdays they encountered each other at the Steins' 'evenings' in the rue de Fleurus, Matisse urbane and discursive, but always to the point, Picasso silent and smouldering. In 1907 they exchanged pictures, each carefully choosing a work that underlined their temperamental differences (nos.3–4).

At the time of their encounter Matisse's art was in advance of Picasso's, not in terms of quality, but in audacity and colouristic freedom. Picasso was fully aware of developments in French Post-Impressionism, and they had already found their way into his art. The most recent work of Picasso's that Matisse was encountering, on the other hand, showed him identifying with an archaic classical past, exploring the cradles of Mediterranean culture. Matisse himself, in *Le Bonheur de vivre*, had consulted a wide variety of Renaissance and post-Renaissance sources as well as synthesising the achievements of his more immediate Post-Impressionist mentors. But despite his early immersion in Dutch and subsequently in Italian Trecento sources Matisse remained an artist in the classical French tradition. Picasso's work, on the other hand, at the time of their encounter was already beginning to exude that sense of universal atavism which was to brand so large a part of his subsequent production.

Early in 1906 Picasso had executed various studies and sketches of naked youths and horses which suggest that he was preparing to embark on an ambitious, large-scale project. This he now abandoned, possibly because he felt that if he was to make an answer to *Le Bonheur*, it must be of a more radical nature. In the autumn of that year his work was in a state of crisis. Standing in front of, for example, *Two Nudes* (no.103), painted late in the year, in the exaggerated girth of the figures one senses an impending explosion. It came in the spring of 1907 when he began work on the great canvas that was to become known as *Les Demoiselles d'Avignon* (no.7). If *Le Bonheur de vivre* is one of the landmarks in the history of art, the *Les Demoiselles* is one of those rare individual works of art that changed its very course. It remains the most significant single twentieth-century painting.

Matisse disliked *Les Demoiselles* and was indeed upset by it, a reaction shared by virtually everyone else on their first encounter with the picture.[8] And this despite the fact that his own *Blue Nude* (no.14), hung in the Salon des Indépendants

of the spring of 1907, had left its mark on the picture. Matisse had paved the way for Picasso in other respects. Picasso had long since been aware of the art of Cézanne, but by his example Matisse had demonstrated to Picasso that Cézanne's work could be put to new and revolutionary conclusions. Then, soon after their meeting, Matisse had shown Picasso an example of tribal art, which he had recently begun to collect, a prelude to the revelation that Picasso experienced when he visited the Trocadéro Museum while at work on *Les Demoiselles* (fig.3). Despite his admiration for the formal properties of 'art nègre', it affected the appearance of Matisse's art relatively little, although its presence can be felt at a distance in certain works such as the *Portrait of Madame Matisse* of 1913 (no.52). Matisse was a discriminating collector of tribal art. Picasso, who was as much interested in the principles behind it as in the art itself, tended to pick up anything that came his way. It could even be argued that some of the rougher, more truly primitive examples of tribal art that he owned helped to foster the anti-aesthetic bias of much of his own work, a bias emphatically not shared by Matisse (fig.4). Cézanne and tribal art were to be the two greatest influences on the *Les Demoiselles*. Nevertheless, Matisse recognised that the picture presented to him a threat that could not be ignored.

Matisse responded to it in 1908 with his own *Bathers with a Turtle* (no.8), a canvas of comparable dimensions, and imbued with a gravitas that was new to his own art. In the summer of 1907 Matisse had travelled to Italy for the first time and his contact with Italian art of the fourteenth and fifteenth centuries – with the work of artists still being referred to as the 'Italian Primitives' – and above all with its mural art, demonstrated to him how he could adapt his own art within a tradition of Western painting in such a way that it could accommodate or answer the challenge of the so-called primitivism of Picasso's work that formed the prelude to the emergence of Cubism. In Matisse's great canvas the influences of Giotto (fig.5) and Cézanne are together paramount. Picasso admired the *Bathers with a Turtle*[9] and was in turn to reply to it with a series of three figure compositions – the most celebrated is *Three Women*, completed probably late in 1908 and now in the Hermitage Museum – which together with the still lifes that accompany them are the antechamber to his own true Cubism. He embarked upon Cubism

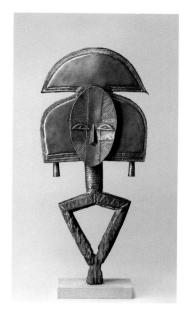

fig.3 Reliquary figure from Kota, Gabon
Early twentieth century
Wood, copper and brass 67 x 30.5 cm
Musée des Arts d'Afrique et
d'Océanie, Paris

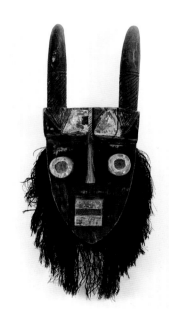

fig.4 Grebo Mask, Ivory Coast
Nineteenth century
Painted wood and fibre 64 x 25.5 x 16 cm
Musée Picasso, Paris. Formerly in the
Picasso collection

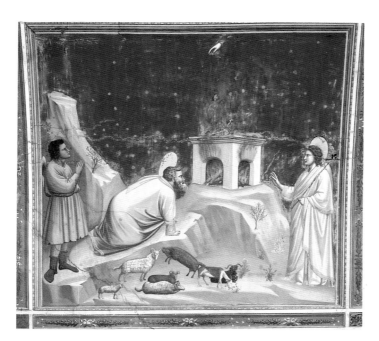

retreated from this threshold; but it was one which Matisse, to whom total abstraction was equally unsympathetic can only have viewed askance. 'Picasso shatters forms', Matisse said later, 'I am their servant'.[10] The Cubism of Picasso and Braque involved the reinvention of the vocabulary of painting (and subsequently of sculpture) in the interests of creating an art that was representational but anti-naturalistic. This is confirmed by the bulk of their entire subsequent production. Matisse's art, throughout his entire life, is tinged by naturalism. For him, art 'consists of a meditation on nature, on the expression of a dream which is always inspired by reality'.[11]

Matisse, in his celebrated *Notes of a Painter* of 1908, writes: 'For me all is in the conception. I must have a clear vision of the whole right from the beginning'.[12] The intellectual implications of Cubism were greater than those of the art of Matisse: for example, the substitution of the solid by the void, or the introduction of illusionism into an art whose initial premises had challenged its validity. Despite the immediate visual splendour of so much of Matisse's art, in the final analysis his approach was more pondered, more intellectually calculated, than that of Picasso. And yet, paradoxically, throughout his life Matisse preached the doctrine of intuition; Bergson appears to have been the only philosopher whom he read in depth. Yet looking at his work, and trying to recreate his working processes, one often senses that he sought for effects of spontaneity rather than for spontaneity itself. On the other hand many of Picasso's innovations during his pre-war Cubist years were first explored in experimental drawings and to this extent some of his canvases had been worked out before they were begun. In turn Matisse's own works on paper are often of a genuinely exploratory nature.

If Matisse had nevertheless absorbed something of Analytic Cubism (no.63) it was to the second major or Synthetic phase of Cubism that he felt he must react. His engagement with it was preceded and in a sense prepared for by his growing identification with Islamic art, confirmed by his visit to Munich in 1910, undertaken especially to

however, characteristically enough, hand in hand with an artist whom he regarded not so much as a rival, but rather simply as a useful collaborator: Georges Braque.

By 1909 Cubism had made its initial premises clear (no.54). The dismissal of traditional Western single viewpoint perspective now enabled Picasso to take possession of his subjects totally, and in a new way, by viewing them from all angles. The following year Cubism entered its crystalline or 'hermetic' period which was to last some two years. It produced works of haunting but enigmatic beauty. Initially, at least, Matisse disliked all Cubism's early manifestations. He appears to have found Analytic Cubism too austere, too cerebral. This may be in part because in their quest to reinvent the vocabulary of painting Picasso and Braque had been forced temporarily to suppress colour which Matisse had come to view as his own prime vehicle. Here we face a paradox. As the Cubists evolved new techniques, new compositional procedures, they were at times relentlessly carried along by their discoveries, their improvisations. Many Cubist paintings were begun as pictorial adventures whose final destinations were not recognised until they had been achieved. Although neither Picasso nor Braque were interested in abstraction as such, during the summer of 1910 Picasso's search for new ways of depicting volumetric forms involved him in dissolving his subjects into complexes of semi-transparent, interacting planes and brought him to the threshold of abstraction (no.62). He

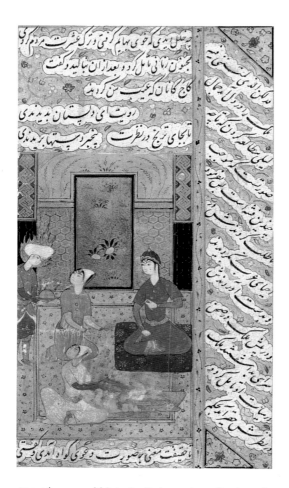

see a large and historically important display of Islam's visual magnificence. He said, 'Persian miniatures . . . through their accessories . . . suggest larger spaces, a more truly plastic space. They helped me go beyond the painting of intimacy'.[13] So, subsequently, did his recognition of the compositional procedures of Cubism. Matisse's apprehension of Islamic art was to be of comparable significance to his entire subsequent production as was Picasso's instinctual identification with the visual principles of tribal art and the animating forces behind them for his.

Islamic art spoke to Matisse at various levels. He was attracted to its colouristic richness and its strong decorative appeal. Matisse talked and wrote often of the 'decorative' in art and over the years he gave the term a series of different inflections. But basically for him the decorative came to mean an allegiance to the totality of the painted surface and to the overall spiritual and emotional aura that radiated from it. In this respect his approach contrasts strongly with that of Picasso who was above all a maker of images, images which are often strongly centralised. The areas or spaces around

these images, his subjects, were for the most part of lesser pictorial interest to him and often in his work have about them a slightly perfunctory or 'unfinished' quality. Then Matisse is one of the very few Western artists who have been able to invest pattern, normally associated with flatness, with spatial properties. The spatial conventions of Islamic art (which had something in common with those of the Italian Quattrocento) allowed its practitioners to convey a wealth of spatial information, often precisely by the use of differentiated patterns and decorative devices. Thus within a format of some few square inches a Persian miniature can evoke the space of a great interior, of the rooms below or above, of the stairwell that connects them and of the balconies and gardens beyond (fig.6). Later in life when from time to time pictorial space becomes of greater concern to Picasso, as for example in the studio pictures of the mid-1950s (no.156), one often senses Matisse's influence very strongly.

Matisse's interest in Cubism was given impetus by his contacts during the summer of 1914 in Collioure with Juan Gris, the third and youngest of the major initiators of Cubism. Gris had begun his career as a painter under the auspices of Picasso

fig.6 Anonymous
Yusuf Entering the Presence of Zulaynka for the First Time 1750
Courtesy of the Trustees of the British Museum

fig.7 Henri Matisse
The Painter's Family 1911
Oil on canvas 143 x 194 cm
The State Hermitage Museum, St Petersburg

and it was his *Homage to Picasso* of 1912 (a Cubist portrait of his fellow Spaniard) that had first brought him to the attention of the public. In Gris's hands and work the flexible grids of Analytic Cubism became more rigorously organised into compositional devices extending to the canvases' outer edges (fig.8). This fealty to the totality of the painted surface Matisse would have respected. He also saw that, as in the case of Persian miniatures, the pictorial areas created by these grids could be viewed as space cells to be enriched by colour and pattern. Matisse was also clearly drawn to Gris

fig.8 Juan Gris
The Watch 1912
Oil and paper on canvas 65 x 92 cm
Private Collection

because of the rigours of the younger man's work and mind, and at Collioure they talked endlessly about pictorial theory;[14] Picasso's early pronouncements on art tended to be of an anarchistic and abrupt nature. There are indications that relations between Matisse and Picasso had recently undergone a period of strain.[15] But friendly relations had been restored: in 1913, for example, they had gone riding together. Certainly there can be no doubt at all that during the years between 1914 and 1917, when Matisse felt that his art could no longer ignore the achievements of Cubism, it was with Picasso that he saw himself in dialogue and confrontation.

The second or Synthetic phase of Cubism was initiated by the invention of *papier collé*, a device inspired, in part at least, by the Cubists' desire to reintroduce colour into their paintings in such a way that it could reinforce the presence of objects, of the subject, yet remain independent of it, unconditioned by the outlines or contours of things.[16] To take a simple example: an irregularly cut piece of green paper is laid on a ground and the outline of a bottle is laid over it. By implication the green is drawn into the representation or substance of the bottle. Yet it remains a flat, independent compositional and colouristic element in its own right. Now, rather than analysing and fragmenting their subjects and the space around them the Cubists were building them up with self-contained but interacting elements, with pieces of cut and pasted paper

or with flat shapes of unmodulated colour derived from them. In the process of doing so they were inventing totally new compositional procedures. Because colour was involved Matisse could not ignore them. The flat unmodulated colour introduced into Cubism originally through the use of cut and pasted paper, however, finds an echo in Matisse's art. He was to speak of working 'according to modern methods of composition'.[17]

From Fauvism onwards Matisse had orchestrated and unified his pictures through colour, which could be broken and dappled or else used pervasively, as a field into which other colour areas could be introduced. He now saw how he could construct his pictures more architecturally in terms of flat coloured areas that would bond together on the canvas surface, but which could yet suggest a naturalistic space. Matisse's engagement with certain aspects of Cubism enabled him to produce a series of masterpieces, more rigorous in their surface organisation than anything he had yet executed (nos.71–2, 75). These are some of the most rigorously flat pictures that Matisse ever produced. And yet they are imbued with spatial sensations that are measurable to the eye. The deliberate spatial ambiguities and tensions created by colour relationships in Picasso's Synthetic Cubism (nos.60, 66), and in which he delighted, were foreign to Matisse's concerns. And whereas in Matisse's Cubist-related paintings colour at first sight appears to be applied flatly, it is invariably

17

subtly inflected, often by allowing traces of the white ground to glimmer through. Only a colourist of Matisse's genius could have achieved a balance between colour that adheres so strictly to the pictorial surface and which can yet suggest to the viewer a naturalistic space, the space we all experience in our daily lives. It is significant that with a single exception,[18] Matisse's most overt responses to Cubism's compositional procedures should be on a monumental scale. Most of Picasso's Cubist pictures executed between 1909 and 1914 are of average size. Now a larger format was once again becoming of interest to him, most notably in his *Harlequin* of 1915 (no.70) and above all in *Man Leaning on a Table* of 1916 (fig.44), his last truly experimental Cubist masterpiece. In succeeding years, and in response to Matisse's achievements, his Cubism becomes simplified, more immediately accessible, even at times somewhat theatrical in its effects (nos.73, 76).

At the time of the outbreak of war in the eyes of many Matisse and Picasso were firmly established as the two greatest living painters.[19] They were represented as such in the Moscow collection of Sergei Shchukin, possibly the finest of its kind. Here the two men emerged as the true and revolutionary heirs to the artists in Shchukin's holdings of French Post-Impressionism. Despite the altered artistic circumstances Paris was experiencing, during the first two years of the war Matisse and Picasso contrived to meet fairly frequently. Both artists were exhibiting a certain amount, and were following developments in each other's work closely. Both contributed to the Salon d'Antin in July 1916, one of the most significant of wartime cultural events (literary and musical sessions accompanied the exhibition).[20] It was here that *Les Demoiselles d'Avignon* was first shown publicly. Matisse had just finished a key work of what might be termed his 'heroic' period: *The Moroccans*, of 1915–16 (no.72), and was still struggling with the culmination of his compositions 'in the modern manner' – the great *Bathers by a River* (fig.12), begun in 1909–10, reworked between the spring and early autumn of 1913, and brought to completion probably soon after the Salon d'Antin closed.

The lifestyles of the two painters and their art were, however, about to diverge sharply. Already in the years 1914–15, just at the time that Matisse was starting to assess the Cubist achievement with such formidable results, Picasso's work was beginning to show a certain stylistic restlessness. In the summer and autumn of 1914 he executed some naturalistic, detailed drawings, a prelude to a series of Ingresque portrait drawings, some of them executed from photographs. At the end of 1915 he made the acquaintance of two impresario figures from a world hitherto outside his own: Jean Cocteau and subsequently, and more importantly for immediate developments in his art, Serge Diaghilev. By the autumn of 1916 he had agreed to cooperate with them and the composer Erik Satie on the ballet *Parade*. Preparations for it took him to Rome and further extended the new cast of characters in his life. These soon brought him into contact with 'le beau monde'. By the end of 1918 he had married the ballerina Olga Khoklova, the daughter of a Russian army officer, and had moved to a fashionable address in the rue La Boëtie. Olga had social ambitions and these inevitably affected Picasso, too.

Already during the course of 1917 Matisse's art had begun to show a reversion to a more naturalistic and less self-consciously modernist approach. At the end of the year he moved to Nice. He was to live in Nice and its vicinity for the greater part of the year for the rest of his life. The works of his first Nice period at their most characteristic are modest in scale and show interiors, often furnished by anonymous young women, posed sometimes against patterned screens, and bathed in a soft, pure light that filters in through half-shuttered or curtained windows. Matisse's new naturalism was in a sense the counterpart to the prevalent trend in the early 1920s towards neoclassicism, initiated in large part by Picasso himself. Yet in Picasso's large-scale, increasingly pessimistic and often disturbing and monumentally distorted nudes and figure pieces of his neoclassical manner (no.102), and in the ferocity and violence of his two key works of 1925 – *The Three Dancers* (no.82) and *The Embrace* (fig.9) – he and Matisse had drawn as far apart from each other's art as they had ever been since first they recognised each other's importance, even allowing for Matisse's resistance to Analytic Cubism. Only in some of Matisse's sculpture is it possible to find parallels with the girth and weight of Picasso's new neoclassical figure style (nos.104–5). And even in *The Three Dancers*, a turning point in Picasso's career, one senses that Picasso is still haunted by memories of Matisse's earlier work.[21]

fig.9 Pablo Picasso
The Embrace 1925
Oil on canvas 130 x 97.7 cm
Musée Picasso, Paris

fig.10 Pablo Picasso
Nude with Guitar Player 1914
Pencil on paper 20 x 29.8 cm
Musée Picasso, Paris

ling and seeing other painters. Several times he visited Renoir, revered also by Picasso. In particular he was being drawn close to Bonnard, whose work Picasso disliked. But Matisse was also becoming increasingly turned in upon himself and his own working processes. Already by 1919 Matisse was having photographs taken of works in progress to record the workings of his own mind, the movements of his hands. Despite the fact that Picasso's work was punctuated by major masterpieces, increasingly he worked in series, his quicksilver mind substituting one image for another. Matisse pruned and honed.

At another and deeper aesthetic level it was the Surrealist ethos, which increasingly dominated cultural life in Paris as the 1920s progressed, that was driving such a deep wedge between Matisse and Picasso. In 1914 Picasso had produced a series of some one hundred drawings of a strongly proto-Surrealist flavour. In them the reductive linear language sign evolved by Picasso during his Cubist years was put to different effects; the ubiquitous Cubist double curve, for example, could be used to signify a head seen from two viewpoints, or it

In the summer of 1926 Matisse wrote in a letter to his daughter: 'I have not seen Picasso for years. I don't care to see him again . . . he is a bandit waiting in ambush.'[22] Here it was almost certainly not only of Picasso's recent work but also of Picasso's lifestyle that Matisse was disapproving. He himself had by now worked for Diaghilev but unlike Picasso (however temporarily) he was uninfluenced by the glamour of theatrical life. The reception of *Le Chant du Rossignol*, premiered at the Paris Opéra in February 1920, was not favourable, although this had more to do with the music (by Stravinsky) and the choreography (by Massine) than with the sets and costumes. Unlike Picasso, Matisse was not stimulated by collaboration. Again, as opposed to Picasso, whose curiosity about patterns of human behaviour was boundless, Matisse was never a social or artistic tourist. Matisse's eye was selective. Picasso's could be caught by anything on which it settled. During his first eight or nine years in Nice Matisse was living in comfortable but modest quarters in hotels and rented apartments. Summers were mostly spent at the house and studio at Issy-les-Moulineaux, just outside Paris, with working spells in Paris itself. He was not living a totally reclusive life; he was travel-

could represent the outline of a guitar or the contours of a female body (fig.10). The interchangeability of imagery, particularly of facial and bodily parts, was something in which the Surrealists were to revel. Picasso never became a true Surrealist, primarily because he was unable to approach the external world, to use a phrase of André Breton's, 'with the eyes closed', Surrealism's ideal way of facing perceived reality. Nevertheless he was to become, together with De Chirico and Marcel Duchamp, one of the three major influences on visual Surrealism. In the second half of the 1920s Picasso was evolving a new, pliable and fluent biomorphic idiom. And it was the principle or concept

of biomorphism that for the first time was to bring visual cohesion to much Surrealist painting, which had hitherto been stylistically so disjunctive. Picasso's own biomorphic figure style drew upon a plethora of new 'primitive' or tribal enthusiasms enjoyed by the Surrealists – Oceanic art, Neolithic rock painting, Easter Island heiroglyphs amongst them. Biomorphism was highly susceptible to eroticism, one of the Surrealists' prime concerns. And no one, with the exception of Miró, whose use of it was to be whimsical, if often brutal, exploited it to greater erotic effect than Picasso himself.

The Surrealists, initially at least, admired Picasso above all other figures and courted him almost as a deity. The movement's leader, Breton, was to write: 'Proudly we claim him as one our own . . . Surrealism, if it is to adopt a line of conduct, has only to pass where Picasso has already passed and where he will pass again'.[23] Picasso exhibited with the Surrealists and his work was prominently figured in the movement's official publications, most notably in the July 1925 issue of La Revolution surréaliste.[24] Breton had in youth been a devotee of Matisse's work. Now he viewed its latest manifestations with distaste, even a certain contempt, as the epitome of bourgeois conservatism.[25] The critical position that Matisse was now occupying was ambiguous. On the one hand he was regarded as a master who had been assimilated into a recognisable French tradition. He was the only twentieth-century painter to be included in an important exhibition held in 1919 in New York, and which featured works by Courbet, Manet, Renoir and Cézanne. On the other hand he was seen as a once daring innovator who was now a spent force. In 1919, reviewing an exhibition of Matisse's drawings, already Cocteau wrote dismissively: 'The sun-drenched beast of Fauvism has turned into one of Bonnard's kittens'.[26] Matisse makes no mention of Surrealism in his published writings, but to someone of his temperament its aesthetic can only have been repugnant. He would have disliked its obsession with the overtly erotic. For him beauty lay in serenity and not in the disquieting and 'convulsive'.

During Matisse's first Nice period, subtly, and at times imperceptibly, a new theme, which had figured in his work earlier, begins to permeate his art. Now, and increasingly, the anonymous young women who furnish his interiors were taking on the attributes of oriental odalisques. Clothed, partially clothed, or nude, they adopt languid attitudes and are often given oriental attributes of dress. Even the paintings depicting women in contemporary dress have about them the flavour of subject pieces. Some of the earliest Nice works are markedly naturalistic, in particular the landscapes. But the interiors are not as straightforward as they might at first seem, because pattern tends to be used disjunctively, anti-perspectivally, giving it a floating and often slightly exotic and dreamlike air. The harem has invaded the bourgeois French interior. The odalisque was to form an important part of Matisse's repertoire for the rest of his life. Again, it was placing him in a French nineteenth-century tradition. The names of Delacroix and Ingres come to mind among a host of others.

It was through the odalisque that Picasso now invaded Matisse's territory and partially justified the accusations of banditry. Matisse's nudes and semi-nudes are sensuous but seldom sensual; their eroticism is always filtered, veiled. They seduce the viewer through art, visually but rarely corporeally, although some of his drawings are more overtly physical in their appeal. Picasso's single female nudes of the late 1920s are charged with an overt, overwhelming sexuality that is not inviting but is, rather, threatening, devouring. By his own admission he was an autobiographical artist, and his art now tells us, indirectly, about the deterioration of his private and domestic life with his wife Olga, and of the threat he felt it was posing to his creativity. At virtually no point in his career does Matisse give us more than a glimpse of his private life or how it might be affecting his art. He invites us into his studios and his living quarters, although from the first Nice period onwards the two were to become increasingly synonymous.[27] But of his personal pleasures and problems he tells us virtually nothing. To have done so, he would have reasoned, would be to destroy the purity of his art. It might perhaps be fair to say that for Picasso all of life was there to be put at the service of art, while for Matisse art was a sublimation of it, even, at times, a substitute for it.

Many of Picasso's nudes of the second half of the 1920s look like brutal challenges to Matisse's odalisques. In a sense they are anti-odalisques (nos.112, 115). Then, in 1932, with his overt allusions to a new muse who had entered his life several years earlier, Marie-Thérèse Walter, his art entered a new phase. The Marie-Thérèse series are the ripest pictures he ever executed and are also

among the most colouristically opulent. His use of colour was never to match that of Matisse in terms of subtlety and nuance. Years later he was to say to Matisse: 'I've mastered drawing and am looking for colour; you've mastered colour and are looking for drawing'.[28] Colour in some of the Boisgeloup pictures is explosive, even occasionally bordering on the excessive, underlining Picasso's Spanish propensities for extremes. Yet in others the debt to Matisse is palpable, as contemporary critics observed.[29] These are his true answers to Matisse's odalisques and his response to the major retrospective of Matisse's mounted at the Galeries Petit in the summer of 1931. A year earlier, in 1930, the Galerie Pierre staged an exhibition of Matisse sculpture and this, too, had affected Picasso deeply. He had very recently purchased the Château de Boisgeloup, near Gisors, some forty miles out of Paris, partly at least as storage space. After taking possession of Boisgeloup he converted the stable into a sculpture studio and entered a phase of intensive sculptural activity.

Despite the importance of Matisse's 1931 retrospective its selection had been somewhat haphazard with an emphasis on the early Nice period when Matisse was producing some of the least obviously innovative works of his entire career. Critically the exhibition was not a success. Exactly a year later, in 1932, the same gallery accorded Picasso an even larger retrospective. Having observed the lack of rigour in the organisation of his rival's display, Picasso selected and installed the exhibition himself (the last time he was to do so). It was thus weightier and more truly representative of his achievement. Again critical reception was mixed. Picasso continued to astound by his infinite variety, but because of this many viewed him warily as a leopard who had too often changed its spots, and hence as too eclectic and by implication too intellectual an artist.[30] Although the mounting literature on both artists tended to polarise them,[31] interestingly enough certain critics were now also stressing Matisse's changeability.[32] In truth, as

has been suggested, Picasso was basically an instinctual and impulsive artist whereas Matisse's seemingly effortless and hedonistic approach was more truly pondered. The fact is that the celebrity of both artists had by now become so overwhelming that a critical backlash was inevitable. But negative reactions to their most recent work must, subconsciously at least, have helped the two artists to begin reforming ranks. There is a sense in which their very fame was creating new bonds between them.

During the course of 1929–30 Matisse's own production, in terms of easel painting, declined sharply, possibly in part because of his recognition that temporarily the critical tide had turned against him. He re-entered high modernism through his Barnes Murals (fig.11), his intensive works on graphics and in particular, it has been suggested, through his illustrations for Mallarmé's *Poésies*.[33] These were executed in partial rivalry with Picasso's for Ovid, themselves somewhat Matissean in their reductive purity of line. *Les Métamorphoses d'Ovid* appeared in 1931, the *Poésies de Stéphane Mallarmé* a year later. If in France Matisse was still not being accorded the official recognition that his position demanded, his status abroad, and now particularly in America, was more deeply entrenched. His 1931 exhibition in New York had been a great success, and as a juror that same year of the Carnegie prize he had been instrumental in awarding the prize to Picasso. In America he visited one of the greatest of all his patrons, Albert Barnes, at Merion, just outside Philadelphia. There

fig.11 Henri Matisse
The Dance I (The Barnes Murals) 1932–3
Oil on canvas 339 x 441.3 cm (left),
355.9 x 503.2 cm (centre),
338 x 439.4 cm (right)
The Barnes Foundation, Merion Station,
Pennsylvania

fig.12 Henri Matisse
Bathers by a River 1909–16
Oil on canvas 259.7 x 389.9 cm
The Chicago Art Institute. Charles H. and
Mary F.S. Worcester Collection, 1953

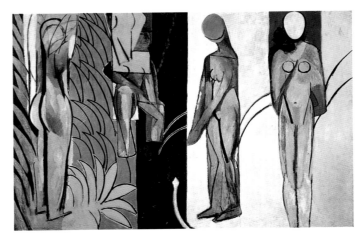

he saw many of his own early masterpieces, including *Le Bonheur de vivre*. This undoubtedly revitalised him and it was now that the idea for the Barnes murals was born and soon formalised.

Matisse worked on the project almost exclusively from early 1931 through to May 1933. The murals (there are three sets or variants) represent a new pinnacle in his art and they look back to the heroic years of his modernism. Their closest compositional analogies are with the great *Bathers by a River* (fig.12), completed 1916, when he had digested Cubism's compositional procedures and transformed them to his own ends. The abstract compositional backgrounds of the Barnes murals, into which the dancing figures are inserted and fused, were achieved by endless adjustments of cut and pasted paper, a procedure which on visual evidence alone was probably used for the first time in the great Chicago painting. *Papier découpé*, in a sense Matisse's totally personal variant of Cubism's original *papier collé,* was henceforth to be of prime importance to much of Matisse's art. In 1933, having installed his murals in The Barnes Foundation, Matisse sought respite at an Italian spa (Abano-Bagni), and from there he returned to Padua to look once more at the Giottos which he had consulted in 1907 when he was first facing Picasso's challenge. There is a sense in which he now was revisiting his own revolutionary past. In September, back in Nice, he resumed painting. His canvases become once again more compressed, more monumental. They show an awareness of Picasso's recent achievements and of the debt which Picasso in turn owed to him (no.120). In 1935 Picasso himself stopped painting for a longish spell and turned for release to an outpouring of surrealistically-turned poetry. In the spring of 1936 both artists had exhibitions of recent work at the Galerie Paul Rosenberg. The following year, 1937, has been viewed as one of intense competition.[34] Much of Picasso's immediately pre-Second World War work remains violent and troubled. Yet in moments of calm, as for example in the last of the Marie-Thérèse pictures (she now appears most often costumed rather than nude), or in the majestic early portraits of Dora Maar, Picasso draws pictorially close to Matisse in a new more relaxed, almost fraternal fashion. Matisse himself was by now experiencing a domestic crisis; he was in the process of separating from his wife of many years. Of this, in his work, he tells us nothing.

May 1940 saw the last meeting of Matisse and Picasso for almost five years. By now their relationship had moved onto a plane of truer, deeper friendship.[35] They were bound together by the recognition of each other's genius, but also, and possibly at an even deeper level, because, although they both saw themselves as modernists, each saw the other as extending the frontiers of tradition. It is this that gives their rivalry a very different dimension from that of the exchange that Matisse had enjoyed with his younger collaborators, Derain and Vlaminck, in the creation of Fauvism, and the even deeper collaboration between Picasso and Braque in the invention of Cubism. Indirectly, the war itself helped to cement this closeness. Spanish to the core of his being, France was Picasso's adopted country. And to him Matisse now represented French culture. For some time he had associated Matisse with Delacroix whom he had come increasingly to venerate. Similarly, whenever the name of Baudelaire was mentioned Picasso invariably switched the conversation to Matisse.[36] In November 1940 Matisse wrote to his son Pierre with obvious pride, 'Pablo doesn't wish to leave France at any price, this gives me pleasure'. In another letter of June 1942 Matisse rails against the enemies of Picasso's painting: 'This poor man is paying a hard price for his uniqueness ('ce qu'il a d'exceptionel'). He is living in Paris quietly ('dignement'), has no wish to sell, asks for nothing. He has taken upon himself the dignity of colleagues who have abandoned it in an inconceivable fashion.'[37] In December 1940 Matisse had asked Picasso to inspect his pictures stored in the vaults of the Banque de France and Picasso had done so.

During the war years the two men could see little of each other's contemporary work. Matisse had in any case been forced to undergo major surgery in 1941 and painted little until the end of the war, experiencing instead an extraordinary flowering in his skills as a draftsman. His series of drawings, *Thèmes et variations*, were later to affect Picasso. Yet each of the partners – for that is in effect what they had now become – needed to feel the other's presence. They exchanged works. In the years after achieving success and financial security both artists had assembled relatively small yet significant collections of the works of other artists, mostly their immediate predecessors and mentors. Both men owned works by Courbet, Renoir and

fig.13 Pablo Picasso
The Joy of Life (Antipolis) 1946
Oil on fibrocement 120 x 250 cm
Musée Picasso, Antibes

Cézanne. Picasso enjoyed distributing them, from time to time, around his premises. Matisse had begun to rid himself of his own collection, feeling the need to live entirely within the confines of his own vision.[38] But the severe portrait of Dora Maar, sent to him by Picasso in June 1942, he kept beside him, always within the periphery of his vision. In November 1942 Picasso acquired one of the finest of all Matisse's still lifes, *Still Life with Basket of Oranges* of 1912 (no.45). This was to become one of his most prized possessions. It was for a time prominently displayed on the ground floor studio full of sculpture at 7 rue des Grands Augustins, flooding the vast and somewhat forbidding space with light and colour. Further exchanges between the artists took place. During the Occupation Picasso had been forbidden to exhibit. But he was given the accolade of a large room all to himself at the Salon de la Libération held in the autumn of 1944. To Matisse's immense pride, he lent to the same exhibition Matisse's *Oranges*, the greatest of the Matisses in his possession.

Both men were now household names and in France were regarded as national treasures. Matisse was at last being accorded the official recognition too long delayed to him: in 1945 the French State acquired six significant pictures for the Musée national d'art moderne ranging from a cardinal work of 1907, *Le Luxe (I)* (no.6), through to the relatively recent *Still Life with a Magnolia* (no.153). In 1947 Picasso donated ten canvases to the same museum, including one of the most important of his wartime canvases, *Serenade* of 1942 (no.150). Picasso had by now achieved greater international acclaim than any other artist in history had enjoyed during his own lifetime. On the occasion of the parallel exhibitions mounted at the Victoria and Albert Museum in London during the winter of 1945–6 – the most publicly symbolic pairing of the artists since they had exhibited together in 1918 at Paul Guillaume's gallery – Matisse had first of all characteristically remarked

that is was, 'as if I were going to co-habit with an epileptic'.[39] After seeing the press cuttings he complained, equally characteristically, sadly, and with regret, that it was Picasso who was under wider critical attack – he would have preferred to share more fully in the opprobrium[40] and in the ongoing battles of modernism.

After 1946, and as Picasso began to spend an ever greater part of his time in the South, the relationship between the two artists moved into its final phase. Françoise Gilot, Picasso's new partner, tells us that she and Picasso visited Matisse more or less fortnightly. The two men continued to grumble about each other, and behind each other's backs were often unkind about each other. On the 19 March 1946 Matisse wrote to his son Pierre: 'Three or four days ago Picasso came to see me with a very pretty young woman. He could not have been more friendly, and he said he would come back and have a lot of things to tell me. He hasn't come back. He saw what he wanted to see – my works in cut paper, my new paintings, the painted door, etc. That's all he wanted. He will put it all to good use in time. Picasso is not straightforward. Everyone has known that for the last forty years'.[41] Picasso, who by his own admission was a great artistic thief, clearly enjoyed teasing Matisse and living up to the latter's picture of himself as a 'bandit'. Matisse, on the other hand, and for all his carping, looked forward to Picasso's visits and clearly felt that an interval of 'three or four days' was too long a delay. He must have felt rejuvenated by Picasso's unique vibrancy and vitality and his sense of fun. In 1952 just after the consecration of the Chapel at Vence, the poet André Verdet ran into Picasso: 'The previous evening I had encountered Matisse. I said to Picasso: Matisse confided that your sincerity was total, despite the pleasure you take in (your) devilries'.[42] Picasso in turn was sustained more and more by Matisse's inner serenity, greater than ever since Matisse's brush with death. It had become a stabilising factor in Picasso's own

23

life. He would take or send examples of his recent work for Matisse to look at or comment on.[43]

In April 1948 Matisse, although all form of travel was now arduous to him, made the short trip over to Antibes to see the works with which Picasso had filled the Palais Grimaldi.[44] He sketched from some of these Picassos (although they were far from Picasso's best), trying to learn from them and choosing works that were furthest in feeling from his own. He was to return for a second look. The largest of Picasso's panels at the Grimaldi Palace, *The Joy of Life (Antipolis)* of 1946 (fig.13), pays open tribute to Matisse's own great canvas of the same title, executed forty years earlier and still resonating in Picasso's mind. Matisse at the time was becoming absorbed with his projected chapel at Vence. Predictably, Picasso attacked him for becoming involved with a religious venture.[45] Yet he introduced Matisse to the Vallauris pottery works, the firm that was to execute the tile murals for the chapel. Picasso's influence can be felt in *The Stations of the Cross* (1950),[46] one of Matisse's rare and unwilling recognitions of the existence of pain and suffering, of the tragic in life, qualities at the heart of much of the Spaniard's art.

Ever in competition, and before the chapel at Vence was inaugurated, Picasso had announced his own secular 'Temple of Peace' at Vallauris. The two men had become the most important fixed points in each others' artistic lives. Picasso said, 'All things considered, there is only Matisse'.[47] And Matisse: 'Only one person has the right to criticise me . . . It's Picasso'.[48] When Matisse's died, on 3 November 1954, his daughter's first thought was to let Picasso know. Picasso refused to come to the telephone or to offer any comment. He did not attend the funeral. Like so many Spaniards he was obsessed with the concept of death, and his own terror of it was legendary. Possibly he felt that with Matisse's passing some aspect of himself had been removed.

Then, almost at once Picasso began his variations on Delacroix's *Women of Algiers* (nos.178–80). 'When Matisse died', he said quite simply, 'he left his odalisques to me as a legacy'.[49] The theme of the artist and model had appeared early in Matisse's art, and it resurfaced in his early Nice years. Both artists turned to it in the 1920s and it becomes an obsessive iconographic motif for them in their graphic work of the 1930s. In Picasso's late work it once more surfaces, in works that pay indi-

rect homage to his old rival. And after Matisse's death the two men's paths crossed in yet another way. Matisse's large blue cut-outs or *papiers découpés* of 1952 are in a sense surrogate sculptures, carvings in paper, the only medium he was now strong enough to handle (nos.166, 174). Picasso's bent and folded metal sculptures were begun in 1954, the year of Matisse's death and they are a response, in part at least, to the *découpages* on which he had seen Matisse at work at Vence and then at Hotel Régina at Cimiez. Many of Picasso's late sculptures were preceded not only by drawings but also by cut and folded paper models. Some of the bent metal sculptures are embellished with colour, but like those which are simply painted white (nos.170–1) they appear, in a converse fashion to Matisse's blue *découpages*, to aspire to the condition of painting.

A quotation has been ascribed to both Matisse and Picasso, and both of them very possibly spoke the words: 'We must talk to each other as much as we can. When one of us dies, there will be some things that the other will never be able to talk of with anyone else'.[50] This dialogue is what this exhibition is about.

fig.14 Henri Cartier-Bresson
*Matisse observing a ceramic vase by
Picasso in the villa of the editor E. Teriade
at Saint-Jean-Cap-Ferat, June 1951*
Henri Cartier-Bresson/Magnum Photos

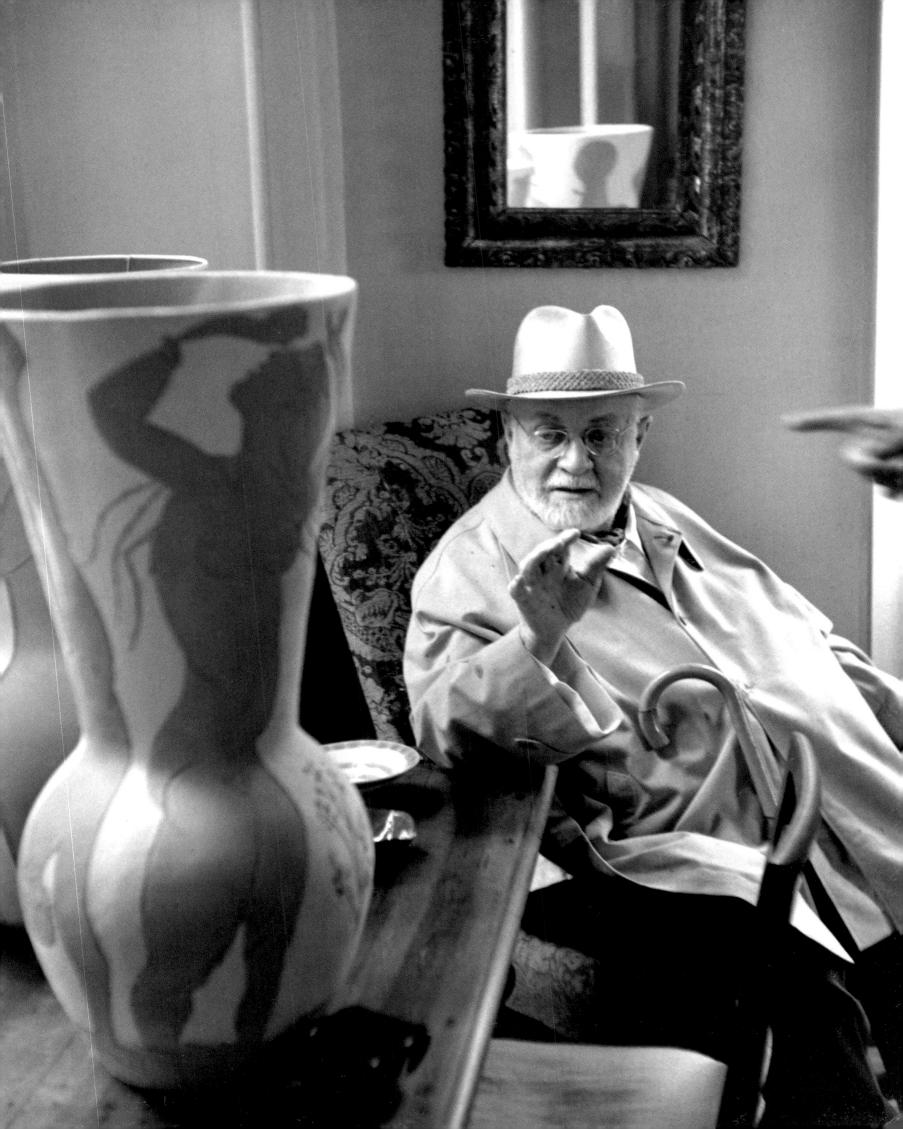

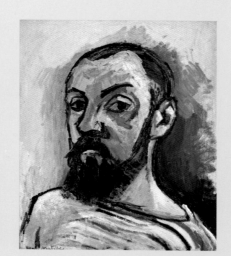
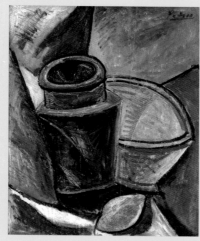
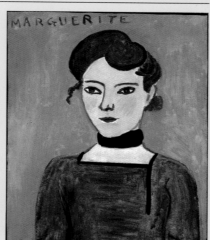

1

In the Spring of 1906, when they met for the first time, Matisse was thirty-seven, fresh from scandalous successes at the spring Salon, and anointed by general assent 'the king of the Fauves'. Picasso was a precocious cadet of twenty-five, his work still tinted with the residues of symbolist sentimentality. But they spent that summer in parallel explorations, testing possible splices between an imagery of youth, reflecting the upstart energy of the new century, and a 'primitivism' grounded in archaic, untutored or non-Western art. From the premise of that conjunction, Picasso (in Gósol, in the Spanish Pyrenees) painted an unvarying string of muscular, blankly wide-eyed ephebes, with schematic features that announced his new focus on early Iberian carvings. In the same months, Matisse (working in Collioure, on the south-west coast of France) essayed disparate simplifications whose primitivism ranged from a sleek decorative exoticism (*The Young Sailor II*) to a childlike naivety of watercolour delicacy (*Pink Onions*).[1] The contrast typifies the moment for each artist: Picasso searching out a new mode, headlong and headstrong, in a relatively straight line, with major stylistic ruptures occurring within single, pivotal pictures (for example, *The Portrait of Gertrude Stein* in 1906, *Les Demoiselles d'Avignon* in 1907); while Matisse, more anxious and restless, worked near-simultaneously with several different styles, or tried out differing approaches to the same motif.

Their self-portraits that autumn were appropriately opposed. With a blanched, cement-and-putty palette, Picasso's subsumes the lessons of Iberian archaism into blunt caricatural reductions. A youthfully shorn ovoid head balances, chin to clavicle, atop a squat and squared-off torso. Its mask-like, unfocused stare – with no suggestion of mirror self-inspection – is far removed from the self-pitying, sad-poet vulnerability in which Picasso had cloaked himself a few years earlier. Matisse, by contrast, never presented himself more intimately than here. Throughout his career, he typically shows himself at work, usually with the model, and often acknowledging the mirror as a distancing device. Just this once he is disarmed, stripped not only of his artist's attributes and the usual professorial coat and tie, but even of his glasses, the better to press the drilling gaze. The head dominates the space, looming (in the inverse of the block-bodied Picasso) over shrunken shoulders clad in an open-necked sailor's jersey – the type that, ironically, would become a virtual uniform for Picasso in later life. The attire links Matisse to his own *Young Sailor*, but the picture as a whole has a gruff, rusticated masculinity leagues distant from that boy's faun-like androgyny.

Both pictures present paradoxical splices of head and body. Picasso's thousand-yard gaze has the rapt fixation of the seer, while his smocked physique with its Popeye forearm and fist signal a labourer (a typical self-reckoning as both supernatural and earthy, the shaman *bricoleur*). By contrast, Matisse's boating shirt speaks of voyage and the open air, while the sober,

bearded mien is the type of the philosopher, tautened with the exercises of the mind – an *invitation au voyage* appropriate for the architect of empyreans to console the mental worker. Matisse's stare seems part wary, part defiant, and critics have seen in it both arrogance and tragedy.[2] The aggression, if aggression it is, owes more to painterly means than facial expression: hatchets and chisels have been evoked to describe the deliberate roughness, and sculptural force, with which those features are hewn.[3] A closer analogy (in contrast to the smooth, Brancusi-like egg of the Picasso cranium) would be the trowel-heavy modelling Matisse had used in previous clay sculptures, to translate Cézanne's stroke into Rodin's metier. By 1906, both Matisse and Picasso were well engaged with Cézanne's work, but on different levels. Picasso was for the moment still paying homage by borrowing motifs: Cézanne's *Portrait of the Artist With a Palette* of 1890 (fig.15) is clearly the model he used here, but only the form of the palette itself announces, tentatively, the sense of angular order he would soon begin to find so telling in the older master's work. (The overall sand-and-terracotta blondness of this self-portrait, as in the equally Cézanne-inflected *Boy With a Horse* (no.5) a year earlier, still owes more to Puvis de Chavannes than to Cézanne's light.) Matisse had, by longer cogitation, already assimilated Cézanne's colour and facture more deeply into his own style. The results in the *Self-Portrait* were a relatively sombre palette and a shadowy, volumetric density, utterly different from the rosy airiness of the *Pink Onions*, painted a matter of weeks before – and also sold, along with this *Self-Portrait*, to Sarah and Michael Stein that autumn.

The sale of those two Matisses may have been a catalyst for a missing third item in this comparison. Each artist made his 1906 *Self-Portrait* without any apparent reference to the other's work. But a year later, when Picasso painted the fiercely 'Africanised' *Self-Portrait* now in Prague (fig.16), he adopted a head-and-shoulders format that seems addressed directly and competitively to this Matisse, which he would doubtless have studied on the Steins' wall in the intervening months. Over those months, the two artists would have seen each other frequently – Matisse introducing Picasso to African sculpture by some accounts, by others Picasso listening rather tongue-tied and with resigned patience to Matisse's frequent expositions on colour theory and such. But by the autumn of 1907 the respective positions of the two artists had shifted. Like many other Parisian painters, Matisse had seen in Picasso's studio – and been shocked by – the younger man's breakthrough canvas of that summer, *Les Demoiselles d'Avignon* (no.7); and he was aware that Picasso was fast forming a band of followers eager to affirm him as new chief of the city's avant-garde. It was in this context of intensified rivalry that the two agreed to an exchange of paintings in the late autumn. We have no idea of the protocols involved – whether each chose or each offered, who went first, or what conventional parameters may have limited the field of choices – but we know that Matisse took home Picasso's *Pitcher, Bowl and Lemon*, recently painted, and Picasso acquired Matisse's portrait of his eldest daughter, Marguerite, also done that autumn. The Picasso shows the strident palette and slashing line quality that marked the 'savagery' of his work immediately following *The Demoiselles*, while the Matisse is one of the artist's closest approaches to the art of children, in its simple linear rendering and the ingenuous lettering across its top.

The classic account of this swap is the malicious one penned by Gertrude Stein in 1933. According to her, while each man pretended to choose the picture that interested him the most, in fact they 'chose each one of the other one the picture that was undoubtedly the least interesting either of them had done. Later each one used it as an example, the picture he had chosen, of the weaknesses of the other one. Very evidently in the two pictures chosen the strong qualities of each painter were not much in evidence'.[4] This cynicism may well have echoed studio talk from both sides – Stein goes on to say that in this period '(t)he feeling between the Picassoites and the Matisse-ites became bitter' – but the reality was doubtless more complex. Obviously neither of the pictures in this swap wastes any time trying to look artful or agreeable; each pushes instead to be crude – and succeeds, though each in a different way. It is likely, if they were chosen by their recipients, this is exactly why.

Given what we know of Picasso, several contradictory motivations probably informed his choice of *Portrait of Marguerite*. By picking a picture that was extreme in its experiment, he may have thought in part to disconcert Matisse – who might well have been unnerved to have this be the sole representative of his art in Picasso's studio. And in fact, we know that Picasso's band of cohorts did indulge in club-house mockery of *Marguerite* (even using it for target practice with fake darts).[5] Picasso could always employ this 'naive' little face to make Matisse look bad in the eyes of others, or alternatively to show – by virtue of the 'sideways' nose schema – that Matisse was just doing the same kind of thing he was. But at the same time he would have understood that *Marguerite* embodied something central to Matisse's singular achievements. Picasso said of it in 1962: 'I thought then that it was a *tableau-clé* [key picture] and I still think that' – a double-edged remark, allowing only that in his eyes it contained a defining essence of his rival's aesthetic, for better or worse.[6] But there is no reason to doubt, either, Françoise Gilot's testimony that Picasso admired the spontaneity, courage, and candour of the picture, and later regretted his earlier complicity in the jest his friends had made of it.[7]

For all that Picasso's Matisse was flattened, smooth, simplified, and so wilfully 'innocent' and benign, Matisse's Picasso was the opposite: a rough, agitated image of shrill contrasts, colliding angles, and an unsettled space of crowded overlaps. Up to this point, Matisse had worked more frequently than Picasso in still life, often with simple crockery, so the table-top tumult of *Pitcher, Bowl and Lemon* landed cacophonously in an area where he had sought the graceful and harmonious. By some stretch – the same kind that Picasso made when he pointed out Marguerite's nose – Matisse could well have seen, in the rhyming of convex and concave (the lemon and the open bowl), and in the overall tensions between the flat, rhythmic structuring of lines and the residues of modelling or perspectival depth, some echo of the dialogue between sculptural form and decorative design that informed his own art. But more likely he saw in this roughly planed board with its 'savage' combination of fearless brio and aggressive clumsiness, as Picasso saw in *Marguerite*, a particular kind of audacity that was, for better and worse, alien to him and defining to the force of his rival. Looking for long years, often in private hours, on the fruits of this exchange, each man could repeatedly comfort himself that he would never do anything like that, and reproach himself for the same.

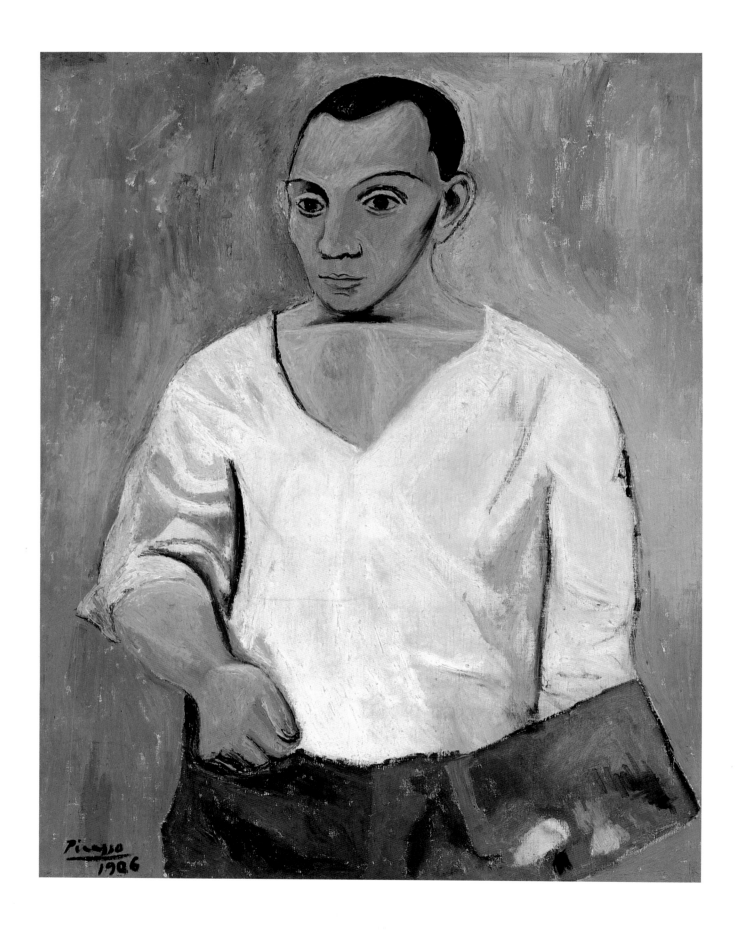

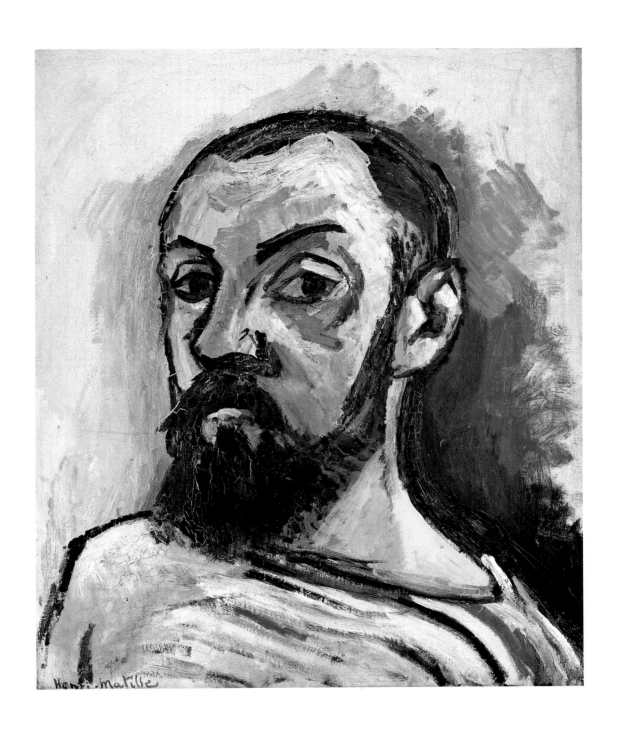

PABLO PICASSO

1 *Self-Portrait with Palette* 1906

Autoportrait à la palette

Oil on canvas 91.9 x 73.3 (36¼ x 28¼)

Philadelphia Museum of Art:

The A.E. Gallatin Collection, 1950

HENRI MATISSE

2 *Self-Portrait* 1906

Autoportrait

Oil on canvas 55 x 46 (21⅛ x 18⅛)

Statens Museum fur Kunst, Copenhagen.

Johannes Rump Collection

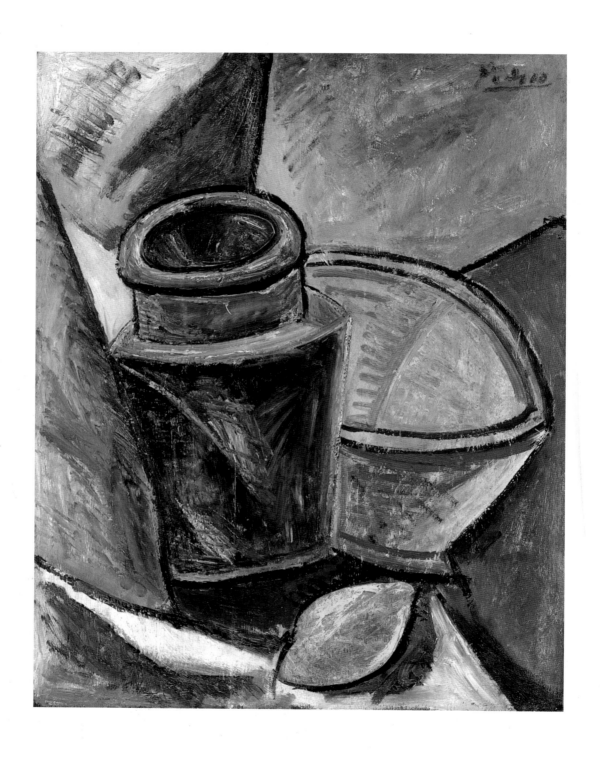

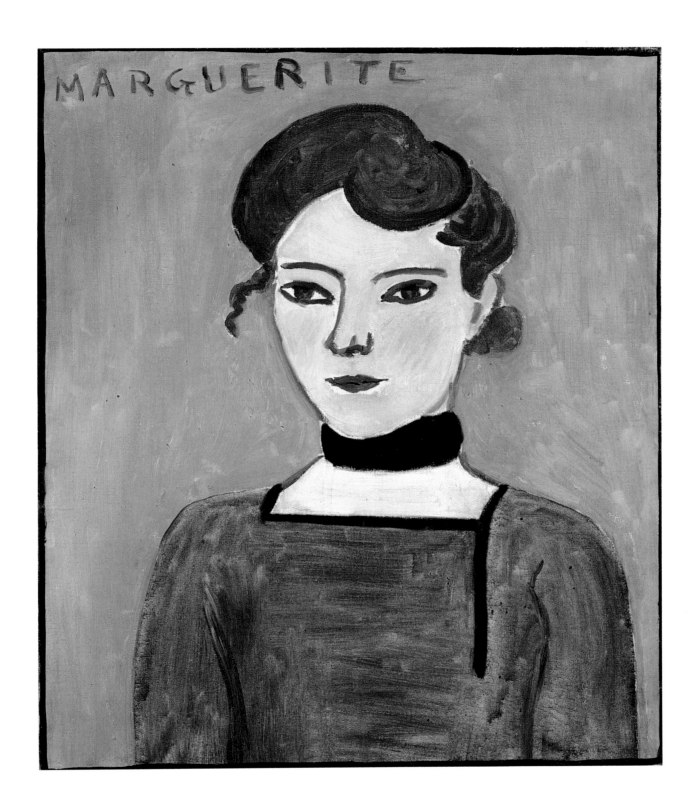

MARGUERITE

PABLO PICASSO

3 *Pitcher, Bowl and Lemon* 1907
Cruche, bol et citron
Oil on wood 63.5 x 49.5 (25 x 19½)
Private Collection, Courtesy Beyeler
Foundation, Riehen/Basel

HENRI MATISSE

4 *Portrait of Marguerite* 1906
Portrait de Marguerite
Oil on canvas 65 x 54 (25½ x 21¼)
Musée Picasso, Paris

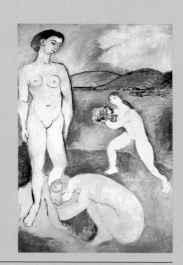

2

Grand in scale, but extremely sketchy; wilfully 'primitive', but dependent on the classical tradition; mythic in ambience, but devoid of explicit content: the similarities between *Boy Leading a Horse*, completed in the spring of 1906, and *Le Luxe I*, painted in Collioure early the following summer, are such as to encourage direct comparison. It was a comparison anyone on calling terms with Gertrude and Leo Stein was well placed to draw because for several years both pictures hung within a stone's throw of each other in Paris – *Boy Leading a Horse* at the Steins' apartment at 27 rue de Fleurus,[1] and *Le Luxe I* round the corner at 56 rue Madame, home of their brother, Michael, and his wife Sarah.[2]

Boy Leading a Horse belongs to the critical moment when Picasso was engaged in a sustained effort to rid his work of all trace of the romantic charm and sentimentality of the Saltimbanque scenes of 1905 and to infuse it with the hieratic power and gravity of the ancient sculpture in the Louvre, where, according to Ardengo Soffici, 'he would pace around and around like a hound in search of game'.[3] Although – except in the built-up area of the boy's head – it gives every sign of having been executed rapidly and spontaneously with liquid paint and sweeping movements of the brush, the many preparatory and related works on paper bear witness to hesitation and struggle. His first idea was, in f for a circus scene, with a girl bareback rider mounted on a white circus horse and boy in a ight-fitting costume acknowledging the audience's applause. Having banished the girl, Picasso's next idea was to include the boy (now naked) and his horse at the centre of a frieze-like scene depicting a company of youths watering their horses at a pool in a hilly landscape. But this ambitious composition was never transferred to canvas, no doubt because Picasso felt it was too close to similar scenes by Puvis de Chavannes and Gauguin, and too animated and anecdotal.[4] In ttli g on the archetypal motif of man and beast, reducing the landscape to the merest suggestion of a primeval desert and choosing a severe colour scheme of bluish-greys and pinkish-browns, he accentuated the references to ancient art – the riders on the Parthenon frieze, the striding *kouros* statues of the Archaic period and the weathered surfaces of stone, terracotta and fresco. These references are so pronounced, indeed, that they mask the debt to Cézanne's richly coloured but rough and awkward painting of a male bather walking towards the spectator which Picasso admired in Ambroise Vollard's gallery.[5]

In seeking atavism and an austere sculptural quality, Picasso placed himself at the opposite pole to the sizzling prismatic colour, impressionistic handling and contemporary life imagery of Matisse's submissions to the 1905 Salon d'Automne – notably the flamboyant *Woman with the Hat* (fig.33), which was bought by Leo Stein despite the barrage of hostile press criticism. As he was occupied with Gertrude Stein's portrait over the winter of 1905–6 (no.58), Picasso must

have heard gossip about *Le Bonheur de vivre* (fig.2), the great canvas Matisse was currently engaged upon. His abandonment of the multi-figure pastoral scene of *The Watering Place* and move towards a limited, sombre, tonal palette may have been motivated, at least in part, by the desire to set a greater distance between himself and the headline-grabbing *roi des fauves*. At all events, *Boy Leading a Horse* must have struck contemporaries as an anti-Fauve painting: the single, startling patch of brilliant red between the horse's muzzle and neck is a reminder of what has been rejected.

The pursuit of the 'naive' and 'primitive' was the driving preoccupation of the avant-garde in Paris at this time, and Matisse himself appears to have felt that *Le Bonheur de vivre* was too full of incident, too dependent on familiar Golden-Age imagery, too similar in its theatrical layout to famous paintings by the great French classical masters. In *Le Luxe I* he explored the same type of theme, but on a nobler scale and in a less illustrative manner, synthesising into just three figures a range of strongly contrasted poses (upright and facing forward, bent double and in profile, running and in three-quarter view), and simplifying the background into large, loosely painted bands of contrasting rainbow hues. This process of reduction and abstraction, also discernible in the slightly earlier *Blue Nude: Memory of Biskra* (no.14), parallels Picasso's strategy in simplifying the iconography of *Boy Leading a Horse*, and is one sign of the common ground between the two painters, despite salient differences of approach.

Exhibited at the Salon d'Automne of 1907 as an *esquisse* (sketch), *Le Luxe I* was preceded by a full-size cartoon, which is somewhat more refined and naturalistic in draftsmanship, and followed by the flatly painted, firmly drawn and more schematic definitive version[6] – a systematic method of working which betrays Matisse's academic training and knowledge of the methods of the Renaissance masters. Indeed, if the crouching figure is the mirror-image of her counterpart at the left of *Le Bonheur de vivre*, the standing nude and the flower-bearing figure appear to derive from Venus and the Hora in Botticelli's *Birth of Venus* – an anticipation of Matisse's trip to Italy in July to August 1907.[7] His interest in early Renaissance Italian painting went hand in hand with a deep interest in Japanese woodblock prints, and there are similarities in composition, drawing and tonality between *Le Luxe I* and Kiyonaga's *Visitors to Enoshima*.[8] Picasso, for his part, did not appreciate the decorative stylisation of Japanese prints because it conflicted with his innately sculptural conception of form and preference for classical, centralised compositions – a key difference between his and Matisse's taste in art and sense of design.[9] So, although both paintings involved a dialogue with other works of art, the painters' interlocutors were different.

The resonant combination of athletic youth, handsome steed and barren landscape suggests some nature myth or fairy-tale in which man and beast materialise miraculously, but *Boy Leading a Horse* is resistant to any definite reading. *Le Luxe I* is equally ambiguous, despite the strong implication that the standing bather is the object of a cult and the other two her acolytes, and that the myth of the birth of Venus was at the back of Matisse's mind. Whereas Picasso's painting evokes the dry, earthy, dense and tactile, *Le Luxe I* is so ethereal, evanescent and visionary that it is only at close range that the full – luxurious – richness of its colour harmonies

is revealed. The shimmering greens, blues and aquamarines transform the golden-haired crouching figure into a mermaid or water-nymph and the towel at the standing bather's feet into a miraculous, gushing stream. Unlike the overcast, land-locked world of *Boy Leading a Horse*, which was painted on a dark ground, this is a world of iridescence, where angelic bodies emanate a blond light and the shadows playing over them glow pink.

In comparison to the astonishing liberty Matisse allowed himself when brushing on the colour and drawing and redrawing the contours of the ungainly figures of *Le Luxe I*, *Boy Leading a Horse* seems almost academic in its rendering of anatomy: there is nothing to equal either the 'caricatural' 'deformations', which offended the first critics of Matisse's painting and struck at least one as 'malevolent', or the flagrant inconsistencies of handling, which led another to bewail 'cette maladie de l'inachevé' (this unhealthy obsession with the unfinished).[10] The balance was dramatically reversed, however, when, that same autumn, Picasso unveiled *Les Demoiselles d'Avignon* (no.7) to the horrified visitors to his studio, Matisse among them. In *Bathers with a Turtle* (no.8), which develops out of *Le Luxe I*, the beguiling dream of innocent, untrammelled, guilt-free sensuality no longer seems tenable.

EC

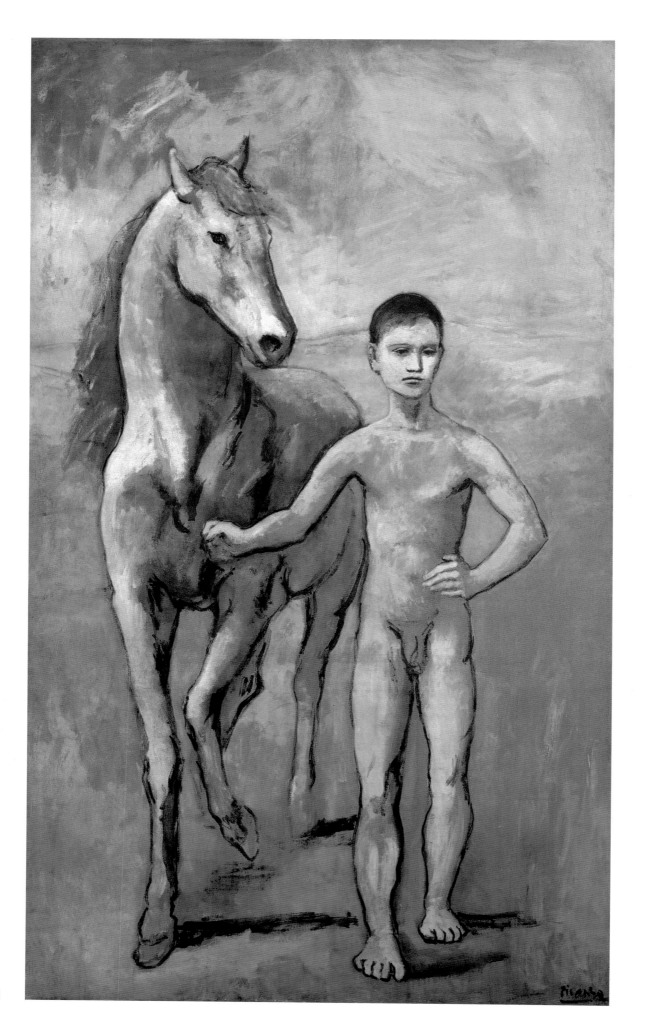

38

PABLO PICASSO
5 *Boy Leading a Horse* 1906
Le Meneur de cheval
Oil on canvas 220.6 x 131.2
(86¼ x 51½)
The Museum of Modern Art, New York.
The William S. Paley Collection

HENRI MATISSE
6 *Le Luxe I* 1907
Oil on canvas 210 x 138
(82⅝ x 54⅜)
Centre Georges Pompidou, Paris.
Musée National d'Art Moderne/
Centre de Création Industrielle.
Achat à l'artiste en 1945

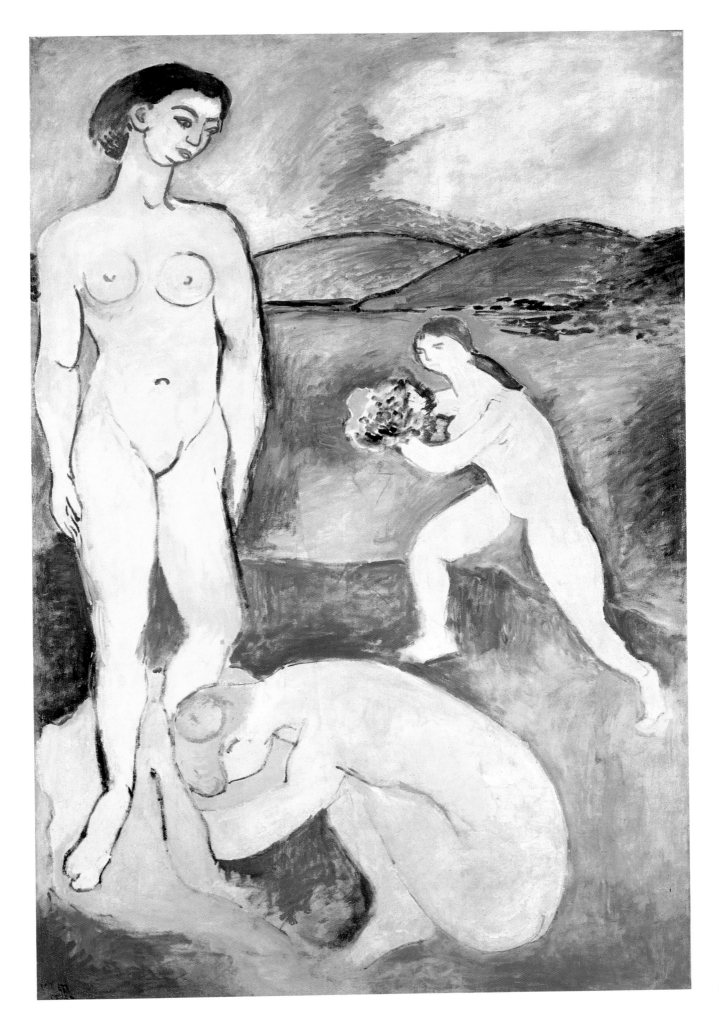

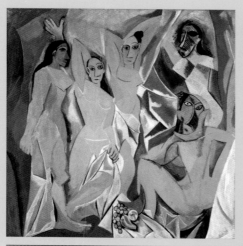
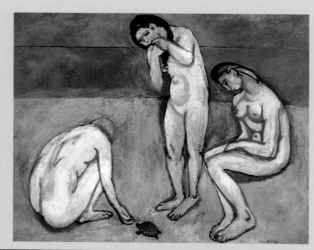

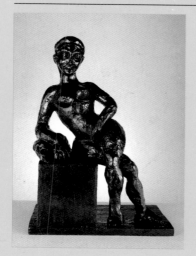

3

The visual dialogue between Matisse and Picasso was never more intense than in the two years that followed their first meeting in spring 1906.[1] When they met, Matisse's Arcadian figure composition *Le Bonheur de vivre* (fig.2) was creating a sensation at the Salon des Indépendants. Picasso had just abandoned the attempt to create such a composition, and must have felt the admiration, or envy, or fear of envy, of an ambitious, discouraged rival.[2] Like Matisse and other progressive painters conscious of the historicity of their art, Picasso had been struggling to use, and escape, the influence of some of the nineteenth-century French artists canonised by special presentations at the avant-garde Salons, notably Ingres, Gauguin and Puvis de Chavannes.[3] Matisse's big painting was an impossibly successful *pot pourri* of these same sources, and more, in which stylistic disunity had been seen, surprisingly, not as a threat but an opportunity. It sanctioned (or was sanctioned by) a dislocated composition of separate figural incidents, each one, to add to the unconventionality, made from inhabitants of uncertain anatomy and, sometimes, gender. And not one incident encouraged the eye to rest there, such being the visual restlessness prompted by the serpentine contours and cacophonous colours.

That summer, Picasso painted a picture called *The Harem*.[4] The women in it were studied separately and in pairs, swelling to massive proportions, in paintings and drawings made in the autumn (see no.103). In the winter came the first sketches for a new brothel composition, leading to a first ensemble drawing.[5] In March or April, Picasso made a full colour compositional study, showing a sailor surrounded by five nudes, with a figure he described as a medical student bursting into the scene from the left (fig.17). But then Matisse again delivered an ambitious painting, *Blue Nude: Memory of Biskra* (no.14), to the spring Salon, adding Cézannean volumes and the experience of North Africa to his list of appropriations. Picasso's first reaction was to adapt Matisse's pose for the second-from-left figure of his work-in-progress,[6] abandoning an earlier seated pose, memorialised in an independent painting done the previous winter (no.11). Next, taking a month-or-so break from his figure composition, he responded to the *Blue Nude* with a savagery previously unknown in his art. *Blue Nude* is African more in its oasis setting than in its style. *Nude with Drapery* (fig.18) is a set-piece demonstration of what, *pace* Matisse, 'primitivism' in painting really can be.

Returning to the figure composition in April or May, Picasso made, among other studies, two huge drawings that explore a hieratic pose for the central figure with raised arms (nos.9–10). One drawing studies the back of the figure, which will be visible in the final work only to the 'curtain-parter' on the right. (Below her will crouch, appropriately, the one figure ambiguous as to whether we are shown her front or back.) But by June, in another full-colour compositional study (fig.19), the central figure had again been transformed – to resemble the standing figure at the

left of *Le Bonheur de vivre*. This study finally laid out the five-figure composition that *Les Demoiselles d'Avignon* (no.7) would become. (Thus, the sailor and one of the female nudes had been eliminated and the medical student transformed into a female nude, the 'curtain-puller' at the left.) But precisely what it did become emerged simultaneously with the development of the figural poses in the creation of the actual painting in June and July. As with the preparatory drawings, this process occupied two stages, the second of which involved the extensive repainting of the two right-hand figures in response to a visit to the Trocadéro Museum, which revealed to Picasso a wider range of African art than Matisse had introduced to him the previous autumn.[7]

Matisse was now in Italy, looking at the work of the then so-called Italian Primitives, discovering in Giotto's Arena Chapel boldly monolithic figures that may have recalled to him Picasso's paintings of the previous autumn. In any event, these works, as well as African art, seem to have been in his mind when, that summer, he made the sculpture *Two Women* (no.12).[8] Matisse's painting that summer, in contrast, was in the process of surrendering volume, seemingly forsaking Cézanne and African art to build on the decorative style of *Le Bonheur de vivre*.[9]

This, unquestionably, must have added to Matisse's shock of disbelief on seeing *Les Demoiselles d'Avignon* that autumn: he saw Picasso advancing what he had set aside, and in such an incomprehensible, aggressive way that it seemed like a hoax.[10] Did it occur to him, we have to wonder, that even the pink-and-blue coloration, posturing as a unifying force in *Les Demoiselles*, is an impertinent valediction to *Le Bonheur de vivre* as well as to Picasso's surrendered popularity? Matisse quickly responded. First, he repudiated his own art's African associations, encouraging Apollinaire to claim that he was a European painter for all his curiosity about non-European cultures.[11] And second, he demonstrated his European affiliation in another big figure composition, completed by February 1908. *Bathers with a Turtle* (no.8) draws upon the memory of Giotto while also borrowing directly, for the pose of the left-hand figure, from Cézanne's *Large Bathers,* shown at the Salon d'Automne of 1907.[12] Matisse also turned, as usual, to sculpture for help. His *Decorative Figure* (no.13) reprises a pose, connotative of bisexuality – being adapted from Leonardo da Vinci's *Bacchus* in the Louvre – that he had used in his own *La Coiffure* of 1907, a picture that repeated a subject recently used by Picasso.[13] The sculpture records the auto-erotic pose of the right-hand figure in *Bathers with a Turtle* before it was revised in its painting.[14] Its associations exemplify the tangle not only of ambiguous sexual representation but also of competition and replication in which Matisse, as well as Picasso, was enmeshed.[15]

Les Demoiselles and the *Bathers with a Turtle*, both begun as narrative paintings, thus belong in a developmental narrative that starts in the art-historical past and continues in the form of a two-stranded chain, whose individual links are Matisse's and Picasso's own compositions. Figure composition, traditionally the most important form of painting, had long been the most challenging test in an artist's competition with both predecessors and contemporaries. What Matisse and Picasso were doing in 1906–8 was not unusual. But figure compositions traditionally required that they be composed so as to tell a story; in consequence, such compositions had the complementary functions of describing an internal narrative and finding a place in the external narrative of the history of painting. Matisse and Picasso, in 1906–8, challenged the

necessity that figure compositions describe an internal narrative. In doing so, they took on the complementary function of challenging the external narrative of historical continuity. Both *Les Demoiselles* and *Bathers* were thus interpreted as debasing and overturning the traditions of Western painting.

Les Demoiselles began as a narrative whose subject was a medical student entering a brothel; that is to say, something suddenly happening and causing a reaction.[16] Although a contemporary subject, it belongs to a long tradition of images of a surprising entrance; a faun surprising a group of nymphs offers the most obvious parallel, and reminds us of the association with sexual assault.[17] The *Bathers* began as a scene of bathers on a beach, one wringing water from her hair. In this case, the traditional association is to the so-called Venus Anadyomene, an image of the goddess of love emerged from the waves to bring sexual difference into the world.[18] The *Bathers* began, that is to say, as an account of something having already happened in the distant past. (In this respect, it originally resembled *Le Bonheur de vivre*.) However, while making the painting, Matisse inserted the image of a turtle, adjusting the three figures to make room for, and show their reactions to, the creature. He thus transformed his painting so that its subject, too, was something suddenly happening and causing a reaction. The subject of both paintings is what a narrativist would call a 'climax', a turn in the action, and a phenomenologist, 'a change of aspect', a reconfiguration of the visual field.[19]

Painting *Les Demoiselles*, Picasso rearranged the figures so that they occupied their own separate spaces, and turned them to face the viewer; in consequence, they neither interact nor communicate with each other, but relate directly and singly with the viewer.[20] The figures in the *Bathers* also occupy their own spaces, neither interacting nor communicating with each other. However, they all face the turtle and relate directly and singly with the turtle. In Michael Fried's terminology, the former painting is 'theatrical', addressing the viewer, and the latter is 'absorptive', ignoring the viewer.[21]

A truly theatrical entrance, lifting a curtain, was integral to the original theme of *Les Demoiselles*; it was realised by establishing a theatrical relationship between the viewer and the depiction. As Leo Steinberg has observed, Picasso's revisions of the painting effectively place the viewer in the position of the person who makes the sudden entrance, and it is as if the figures in the painting respond to the surprising presence of the viewer.[22] In Matisse's painting, the sense of closed self-sufficiency afforded by its absorptive quality also realises its original theme – something strange happening in the distant past – but the revisions done to it also enrol the viewer in a sudden change of aspect. The vertical channel Matisse opened between the turtle and the face of the central figure encourages the viewer's gaze to oscillate up and down between the subject and the surprising object of the gaze thus depicted in the painting, in a mesmerising absorption equal to that of the subject itself. Both paintings were designed to elicit a response, and the meanings of both lie in the qualities of perceptual experience that we derive from them. The internalisation of narrative subject matter within the form of the execution effectively reallocated the narrative component of the paintings to the perception of the beholder.

Critical to this is how, in another change of aspect, both works exhibit a unity that gives way, in their viewing, to disunity, which solicits continued viewing. The shrill Spanish Mannerism of *Les Demoiselles*, with its nervously crumpled, solidified space, is utterly distant from the sombre Italian Trecento mood of the *Bathers*, its banded backdrop hanging like a banner. However, the two are alike in being emphatically unified. Each depicts a tightly circumscribed space; is composed from close-up, packed-in figures on a squarish canvas; and employs a limited colour range and the repetition of like contours as cohesive devices.[23] It is in the means of their *disunification* that they differ most conspicuously. *Les Demoiselles* is divided into three by the three stylistic figure types – dark archaic for the curtain-puller on the left; Iberian (and somewhat Matissean)[24] for the central two figures; and African for the pair on the right – but, more critically, into five by the five figures themselves, in so far as, in Steinberg's words, 'each figure at its own terminus connects individually with the viewer, much as our five fingers connect with the arm.'[25] This aspect is signalled metonymically by the hand in the top left corner, apparently growing from the head of the curtain-puller, which tells us that the composition as a whole was conceived to resemble a hand, even that Picasso's hand reached to that particular place in painting it.[26] In contrast, the *Bathers* divides emphatically into three – three figures (or versions of the same figure) in three different poses with three differently featured identities showing three different responses to the appearance of the turtle – then encourages reiterative eye movements that loop around the figures, to form what is known as a feature ring, springing from the single recurring fixation point that is the turtle.[27] A feature ring also develops in the visual perception of *Les Demoiselles*; only it is constrained by not one but five fixation points, all but one of which remind the viewer that he, too is being observed.

The exceptional figure, upper right, is the curtain-parter. Her orientation and blacked-out eye prevent her from looking at the viewer, and she looks instead onto the scene from the right background, thus observing the observing *demoiselles* and reversing the momentum of a left–right reading. In both respects, this figure introduces a final climax, or change of aspect, into the painting. The *Bathers*, too, contains a final change of aspect. When Matisse revised the central figure, he moved her head down and to the right so that her hands were no longer by her hair, in the Venus Anadyomene pose, but placed anxiously by her mouth. In doing so, he transformed the head into a primitivised mask,[28] and he neglected to paint out entirely the earlier head, leaving an eye nestling within her hair. In this one region, the picture looks back, is 'theatrical', and thwarts visual enquiry. Picasso's curtain-parter, in contrast, is 'absorptive', and demonstrates visual enquiry. Both these changes of aspect contradict the dominant thematic effects of their respective paintings, were made late in their development, and are presented as bringing the paintings to a conclusion in an act of sudden, disfiguring alteration. It is as if the climactic suddenness of a painting's theme could only be simulated, and the painting surrendered, when its thematic effect was seen suddenly and violently to have been repudiated and a very opposite effect shown – and, with it, that discontinuity is both medium and message.[29]

Each work, moreover, places within arm's reach of the viewer its most discontinuous feature, which also forms a link between two systems that are discontinuous, the painting's and our

own.[30] I refer to the turtle in the *Bathers* and the still life in *Les Demoiselles*, the non-figurative protagonists of these compositions. Matisse, more than Picasso, gives a greater descriptive specificity to this feature than to any other. In a story, a description causes an interruption in the narrative, slowing and even stopping it. This is one of the functions of this feature, and Matisse's use of the slow-moving turtle for this purpose is a nice self-referential touch. Picasso's use of a still life offers the same interpretation, except that the *demoiselles* are immobile, too, and, in such a context, an edible still life obviously evokes other associations.[31] Indeed, a second function of this feature is in its sexual connotations. Again, the artists make visual puns. Not only is a turtle a sexual symbol, but the carapace evokes the concealment of sexuality within a surface. *Les Demoiselles*, in contrast, is all sexualised surface as if impaled upon an assaultive table.[32]

What kind of sexuality is overdetermined? When faces become masks, when a language of gestures freezes and loses its conventional meanings, and when figures become either puppets or prehistoric, a grotesque desexualisation occurs. Yve-Alain Bois has noted how *Les Demoiselles*, by turning the paralysing gaze of the figures onto the viewer, evokes Freud's interpretation of the sight of the mythical head of Medusa as causing, at once, fear of castration, because it substitutes for the female sexual organ, and at the same time denial of that fear, because it turns the viewer into an erect stone.[33] The *Bathers* operates in the same territory in so far as its founding theme, the story of the birth of Aphrodite, tells of the creation of sexual difference after the castration of Uranus. In its realisation, the 'hidden' eye in the hair of the central figure, her stiffened pose, the seeming disconnectedness of her head, and the object she, horrified, looks at on the ground are all associable with the Medusan theme.[34]

Such startling re-imaginations of 'harem' and 'bather' compositions, which traditionally mimicked a sexual invitation, were bound to provoke controversy as to what messages they actually convey, and continue to do so. One non-sexual message deserves final mention. A Freudian castration theme not only offers a challenge to the traditional male viewer. It is also associable with fratricide, hence with the rivalry, admiration, envy, and fear of envy that an ambitious artistic follower will feel about an authoritative predecessor. Matisse and Picasso are now equals, therefore now mutual followers and predecessors, and such emotions, nurtured in the painting of these two pictures, remain the natural consequences of and motivations for their practice of art.

JE

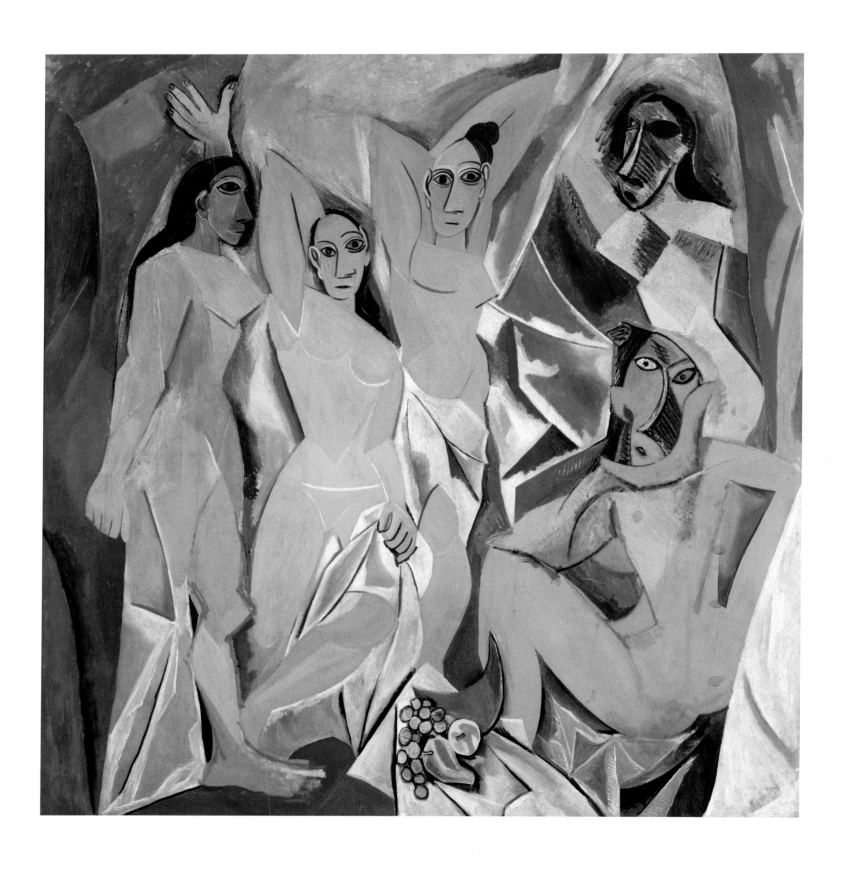

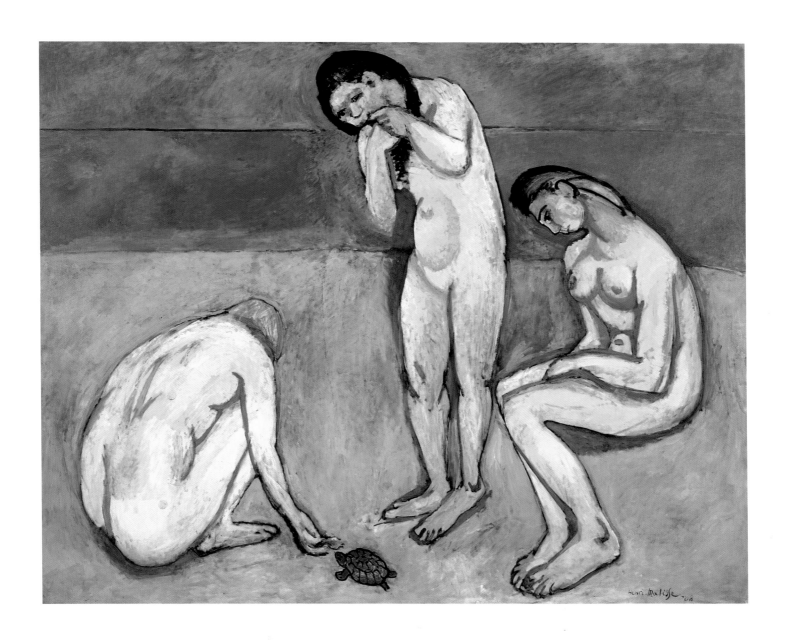

PABLO PICASSO

7 *Les Demoiselles d'Avignon* 1907

Oil on canvas 243.9 x 233.7 (96 x 92)

The Museum of Modern Art, New York.

Acquired through the Lillie P. Bliss Bequest

HENRI MATISSE

8 *Bathers with a Turtle* 1908

Baigneuses à la tortue

Oil on canvas 179 x 220 (70½ x 87¾)

The St Louis Art Museum.

Gift of Mr and Mrs Joseph Pulitzer, Jr

PABLO PICASSO

9 *Nude with Raised Arms, seen from Behind*
(Study for 'Les Demoiselles d'Avignon') 1907
Nu de dos aux bras levés (Etude pour
'Les Demoiselles d'Avignon')
Oil and charcoal on paper 134 x 86 (52¼ x 33⅞)
Musée Picasso, Paris

PABLO PICASSO

10 *Nude with Raised Arms, seen from the Front*
(Study for 'Les Demoiselles d'Avignon') 1907
Nu de face aux bras levés (Etude pour
'Les Demoiselles d'Avignon')
Oil, crayon and charcoal on paper 131 x 79.5 (51⅛ x 31¼)
Musée Picasso, Paris

PABLO PICASSO

11 *Seated Nude (Study for 'Les Demoiselles d'Avignon')* 1906–7

Nu assis (Etude pour 'Les Demoiselles d'Avignon')

Oil on canvas 121 x 93.5 (47⅝ x 36¾)

Musée Picasso, Paris

HENRI MATISSE
12 *Two Women (Two Negresses)* 1908
Deux négresses
Bronze 49.5 x 28 x 20 (19½ x 10¼ x 7⅞)
Centre Georges Pompidou, Paris.
Musée National d'Art Moderne/
Centre de Création Industrielle.
Dation en 1991

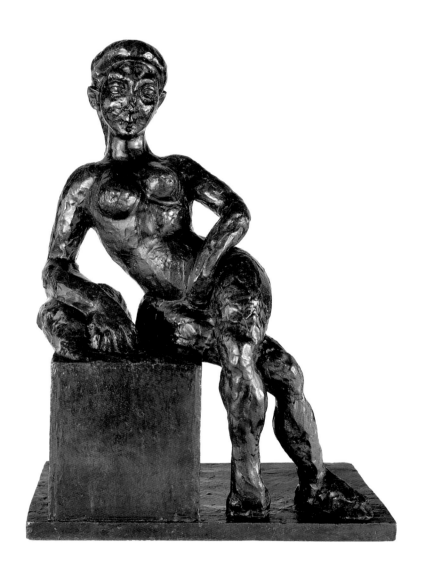

HENRI MATISSE

13 *Decorative Figure* 1908

Figure décorative

Bronze 73 x 51.4 x 31.1 (28⅛ x 20¼ x 12¼)

Hirshhorn Museum and Sculpture Garden, Smithsonian

Institution. Gift of Joseph H. Hirshhorn, 1936

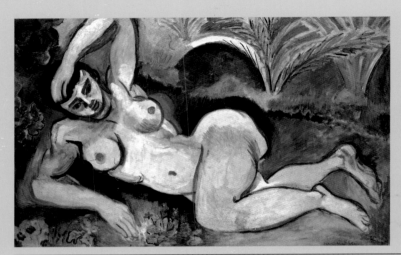
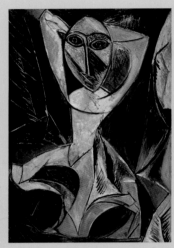
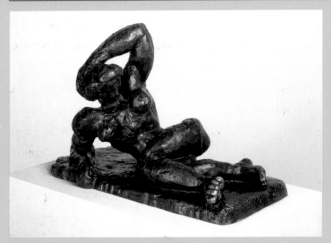

4

These women are *ugly*. Anatomically peculiar and often coarsely rendered, they embody twinned and wilful aggressions against the canons of both art and feminine allure – aggressions made all the more evident by the artists' ironic, even sardonic, retention of clichéd poses of seductive self-display. Notions of artifice and authenticity, tradition and truth, are clearly in play throughout the seven works, and the female body, posed to please, is the zone where those matters of art intersect with parallel issues of the libido.

The nude was an ossified category of idealisation for many modern artists. Rodin had tried to rejuvenate it by capturing liberated movement, and the Futurists would call for banishing it altogether. But in this seven-part dialogue from 1907 through to 1909, Matisse and Picasso accepted as points of departure both the artificiality of the nude as a category, and the reality of the posing model. Only Matisse's *Blue Nude* (no.14) and Picasso's 1909 *Bather* (no.20), with their stage-flat backdrops, do anything to suggest a world beyond the studio and its desultory props. Within these parameters, the two artists wrestled not only with the challenges each posed to the other, but with a constellation of shared issues: the legacy of Cézanne, especially in his late *Bathers*; the question of 'primitivism'; and the dialogue of sculpture and painting.

The starting point is Matisse's paired creation of the *Reclining Nude I (Aurora)* (no.15) and *Blue Nude: Memory of Biskra*, in the early months of 1907. In the sculpture, Matisse set out to model a figure in virtually the same supine, raised-arm attitude he had essayed in a smaller statuette, *Nude With Chemise*, two years previously – a pose often cited as deriving from a familiar classical marble, the *Sleeping Ariadne*.[1] Working on this new version in Banyuls on the southwest coast of France, he was in near-constant dialogue with the sculptor Aristide Maillol, who lived nearby.[2] The contact was telling, for in the years just past Maillol's sculptures had been effecting, against the grain of Rodin's powerful supremacy, a notable change in the physiology and psychology of the nude. Drawing inspiration from the thick-jointed Tahitian women in Gauguin's paintings, from the sturdy physiques of the local peasant girls who posed for him, and from a generalised notion of the Greco-Roman heritage of the Mediterranean basin, Maillol had fashioned a female type of heavy-boned stolidity and almost somnolent *gravitas* – an inward-turning, more placid and passive antidote to the lean, sexually driven females that populated Rodin's work and Symbolism in general. With broadened shoulders and girth, Maillol's early figures had an air of grounded force that at least once – in his *Chained Action* of 1906 (fig.20) – crossed over into an explicitly masculine sense of muscular power. A similarly chunky body type appears in Picasso's work of 1906, most notably in the *Two Nudes* (no.103). But there are no more pointed examples of this new empowerment, and accompanying masculinisation, than Matisse's *Reclining Nude I (Aurora)*, and the painting it provoked.[3]

Modelling the sculpture, Matisse looked past the smoothly rounded volumes of Maillol to the knobbly, muscular, insistently mannish physiques and reclining contraposto poses of Michelangelo's female figures for the Medici Tombs. The narrow frame of the base, crowded at every edge and exceeded by the right hand, helps emphasise the force with which this torqued body combats the ostensible leisure of the pose, especially in the dominant vertical thrusts of elbow and hip. Out of what at first seems languorous repose, Matisse's figure generates potent motion from virtually every angle as the viewer moves around it, following the twisting interlace of an arabesque that governs its rhythmic thrusts and counter-thrusts.

When the first clay of *Reclining Nude* was accidentally broken, Matisse apparently committed *Blue Nude* to canvas immediately, as a response to the accident.[4] But, despite the parallelism of pose, *Reclining Nude,* with her downward-turned face shadowed beneath a Maillol-like crown of hair, seems far more inward than her painted sister. The top half of the body bends to face the lower in a way that makes the waist all but vestigial, and breaks the sculpture into a landscape of paired forms that anticipates the formulations of Henry Moore. In the extroverted painting, by contrast, the rotation of the upper body to offer a frontal display, parallel to the picture plane, gives the lower chest and waist huge prominence as a sweeping, muscular curve. The counter-twist of the lower body leaves the lower legs – thick and weighty in the sculpture – diminished and inconsequential, in comparison to the now even more forcibly vertical thrust of the left thigh and hip. The crowning push of that painted haunch is further emphasised by its seeming deformation of the earth behind it – as if some tuber were irresistibly burrowing upward from under the soil[5] – and by the eruptive arc of the background palm, whose curving branch repeats, like a shock-wave, the swollen push of the upthrusting hip. Swollen, or, one might say, tumescent – for the bony vertical of the thigh and its bulbous cap have a phallic aspect that subsumes, and takes to another level of meaning, the masculine qualities of the figure.[6]

Later, in works such as Brancusi's bust of *Princess X* (1915–16),[7] or Picasso's heads done at Boisgeloup in the early 1930s, modern art would become familiar with the image of the phallic female, and with a notion of eroticism by which the stimulus (a woman) became subsumed into the form of the response (male arousal). Surrealism would provide a context for such transgender phantasms. In 1907, though, the masculinisation of the nude had a rawer edge of energy, especially when seen against the forms of gender-mixing – mostly in wan and vulnerable androgynes beset by sexless enervation – that had been associated with *fin-de-siècle* decadence. For younger artists in search of a greater erotic honesty and a fresh expression of sexuality's imperatives, the received codes of feminine seductiveness – lanky, distended curves, hooded gazes, feline sleekness – came to seem creaking falsehoods in need of insult. Transgressing the conventions of gendered bodies by levelling differences, and by pumping testosterone into the issue, came to be one of the avenues by which a more challenging imagery of sex could emerge.

Cézanne's late canvases of *Bathers* were liberating in this regard, as they introduced into a traditional motif of ideal beauty peculiar anatomies that ignored conventions of grace and often seemed to confound those of gender as well.[8] Matisse's *Standing Nude* (no.17), completed around the time of the *Blue Nude,*[9] seems clearly to show this influence, in the way Matisse felt

free to accept and even emphasise the short-shanked heaviness of a model's body he had found in a banal photo document.[10] But the densely worked tapestry of the late Cézanne figures is here translated by the younger man into a more brute, wooden sculptural language of heavy contours and crude modelling, further insisting on blunt candour over exalted mystery. The dark outlines of the *Blue Nude*, albeit far more fluid, follow the same path in the same spirit – an urge of youthful, simplifying 'primitivism' that probably had as yet no specific source in primitive art.

The subtitle *Memory of Biskra* (added later) and the nominal palm decor refer to Matisse's recent voyage to North Africa,[11] but the explosive sexuality of *Blue Nude* has less to do with the specifics of this experience than with Matisse's aggressive updating of Delacroix's harem exoticism, and with the venerable Western fantasy of North Africa as a place of strong sensuality and weakly constrained lust. By contrast, a guiding force behind Picasso's *Nude With Raised Arms* (no.16), several months later, is his direct contact with sub-Saharan sculpture – and with a different Africa of the mind, more terror than titillation. Picasso had already been preoccupied with Matisse, and out to rebuke his *Le Bonheur de vivre* (fig.2), which he had seen in the spring of 1906, when he was surprised by the altogether more 'savage' impact of the *Blue Nude* at the Salon des Indépendants in the spring of 1907. This encounter doubtless provoked him to make even more inflammatory the image of prostitutes in a brothel – the eventual *Les Demoiselles d'Avignon* (no.7) – he then had in progress. That competitive fervour informed the 'revelation' of his fresh response to the voodoo-charged power of the tribal art in the Trocadéro Museum, most likely in June, and helped fuel his subsequent reworking of parts of *Les Demoiselles*.[12]

Picasso purged the residual veneer of comfortable grace (e.g. the *Sleeping Ariadne*) from the pose of twisting body and uplifted arm. The whores of *Les Demoiselles* squarely pegged this stretching display of hip and breast as a flaunting provocation, and advertisement for sex; and their inflection carried over in the heavily hatch-marked and stridently linear nudes that followed. Among these, the impressive *Nude With Drapery* (fig.18) in the Hermitage still retains, with her closed eyes and improbably Ingres-like twist,[13] a residual air of passive posing; but the wide-eyed *Nude With Raised Arms* shown here splays herself open at the chest and at the crotch in an attitude of confrontation and in a spirit of unflinching 'savagery' that – intentionally – makes the *Blue Nude* seem merely husky and hearty by comparison. Matisse had increased the energy of his figure by bolder sculptural modelling and muscular bulges. Picasso does something like the inverse, drastically flattening the volumes, and reproportioning the body as a bizarre origami – elbows far thicker than shoulders, breasts and hips virtually non-existent – that seems to hang from the oversized, mandorla-shaped, fright mask face. Matisse's swell and thrust is replaced by slash and cut, in an orchestration of sickle curves and brittle, angular hatching that locks the agitation of the nude into the inhospitably spiky surroundings, and in the process does mortal violence to any remaining hint of sensuality. The pose's exaggerated incitement to possess this body is fused with the utterly alien defiance of the gorgon gaze, and with the show of razor-edge scimitars at every approach. The *Nude With Raised Arms*'s stylistic debts to African sculpture may actually be less than we think (superficial, indirect, or fragmentary as scholars have shown),[14] but the fantasised tribalism of the conception – the fusion of primal lust

with repellent terror in this horrific satire of beauty – is shockingly authentic. In the years before World War I, the simplifications of folk art and tribal art often became associated with the imagination of a liberated libidinal life, but no marriage of primitivism and eroticism ever spawned a more assaulting – or more fiercely inassimilable – devil-doll than this.

How surprising, then, to see how the field is reversed in 1909. Matisse's *Nude with a White Scarf* (no.19) still manages to stay in his line of investigation of two years before, reiterating the motif of the posed model (down to the peculiarly forced propriety of the fig-leaf cloth), and including a reference to older sculpture. (As John Elderfield has pointed out, the raised arm and thrusting knee echo the antique marble *Barberini Faun*, encouraging again the overtones of masculinity).[15] And it continues as well the translation of Cézanne's influence, albeit now into a scumbled, summary modelling of the flesh and more choppy, staccato contours. The arcs and dashes of those outlines tellingly betray – as do the overall flatness of the figure and the sharply defined spaces between the legs and at the right of the torso – an undeniable attention to recent Picassos (for example, *Dancer With Raised Arms*). But the other two 1909 nudes at hand, Matisse's oddly miniature *La Serpentine* (no.18), and Picasso's oddly monumental *Bather* (no.20), replay some of the same familiar issues – of the arabesque, of sculpture and painting, of naturalism and deformation – in what seems a sharply altered spirit, less barbaric than mannerist, and in attitudes where bold confrontation has been supplanted by a coy and even prim poise.

Like the *Standing Nude* of 1907, *La Serpentine* also had its point of departure in a photograph Matisse found in a compendium of nudes published as documents for artists.[16] (The pose itself, as has been pointed out, is a somewhat farcical echo of the familiar stance of the aged Hercules in classical sculpture – yet another male comportment travestied.)[17] But where he had previously dwelled on and even underlined the squatness of the 1907 body, here he first transferred intact the pudgy physique in the photo, then radically remade it, leaving comically ballooning calves and gunboat feet below sharply pared-down thighs that share with the arms and torso an improbably similar, ropy slenderness.[18] The Michelangelesque torsions and volumetric thrusts in *Reclining Nude I (Aurora)* of 1907 have been elevated, aerated, and sublimated into a more smoothly rolling dialogue of looping figure-eights or infinity signs. And gravity – so important to the power of that earlier, upthrusting but ground-hugging pose – has been demoted to a plaything, satirically nodded to in the oversized feet and large flat base, and then lightly acknowledged in the tilt and the touch of the little elbow against the foil of the outsized and off-centre pedestal of support. Lighter psychologically as well as physically and formally, this sprite has none of the shadowed inward turn of the 1907 figure. She acknowledges the trite codes of appeal her posing involves, with the self-consciously cute and sexy little-girl gesture of finger to mouth. The artist steadfastly retained that piquant detail from the photo, along with the abundant hair, as he reduced to adolescent leanness the breasts and hips that had been the featured attractions of the 1907 pose.

Picasso's exceptional *Bather* of the same year shows some parallels with this unexpectedly delicate demeanour. Light years from the staring menace of the *Nude With Raised Arms*, and

equally removed from the Neanderthal heaviness of some of his intervening figures of 1908 (for example, the *Three Women* now in the Hermitage),[19] this improbably preening creature, with her pile-driver haunch, bowling-ball belly, tiny breasts and segmented little arthropod arms, has a comically smug, closed-eyes equipoise, and is rendered with a fine-brushed, mincing precision that seems at odds with the radical reformations of her anatomy. The scarified webs of lines that marked the Africanising nudes has here given way to explicitly sculptural concerns, just near the time when Picasso made his most concerted effort (in *Head of a Woman (Fernande)*, 1909, no.139) to realise the tenets of early Cubism in three-dimensional form. In the painting, those concerns for three-dimensionality appear locally and directly in the separate, swelling units – breasts, abdomen, rib cage, hip, pubis, buttock – that assemble to yield a taut, carapace-like, and insistently un-sensual physique. But the urge for a fuller rendering of volume appears more innovatively, and more peculiarly, in the way Picasso combines profile, three-quarter front and three-quarter back vantages that pull into view both sides of the body. The basic pose is set by the figure's left leg facing left in full profile, and the torso above rotated toward us, showing the middle of the abdomen and the figure's right breast in profile. But along the right edge, the figure has been oppositely rotated, so that the midline of its back appears, and the far buttock is swung around, parallel to and larger than the near one. Just below the neck, the anomalies are less prominent, but equally peculiar: the figure's right shoulder, rotated to full frontality above a profile breast, has its back in view on the opposite side of the body – with the odd, insectile socket-joint of the other shoulder in between. *La Serpentine*'s emphasis on criss-cross looping to conjure volume by constantly turning vectors is replaced here by a conceptual splitting and splaying of the body, bringing the backside to the eye instead of the other way around.

Such radical opening-up of solid volume usually took place, in Cubism, in conjunction with an equally active and closely connected restructuring of the space around. (And indeed, virtually this same posed figure would appear a year later in another painting, comfortably embedded in a fully articulated Cubist environment.)[20] By here imagining such a 'monster' cleanly bound in at all its edges, before a deep space of sand, sea, and sky, Picasso looked ahead to his Surrealist works of the 1920s and 1930s, where not only the fusion of frontal and profile views first essayed in this *Bather*'s shadow-divided face, but also the general vision of impossible anatomies rising monumentally on dream-like beaches, would become central to his imagination.[21] In the midst of the intense early years of their confrontations with each other's art, the *Bather* also stands as an apt reminder that, within all they shared, Picasso was from the outset more frequently ready to press their common investigations into territories Matisse generally avoided, where the radical in art opened onto the grotesque, the horrific, and the absurd – sometimes all at once. Throughout this series of seven transgressions on the tradition of the female nude, it is Matisse who ultimately seems more bent on reforming, rejuvenating and giving fresh power to the sensuality at issue, while Picasso recurrently explodes it to get beyond, into unsettling or even misogynist new forms of the uncanny or bizarre.

KV

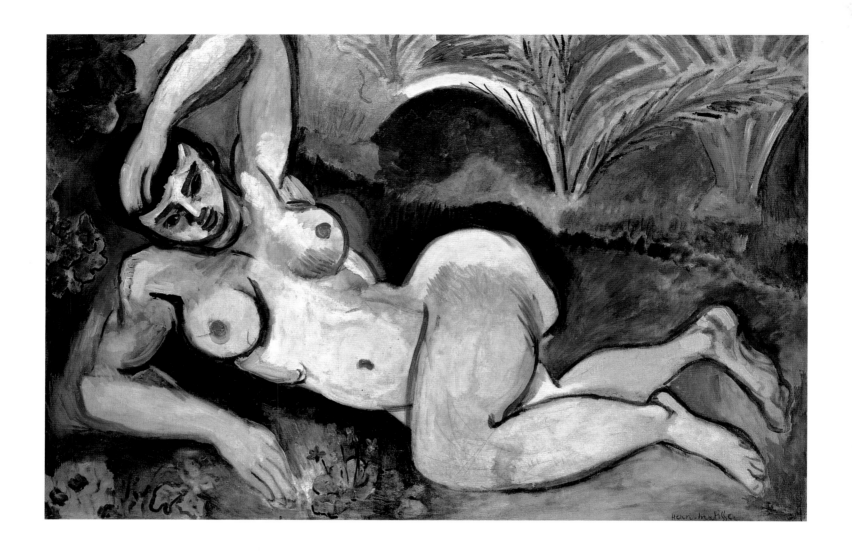

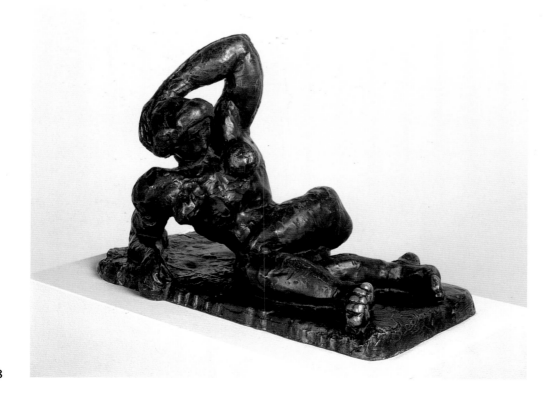

HENRI MATISSE
14 *Blue Nude: Memory of Biskra* 1907
Nu bleu: Souvenir de Biskra
Oil on canvas 92 x 140 (36¼ x 55¼)
The Baltimore Museum of Art: The Cone Collection,
formed by Dr Claribel Cone and Miss Etta Cone

HENRI MATISSE
15 *Reclining Nude I (Aurora)* 1907
Nu couché I (Aurore)
Bronze 35.5 x 50.5 x 28 (14 x 19⅞ x 11)
Centre Georges Pompidou, Paris.
Musée National d'Art Moderne/
Centre de Création Industrielle.
Don des héritiers d'Alphonse Katin en 1949

PABLO PICASSO
16 *Nude with Raised Arms* 1907
Femme nue aux bras levés
Oil on canvas 150 x 100 (59 x 39¼)
Private Collection

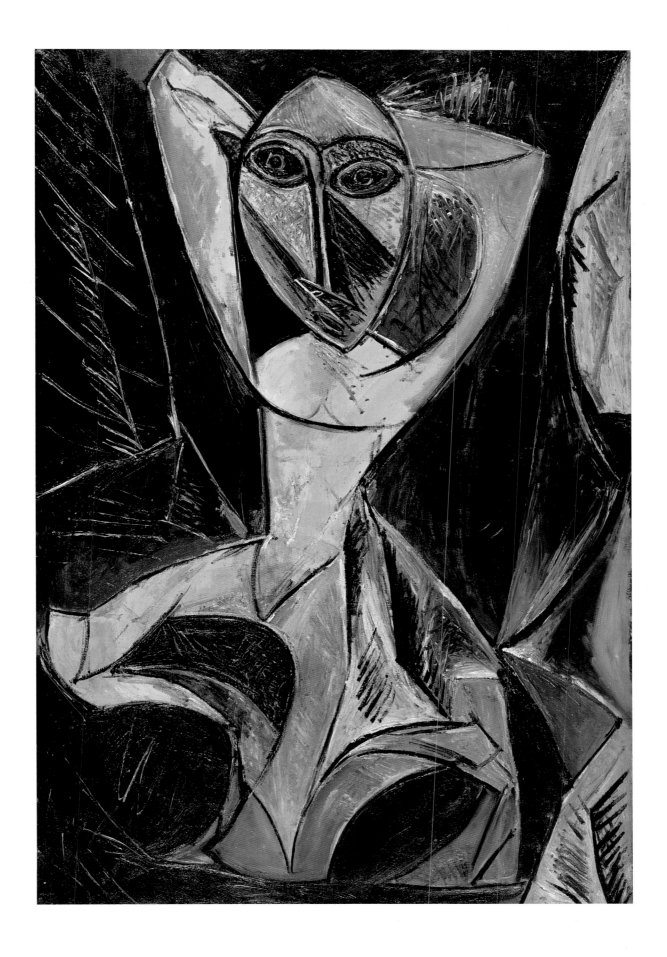

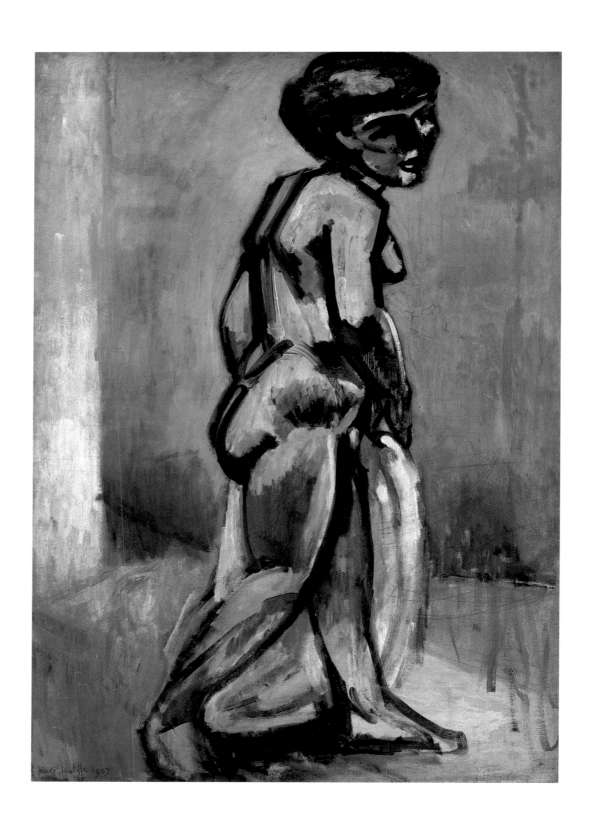

HENRI MATISSE

17 *Standing Nude* 1907
Nu debout
Oil on canvas 92.1 x 64.8 (36¼ x 25½)
Tate. Purchased 1960

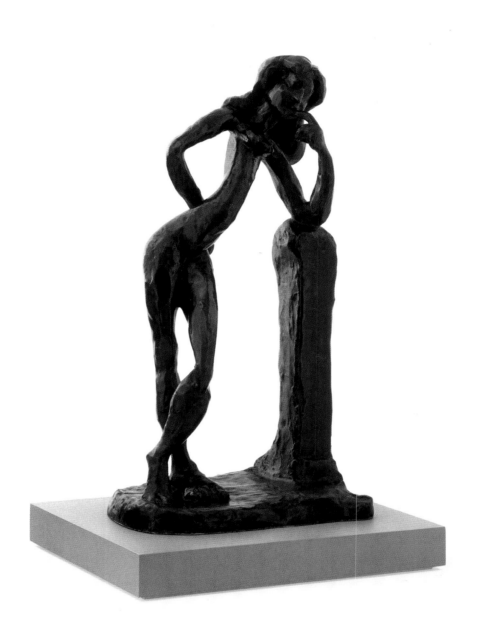

HENRI MATISSE
18 *La Serpentine* 1909
Bronze 56.5 x 28 x 19 (22¼ x 11 x 7½)
The Museum of Modern Art, New York.
Gift of Abby Aldrich Rockefeller

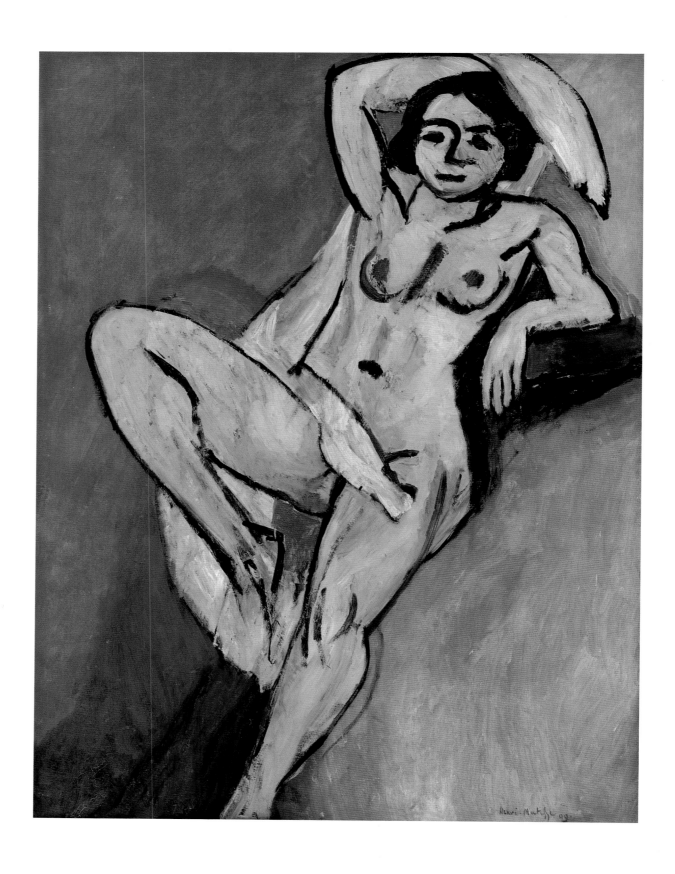

HENRI MATISSE

19 *Nude with a White Scarf* 1909

Nu à l'écharpe blanche

Oil on canvas 116.5 x 89 (45¾ x 35)

Statens Museum for Kunst, Copenhagen.

Johannes Rump Collection

PABLO PICASSO

20 *Bather* 1908–9

Baigneuse

Oil on canvas 129.8 x 96.8 (51⅛ x 38⅛)

The Museum of Modern Art, New York.

Louise Reinhardt Smith Bequest

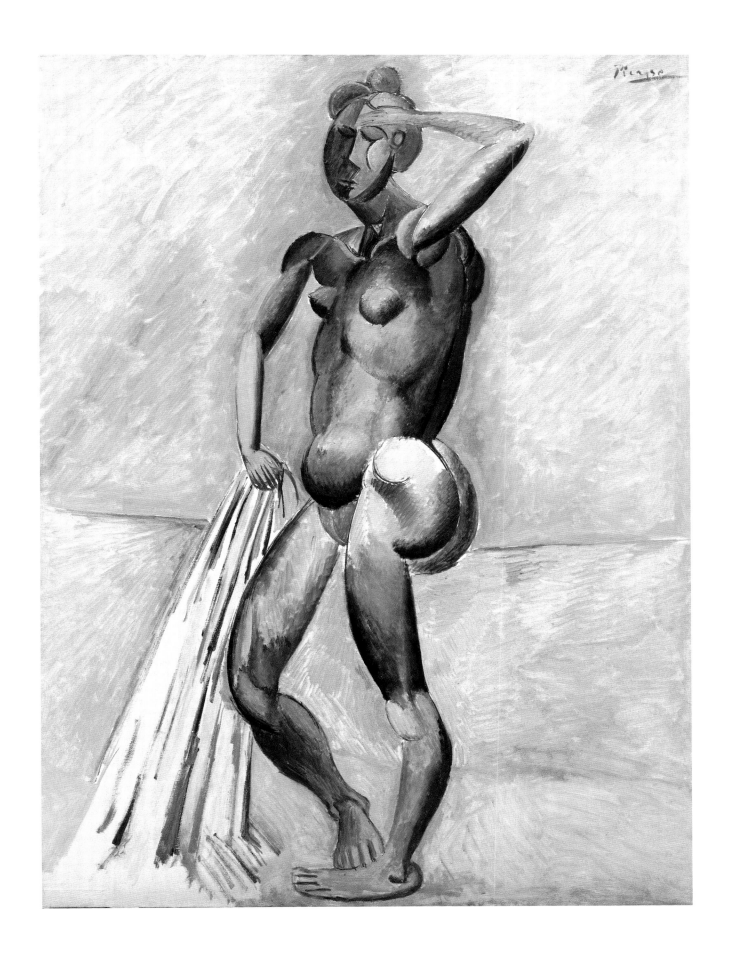

 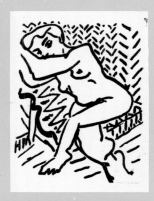 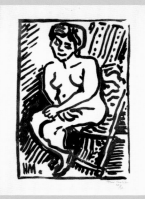 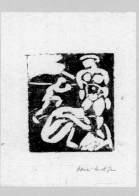 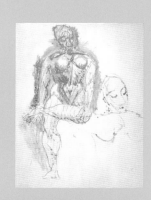

5

'Matisse does a drawing, then he recopies it. He recopies it five times, ten times, each time with cleaner lines. He is persuaded that the last one, the most spare, is the best, the purest, the definitive one; and yet, usually it's the first. When it comes to drawing, nothing is better than the first sketch.'[1] Picasso, setting out in this comment that which distinguishes his drawing, methodologically and phenomenologically, from that of Matisse, speaks of his conception of a primal drawing which in no way excludes an outstanding requirement: 'There is nothing more difficult than a line.'[2] Both these artists, however, sought by means of the line only to access that which drives the work process. In order to guarantee an upsurge of drawing, Picasso points out, the artist has to know how to surrender, to submit his work to the intermittent exchange of consciousness and unconsciousness: 'I believe the work of art to be the product of calculation, but such calculations are often unknown to the author himself . . . Or one should presume, as Rimbaud said, that in us it is the other who calculates.'[3]

Matisse shares this interior split with 'the other', whereby graphic automatism is able to open up creative introspection: 'I do the drawing almost with the irresponsibility of a medium . . . I seek revelations on myself, I consider my drawings the materializations of my sensation.'[4] Thus Matisse can follow up on Picasso's statement: 'the route of my pencil on the sheet of paper is, in some respects, analogous to the gesture of a man groping in darkness . . . I am led, I do not lead.'[5] From this same premise, Matisse and Picasso implemented techniques, throughout the various stages of their respective oeuvres, that systematically rehearsed the graphic question, that phenomenal alchemy described by Picasso: 'It is a grave and quite mysterious thing that a mere line can come to represent a living being. More than just his image, what he is in truth. How marvellous this is! Is it not more surprising than any sleight of hand and "coincidence" in the world?'[6]

Whether in the form of a street or cafe sketch, Matisse and Picasso both had a stenographic approach to drawing in the years 1899 to 1901, each artist putting into practice a piece of advice offered by Delacroix to draw on the motif. By doing this, the artist requires himself to break the accepted habits of academic drawing: 'The mastery of the hand', said Matisse, 'I forced it to forget acquired gestures . . . You know what I am referring to: perfection in a single stroke of the pencil.'[7] The graphic sign is thus the preliminary incidence of the relationship between what is seen and he that sees, the event binding the artist to his subject. In the course of the years 1905–8, drawing was nevertheless to take on unprecedented importance in a formal revolution in which drawing would no longer be mere preparation for painting but would become the laboratory of mutations in pictorial language. For Picasso the ever-increasing complexity of form required a new concentration on drawing in its constructive role. For Matisse,

however, the primacy of colour, had led to the disintegration of contour which required at the same time to be necessary re-established through drawing. From this point of view, the imperious presence of Matisse's *Seated Nude* (no.44) in Sarah and Michael Stein's apartment, facing his monumental composition *Le Luxe I* (no.6), can be considered the manifesto of a Fauve drawing, in which the synthetic line, the primary colours, the frontal collapse of perspective, the violence of the execution and the intentional unfinished appearance all result in a re-evaluation of current aesthetic criteria. Charles H. Caffin witnessed the extent of this mutation during a visit to Matisse's studio in the spring of 1908: 'He shows me a series of drawings from the nude. In the first, he explains that he has drawn "what exists"; and the drawing shows the knowledge and skill characteristic of French academic art. Then others follow in which he has sought for further and further "simplifications", until finally the figure, as he expressed it, was *organisée*.'[8] Matisse therefore had, at this time, already contrasted his two graphic approaches to drawing, which he would theorise in 1941 by distinguishing his 'themes', studies often done in charcoal for the 'very deliberate'[9] elaboration of the model's representation, and the 'variations' in which the artist executes a sequence of drawings allowing his 'instinct to surge up clearly'.[10]

While Matisse's practice had hitherto been devoted mainly to landscape, still life or portrait painting in the immediate family circle, in 1905 and 1906 the motif of the nude came to the fore in drawing and engraving (nos.21–2, 31–2). This series of studies, with their heads hidden or cut off, usher in a new phase of work centred on an elaboration of *Le Bonheur de vivre* (fig.2). Should we surmise that the banned representation of the face hints that Amélie Matisse might be the subject of these nudes?[11] But might the model not rather be the Italian Rosa Arpino, with her twisted, juvenile body , whom Matisse used for his studies on *Le Bonheur de vivre*, and who initiates the long-lasting dependency of the artist on his models? There is a well known story that Matisse, while waiting in a post office, absent-mindedly sketched a woman's head which turned out to be his mother's portrait.[12] Thus, whether in the case of spouse or models, these headless women perhaps suffer only from being but a substitute for this primary image. A youthful Olympia with a ribbon of suffering,[13] the 1906 *Portrait of Marguerite* (no.42) represents an exceptional moment in Matisse's graphic work. In a fusionist hallucination of artist and model, the face takes from the self-portrait its implacable pursuit of self-inspection. Matisse is in fact facing himself as much as he is deciphering the countenance of his daughter, with the same tense attention at work in the *Portrait of Madame Matisse, The Green Line*, of which Gelett Burgess said: 'She is alive – awfully alive.'[14] As for Picasso, he confessed, with more humour than worry: 'Every time I draw a man, involuntarily I think of my father ... He wore a beard. All the men I draw have more or less his features.'[15] He was thus able to deduce the feminine character of a figure by means of a Spanish saying: 'If it has a beard, it's Saint Joseph; if it doesn't have a beard, it's the Holy Virgin.'[16] We know that Picasso did not use models; his figures show as much in their indistinct, generic aspects. At stake for him is not the capture of the essence of Amélie, Marguerite or Rosa but the act of signifying a being without a beard, who is not his father and who is not a man: the other. All these feminine figures constitute a collection of signs, beings and bodies – they could be called precipitates in the chemical sense of the term – which,

in the synthetic structure of these nudes, the painter wishes only to express as a whole of each of their parts: 'I want to say the Nude. Not make a nude like a nude. I want only to say breast, foot, to say hand, stomach . . . A way must be found to do the nude as it is.'[17]

In early 1906 – January for Matisse, April for Picasso[18] – the painters paid a visit to Gustave Fayet who at the time was one of the main collectors of Gauguin's work. Fayet owned paintings, wood reliefs and engravings and notably had the mock-up for the illustrated volume *Noa-Noa*, which Picasso was familiar with, having been offered a copy by Charles Morice in 1902. Matisse had regularly referred to Gauguin since the turn of the century, but it was in the aftermath of the shock of his visit to Fayet that he began a series of woodcuts. Exhibited in March 1906 at the Druet gallery, *Large Woodcut, Small Light Woodcut* and *Small Dark Woodcut* (nos.21–3) are inspired by Vallotton and the Nabis; despite their exaggerated facture, they remain in the sway of 'modern style'.[19] All three of these woodcuts set off the sinusoidal curves of the nude to the structure and straps of a folding chair. These nudes are tormented by the foreshortening of the perspective and the harsh treatment by the reed pen. The systematic decentring of the composition puts pressure on the edges of the drawing sheet, invading its margins. The white of the flesh left in reserve on the hatchings reduces the range of tonal values to a tense contrast of white and black. The thick and ductile line closely tracks the curve of the bodies by kinetic arcs that multiply their contours. The resulting optical phenomena of folds and wrinkles of the surface confer to these drawings a paroxistic nature as intense as that of the colour in Fauve painting. Comparison of the preparatory sketch and the engraving of *Large Woodcut* shows that Matisse has faithfully transferred onto the plate the motif of the original drawing. He also incorporates its dimensions and format. There is, however, something paradoxical in Matisse's *modus operandi*. Unlike the woodcut *Le Luxe* (no.24) where the bodies, swept up in a single stroke of the gouge, are rendered negatively in white on a dark ground, here, the engraving mimes positively the delineations of the reed-pen drawing. With this end in mind, the tool must smooth over with scrupulous cuts everything that would not be the line defined by the jutting of a sinuous relief. The path of this line, as an expression of the spirit, is submitted to the minute control of the tool which nevertheless deforms the arabesque, as if the engraving had simultaneously portrayed and betrayed the drawing. The effect of this exchange between techniques announces a different rendering of the figure in *La Danse* and *Bathers with a Turtle* (no.8). Their 'primitivism' will be filtered by this stiffening of the graphic work and the intentional hesitancy of the line.

Picasso probably was able to see Matisse's series of engravings at the Druet gallery, and his own visit to the Fayet studio created the need to experiment with sculpture and wood-cutting. Usually dated to the autumn of 1906, the woodcut *Bust of a Woman*[20] might well be a part of or perhaps anticipate the high reliefs done by the artist in Gósol, and in whose cutting Picasso was able to practise the brutal technique demanded by this material. An evident reference to Gauguin, the face surrounded by uncombed hair exudes the serenity of a Polynesian goddess. Its treatment follows the same principle as the series of self-portraits from which derive the *Studies for 'Self-portraits with a Palette'* (no.41). Thus, in late 1906, we have the generalisation of an

'Afro-Iberian' type forsaking individual resemblance for the construction of a mask. As concerns the woodcuts *Studies for 'Standing Nude'* (nos.25–6) of the following year, they share with Matisse's *Le Luxe* (no.24) the same work of negative engraving by the hollowing out of large areas which, once printed, appear light. However, Picasso chooses a grained piece of wood in which the original shape is conserved, in order to engrave as much *with* as *on*: 'I understand how you could see something in the root of a tree, a crack in the wall, in an eroded stone or pebble', as he said to Brassaï.[22] The pregnancy of the wood piece and its material uniqueness remains perceptible in the prints, where the play of inking makes the grain of the wood a dominant element in the drawing. The cut of the blade used to render the ground as well as the figure incised a scarification across the surface of the material. There is thus no longer any difference between the medium and the line, the line and the figure, and the woodcut meshes with the configuration of the wood and the psychic drive of the instrument.

The stylistic mutation which Picasso had begun in the 1906–7 woodcuts became more radical in the constellation of studies for *Les Demoiselles d'Avignon* (nos.34, 37) and the large-scale paintings *Nude with Drapery, Friendship, The Dryad* or *Three Women*.[23] Standing, arm behind the back or arms raised, the nude dictates all of the architecture of these moments of painting. The artist works relentlessly, constructing the body in the fetishism of a morcelled inspection and a process of assemblage: 'A head *plus* arms, *plus* a torso, *plus* legs.'[24] The figure is a graphic vortex of articulations and lines of force. It is not a question of a 'woman' or at least not in line with the paradigm of the arabesque and the sensual to which Matisse so often complies. Although for both artists drawing is a process of knowledge, for Matisse the process works by the proximity of identification and emotional response whereas for Picasso the process consists of perception and constructive montage. Leo Stein tells how Matisse, on seeing such 'Negroid things' is supposed to have said: 'Yes, it's very ni-ice, very ni-ice, but isn't it just the same thing?'[25] which is a way of remaining convinced that, however reworked, faceted and carved, the figure still remains the same: a full length woman on a background. It was as if nothing more than the material, ink or charcoal, truly distinguished his *Standing Nude, Arm Covering her Face* of 1907 (no.31) and Picasso's *Study for 'Bathers in the Forest'* of 1908 (no.30). In this same period, Gelett Burgess, whose opinion was that Matisse 'took the first step into the undiscovered land of the ugly'[26] classed his nudes among those that 'defied anatomy, physiology, almost geometry itself.'[27] He nevertheless noted how Matisse could become indignant to see his 'theory of simplicity' perverted by Braque, Derain or 'little madcap Picasso'[28] in what for him was merely a formalistic reprise of the geometric principle he had followed: 'To my mind, the equilateral triangle is a symbol and manifestation of the absolute. If one could get that absolute quality into a painting, it would be a work of art.'[29] Matisse's graphic tactic for the 1906 woodcuts would thus be governed by an 'equilateral' schema that can be seen all the way to the chevron motif. The decentring of this structure which moves the centre of gravity of the work off field, forms the triangle of the 'absolute' between eye, hand and model. Foreshortenings, counter-angles, the deformation of the motif indicating the position of the painter, all denote the physical proximity of a glance at the outskirts of the body. Matisse is just there, skimming the

drawing in progress, his 'eyes less than a metre from the model and knees close enough to touch the model's.'[30] The painter encloses his subject in the continuous binding of the line, unceasingly unwinding and winding its thread.

While Picasso was working on the large paintings of the winter of 1907–8, Matisse and Leo Stein visited him at the Bateau-Lavoir, a visit Picasso would recall some years later in a letter to Daniel-Henry Kahnweiler: 'They quite openly joked in front of me. Stein said to me (I was telling him something to try and explain to him) "but that's the fourth dimension" and then started laughing.'[31] Leo Stein's *Appreciation* features an indirect reference to the debate between Matisse and Picasso, during which the latter attempted an explanation by means of rapid drawings: 'He would stand before a Cézanne or a Renoir picture and say contemptuously, "Is that a nose? No, this is a nose", then he would draw a pyramidal diagram. "Is this a glass?" he would say, drawing a perspective view of a glass. "No, this is a glass", and he would draw a diagram with two circles connected by crossed lines.'[32] In all likelihood Matisse would have considered such 'diagrams' as well as the drawings in which Picasso duplicates that 'immense naked woman entirely composed of triangles' referred to by Gelett Burgess,[33] as nothing better than 'very deliberate' demonstrations. For Matisse, the true stakes of drawing, as he taught his students, could only come out through a first and last reference to the model: 'All things have their decided physical character – for instance a square and a rectangle. But an undecided, indefinite form can express neither one. Therefore exaggerate according to the definite character for expression. You may consider this Negro model as a cathedral, built up of parts which form a solid, noble, towering construction – and as a lobster, because of the shell-like, tense muscular parts . . . But from time to time it is very necessary for you to remember that he is a Negro and not lose him and yourself in your construction.'[34]

As if in response to Matisse's warning, Picasso would give his own advice, noted by Apollinaire: 'An artist worth his weight must give to objects to be represented the most possible plasticity. Thus for the representation of an apple; if you draw a circle, it will be the first degree of the plasticity of the model. It is possible, however, that the artist wishes for a greater degree of plasticity and in this case the represented object will end up depicted in the shape of a square or cube which in no way negates the model.'[35] Already in the 1907 or 1908 drawings, Picasso's graphic work changes terrain in order to commence a self-referential plastic idiom: it is no longer a case of a mere stylistic procedure and the cataloguing of its effects, but of what might be called the extraversion of the signifier.

AB

HENRI MATISSE

21 *Large Woodcut (Seated Nude)* 1906
Le Grand Bois (Nu assis)
Woodcut 47.5 x 38 (18¾ x 15)
The Victoria and Albert Museum, London. Bought with
assistance from the National Art Collections Fund
(shown at Tate Modern)
Bibliothèque d'Art et d'Archéologie Jacques Doucet
(shown at the Grand Palais)
The Museum of Modern Art, New York.
Gift of Mr and Mrs R. Kirk Askew, Jr
(shown at The Museum of Modern Art)

HENRI MATISSE

22 *Small Light Woodcut (Seated Nude)* 1906
Petit Bois clair (Nu penché)
Woodcut 34.2 x 26.6 (13½ x 10½)
Bibliothèque d'Art et d'Archéologie Jacques Doucet
(shown at Tate Modern and the Grand Palais)
The Museum of Modern Art, New York.
Abby Aldrich Rockefeller Fund
(shown at The Museum of Modern Art)

HENRI MATISSE

23 *Small Dark Woodcut (Seated Nude)* 1906
Petit Bois noir (Nu assis)
Woodcut 34.2 x 26 (13½ x 10⅝)
Bibliothèque d'Art et d'Archéologie Jacques Doucet
(shown at Tate Modern and the Grand Palais)
The Museum of Modern Art, New York.
Gift of Mr and Mrs R. Kirk Askew, Jr
(shown at The Museum of Modern Art)

HENRI MATISSE

24 *Le Luxe* 1906

Woodcut 10.7 x 9 (4¼ x 3½)

Private Collection

PABLO PICASSO

25 *Study for 'Standing Nude'* 1907–8

Etude pour 'Nu debout'

Woodcut 20.1 x 99 (8 x 39)

Musée Picasso, Paris MP3164

PABLO PICASSO

26 *Study for 'Standing Nude'* 1907–8

Etude pour 'Nu debout'

Woodcut 20.1 x 99 (8 x 39)

Musée Picasso, Paris MP3165

PABLO PICASSO

27 *Nude with Raised Arm* 1907

Nu au bras levé

Woodcut 20.1 x 99 (8 x 39)

Musée Picasso, Paris MP3163

PABLO PICASSO

28 *Standing Nude with Raised Arm* 1908

Nu debout au bras levé

Charcoal on paper 62.7 x 48.1 (24⅝ x 19)

Musée Picasso, Paris MP554

PABLO PICASSO

29 *Standing Nude with Raised Arm* 1908

Nu debout au bras levé

Ink on paper 62.6 x 48.3 (24⅝ x 19)

Musée Picasso, Paris MP557

PABLO PICASSO

30 *Study for 'Bathers in the Forest'* 1908

Etude pour 'Baigneuses dans la forêt'

Charcoal on paper 62.7 x 48 (24¾ x 19)

Musée Picasso, Paris MP556

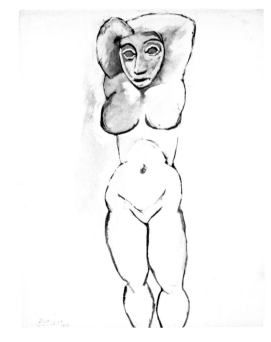

HENRI MATISSE

31 *Standing Nude, Arm Covering her Face* 1907
Femme nue debout, bras cachant le visage
Brush and pen and ink on paper
26.4 x 20.3 (10⅜ x 8)
The Museum of Modern Art, New York.
Gift of Edward Steichen

HENRI MATISSE

32 *Standing Nude, Undressing*
1906
Femme debout, se déshabillant
Ink on paper
75 x 32.5 (29½ x 12¾)
Private Collection

PABLO PICASSO

33 *Standing Female Nude* 1906–7
Nu debout
Watercolour on paper 63.5 x 48 (25 x 19)
Musée Picasso, Paris MP529r

PABLO PICASSO

34 *Standing Nude (Study for*
'Les Demoiselles d'Avignon') 1907
Nu de face (Etude pour
'Les Desmoiselles d'Avignon')
Gouache on paper 63 x 46 (24⅞ x 18⅛)
Robert and Lisa Sainsbury Collection,
University of East Anglia, Norwich

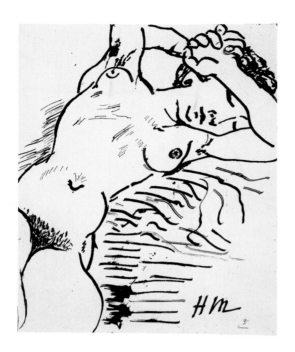

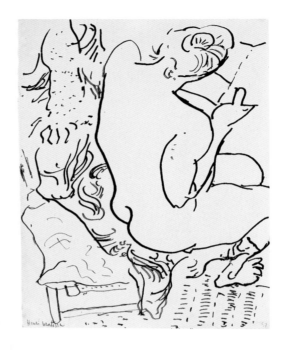

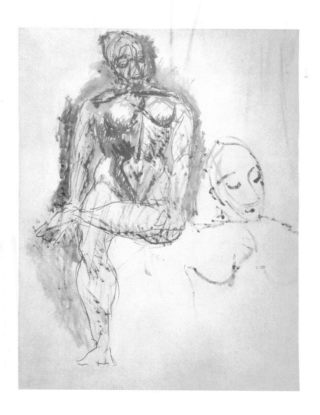

HENRI MATISSE

35 *Reclining Nude* 1906

Nu allongé

Indian ink on paper 27 x 21.5 (10⅝ x 8½)

Pierre and Maria Gaetana Matisse

Foundation Collection

HENRI MATISSE

36 *Seated Nude* 1906

Nu de dos assis

Ink on paper 27 x 20.9 (10⅝ x 8¼)

The Phillips Collection, Washington DC.

Gift of Marjorie Phillips, 1984

PABLO PICASSO

37 *Seated Nude*

(Study for 'Les Demoiselles d'Avignon') 1907

Nu assis (Etude pour 'Les Demoiselles d'Avignon')

Watercolour and graphite on paper

62.6 x 46 (24⅝ x 18⅛)

The British Museum, London

PABLO PICASSO

38 *Reclining Nude* 1907

Nu couché

Pastel on paper 48 x 63.5 (19 x 25)

Musée Picasso, Paris MP547

PABLO PICASSO

39 *Reclining Nude (Study for*

'Nude with Drapery') 1907

Nu couché (Etude pour 'Nu à la draperie')

Gouache on paper mounted on canvas

31.8 x 23.5 (12 x 9¼)

Private Collection

PABLO PICASSO

40 *Study for 'Nude with Drapery'* 1907

Etude pour 'Nu à la draperie'

Watercolour on paper 31 x 24 (12¼ x 9½)

The Baltimore Museum of Art: The Cone

Collection, formed by Dr Claribel Cone

and Miss Etta Cone

PABLO PICASSO

41 *Studies for 'Self-Portrait with a Palette'*
1906
Etudes pour 'Autoportrait à la palette'
Pencil on paper 31.5 x 47.5 (12³⁄₈ x 18³⁄₄)
Musée Picasso, Paris MP524r

HENRI MATISSE

42 *Portrait of Marguerite* 1905
Portrait de Marguerite
Pen and ink on paper
39.7 x 52.1 (15⁵⁄₈ x 20½)
Carol A. Cowan

PABLO PICASSO
43 *Nude in the Forest (The Dryad)* 1908
Nu dans la fôret (La Dryade)
Gouache, ink and pencil on paper
62.5 x 37 (24⅝ x 14½)
Private Collection

HENRI MATISSE
44 *Seated Nude* c.1906
Nu assis
Pastel, brush and ink on paper
74.3 x 54.6 (29¼ x 21½)
Collection Jan and Marie-Anne
Krugier Poniatowski

6

Still Life with Death's Head is the most important of Picasso's early still lifes and also the most striking. Because it is so obviously a *memento mori* or 'vanitas' attempts have been made to associate the picture with the deaths of characters who figured in his life. It has been suggested that the picture refers to the suicide of a neighbour of Picasso's in the studio complex of the Bateau Lavoir, the German artist and drug addict Karl-Heinz Wiegels, who hanged himself in front of his studio window on 1 June 1908.[1] On stylistic grounds, however, the painting is more likely to have been painted some months earlier. The death of Alfred Jarry on 1 November 1907 has also been suggested as a provocation.[2] In this connection it is worth remarking that the first three of the four deaths that left the deepest mark on Picasso's art (before Matisse's own), those of Carles Casagemas, Guillaume Apollinaire and Ramon Pichot (in 1901, 1918 and 1925 respectively), were acknow-ledged in Picasso's art by figure pieces and not still lifes. Picasso's projects for a memorial to Apollinaire were to condition his sculptural thinking for over a decade. However the death in 1942 of a close friend with whom he had worked in partnership, the sculptor Julio González, was commemorated in two of Picasso's greatest wartime still lifes; these, however contained depictions of a steer's rather than a human skull.[3]

Before 1908 Picasso had shown relatively little interest in still life, although by the middle of the first decade of the century the genre was becoming increasingly important to artists intent on formalistic experiment. By mid-1908 Picasso himself was immersed in it, and, through it, ever deeper under the spell of Cézanne. At least two of his immediately pre-Cubist figure pieces were transformed into renditions of inanimate objects. He was almost certainly aware of Cézanne's paintings of skulls and it has also been proposed that this *memento mori* might commemorate Cézanne's own death in 1906.[4]

Still Life with a Skull can perhaps best be viewed as it has most often been, as a pendant to *Les Demoiselles d'Avignon* (no.7) and simultaneously as a farewell to the expressionistically orientated paintings *Les Demoiselles* engendered and a prelude to the more objective, formalistically biased canvases that were to follow. Preliminary studies for *Les Demoiselles* show two male figures: a sailor at the centre, amongst the women, and on the left a medical student who appears to clutch what Picasso identified as a book, but which is more likely a medical dossier, and subsequently a skull. In one study he holds both. The position assumed by the squatting 'demoiselle' to the right might be explained by the fact that she awaits medical inspection. In the first decade of the twentieth century venereal disease and death were still not unknown to one another.

Still Life with a Skull is divided compositionally into images which to the left are symbolically male, to the right female. A pile of books, or of books and documents, traditional to the

memento mori theme, appears at the bottom left. On top of them rests a pipe, phallic in its implications, an instrument for insertion (perhaps a residual reference to the medical student's function). The skull (Picasso smoked a pipe and owned a skull), could be either male or female. But as John Richardson points out, when Sergei Shchukin bought the picture from Kahnweiler's gallery in 1912, it was entitled *Tête de mort sénile*, a reference to Josep Fontdevila, the nonagenarian keeper (and a former smuggler) of the inn at Gósol in which Picasso had stayed in the summer of 1906. He had taken to Picasso, who in turn identified with him. Fontdevila also became, to Picasso, a metaphor for this austere region of Spain. Richardson also points out the similarities between Picasso's depictions of the old man and his own last skull-like self-portraits.[5] Above the head is placed a rectangular artist's palette, its hole pierced by five brushes symbolising perhaps the artist's fingers. Again one is reminded that in Picasso's overtly erotic etchings executed in old age, the palette, held in place by the painter's thumb, becomes a metaphor for copulation. Behind the palette is an imaginary landscape derived from the studies of bare branches and foliage executed during the summer of 1907. To the right of the skull, and allied to it, is the empty double-ringed bowl or receptacle, and above it the image of a female nude, either framed or seen in a framed mirror.[6] Death, sexuality and creativity go hand in hand.

A confrontation between *Still Life with a Skull* and Matisse's *Goldfish and Sculpture*, executed four years later is revealing at many levels. Most immediately it serves to underscore the differing temperamental and aesthetic characteristics of the two artists. The Picasso is simultaneously melancholy and corrosive, deeply Spanish in feel. It has been remarked that Picasso often depicts grief and anguish in shrill, discordant colours.[7] Contours are sharp and jagged. The Matisse, on the other hand, has about it a diffuse, almost subaqueous quality. The pervasive blue endows the picture with a floating, expansive air, partly the result of the fact that the objects depicted are not laid down on the blue ground; rather the blue is painted up towards them often leaving a linear white nimbus of bare canvas at the point of nearest meeting—this characteristic Matissean device Picasso was later to exploit. The contours of objects are then at intervals reaffirmed softly by darker, mostly curving, linear elements.

Nevertheless the paintings have much in common. Both are are pictures about contemplation—on the one hand of death, on the other of a particular phenomenon of nature—to achieve a sense of higher consciousness or reality. Both pictures use the studio and its attributes as the theatre against which their respective visions are set. Picasso's inclusion of his own work anchors the wider implications of the subject to his own particular domain. In the Matisse the sculpture at the bottom right is the terracotta version of his own *Reclining Figure I (Aurora)* (1907, no.15), a work that meant much to him. He makes repeated use of it to furnish his still lifes and interiors. Here she is both a stand-in work of art and a surrogate human presence. She appears to float forwards from the edge of the table on which she is placed and is metaphorically crowned by flowers (nasturtiums). Plants and flowers were essential elements of Matisse's environments. (Picasso was not fond of flowers, and when admiring visitors presented them to him was wont to place them in waterless containers, remarking that they would soon die in any case.)

But it is the goldfish that are are the key to the significance of this Matisse painting, and temporarily they were to become an emblem of Matisse's philosophy of life. Here they make an early appearance in his art and over the next few years they reappear frequently. They can perhaps best be seen as an extension of Matisse's immersion in the world of Islam. Goldfish, long known in the Far East as symbols of luxury and contemplation, had been introduced into Europe in the seventeenth century.[8] *Goldfish and Sculpture* was executed in the studio at Issy-les-Moulineaux after a two month sojourn in Tangier; and Morocco, in a sense, had been annexed to the East because of its religion. Goldfish appear in the paintings of Matisse's second working visit to the country, from October 1912 to February 1913. In a key work, *The Moroccan Café* (fig.22), painted either in Tangier or soon after his return to Issy in the spring of 1913, the two Arabs that occupy the foreground squat and recline on the ground, lost in reverie before a bowl containing goldfish and a small vase of flowers placed next to it.

Matisse's own goldfish were kept in a large cylindrical laboratory jar. Fascinated as Matisse was by transparency, he insisted that the water must be kept crystal clear, a task assigned to his children.[9] For Matisse the brilliantly coloured fish contained in and gliding through colourless substance were clearly a source of wonder and fascination. Despite the physical presence of the fish they simultaneously act as patches of dazzling, disembodied colour. Matisse's friend, the painter Jean Puy, was to compare Matisse himself to a goldfish gazing out on the world.[10] In 1930 in Tahiti Matisse was spellbound for long hours looking down into the glass bottom of a small converted boat. Transparency he associated with light. He was to say: 'for a long time now I've been conscious of expressing myself through light or in light, which seems to me like a crystal within which something is taking place'.[11]

There is very little thematic connection between *Still Life with a Skull* and *Still Life with Basket of Oranges*. The one is tragic, the other frankly hedonistic. The Picasso entered the collection of Sergei Shchukin in 1912. The Matisse was one of a trio of paintings commissioned by Ivan Morosov, Shchukin's only rival Russian collector in the field of modern French art.[12] In the event Matisse sold the picture to the Bernheim Jeune Gallery on 27 April 1912; it is conceivable that Picasso saw it there before it passed on a month later into a German private collection. At this time both artists were relying heavily on their sales to Russia, and the fact that *Still Life with Basket of Oranges* was originally destined for Moscow would have lent the picture an additional interest in Picasso's eyes.

Thirty years later Picasso acquired *Basket of Oranges* for his own private collection.[13] It entered his quarters in the rue des Grands-Augustins in November 1942 and he asked friends around to see it.[14] At the time of Picasso's death there were seven of Matisse's paintings in his possession: 'more and more I feel the need to live with these', he confided to a friend.[15] *Still Life with Basket of Oranges* was the most important of them and became possibly his most prized possession. In the sculpture studio at the rue des Grands-Augustins it was prominently displayed, illuminating a large and somewhat sombre space. Later, in the south of France, at Notre Dame de Vie in Mougins, the most loved of all Picasso's homes, the Matisse took pride of place in the central hall, where much of his life was lived. Visitors who could not agree on the picture's

greatness were given short shrift.[16] Picasso's acquisition of *Still Life with Basket of Oranges* further cemented the ever deepening friendship between the two men. In February 1945 Matisse wrote to his son Pierre: 'Picasso has bought the Tangier still life which used to belong to Madame Sternheim. He is very proud of it.'[17] Legend has it that when Matisse learnt that the picture was up for sale he wanted to buy it back for himself and that on learning it had already gone to Picasso he was so moved that he wept.[18]

In Tangier the great picture was probably executed in a room in the grounds of the Villa Brooks where Matisse had obtained permission to work.[19] It is the most opulent and fully realised of all the works of Matisse's first Moroccan period. The majority of the Moroccan pictures are thinly painted, shimmering and vaporous in effect.[20] Here pentimenti are clearly visible and it is obvious that much effort was expended in the picture's creation. The final result shows no signs of strain, although the composition is taut and the linear elements that tie the still life back into space and out to the canvas's edges are exceptionally pronounced for Matisse at this time, and recall at a distance the compositional procedures employed by Picasso in *Still Life with a Skull* . The exceptional colouristic richness of *Basket of Oranges*, together with its dense yet creamy surface, may have come to awaken in Picasso echoes of Delacroix, the painter with whom he came increasingly to associate Matisse. Both Matisse and Picasso were fully aware of the results of Delacroix's Moroccan expedition undertaken ninety years before Matisse's own. Matisse rejected the suggestion that in seeking visual stimulus in Africa he was emulating his great and colouristically revolutionary predecessor, but in Morocco Delacroix's achievements were unquestionably much on his mind.[21]

Even more than goldfish and for a much more extended period of time, oranges were to be a leitmotif in Matisse's art. They first put in an appearance in 1896 and he was still referring to them in 1953, a year before his death. As early as 1915, in a preface to the Matisse–Picasso exhibition at the the Paul Guillaume Gallery, Apollinaire had written: 'If one has to compare Henri Matisse's work to anything, one should choose the orange. Like it, Henri Matisse's work is a fruit of dazzling light.'[22] The fruit became for Matisse something hallowed, and in his art he achieved for it the status that Cézanne had conferred upon the apple. He rejoiced in its pure, spherical luminosity, and it became for him a symbol for a lost Golden Age.[23] Matisse believed in the orange's health-giving properties, just as he believed in the restorative, healing properties of his own art. In the summer of 1913 when Picasso was temporarily indisposed Matisse visited him in his studio on the boulevard Raspail, bringing with him flowers and oranges.[24] Later in life Matisse arranged to have delivered to Picasso a crate of oranges on every New Year's Day.[25]

JG

HENRI MATISSE
45 *Still Life with Basket of Oranges*
1912
Nature morte à la corbeille d'oranges
Oil on canvas 94 x 83 (37 x 32⅝)
Musée Picasso, Paris

83

PABLO PICASSO
46 *Still Life with a Skull* 1908
Nature morte à la tête de mort
Oil on canvas 115 x 88 (45¼ x 35⅛)
The State Hermitage Museum,
St Petersburg

HENRI MATISSE
47 *Goldfish and Sculpture* 1912
Poissons rouges et sculpture
Oil on canvas 116.2 x 100.5 (45¼ x 39⅝)
The Museum of Modern Art, New York.
Gift of Mr and Mrs John Hay Whitney

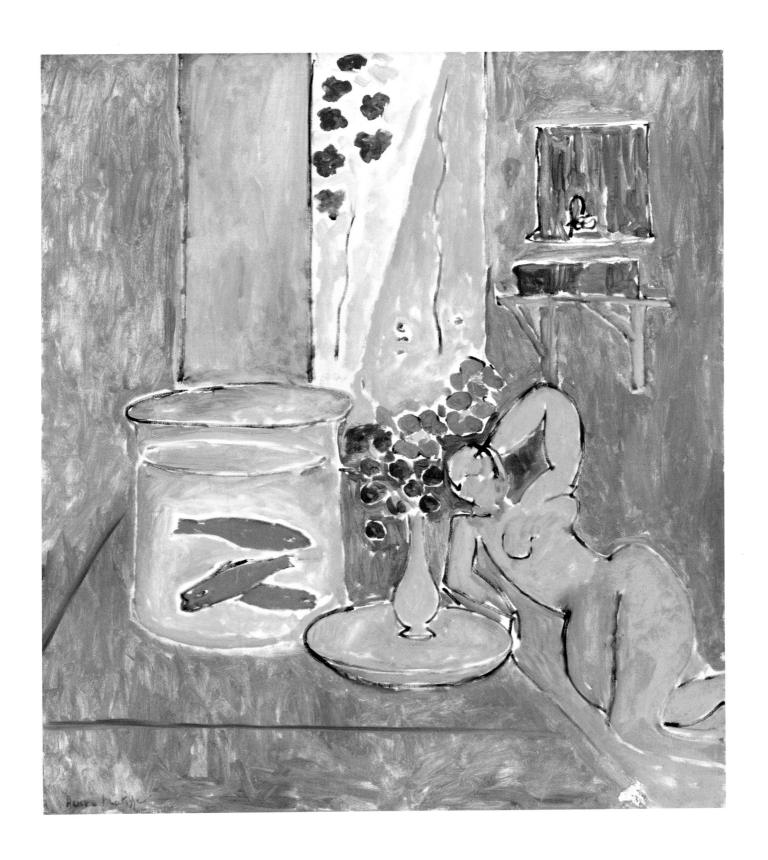

7

It is impossible not to notice that out of the thirty-four sections of the exhibition, this is the only one devoted to 'landscape' in the traditional sense of the term. And landscape is almost the only breath of fresh air in an otherwise obsessive confrontation with the *figure* as model at the heart of the oeuvres of Picasso and Matisse. Matisse, probably more than Picasso, seriously engaged with this major category of classical painting, landscape, if only to subvert it. Was it not by means of landscape that Matisse (with Derain in 1905) invented what would come to be called Fauvism? Was not the framing of landscape by the contours of a window as the homothetic equivalent of the painting, the foundation of his vision of space?

Perhaps the reason why Picasso painted relatively few landscapes lies in the fact that the only space that truly interested him was the one engendered by the figure, the one intensely opposed by the figure, the one which, in the final analysis, only the figure can qualify.

Whatever the reason, the complex relations between the three landscapes under scrutiny here, and their place in the canon of works contemporary with them, themselves trace an interlocking space humming with contradictory forces, the active workplace of the years between 1907 and 1917.

Like a musical theme, the motif of trees in a wood obviously links these three paintings: the same vertical rhythm, imparted by more or less parallel tree-trunks, cuts their surface from bottom to top. Bringing the three paintings together in a virtual triptych also reveals a much broader relationship. The central confrontation between Matisse and Picasso at the turning point of 1907–8 has its counterparts in other dialogues – the one between Derain and Matisse in 1907, and those of Derain or Braque with Picasso in 1908. The triptych takes on a new turn in Matisse's confrontation with himself, over a period of ten years, before and after the frontal clash with 'the invention of Cubism' and the triumphant arrival of the symbiotic duo Braque and Picasso.

View of Collioure was begun in early summer 1907, in Collioure where Matisse had lived for long periods since his first stay two years previously. Collioure can indeed be considered his main place of work at this time, since over a period of fourteen months, from late June 1906 to September 1907, he spent only three months in Paris. During the winter of 1906–7 and throughout the following months Matisse worked intensively on experiments in distancing: the setting at a distance of the model, either by contradictory treatment (the two versions of *Young Sailor*,[1] the two versions of *Portrait of Marguerite*)[2] or by recourse to photography (*Reclining Nude I*, no.15, *Two Women*, no.12 and *Standing Nude*, no.17); the setting at a distance of painting by sculpture and of sculpture by painting (*Blue Nude: Memory of Biskra*, no.14, undertaken in the aftermath of the accident with the sculpture *Reclining Nude I*, no.15). *View of Collioure* is a step in this process. Its subject, the village of Collioure and the sea seen from above, through trees,

is literally a setting at a distance of the first motifs of the summer of 1905: the sea and the rocks were then viewed close up, no less so than the port and the skiffs, or the lighthouse/bell tower of the fortified church. Matisse and Derain had at that time worked at translating, almost simultaneously, their coloured sensations by means of juxtaposed marks retaining every bit of the vivacity of touch of their brushwork. From this first summer on, however, Matisse had chosen a particular locality – two curtains of trees on the way to the seaside (*Landscape at Collioure*)[3] which, simplified and set at a transcendent distance, he would transform into the majestic setting for the 'pure theoretical figures'[4] of *Le Bonheur de vivre*.[5]

In *View of Collioure* the constitutive elements of a basically similar landscape reappear, but reorganised in such a way as to render them unrecognisable. First of all the tree-trunks are no longer organised symmetrically, in a perspectival and theatrical structure. The winding lines of the drawing compose a black network on the surface, dismembering each of the calmly superimposed horizontal elements of the landscape – the pink sky, the blue sea, the ochre sand, the brown earth of the wood. Done in large supple shapes (as in *Le Bonheur de vivre*, fig.2) and resembling immense leaves, these masses of foliage constitute a series of complete colour-enclosing cells, and contribute to the strong compartmentalising effect which gave its nickname to the work during its time in the studio: the stained glass window.[6]

The contrast is slightly strained between the firmness of the black arabesques and the vibrant liquidity of the colour filling each of the sections thus set off. Matisse later dropped this procedure, which too literally turns the painting into a window of stained glass. In the landscapes seen through trees that he made in Cassis in the summer of 1907, Derain sometimes succumbed to this partitioning effect. On his way to Italy, Matisse stopped off to see his friend (and his paintings) in Cassis, as we learn from two letters Derain sent to Vlaminck.[7] Matisse showed him photographs of his work in progress, which elicited from Derain, in a state of self-doubt, the possibly envious remark: 'I believe he has crossed over the threshold of the seventh garden, that of happiness'.[8] A photograph showing *Standing Nude* (Tate), still yet unfinished, and *View of Collioure* already signed and, apart from a few minor details, in its final stage, may have been among the photographs shown to Derain in July 1907.[9] This would be additional evidence to establish that the painting was finished at the end of that summer, and that it could have been shown in the Salon d'Automne, as Jack Flam also believes.[10]

It is therefore likely that Picasso saw this painting at the Salon, with the other Matisse contributions (such as *Le Luxe I*, no.6) bearing the designation 'sketch'.[11] There was a Cézanne retrospective at this same Salon. Influenced by this event, after the effort expended to finish *Les Demoiselles d'Avignon* (no.7), and probably affected by his relationship with Braque, Picasso began a series of studies on the Cézannean theme of bathers in a forest – nudes progressively reinstalled in landscape. Braque (who at the same time would try his hand at figures – see his *Large Nude* begun in the spring of 1908) had indeed been working for several seasons on an approach almost exclusively involved with landscape, with the 'fundamentals' of Cézannean landscape at work in the views of Estaque, where Braque took up residence during three consecutive summers. This is the context in which Picasso (who was feeling quite lonely in Paris, as

he wrote to his friends the Steins on 14 July)[12] left Paris late in July 1908 to spend several weeks on La Rue-des-Bois, north of Paris, near Creil, a long lacklustre village, swamped in the green of the ancient trees of the Halatte forest. This is what is meant by the French expression '*faire bande à part*', to make a separate group of oneself: the others (the 'independent painters', as Picasso describes them) were in the south of France, Braque in L'Estaque, Derain in Martigues. Matisse, however, seems to have spent the summer in Paris, but there is no record of correspondence, whereas Derain (according to a later report by Fernande Olivier) is supposed to have paid a quick visit to Picasso during this stay.

Picasso was in a dour mood, if not totally in the grip of a 'kind of neurasthenia'[13] in this month of August 1908. No doubt deeply hurt by the negative reception of *Les Demoiselles d'Avignon*, and anguished over how to advance in the project undertaken (*Three Women*, no.00), he was also affected by the recent suicide of a young friend and fellow painter from the Bateau Lavoir, the German Wieghels. 'In La Rue-des-Bois, he did manage to rest . . . We had our meals in a room smelling like a farm. We would sleep rocked by the vague murmur coming from the forest. We would rise late, indifferent to the noises of the farm, having been awakened as early as four in the morning', recounts Fernande.[14] From out of this immersion in greenery, Picasso would paint a series of fascinating landscapes, of an almost metallic solidity, which enter into a strange dialogue with those painted by Derain (in Martigues) and by Braque (in L'Estaque). Filtered by a gaze informed by the contemplation of Cézanne, as in a joint effort at simplification and reduction (reduction of volumes to geometrical shapes, reduction of colour) these three groups of paintings indubitably resemble one another. But unlike those of Braque, Picasso's landscapes are empty theatres. Of course he erects entities that could be called trunk beings, leaf beings, beings imposing themselves on the gaze with incredible force. As in a theatrical decor, compact shapes, filled with dense colour, rise toward an encounter with the beholder. The jungles of Le Douanier Rousseau come to mind.[15] More important, however, is the impact on Picasso (perhaps relayed by Braque and Derain) of Cézanne's recommendation: 'Everything in nature is modelled on the sphere, the cone and the cylinder. One must learn to paint from these simple forms; it will then be possible to do whatever one wishes'.[16] Between this lesson, and that of the African sculptures, between the will to geometrisation and a more 'animist' and sculptural vision, the landscapes of the Rue des Bois, call for, evoke, and lack figures. During that summer Picasso painted a *Farmer's Wife*, as crude and rough as a barely squared-off tree trunk. The next autumn he finished a *Dryad (Wood-Nymph)* which is much more emblematic, seeming to arise from out of a primeval forest. He then resumed work on *Three Women*, three reddish nudes, carved in the mass, hardly distinguishable from the confusedly green background. The empty scene of *Landscape*, between the trunks disposed like uprights, hollows out as if in expectation of one or several of these giant, vaguely mythological, creatures. The problem is closer than it might first appear to a Matissean one, and thus less close than might be expected to the already Cubist Braque of L'Estaque in 1908.

Seven years later, in the middle of the First World War (December 1915), Matisse returned to Marseille, to L'Estaque, perhaps to rediscover Cézannean if not Cubist sensations. On 19 Janu-

ary 1916 he wrote to Camoin in Paris: 'I'm planning to return to Marseille in a month or two. I have begun here in L'Estaque a drawing of leaning trees, pine trees, that I want to finish. These trees, you may know them, are on the other side of the road, on the upswing leading to the restaurant on the cliff.'[17] This superb drawing, with an almost abstract rhythm, places in the wake of Cézanne an entire series of landscapes which subsequently would be done in the forests around Issy-les-Moulineaux. In the spring of 1917 a small automobile allowed Matisse to 'easily transport myself and my materials to the forest'.[18] Is Matisse not once again working on the motif, on the landscape as he was in the Collioure period, and during his stay in Morocco?

The radical nature of the painting entitled *Shaft of Sunlight, the Woods of Trevaux*, which never left the artist's studio and was rarely exhibited and not reproduced before 1951, has occasioned many commentaries. Alfred Barr, following indications from Matisse himself in answers to his questions, ascribed the painting to 1912, associating it with the stay in Morocco. It is now known that the painting belongs with those of the spring-summer season of 1917, that is to say, at the time of a double movement in his painting career: one back towards his work of the preceding years and one consisting in reflection about a possible reorientation. At the precise moment when Matisse was at the very edge of abstraction, a growing number of paintings, more relaxed and more 'lifelike', announced a profound change. This is the oscillation between the severe *The Piano Lesson* (no.71) and the lovely *Music Lesson* (1917), or between the first 'soft' version of the *Portrait of Auguste Pellerin* (1916) and the second, grandiose and geometrical icon of late 1916 to early 1917 (no.59). This swing back and forth, this rapid change in tone is sometimes even more abrupt: only a few weeks, perhaps just a few days separate *Shaft of Sunlight* from its twin *Walk at Trivaux*,[19] whose subject and dimensions are identical, there being no way of determining which was painted first. *Shaft of Sunlight* does show the same streaks of shadow and light, the opening onto the sky, the perspective of the walk and the trees alongside. But the extreme clarification of the motif, the violence of the optical contrasts, the crudeness of the splashes of spring green, the feeling of blindness produced by the large criss-crossing black and white bands recall the elliptical masterpieces of 1916: *The Moroccans* (no.72) and *Bathers by a Stream*.

IMF

90

HENRI MATISSE

48 *Shaft of Sunlight, the Woods of Trivaux* 1917
Coup de soleil dans les bois de Trivaux
Oil on canvas 91 x 74 (35⅞ x 29⅛)
Private Collection

HENRI MATISSE

49 *View of Collioure* 1907

Vue de Collioure

Oil on canvas 92 x 65.5 (36¼ x 25¾)

The Metropolitan Museum of Art, New York.

Jacques and Natasha Gelman Collection, 1998

PABLO PICASSO

50 *Landscape* 1908

Paysage

Oil on canvas 73 x 60 (28¾ x 23⅝)

Private Collection

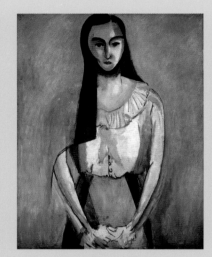

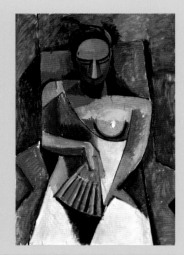

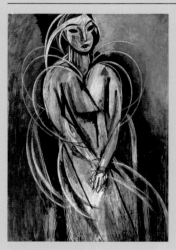

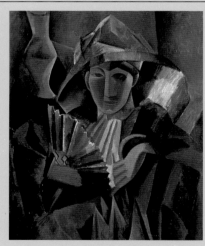

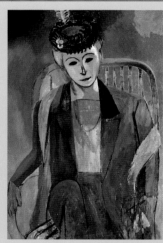

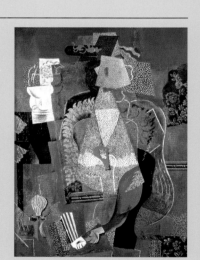

8

These seven magnificent feminine creatures are facing us, though not full length; seated or standing, we see them only in three-quarter length. They have all undergone a radical operation of geometrisation. Flattened, reduced to a few curves, a few colours, a few shadows, a few articulations, they all maintain the traces of a resemblance (each was inspired by a model and at least two of them were conceived as actual portraits), itself in a state of tension resulting from a will to abstraction. The intense presence of each of these effigies, and the power of fascination emanating from them, derive from this fundamental contradiction. Like the seven queens of a monumental deck of cards on the scale of the match between Matisse and Picasso in the period 1907–1916 and their respective confrontations with Painting,[1] they sport attributes at once specific and interchangeable: fans, blouse or umbrella, hats, thin scarf or feather boa.

These female creatures should, as is customary, first be considered from a chronological point of view. These paintings bridge a period from 1907 to 1916, that is to say, the exact arc of Cubism, and their comparison shows up the delayed reactions of Matisse (in 1913, 1914, then 1916) to the brutally audacious propositions drawn up, each year in a new way, by Picasso in 1907, then in 1908 and 1909, with respect to their common Cézannean inheritance. Picasso's 1914 *Portrait of a Young Girl* is nothing more, despite its virtuoso perfection, than a playful rejoinder to Matisse's 1913 *Portrait of Madame Matisse*.

Woman in Yellow, according to Pierre Daix, belongs to the period of spring 1907, that is, to a small series of works contemporaneous with the inception of work on *Les Demoiselles d'Avignon* (no.oo), without being directly linked to it.[2] Daix compares *Woman in Yellow* to the central figures of a first state of *Les Demoiselles*, pointing out the shape of the taut bun, the almond-shaped eyes, and the mouth drawn in a single stroke. But the face is much flatter, despite the position of the nose, slightly offset. The muscular arms, like cords, are a strange detail, in no way a match for the very feminine corsage – which in fact is rather like a corset, which brings the figure into the orb of the bordello – their lines, resonating with the draped background, drawn with a brutality matching that of the colour, an aggressive yellow and a blue. This work entered the Paul Guillaume collection, before being purchased by Joseph Pulitzer. It can be seen in several photographs of his living room, 20 avenue de Messine, in 1927, then in the exhibition organised by the Bernheim Jeune gallery in 1929.[3] A year later *Woman with a Fan* (no.53), painted in the spring of 1908 (before the departure for the Rue des Bois) and purchased almost immediately by Shchukin, can be attributed to an antithetic vision, as if Picasso had deliberately countered the aggressively flat array of paint of the preceding work by dealing exclusively with the depiction of a figure in schematically carved volumes, in harsh light, and using an array of colours limited to white, black and tints of ochre. Fernande undoubtedly inspired the work (see

the drawing Daix refers to in notebook 16, and also the x-ray photograph of the painting in the Hermitage Museum, showing the first version of the face with open eyes, as in the drawing).[4] But *Woman with Fan* undergoes a ruthless geometrisation, and is organised in a rigorous symmetry. The painting is divided down the middle by a vertical line extending from the nose to the hollow between the knees, keeping a spherical breast on the right-hand side and the triangle of the fan on the left. Light spreads like a curtain, highlighting the forehead and the bridge of the nose (the eyes remain lowered, shadowed, like those of some masculine heads drawn in spring 1908)[5] and the two large white triangles (the dress draping the knees), pushing the whole composition forward. Picasso here is obviously in a dialogue with Cézanne and Braque, whereas Matisse, at the same moment, explores, in *Portrait of Greta Moll*, another, looser kind of stylisation of volume reinterpreted in the wake of the Venetian masters.[6]

In the second *Woman with a Fan* (no.54) Picasso reverts to Cézanne; one might say Picasso gets even closer to him as his relationship with Braque becomes more intense, and the purely 'Cubist' formulations and future crystallisations (which would reach their first already simplified form, simplified to the point of transparency, in the landscapes painted that summer at Horta de Ebro) progressively take shape. Constructed in a pulsation of shadow and light materialised in the recurrent motif of the fold (folds of the fan, the white jabot, the umbrella), the painting aligns references to Cézanne: the large hood around the figure's face, strangely reminiscent of the three-cornered hats of the Harlequins (a Cézannean emblem) painted at this time.[7] Immediately purchased by Shchukin, like the preceding painting, it had never been shown in a public exhibition.

This is not the case for *Portrait of Madame Matisse*, worked on throughout the summer, finished on the eve of the opening of the 1913 Salon d'Automne, the only work by Matisse to be exposed there, and which created a sensation. Apollinaire's dithyrambic reaction, which is well known (in his articles dated 14 and 15 September 1913),[8] and the still positive but more measured reaction of André Salmon,[9] the inveterate Picassian, are two typical responses to the painting.

Quite similar to the photograph taken by Alvin Langdon Coburn in May 1913[10] in the Issy-les-Moulineaux studio in which she sits (in the company of Matisse) before *Bathers by a River* in progress, seated on the same wicker lawn chair (painted in green?), Amélie Matisse is obviously not just any model. Her portrait is that of the artist's spouse, for the first and last time announced, exhibited and published as such, for friends (Charles Camoin),[11] for collectors (Sergei Shchukin who decided on the spot to purchase the painting),[12] for the critics and public of the Salon d'Automne, duly informed that the painting is indeed a portrait. In emulation of Cézanne, whose two portraits of Madame Cézanne[13] are a source of Matisse's painting, but in opposition to the Cubists and particularly to Picasso who, while continuing to work from model or companion, is at this time (1913) avoiding all overly precise representation.[14] Although Apollinaire called it 'voluptuous', the *Portrait of Madame Matisse* nevertheless introduces a new severity, a new insistence on construction by means of lines and schematisations as much as by the work of colour. One can sense how strongly Matisse at the time feels challenged by Cubism and by the system of signs devised by Picasso and Braque as early as 1910, and subsequently,

endlessly, revised and perfected so as to capture within it the representation of the figure as well as the objects and the elements of landscape.

The history of the large portrait of Yvonne Landsberg is also well-documented: begun on 8 June 1914, completed in mid-July, after several drawings, five prints and innumerable sittings.[15] Like *Portrait of Madame Matisse*, this work is a manifesto. That which Matisse calls into question at each sitting is not only the surface of the painting but the totality of his relation to the model: the tension between the dependence on the model still essential to him, and the autonomy of the painting as 'pictorial fact'.[16] The 'lines of construction'[17] that he had scratched into the fresh paint of the surface with the brush handle, during the last sitting, are neither 'lines of deconstruction'[18] as has often been said, in a reversal of Matisse's expression, nor a mere decorative armature reinforcing, after the fact, the installation of the figure. The aim of these lines is to confer on the picture the coherence of a plastic fact, to impart to the figure a materialised aura – in much the same way as the rays of a halo announce a concentration of saintliness. Line for line, sign for sign, construction for construction, these lines correspond to the delicate orthogonal grids on which exploded, dispersed elements of figures or still lifes are suspended in the paintings of so-called Analytic Cubism. Matisse's expanding curves are set to win on the Cubist chessboard.

Portrait of a Young Girl, painted by Picasso in Avignon in July–August 1914, is thus exactly contemporaneous with the *Yvonne Landsberg*. By its format, its subject (a woman in an armchair), several similar details (hat, scarf, feather boa), and even the use of colour (a saturated green ground), it seems nevertheless to be the companion piece of *Portrait of Madame Matisse*, and its rejoinder: an allegro in lively green to respond to an elegy in dark blue? The young lady in question is believed to be Eva Gouel, Picasso's much loved companion since 1912, whose name figures in his paintings. It is a celebration of effortless grace – the feathers of the boa, the stippling joyful like confetti – unfolding a veritable fireworks of plastic solutions, *trompe l'oeil* effects (imitation collages, the incrustation of the 'academic' drawing of a bunch of grapes in a fruit bowl) and graphic fantasies.

As for the austere *The Italian Woman*, its model was Lorette, a professional model with whom Matisse inaugurated, in late 1916, a system of working which would continue in Nice after 1918 with Antoinette (1918–19), then Henriette (1920–7) and afterwards so many others. Lorette sat for some forty paintings in a little more than a year, beginning Matisse's deliberate return to the figure and the nude as his main motif. We know through a photograph taken in the studio at quai St. Michel in late 1916[19] that a first state of *The Italian Woman* is a better likeness, with fuller, rounder shapes. Progressively thinned down, reduced to a thin silhouette, the figure is built by successive subtractions, as if it were a sculpture carved in the mass. A similar process led Matisse, from the photograph of a model with full, round forms, to the construction of the lanky *La Serpentine* in 1909 (no.18). The disappearance of the right shoulder of *The Italian Woman* can be compared to the brutal 'dis-orbiting' of *Jeannette V* (no.142), which probably took place in 1916 as well. The simplification of colour in *The Italian Woman* (a 'Cubist' range of greys and ochres) echoes the progressive dis-incarnation of the model. This canvas, so strangely com-

parable to *Woman in Yellow* (the corsage, the outline and the position of the arms and hands, the verticalisation, the thinness) is, almost ten years later, an ultimate Cézannean manifesto, before the first odalisques, painted with Lorette in 1917.

In terms of symmetry and outlining, the problem inherent in all these figures, provoking the invention of various brilliant solutions by Picasso and Matisse, was how to handle the line of the shoulders, complicated as it was in at least four cases by the inference of the back of the chair on which some of the models are seated. In *The Italian Woman*, the amputation of the right shoulder, replaced by a sheet of paint extending the ground to the edge of the black and rigid effusion of the shock of hair, causes a veritable destabilisation, and reinforces the impact of the face modelled by the light; placed in the exact upper centre of the canvas, it is flanked by two islands of hair which are themselves placed in two different planes. The same energy-building imbalance can be found in several ways in the first *Woman with Fan*, the 1908 version: first of all because the dress or shirt reveals only one breast – does this terrible amazon woman possess another? We are entitled to our doubts – especially because the right shoulder is shifted upward in an improbable fashion. From here, a whole system of oppositions between curves, triangles and right angles empowers the space of the painting with movement: especially the large curve formed by the edge of the dress, which plays as counterpoint and balance with the rectangle of the armchair's back, itself framing and repeating the double right angle of the shoulders.

Portrait of Madame Matisse, the portrait of *Yvonne Landsberg* and *Portrait of a Young Girl*, on the other hand, count on the more gentle effects of multiple curves, the shoulders of the model echoing the rounded backs of the armchairs, and the scarves or boas around the neck. Similar to the 1908 *Woman with Fan*, the shoulders of Madame Matisse, or rather, the shoulder pads of her elegant suit take up all the width of the open-worked back of the wicker armchair. Her right arm, exaggeratedly thinned to the point of atrophy, creates a dissonance. The circulation of the ochre ribbon serving as a scarf also lightens the symmetrical construction. Picasso returns to this motif in *Portrait of a Young Girl*; the feathered boa is evocative both of the gentleness of a line of shoulders and the curves of a rococo wing-chair, one that possibly exists only in the imagination of the beholder, but that the bourgeois atmosphere of the room (chimney, fruits, flowered wallpaper,[20] ribbons) might call up. Last but not least, the incised lines in waves around the shoulders of *Yvonne Landsberg*, resonating with the armrests of the green wicker armchair – the same one in which Madame Matisse sat for her portrait – are the most important elements of the painting, conferring on it from the start an extraordinary energy.

It is notable that the surface, or the coloured skin, of all these paintings is densely worked, perhaps to compensate for the sensation of flatness arising from the effort at geometrisation, and to configure against all odds a thickness, either by the use of shading, or by purely graphic means. In *Woman in Yellow* (as in all the experiments contemporary with *Les Demoiselles d'Avignon*) Picasso resorts to hatching, to violently contrasted parallel streaks, either dark on a clear ground (the corsage) or the opposite (the folds of the drapery serving as background). As much as the black lines slicing the body of the model into basic geometric elements (the hexag-

onal pelvis, for example), the hatchings brutalise and dehumanise the figure, contributing to its depiction as a geographical map or an anatomical schema lacking only captions and titles. If the work was indeed done prior to Picasso's visit to the Trocadéro museum,[21] or if, according to some, it should rather be considered in relation to an Iberian influence,[22] the surface of this painting is nonetheless handled like a tattooed skin. Paradoxically it is primarily the yellow corset – a typically Parisian article of lingerie, associated with bordello ladies since Degas and Lautrec – that, hatched and stippled with black like a tiger's skin, calls up these primitive or primitivistic associations.

In *Portrait of a Young Girl* Picasso, by an excess of antinomic procedures, tested or invented *ad hoc*, marks the whole surface of the painting, and kneads the space on the inside and around the figure to give it a consistency that surprises at every point. This 'portrait' cannot be apprehended as a whole, regardless of the unifying green. The eye is constantly teased, disoriented and finally enraptured before so much exultant fantasy. The outlines stippled in red and white, black and blue, yellow and black, white, blue or black modify the green background, giving it sometimes the value of a shadow, sometimes one of light, or at other times defining the figure (face and central zone). The surface of the painting is also tattooed here and there with imitation *papiers collés*,[23] stripe motifs (right arm, light bulb), imitation marble, flowers, imitation mouldings or braids, by a row of small feathers naively aligned, or again by a fruit bowl under its bunch of grapes carefully drawn in perspective on a white sheet of paper. It is the juxtaposition of the multifarious textures composing the everyday universe, each motif being moreover doubled up, following the random distribution of sunlight or shadow (the marble of the chimney, the boa, or the fruit dish, alternately dark or clear). The figure itself, handled mainly in stipplings letting the green ground show through,[24] has a part in the plasticity, the fluidity of this space. It is therefore in a way transparent, painted as if superimposed, in stipplings floating along with its feathered scarf like a spectre on the surface of a small world of objects whose materiality is less of a problem.

Matisse, in order to get through the experience of painting the portrait of his wife, and especially the *Yvonne Landsberg* adventure, recurs to an actual scarification of the pigmented skin as it is applied sitting after sitting on these paintings. These gestures of incision and scratching, with something about them rather violent and compulsive,[25] force the ground to come up and skim the surface, which allows the gaze to perceive the layers of colour, as well as the accumulation of time in the slow elaboration of the painting. It must however be pointed out that the film of colour attacked in such a way, scraped by the brush handle during the final sitting, has itself been abraded in advance, in the wear and tear of successive erasures: it seems as though Matisse had several times reprised the entire surface of the portrait of *Yvonne Landsberg* after having removed the traces of the previous sitting.

It is no longer a question here of specifying the form of these 'lines of construction',[26] or even of trying once again to figure out what they might mean, but one of noticing their materiality: these clawed zones extend all the way to the interior of the figure, covering the quasi-totality of its mask – of which only shreds of a livid white remain – and onto entire patches of her

dress. These are zones of non-description, a formless and fascinating blend of incised hatchings and coloured remains, which nevertheless cohere. It is surprising that at the same time, in July 1914, Matisse and Picasso occupy symmetrical, although inversed positions: scratching is the opposite of collage, whose role is to hide a ground the existence of which it implies. Bands and incisions 'add subtractions' in *Yvonne Landsberg*, whereas the outstanding performances that the imitation collages bring off, incorporated into the green ground of *Portrait of a Young Girl*, 'subtract additions'.[27]

The seven portraits can also be read as a variation on the theme of the mask. Matisse and Picasso were early on fascinated by the formal possibilities of these objects, as well as by their emotional and spiritual potential. Among all other parts of the body, the geometrisation (mechanisation) of the face and the eyes is the most significant operation, if not the most scandalous: see the reactions of horror, including those of Picasso's most 'advanced' colleagues, to *Les Demoiselles d'Avignon* (no.7) and their Medusian gazes! *Woman in Yellow* has been studied in relation to a votive statue of Despenaperros[28] and the face of Mme Matisse to a Punu mask.[29] The simplifications of Fang masks (forehead and nose all of a piece, hollow eye sockets) no doubt influenced the first *Woman with Fan* of 1908. Regardless of the precise nature of the objects they connote, the other figures, with their oval shaped faces of idols (the second *Woman with Fan*, *Yvonne Landsberg*, *The Italian Woman*) owe much to the aesthetics of the mask. Only Eva, hidden in the *Portrait of a Young Lady* by a fold of stippled planes, offers just a green nose and two almost invisible slits – two thin black lines – in guise of a gaze, just as in the masterpiece of 1913, *Woman in a Chemise Seated in an Armchair*, also inspired by Eva, there are just two almost imperceptible points suggesting eyes on either side of a line depicting a nose. In both cases the mask is reduced to its most elementary expression.

The most suggestive in this series of faces/masks remain, nevertheless, those painted white of Madame Matisse and Yvonne Landsberg – or, to be more precise, scraped down to white in the case of the portrait of the young American woman. They manifest a dour charm and this aspect did not elude the attention of André Salmon, who, as early as December 1913, noted to what extent 'the human face inspires horror in Matisse, who has never interpreted a single one. This time, again, his woman in blue wears a wooden mask smeared with chalk, and it is again a figure from out of a nightmare, although quite a harmonious nightmare.'[30] Salmon seems in effect to be referring to the Gabonese white masks covered with kaolin (Punu or Shira Punu) whose function is to represent ghosts or spirits. And in fact the face of Amélie and her chalk coloured hair, as well as the general tonality of the work in cold blues and greens, give an impression of almost funereal melancholy, as if this figure leaning slightly forward toward the beholder had come from a considerable distance, perhaps even from beyond. Let us recall here that this was the last painting actually modelled – and with what patience[31] – by Amélie for her husband, on the eve of numerous years of sickness and more or less chronic depression which, progressively, would draw them apart. As is often the case with his loved ones, the portrait of Madame Matisse, as a well-wishing ghost or a Eurydice on the point of returning to the netherworld, seems premonitory.

Paradoxically it is the mask, in its status as a mere geometrical convention, like the convention of white as the colour of death, that enables Matisse to conjure up a *presence*. A mysterious, unforgettable presence,[32] opaque and transparent, sedimented with a Proustian temporality, shuffling the ruffled pages of the past, present and future. In this sense the portrait can be compared with the 1906 *Portrait of Gertrude Stein* (no.58), which is another similarly masterly composition which uses a mask and hints at a likeness of the model in later years, but with one notable difference: the springs of nostalgia do not operate in this work of Picasso, nor in the works of 1908, 1909 or 1914. With the *Portrait of Madame Matisse*, on the contrary, it is the essential motive.

IMF

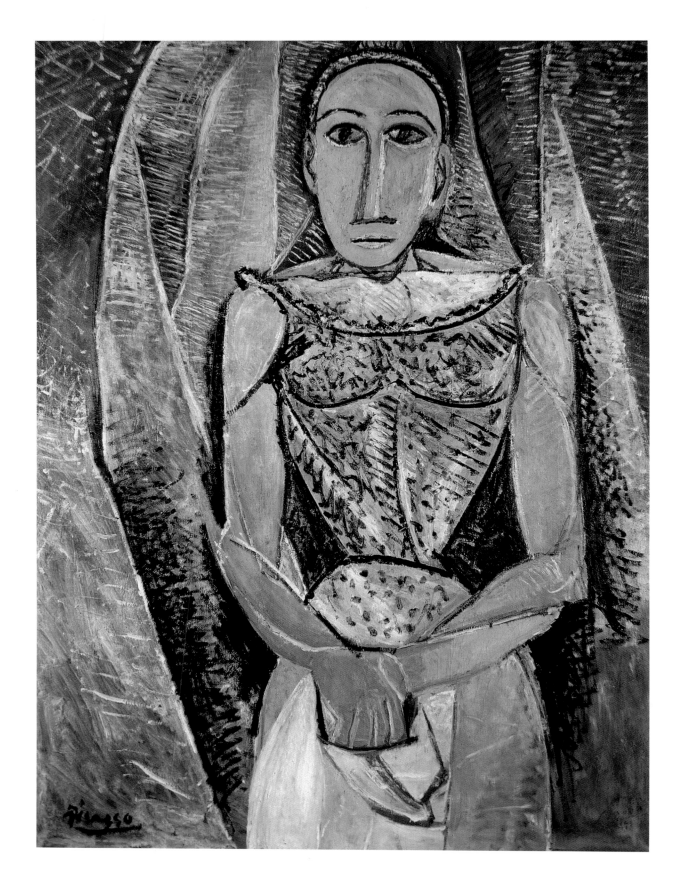

PABLO PICASSO

51 *Woman in Yellow* 1907

Femme au corsage jaune

Oil on canvas 130 x 97 (51¼ x 38¼)

Private Collection

HENRI MATISSE

52 *Portrait of Madame Matisse* 1913

Portrait de Madame Matisse

Oil on canvas 146 x 97.7 (57½ x 38½)

The State Hermitage Museum, St Petersburg

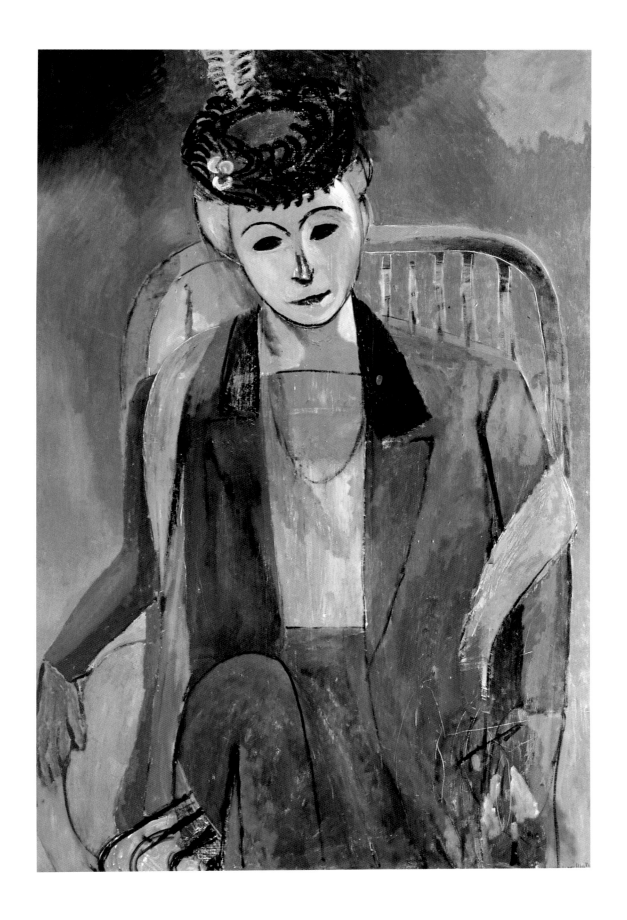

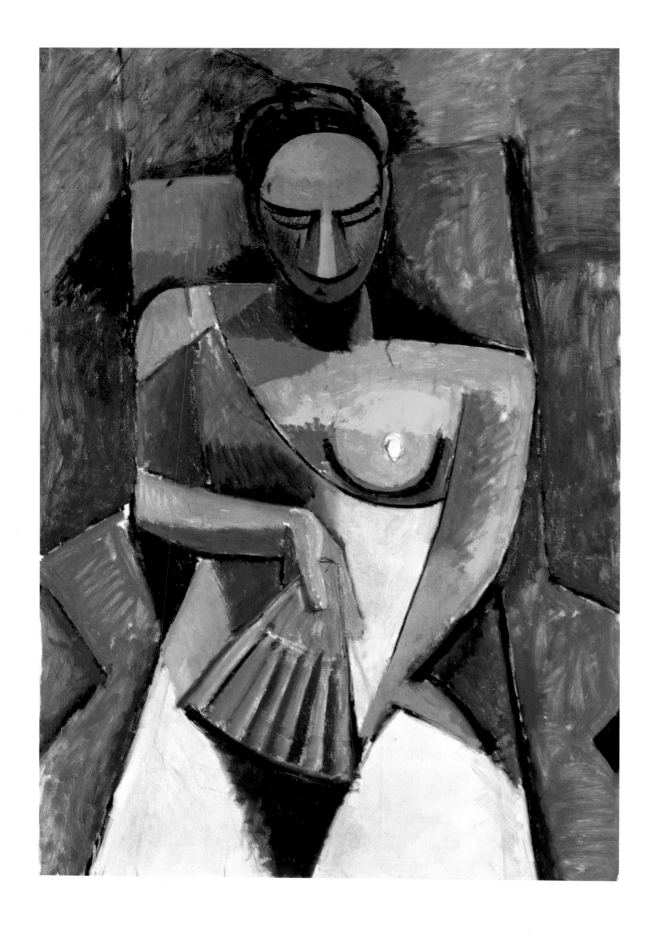

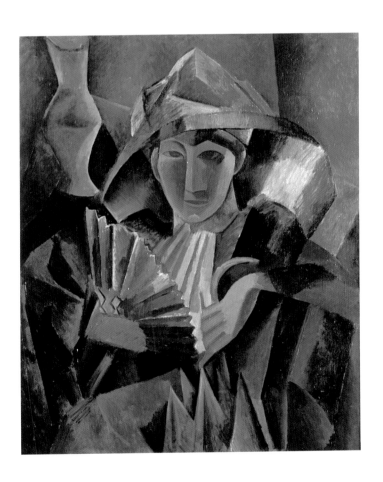

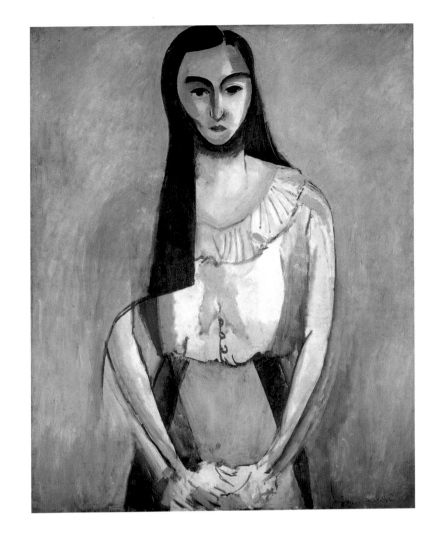

PABLO PICASSO

53 *Woman with a Fan* 1908

Femme à l'éventail

Oil on canvas 150 x 100 (59 x 39⅜)

The State Hermitage Museum,

St Petersburg

PABLO PICASSO

54 *Woman with a Fan* 1909

Femme à l'éventail

Oil on canvas 100 x 81 (39⅜ x 31⅞)

The Pushkin State Museum of

Fine Arts, Moscow

HENRI MATISSE

55 *The Italian Woman* 1916

L'Italienne

Oil on canvas 116.7 x 89.5 (46 x 35¼)

Soloman R. Guggenheim Museum,

New York. By exchange, 1982

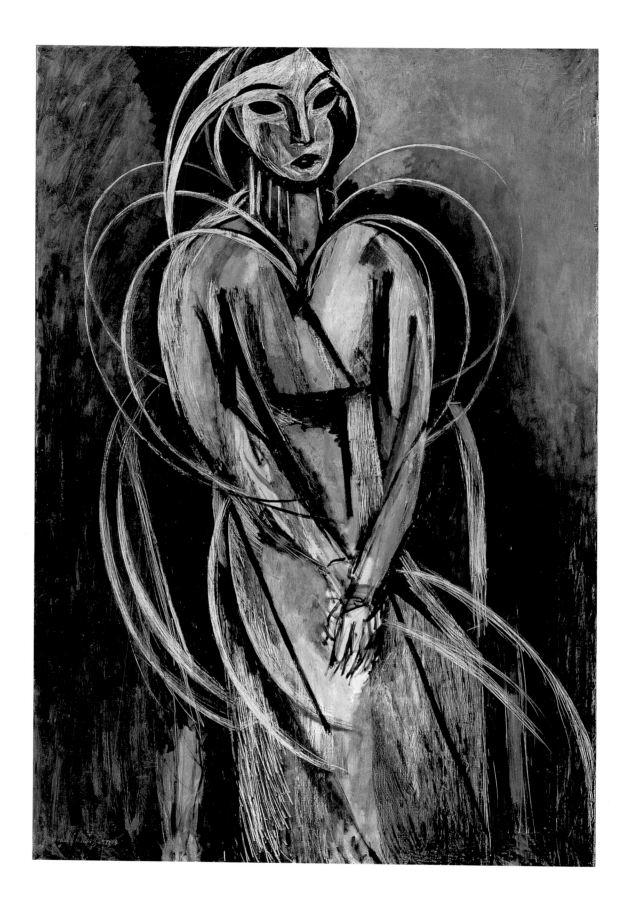

HENRI MATISSE

56 *Portrait of Mlle Yvonne Landsberg* 1914

Portrait de Mlle Yvonne Landsberg

Oil on canvas 147.5 x 97.6 (58 x 38⅜)

Philadelphia Museum of Art. The Louise and

Walter Arensberg Collection, 1950

PABLO PICASSO

57 *Portrait of a Young Girl* 1914

Portrait de jeune fille

Oil on canvas 130 x 96.5 (51¼ x 38)

Centre Georges Pompidou, Paris. Musée National

d'Art Moderne/Centre de Création Industrielle.

Legs de Georges Salles (Paris) en 1967

9

The story of Picasso's *Portrait of Gertrude Stein* is famous.[1] In the autumn of 1905, shortly after Leo Stein had first seen paintings by Picasso, he invited Picasso and his lover Fernande Olivier to dinner at 27 rue de Fleurus. There they met Leo's sister, the writer Gertrude Stein, and soon afterwards Picasso asked her if he could paint her portrait.[2] She agreed. The painting was begun in Picasso's decrepit studio in the Bateau Lavoir, with Fernande reading aloud La Fontaine fables to amuse the sitter. (Was anyone thinking of *Sheherazade*?) The painting was admired, but not deemed finished by Picasso, and the sittings continued for more than three months until they supposedly numbered ninety. The winter was nearly over, the sitter reports, when 'all of a sudden, one day, Picasso painted out the whole head. "I can't see you any longer when I·look", he said irritably. And so the picture remained like that and he left for Spain.'[3] When he returned to Paris in the autumn of 1906, having absorbed in Gósol the lessons of archaic Iberian sculpture, he repainted the erased face from memory. Gertrude Stein was delighted, and when others demurred, Picasso replied: 'Everybody thinks she is not at all like her portrait but never mind, in the end she will manage to look just like it.'[4]

His remark may be interpreted to mean 'She will model herself on my portrait' or 'I have painted not the topical but the future, characteristic image'. (Matisse once said to someone whose portrait he was painting, 'I want it to resemble your ancestors and descendants.')[5] In any event, the record of a frustrated perceptual performance was replaced by a mask.

One factor that unquestionably added to the frustration was the example of Matisse. When Picasso sat down for dinner at the rue de Fleurus, what did he see but Matisse's *Woman with a Hat* (fig.33), the scandal of the 1905 Salon d'Automne, purchased by the Steins.[6] Not only its colour but also the harshness of its drawing would have been felt as a reprimand to the sentimental neoclassicism of Picasso's current work. Besides, its uncompromising liberties with representation posed an outright challenge to his own recent portraits, which the new portrait presumably first resembled, and which – he must have known – seemed by contrast almost pallid.[7]

Picasso, his enthusiasm for the paintings of Ingres fuelled by the retrospective devoted to this artist at the same 1905 Salon, had posed Stein in imitation of Ingres's great portrait of Louis-François Bertin in the Louvre (fig.34).[8] And he had also begun work on a big Arcadian figure composition in the manner of Ingres (or, at least, of Degas's Ingres homages).[9] Picasso laboured on these projects over the winter of 1905–6, only to concede defeat in both. Then, in the spring of 1906, Matisse and Picasso finally met. Their meeting is thought to have coincided with the Salon des Indépendants,[10] at which Matisse's *Le Bonheur de vivre* (fig.2) was an even greater sensation than had been his *Woman with a Hat*.[11] And it was an Arcadian figure composition based on

Ingres. Moreover, the woodcuts and lithographs that Matisse was concurrently exhibiting at the Druet Gallery were tough, anticlassical extrapolations of Ingres that complemented the already very radical painting – which the Steins then bought. Picasso must have felt upstaged.

But when Picasso had been struggling with the Stein portrait, he had also been looking at a portrait by Cézanne of his wife, also recently purchased by the Steins.[12] His struggle was not simply with Ingres and Matisse; it was, John Richardson says, 'to reconcile Ingres and Cézanne and win out over Matisse.'[13] It was, in fact, an even larger struggle. The Stein portrait would be resolved after Picasso had assimilated the lessons of archaic Iberian sculptures in Spain in the summer of 1906. However, Picasso apparently first discovered such sculptures in the spring, at a display in the Louvre, which included works excavated less than fifty miles from his Andalusian birthplace.[14] This experience of a vital art indigenous to his own heritage must have been as unsettling as the effects of Cézanne or Ingres on Matisse.

Stein's account of the genesis of her portrait, the basis of the foregoing description, has been accepted almost without question. However, it is hard to believe that Picasso devoted ninety sessions to this portrait; to have done so would have been utterly exceptional in his practice and recent scientific analysis of the portrait hardly supports this claim.[15] What is more, even if Picasso did indeed work on the portrait over a period of more than three months, as Stein claims, this length of time is insufficient to support her more specific claim that he worked on it from late October 1905, shortly after they met, until spring 1906, implicitly late March 1906, when Stein introduced Picasso to Matisse and to the shock of *Le Bonheur de vivre*. This would give a five-month period; the arithmetic just doesn't work out.[16] Just as Stein hyperbolised the creation of her portrait by claiming that Picasso normally did not paint from a model,[17] so she may well have exaggerated the number of sittings and the time that it took to paint it. In doing this, she may have been seeking to emulate Cézanne's 1899 portrait of Vollard, and its reputed 115 sittings, also probably an exaggeration, or Ingres's portrait of François Bertin, whose lengthy, frustrating development was suddenly resolved in an epiphany.[18]

This is not to say that it was an easy portrait to paint. Unquestionably, Picasso was struggling with his artistic predecessors. And there was, finally, the fact that Stein was not only a lesbian, but utterly unlike the lesbian prostitutes that Picasso knew in the demi-monde, and the lesbian vampires in Symbolist art; as Robert Lubar has properly insisted, she was an impressive, forbidding, hard-to-place subject for a painting.[19] Both the effacement of her features and their delayed substitution by what resembles a mask unquestionably signify that something was eluding Picasso's representation. That he found himself forced to suspend work had, indubitably, many complex reasons. Rilke once wrote of how Balzac had 'sensed long ahead that in painting, something so tremendous can suddenly present itself, which no one can handle.'[20] A concurrence of circumstances had produced such an occasion, provoking the question: Was it accidental that Picasso depicted the writer dressed, not in her usual corduroy suit, but in a vast robe, like the author of the fable of the unfinished masterpiece?[21]

Before this particular masterpiece was taken up again and finished, Picasso, in Gósol,[22] had made portraits blending the influence of Ingres and Matisse. Then, having discovered a twelfth-

century sculpture known as the Virgin of Gósol, he had begun to portray his lover Fernande's face with highly simplified, chiseled features, exaggerating the prominence of her long, almond-shaped, heavily lidded eyes. He had also made a series of similarly simplified, haunting studies of the ninety-year-old Gósol innkeeper, Josep Fontdevila, one of which is explicitly a mask, and, in an opposite vein, had explored a wide range of sexualised subjects from ephebic youths to harem scenes. It was, of course, a mask whose features bear a family resemblance to Fernande's that Picasso substituted for Stein's erased face in the autumn. Then he pictured himself as a painter with a palette, similarly masked, part of the same family (no.1).[23]

Never again would Picasso paint a monumental portrait of a woman who was not for him a romantic attachment. Lubar has suggested that he gave his sitter a mask in order to shield himself from, and acknowledge, his confrontation with a non-normative sexuality that triggered an awareness of gender instability, even in his own self-image.[24] Conversely, of course, the mask protects her from his and any subsequent viewer's gaze. A conventional representation of self-absorption would leave a figure too exposed to desire, even if indifferent to it, but a masked figure will be an image of protected self-sufficiency, whose invitation to the viewer can be to identify enviously with its narcissistic omnipotence.[25] A masked figure thereby affords a vehicle for the imagination of boundary-crossings, of both gender and age, such as populate Picasso's art in the autumn of 1906, and with them, homologous crossings of embodiment and disembodiment, figuration and defiguration. As Margaret Werth has pointed out, this aligns his art with the unstable identities of Matisse's *Le Bonheur de vivre*.[26] The Stein portrait itself still partakes of the modalities of Picasso's earlier paintings of performers in so far as its masking is recognisably a cover-up, a disguise hiding an internal reality to allow the projection, and the deflection, of an external desire.[27] But, with it, the object is empowered as never before in Picasso's art. The non-dissembling, objectifying masks that follow would lead, within a year, to the more than barefaced aggression of *Les Demoiselles d'Avignon* (no.7).

A decade later, Matisse agreed to paint a portrait of Auguste Pellerin, a prominent industrialist and collector.[28] He had just painted both Michael and Sarah Stein,[29] and memories were perhaps stirred. He first made a generic Matissean portrait of a generic businessman behind a generic desk (fig.35). The sitter rejected it, saying it was too daring – 'too much of a mask' – to hang on his office wall.[30] Matisse's response (his hackles rising, perhaps), in another delayed substitution, now a familiar strategy, was truly to paint a mask.

If Gertrude Stein was an impressive, forbidding figure to Picasso, evoking in him confused feelings of gender instability, Auguste Pellerin, for Matisse, turned out to be alarming for a very different reason. In his second portrait (no.59), he evokes paternal authority with a vengeance.[31] Matisse, like Picasso, summoned up Ingres's *Bertin* to set the tone of domination, and with a greater justification; he was, like Ingres, looking to depict a Buddha of the bourgeoisie.[32] But Matisse also summoned up, by way of a famous photograph (fig.36), an image of his artistic father, Cézanne, whose works Pellerin collected in extraordinary, unparalleled depth.[33] Interestingly, though, the painting on the wall behind Pellerin is not a Cézanne, but a recently acquired Renoir, the richly beautiful *Portrait of Rapha Maître* (fig.37), a work in the genre of the Parisienne

with fashionable accoutrements, painted a year or so after Matisse's birth.[34] Of course, it must have just been there. But Matisse's ghostly suggestion of this female image, which passes across the space on high, is framed as though it were a thought or a memory unspoken in a silent, very chilly face-off between Pellerin and the artist, and subsequently anyone else who looks at the painting.

The mask doesn't dissemble. There's nothing else there. But the mask is not anonymous. Variants of the same type – *papier mâché* thin, heavily outlined features, rounded cranium running into prominent cheekbones, and blank black eyes – do appear in other of Matisse's paintings of the period, ultimately deriving from the West African masks that he and his friends first came upon in 1906, and from the early Cubist paintings that the masks helped to spawn.[35] But each variant is truly individualised, a device first adopted for its shielding of personality having become a device of psychological revelation. Suddenly, then, this particular mask will break loose from its moorings, shift to the left, and float forward, its sternness softening.

Both the Stein and Pellerin portraits adapt from old master chiaroscuro paintings a familiar combination of local contrast and unequal distribution of detail.[36] They are composed from a small number of extremely light zones, in which detail is concentrated, set against a larger number of middle dark and extremely dark zones. This format exploits the peculiarities of our centralised acuity of vision, which decreases in intensity from fovea to periphery. The viewer's gaze is attracted to the lightest zones, thereby allowing his fovea to capture detail, while those parts of the painting that offer little or no detail fall into that part of his vision outside of the fovea that is physiologically incapable of noting the absence of detail.[37] When Matisse was scrutinising Pellerin's face, he was not at the same instant scrutinising his jacket, which at that instant was without detail in Matisse's perception, because falling outside the range of his fovea. His and Picasso's paintings thus record the perceptual performance of paying attention to salient features in the external world.[38]

But the paintings also record the involuntary distraction of attention. Both place a distracting accent (the brooch and the Legion d'Honneur rosette, respectively) outside, but nearby, a focal region of finer detail. To succumb to the distraction places the light, detailed areas outside foveal vision, where minor eye movements will destabilise them. This accounts for the unsteadiness with which Stein's and Pellerin's masks attach to their respective bodies. Conversely, mysterious areas set in deliberate counterpoint to these distractions (the floral area of chairback and Stein's left proper hand; the chairback and blotter beside Pellerin) will gain a temporary plausibility outside foveal vision, until they are looked at again and return to their ambiguity. With the Matisse, the distraction additionally completes contours (the shoulders and arm, the shadow running from the painting onto the wall) that uncannily disappear when you actually look at them.[39]

Indeed, with the Matisse, distraction battles very hard against attention, despite the sitter's attentive pose. The artist subverts attention to disperse it, even from the principal focal zone. Pellerin's mask carries an affront, which makes it difficult to look at, as well as commanding attention, which makes it hard to look away. Within that zone, attention likely will focus on what

symbolises the affront to seeing, the blind eyes of the mask, and the viewer will reenact their blinding when tearing his own eyes away; the blackness and opacity of the surrounding areas offer no visible respite.[40] Moreover, the two secondary focal zones, at top and bottom of the painting, although light, contain details that frustrate visual identification, and the upper zone additionally shows the effects on a painting of the occlusion of visible light. None of these obstructions to seeing are experienced as hostile, however. To the contrary, once the viewer agrees to collude with Matisse's manipulation of his perceptual performance, a livelier, even friendlier ebb and flow in and out of the pictorial space is the reward.[41]

If, with the Matisse, visual distraction thus opposes the sitter's attentiveness, with the Picasso, conversely, attention is demanded, although denied by a distracted pose. Distraction is a drawing asunder, a drawing of the sight, mind, or attention to a *different* object. It is not only a looking at something or for something, but also a looking away from something, at something else. Stein, in her portrait, looks for something different (with eyes of a different size and colour, by the way), and the viewer's attention is commanded by a face that looks like, but is different to, a face, signifying something different, something remote. Moreover, while Matisse's painting is visually mobile, therefore encouraging a prolonged viewing, it also presents itself, at any instant, instantaneously, as if frozen in present time. Picasso's, in contrast, although much quicker to capture visually, presents itself as of extended duration, as if even containing the extended time of its painting, or of its sitter's patience. (Auguste Pellerin is silent, sitting across from us, but impatient for attention. Gertrude Stein, ignoring us in the indifference of the truly powerful, waits.) Moreover, whereas it is distraction in the Matisse that blinds the viewer, by not allowing his gaze to settle, in the Picasso the mask obstructs visual access, in the very line of attentive sight itself, to the face beneath it. 'I can't see you any longer when I look', Picasso said irritably. And that is precisely what he painted. Painting the mask did not solve a problem; it explained a problem. And thus established a new genre for the exploration of scepticism about perceptual presence, which soon became famous not for this, its function, but for its means, the use of so-called 'primitive' styles.

JE

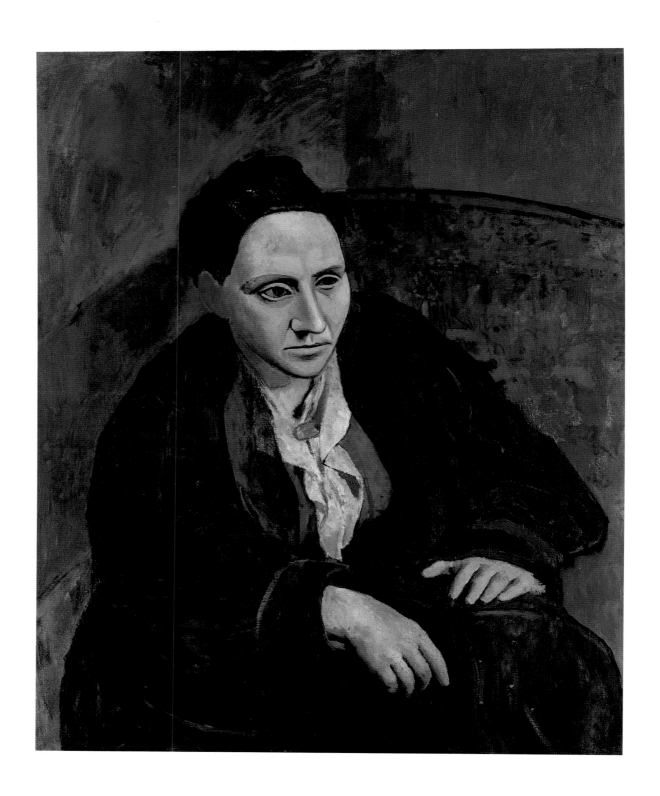

PABLO PICASSO

58 *Portrait of Gertrude Stein* 1905–6

Portrait de Gertrude Stein

Oil on canvas 100 x 81.3 (39¼ x 32)

The Metropolitan Museum of Art.

Bequest of Gertrude Stein,

1946

HENRI MATISSE

59 *Portrait of Auguste Pellerin II* 1917

Portrait d' Auguste Pellerin II

Oil on canvas 150.2 x 96.2 (59⅛ x 37⅞)

Centre Georges Pompidou, Paris.

Musée National d'Art Moderne/

Centre de Création Industrielle.

Dation en 1982

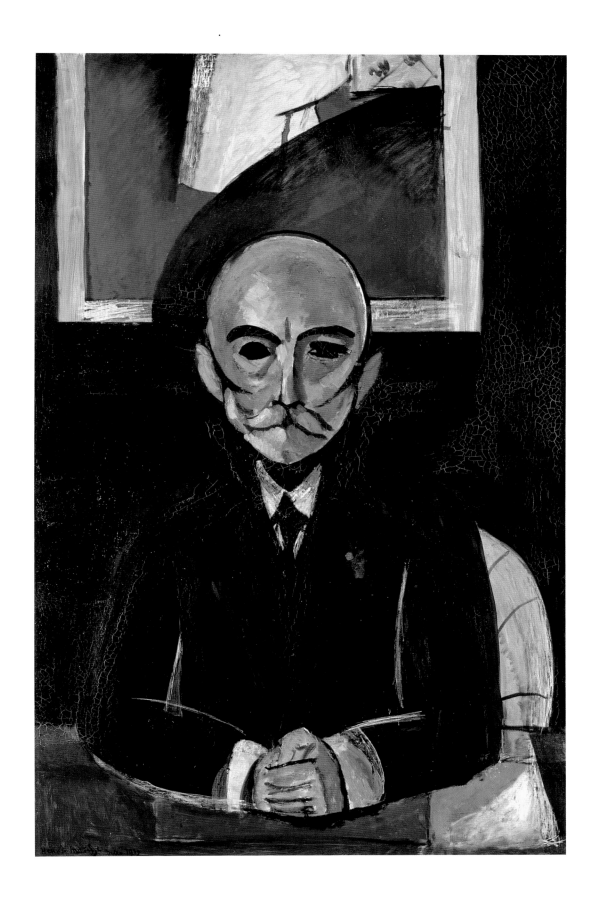

10

The Card Player is a masterly summation of the structural devices of collage Cubism, a cunning and convincing imitation of the overlapping cut-out shapes, oblique angles, abrupt junctions, varied textures and patterns and schematic style of drawing typical of Picasso's *papiers collés* of 1912–13 (no.67). It also anticipates future developments, for the still life at the centre, which insistently draws the spectator's attention away from the card player's head and seems to push forward, plane by plane, is like a blueprint for the still lifes Picasso constructed from scraps of painted wood and cut and bent tin in the spring and summer of 1914.[1] In this context the letters JOU may refer to 'jouer' (to play) rather than the ubiquitous 'journal' (newspaper) of Cubism.

In view of Picasso's devotion to Cézanne, he was probably thinking of the famous series of card players Cézanne executed in the 1890s: the legs of the central figure in the monumental canvas in the Barnes Foundation are framed in a similar fashion by the table-legs; there, also, a clay pipe lies beside a spread of cards.[2] However, the way Picasso's card player fixes the spectator with one round black eye while turning up the Ace of Clubs suggests his game may be fortune-telling. If so, the portents must be good because the Ace of Clubs is generally believed to promise 'great wealth, much prosperity in life, and tranquillity of mind'.[3] (Being superstitious, whenever Picasso included a single playing card in his still lifes, as he often did in 1914, he invariably chose the Ace of Clubs.) In any case, the subject – fortune-telling, playing cards, perhaps card-sharping – in alliance with the dark background, brilliant spotlighting and sense of drama, suggests that Picasso was also acting the part of a Cubist *Caravaggisto*.

In the Kahnweiler archives *The Card Player* is dated 1913. It was probably painted in the autumn following Picasso's return to Paris from Céret, where he had stayed on and off since late December 1912. He was joined there in April 1913 by Max Jacob, who may perhaps have exercised his talents at palmistry and cartomancy.[4] Not that the mustachioed man with his long thick hair represents the clean-shaven, balding Jacob: he probably represents the type of French or Spanish peasant Picasso would have come across in the Céret taverns.[5] Or there may be a private allusion to the acrobats in the travelling circus which came to Céret while Picasso and Jacob were staying there. In a letter to Kahnweiler of 2 June 1913 describing its rustic charm, Jacob mentions 'mustachioed clowns who look as if they got their make-up during some Cubist studio prank'.[6] The anchor inscribed on the bowl of the card player's pipe, which wittily repeats the rudimentary sign for his eyebrows, nose and mouth, probably records a moulded trademark and appears on the pipes in other Cubist paintings of the period. Juan Gris was another visitor to Céret that summer and *The Card Player* reflects Gris's bold colour schemes and way of animating his still-life compositions by slicing them into contrasting vertical bands (see fig.38).[7]

If Matisse did not see *The Card Player* in Picasso's studio, he would have seen it either at Kahnweiler's gallery before war broke out or thereafter at Léonce Rosenberg's gallery, for it was probably one of the 'fifteen or so works' Rosenberg already owned when he wrote to Picasso on 30 October 1914 with a view to further purchases.[8] Its humour and ingenious patchwork composition ultimately had less meaning or appeal for Matisse than the simpler, graver and more monumental *Harlequin* (no.70), but when he painted *White and Pink Head* in the autumn of 1914[9] – perhaps his most candid experiment in Cubist methods of construction – he imitated the grid and the schematic facial features, and the division into flat geometric planes, in paintings like *The Card Player* and comparable works by Gris (see fig.8), with whom he was by then on very friendly terms. Although the similarities in palette between *Portrait of Greta Prozor* and *The Card Player* are surely coincidental, the stress on the geometry of the body and the evidence of a grid controlling the composition and dividing it into three parallel, vertical bands indicate Matisse's continuing dialogue with Synthetic Cubism during 1916. In other respects, however, the painting represents a reassertion of the Cézannean principle of working from life and owes as much to Cézanne's hieratic portraits of his wife (see fig.32) as to Cubist figure painting.

Greta Prozor was also acquainted with Picasso. Part-Lithuanian, part-Swedish, aristocratic and cultured, she was an actress who moved in vanguard circles in Paris and performed during the war at soirées organised by the *Lyre et Palette* group. Max Jacob was an admirer.[10] Her husband, the Norwegian Walther Halvorsen, had studied at Matisse's 'academy' in 1909–10 and subsequently became an art dealer. He was close enough to the Cubists' inner circle to be on the organising committee – alongside Matisse and Picasso – of the (somewhat riotous) dinner held on 14 January 1917 in honour of Braque's return to civilian life.[11] Matisse's portrait was not a commission, for, as Greta Prozor explained in a radio interview in 1967, he invited her to pose and, having set her at her ease by conversing about the theatre, began by making a series of informal drawings. Dissatisfied with the painting itself, he dismissed her after several further sessions, apologising for 'having wasted my time'.[12] Like Picasso's *Portrait of Gertrude Stein* (no.58), the painting was completed when Greta Prozor had ceased to sit for him; its surface is imprinted with his struggle in numerous signs of scraping back and rough, somewhat impatient over-painting. The gestural vigour and the combination of impasto and incising into the top layers of paint are reminders of Matisse's contemporary sculpture; the urgent and brave redrawing of the contours anticipates the great brush drawings in Chinese ink at the end of his career (nos.168–9).

Judging by a photograph of the unfinished picture (fig.39) and the initial drawings done from life, Greta Prozor posed in a light-coloured dress and a softer, less imposing hat. The photograph shows a more relaxed pose, with her head inclined slightly downwards to her left; the chair-back fans gently outwards, echoing the fanning of the skirt. The effect must have been graceful and flattering, reminiscent of society portraits of the pre-war era. As Matisse reworked the canvas the summery dress became as dark as the uniforms many women donned during the war, with cement-grey shadows threatening to obliterate the rich blue; the high buttoned collar was transformed into a fetter; the hat became stiff and black, its yellow decoration doubling as a badge.[13]

Meanwhile, the armchair turned into a skeletal iron throne guarding and caging her, and her handsome face set into a melancholy mask. Only the slender legs traced within the loose, transparent skirt hint at the sensuality and vitality which are under such severe restraint. The sense of harsh wartime austerities and the sobering awareness of the prolonged agony on the battlefield of Verdun inflect the painting with profound sadness.

The yellow ochre which lies alternately over and under the surrounding grey has been likened to the gold of the Byzantine icons Matisse admired on his trip to Russia in 1911.[14] By effacing any indication of the floor and suffusing the ground and the sitter's feet with a scumbled cloud of gold, Matisse creates an effect of supernatural levitation quite different from the tongue-in-cheek witchery produced by the melodramatic lighting in *The Card Player*. The otherworldly, apparitional effect is enhanced by the technique, which in so many places involves some form of dematerialisation: absence (almost bare canvas for the tiny hands); transparency (the skirt, the feet); stripping back (the hat-badge, which was created not by adding colour but scraping through to the yellow under-layer); unveiling (the ghosts of previous states).

In its commanding dignity and simple, classic pose the painting calls up not only Byzantine icons but the tradition of formal, full-length portraiture from the Renaissance onwards. In an essay on his portraiture written shortly before his death Matisse remarked: 'In the West the most characteristic portraits are found in Germany: Holbein, Dürer, and Lucas Cranach. They play with asymmetry, the dissimilarities of faces, as opposed to the Southerners who usually tend to consolidate everything into a regular type, a symmetrical structure.'[15] In *Portrait of Greta Prozor* those Northern irregularities, which lend the painting such energy and tension despite the model's apparent passivity and introspection, are visible in, for instance, the asymmetry of the unseeing eyes, the listing of the plinth-like neck on which the head balances so precariously, and the surprising disjunction between the boyish chest and feminine legs.

Since the two artists met regularly during the first two years of the war Picasso may have seen the painting in Matisse's studio. His own return to classical styles during the war was manifested particularly in portraiture. One (usually unacknowledged) factor in this reorientation was his appreciation of the wholly convincing balance Matisse had struck in portraits such as *Greta Prozor* between the authority of traditional forms and a radical, expressive style, reinvented on each occasion in obedience to the artist's deepening emotional response to each sitter. Picasso's sober, classicising portraits of his wife, seated patiently in a high-backed chair, unsmiling, sometimes pensive, seem to be shadowed by Matisse (no.93).[16]

EC

PABLO PICASSO

60 *Card Player* 1913–14

Joueur de cartes

Oil on canvas

108 x 89.5 (42½ x 35¼)

The Museum of Modern Art, New York.

Acquired through the Lillie P. Bliss Bequest

HENRI MATISSE

61 *Portrait of Greta Prozor* 1916

Portrait de Greta Prozor

Oil on canvas 146 x 96 (57½ x 37¼)

Centre Georges Pompidou, Paris.

Musée National d'Art Moderne/Centre de

Création Industrielle. Don de la Scaler Westbury

Fondation (Houston, Texas, Etats Unis) en 1982

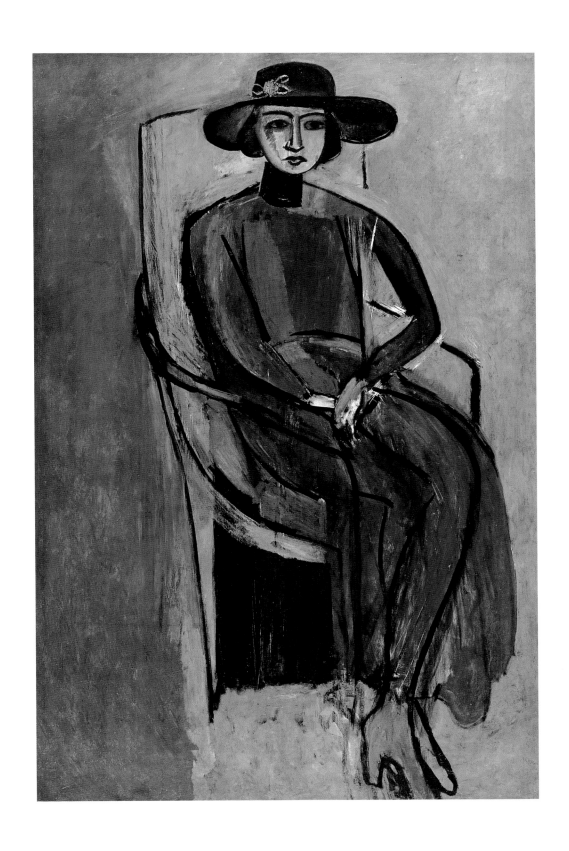

11

'**F**it your parts into one another and build up your figure as a carpenter does a house. Everything must be constructed – built up of parts that make a unit: a tree like a human body, a human body like a cathedral.'[1] Matisse's instructions, from 1908, to the students of his 'Academy', are a reprise of Cézanne's precept on the study of elementary volumes: 'Everything in nature is modelled on the sphere, the cone, and the cylinder.'[2] For Matisse, however, this constructive approach is merely preparation for the arabesque which must revisit and transcend 'the almost religious awe' the subject inspires in him.[3] In harmony with the classical approach, Matisse deals in the opposition between the introductory, sub-structural approach and the expressive synthesis of painting. His stance in *Notes of a Painter*[4] occurred during a debate Matisse had engaged in with several young 'disquieting' painters like Derain, Braque and Picasso.[5] According to Gelett Burgess, these painters were satisfied with a quasi-parody of an application of Matissean principles.[6] Yet they referred, as he does, to Cézanne who remained the touchstone of their reflection and practice. But for them, the constructive element was more than a preparatory step: it would go on to drive the formal revolution leading to Cubism, and would affect the very status of the pictorial subject. This divergent reading of Cézanne is part of the divide occurring at this time between the 'Picassoites and the Matisseites'.[7] As a member of the jury of the Salon d'Automne, Matisse agreed to refuse the painting submitted by Braque and played a part in the anathema growing around the word 'Cubist'.[8] In the Cézannean approach, the cube cannot be found in nature and Matisse's refusal would consign to an artefact the geometric handling of this elementary volume by the Cubist innovators. Yet, by submitting the cathedral to the same constructive law as the tree or the figure, Matisse himself opts for the necessity of just such an extrapolation of Cézannean thought.

In the summer of 1910 when Picasso, having begun to transform the first stage of Cubism – the Cézannean stage – into a 'semiological' version, painted *The Guitar Player*, he was still following Matisse's precept. The body of the guitar player can indeed be seen as modelled around the scaffolding of its essential planes and on the lines of force which constitute it as a 'figure'. There is no question here of a resemblance even to a virtual or generic model; Picasso is creating a plastic sign to which the term 'guitarist' is arbitrarily attributed. The physical fitting together of the parts, as recommended by Matisse, opens here onto a metonymic connection: guitarist and guitar, figure and ground, guitar and painting, make their indefinite monochrome slabs slide over one another. In the absence of any other iconic reference than those inherent in its vertical format – precisely called in French 'Figure' – its spatio-linear dynamic and its title, this pigmented amalgamation could thus become, by default, a construction. Neither object, nor figure, nor even cathedral, at this time Picasso's aim is to make construction into painting and vice versa.

In this intermittent pulsating form, the figure of the guitarist takes shape and dissolves, is named and undone. The separation between eye and brain established by Cézanne[9] was carried on by Matisse, who placed the eye on the side of recording and study, and the brain on that of concept and realisation. With Picasso this separation becomes the inner spring in the construction of painting.

Matisse saw quite clearly the analysing function of Cubism: 'The Cubists' investigation of the plane depended upon reality. In a lyric painter, it depends on the imagination. It is the imagination that gives depth and space to a picture. The Cubists forced on the spectator's imagination a rigorously defined space between each object.'[10] Placing himself in all likelihood on the side of the 'lyric painters', Matisse could not approve of an approach which he judged effective in its capacity to counter 'the deliquescence of Impressionism',[11] but limited to a 'kind of descriptive realism'.[12] His remark to Walter Pach could be applied to the paintings of the Analytic Cubist period such as *The Guitar Player*: 'If your artist could see his subject with enough clarity and force, he would render his vision in such a way that the beholder could feel each of its constitutive elements. He would pay no attention to all these meshings of lines and planes.'[13] Picasso, distancing himself from the Cubist apparatus as early as the 1912 Salon, at the very moment of its public consecration, espouses a similar approach: 'In the end Cubism – the true Cubism – was an awful materialist affair, a cheap materialism . . . I am thinking of the imitation of material form. You see what I am talking about: objects depicted from the front, in profile, from above'.[14] On the basis of this critical stance, Picasso would then set out on the elaboration of *papiers collés* which would help to settle the score on the question of mimetism: 'The *papier collé* was really the important thing . . . one of the fundamental points about Cubism is this: not only did we try to displace reality. Reality was in the painting . . . We always had the idea that we were realists, but in the sense of the Chinese who said, "I don't imitate nature; I work like her".'[15] The project of this 'competition' with reality[16] subverts the Cézannean submission to nature, moving it simultaneously towards an asceticism – the deliberate paucity of means – and towards play.

In the summer of 1913 Matisse and Picasso become closer than they had ever been before. The two artists exchanged their points of view and hiked out to the Bois de Clamart.[17] The compositions of cut-out and pasted paper, touched up by drawings, that had occupied Picasso for the preceding six months, were still tacked onto the walls of the boulevard Raspail studio. The radical innovation they represented did not escape the gaze of Matisse and, as of the following winter to spring, he would transpose their principle in *View of Notre-Dame*, a painting which would initiate the gestures seen in his 1914–17 work. *Table with Guitar* and *Bottle and Glass* belong to the first generation of *papiers collés* and manifest the stakes and plastic potential of the technique.[18] The artist draws diagrams of his still lifes with charcoal the while undermining their interpretation by adding in one case a piece of wallpaper, in another a press clipping. The pattern characteristic of the large alternating stripes of the wallpaper come into play in an illusionist relation to the line of *Table with Guitar*, giving up the perception of a fold along a virtual line separating shadow from light. In *Bottle and Glass*, the piece of newsprint belies, by its tex-

tual report – which, read or not is nonetheless recognised as a message[19] – the representation-al nature of the drawing. This 'grey matter' of the text which can refer to daily events, advertising iconography,[20] or current affairs,[21] brings the work to the surface both intellectually and physically. The intrusion of fragments of material reality and industrial artefacts constitutes an epistemological rupture in the status of the artwork.

From his studio window at 19 quai Saint-Michel, Matisse, from the onset of the century, was able to choose for motif the cathedral of Notre-Dame.[22] When he began *View of Notre-Dame* in 1914 Matisse was watching the irresistible explosion of springtime in Paris, and would once again, in his own manner, go out 'to the motif.' Through the simultaneous execution of twin paintings, Matisse sought to understand how 'sensation' is generated and then settles into his make-up. These versions, which aim to separate vision and 'condensation', show the difference in Matisse's work between 'what is seen and what is painted.'[23] If Matisse was able to develop such a specular strategy, especially in *The Young Sailor I* and *II* (1906) or in *Le Luxe I* (no.6) and *II* (1908), here the procedure becomes a manifesto. Matisse decides *in situ*, in a major and unprecedented stylistic change, to adapt a principle alien to his own pictorial idiom. When he says 'A rapid translation of the landscape can only give a moment of its life duration. By insisting on its character, I prefer to risk losing some of its charm and gain more stability',[24] his statement has much in common with Picasso, who declared: 'In my case painting is a sum of destructions.'[25] In this respect both artists rise up in opposition to the Impressionist option as set out by Mallarmé: 'I seek only to reflect on the lasting and clear mirror of painting that which lives perpetually, and yet dies at each instant, that which exists only in the will of the idea, and yet which constitutes the sole, authentic and certain advantage of nature: the Aspect.'[26] This immanent presence to the world can be considered to constitute the lost paradise of modern painting to which Matisse, before breaking free by the 'mechanics of painting',[27] once again submits himself by painting a naturalistic painting with luminous and airy accents. 'What happiness to be an Impressionist. This is the painter in the sheer innocence of painting', as Picasso describes this native state.[28]

In *View of Notre-Dame*, the landscape is exactly framed by the rectangle of the window. Matisse has given the work the physical dimensions of the window, not only enclosing its frame and shutter within the painting, but also projecting the chequered pattern of its panes upon it.[29] The painting has thus quite literally made the point of view its object.[30] We are not viewing the simple coinciding of interior and exterior landscapes, but a homothetic relation between painting and the frame or stretcher of vision. The structural graph superimposing the triangular geometries composed by the window frame and the lines of force of the landscape are marked up in black on monochrome blue.[31] Painted in large, free brushstrokes, this blue lets the ground that has been left unpainted show through. As a pictorial palimpsest, the half-erased lines re-weave the naturalistic version of the motif, and the square shape of the cathedral appears superimposed like a section drawing on the previous perspective view of the building. This underlying presence of the original image results in the final painting being abruptly projected forward, turning it into a surface phenomenon.

The functioning of the painting on two levels calls up the dialectic of planes in Picasso's *papiers collés*, playing on the disparity of codes and meanings. By superimposing naturalistic and synthetic notations, Matisse achieves a visual back and forth movement similar to Picasso's reworking of figure/ground and surface/depth relations. Matisse also gave predominance to voids over filled spaces in composition, which marked with the *papiers collés* a clear affirmation of the physical base, its format and materiality, as the primary prerequisite of vision. Besides the primacy of the surface and the void and the superimposition of levels of representation, *View of Notre-Dame* also borrows from Picasso's Cubism the oblique line at the heart of the painting. The powerful diagonal reworking and energising the organising grid of *The Guitar Player* also thrusts its pictorial plane forward, defying all laws of perception by straightening the lines of the vanishing point. The painter is revealed to be the true subject of painting, for it is on him that psychic as well as physical pressure of space is exerted, rather than leading out in the opposite direction. As Matisse says, 'It is the tremor of the individual that counts, rather than the object which produced the emotion',[32] insisting once again: 'Everything must be constructed'.[33] From different directions, Matisse and Picasso set down the same claim: nature must henceforth be set at a distance and the painting is the place for this distancing.[34] The Impressionist artist identifying with the world by effusion with it and through the loss of self, gives way to the modern painter, solitary, cut off from nature, absorbed, in competition with reality, in a self-referential elaboration of signs.

AB

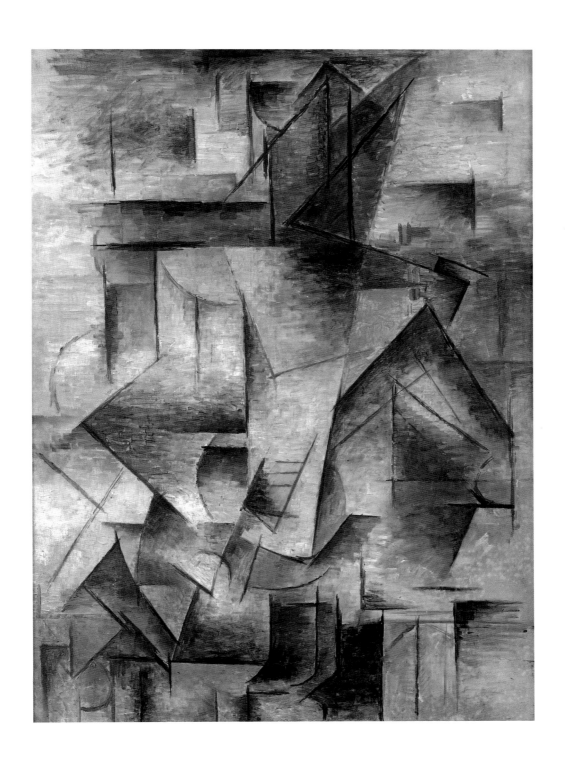

PABLO PICASSO

62 *The Guitar Player* 1910

Le Guitariste

Oil on canvas 100 x 73 (39⅜ x 28¾)

Centre Georges Pompidou, Paris. Musée National d'Art

Moderne/Centre de Création Industrielle. Donation de

M. et Mme André Lefèvre (Paris) en 1952

HENRI MATISSE

63 *View of Notre-Dame* 1914

Vue de Notre-Dame

Oil on canvas 147.3 x 94.3 (58 x 37⅛)

The Museum of Modern Art, New York. Acquired through the Lillie P. Bliss Bequest, and
the Henry Ittleson, A. Conger Goodyear, Mr and Mrs Robert Sinclair Funds, and the Anna
Erickson Levene Bequest given in memory of her husband, Dr Phoebus Aaron Theodor Levene

PABLO PICASSO
64 *Table with Guitar* 1912
Guitare sur une table
Charcoal and collage on paper
47.7 x 62.5 (18⅞ x 24⅝)
Kerry Stokes Collection, Perth, Australia

PABLO PICASSO
65 *Bottle and Glass* 1912–13
Bouteille et verre
Charcoal, graphite and pasted newsprint (*Le Journal* 3 December 1912)
on paper 61.9 x 47 (24⅜ x 18½)
The Menil Collection, Houston

12

At the core of this five-part group is a confrontation between two unforgettable paintings, Matisse's *Goldfish and Palette* of late 1914, and Picasso's *Harlequin* of late 1915. The pairing would be fully warranted visually, by parallels of form and emotive impact, even if it were not mandated historically – by Matisse's claim that *Harlequin* showed how much attention Picasso had paid to *Goldfish and Palette*.[1] But then, *Goldfish and Palette* also shows how much attention Matisse had paid to Cubism. The other three works in this section embody the kinds of structural strategies (if not some of the very forms) Matisse could have drawn from Picasso in conceiving his picture.

The motif of the goldfish bowl, of course, was not borrowed from anyone. By the time he started this canvas Matisse had already painted five other scenes featuring this captive 'floating world,' both in his suburban studio at Issy-les-Moulineaux and in the Parisian apartment he rented in late 1913.[2] But in culminating the series here, he stunningly reconceived the theme – till then essentially domestic and lyrically intimate – in a deeper register of darker power. A decade after it was made, André Breton wrote of *Goldfish and Palette*: 'I believe Matisse's *genius* is here, whereas everywhere else there is only his talent, which is immense . . . it's truly, all at the same time, of a liberty, an intelligence, a taste and an audacity that's unheard of . . . I'm persuaded that nowhere has Matisse put so much of himself as in this picture.'[3] Indeed, the artist's identification with this 'signature' painting and its theme was such that the dealer Léonce Rosenberg (who had purchased the canvas shortly before) could start a 1915 letter to Picasso by referring to 'the master of the goldfish' and be confident Picasso knew exactly who he meant.[4] Yet *Goldfish and Palette* magisterially confirms, among other things, the paradox we often trivialise by the word 'influence' – the paradox by which an artist's most telling expression of his most personal motif can sometimes draw its very force of originality from the lessons and challenges of another creator.

The scene was set, literally, a year before, in the *Interior with a Goldfish Bowl* (fig.42) Matisse painted just after he moved into the apartment on the quai St-Michel.[5] Here, far less abstracted, is the small table supporting the columnar bowl and potted plant, before the French window with its iron balcony grill. The water in this bowl, bringing the luminous exterior into the shadowy room, subsumes the blues of both the Seine and the sky, and the light accents of the limestone facades on the Ile de la Cité, into a soft patchwork abstraction that glowingly centres an otherwise rigidly linear, zig-zag construction of rhomboids and rectangles. But in *Goldfish and Palette*, this oblique contemplation of light and shade, and of private and public worlds, was compressed into a face-on drama of radically greater severity.

Two key developments intervened in the months between these pictures. One was the

advent of war. Matisse was in Collioure, on the south-west Mediterranean coast, when hostilities broke out in August 1914; and his bottomlessly bleak *French Window at Collioure* (fig.41) is our most original and haunting icon of the emotional darkness of that moment. Its ominous night is also the key precedent, formally and psychologically, for the central black structure of *Goldfish and Palette*. The other development was Matisse's concerted engagement with the language of Cubism – a shift that has traditionally been linked to the prolonged dialogue he had with Juan Gris in Collioure that September. The vertical banding of *Goldfish and Palette*, as well as other aspects of the picture, have been seen as echoing Gris' own work.[6]

Yet Matisse's painting has a nobler starkness, and its concept of the 'decorative' is by a quantum more powerful, than anything Gris ever conceived. As demonstrated by the three Picasso still lifes in the present grouping, Picasso's *papiers collés*, paintings, and sculptures of 1913–14 may provide closer antecedents. Several elements of *Guitar*, for example, a *papier collé* of 1913 (no.67), seem premonitory: the sharp division of light into large vertical slabs and smaller blocks and triangles, on a uniform blue ground; the evocation of shadow by a thick black bar; the incorporation of an organically curvilinear decorative element in a divided, transverse band; and the combination of abstractly geometric cut shapes with hand-drawn lines and shading. Overall, both this paper work and the painted wooden *Still Life* construction of 1914 (no.68) demonstrate how, working small, Picasso thought big. Both have spare tectonics whose latent monumentality seems junior kin to the imposing architecture of *Goldfish with Palette*.

The ornate wallpaper pasted onto the 1913 *Guitar*, on the other hand, may tell a more complex and reflexive tale. Looking ahead to Matisse's balcony grill, it also looks back – probably self-consciously – to Matissean decorative conceptions such as *Harmony in Red* of 1908. As Jack Flam has pointed out, Picasso's inclusion of flowered wallpapers, from his earliest *papiers collés* on, almost certainly satirised the floral patterns that often claimed so much attention in Matisse's art.[7] Yet, in a further extension of this give-and-take, the most insistently 'Matissean' element in *Goldfish and Palette*, the scrolling iron grillwork, seems to exaggerate and double its curves in direct echo of the double 'B' forms Picasso frequently used to denote guitars, violins, and other rounded forms (as, for example, in *Table With Violin and Glasses* of 1913).

Comparing these smaller Picassos with *Goldfish and Palette* also helps bring into relief some critical differences of approach. The element of play and picturesque variety in this phase of Picasso's Cubism – the multiple levels of abstraction and naturalism, the fragmentary and floating disconnectedness of things, the fascination with collage and *trompe-l'oeil* – is strongly at odds with Matisse's more thorough and graver abstraction. The primary anchoring notes of recognisable reality in *Goldfish and Palette* are the rounded volumes of the fishbowl and the lemon – more naturalistic, in their way, than anything in Picasso's work of the time. But mask the area of the bright-hued fish and fruit, and the composition becomes a drastically reductive and sombre graphic structure of planes and lines. Setting it against a Picasso such as *Table with Violin and Glasses* obviously points up elements Matisse could have appropriated from Cubism (the moment of overlap and transparency at the table's corner, to the left of the lemon, is one such instance). But the comparison also highlights the huge gap between the characteristic

combination of centred frontal stasis and syncopated variety in this Picasso, and the very different fusion of drastic simplification, bold cropping, and potent spatial torquing in *Goldfish and Palette*. The Cubism Matisse could have seen in Picassos of the early 'teens (or in Braque's work, or Gris's) was often witty, playful, even rococo; the transposed Cubism in *Goldfish and Palette* is a matter of massive abstract authority. The picture's muffled underlying colours (residues of the 'red-brown harmony' Matisse described when he began the work)[8], and above all its frequent passages of scraping, further convey a potently physical sense of the matter and labour of painting that stands well apart from the smooth industrial pigments and imported textures (for example, sand) the Cubists then favoured. Finally, we should consider the differences in social and personal focus between Matisse's painting and a work like Picasso's wooden *Still Life* of the same year. The Picasso also features a table arranged with a vessel of liquid and something edible, but its interests, besides *trompe-l'oeil* gamesmanship, centre on the conviviality of café life, and on appetites. The intense force of *Goldfish and Palette* – what one could even call its hunger – is, by contrast, entirely one of privately fixated looking.

In all the pictures where Matisse had previously dwelled on goldfish bowls, these little liquid worlds had been fluid, dreamy emblems of nature encapsulated and made decorative, often juxtaposed with a small sculpture – the *Reclining Nude I (Aurora)* of 1907 (no.15) – as an emblem of art's parallel powers. In this final revision of the motif, Matisse forcefully collapsed the distance between himself and his subject, not least by inserting himself into the scene. At the outset, Matisse wrote to his friend Camoin that he was 'remaking' his 'goldfish picture', adding 'a personage who has a palette in his hand and who observes.'[9] And with this little post-card note he drew a summary sketch of that personage – recognisably Matisse himself – on the right, looking down at the goldfish bowl.[10] This helps confirm that the tilted white plane at the right is in fact the artist's palette (and by extension that, in this plane's upper left, the shaft within an oval shows the artist's thumb protruding through). We are on shakier ground, though, when we try to read legs into the blackness below, or (as is sometimes proposed) to see the artist's head schematised in the anomalous wedge of geometry that occupies the corner of the canvas directly above.[11] In any event – and by any interpretation – the zone of human presence on the right is the most troubled slice of the image, filled with a clatter of angles, intersections, overlaps and scumbled and scraped second thoughts, in foil to the luminously serene wholeness of fish and fruit, and the hugely decisive black slab that anchors them.

Doubtless it was partly the echo of this dramatic use of black that Matisse thought he saw when he first confronted Picasso's *Harlequin*, a year later at Rosenberg's gallery. The dealer had purchased *Harlequin* from Picasso in early November of 1915, and on the twenty-fifth of that month, he wrote to Picasso to describe Matisse's reaction to his new acquisition.[12] 'After having seen and re-seen your picture', Rosenberg told Picasso, 'he honestly recognised that it was superior to everything you've done and that it was the work that he preferred to all those you've created.' At the same time, the dealer reported, Matisse concluded his laudatory remarks by expressing 'the feeling that "his goldfish" led you to the harlequin.'[13]

Matisse was not alone in thinking this picture was Picasso's finest work to date. Picasso 133

himself, writing to Gertrude Stein in early December that year, spilled out his worries about the (declining and soon to be fatal) illness of his mistress, Eva Gouel, and complained about the obligations that kept him from work, but concluded: 'Nevertheless, I have done a painting of a harlequin which in the opinion of myself and several others is the best thing I have done.'[14] Clearly the picture caused a shock, in the way it suddenly renounced the decorative complexities of the 'rococo' Cubist style Picasso had recently been using. ('Your *Harlequin* is such a revolution on yourself that those who were used to your former compositions are thrown off', said Rosenberg.)[15] Just as clearly, in retrospect, its unified background and sharply simplified planes of colour mark a decisive turn that points the way towards – and anticipates, in the haunting mix of carnival and melancholia – *Three Musicians* of six years later (no.73).[16] Adding to the weight of the picture are its strong autobiographical implications. It marks the first reappearance in Picasso's art, after a prolonged absence, of the harlequin figure who in earlier work had recurrently been the artist's own avatar.[17] The composition had its beginnings in drawings of a dancing couple, but (perhaps in anticipation of Eva's looming death), the final painting reshuffles the jauntily tilting planes into this divided jester, fused with an easel as his sole companion in a world of darkness.

To further cement the self-portrait aspect, the figure carries a palette at hip level, in his left hand. That white rectangle, which provides another formal echo of *Goldfish and Palette*, points to a common source, the Cézanne *Self-Portrait with Palette* (fig.15) that Picasso had virtually 'quoted' in his own 1906 *Self-Portrait* (no.1). As John Richardson has noted, Matisse's protruding thumb seems to echo the same Cézanne detail Picasso had appropriated years before.[18] Picasso's profile may also be evoked, as a ghostly presence, in the shape of the unpainted area on *Harlequin*'s palette.[19] One hardly needs such a phantom, though, to affirm how deeply personal the picture is. Suddenly, out of a world of lively, playful, and even extravagantly clever Cubism (see, for example, no.57), Picasso brought forth this austere, stiff, uncanny surrogate for himself – a tragic comedian, part black, part white, robed equally in wartime night and festive raiment, surmounted by one blank eye and one staring, fixed orb, and animated by a toothy, death's-head grin that seems part circus, part rictus.

Matisse was right, surely. More than just the striking use of black, it is the newly reductive simplicity, and the gravity of this unfamiliar mood, that almost certainly resonates with Picasso's response to *Goldfish and Palette*. If this intuition is correct, here then is overwhelming proof again, and now by the inverse of the exchange, that one artist's decisive originality and deepest personal expression can involve, intimately, engagement with the work of another. But this time the dialogue seems still more telling, for *Harlequin* would acknowledge that *Goldfish and Palette* was in some ways a mirror in which Picasso saw himself afresh. Matisse's picture invented possibilities from within Picasso's own work that Picasso himself had not yet explored. By a forceful personal reinterpretation of Cubism (a 'strong misreading', in the terminology of the critic Harold Bloom),[20] the outsider Matisse may thus have helped catalyse a key change within the evolution of the style itself. But, of course, the story does not end there, either. When Rosenberg wound up his recounting to Picasso of Matisse's responses to *Harlequin*, the dealer said:

'To sum up, although surprised, he couldn't hide that your picture was very beautiful and that he was obliged to admire it. My feeling is that this work is going to influence his next picture.'[21]

That influence may in fact be visible in works Matisse made soon after, like *Gourds* (fig.43), and eventually in larger efforts such as *The Moroccans* (no.72), which elsewhere in this book bears comparison to Picasso's *Three Musicians* (no.73) – thus turning the wheel of interchange yet again. That latter comparison, though, confirms what is already clear when we juxtapose *Goldfish and Palette* to *Harlequin*: that such pairings, while revealing, have disparities that make them arguably unfair. The curious truth already noted – and seemingly 'out of character' for our stereotypes of these artists – is that Picasso's planar, Synthetic phase of Cubism, while it provoked a weighty, bold rhetoric of scale in several key Matisses, was in Picasso's own hands more frequently alloyed with delicate detail and quiescent refinement. This split in pictorial temperament remains, despite what Rosenberg called Picasso's 'revolution on [him]self' in *Harlequin*. *Goldfish and Palette* 'blows up' its subject to larger-than-life and broadcasts its expressionist elements – prominent scraping and pentimenti, wholesale simplifications, frame-challenging fragmentation and compression of large forms. The smaller-than-life *Harlequin*, on the other hand, is comparatively classic in its centred, contained frontality and stasis, and holds critical minutiae – the tiny fingers, the tesselated costume, the eyes and teeth – that yield a different sense of scale, and insinuate into the image its wilfully fragile sense of chilling comedy. Put the two paintings side by side, and the Picasso can be made to seem thinner, even spindly, with its slow-burn Halloween magic put at a disadvantage by the ruggedness of the Matisse. In these moments of comparable ambition and gravity, Matisse plays the bigger bass vibrato, while Picasso's flute-and-woodwind threnody, laced with a lonesome, distant calliope, demands a different kind of listening.

KV

PABLO PICASSO
66 *Table with Violin and Glasses* 1913
Violon et verres sur une table
Oil on canvas 65 x 54 (25⅝ x 21¼)
The State Hermitage Museum,
St Petersburg

PABLO PICASSO
67 *Guitar* 1913
La Guitare
Pasted paper, charcoal, ink and
chalk on paper, mounted on
ragboard 66.4 x 49.6 (26⅛ x 19½)
The Museum of Modern Art, New York.
Nelson A. Rockefeller Bequest

PABLO PICASSO
68 *Still Life* 1914
Nature morte
Painted wood and upholstery fringe
25.4 x 45.7 x 9.2 (10 x 18 x 3⅝)
Tate. Purchased 1969

HENRI MATISSE
69 Goldfish and Palette 1914
Poissons rouges et palette
Oil on canvas 146.5 x 112.4 (57¾ x 44¼)
The Museum of Modern Art, New York. Gift and Bequest
of Florene M. Schoenborn and Samuel A. Marx

PABLO PICASSO
70 Harlequin 1915
Arlequin
Oil on canvas 183.5 x 105.1 (72¼ x 41⅜)
The Museum of Modern Art, New York.
Acquired through the Lillie P. Bliss Bequest

13

Matisse's *The Moroccans* of 1915–16 and Picasso's *Three Musicians* of 1921 are both large, dramatic compositions of mainly figural and architectural elements, not easily decipherable. *The Moroccans* is more broadly conceived than *Three Musicians*, which juxtaposes detailing and generalisation. Moreover, its planarity opens before us like a scene, and draws us towards it, whereas Picasso's painting faces us, as its figures do, and forces us back. Still, the two works are indubitably of a type: severe and somewhat forbidding, seemingly frozen in time, their vividly coloured zones shining with attraction because thrown into light by the preponderant dark planes around them.

Matisse and Picasso had been competing in the area of large subject paintings since 1905. These two paintings belong to the round of that competition that began in 1909 with the birth of Cubism, a style that, ironically, could hardly have been less suited to the purpose of making grand compositions. Indeed, they were made, it seems fair to say, only because Matisse and Picasso were in competition and, moreover, in each other's confidence. 'There is no question that we each benefited from the other', Matisse said later. 'I think that, ultimately, there was a reciprocal interpenetration between our different paths.'[1] The nature of this reciprocal interpenetration is illuminated in the historical relationship between these two paintings, Matisse's *The Piano Lesson* of 1916, and some other works, beginning in 1909.

Cubism, as created and developed by Picasso and Braque in the years 1909–14, was unsuitable for grand compositions because it was essentially an art of small size because an art of small scale. The scale of Cubist paintings of these years was determined by their having been handmade, by highly nuanced and visible touches and traces produced by movements of an artist's fingers, wrist, and sometimes forearm. The small still-life objects depicted in many Cubist paintings required that these paintings be relatively small – or was it that the smallness of touch in these paintings required relatively small compositional units? However, it was the fragmentation of such objects in strokes of paint that mainly shaped the internal scale of Cubist paintings, causing most of them to fall comfortably below a maximum dimension of one metre, and many at a half, and some at even a third of that. Of course, Cubist paintings of a larger size were made, but the essential dialogue of Picasso and Braque in this five-year period can be recounted without them. What cannot be described in the history of Cubist painting, however, is the dialogue of Picasso and Matisse.

Before 1909, Picasso had painted three very large compositions, all critical to the development of his art, the largest being *Les Demoiselles d'Avignon* of 1907 (no.7), at roughly 244 x 234 cm.[2] In the winter of 1908–9, he made a painting some 165 cm tall and, in the spring, one 130 cm tall.[3] But then his painting generally settled to a maximum dimension of 100 cm or less.

Before 1909, Matisse made four very large compositions of similar importance to Picasso's, the largest being *Le Bonheur de vivre* of 1905–6 (fig.2), at 174 x 238 cm.[4] Two of them, however, were 180 x 220 cm in size, which was established as a favoured format. Although there was no intrinsic, stylistic reason for Matisse to move to making smaller paintings in 1909, as there was for Picasso (quite the reverse, in fact), there was a sound commercial reason; large paintings were harder to sell. Thus, the maximum size of a painting covered by Matisse's September 1909 contract with the Bernheim-Jeune gallery was the standard size 50, whose maximum dimension was 116 cm.[5] In conclusion, before 1909, both artists had been fairly evenly matched in the production of large canvases. In 1909 the practice of both artists was based in the production of smaller canvases, Picasso's only somewhat smaller than Matisse's.

In 1909, however, the balance changed drastically in Matisse's favour when he gained a commission from the Russian Sergei Shchukin to paint the huge canvases *Dance* and *Music*, both 260 x 390 cm in size.[6] He also began another painting of the same size owing to his mistaken belief that Shchukin wanted three compositions. And in their wake, he painted four big compositions in 1911 (two in the 180 x 220 cm format), another four in 1912 (one of them at 180 x 220 cm), and yet another 180 x 220 cm painting in 1913.[7] Matisse's so-called Decorative style in these years – large compositional units, flatly coloured, usually without highly visible brushstrokes – allowed for, and was reinforced by, paintings of a large size, just as much as Picasso's Cubist style inhibited their creation.

Nonetheless, Picasso's response to Matisse gaining the Shchukin commission – which was not only a professional victory but also caused Shchukin temporarily to stop buying Picasso's work – was rashly to accept a much larger commission from the American collector Hamilton Easter Field, whose provisions included fourteen paintings 185 cm tall, nine narrowish verticals and five horizontals reaching to as much as 300 cm wide.[8] Given the aforementioned constraints of the Cubist style, it was utterly foolhardy of Picasso to have taken on Matisse at such a large size, not to mention quantity. But, having received the specifications of the commission in July 1910, he set to work, and immediately, predictably, found that repeating easel-scale elements on large canvases produced works that looked over-extended, or broken into localised sections, or clogged with detail. Only one tall canvas was completed.[9] It must, therefore, have been a bitter shock for Picasso to see *Dance* and *Music* completed and hung to an extraordinary sensation at the Salon d'Automne. Their remarked-upon fierceness of colour and 'primitivism' of drawing made his paintings now seem of armchair sedateness.[10] A useful lesson, however, was that it was not just Matisse's style but also his quasi-narrative subject matter that provided the large binding compositional elements necessary to huge surfaces. Hence, when Picasso returned to his commission the following summer and attempted the largest painting required, he chose as his subject 'a stream in the middle of town with some girls swimming'[11] – which happened to be almost identical to the subject of Matisse's companion painting to *Dance* and *Music,* the painting that would be completed in 1916 as *Bathers by a River* (fig.12).

Picasso valiantly persisted with the commission in the autumn of 1911, completing a 160 cm-tall canvas and two smaller works, but he was unable to realise another full height vertical. And

the large painting from the summer, looking perilously close to a Le Fauconnier, was eventually destroyed.[12] And thus the commission foundered. But once the brushstroke had been superseded as the basic compositional unit of Cubism by the piece of cut paper, with the invention of *papier collé* in 1912, the way was opened to free Cubism from the scale of the handmade. This new compositional unit might be expanded, in painted form, to become one of a number of large flat units, which could function as binding elements for large compositions. In 1913, Picasso reworked a 1911 painting for the Field commission, 155 cm tall, along just these lines.[13] However, it was not until late 1915 that he pushed up the size of his paintings to create new full height, 185 cm-tall verticals.[14] As William Rubin, who unravelled the basics of the Field commission, has pointed out, one of these was probably a disquieting painting with a black ground called *Harlequin*, made while Picasso's lover Eva Gouel lay dying (see no.70).

Matisse had not painted a very large picture since finishing his 180 x 220 cm *Moroccan Café* in early 1913, thus breaking a routine that stretched back almost a decade. This was probably in part because, since autumn 1913, he had re-established a studio in Paris smaller than that at his house at Issy-les-Moulineaux, which in August 1914, at the outbreak of the war, was requisitioned by the French military for the remainder of the year. But it was also probably because, since early 1913, when he returned from the second of his two frankly escapist visits to Morocco, he had begun to engage with Picasso's Cubism, and since late 1913, with Picasso himself and other Cubists in Paris. Thus, he attempted two additional large paintings in 1913, but was unable to complete them. One was to have been a souvenir of Morocco, intended as a companion to the *Moroccan Café*.[15] The other was a reworking of the huge 1909 painting *Bathers by a River*, possibly with the idea of making it a Moroccan beach scene.[16] Both projects foundered, we may surmise, for a similar reason to Picasso's Field commission having foundered: the difficulty of adapting a Cubist vocabulary to large canvases. Although, as we have seen, the means existed by 1913 for achieving this, the example did not. Consequently, Matisse's 1913–14 production engaged Cubism in the main in tall canvases associable with Picasso's grandest contemporaneous paintings, the most imposing in the 150 x 100 cm range, and, increasingly, anchored these canvas with areas of dense black.

Elsewhere in this catalogue is an account of how one of these works, *Goldfish and Palette* of autumn 1914 (no.69) was influential upon the aforementioned *Harlequin*, and how Picasso and Matisse separately said that it was the best painting that Picasso had ever made (see pp.131–5). What is important here is how Matisse, in *Goldfish and Palette* and similar works, had transformed his familiar decorative, planar units, making them geometric and darkly severe so that they would be consonant with the novel feature of such works, the imposed linear grid. For Matisse, this grid was quintessential to Cubism. When, just before seeing Picasso's *Harlequin*, he set about making a new large painting in the favoured 180 x 220 cm format, the *Still Life after Jan Davidsz. de Heem's 'La Desserte'* (no.75), he somewhat self-consciously plotted it out with ruled, gridded lines and successfully completed the composition.[17] For Picasso, however, the explicitly drawn grid was old news. What interested him in **143**

Goldfish and Palette was not this old Cubist feature but, rather, the transformation of Matisse's planar vocabulary to accommodate it, which cannot but have reminded him of a new Cubist element, the planes of *papier collé*. Thus, Picasso created in the *Harlequin*, from an extrapolation of the *papier collé* technique, what Matisse recognised to be a Matissean Cubism of thin, flat planes of colour.[18]

This was often how the two artists most fruitfully borrowed from each other: not simply by borrowing from the other, but from oneself in the other; by discovering oneself in the other and, therefore, the other in oneself. The outcome, in this instance, was that both artists quickly grasped that, if Picasso's *papier collé* technique could be remade as large, flatly coloured Matissean planes, the way had been opened to the creation of large Cubist compositions. Matisse had been struggling in his painting through 1915, but now he engaged in three very ambitious projects.[19] First, he returned to his idea of painting a souvenir of Morocco, taking up yet another 180 x 220 cm canvas, which when enlarged somewhat became *The Moroccans*. Second, in spring 1916, he returned to the huge *Bathers by a River*. And third, in summer 1916, he engaged in another large painting, *The Piano Lesson* (245 x 215 cm), with basically the same colour scheme as *The Moroccans* except that black is replaced by what Matisse would call 'blanc noir', namely grey.[20] Before these three compositions were completed, however, Picasso had intervened again.

According to John Richardson, when Picasso sold his *Harlequin* to his dealer Léonce Rosenberg in early November 1915, at the same time he made a sale agreement with Rosenberg for a large, 200 x 130 cm painting, only to fail to release it, feeling that it needed to be reworked.[21] This painting, also on a harlequin-like theme,[22] would become *Man Leaning on a Table* (fig.44). Perhaps it was the consensus that the *Harlequin* was a truly breakthrough painting that caused Picasso to want to re-engage with this large composition, which, in its late 1915 state, comprised a complicated pyramid of rectilinear planes.[23] In any event, it was apparently completed by mid-April 1916, and again ready to be released to Rosenberg. But again, Picasso failed to release it, preferring to work on it further. We do not know what its spring 1916 state looked like, but if it at all approximated the final state, it would have offered a spectacular demonstration of how the overlaid, broad bands of the *Harlequin*, shifted to the vertical, could be used to both bind and expand large compositions.[24] And *Man Leaning on a Table* was large – Picasso's largest painting since *Les Demoiselles d'Avignon* nine years earlier, which had to have been on Picasso's mind that spring, for he then sent it to the Salon d'Antin for its first public exhibition.[25] Richardson perceptively observes that *Man Leaning on a Table* 'stands in somewhat the same relationship to the end of cubism as *Les Demoiselles* stands in relation to the beginning'.[26] Was it, perhaps, because it was not completed in time for the Salon d'Antin that *Les Demoiselles* was sent instead?[27]

Matisse must have had both of these works in mind, in addition to the *Harlequin*, as he worked frantically to complete his three very large paintings.[28] They are conceived as large *papiers collés* and their drawing, not unlike that of a *papier collé*, offers a counterpoint of sign-like lines and seemingly cut edges. *Bathers by a River* was composed in vertical bands, proba-

bly with the aid of cut-out paper (as the others may have been, as well).[29] All three have a certain elegiac quality.[30] The *Bathers* completes with a great stern pessimism the triad begun by the joyous *Dance* and barbaric *Music*. The black field of *The Moroccans* not only generates contrasting light, and connotes heat, but also signals remembrance, and with it elegy, as the black field does in the *Harlequin*. *The Piano Lesson* shows an art practised under the duress of an aloof supervisor, with the most sexual of Matisse's sculptures, the 1908 *Decorative Figure* (no.13), shrunken in size in the opposite corner. Given this iconography of suppressed passion, it is interesting to note that *The Piano Lesson* is almost identical in size to the utterly uninhibited *Les Demoiselles*, may have been a specific response to it, and may even have borrowed from it the idea of placing two supercolumniated figures over a still life at the right hand side.

These three great compositions, completed by autumn 1916, represent the very summit of Matissean Cubism. What is open to question is whether the culminating moment of Picasso's late Cubism, *Man Leaning on a Table*, comprises a response to Matisse's. Just as we do not know what the spring 1916 state of Picasso's painting looked like – and, therefore, what its specific impact on Matisse might have been – neither do we know when precisely it was completed, and, therefore, whether it might reflect sight of Matisse's three completed compositions. In any event, Matisse's compositions were certainly completed when, in late November 1916, Picasso and Léonce Rosenberg agreed to annul the promised sale of *Man Leaning on a Table*.[31] This ended, for now at least, the public history of large Cubist paintings. Picasso shifted direction, to address the expanded scale of the theatre, beginning to design for the Ballets Russes. In 1917, it is true, he did make a massive Harlequin-theme painting, two metres square.[32] However, this canvas has the quality of a theatrical decoration, being conceived as a theatre curtain.

The theatre curtain, flatly covering the space behind the proscenium, may be thought of as one modernist paradigm of the large painting. A second, older paradigm would be the stage setting itself. And Picasso, shortly after painting the 1915 *Harlequin*, had opened that second front with the theatrical *The Fireplace*, another elegy for the death of Eva Gouel.[33] In the turbulent five years that followed, which included his marriage in 1918 to the ballerina Olga Khoklova, he worked in two different representational styles, one fully illusionistic, the other building on the geometric planar style of 1915, at times following the theatre curtain paradigm and at others the stage setting paradigm.[34] In 1919, the latter paradigm came to the fore in a group of paintings, made on the Riviera and hinting of Matisse, of laden tables standing on narrow stage-like spaces before open windows. But flat Harlequin images continued to be made, and in 1920 illusionistic images of this and other Commedia dell'Arte figures. Then, in 1921, the two paradigms were conflated in *Three Musicians*. The larger of the pair of paintings that Picasso painted on this subject is, at 200 x 230 cm, close in size to *Les Demoiselles d'Avignon*.[35]

Theodore Reff has drawn attention to the autobiographical theme of *Three Musicians*, how the harlequin, pierrot, and monk stand, respectively, for Picasso himself and the poets Guillaume Apollinaire and Max Jacob, the principal member of the Picasso gang in the golden age of

145

the creation of Cubism.[36] Thus, the *Three Musicians* looks back to the 1915 *Harlequin* and the death of Eva Gouel, when that golden age began to decline, when World War I began to close a major period of modernist culture, and when the first great period of creative competition with Matisse, a decade long, produced its final flourish before it, too, came to an end.

But the remembrance of that ending sparked a new beginning. Four years later, Picasso's *The Three Dancers* (no.82) transformed the subject and format of *Three Musicians* with a new appeal to Matisse, opening the way, when it was answered, to a conversation that neither artist would want to close.

JE

HENRI MATISSE
71 *The Piano Lesson* 1916
La Leçon de piano
Oil on canvas 245.1 x 212.7 (96½ x 83¾)
The Museum of Modern Art, New York.
Mrs Simon Guggenheim Fund

HENRI MATISSE

72 *The Moroccans* 1915–16

Les Marocains

Oil on canvas 181.3 x 279.4 (71⅜ x 110)

The Museum of Modern Art, New York.

Gift of Mr and Mrs Samuel A. Marx

PABLO PICASSO

73 *Three Musicians* 1921

Trois musiciens

Oil on canvas 200.7 x 222.9 (79 x 87¾)

The Museum of Modern Art, New York.

Mrs Simon Guggenheim Fund

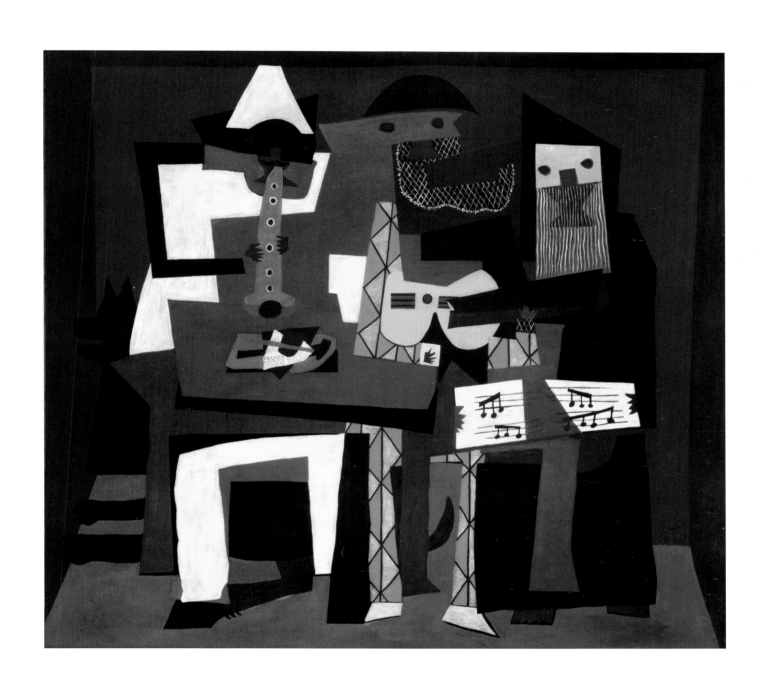

14

It was while in Avignon during the summer of 1914 that Picasso began to alternate between works in his latest Synthetic Cubist style and works in various naturalistic styles derived principally from French nineteenth-century painting. Building upon his earlier *papiers collés*, which frequently incorporated cut-outs of stylistically disparate types, Picasso also mixed both modes together in the same work. This happens in *Still Life with Compotier*, which, although inscribed 1915, is thought to have been begun in Avignon: flat, highly abstracted elements rub shoulders with elements painted in a *faux-naif* realist style, and the illusion of piecemeal construction from ready-made materials is ingeniously created through the systematic exploitation of fragmentation and discontinuity (seen, for instance, in the splitting apart of the two fragments of the newspaper – JOURN/AL).

An exceptionally intricate and meticulous painting, it reflects the blend of admiration and rivalry which characterised Picasso's response to the contemporary work of Gris. Like Gris, he makes bold use of thrusting diagonals and convoluted curves to create rhythm and animation; like Gris he organises the objects on the table into a fan-like sequence of planes, with the knob of the drawer acting as the pin; like Gris he juxtaposes flat and modelled elements and contrasting patterned and plain areas.[1] But he was also in affectionate, if irreverent, dialogue with the past: if the curling apple-peel parodies the lemon-peel of seventeenth-century Dutch specialists like Kalf and De Heem and the colour scheme reminds one of Spanish masters like Pereda and Meléndez, the open drawer and crumpled napkin clinging to the table-ledge ape two of Chardin's favourite spatial devices. (The miniature brioche in the compotier may be a playful reference to the imposing brioche in a well-known Chardin in the Louvre.)[2] Cézanne was, however, the principal point of reference. It is his apple which has been peeled, and Picasso exaggerates typical Cézannean effects in the steep raking of the table-top and dramatic shift in level of the chair-rail. Moreover, the abstract speckled shapes separating the more realistically described objects are probably his translation of a favourite motif in Cézanne's late still lifes – the patterned drapery and carpet which provide a sumptuous foil to the fruit, china and white napery in works like *Apples and Oranges* of *c*.1899 (fig.45).[3] These allusions to the great masters of the genre are complemented by the ironic imitation of the *peintre-décorateur*'s skill at faking marble, wood-grain and wooden mouldings. But Picasso was not so immersed in the business of his art as to be oblivious to the terrible events in the wider world: the black shadow cast over the table and the black newspaper sound ominous notes, while the desperate vulnerability of France is symbolised in the spectral *fleurs de lis* hovering at the back and in the foreground.[4]

No sense of foreboding or tragedy seems to trouble Matisse's *Still Life after Jan Davidsz. de Heem's 'La Desserte'*. Yet we know from the letters in which he mentioned the painting that

Matisse was suffering from acute anxiety and a painful sense of impotence as he waited for news of his family and friends at the Front.[5] At one level the painting was an exceptionally demanding undertaking, for he had set himself to come to terms with Cubism by executing it 'with the methods of modern construction'.[6] At another it must have been reassuring, if not exactly therapeutic, to revisit a masterpiece he had copied faithfully in the Louvre as a student in 1893 and which lay behind other paintings that were watersheds in his development (fig.46).[7] By conducting the experiment with De Heem's grandiose Baroque composition as the interme- diary – or, rather, with his 1893 copy he made of it, for that is what he worked from[8] – Matisse gave himself the task of reconciling two totally opposed types of painting, but at the same time set limits on the degree to which he was prepared to succumb – even temporarily – to the style which had effectively ousted him from his position as the leader of the avant-garde.

An analysis of the geometric grid underlying the composition of the 1915 'copy' reveals how closely Matisse attended to paintings by Juan Gris, such as *The Watch* of 1912 (fig.8).[9] Other pas- sages, especially the lute which is pulled round so that one can see its face and its side view simultaneously, are derived from the early Analytical Cubism of Braque and Picasso, while the small vignette of a goblet, fruit and bread on a silver tray at the far right of the table and beneath the hanging tassel suggests Matisse had studied closely the proto-Cubist still life Picasso had given him in 1907 (no.3). Indeed, the uneven, vigorous, exploratory handling of the 'copy' as a whole is quite similar to Picasso's handling in that painting. Matisse must also have been inter- ested in recent works like *Still Life with Compotier*, which he would have seen chez Léonce Rosenberg if not in Picasso's studio, if only because the rich colour and pattern betokened tres- pass on territory which, by common consent, belonged to him.[10] Evidently, Matisse was assess- ing different styles in the history of Cubism, and not committing himself to any. The painting is flooded with light and air, and in that sense looks back to the more hedonistic and sensual paintings which predated his concern with Cubism and forward to the interiors he would exe- cute in Nice after 1917. In the words of Charles Sterling, 'We get the impression that he took De Heem's well-appointed table and set it up on the sunny deck of a yacht in Mediterranean waters.'[11]

Léonce Rosenberg bought *Still Life after de Heem's 'La Desserte'* straight from the easel in mid-November 1915,[12] and since he enjoyed stirring the rivalry between the two painters it is more than likely he discussed Matisse's interpretation of Cubism with Picasso.[13] Although superficially they are very different, the idiosyncratic 'copy' Picasso painted a couple of years later of Louis Le Nain's *The Happy Family* may be a delayed response, for like Matisse he took a seventeenth-century illusionistic painting and recast it in an alien, modernist style, which – and this is the key similarity – was not his own.[14] It must also be significant that the borrowed style, pointillism, had been practised by Matisse before they first met. But the greatest challenge posed by the De Heem 'copy' was the application of Cubist principles to a still life on the scale of a narrative painting. *Mandolin and Guitar* was one of several large, visually aggressive still lifes with which Picasso sought to regain the initiative and staked his claim for Synthetic Cubism as the most exciting contemporary decorative style.

With the experience behind him of designing for the Ballets Russes, Picasso appears to have regarded the Matissean motif of the still life spread out on a table before a window as essentially theatrical. In the summer of 1919, fresh from the critical success of *Le Tricorne*, his second ballet for Diaghilev, he not only painted a series of diminutive pictures on this theme in an eye-fooling style similar to that of stage-painting, but also created several small cardboard constructions set up to look like toy theatres.[15] In *Mandolin and Guitar* the theatricality is underlined by the wide format. The raked floor suggests a stage; the space between the table-legs recalls a prompter's box;[16] the wedges of papered wall to left and right double as curtains; the balcony looks as insubstantial as a painted set. And in fact Picasso developed the composition from his set for 'Night' (fig.47), the introductory scene of *Mercure*, an avant-garde ballet produced and choreographed by Massine for Count Etienne de Beaumont's *Soirées de Paris*: the reclining figure of the set has been replaced by a group of still-life objects and the stars of the backdrop have migrated to form the pattern on the table-cloth. *Mandolin and Guitar* itself was executed in Juan-les-Pins only a matter of weeks after the première of *Mercure* on 15 June 1924. Although Matisse's updating of De Heem's *Desserte* looks as much like a fancy set-piece as the original and is opulent in an *Arabian Nights* way, it is not structured as a stage: the composition spreads beyond the limits of the frame, as if one were seeing only a slice of a much larger whole.

Even without knowing the origins of the composition, some viewers may be tempted to read the still-life imagery of *Mandolin and Guitar* in anthropomorphic terms because of the organic language used. One might see a huge, leering clown-like mask, with the wine-bottle as the nose; or (as in the tableau for *Mercure*) a nude reclining on a bed, the guitar and bottle forming her body from head to buttocks, the mandolin her hips and legs; or even three figures – two women (the curvaceous instruments) – and a man (the phallic bottle) – their orgiastic revels symbolised in the three interlinking apples. Read in this way, it is as if the sublimated content of a dream were being unveiled by a Freudian analyst. Some connection with Freudian theory is not impossible because *Mandolin and Guitar* was painted at a moment when Picasso was drawing ever closer to the Surrealists. Early in 1924 André Breton finally succeeded in persuading a hesitant Jacques Doucet to buy *Les Demoiselles d'Avignon* from Picasso (no.7); in June, with Louis Aragon, Breton penned an impassioned defence of Picasso's designs for *Mercure* against the ridicule and opprobrium of Picabia and the other old-style Dadaists;[17] in December Picasso would be represented in the first issue of *La Révolution surréaliste* as if he were a paid-up member of the movement. (His face appears, with Freud's, in Man Ray's gallery of photographs of the Surrealists.) It is no coincidence that the molten calligraphy of *Mandolin and Guitar* has a good deal in common with the contemporary paintings and drawings of André Masson, Breton's current favourite.[18]

The quasi-Surrealist aspects of *Mandolin and Guitar* are what distinguish it fundamentally from *Still Life after de Heem's 'La Desserte'*, for whereas Picasso was profoundly attracted to Surrealism and its preference for 'the forbidden zone',[19] Matisse always steered clear. The convulsive, spasmodic calligraphy of Picasso's painting is wholly at variance with the harmonious rhythm and fluency of Matisse's arabesque, and although in the Matisse the luxuriously

appointed banquet glowing beneath the golden awning carries more than a hint of the sensual Orient of European fantasy, there is no suggestion that, say, the lute *is* an odalisque or that the two lemons on the compotier *are* lovers. This is not to say that Matisse's still lifes never possess the erotic undercurrent which is often present in Picasso's: they do, but, as in *Goldfish and Sculpture* (no.47), it tends to be externalised in the form of Matisse's own figure sculptures, which thus become surrogates for the voluptuous posing model. Like so many of his interior scenes which have no figures, the De Heem 'copy' suggests human presence and human inter-course through the telling placement of the objects and furniture, but Matisse stops short of the metaphoric substitutions which lend some of Picasso's most memorable still lifes a provocative, metamorphic personality (see also nos.108, 162).

The scale and iconography of *Mandolin and Guitar*, and compositional devices such as the rhythmic alternation between the extremes of dark and light and the division of the surface into vignette-like zones locked together by the underlying grid, point to a possible connection with the de Heem 'copy'. But one should not underestimate the impact of Matisse's post-war Nice interiors on Picasso, despite their modest dimensions and *intimiste* character: the pink, tiled floor, the balcony overlooking the sea, the light flooding through the open French windows, the lively patterns of wallpaper and fabric, the startling use of black to heighten the sensation of light are like so many quotations. The Nice paintings enjoyed great success after the war and were exhibited in Matisse's regular one-man shows at the Galerie Bernheim Jeune. Picasso must have gone to Juan-les-Pins with vivid impressions of the latest exhibition, held in May 1924, in his mind.[20] But the ongoing Matisse–Picasso dialogue was neither one-sided nor closed: *Mandolin and Guitar* and other bold, decorative still lifes of the mid-1920s by Picasso probably played some part in Matisse's eventual return to a simplified, abstracted style and may even have nourished the *découpages* executed in the last decade of his life (see no.163).[21]

EC

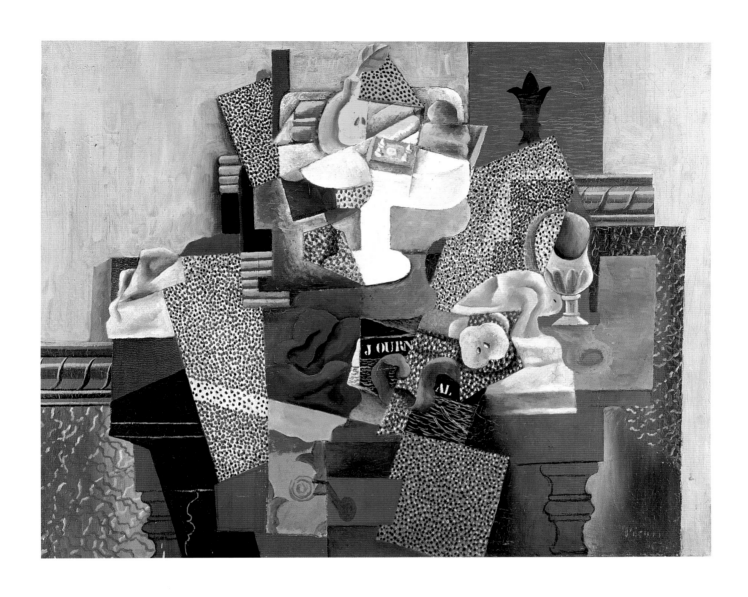

PABLO PICASSO
74 *Still Life with Compotier* 1914–15
Nature morte au compotier
Oil on canvas 63.5 x 78.7 (25 x 31)
Columbus Museum of Art, Ohio:
Gift of Ferdinand Howald

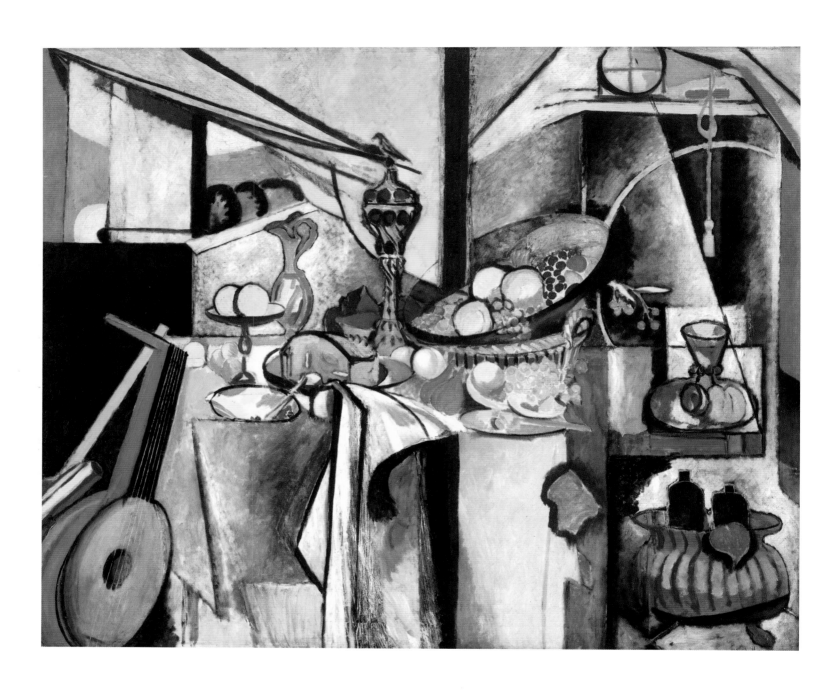

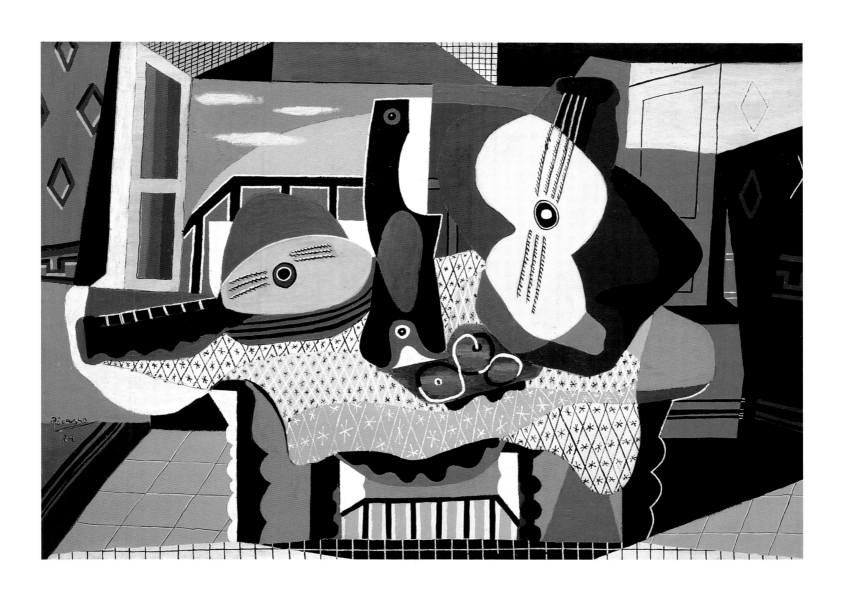

HENRI MATISSE

75 *Still Life after Jan Davidsz. de Heem's 'La Desserte'* 1915
Nature morte d'après 'La Desserte' de Jan Davidsz. de Heem
Oil on canvas 180.9 x 220.8 (71¼ x 86⅞)
The Museum of Modern Art, New York. Gift and Bequest of
Florene M. Schoenborn and Samuel A. Marx

PABLO PICASSO

76 *Mandolin and Guitar* 1924
Mandoline et guitare
Oil on canvas with sand 140.6 x 200.4 (55⅛ x 78⅞)
Solomon R. Guggenheim Museum, New York

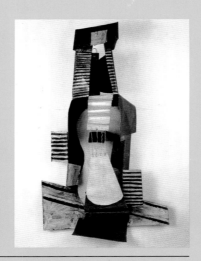

15

Interior with a Violin is a key work in Matisse's oeuvre, one over which he struggled greatly. It depicts the room in the Hôtel de Beau-Rivage which he took when he arrived in Nice on the 20 December 1917. The rooms at the Beau-Rivage, like those of many of the hotels fronting onto the esplanade and the sea beyond, were relatively small, long and narrow.[1] Matisse's contained a single, largeish window, its most attractive feature, a single bed, an armoire, and a nondescript armchair – truly an astonishing abode, however temporary, for one now established in the eyes of many as one of the two greatest living painters. All the more so in that Matisse cared about his surroundings in a way that Picasso did not.

A slightly earlier picture, *Interior at Nice* (1917–18, fig.48), gives a truer impression of the modest conditions in which Matisse was living. In *Interior with a Violin* the space has been monumentalised by the use of pictorial devices: the angles between the internal open window and external half-open shutter have been emphasised with an almost sculptural power. The residual, caught back, gauzy curtains at the top corners act as subliminal notes against which the powerful drama of light and dark is played. Some years later Matisse stated: 'In that picture I painted light in black. It was painted in Nice during the war in a small hotel. There were Venetian blinds to the window, the sun was shining outside, but it was dark in the room; a hatch had been opened in one of the blinds so that the light entered the room like a flame'.[2] In 1919 Matisse described the picture as 'a canvas of last summer in which I have combined all that I gained recently with what I knew I could do before'.[3] The picture acts as bridge between the work of the architectonic style of the heroic years between 1913 and 1916 and the superficially more relaxed manner characteristic of the first Nice period.

Interior with a Violin began life as a much blonder, higher-keyed work, depicting a vase of flowers at bottom left, subsequently to be replaced by the violin in its open case. Traces of paint show that the floor was originally rendered in pink, and that the panel below the window was pale grey. The contours of the violin have been altered and expanded.[4] As the picture stands the eye is given a few clues as to where floor and wall meet but is simultaneously forced to reconstruct the juncture for itself – a distinctive feature of Matisse's work which generates visual tension. Even in his most seemingly accessible works things are not as easy as they might at first seem, and the spectator is made to work, to look, to participate. Matisse's daughter Marguerite, who arrived on one of her frequent visits to Nice during the Easter break of 1918, saw the picture in one of its earlier versions and described it as 'pretty'. Matisse regarded her as one of his most acute and perceptive critics, and her remark might have been instrumental in encouraging him to rework the painting.[5]

The pervasive blacks which structure the painting compositionally relate it to Matisse's

works of the immediately pre-Nice years (see no.72). But they may also owe something to the most historically important of his visits to Renoir. Matisse had taken along a few of his recent pictures for inspection and told the story to Picasso thus: 'He looked them over with a somewhat disapproving air. Finally he said, "Well, I must speak the truth. I must say I don't like what you do, for various reasons. I should almost like to say you're not really a good painter, or even that you're a very bad painter. But there's one thing that prevents me from telling you that. When you put on some black, it stays right there on the canvas. All my life I have been saying one can't use black without making a hole in the canvas. It's not a colour. Now you speak the language of colour. You put on black and you make it stick. So even though I don't like at all what you do, and my inclinaton would be to tell you you're a bad painter, I suppose you're a painter after all".'[6]

Picasso's great *Guitar* of 1924 looks back directly to his previous *Guitar* (fig.48), frequently dated ?1912–13 but more convincingly ascribed to 1914.[7] It was to reshape the entire concept of Western sculpture. Also made out of sheet metal and wire, this was in turn a close replica of a cardboard maquette produced almost certainly in October 1912, and now like the sculpture itself in New York's Museum of Modern Art. Over the next months Picasso executed some two dozen constructions almost all of which included musical instruments. The paper maquette and three other constructions were illustrated in the 11 November 1913 issue of Apollinaire's *Les Soirées de Paris*, to considerable scandal; the subscription rate to the journal fell drastically. The young André Breton, about to fall under Apollinaire's spell as a writer, felt that his visual sensibilities had been totally transformed by the somewhat blurred and unsatisfactory reproductions of Picasso's work. Throughout his life Breton maintained that the early constructions were amongst Picasso's most significant achievements. He viewed them as precursors of Surrealism because he was struck by their anti-aesthetic bias and because he saw them as supreme examples of visual alchemy: the transformation of fragments of base or waste matter into commanding and challenging art. It is not by chance that the latter-day *Guitar*, the largest of all Picasso's Cubist constructions,[8] should have been produced in 1924, the year in which Surrealism proclaimed itself publicly as a new, revolutionary intellectual and moral force. *Guitar* was illustrated, prominently, in the first (December) issue of *La Révolution surréaliste*, the movement's official mouthpiece. The back page consisted of an advertisement for the First Surrealist Manifesto which had been issued two to three months earlier.

The first sculpted metal *Guitar*, like its successor, is in a sense a sculpted relief in that, like many other of Picasso's constructions, it was designed to be suspended on a wall or upright surface. In this connection it is worth remarking that the great Spanish guitar-maker Julián Gómez Ramírez was a neighbour of Picasso's in Montmartre;[9] his premises in the rue Rodier were so small that he was often forced to work on his guitars in the street, suspending them, one imagines, from time to time on the street wall. In Picasso's paintings of 1913–14, and even more explicitly in his drawings, an analogy is often made between a guitar and the female body, a commonplace in Spanish art and lore. But the configurations of the original *Guitar* appear to stand in only for the musical instrument itself, while challenging our notions of perceived real-

ity: the hole of the guitar, for example, rendered by a fragment of stove pipe, projects forward, while its neck is concave rather than flat. *Guitar* of 1924, by contrast, now projects a strong female aura and has taken on the aspect of a giant fetish. Like its predecessor it is rough in its execution, yet the colours – blacks, off-whites, greys and fawns – are now elegant in their sobriety, suggesting those of expensive cars of the 1920s, in which Picasso took an interest.[10]

The iconographic and stylistic bonds between *Interior with a Violin* and *Guitar* are both obvious and yet also oblique and challenging. In the Matisse painting the violin lies in its case, waiting to be picked up and played by the artist himself. To this extent it has a strong tactile appeal, something that is on the whole rare in Matisse's art. Picasso's musical instrument, with its central concavity, is in a sense also its own huge container. Its physical presence is overwhelming and yet as an object it is curiously untouchable. In both works space is created by ridged, strutted elements, some of them in the Matisse parallel to the pictorial plane and in the Picasso to the surface on which the guitar must be attached; others on the diagonal work their way backwards and forwards through space. Matisse's violin sits into and is cradled and protected by the space into which it has been inserted. Picasso's *Guitar* creates its own environment. The Matisse is both grandiose and intimate. The Picasso compels awe, even a certain sense of fear.

JG

HENRI MATISSE
77 *Interior with a Violin* 1917–18
Intérieur au violon
Oil on canvas 116 x 89 (45⅝ x 35)
Statens Museum for Kunst, Copenhagen,
Johannes Rump Collection

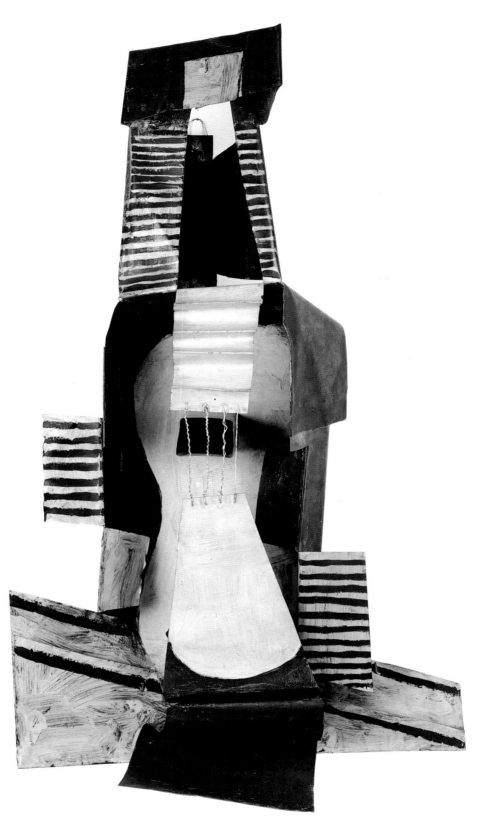

PABLO PICASSO
78 *Guitar* 1924
Guitare
Painted sheet metal
111 x 63 x 27 (43 ¾ x 24 ¾ x 10 ⅝)
Musée Picasso, Paris

163

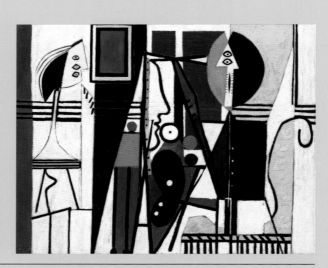

16

In December 1913 Matisse rented a studio at 19 quai Saint-Michel where he had worked in the early years of the century, commemorating in stylistically diverse paintings the views it commanded: towards Notre-Dame on the right and back towards the Pont Saint-Michel on the left. His new working space was on the fourth floor, directly below his old studio, now occupied by his close friend Albert Marquet. It was in 1913 that Matisse began to reassess the foundations of his art (no.52). He remained distrustful of many aspects of Cubism but now recognised that he could no longer ignore its implications. In a sense, his adoption of a new base in the heart of Paris was an indication that he was once more going down into battle. Matisse continued to spend the middle months of the year at Issy-les-Moulineaux and travelled back and forth to Paris freely; but he found the winters at Issy dank and sad and was thus dividing his time between two centres of painterly activity. It was at quai Saint-Michel that he painted some of his most sober and experimental pictures (nos.55–6, 63).

Matisse also commemorated his new Paris studio in three major masterpieces. They are in a sense the counterparts of his three 'symphonic' studio pictures of 1911: *The Pink Studio*, *The Red Studio* (fig.73), both depictions of the studio he had had constructed at the bottom of the garden at Issy, and *Interior with Aubergines*, executed in temporary accommodation at Collioure that summer.[1] These were the works that established Matisse as the greatest colourist of his age. All are horizontal in format. The quai Saint-Michel studio pieces, on the other hand, are all vertical pictures. They are colouristically majestic but simultaneously more restrained in their harmonies and place a greater emphasis on compositional structure. The studio at Issy was fairly large, as – to judge from its pictorial furnishings – was the space at Collioure. The new studio or working space at quai Saint-Michel, on the other hand, though well proportioned, was relatively small – measuring only about ten by fourteen feet.[2] It was one of Matisse's great achievements to invest this modest domestic space with a sense of breadth and grandeur.

The first of the great quai Saint-Michel studio pictures, *Interior with a Goldfish Bowl*, a work of early 1914,[3] is perhaps the most accessible, although its silvery and blue-grey colouristic range and its compositional rigour reflect Matisse's new pictorial concerns. As yet there is no sign of the artist himself, who makes his entrance, in the form of a recondite cipher, in the related still life *Goldfish and Palette* (no.69), painted during the autumn.[4] The two later studio pictures, *The Studio, quai Saint-Michel* in the Phillips Collection (no.79) and *The Painter in his Studio* in the Centre Georges Pompidou (fig.79), are generally ascribed to the autumn and winter of 1916–17 and reflect Matisse's tendency in the years between 1907 and 1917 to think in terms of coupled or paired images; while at work on a major picture Matisse would begin to form a mental image of the same subject treated differently. These pictures are of the same

height, although the Phillips picture is somewhat broader in format. Scholars disagree on the order in which they were painted. The majority place *The Studio, quai Saint-Michel* first, presumably on the principle that hitherto in his paired variants Matisse had almost invariably moved from more naturalistic and loosely painted works to more rigorous and often more abstract effects. But the pendulum was in the process of swinging, and it is possible that the Phillips painting was finished as late as the spring of 1917.[5] Both pictures show the same model, Lorette, posing in a corner beyond the window.[6] Both include an easel (a true one in the case of *The Painter in his Studio*, fig.79, and here one that has been improvised), and on it an image of the model – a picture within a picture. *The Painter in his Studio* is the most abstract of the quai Saint-Michel interiors and demonstrates the compositional lessons Matisse had learnt from his study of Synthetic Cubism. In it Matisse appears almost as a dummy or lay figure, apparently naked – a passive servant to his model and to the act of creation.

In the Phillips painting Matisse has, it seems, temporarily left the room and is, so to speak, present by absence. With consummate assurance the picture treads a tightrope between naturalism and pictorial abstraction; and possibly because of this it is one of the most emotive and moving of all Matisse's major masterpieces. The sunshine coming through the window is pale, but the painting nevertheless vibrates with light. The model appears to be seen at a great distance but cannot in fact have been more than a few feet away from Matisse when he was at work on his depiction of her. Throughout his life Matisse liked to work at touching-distance from his subject, and the contemporary painting of Lorette in the same pose, on the same divan draped with the same red cloth, implies a close-up view and required a canvas the size and shape of a single bed.[7] In the Phillips picture the studio itself, in effect a small apartment sitting-room, has been given the same amplitude as the external cityscape glimpsed through the windows. This is the only one of the three quai Saint-Michel studio paintings to include a glimpse of the spire of the Sainte Chapelle, at the top right beyond the Palais de Justice. The bending, golden or ochre forms at the extreme right of the composition, which combat the rigid architecture of the window, suggest an improvised curtain, possibly used to control the disposition of light at different times of day.

Recording his own environment in this way was far from being Picasso's purpose when he embarked upon his series of artist-and-model paintings in the spring of 1926 – the date of the first, the huge, labyrinthine *Painter and Model* in the Musée Picasso in which he explored the 'pure psychic automatism' of the Surrealists.[8] The numerous photographs of his studios and working spaces, some taken by himself, like the occasional drawings in which he took stock of the current state of his studio,[9] reveal that Picasso painted in the midst of epic disorder and clutter, with stacks of canvases and frames propped against the walls or on easels and furniture, objects from his heteroclite collection placed wherever a space had once been found, the floor littered with messy paint pots, trails of waste paper and cigarette butts (fig.89). Ever since the Cubist period, working from the posing model, or indeed from the set-up still life, had become a rare event for Picasso, and even when making portraits of his intimates he often preferred to work from photographs.[10] Eye-witnesses claim that he did not work at an easel.[11] The spare,

austerely geometric *Studio* of the winter of 1927–8[12] and the more cluttered, but still orderly *The Painter and his Model* of spring 1928 (no.80) have, if anything, an ironic relationship to Picasso's actual environment, and were conceived as generic set-pieces depicting the classic confrontation between the painter at his easel, palette and brushes in hand, and his chosen motif.[13]

Neither *The Studio* nor *The Painter and his Model* aspire to be Surrealist paintings. On the contrary, the insistent geometric grid, a legacy of pre-war Cubism, implies a rational approach to composition, and the flat, clearly demarcated areas of colour and impersonal technique have much to do with the clarified form of Synthetic Cubism which emerged immediately after the war and was supported by Amédée Ozenfant and Charles-Edouard Jeanneret (better known as Le Corbusier), the leaders of the newly founded Purist movement. The subject of the artist at his easel working 'from life' has, however, no more to do with Purism than with Surrealism, and in turning to this theme Picasso moved his long-standing dialogue with Matisse onto new terrain – terrain Matisse had made his own. By covering the painter's chair in *Painter and Model* with the kind of brightly coloured, patterned fabric which is a constant in Matisse's work he dropped a clear hint of what he was about.

Picasso must have seen some of Matisse's most recent artist-and-model paintings, such as *The Three O'Clock Session*, painted in Nice early in 1924 and exhibited at the Salon d'Automne in 1925.[14] No doubt he had also seen photographs of Matisse drawing or painting his model, Henriette Darricarrère, in the festooned interior of 1, place Charles-Félix in Nice – photographs designed to demonstrate Matisse's commitment to the principle of working from life.[15] In treating the familiar realist subject in a flagrantly anti-naturalistic style in both the 1928 *Painter and Model* and *The Studio*, Picasso announced his commitment to a fundamentally different principle, articulated in 1923 in an interview with Marius de Zayas: 'Nature and art, being two different things, cannot be the same thing. Through art we express our conception of what nature is not.'[16]

There is reason to believe that Picasso also had Matisse's interiors of the studio at quai Saint-Michel in mind when executing the 1928 *Painter and Model*. Since he saw Matisse quite regularly in 1916–17, he may have seen both *The Painter in his Studio* (fig.79) and the Phillips painting in the studio itself,[17] and it is possible that the Phillips painting was the *Intérieure d'Atelier* included in the exhibition Matisse and Picasso shared at the Galerie Paul Guillaume early in 1918.[18] At all events, he must have seen *The Painter in his Studio* (fig.79) in 1926 when it was included in an important anthology exhibition at the Grand Palais.[19] Significantly, he reproduces the essentials of its iconography in *Painter and Model*, even down to what can be read as the non-reflecting mirror placed in the wedge between the model and the painting of her.[20] However, incidental details, like the pattern on the painter's chair and the circular apple precariously poised on the spindly table, recall passages in the busier, more detailed Phillips painting. Perhaps, too, *The Studio, quai Saint-Michel* was a precedent for the fundamentally ambiguous scenario in *Painter and Model*, where the androgynous classical profile being traced on the canvas resembles neither the sculpted female bust nor the staring painter himself, and might conceivably represent someone on the spectator's side of the divide. In the Phillips paint-

ing the sketch propped up on the chair bears only an oblique relationship to the posing Lorette. One infers that it shows the outline of her hips or her arms, but one cannot be quite sure. In a literal sense, the picture the unseen Matisse is working on is, after all, the picture we are looking at, not the enigmatic sketch on the chair. In *The Studio, quai Saint- Michel* Matisse injected the element of mystery which lies at the heart of some of the greatest paintings-about-painting of the past – Velázquez's *Las Meninas*, in particular (fig.74) – and in *Painter and Model* Picasso followed suit.

In his studio paintings of the late 1920s Picasso's dialogue with Matisse is discreet and might fairly be described as oppositional – a critique of the principle of working from life. When he returned to the theme in the 1950s his dialogue with Matisse had a quite different tone. In December 1953 he began a new series of painter-and-model drawings as a belated follow-up to his prints and drawings on this theme of the 1930s (nos.129, 133–4). Some of these new drawings are almost caricatural in style, and the bent, bearded, elderly painter who peers through his spectacles at the beautiful young model in several of them is clearly a reference to Matisse himself.[21] On the penultimate day of the year, Picasso completed *Nude in the Studio* (fig.80), one of the first of his overt homages to Matisse.[22] He had long been aware of the fragility of Matisse's health and of the fact his death was approaching. The painting evokes comparison with *The Studio, quai Saint-Michel*, which he would have seen most recently in Matisse's major retrospective at the Galeries Georges Petit in 1931,[23] and which by 1953 had been reproduced several times, most recently in Alfred Barr's classic monograph.[24] One senses that this particular Matisse would have gone to Picasso's heart as being, in his eyes, possibly more quintessentially Matissean than the contemporary works demonstrating an overt debt to Cubism. In *Nude in the Studio* the model is shown in the same pose as Matisse had depicted Lorette, although in reversed axis. The easel to the right echoes Matisse's chair-easel, and the canvas seen from behind to the right mirrors the construction of the quai Saint-Michel window. Picasso's nude reclines on plain blue drapery, but the floral motifs against which Lorette is placed are picked up in the decorative floor coverings in the Picasso. The similarities between the two paintings are possibly fortuitous, but it is nevertheless significant that whereas Picasso's use of pattern had often evoked memories of Matisse – as in the 1928 *Painter and Model*, for instance – pattern is used here both perspectively and disjunctively to create a sense of deep space, a device fundamental to Matisse's art from 1908 onwards. Space had never hitherto been one of Picasso's prime concerns. Now, in the 1950s, when it often informs and floods his work as seldom before, one is aware of a new debt to his older friend and to the artist he saw as his only rival.

In June 1955 Picasso purchased a large Belle Epoque villa overlooking Cannes called La Californie. This new sense of spatial fullness and complexity, achieved through the manipulation and dislocation of ornament, informs the second series of studio paintings begun there in March 1956. These are all horizontal in format and most of them depict the three windows of Picasso's studio. The upright pictures in the first series, dating from the autumn of 1955, give the impression of depicting angles or corners of working space (no.156). Now, in the second series, the studio space in its totality has become the artist's subject. These pictures are sombre and Hispanic

in feel, and tonally more orchestrated and complex than their vertical predecessors, as if in anticipation of the *Las Meninas* series of 1957 (no.158). But the references to Matisse are still overt. Once again one is reminded of Picasso's admiration for the Vence Interiors of 1947–8 (nos.155, 157), while the wide-angle views and the plethora of studio paraphernalia suggest that he may also have been thinking back to Matisse's great studio pieces of 1911 (fig.73). The brass Moroccan charcoal burner to the left of the compositions of the second La Californie series reads almost as a Matissean signature (see fig.63).[25] Iconographically, what distinguishes the two groups most markedly is that in place of the plaster head of the first series, and at the centre of the compositions of the second series, there is a blank canvas ready on an easel, surrounded by others, some in progress, some turned face to the wall. Surely it is not too fanciful to suggest that Picasso is metaphorically beckoning to the dead Matisse, inviting him to fill those expectant, empty canvases.

EC/JG

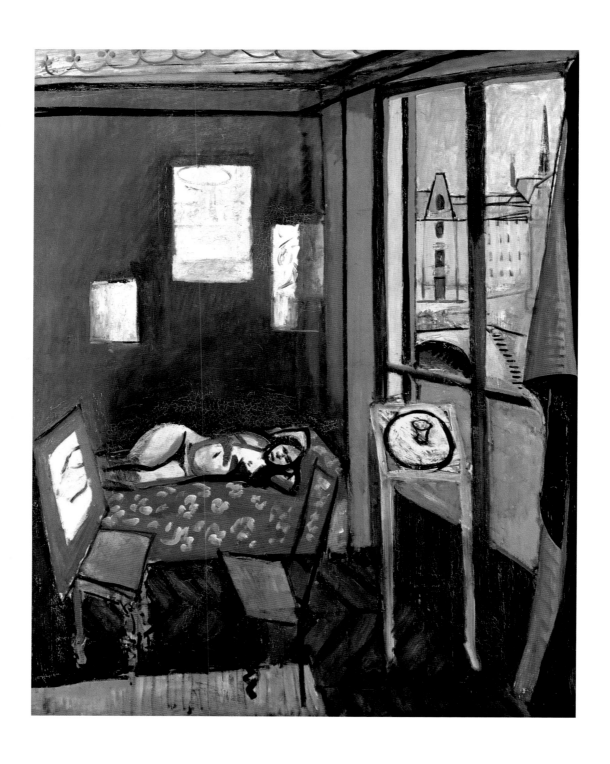

HENRI MATISSE
79 *The Studio, quai Saint-Michel*
1916–17
L'Atelier du quai Saint-Michel
Oil on canvas 147.9 x 116.8 (57¼ x 46)
The Phillips Collection, Washington DC

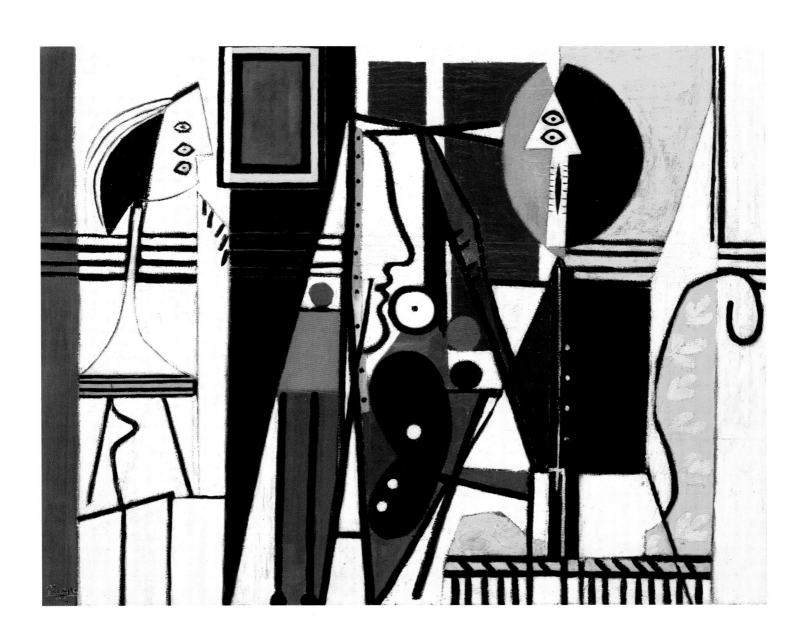

Pablo Picasso

80 *Painter and Model* 1928

Le Peintre et son modèle

Oil on canvas 129.8 x 163 (51⅛ x 64⅛)

The Museum of Modern Art, New York.

The Sidney and Harriet Janis Collection

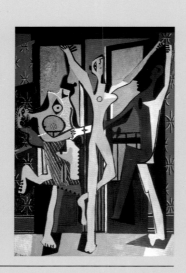

17

Nasturtiums with 'Dance' II is the last of four paintings of the interior of Matisse's studio at Issy-les-Moulineaux showing the full-scale study for what was to become *Dance II* of 1910.[1] It and its pendant, *Music*, had been commissioned by the Russian collector Sergei Shchukin as mural decorations for the landings of the staircase of his palatial Moscow home. Prior to their departure for Russia at the end of 1910 the two great canvases had been shown at the Salon d'Automne to virulent critical response. Many years later Matisse remembered standing with Picasso in front of *Music* and discussing with him the question of scale.[2] Matisse had shown *Dance I* (the study, fig.50), freshly painted, to Shchukin in his studio in March 1909. The Shchukin commission marked a high point in Matisse's career and appears to have awoken resentment in Picasso,[3] although it has been generally accepted that it was Matisse who had brought his patron to Picasso's studio in the first place, in the autumn of 1908.[4]

Throughout his entire career Matisse made frequent use of pictures within pictures, and in a similar fashion, mirrors and above all open windows. For the most part these are placed parallel to the picture plane. They serve as compositional devices, punctuating the picture surface. But above all they enrich the spaces of interiors, defining them but simultaneously extending them. In the four studio pictures showing the study of *Dance*, the large mural project is shown at an angle, introducing perspectival diagonals. In both *Nasturtiums with 'Dance' I* and *II* the studio setting is conveyed simply by the presence of a sculptor's wooden tripod or modelling stand. And in both canvases the study occupies approximately two thirds of the pictorial arena, so that in a sense these are paintings about another painting and hence, by implication, about the processes of painting. *Nasturtiums with 'Dance' I* (fig.51) retains a sense of frontality, despite the very slight angling of the picture depicted, and has about it a floating, airborne quality. The second, stronger and more compelling version, *Nasturtium with 'Dance' II*, is more heavily worked, and although the greensward beneath the dancers' feet has been eliminated, their movements are tauter and more dynamic and echo more closely those of *Dance* in its final mural version. The negative spaces are also more carefully calculated, setting up a perfectly balanced dialogue between recessive effects and the powerful surface organisation of the composition. The formalistic rigour of the painting makes it a precursor to the works of 1913–14 in which Matisse began to acknowledge the achievements of Picasso's immediately pre-Cubist works and subsequently the achievements of Cubism itself.

Picasso's *The Three Dancers*, an even more heavily worked canvas, was begun in the spring of 1925 and finished in June. The painting marks a turning point in his career. It was reproduced, together with *Les Demoiselles d'Avignon* (no.7) (to which it is in many ways linked) within a few weeks of its completion, in the 15 July issue of *La Révolution surréaliste*. This was part of the

movement's attempt to claim Picasso as 'one of their own'.[5] Picasso never subscribed to the Surrealists' cult of the dreamworld which they saw as being more potent than waking, perceived reality. Yet perhaps more than any other single work *The Three Dancers* demonstrated their claim that beauty must be 'convulsive'. It generates an overwhelming sensation of obsessive neuroticism. And if Picasso had done much to form the climate in which Surrealist art was now flourishing, he was now to be profoundly influenced by the Surrealist ethos. Matisse shunned Surrealism, and in turn was shunned by it. During the decade between 1917 and 1927 Picasso and Matisse had drifted apart. They were enjoying very different lifestyles and the artistic and intellectual climate generated by Dada (to which Picasso had once again contributed), and subsequently by Surrealism, had driven a deep aesthetic divide between them.

If *Nasturtiums with 'Dance' II* is concerned with the processes of art and how it is made, *The Three Dancers* has about it a strongly autobiographical quality. While he was working on the painting Picasso had received the news of the death of a close friend of his youth, the Catalan painter Ramon Pichot, and he remarked to Roland Penrose that the painting should really be called 'the Death of Pichot',[6] adding that 'the tall black figure behind the dancer on the right is the presence of Pichot'. The death of Pichot must in turn have reminded Picasso of the tragic end of another friend of his Barcelona days, Carles Casagemas, who had killed himself in 1901, an event which is commemorated both directly and indirectly in Picasso's early work. *The Three Dancers* is iconographically more densely layered than *Nasturtiums with 'Dance' II*, and its sources are legion, ranging from the Three Graces and the dancing maenads of antiquity through to his own relatively recent line drawings of the dancers of the Diaghilev ballet. It also has about it unavoidable overtones of a crucifixion. Picasso has been touched, too, by the new and extended wave of interest in tribal and ethnic art which the Surrealists were experiencing and popularising. Here, for example, if the dancer on the right emanates an African aura, her companion on the left reflects Picasso's new fascination with Eskimo art.

The compositional procedures employed by Picasso, on the other hand, are still basically those of Synthetic Cubism and do not differ fundamentally from those of, for example, *Three Musicians* of 1921 (no.73). The motif of the window, so dear to Matisse, begins to interest Picasso seriously only in a series of small works executed in Saint-Raphael on the Riviera in the summer of 1919; these are all related to his incursions into stage design and have about them a somewhat theatrical feel. Picasso's windows, unlike Matisse's, seldom look out onto anything very specific other than the sky and the sea. Here they appear simply as compositional or framing devices. Matisse's blues are almost invariably imbued with spatial sensations even when they drench the entire picture surface, as they do in *Nasturtiums with 'Dance' II*, where they have about them a soft, smoky quality. Picasso's blues tend to be flat and cool and are often used, as here, simply to throw his images into relief, although the blue areas in this picture are subtly differentiated.

Yet if these two paintings inhabit totally different aesthetic worlds, at a superficial level the iconography is similar. Matisse has chosen to focus on three of his original five dancers, although the all-important compositional note, top right, is the knee of a fourth. And the purely

visual, formalistic links between them are striking. The rhythms of Picasso's three dancers echo those of Matisse's although they face the spectator more frontally and certainly more agressively. The dancer at the centre of Matisse's composition, although her legs are fractionally to the left of them, appears almost to be impaled on the objects below her (the container of the nasturtiums and the tripod on which it stands). The lower limbs of the corresponding figure in Picasso's composition have about them a rigid, wooden look and are are encased in upright configurations with connotations of both columnar architecture and classical drapery. Both compositions pivot on the outstretched hands of the two side figures. Those in the Matisse strain to once again clasp.[7] Those in the Picasso are locked but simultaneously sharply divided colouristically.

It is possible that the pictorial affinities between the paintings are fortuitous. And yet one senses that even at this moment of great psychological divorce from his older rival, Picasso still had Matisse's art lurking somewhere in the recesses of his mind. Shchukin, who had purchased *Nasturtiums with 'Dance' II* out of Matisse's studio earlier in the year, had agreed that the work should be shown at the Salon d'Automne of 1912.[8] Knowing of the painting's ultimate destination – to a collection in which Picasso and Matisse, as exemplars of contemporary art, together reigned supreme – it is more than likely that Picasso would have gone to look at it. In this connection it is worth remarking that Picasso's visual recall was astonishing and virtually total; all who knew him testified to this. Although André Breton, the high priest of Surrealism, came to view Matisse's post-war art with contempt,[9] in 1916, while stationed in Saint-Dizier working as an orderly in an army mental clinic, he had put up a reproduction of *Nasturtiums with 'Dance'* in his living quarters.[10] It is tempting to think that Breton was at least unconsciously thinking of Matisse's canvas when he instantly recognised the importance of *The Three Dancers* in relation to the recently born Surrealist movement.

JG

HENRI MATISSE

81 *Nasturtiums with 'Dance' II* 1912

Capucines à 'La Dance' II

Oil on canvas 190 x 114 (74¾ x 44⅞)

The Pushkin State Museum of Fine Arts,

Moscow. S.I. Shchukin Collection

PABLO PICASSO

82 *The Three Dancers* 1925

Les Trois Danseuses (La Danse)

Oil on canvas 215.3 x 142.2 (84⅞ x 55⅞)

Tate. Purchased with a special Grant-in-Aid and the

Florence Fox Bequest with assistance from the Friends of

the Tate Gallery and the Contemporary Art Society 1965

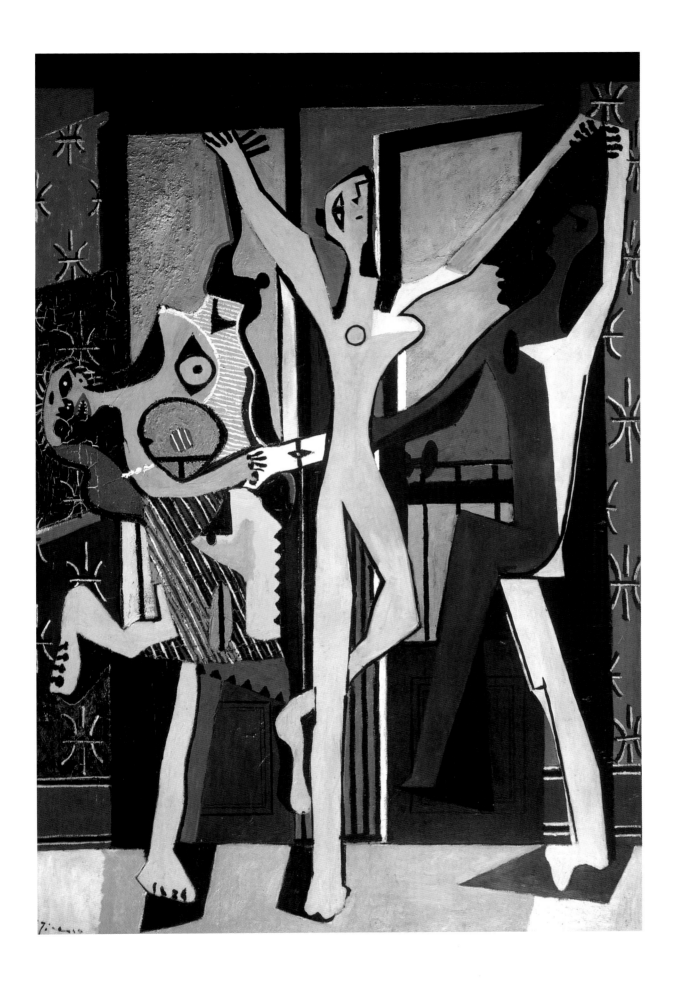

18

1917 marked a change in relations between Matisse and Picasso. Picasso's spell in Rome, working for the Diaghilev Ballet, left a deep mark on his art and brought about far-reaching changes in his personal life through his marriage to the Russian ballerina Olga Khoklova. Right at the end of this year Matisse settled into what was to be the first of his various working spaces in Nice. He was not working in complete isolation. He called on both Renoir and Bonnard and was visited occasionally by artist friends. But when in Nice his artistic contacts were circumscribed, and increasingly he was turning in upon his own resources. As painters the concerns of Matisse and Picasso were to differ widely for a decade, although, ironically, their first shared exhibition was held just as their paths began to separate.[1] As draftsmen they continued to have much more in common, however, and, it could be argued, were presenting different sides of the same coinage, for, as has often been suggested, the revival of a tradition of French realistic or naturalistic art was the counterpart to the more stylistically self-conscious neoclassicism that was so prevalent in Paris during the first half of the 1920s. Thus, despite their differences of interpretation and bias, Ingres, Courbet and Renoir became important to both Matisse and Picasso at this time, as the latter's identification with the French tradition became more marked than hitherto.

Picasso had shown his stylistic restlessness in 1914 when he produced detailed, illusionistic pencil drawings of a delicacy and precision new to his art. These form the prelude to his experience of Rome and his creation of a fully-formed neoclassical idiom. Matisse, by contrast, when he was experiencing the impact of Cubism, was working towards a reductive linear idiom: 'Fauvism, the exaltation of colour; precision of drawing from Cubism.'[2] Some of his most angular and severe drawings of 1915 are, however, superimposed over the ghosts of elaborately worked naturalistic images that have been erased and cancelled. These are spelt out by a handful of exquisitely rendered naturalistic pencil still-life drawings.

In Nice Matisse's draftsmanship experienced an almost instant sense of relaxation, which he celebrated in 1920 by arranging for the publication of a volume entitled *Cinquante dessins*. As John Elderfield has observed, 'It was a sort of anniversary present to himself: fifty drawings at fifty years of age.'[3] The quality of the works chosen by Matisse for his commemoration is uneven. And throughout his life Matisse showed a much more uncritical attitude towards his drawings than towards his paintings, possibly because he saw them not only as the immediate record of the sensations he experienced in the face of observed reality, as recording something, but also as always leading onwards. Up until the 1940s, when colour and line took on an equal importance to him, colour – 'cette magie' – was his prime concern, and as must true magic it remained a mystery to him. Drawing he saw as more of a discipline, albeit one in which he revelled and delighted. His drawings form a sort of visual autobiography in a way which the

paintings do not. Despite their varying quality, the best of the fifty drawings are among the most self-assured Matisse had yet produced. A few are in ink, but most are executed in a fine to medium-hard pencil and they have about them a feathery, silken quality. All of them emanate a sensation of filtered, slightly dream-like light.

In the meantime Picasso was consolidating his overtly neoclassical manner, initially and most strikingly and consistently in his draftsmanship. No longer constrained by a sense of total commitment to Cubism, he explored an astonishing range of graphic styles and media simultaneously, exploiting the facility he had acquired as a boy when under pressure from his father to attain total mastery of the draftsman's traditional skills. (The present selection, chosen to complement the drawings by Matisse, gives only a very limited sample.) Refined and elegant drawings in silverpoint and ink coexist with heavily modelled, over-life-size drawings in pastel and charcoal, series done at lightning speed with individual works executed with meticulous care. Occasionally alternative techniques were combined in a single drawing as a way of demonstrating the artistic process and the expressive character of style (see no.97). Quite often he chose to work in extended series, sometimes employing strongly contrasted manners (as in the suite of autumn 1920 devoted to the mythological story of Nessus and Dejanira), sometimes the same ultra-simplified, pure outline style (as in the recurring neoclassical suites of nudes and bathers, no.95). But although the spectator senses the shadowy presence of Picasso's historical sources, they are invariably adapted and interpreted rather than reproduced straightforwardly. Later he would explain to critics bemused or scandalised by all this variety that his technique 'wanders a great deal, according to the mood I'm in when I begin working', and stressed his openness to change, which for him signified both liberty and vitality: 'I think I have discovered many methods of expression, and still believe there are a great many more to discover.'[4]

Although some portraits and studies of dancers in the Diaghilev Company were done from life, unlike Matisse Picasso generally preferred to do without the posing model, and at this period often worked from photographs instead.[5] The majority of his drawings were, however, generated from the imagination and memory. The greatest of the neoclassical oil paintings, which date from the first half of the 1920s, follow on from his drawings. Indeed, such was his commitment to drawing that some of his grandest works either were executed in pastel, chalk and charcoal, or look as if they were because he stroked and rubbed the oils on so gently that the surfaces have the velvety glow, softness and fragility associated with those media.[6] Like a Renaissance masterpiece, *Three Women at the Spring* of 1921 was preceded not just by small-scale sketches but a full-size cartoon in sanguine on canvas.[7] By contrast drawing played a relatively insignificant role in Picasso's contemporary Cubist work, where the emphasis was on geometric order and bold decorative effects and the style remained, broadly speaking, consistent: the twin to the Museum of Modern Art's *Three Musicians* (no.73), painted in Fontainebleau at the same time as *Three Women at the Spring*, was not a drawing, but another oil painting on the same theme with a more crowded composition.[8]

A comparison between Picasso's *Portrait of Madame Georges Wildenstein* (no.88), executed during his honeymoon in fashionable Biarritz in the summer of 1918, and one of the most per-

sonal and touching of Matisse's *Plumed Hat* series of 1919 (no.89), the most celebrated of the early Nice drawings, is instructive. Picasso has shown his sitter, the wife of the leading dealer in old master paintings in Paris, as both she and her husband would have wished her to be viewed – well-born, self-possessed, and fashionably but not ostentatiously dressed. She instantly evokes echoes of Ingres's pencil portraits of the wives of the powerful and newly rich executed one hundred years earlier. Particularly Ingresque is the attention paid to the sitter's head, while social status is discreetly conveyed in the subsidiary rendition of costume, jewellery, and the brocaded chair on which she sits. The same chair served as the throne for every woman who posed for Picasso that summer (see no.87), underlining the unity of the series as a whole and the social ties between the sitters. (All were friends of the Picassos' hostess, the Chilean balletomane and patron of the arts, Eugenia Errazuriz.) Clearly, Picasso had decided that penetrating characterisation would be out of place in these formal presentation drawings, which are more standardised and less revealing than the portrait drawings of Ingres, as well as more extreme in the discrepancy between the meticulous treatment of the head and the summary treatment of the rest of the body. These differences point to the wilfully stylish nature of the drawings.

The Plumed Hat in question shows a nineteen-year-old model known as Antoinette. She sat for Matisse for approximately one year and he was attracted by the quality of innocence she emanated. But she was also – as were all his subsequent models – a vehicle onto which he could project his own shifting sensibilities. Her physiognomy varies from depiction to depiction and she can appear coolly detached and of classical feature (no.83), girlish (no.98), asymmetrical of feature, and even at times somewhat plain (no.90). Here she wears a loose, timeless garment, and sports the famous plumed and beribboned confection engineered by Matisse himself. Unlike Madame Wildenstein she conveys an air of vulnerability. A further comparison with Picasso's *Olga in a Feather* of 1920 (fig.93) demonstrates that in his use of pure line Picasso was a virtuoso in a way that Matisse would not have wished to emulate. The firm, emphatic contours were laid over a pencil sketch and all inessential details erased to leave an image which resembles a tracing. The reductive, formulaic approach, the flatness of the image and the effect of rational calculation and psychological distance are paralleled in Picasso's contemporary 'crystal' Cubist paintings.[9] In different clothes or a different pose, Olga Picasso served as a convenient vehicle for the exploration of this style, and her own personality and fluctuating moods generally seem of less account than Antoinette's. Drawings of this type often originated in photographs and the style itself probably developed in response to the need to provide images which would reproduce well in the official programmes of the Ballets Russes.[10]

Matisse's nudes of the period are quite frankly studio nudes and studies for paintings (no.99). Picasso's claim a classical heritage and are archetypal in their anonymity; some of them have a bulk that relates them to the painted nudes of 1906 (nos.97, 100), others are in pure line (no.95) and realise his aim to achieve a non-imitative form of representational drawing.[11] The distortions of anatomy and preference for awkward, splayed poses in which hands and feet seem gross and over-prominent surprise and shock and keep conventional grace and beauty at

bay, despite the fluency of the line and the Arcadian atmosphere. Matisse's odalisques are costume-pieces and reaffirm his own very subjective view of the Orient (nos.92, 94). Antoinette had posed occasionally in an oriental costume at odds with the domestic European setting (no.90), but her successor, Henriette Darricarrère, was the main model for the more theatrically conceived odalisque scenes of the 1920s (no.94). On the rare occasions when Picasso depicted women in exotic costumes – more often at this time than any other – he turned to his collection of photographs and postcards. *Woman with a Pitcher* of 1919 (no.91) is derived from a late nineteenth-century albumen print of an Egyptian woman, but monumentalises the image and – a great contrast to Matisse – eliminates the pattern on her dress.[12] Like other drawings of this period it reflects Picasso's response to the blend of the sculptural and the sensual in the work of Courbet and Renoir. That year, 1919, saw both the death of Renoir and the centenary of Courbet's birth and the link between the two artists was made by several artists and critics at the time.[13]

Matisse's drawings executed between 1922 and 1924 were dominated by his use of charcoal and *estompe* (stump or eraser) (no.92). In the earlier Nice drawings tonal values are stroked up through gentle hatchings and markings in a fashion that is sometimes reminiscent of Renoir, with the white page generating a sensation of light behind and through them. In a letter of 1918 to his friend Camoin he compared Gauguin to Corot and decided that the use of firmly drawn contours produced a 'grand style', but that the use of half-tones was 'much closer to the truth'.[14] Now, through the use of smoky charcoal and its erasure, which simultaneously involved a softening of the different tonal values, light takes on the quality of being released from the human body itself, while its shadowy surround is also imbued with sensations of shifting tones and at times, miraculously, of colour itself. Through this medium his drawings were also becoming more sculptural and volumetric, and the physicality of some of his nudes conjures up the name of Courbet. Picasso was impressed by these drawings and later admitted that he had used *estompe* in imitation of Matisse.[15]

In 1925 Matisse embarked on an odyssey which was to occupy him for the rest of his life: that of pure line, rendered spontaneously in pen and ink (nos.135, 137–8) and then eventually in brush and ink (nos.168–9), although he remained a master in the use of charcoal and with it of chiaroscuro. The neoclassicism of Picasso's draftsmanship did not alter radically in the years before 1925, although it found more tender expression in his maternities and the studies of his young son Paulo. That year marked the death of neoclassicism in his painting and his immersion in a very different pictorial world, but in his graphic work the style lived on – at first barely, but with the ascendancy of Marie-Thérèse Walter, a young woman of a classic, statuesque type of beauty, it broke out anew, especially in dazzling suites of etchings on mythological themes and the symbolic subject of the artist's studio (see pp.254–63).

EC/JG

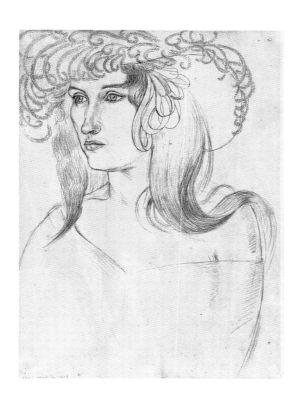

HENRI MATISSE

83 *The Plumed Hat* 1919

Le Chapeau à plumes

Pencil on paper 34.9 x 29.2 (13¾ x 11½)

Private Collection

HENRI MATISSE

84 *Portrait of Léonide Massine* 1920

Portrait de Léonide Massine

Graphite on paper 39 x 29 (15⅜ x 11⅜)

The Art Institute of Chicago, Samuel A.

Marx Purchase Fund

PABLO PICASSO

85 *Portrait of Léonide Massine* 1919

Portrait de Léonide Massine

Graphite on ivory laid paper

33.9 x 31 (13⅜ x 12¼)

The Art Institute of Chicago,

Margaret Day Blake Collection

HENRI MATISSE

86 *Lorette's Sister* 1916–17

La Soeur de Lorette

Charcoal on paper

56 x 37.5 (22 x 14¾)

Private Collection

PABLO PICASSO
87 *Portrait of Madame Patri* 1918
Portrait de Madame Patri
Pencil on paper
36.5 x 26.8 (14⅜ x 10½)
Private Collection

PABLO PICASSO
88 *Portrait of Mme Georges Wildenstein*
1918
Portrait de Mme Georges Wildenstein
Graphite on paper 35 x 24.3 (13¾ x 9⅝)
Private Collection

HENRI MATISSE
89 *The Plumed Hat* 1919
Le Chapeau à plumes
Pencil on paper 54 x 36.5 (21¼ x 14⅜)
The Museum of Modern Art, New York.
Gift of the Lauder Foundation

PABLO PICASSO
90 *Olga in a Feathered Hat* 1920
Olga au chapeau aux plumes
Graphite on paper 61 x 48.5 (24 x 19⅛)
Musée Picasso, Paris MP902

PABLO PICASSO

91 *Woman with a Pitcher* 1919

Femme à la cruche

Pencil over charcoal on paper 65.5 x 48.5 (25¾ x 19⅛)

Santa Barbara Museum of Art,

Gift of Wright S. Ludington

HENRI MATISSE

92 *Standing Woman* 1923–4

Femme à demi nue debout

Charcoal on paper 47.6 x 31.5 (18¾ x 12⅜)

Centre Georges Pompidou, Paris. Musée National

d'Art Moderne/Centre de Création Industrielle.

Don de l'artiste en 1932

HENRI MATISSE

93 *Odalisque in an Armchair* 1919

Odalisque assise dans un fauteuil

Crayon on paper 37 x 27 (14½ x 10⅝)

Private Collection

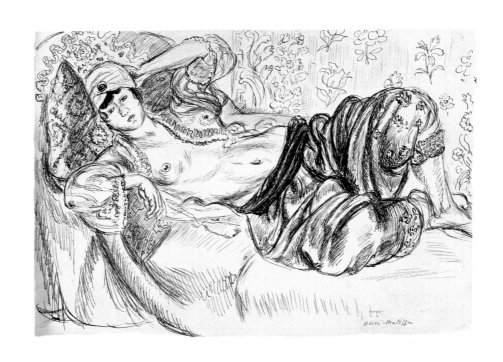

HENRI MATISSE

94 *Reclining Odalisque with Turkish Trousers* 1920–1
Odalisque étendue, pantalon turc
Ink on paper 28 x 39 (11 x 15⅜)
Centre Georges Pompidou, Paris. Musée National d'Art
Moderne/Centre de Création Industrielle. Don de
l'artiste en 1932 (au Musée de Luxembourg)

PABLO PICASSO

95 *Nude with Raised Arms* 1920

Nu aux bras levés

Pencil on paper 34.5 x 23.5 (13⅝ x 19¼)

Private Collection

PABLO PICASSO

96 *Olga Reclining on a Sofa* 1917

Olga allongée sur un sofa

Crayon on paper 15.5 x 23.5 (6⅛ x 9¼)

Marina Picasso Collection

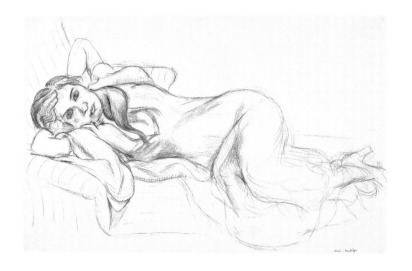

PABLO PICASSO
97 *Reclining Bather* 1923
Baigneuse
Crayon on paper 49 x 63.5 (19¼ x 25)
Bibliothèque nationale de France,
(Département des Estampes)

HENRI MATISSE
98 *Reclining Woman* undated
Nu couché
Pencil on paper 27 x 54 (10⅝ x 21¼)
Pierre and Maria Gaetana Matisse
Foundation Collection

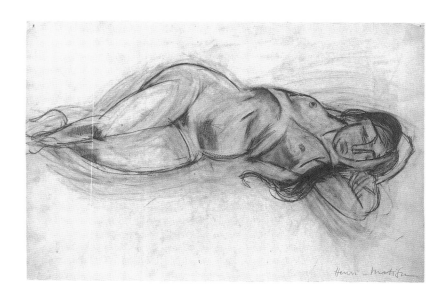

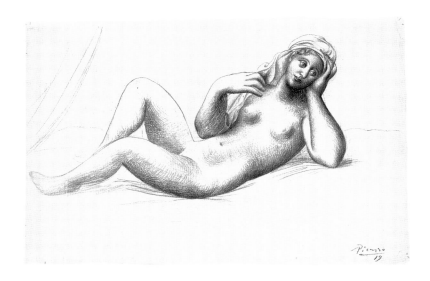

HENRI MATISSE

99 *Reclining Nude* 1916–17

Nu couché

Charcoal on paper 37 x 56 (14½ x 22)

Staatliche Museen zu Berlin, Nationalgalerie.

Sammlung Berggruen

PABLO PICASSO

100 *Reclining Nude with Turban* 1919

Nu couché au turban

Crayon on paper 21.5 x 31.5 (8½ x 12⅜)

Collection Hegewisch at Hamburger

Kunsthalle

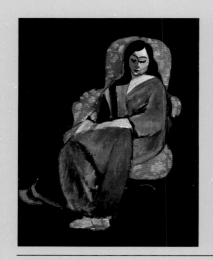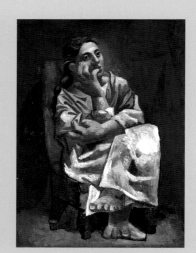

19

The titles of these two almost symmetrical canvases give clues to their meaning. Picasso's model is indeed seated, solidly set in the picture frame by means of an enormous foot or pedestal, and so motionless as to appear petrified. Seated: the word and the posture immediately call up, in the most everyday sense, a three-dimensional space, and hollow, allowing the body total freedom of movement. A seated body indeed occupies three separate planes, although they are not strictly parallel: the vertical plane of the bust, the horizontal plane of the thighs, and the diagonal plane of the legs. This zigzag is doubled up by the articulation of the support of the seated figure, providing it has the full array of back, seat, and legs, as it does in Picasso's painting.

Matisse's *Lorette in a Green Robe against a Black Background* offers with this same sense of immediacy a perception of the model laid out on the canvas, like one splash of colour on another. The title of the painting immediately evokes a Matissean problem – the figure/ground dialectic, the work of colour, and even the importance of the colour black. The opposition between Picasso's bulky, static, almost sculpted figure, and Matisse's figure, cut into two planes of colour, is striking. No less striking, however, are the symmetries between the two paintings: their rectangular format (Picasso's rectangle is slightly more elongated), a similar oblique placement of both figures in their respective spaces, the same flowing hair, and the way the two women are cloaked in ample, ageless clothes, and the fact that both stand out against a dark background. Other less visible symmetries bind them still closer together, for example their dates of completion with regard to the end of the war, as marked by the armistice of 11 November 1918. Matisse's painting was done approximately two years before the armistice, in the middle of the war, somewhere between late November 1916 and the following spring, simultaneously with *The Painter in his Studio* (fig.79) in which the model and the painting in progress can be seen. *Seated Woman* was painted exactly two years later, in the autumn of 1920, after Picasso's return from a socialite summer in Juan-les-Pins. Both figures refer to an identifiable model. For Matisse, as was often the case, it was a professional sitter, Lorette,[1] who would pose for some forty paintings between November 1916 and the beginning of Matisse's long stays in Nice, which began in 1918. Picasso, on the other hand, was inspired by Olga for this series of neoclassical figures, after his encounter with her during his stay in Rome in 1917. Picasso did not exactly have her pose for him, but it is nevertheless clear that his commerce with her beautifully regular features, the dignified poses she liked to strike – seated, her arm across an armrest, or reading, as Picasso would often photograph and draw her – and the wistful, even melancholy expression of her large eyes do relate to Picasso's growing interest in the calm monumentality of a classicism he would characteristically modify, by channelling it through the works of Ingres and Renoir among others.

Picasso had acquired several paintings by Renoir (who died on 3 December 1919) before January 1918: a painting entitled *Woman Reading*, then in 1919 or at the very beginning of the

1920s, a large late work entitled *Bather Seated in Landscape* (1895–1900).[2] We know that on 4 May 1918 Matisse actually showed *Lorette in a Green Robe* to Renoir, having chosen it among the paintings his children Marguerite and Pierre had brought down from Paris for safekeeping several weeks earlier. Matisse had described Renoir's reaction to his paintings to his wife: 'He found a frankness about them, he was genuinely impressed that my works carry so well so far.'[3] The remark certainly holds for *Lorette in a Green Robe:* the apparent simplicity of the arabesque drawn in black (it is visibly set in some places *over* the pink of the armchair), the chromatic efficacy of the shock between complementary colours, the accuracy in the placement of ochres and yellows here and there (face, neck, arm, yellow babouche slippers) and above all the striking black borrowed from Manet all make this painting an absolutely convincing confirmation of Renoir's judgement. Though it is as far removed as is imaginable from the world of Renoir – who seems to have banished black from his palette[4] – the old master managed to appreciate its qualities. Matisse returned frequently to visit Renoir at les Collettes in the first stage of his stay in Nice: there were at least four visits between the first, on 31 December 1917, one week after his arrival, and the last on 4 May 1918. During this epochal period in which Matisse was changing the site of his work, his lifestyle, and above all during which the very foundations of his painting were being questioned, Renoir undoubtedly represented a sorely needed source of support and confirmation of the new orientations he was adopting, and which would result in the odalisques of the Nice period. This genuine internal conflict found expression in the homage he published early in 1918 in a catalogue of French art in Oslo, in which on the pretext of an opposition between Cézanne and Renoir, Matisse calls into question his own painting: 'Second only to Cézanne, whose great influence was first apparent in the work of artists, Renoir rescues us from the atrophying effect of pure abstraction through his example. The rules one may try to deduce from studying the work of these two masters are more difficult to detect in the case of Renoir, who has concealed his mental effort more thoroughly. By contrast, the constant tension of Cézanne's mind, his lack of self-confidence, may have prevented him from abandoning himself entirely to us, even though he allows us to see his corrections clearly – corrections which have been too glibly interpreted as evidence of mathematically precise rules'.[5] Matisse always insisted on the fact that Renoir's personality, as much if not more than his painting, had led to the project of a meeting between them. 'Renoir was interesting otherwise than in his painting', he declared subsequently, once again contrasting him with Cézanne.[6] And yet, like Picasso, Matisse would acquire one of Renoir's smaller paintings in 1919. In a letter to Alexandre Romm in 1934, he precisely formulates what there is to learn from Renoir's technique in colour: 'You can superimpose one colour on another and employ it more or less thickly. Your taste and your instinct will tell you if the result is good. The two colours should act as one – the second should not have the look of a coloured varnish, in other words the colour modified by another should not look glassy. The painter who best used slightly thinned paint and glazes is Renoir – he painted with liquid: oil and turpentine (I suppose two-thirds poppy seed oil and one third turpentine) quite fresh and not syrupy'.[7]

The project aiming at the production of liquidity (in opposition to the 'drying out' Matisse associated with Cézanne's influence), and the achievement of fluidity of a colour applied in suc-

cessive transparent layers, was to be much more systematically implemented from 1918, that is, starting from Matisse's residency in Nice. But the project actually precedes the visits to Renoir, particularly in the paintings with Lorette as sitter in 1916–17 – almost all of which were painted in pairs.[8] Just as Picasso in the years 1915–20 functioned in alternate modes – Cubist (or post-Cubist) or classical (or neoclassical) – Matisse, in the same manner, alternated between tightly worked paintings, Cézannean in influence, with sharply defined architectures and geometrised motifs, and paintings in which the liquified paint circulates freely. To *Lorette in a Green Robe*, incorporating cut-outs, curves and counter-curves meshed with one another, in equally powerful planes of colour, corresponds *Lorette in Green in a Pink Armchair*, painted several months later in the same colour scheme of black, green and pink; but there the muted colours insinuate themselves into one another, instead of remaining distinct, the mobile grey of the ground contaminating both the green and the pink. Only the hair shines with a little of the pure black omnipresent in the first painting. In both cases, however, the figure floats in an expanding space out of its control. As precisely delineated as it appears, the figure in the first painting is inseparable from the black ground absorbing and reflecting light like a mirror. The black ground so frequently used by Matisse, especially in the years 1914–18, often masks other colours without totally obliterating them. It contains them, and acts as a screen, in the cinematographic, dynamic sense of the term: as an accumulator of light, a reservoir of memory. It is the memory of the painter – the choice of an Italian model with black hair, the gandoura and the babouche slippers recalling Morocco, and the figure surging up from the black ground, as if illuminated by memory – but also the memory of the beholder.

Picasso was just as preoccupied by Renoir in 1919–20, but not by the same elements; his is rather the search for a standardisation, a serialisation of the ever-expanding figure, systematically blown up and equipped with oversized hands and feet. He must have been interested also in a practice of monochrome painting, which he would reinterpret by overturning it, transforming the blond light and radiant flesh of Renoir's late nudes into solidified grey shadows by the use of thick paint and vigorous superimposed brushwork. The sketches of Olga seated, sewing or reading in Juan-les-Pins are the points of departure for *Seated Woman*, or *Woman Reading* or even for the giant *Bathers* of 1921.[9] Jean Cocteau described them generically as 'Juno with the eyes of a cow, whose hands clench a stone towel',[10] in a formula recapping several references visible here: the status of goddess conferred to figures domestically draped in bathrobes, the vacuous gaze of their eyes, their statuesque weight, and more generally the evocation of Roman antiquity. The pictorial substance in which they are modelled – they might be called mineral pigments – ranging from all the shades of brick (from pink to ochre) to those of stone (from white to grey to black) recall as much the apparatus of architecture and Roman sculpted decors, as the memory of Picasso's own work in pink, in 1905–6, already linked to a reinterpretation of the classical canon.

What Cocteau's formula does not account for, however, is the melancholy in *Seated Woman*: she bears the brunt of overwhelming shadows[11] and a vague threat of destabilisation. If Matisse's figure is painted against the black screen of reminiscence, Picasso's sinks into the grey-black shadows of melancholy.

193

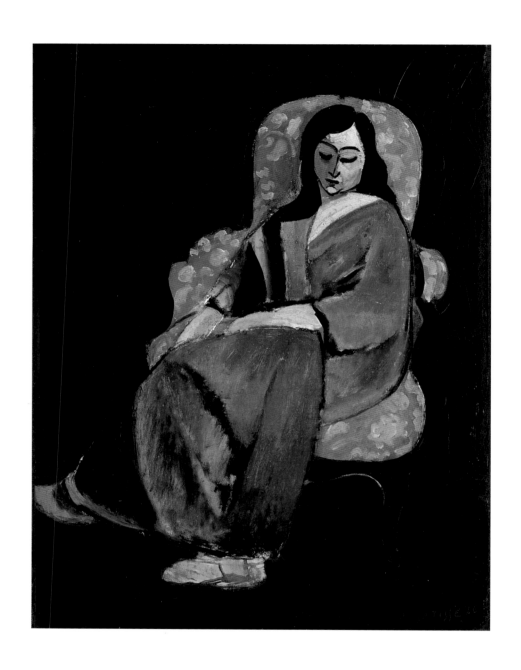

HENRI MATISSE

101 *Lorette in a Green Robe against a Black Background* 1916

Lorette sur fond noir, robe verte

Oil on canvas 73 x 54.3 (28¾ x 21⅜)

The Metropolitan Museum of Art. Jacques and
Natasha Gelman Collection, 1998

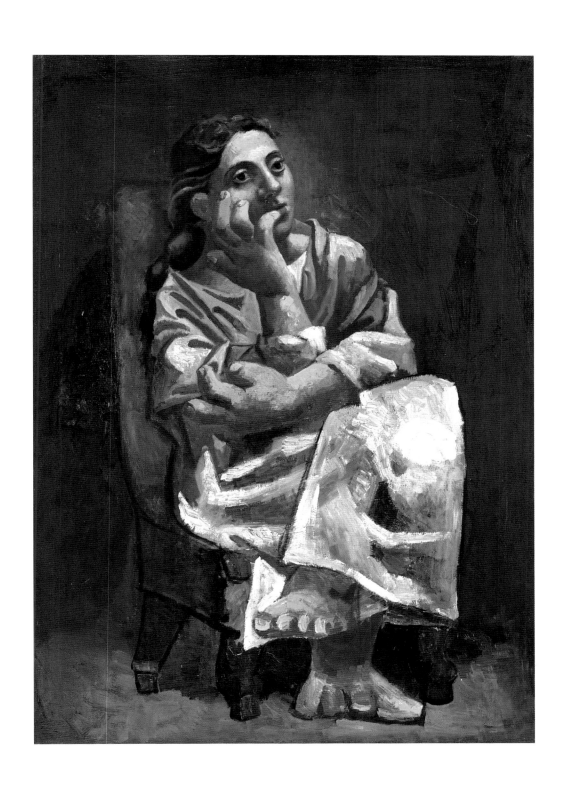

Pablo Picasso

102 *Seated Woman* 1920

Femme assise

Oil on canvas 92 x 65 (36¼ x 25⅝)

Musée Picasso, Paris

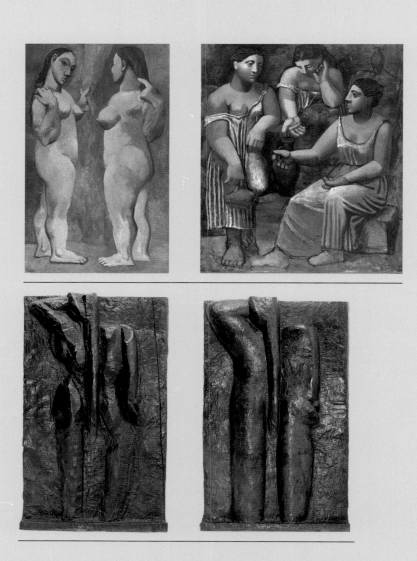

20

'Form, ground, form, ground . . . What is form? What is ground? The ground of the wild straw-berry is the seed and the seed of the wild strawberry, is the surface of the strawberry! So just where is the ground of the wild strawberry? Where is its form, anyway?' Picasso supposedly said.[1] In the 1906 *Two Nudes*, the 'seeds' would then be the eye, the erect nipple, the nail of the extended finger, the sharp angle of the heel, the pointed elbow, the ear, the nose, the cheek-bone. All their pyramidical reliefs intertwine, as if the surface of the canvas had been given an embossed, tin-plated effect. These two monumental ochre nudes facing each other's mirror image are the metaphor of a 'form' to be ascertained in reversible coordinates: face/profile, front/rear, left/right, as well as masculine/feminine, positive/negative, painting/sculpture. At the end of a period of direct wood carving undertaken during his stay in Gósol, under the influ-ence of primitive Iberian statuary and Catalonian Romanesque sculpture, Picasso turned the consequences of his research into sculpture against painting. That was probably the moment when Picasso conceived of his strategy of the painting as a *trompe-l'esprit*, a trap for the mind.[2] *Two Nudes*, vanguard outposts for *Les Demoiselles d'Avignon* (no.7) achieve this new con-sciousness, inspired by the contemplation of Cézanne's still lifes: 'Form itself is only a hollow area with sufficient pressure applied to it by the space surrounding it to make the apple seem to appear.'[3] What then we habitually read as relief may in fact be hollow. Is it convex or concave, this curtain into which a hand disappears and which enfolds the two bodies like clay around fos-sils? Occlusion of space, sign of the undetermined, the curtain simply stands for the materiali-sation of the 'pressure': red-hot air. All in all, might this curtain not be the true subject of the painting, 'the form of the ground'?

Such a paradoxical relation is elucidated in several Picassian approaches to sculpture. In 1933, Daniel-Henry Kahnweiler noted: 'Picasso explains that in order to avoid casting, he has just made, in Boisgeloup, hollow clay sculptures, into whose cavities he then poured plaster. End result: plaster sculpture in relief.'[4] Here, Picasso's hand delves into the clay as the hand of his *Nude* does into the curtain. The pressure exerted by his hand, informed and muscular, blind sculpts a figure in the negative. 'And I want to paint these sculptures', adds Picasso, 'yet paint-ing can only be an art of imitation. If you use black, the spectator will think the shape is "turn-ing", and, indeed, that is the only way to render depth, whereas if a sculpture is painted pink, it will just be pink.'[5]

The flesh-tinted pink of the figure is strange indeed, coming to rest 'in relief' on the red of the clay mould. Similarly, before the ochre covered them, the *Two Nudes* were 'figure pink', 'painting pink'. And the black underscoring their contours would have us believe that the shapes are turning in space, if Picasso had not slipped a few visual traps into the painting: the

197

chromatic passages between the curtain and the bodies, or the hampered light source which should be coming from above, as the cast shadow of the breasts would tend to prove, and yet bathes the legs in the bright light of its rays. Thus the illusion would turn up short so as to allow imagination to take over: couldn't the woman with the pointed finger, the one closest to the viewer, be the same woman who seizes the curtain, her own double seen from the other side of this space warp? Might she not be her own virtual projection, her reflection, her reconstruction? Picasso would play the game of 'what is form and what is ground' with the same iconoclastic pleasure throughout his life. Thus, in 1948, in a description of his work in ceramics, he said: 'I made a head. Well, it can be looked at from all sides, it is *flat*. Of course it's paint that makes it flat – since it is painted. I used colour in such a way as to make it look flat from all sides. What is sought in painting is depth, as much space as possible. With sculpture, you have to make it flat for the viewer, it has to be seen from all sides.'[6] Picasso tells us on another occasion about painting: 'What must be avoided, suppressed, is form. I mean learned, conventional form'.[7] The depth to which Picasso refers, suggesting as much space as possible, will therefore be achieved in an above/below intertwining of the painting's surface planes, an optical maze into which the eye is dizzily attracted. This is not Albertinian perspectival depth, but rather the complex coming and going of virtual planes out of which the perceptive interpretation of the viewer and a work of elision and rupture suggest dimensional depth. Therefore, devising a trap for the mind, a *trompe-l'esprit*, would be a never-ending attempt to undermine visual habits, to delude the deluded eye.

'This is all a part of my struggle to break with the two-dimensional aspect of art.'[8] With the 1921 *Three Women at the Spring*, Picasso deliberately reverts to the tradition of chiaroscuro and sculpture in the round, but only to take pictorial illusionism to a new breaking point. With this painting, outlines, shadings, and half-tones are synthesised in an attempt to assemble bodies in an allusive idiom. If this time the reference is Graeco-Roman, the plastic ambiguity of *Two Nudes* remains.[9] Here, too, a complex lighting models volume, and focuses on fragments of bodies as do pursuit spotlights in the theatre. Of course, in the meantime, Picasso, starting with *Parade* and ending with *Pulcinella*, had grappled with the experience of creating stage sets for the Ballets Russes. The sham scenic space of a stage set emphasises the extravagant perspectives, the short-cuts and contrasts to which Picasso's painting is submitted. By brutally applying this technique to the description of human form, Picasso raises this principle of counter-truths to the status of a style. Accordingly, even when bodies randomly appear and disappear behind cardboard boulders, when objects, like the jar in the background, thin out to designate an outlandish distance, when the spring water wells along an unlikely trajectory, the mind may nevertheless take comfort in the certainty that Picasso, here, wants to name women through painting.[10]

There are three women, and the specular face-off of *Two Nudes* gives way to the circularity of their stroboscopic appearance: the first woman is standing facing three quarters to the right, the second is shown truncated, leaning forward three quarters to the left, and the third is rendered in profile, seated. Three times over, the same woman renders successive aspects of her

identity in an anthropometrical sequence of view-taking.[11] The red and pink, cooled by the ordeal of the Pompeian ash, are turning brown and grey. These 'signs' of a woman endure as the stilled gush of the spring frozen by time. If Picasso borrows his themes here from Pompeii, it is only to superimpose the baroque folly staged by some of its gardens over the flatness of its fresco paintings.[12] By resorting to images, simplifying the composition and geometrising the motif, Picasso seems to have wanted to endow the painting with the legibility and efficiency of the template used in sculpture.[13] 'One would only need to cut these paintings out – the colours are nothing more than indications of different perspectives, planes inclined one way or the other – then to assemble them following the indications given by the colours, to end up in front of a sculpture.'[14] *Three Women at the Spring* could well be one of those states of pictorial exacerbation achieved by a painting prior to being 'cut out' by the blow-torch, prior to being folded, screwed down, bolted and welded like Meccano, in a manner the blue and pink steel sheets of the 1950s would be again: 'Sculpture is the best comment that a painter can make on a painting.'[15]

For Matisse as well, sculpture periodically returns as a practice in conjunction with and as commentary on the painted work: 'I like to model as much as to paint – I have no preference. If the search is the same when I tire of some medium, then I turn to another – and I often make *pour me nourrir* [as a form of nourishment], a copy of an anatomical figure in clay.'[16] The series of large sculpted *Backs* exemplifies this approach.

From 1908 to 1931, the five states of the series constitute a kind of calibration of Matissean research. In the context of the sculptural work of the artist the series is also exceptional owing to its low-relief aspect, which places it formally close to what a painting would be.[17] The starting point was indeed a copy of an anatomical figure in clay, as in the version *Back (O)* (fig.54), a large non-extant study in clay of which the only remaining trace is a photographic plate by Druet.[18] But Matisse here establishes an intermediary space directly intended as the metaphorical setting up of the model over the ground, a sculpture over a painting.[19] As far back as 1901, several of his drawings took up the question of modelling a figure on a ground.[20] For Matisse, 'A drawing is a sculpture, but it has the advantage that it can be viewed closely enough for one to detect suggestions of form that must be much more definitely expressed in a sculpture which will be seen from a distance.'[21] Facing the planks of the studio walls, the women, seen from behind,[22] sink into a cast shadow, a ray of ink in which the architecture of the bodies erects its three dimensions. The amplitude of the body, its mass and its density materialise in these negative doubles which form a halo around the contour. The head and feet bump against, cling to and sink into the edges and base of the slab out of which the body, gently fashioned by this clay touch, comes to light.[23]

For Matisse, the shock wave of the original sensation experienced with the model propagated throughout the next two decades. While working on the first two versions of *Back, O* and *I* (fig.55), Matisse was also particularly involved with the major composition *Bathers with a Turtle* (no.8).[24] The life-size relief allows for the study of the tonal accentuation of the figure. In 1913, *Back II* contributed to research for *Bathers by a River* (fig.12),[25] which in its first red, blue and

green version[26] is still associated with the cycle *Dance* and *Music* of 1909–10.[27] The process of abstraction taking place in 1916–17 with *Back III* implements a rectilinear geometry in a decisive break with the naturalism of the Rodinian model. As in *Bathers by a River*, *Back III* is built around large vertical bands, rhythmically contrasted by means of optical effects, following a scheme similar to the one at work in Picasso's *Two Nudes*. Matisse seems to be appropriating the principle of the salient fold of the Picassian curtain, turning it into the ambiguous motif of the spinal-column-cum-braid separating the two distinct sections of the body of his nude henceforth bound in a fissiparous division. In 1930–1, *Back IV* extends the range of this schematisation: the shaft of the shock of hair rising up in exact continuity and exact proportion to the void dividing the two legs here builds up an alternately positive/negative axis that moulds the motif to the ground. Contemporaneous with the Barnes *Dance* (fig.11),[28] this final stage of the *Back* series represents, just as each of its previous stages, the main lines of the course of research. Here, the main line is the architectonic integration of the figure into space.

In the course of this long process, Matisse obsessively returns to his initial subject, while placing his work under the sign of repetition. Matisse had made a plaster cast from the original clay model which resulted in *Back I*. This process continued in like manner through successive alterations of 'replicas' yielding versions *II* (fig.56), *III* and *IV*. Matisse takes advantage of the ductility of wet plaster, silting figure and support. This progressive erosion lowers the relief and the ground comes up to fill in the voids of the form. As if absorbed by this primeval silt, the body spreads out laterally. The white, chalky, fragile plasters, which Matisse leans against the walls of his studio, re-enact or restage the presence of the original models immersed in their cast shadows. However, as can be seen in a photograph of the studio taken by Hélène Adant,[29] *Back IV* hardly quivers. Whenever light runs over it, gently skimming its surface, nothing stirs but grey hues. The work henceforth becomes the modulation of a buried figure, layer upon layer, embedded in its clay mould and still harbouring the artist's fingerprints, in the negative. From this point, form retreats whereas the gradual rise of the ground to the surface occurs. The flattening out, the erasure, the wear are procedures given theoretical specificity by Matisse in drawing, painting, and here in sculpture. Had he continued to bury in this way 'the emotion awakened by the subject',[30] one day the large quadrangular plaster would have become a planar surface . . . This is the point at which Matisse stops short, or rather, this is the point opening onto the gouache cut-outs, which would provide him with a workable answer.

'I sculpted as a painter. I did not sculpt like a sculptor. Sculpture does not say what painting says.'[31] Their modes of metaphorisation, the reversibility of their original images, the symmetry of their procedures, constitute for Matisse and Picasso one of the hidden axes of their respective oeuvres. In the *Back* series, as in *Two Nudes*, the woman seen from behind is gazing in a direction out of our reach. Her gesture indicates a hidden dimension. Her position, poised between the spaces of sculpture and painting, the real and the represented, makes her a crucial intercessor. For what is at stake is seeing or knowing: the hand on the face, or the hand as a

shade, the eyes between her fingers, these same fingers which, in *Two Nudes*, grip the curtain or designate the unavowable. Outside the picture frame, the 'primal scene' of painting would, under this interpretation, take place here, in the interstitial space between the body and the ground, the hand and the curtain. Matisse and Picasso, in the same movement, with similar means, would thus simultaneously attempt to construct a theory of unveiling. And, though in Picasso's words, they could both conclude: 'To make a painting is to engage in a dramatic action in the course of which reality is found to be torn apart.'[32]

AB

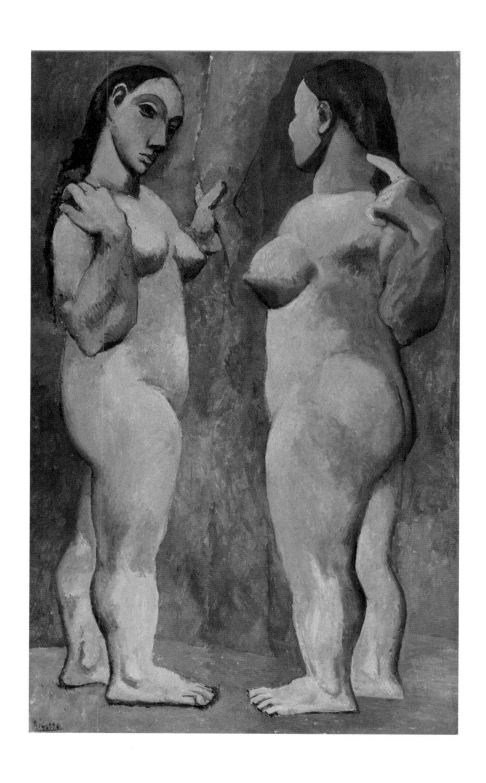

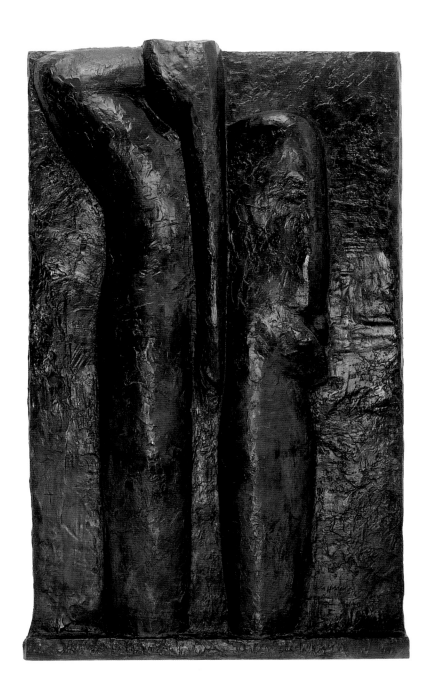

PABLO PICASSO
103 *Two Nudes* 1906
Deux Nus
Oil on canvas
151.3 x 93 (59⅝ x 36⅝)
The Museum of Modern Art,
New York. Gift of G. David Thompson
in honor of Alfred H. Barr, Jr

HENRI MATISSE
104 *Back IV* 1930
Nu de dos IV
Bronze 189.2 x 113 x 15.9 (74½ x 44½ x 16½)
Tate. Purchased with assistance from the Knapping Fund 1955
(shown at Tate Modern)
Centre Georges Pompidou, Paris. Musée National d'Art
Moderne/Centre de Création Industrielle. Achat en 1964 par le FNAC.
Attrib. en 1970 (shown at the Grand Palais)
The Museum of Modern Art, New York. Mrs Simon Guggenheim Fund
(shown at The Museum of Modern Art)

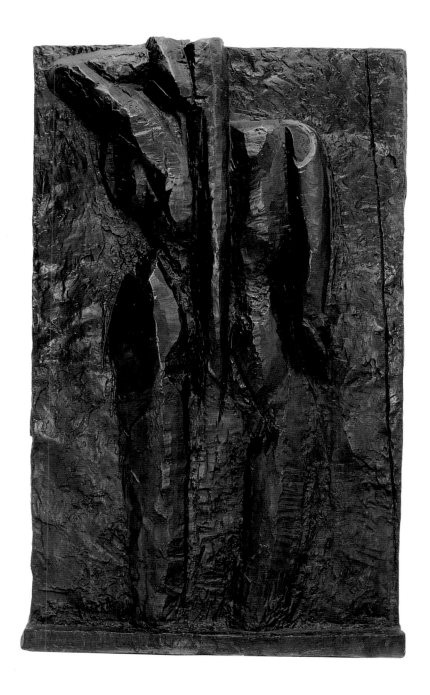

HENRI MATISSE
105 *Back III* c.1916–17
Nu de dos III
Bronze 188 x 113 x 17.1 (74 x 44½ x 6¾)
Tate. Purchased with assistance from the Matisse Appeal Fund 1957
(shown at Tate Modern)
Centre Georges Pompidou, Paris. Musée National d'Art
Moderne/Centre de Création Industrielle. Achat en 1964 par le FNAC.
Attrib. en 1970 (shown at the Grand Palais)
The Museum of Modern Art, New York. Mrs Simon Guggenheim Fund
(shown at The Museum of Modern Art)

PABLO PICASSO
106 *Three Women at the Spring* 1921
Trois Femmes à la fontaine
Oil on canvas 203.9 x 174 (80¼ x 68½)
The Museum of Modern Art, New York.
Gift of Mr and Mrs Allan D. Emil

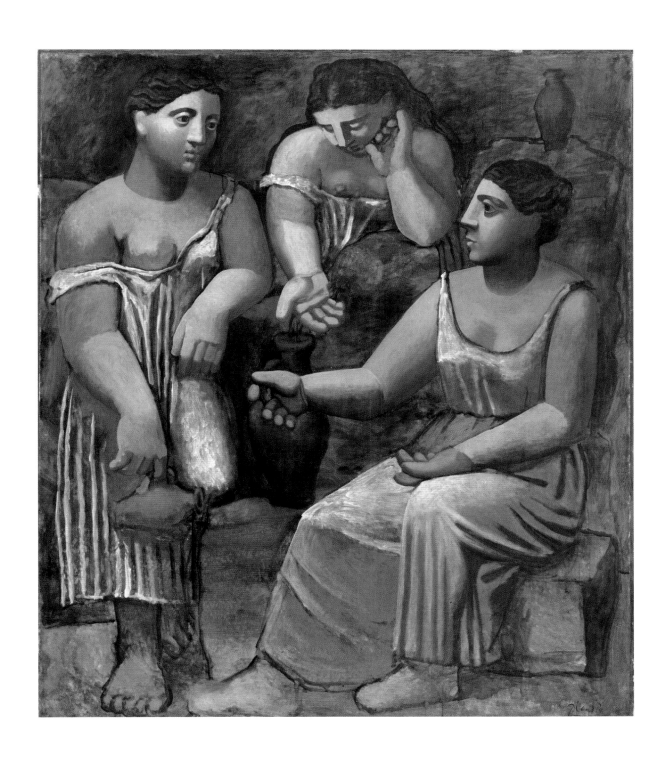

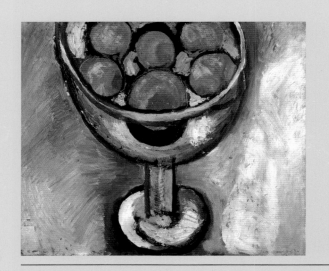

21

Both still lifes are carefully wrought, and share a sense of mystery, as though in spite of the extreme simplicity of what is rendered – a bowl filled with oranges in one case, a simple pitcher topped by a plate of apples in the other – these paintings withhold a hidden meaning. Straightforward as they are, something about them remains at a remove, outside the ken of the closest scrutiny.

The orange, the fruit conflated with the colour so strong and so dense that it has bestowed its name on the fruit, appears frequently in the paintings of Matisse, to the point of becoming for some beholders the emblem of his art. It is precisely this *Bowl of Oranges*, painted in Paris in the spring of 1916, that elicited from Apollinaire the now famous observation: 'If the work of Henri Matisse had to be compared to something, it would have to be the orange. Like the orange, his work is the fruit of dazzling light.' There is little room for doubt that this sentence, which is found in the double preface the poet wrote for both artists in the exhibition catalogue *Works of Matisse and Picasso* organised by the Paul Guillaume gallery in 1918, would have been picked up by Picasso. In fact, symbolically assigning the orange, a Spanish fruit par excellence, to Matisse, could be interpreted as provocation, in the particular context of an organised confrontation such as this one. Yet Picasso never challenged the dictum of his friend Apollinaire. He is even known to have trumped the assertion, saying to Tériade in 1932: 'That is the unique reason why Matisse is Matisse. He carries this sun in his belly' – which is actually an even more brutal way of inscribing light in Matisse's very body, and not only in his painting. Picasso would go so far as to confiscate, in 1942, a basket of Matisse's oranges by purchasing from Fabiani the splendid 1912 still life with this title (no.45), which he included not far from his own work in the 1944 Salon d'automne, and which he would continue to keep close at hand until his death.[1]

The trajectory of the orange (fruit and colour) in the work of Matisse begins with his painting manifesto of 1896–7, *The Dinner Table*. Three bowls filled with fruit (with the one in the foreground filled with oranges) impart rhythm to the rigorously constructed composition of this ambitious painting, as do the various flasks, decanters and glassware set at regular intervals on the dressed table. The painting is a kind of pupil's take on, or explicit homage to, the *Bar at the Folies-Bergère* by Manet, exhibited at the Durand Ruel gallery in 1896,[2] a painting altogether more sumptuous than Matisse's. In the foreground, on the right hand side of Manet's ultimate masterpiece, a fruit bowl filled with oranges, splendidly painted, seems to have haunted the painting of Matisse over the following years. This object of glass or porcelain – at once ordinary and slightly pretentious, designed to present fruit while displaying its shapes – appears again, in a similar manner to Manet's, in *Buffet and Table*, painted in Toulouse in 1899, and especially in *Still Life with Oranges II*. The same fruit bowl can be seen, decanted, simplified and flattened

out, in *Harmony in Red* (1908). The intensity of the oranges recurs, this time in a Moroccan context, in *Still Life with Basket of Oranges*.

The fruit bowl of 1916 has become a simple cup, reduced to its simplest expression: there is no longer any play of transparency and reflection between the glass and the shiny skin of the fruit, but simply a double curve strongly stroked in black, enclosing six, symmetrically arranged spheres, filled with a thick orange, gritty substance, set off against a grey background. The cup is shown both from above, and from the side. Surrounded by all manner of greys, the oranges concentrate the light, and appear exalted, pushed upwards (the edge of the painting cuts through the upper section of the composition and some of the fruits), almost haloed by the cup supporting them. Reduced to essentials, a few lines and colours, the cup thus becomes an icon, a sacred symbol. Rémi Labrusse, in reference to this painting, evokes the silver Byzantine chalice admired by Matisse in the Royall Tyler collection (Tyler had acquired the chalice in 1912, with one of Matisse's former students, Joseph Brummer, serving as intermediary).[3] The modulated silver grey tone over the entire surface of the painting, causing the oranges to irradiate like strange hosts, as well as the depth of the cup and its edge, does in fact evoke that exceptional object now conserved at the Dumbarton Oaks Research Library and Collection.

Pierre Schneider has an interesting hypothesis concerning the colour orange in its role as Matissean emblem.[4] The colour of the orange, spread over its entire surface with equal intensity, prefigures the splash of colour or the stroke that will describe it – the epitome of Matissean oranges would obviously be the three fruit cut out of paper gouached in orange, surrounding a nude drawn in a few brushstrokes, the *Nude with Oranges* of 1953. Thus the colour orange would be in essence 'ill-designed for colour shading, modelling and perspective' and consequently, from all eternity destined to be painted by Matisse.

The apple, however, often the preferred fruit of Cézanne or Picasso, should be classed in the category of the modelled, the tactile. It is easy to see to what extent *Still Life with Pitcher and Apples*, painted in 1919 by Picasso in high neoclassical style, corresponds to this definition:[5] six volumes (a pitcher, a plate, four apples) in a drama of light and shadow, but seemingly muffled on their smoky grey background. Their contours are rounded, thickened, even the contour of the table edge, even the plate which, set strangely on the pitcher, partially obstructs its opening. The colour is partially faded, to the point of becoming a grey out of which spring only yellow, infinitely delicate ochre lights. Each of the elements of this sensuously modelled composition, silken smooth and as if rubbed with ashes,[6] elicits the caress: the round fruit, of course (the apple, *pomme* in French, from *pomum*, the Latin word for fruit *par excellence*, the fruit that set everything in the garden of Eden in turmoil), but also the clay pitcher whose silhouette, both round and slim, with a slightly flared opening, a mouth of open and enticing darkness, is irresistibly evocative of sexuality. Rosalind Krauss rightly distinguishes in Picasso's classic period elements of serialisation and automation.[7] It is as if the systematic thickening of the lines, the practice of 'over-modelling', the enclosure of objects or figures in what would seem to be several layers of successive mediations, tended to mechanise the shapes and finally to turn them into abstractions. *Still Life with Pitcher and Apples* stems in part from this process (the pitcher

concentrates every contour of every pitcher of the universal history of art, from ancient times to the European eighteenth century) but also escapes the process by its strangely disquieting aspect, made to trouble the gaze.

Its commentators have easily detected the hidden woman in this work. Thus Elizabeth Cowling compares it profitably to 'several large pastels of women with hats done by Picasso in 1920–1922'[8] – women with hats adorned with huge ribbons looking like sisters of the pitcher-woman. This pitcher- or amphora-woman will be the model of countless other, more literal pieces during the Vallauris years.

One should however avoid the temptation of opposing the orange icon of Matisse, to be beheld from below, and the excessively tactile apples of Picasso. From one work to the other, the values of abstraction and figuration permutate. The pictorial treatment of the oranges (composed of several layers of colour interacting in transparency, but also in thickness) is rather less abstract than the apples, ideally smooth and spherical. The most abstract element in Matisse's painting is no doubt the crescent of black shadow supporting the central orange (the central star of this microcosm) whose only necessity is pictorial; whereas the dark hollow opening at the beak of the pitcher calls for a more brutal intrusion than that of the sheer gaze.

IMF

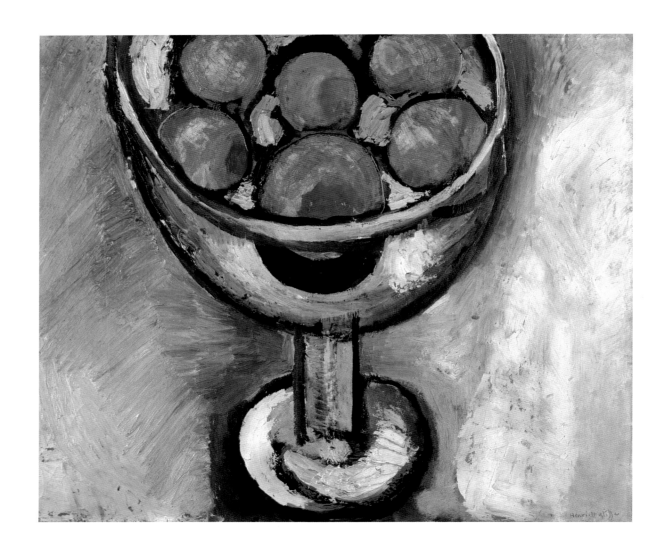

HENRI MATISSE
107 *Bowl of Oranges* 1916
La Coupe d'oranges
Oil on canvas 54 x 65 (21¼ x 25⅝)
Private Collection

PABLO PICASSO
108 *Still Life with Pitcher and Apples*
1919
Nature morte au pichet et aux pommes
Oil on canvas 65 x 43 (25⅝ x 17)
Musée Picasso, Paris

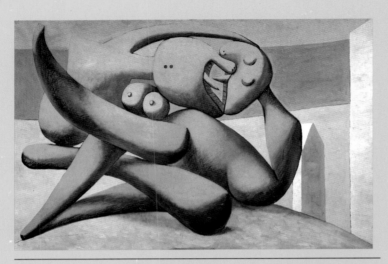

22

'Only when painting is not painting can a public outrage to morals occur.'

—PABLO PICASSO[1]

'**P**ablo and Matisse have a maleness that belongs to genius', commented Gertrude Stein in her notebooks.[2] 'Maleness' as a neologism aims to indicate a quality in the artistic dimension which would be seen as mere virility in the psychology of sex. Thus it would be in art that potency would accomplish its inseminating plenitude.[3] It would fertilise the field of representations, and procreate new forms of modernity. That mission would find its main expression in the motif of the *joute d'amour*, the love joust. To restage such a subject, the epitome of academism, was bound, for the vanguard artists Matisse and Picasso, to trigger excess: the muse would have to be seduced, ravished and crushed. The painter will either play a part in the scene, portrayed as a Hellenistic shepherd, faun or satyr, or else may exclude himself, pointing out from his retreat the object of his desire. Thus, it may be suggested that with Picasso and Matisse, the thematic treasure troves of the embrace or the 'sleeping beauties'[4] that haunt their respective work from the onset of the twentieth century are not mere illustrations or cases of biographical sublimation. By studying the way both artists play with the manifest subject, a deeper insight may be had into the significance of the project: the subversion of painting by overcoming what in it is still paying tribute to conventions, interdicts, and to the unthought. *Nymph and Faun* as well as *Figures at the Seashore* stage this symbolism of pictorial practice, whether it be as in the case of Picasso the explicit act of sexual intercourse or, for Matisse, its imminent occurrence. 'There is no difference between art and eroticism', asserts Picasso, thus establishing the reversibility of these two worlds.[5] Matisse insists differently on the sexual springs in all creation: 'The work of art will then appear as fertile and as possessed of the same power to thrill, the same resplendent beauty as we find in the works of nature . . . But is not love the origin of all creation?'[6] These converging statements nevertheless go well beyond the thesis that all artistic activity is necessarily determined by libidinal drives, and invite us to read sexual representation tautologically as the metaphor of painting procedures and their stakes.

'The presence of the model', says Matisse, 'is important not so much as a potential source of information on her shape, but as a means of holding my emotional state in a kind of flirt which issues in rape.'[7] This heuristic relationship of painter to model takes on symbolic form as early as 1907–8 with the triptych *Osthaus*[8] whose central panel depicts a satyr surprising a nymph. This theme, a recurrent one in Matisse's work, originated in antiquity but in his opinion comes to fruition in *La Lutte d'amour* by Cézanne.[9] In 1909, with *Nymph and Satyr* (fig.58)[10] Matisse strips away the conventional disguise to leave the boy in the nude, and the posture of the

woman gives us no way of determining if she is asleep, lying unconscious on the ground or trying to flee. Conversely, in the charcoal *Faun and Nymph* (1935)[11] in which the man substitutes musical charm for assault, the muse, lying on her back, legs bent at the knee, gives herself over to ravishment in the double sense of the term, either abduction or gift of self. The tension of the unspoken, blind act that presided over former works culminates in the shrill vibrating notes of this minstrel. In 1936, *Nymph in the Forest*[12] again adopts the Cézannean composition, in which the couple is framed on the left-hand side by the abacus-cage of tree-trunks. The flesh of the nude shaded off into a dream-like pink contrasts with the scratched and blurred, mobile graph of the musician defined only by his inner flurry. *Nymph and Faun* synthesises the diverse elements at work since 1907 and linearly fuses the members of the two figures. The composite articulation of the bodies says plastically what the motif would hush. With the preparatory experiments for the triptych *Jupiter and Leda* (1944–6),[13] Matisse accomplished the figural mutation of his satyr or faun into an ithyphallic synecdoche: the neck of the swan for the virile body. In these large charcoal drawings of 1935–45, the outsized hands which formed the axis of the 1909 *Nymph and Satyr* close up around a musical instrument. 'Drawing is possession. Each line must correspond to another line which acts as its counterweight, just as one embraces, possesses with both arms.'[14] That man who, captured in his contemplation, then in turn seizes the model, is in fact the painter. Asleep, indifferent, consenting or reluctant, the muse awakens in him that state of fascination which is that of the artist confronting the real, faced with the necessity of abstracting himself out of it.[15] Pictorial activity in process is thus the true subject of the painting: 'a kind of flirt which issues in rape. Rape of whom? Of myself, of a certain tender feeling before the sympathetic object.'[16] Thus does Matisse conjure his fear away: 'I draw quite close to the model, within her – the eyes less than a metre from her and sometimes even knee to knee.'[17] This contact affords Matisse strength, refuge, and leads him to the locus of painting. 'The model is for me a trampoline. A door I must break open to access the garden where I am alone and so well.'[18] In the rarefied theatre of painting, fauns and nymphs relentlessly restage the scene of thwarted desire, violence and deliverance, a scene in which the painter is at once the assailant as well as his prey.

For Picasso, as he himself said, it would be necessary to consider his entire work to convey in all its polysemy the metaphorical interaction of the painter harassing painting, under the interchangeable masks of the satyr, the Minotaur, the god, the warrior, the musketeer, the muse/model or the lovers. This long, meandering iconological thematic coincides in the mid-1920s with the development of a new, completely graphic reinterpretation of the surface of painting. The thick, black, inset line zigzags across the partitioned surface of the painting, creating a mesh pattern to signify the interpenetration of forms. As in an anatomical cross-section, in *The Kiss* of 1925,[19] both the interior and the exterior, stuck end to end, folded back and welded sign to sign, mouth to mouth, display the vivisection of the subjects as well as their representational reduction.

These *Figures at the Seashore* accompany, on the same 12 January 1931, a second painting,[20] which is to be read as a cut-out forming a close-up on the two faces. The clash of squared

off chins and teeth here replaces the sharp teasing of tongues. Thus, from 1925 to 1931, the variations on the amorous encounter underscore the fact that questions of inside/outside, above/below, front/back, questions embodied by the embracing bodies, are a way for Picasso to affirm once again: 'This is all my struggle to break with the two-dimensional aspect of painting.'[21] He adds, more precisely: 'The secret of many of my pictorial distortions – which many people do not understand – is that there is an interaction, an effect the lines of a painting produce upon one another: one line attracts the other, and at the point of maximum attraction, the line curves towards this point and is modified.'[21] To which Matisse responds: 'One must always search for the desire of the line, where it wishes to enter or where to die away.'[22] The tight tense nexus of the two bodies imparts its form to this desire. In the painting, the lines at the summit of the pictorial act run into each other and blend their curves to form a figural torus man/woman evocative of the singular anatomy of a cosmic but nevertheless carnal union. The organic redistribution of members and attributes of the bodies is shattered by the in-the-round treatment and the spatial-temporal allusions in the background which help to 'naturalise' a scene otherwise totally imbued with the sexual/pictorial drive. 'To displace. And put the eyes in the legs. Contradict . . . Nature does a lot of things as I do. Nature hides them. She must be made to confess!'[23] In contrast with the enigmatic and mortuary architecture of the beach huts, these *Figures at the Seashore* are spiralled, compressed, mentally projected by the force of the orgasmic phenomenon. A gestating clay provoking the beholder to 'vibrate, to be moved to create in turn in imagination if not in effective reality'.[24] To accomplish this aim, 'unacceptable images must be created. People must froth', proclaims Picasso. The ravishment, the enraging of the senses must accomplish this perceptual destabilisation, this weakening of the self allowing painting to perform its deciphering and subversion of reality. For 'it is a weird world', insists Picasso, 'a world not in the least reassuring',[25] and one that bears little resemblance to the 'garden' of Matissean felicity.

Leo Steinberg wrote on the subject of Picasso's *Sleepwatchers*, which belong to this same constellation of Picasso's works, 'His upright watchers and reclined sleepers serve him as a means of constantly charting and redefining the ground of his canvas, his paper, or etcher's plate . . . Perpendicular to each other and parallel to the margins, they span and they scale the picture plane, so that horizontal and vertical materialise in ever-new personifications.'[26] These figures locate the basic coordinates of space while they depict the dreamy pondering of the artist at work. The painter is shown watching over the work in progress, contemplating the magic lifting of the veil of signs. Likewise, the tension which, in Matisse, runs from the faun to the nymph would be expressed by the abrupt passage of the vertical to the horizontal. The man arched above the woman is suspended by the viewer's gaze at the very moment of his collapse, forced downward by gravitational force. He embodies the desire of the line, arched and distorting itself 'at the point of maximum attraction'. 'At stake', says Matisse, 'is winning out over vertigo during the flight.'[27] The revolution to which the artist is submitted triggers this fall of Icarus: the break with the real, with conventional rules. Through this passage, the oblique line gives up on the required verticality of the masculine body and is a prelude to the possession of woman's

horizontality, to the possession of painting. Picasso's *Sleeping Nude* should also be examined in the light of these symbolic spatial coordinates. The woman is reclining, half asleep on her folded arms, she is floating, suspended in a maze of charcoaled azure. The artist has taken on the position of the watchman, and although he remains here off stage, we nevertheless discover the languid nude from the vantage of his gaze, caressing each line of the body, and tracking every breath. The charcoal traces the mobile contour of this breathing and the reflex twitching of sleep's postures. This feminine nude *is* horizontality, it forms this organic, matricial and life-giving landscape. It is the imagined expanse of painting in the making. Thus, as early as 1900, Picasso could dare depict himself draped in semi-nudity, as a male odalisque, in a self-portrait that he entitled *The Muse*.[28] He was already to formulate the Gemini twin relationship linking the painter to painting and which would allow him to claim, contrary to all expectations: 'I am a woman.'[29]

AB

PABLO PICASSO
109 *Sleeping Nude* 1932
Nu endormi
Charcoal and oil on canvas
130 x 162 (51⅛ x 63¾)
Private Collection

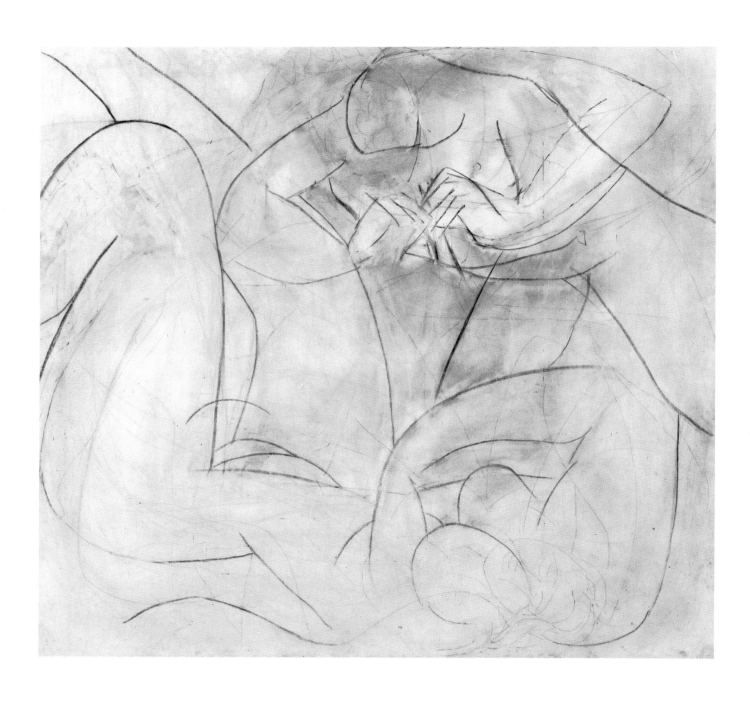

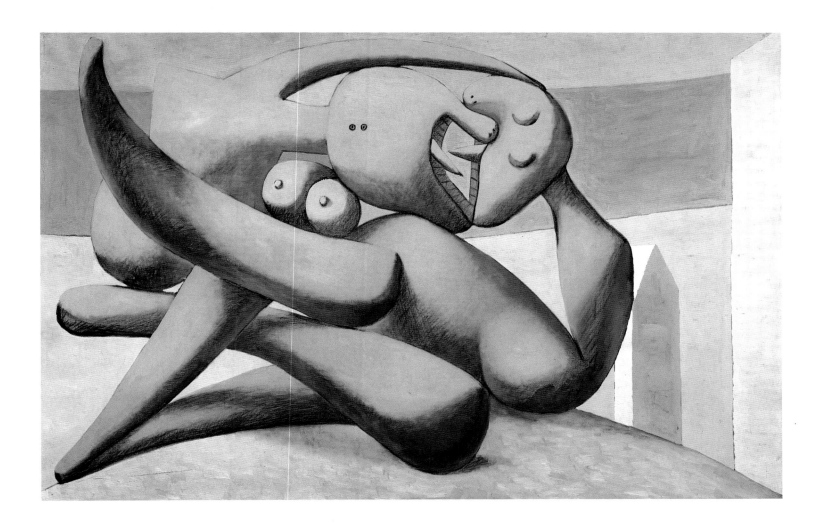

HENRI MATISSE

110 *Nymph and Faun* 1940–3

Nymphe et faune

Charcoal on canvas 154 x 167 (60⅝ x 65¾)

Centre Georges Pompidou, Paris

Musée National d'Art Moderne/Centre de

Création Industrielle. Dation en 1991

PABLO PICASSO

111 *Figures at the Seashore* 1931

Figures au bord de la mer

Oil on canvas 130 x 196 (51⅛ x 77⅛)

Musée Picasso, Paris

23

The celebrity of Matisse's *Decorative Figure on an Ornamental Ground* dates from the moment it was first exhibited in June 1926 at the Salon des Tuileries. Critics at the time were sharply divided, some thrilled by the flamboyant display of colour and pattern, the startling geometry of the figure and the youthful intransigence of the middle-aged painter (see fig.94),[1] others scandalised by the absence of the charm, discretion and naturalism which had made his earlier 'odalisques' popular in the conservative climate of the post-war period. Picasso cannot have missed either the painting or the controversy it aroused.

Like most of Matisse's figure paintings of the period, *Decorative Figure* was modelled by Henriette Darricarrère, although in its definitive state the nude is so generalised and impersonal that it bears little, if any, resemblance to her. Contemporary photographs reveal that Matisse's studio at 1, place Charles-Félix in Nice was equipped with a raised wooden stage and tall demountable wooden frames on which textiles and so forth could be tacked.[2] With these simple devices and his large collection of patterned fabrics and carpets, exotic garments and accessories, he constantly set himself new compositional challenges and contrived theatrical settings for Henriette, a natural performer who thrived on acting out different characters, from indolent odalisque to chic bourgeoise. For *Decorative Figure* Matisse decked the stage with a Persian carpet and a striped runner and stretched a gaudy, Rococo-style fabric across the framework.[3] The irregularities in the pattern of the backdrop and the puzzling architectural relationship between it and the rectangular floor may seem arbitrary, but are in fact a relatively faithful record of the visual effect of stretched and falling drapery. (Similar effects are captured in a humorous photograph of Pierre Bonnard reclining odalisque-style on the stage in front of a different Rococo-style material.)[4] To mitigate the aggressive stridency of the fabric and clarify the pictorial space, Matisse encircled the figure with the fancy Venetian mirror and Chinese jardinière, the bowl of lemons and what is probably a patterned cushion, thus enhancing her austere, hieratic character. The final composition is testimony to his admiration for Persian miniatures (see fig.6), although he totally renounced their exquisite delicacy and refinement.

In painting his make-believe harem scenes – nothing could be less authentic than the heteroclite mix of fabrics, costumes, furniture and bric-à-brac – Matisse sought to personalise and modernise the hackneyed Orientalist subjects which had first come into vogue during the Romantic period. Delacroix's sumptuous *Women of Algiers* (fig.76) was of paramount importance to this enterprise and in the sum total of the Nice odalisque paintings numerous echoes of it can be heard, particularly in those where the model is dressed in Moorish costume. In his apartment on place Charles-Félix Matisse had two studios connected by an internal door, which he kept open but festooned with a heavy, pulled-back curtain. The general effect created by the

patterned wallpaper, textiles, screens and furniture is so reminiscent of the interior in *Women of Algiers* that he must have planned it to be so. *Decorative Figure* is very far from being a pastiche of *Women of Algiers*, but the diagonal arrangement of the Persian carpet, striped runner and flowery cushion, and the Venetian mirror, which is so like the mirror in the background of Delacroix's harem, are inescapable allusions.[5] The billowing white drapery shot with emerald green reflections, which supplies the feminine curves and softness the nude herself completely lacks, is, moreover, Matisse's homage to the nacreous, translucent blouses of Delacroix's Algerian beauties. Picasso understood and sympathised fully with this creative dialogue with Delacroix, and told Roland Penrose that his set of variations after *Women of Algiers* (nos.178–80) was, simultaneously, a tribute to the odalisques of Matisse.[6]

Turning on what Pierre Schneider has described as a 'head-on collision' between the Eastern, ornamental background and the Western, three-dimensional figure,[7] *Decorative Figure* reflects Matisse's current preoccupation with sculpture – his own and that of others. One work which may have encouraged him to substitute a highly conceptualised pose for the simpler, more relaxed pose recorded in the preparatory drawing,[8] is the monumental statue by Maillol now known as *The Mediterranean*, which as Maillol himself pointed out 'is enclosed in a perfect square'.[9] Matisse knew this sculpture intimately, having helped Maillol make the plaster cast prior to its triumphant appearance at the Salon d'Automne of 1905.[10] The two artists became lifelong friends and although Matisse later insisted that 'Maillol's sculpture and my work in that line have nothing in common',[11] in a collection of 'Hommages' published in 1925 he warmly praised Maillol as 'the true aristocrat and our greatest sculptor . . . without the least fuss'.[12] The following February, when he was still at work on *Decorative Figure*, he urged his sculptor-son Jean to follow Maillol's example and 'draw from the antique, where you'd find form in all its fullness and three-dimensionality'.[13]

Decorative Figure and *Large Seated Nude* are closely related and scholars now believe that Matisse began work on both during the autumn of 1925, although the sculpture was not completed until 1929.[14] The distinctive stretching, rocking pose of *Large Seated Nude* originated in paintings and lithographs (fig.60) of Henriette straddling a draped armchair, and studio photographs datable to the spring of 1926 reveal that the clay figure still retained a residual sense of voluptuous sprawling at that point and that the forms of the body were full, rounded and smooth in the manner of Maillol.[15] By rejecting Maillolesque classicism – using a knife, for example, to accentuate the angles of the bent arms, slice off the fullness of the hips and thighs, cut into the waist and facet the torso – Matisse opted for a brutal, rugged, more masculine effect, and in doing so reverted to the experimental style of earlier sculptures such as *Jeannette V* (no.142) and *Back III* (no.105), which reveal his engagement with Analytic Cubism.

In its final athletic incarnation, *Large Seated Nude* is noticeably closer to Michelangelo's sculptures of *Dawn* and *Night*, which Matisse had drawn intensively from the casts in the Ecole des Arts Décoratifs in Nice, hoping, as he wrote in a letter to Camoin of 10 April 1918, 'to instill in myself the clear and complex conception of Michelangelo's construction.'[16] The lessons of Michelangelo also left their trace on *Decorative Figure*, for the square shoulders and taut, powerful

muscles of the stomach are reminiscent of the *Lorenzo de' Medici* statue, and the visible pentimenti suggest that these mannish attributes were introduced at a late stage to enhance the nude's monumentality. On the other hand there is no sign in the painting of the Michelangelesque swivelling movement which is so essential to the tension and drama of *Large Seated Nude*.

At one level Picasso's *Woman in an Armchair* of January 1927 was an act of pure travesty: a monstrous female of indeterminate, primeval species in place of the iconic beautiful female nude. That Matisse's odalisques were in Picasso's sights is implied by the decorative fabric of the chair, which is strikingly similar to the material draped over the armchair in the lithographs of Henriette (fig.60).[17] But far from providing luxurious enrichment, the austere *grisaille* of the chair, in alliance with the dark blood-red 'shadows', creates an ominous mood: the sleeper's dream may be a nightmare and she screaming in terror, not snoring peacefully. Instead of the sunlight intensifying the colours and expanding the space in Matisse's Nice interiors, the walls of the room press sharply inwards and even the patches of harsh white light cast over the body suggest a sudden, potentially hostile intrusion: the grotesque creature with her man-trap jaws is as much victim as aggressor. Indeed, the entire set-up of the painting is like a satire on Matisse's 'dream' of producing 'a soothing, calming influence on the mind, something like a good armchair which provides relaxation from physical fatigue.'[18]

In the awesome *Large Nude in a Red Armchair* of May 1929, the voluptuous pose, patterned wallpaper and, on this occasion, strong colour suggest Matisse was still the specific focus for Picasso's travesty.[19] The association of the gilded mirror with the skull-like head and sagging, shriveling body points to a pitiless *vanitas* message reminiscent of Goya's satirical paintings and etchings of decrepit courtesans. No doubt Picasso took Matisse's odalisques to be an affirmation of sensual beauty and pleasure, and in comparison *Large Nude* reeks of sterility and death. A few days after completing it, he spoke 'of the burlesque and its equivalence to the marvellous' with Michel Leiris, who had recently joined the group of 'dissident' Surrealists led by that implacable opponent of idealism, Georges Bataille. In his diary entry for 11 May 1929 Leiris comments: 'These days it has become impossible to make a thing pass for ugly or repulsive. Even shit is pretty.'[20] In *Large Nude* Picasso succeeded in making the archetype of beauty supremely 'ugly' and 'repulsive', and used gross, comic parody rather than the fantastic imagery of dreams to attain 'the marvellous'.

Woman in an Armchair and *Large Nude in a Red Armchair* ape the biomorphic style of 'automatic' drawing promoted by André Breton in the early years of the Surrealist movement. In *Large Nude* the effect is acutely ironic because the supposedly compulsive, untrammeled line gropes and stutters its way round the body of the nude, as if the painter were struggling to drag the caked and loaded brush. Both paintings reflect the Surrealists' identification with the 'primitive' art of the South Seas: in the case of *Woman in an Armchair*, the mysterious ideograms incised on wooden tablets from Easter Island, which were believed to be the hieroglyphs of an extinct picture-writing (fig.75), and in the case of *Large Nude*, the savage-looking figural art of the Sepik River area of New Guinea.[21] Another source which fascinated the Surrealists may also be operative because in both pictures the gaping figure with her flung-back head recalls the writhing,

screaming hysterics studied by Charcot in the Salpêtrière hospital and photographed by his collaborator Paul Régnard.[22] The diametrical opposition between pure irrationality of being and the orderly bourgeois interior, like the opposition between the 'madness' of the depicted figures and Picasso's obvious control of the means of expression, neatly mirrors the binary oppositions defined by Breton as the gateway to surreality in the Manifestos of 1924 and 1929. By contrast, Matisse's commitment to an 'art of balance, purity and serenity, devoid of troubling or depressing subject matter'[23] precluded any contact with Surrealism.

Like Matisse, Picasso was active as a sculptor in the late 1920s. Under intense pressure to complete the monument for Guillaume Apollinaire's tomb by November 1928, the tenth anniversary of the poet's death, he filled sketchbook after sketchbook with an extraordinary range of sculptural projects, some of them purely fantastic, others realisable only with the expert help of the Catalan metalworker Julio González. The symbiotic relationship between his painting and sculpture emerges clearly when *Woman in an Armchair* is compared with the small plaster maquettes of grotesque, bulbous female figures, which represented one of his first proposals for the monument.[24] Although Picasso developed the design for these works in volumetric drawings executed in Cannes during his summer holidays in 1927, certain details were transposed more or less unaltered from *Woman in an Armchair*, notably the upturned nose and gaping mouth, the contrasting breasts, one treated as a flat graphic sign, the other as a swollen, projecting form, and the contrasting legs, one elephantine, the other relatively slim.

In *Seated Woman* Picasso created the sculptural equivalent to the exactly contemporary *Large Nude in a Red Armchair*. In doing so he took up the challenge of devising a troubling, surreal alternative to the touching realist sculptures on domestic themes, which had become popular during the nineteenth century through the work of Jules Dalou and others. This, rather than caution, explains the sculpture's modest scale, for it was not a maquette for the Apollinaire monument. Picasso's technique in *Seated Woman* is shamelessly crude (as it is in *Large Nude in a Red Armchair*), and the whole surface displays the marks of his palms and fingers. The first preparatory drawings for the sculpture suggest that initially he intended a more radical separation between the component parts because the body is represented as an assemblage of discrete bone-like units balanced against one another and held in place by the armchair. Only the last drawing registers his decision to unify the figure by modelling across the divisions, as in the completed sculpture.[25]

Picasso did not, however, abandon this novel idea for a hybrid type of sculpture combining modelling with assemblage, and several pieces created in his new studios in the Château de Boisgeloup in 1931 take this form, notably *Head of a Woman* (no.143). In *Reclining Bather*, which was originally modelled in plaster, he created a flat base to support the separate, interlocking parts. (They are welded together in the bronze cast.) The relationship to both *Large Nude in a Red Armchair* and *Seated Nude* is clear, although with her burgeoning, tuber-like forms the sprawling bather symbolically evokes youthful vitality, rather than the spectre of death and decay. The striking similarities with the bending, elongated, plant-like forms of Matisse's *La Serpentine* of 1909 (no.18) are almost certainly not fortuitous because Picasso had recently seen *La*

Serpentine in Matisse's sculpture exhibition at the Galerie Pierre in June to July 1930.[26] Other sculptures made in Boisgeloup confirm that Picasso was impressed and stimulated by the revelation of Matisse's originality as a sculptor, although he consistently developed the metaphoric and symbolic dimension of his figurative imagery to a degree Matisse never attempted. The stage was set for the gradual rapprochement of the two 'painter-sculptors', who had ceased to see each other when Matisse settled in the south of France.

EC

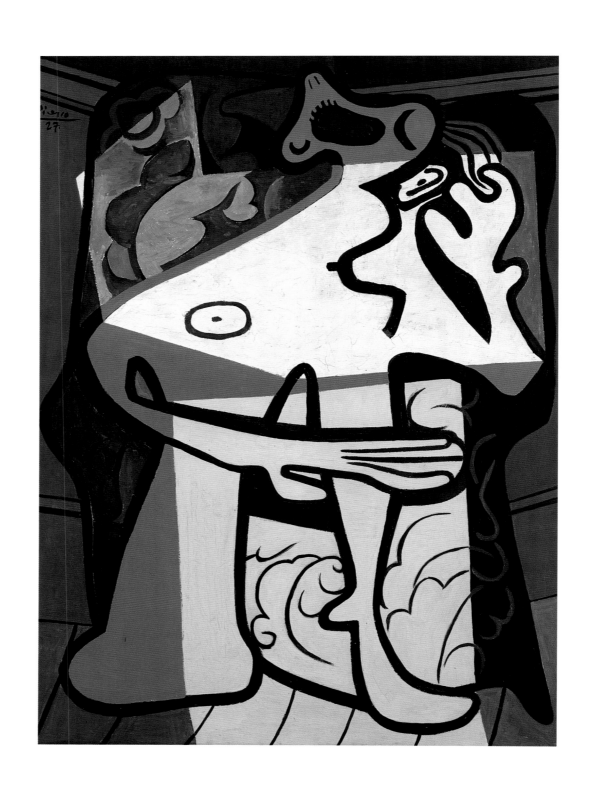

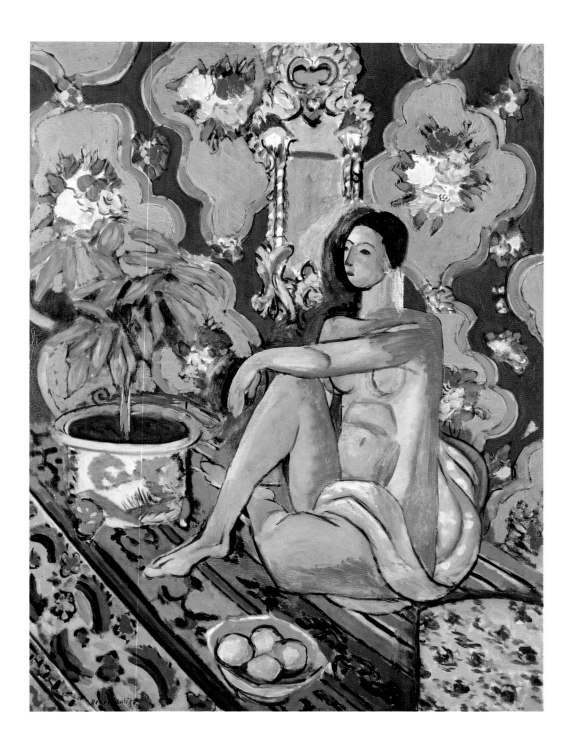

PABLO PICASSO

112 *Woman in an Armchair* 1927

Femme dans un fauteuil

Oil on canvas

130.5 x 97.2 (51⅛ x 38¼)

The Solinger Collection

HENRI MATISSE

113 *Decorative Figure on an Ornamental Background* 1925–6

Figure décorative sur fond ornemental

Oil on canvas 130 x 98 (51⅛ x 38⅜)

Centre Georges Pompidou, Paris. Musée National d'Art

Moderne/Centre de Création Industrielle.

Achat à l'artiste en 1938. Fonds national d'art contemporain

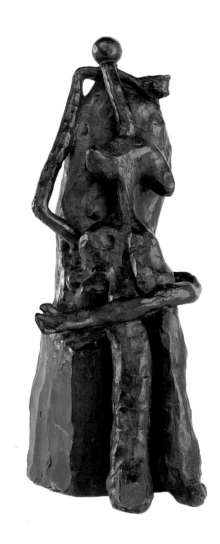

PABLO PICASSO

114 *Seated Woman* 1929

Femme assise

Bronze 42 x 16.5 x 25 (16¼ x 6½ x 9⅞)

Musée Picasso, Paris

PABLO PICASSO

115 *Large Nude in a Red Armchair* 1929

Grand nu dans un fauteuil rouge

Oil on canvas 195 x 130 (76¾ x 51¼)

Musée Picasso, Paris

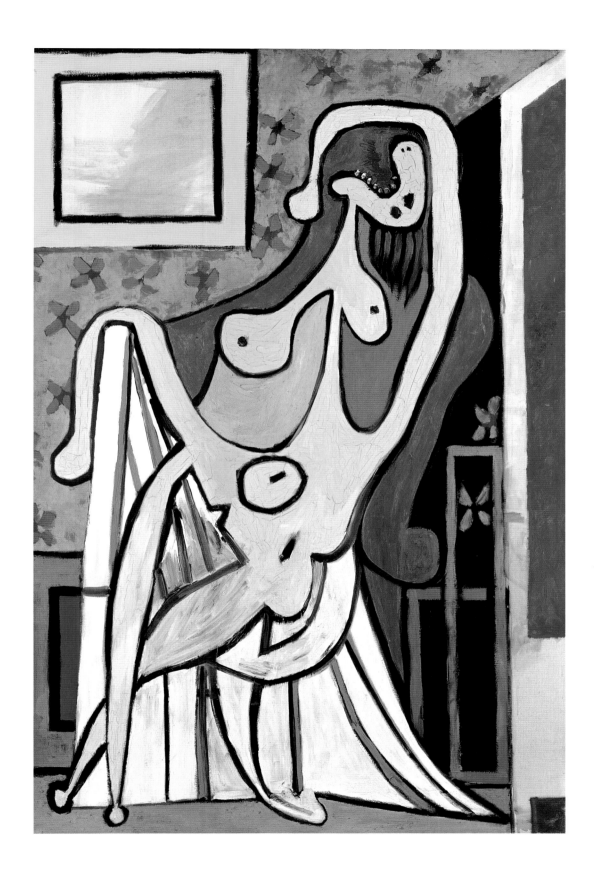

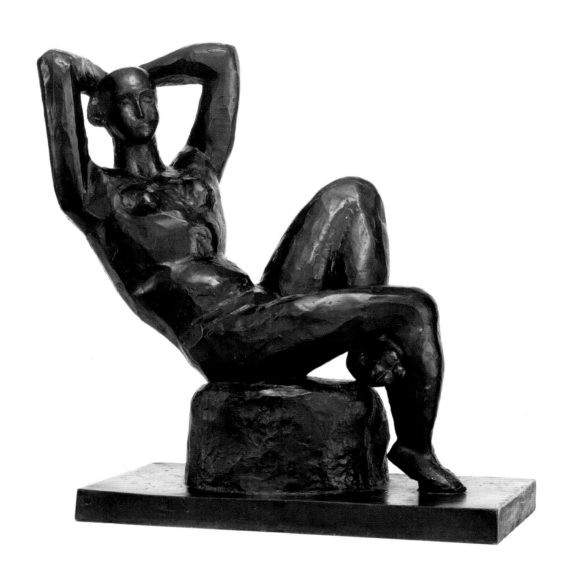

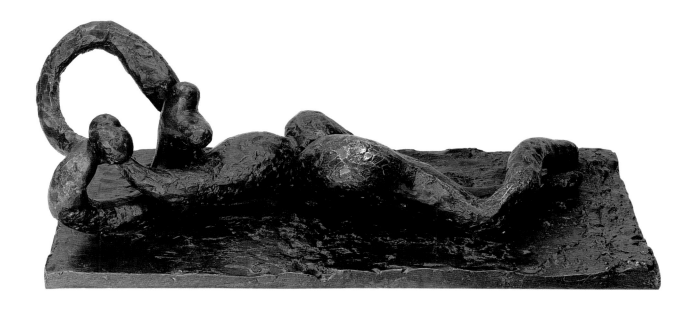

HENRI MATISSE
116 *Large Seated Nude* 1925–9
Grand Nu assis
Bronze 79.4 x 77.5 x 34.9 (31¼ x 30½ x 13¾)
The Museum of Modern Art, New York.
Gift of Mr and Mrs Walter Hochschild (by exchange)

PABLO PICASSO
117 *Reclining Bather* 1931
Baigneuse allongée
Bronze 23 x 72 x 31 (9 x 28⅜ x 12¼)
Musée Picasso, Paris

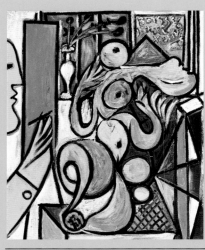

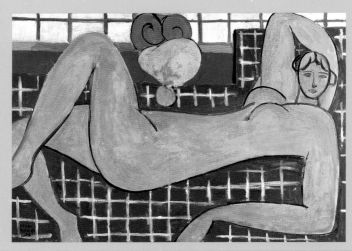

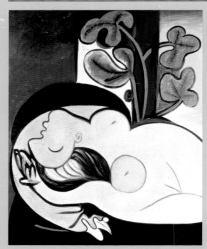

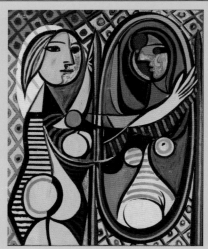

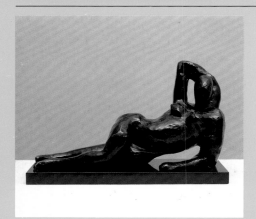

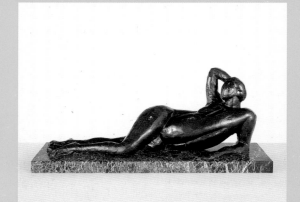

24

On rare occasions, a derivative work will transform its source so memorably that, henceforward, the source will tend to be seen through its derivation, as if an artist is being imitated by his ancestors.[1] Picasso's Matissean paintings of the early 1930s are even more unusual in that they resemble not only earlier paintings by Matisse but, especially, the paintings that Matisse would make in response to them. It is as if, by a preemptive correction of their actual sources, they anticipated the origins from which they derived, which subsequently would derive from them – so proleptic was their capture and restaging of the Matissean.[2]

In 1931, 'Matissean' popularly meant colour and bright light, pattern, plump pink flesh, and a hedonistic, often erotic ambience that deliberately confused Nice with the proche-Orient. For Picasso, it also certainly meant Matisse's deceptively audacious revision of that identity, in progress for the past five years or so, as well as the crisper, flatter origins of the Nice style, now some twenty years in the past. Picasso's *Acrobat* paintings of 1929–30 (see no.167) had reprised that past approach, stirring recollections in Matisse's own mind, perhaps, as he began work on a mural commission for the Barnes Foundation. But the more conservative paintings of the early 1920s dominated Matisse's big June–July 1931 exhibition at the Galeries Georges Petit in Paris, seemingly showing him creating the old from the new, instead of vice-versa.[3] Still, there were some extraordinary earlier and recent paintings, which must especially have attracted Picasso's attention. They included paintings which offer three examples of how Picasso can be thought to have taken possession of Matisse's past and re-presented it as Matisse's future. Firstly, Matisse's *Blue Nude*, 1907 (no.14): in 1934, Picasso made a reprise of this painting in pink, *Nude in a Landscape* (fig.61), repeating the oasis-like setting and use of a tint of the body colour for the area beneath it.[4] Secondly, *The Painter in his Studio*, 1916 (fig.79), and its anniversary pendant, the *Decorative Figure on an Ornamental Ground*, 1925–6 (no.113): Picasso's *Nude in a Black Armchair* of 1932 conflates the black-banded interior of the former with the woman with/as plant theme of the latter. Thirdly, *Apples*, 1916 (fig.62); and *Woman with a Veil* (no.124) and *Reclining Nude seen from the Back* (fig.63), both 1927: Picasso's *The Mirror* of 1932 (fig.80a) treats a Matissean subject, familiar from early Nice paintings, with the bold circular motif of *Apples*; recasts the diamond-patterning of the costume in *Woman with a Veil* as wallpaper; and echoes the buttocks and upper leg of *Reclining Nude seen from the Back* in the reflection in the mirror.[5] And Picasso's *Girl Before a Mirror* of 1932, his greatest painting of this period, may be thought to draw upon these, and virtually all the aforementioned Matissean sources, to offer an object lesson on the depth of psychological complexity possible within a so-called decorative style.

Picasso's paintings, however, did not *require* these particular sources; comparable motifs 233

may be found in Picasso's own earlier work, being in the form-and-image-bank of early modernism. Neither do Picasso's paintings offer themselves as appropriations; if the association with Matisse is recognised, so must be the implicit criticism of the existing Matissean way. The crude form-and-image matches are useful precisely because they tell us that Picasso was not simply stealing from Matisse. Rather, he was discovering pre-existing contact points between his and Matisse's art, turning them to his favour, and thus denying to Matisse, both retrospectively and prospectively, possession of the common ground – indeed, of ground that Matisse had reason to assume was his own.

We have to wonder what was Picasso's motivation for such antagonistic behaviour.[6] To characterise his behaviour thus runs counter to, but is not incompatible with, the motivation commonly ascribed to the creation of these paintings. It, or rather she, is Marie-Thérèse Walter, the voluptuous blonde teenager who had become Picasso's new lover. In order to describe her appeal to him as, in William Rubin's memorable words, 'a kind of squishy sexual toy',[7] what better could he do than take the pillowy nudes of Matisse's Nice paintings, repudiate their domesticated eroticism, and modernise them with the help of the more daring Matisse works. In fact, more than that was at stake. To take possession of the Matissean not only put Matisse in danger; it was also dangerous to Picasso. For all the give-and-take between the two artists, Picasso had never before so thoroughly taken on Matisse's manner. Matisse, in his great works of the teens, had adopted Picasso's manner, and a modernist critic of Matisse's 1931 exhibition had said that these, his most innovative works revealed his indebtedness to Picasso.[8] To take possession is also to confess to indebtedness. Picasso's relationships with women had taught him to disregard that difficult lesson; in painting, that just wasn't an option, even for the most ruthless artist. So, why did Picasso place himself at such a disadvantage?

Nude in a Black Armchair, *The Mirror* and *Girl Before a Mirror* were painted in a five-day period in March 1932: on Friday 9, Monday 12 and Wednesday 14 respectively. They address a long-deferred issue that goes back fifteen years, when both artists stepped aside from their modernism to engage in conservative idioms. In Picasso's case, continuing extrapolations from Synthetic Cubism began to be accompanied by other styles, which sometimes merged with the parent style, which were invariably influenced by it, but which often formed a counterpoint to it. Usually, one style dominated. To put this at its simplest, from the mid-teens to the mid-1920s, neoclassicism dominated, then Surrealism, then, at the end of 1931, came the Matissean style.[9]

Picasso had discovered Marie-Thérèse Walter at the end of the neoclassical period; indeed, she may be thought to have ended it. She is frequently described as having extraordinary classical features; Picasso thus found in reality the very type he had been painting.[10] In order to create the clear, volumetric forms of a neoclassical style, he had to abandon the Cubist disengagement of descriptive contours from descriptive areas of colour. Instead, he would place contours at the perimeters of (tonally modelled) colour areas in order to mark the occluding edges of a figure contrasted to a ground. And, regularly, he chafed against this approach. The number of independent line drawings, paintings with contours like wires, and incompletely coloured paintings, shows that the fusion of colour and contour bothered Picasso about as much as it delighted

Matisse. Thus, the 'Surrealist' period began with an explosion of linearity freed from circumscription, and, except for single images in mono-spatial settings, maintained a Cubist division of colour and contour. By 1929, however, single images increasing in number, Picasso had rejoined colour and contour in the aforementioned *Acrobats*, to form circumscribed, figure-on-ground images in a Matissean way.[11] However, this was a short-lived, not quite satisfactory moment. Volume returned, and with it a sort of Surrealistic recasting of the earlier neoclassical compositions. Then came the great Boisgeloup sculptures of Picasso's neoclassical lover (nos.143–4, 147–8), which call simultaneously on the Surrealism and the neoclassicism that preceded them – and on the Matissean, thus opening onto the 'Matissean' paintings of 1932, which also, in fact, conflate these three stylistic systems.

When, during the 1920s, Picasso used a separated contour-colour system, the colour would usually take the form of flat planes, abutted or overlaid to create perceptual depth, in independent counterpoint to which contours were set down to specify a figurative description. Separating the agents of spatialisation and figuration built an uncertainty into the perceptual performance, which added an enriching variety to the effect. In contrast, when Picasso united contour and colour, using outlined colour areas, the ambiguities of a dual system were denied him, since the forms thus created were simultaneously agents of spatialisation and figuration. The quality of the effect therefore depended far more on the image type itself. The classical tradition and a fertile imagination were both great sources of evocative imagery. And yet, the contours that shape it appear at times almost to connote an imprisonment, so anxiously outlined is the imagery, whether ancient or modern. There was, of course, the option that colour and contour together could be mobilised as agents of spatialisation, but that took Picasso right into the territory of Matisse. Still, where else except in the Matissean could Picasso find a liberating example of colour and contour joined, which might unite the neoclassical and the Surrealist, liberating them? In fact, Picasso would find more.

In the later 1920s, Matisse had been working hard on relearning how to deliver a commanding visual effect *au premier coup d'oeil*, a first, affective, luminous hit of colour.[12] He often did this, and Picasso followed him, by putting colour into light. In *Nude in a Black Armchair, The Mirror* and *Girl Before a Mirror*, the colour of the woman's body is thus lightened further by the judicious use of one or more of the following devices: by the use of massive black accents and saturated or patterned backgrounds; by modelling the areas of light not by darkening their hues, but by further lightening them or by reinforcing their contours with strands of prismatic colour; and by adjusting the surrounding hues as echoes, complements, or extensions of the body in light.[13]

In the later 1920s, as earlier, Matisse also used the optical dazzle of vividly contrasted colours to deflect visual attention from, and defer perception of, the principal figural motif.[14] Picasso quickly picked up on this, using colour in a far more electric, dissonant, and uniformly intense manner than Matisse allowed himself. Hence, in *Girl Before a Mirror*, the patterning changes hue from section to section of the composition. It may be said to reinforce, and to help realise, the theme of change which this painting of a visual, temporal, biological, sexual and

emotional transformation unfolds.[15] The mirror that focuses this theme is itself, of course, a familiar Matissean motif. However, the blatant division of the painting into what may be interpreted as two hinged panels is unthinkable in a painting by Matisse – until after he had seen Picasso's *Girl Before a Mirror*.

Picasso also used colour for its iconography, to code a situation of desire, in a way that Matisse would have found over-literal. Hence, the famous violet-yellow pairing for Marie-Thérèse Walter. Violet, being given by wavelengths at the very bottom of the spectrum, connotes the nocturnal; yellow, being given at the very centre, connotes sunlight. Yellow is also the colour of her hair; the complementary violet can serve for her flesh. And hence its reinforcement by a red-green pairing. (Red is given at the very opposite end of the spectrum to violet. Green is given next to yellow on the side nearer to violet. Green is also the colour of fecundity; the complementary red can serve for passion.)[16] However, Picasso did also learn from Matisse to use adjacent colours to his complementaries to unlock them and mobilise the colour movement; hence the heavy dose of blue in both *Nude in a Black Armchair* and *The Mirror*. As for the black that swathes these figures, especially in the former painting, Picasso said: 'if you see nothing you use black.'[17] This area of the unseen recalls, by way of a similar blanket of darker colour above the reclining nudes of *Le Bonheur de vivre* (fig.2), images in earlier art of cloaks lifted and, within their darkness, nymphs revealed.[18]

The serpentine drawing of these works is also, of course, reminiscent of the Matisse of *Le Bonheur de vivre,* to which their absorptive theme, and its association with both mythology and natural fertility, also relates. But Picasso's paintings also draw upon the ambiguous and often eroticised biomorphism of Arp, Miró, Tanguy, and even Dalí. As many commentators point out, the artist seems to imagine his lover as a buoyant but slippery sea creature, polymorphously sexual.[19] The principal articulating marks on the body are signs for or of sexual arousal, not only breasts, buttocks and vulva, but also anus-like ear, fingers curling like flippers, and profiles that double in perceptual reversal and kiss.

A later painting by Picasso of Marie-Thérèse Walter, *The Painter* of 13 May 1934, compares a biomorphic creature on a pedestal with a vase of flowers – a familiar Matissean *femme-fleur* juxtaposition – and, more surprisingly, with a view of nature seen through a window, which writhes in accompaniment, writing the place, date and artist of its creation.[20] Whereas, in *Girl Before a Mirror*, the model confronts her own sexuality, now, as John Golding has observed, her sexuality is laid out as a sacrifice to the artist's gifts.[21] In forming the shape of the victim, Picasso looks back to the figure of Mary Magdalene in his own Crucifixion studies;[22] a disturbing association for the artist to have made. It suggests a colder, more analytical stance towards the model on Picasso's part, for all the passion of the pose. This may well have caught Matisse's attention.[23] In any event, his own Pink Nude will begin to writhe in position, dispassionately observed, almost exactly a year later.

The ultimate source for these invertebrate bodies by Picasso is Ingres, to whose neoclassicism Picasso thus returns via Matisse and Surrealism. Earlier, the incompatibility of neoclassicism and the separated colour-contour system of Cubism had taught Picasso that neolassicism

236

was an enemy of stylistic innovation, negating the right to be at war with tradition.[24] His discovery of Marie-Thérèse Walter was of a new, contemporary version of the neoclassical, not cold and staid but sexual and youthful, a type for which the apposite pictorial vocabulary was not found until the end of 1931. That year had opened with *Cahiers d'Art* comparing the *Blue Nude* (no.14) and *Les Demoiselles d'Avignon* (no.7) in an article on 'Jeunesse'. Then, in the summer, came Matisse's exhibition, revealing both his decline in the 1920s and his recent signs of recovery. And then, in October, Picasso turned fifty. Youth and age, innovation and tradition, are overdetermined motivations for Picasso, summoning up in his art, from its past, a neoclassical ideal to be renewed in a sexually charged version that might symbolise his own artistic fecundity.[25] The specific art-historical source, the blonde odalisque of Ingres's *Odalisque and Slave* (fig.64), iconographically proclaimed synaesthetic pleasure, only to withdraw into a cold shell.[26] Matisse's odalisques, although aloof, uncovered a promise of passion in their coolness. When, in 1932, Picasso exhibited his far sexier ones, in his retrospective exhibition at the Galeries Georges Petit on the anniversary of Matisse's exhibition, he somewhat backhandedly acknowledged his rival's help by crediting him with his own calorific personality:

In the end, everything depends on one's self, on a fire in the belly with a thousand rays. Nothing else counts. That is why, for example, Matisse is Matisse: the only reason. He's got the sun in his gut. And that is why, too, from time to time, there are some pretty good things.[27]

As for new things, though, there had not been many to see at all. In 1932, Matisse was still hard at work in secret on his commission for the Barnes Foundation, and did not return to easel painting until the 1934–5 season. But when he did, it was to work with a new, young, blonde model, Lydia Delectorskaya. The comparison with Marie-Thérèse Walter is inescapable,[28] and the most important of Matisse's early paintings of his new model, the so-called *Pink Nude* (no.119), unquestionably was affected by his consciousness of Picasso's paintings of his. It is one of the first of Matisse's graphically flat, sensual paintings of the mid and later 1930s that Picasso's 1932 paintings resemble. Although its style is associable with that of the Barnes murals and its subject with many Nice paintings of the 1920s, it still may be said that Matisse's recovery of this focus of his art was helped by Picasso's example.

The *Pink Nude* was begun, on 3 May 1935 (fig.65), with a very different focus, however, as we can tell because the artist had photographs made of the stages through which his painting passed.[29] It began by taking on perhaps the most important of Picasso's artistic challenges, namely, in Leo Steinberg's words, 'to possess the delineated form in a simultaneity of all aspects', which had come to mean, in his recent paintings, 'make recto and verso cohabit in the same contoured shape.'[30] Thus, Matisse's painting began as a tight view onto an interior, a chair with flowers in the background, and, close-up to the viewer, a reclining nude on a chaise longue who looks back at the viewer, returning his gaze, and whose body is turned provocatively to show her buttocks as well as her face and breasts. A simultaneity of aspects is offered, but very clumsily. Matisse is realising how difficult Picasso territory can be.

Matisse may well have chosen to enter that territory by way of a Picasso that emulated the 237

flatness of a Matisse, namely *Three Bathers* of 1920 (fig.66) that was in Picasso's exhibition of 1932. This is suggested by both the pose of Matisse's figure and how he tipped it up to the surface as it developed.[31] Doing this propelled his painting into a multiplicity of changes, the body rolling, twisting, pulling apart, and recombining in its serial depictions. No solution seemed quite satisfactory, but the themes began pictorially to unfold. It had become Matisse's practice to paint only in the mornings, then work in other mediums, especially drawing, in the afternoon.[32] Among the drawings, in Spring 1935, were some of a nymph surprised by a faun or satyr, in one of which a satyr leans right over the nymph, his aggressively phallic pipes and his genitals falling just where the still life cluster is in the *Pink Nude* (fig.67). By then, Matisse was using cut-and-pinned paper to help him plan alterations to his painting. The morning he made that drawing, he had transformed the still life into a collage decal (fig.68), and his drawing explains its meaning: as a male presence above and beyond the female body, akin to one of the 'functioning doubles' that Picasso would use to observe the obverse of the body.[33] That connotation would remain in the completed composition.

After eleven recorded states and two months' work, Matisse set his painting aside, still dissatisfied. Two months later, on 20 August, he returned to it with a tremendous infusion of energy and in direct competition to Picasso. First, in emulation of the confrontational in Picasso, he lifted the model's head to an upright position that returns and challenges the viewer's gaze. Second, he replaced the figure of the model with a new one cut from paper to cover the old, and he drew the new bodily contour inside the cut edges of the paper, effecting a separation of contour and colour area associable with Cubist art. In thus borrowing from Picasso, however, Matisse surrendered the rotational theme that began his painting and, instead, imagined the body as comprising two parallel planes – a near plane joining the left leg and left arm, and a far plane joining the right leg and right arm – and imagined these planes as transparently superimposed on the torso. Instead of trying to combine recto and verso within the same contour, he had conceived of the near and far masses of the body as simultaneously present in a planar surface, an effect rather like that caused when a body is pressed close-up to a mirror – an effect rehearsed in the hinged composition of Picasso's *Girl Before a Mirror*.

Matisse knew Picasso's *Girl Before a Mirror* and other 1932 mirror-theme paintings – and also the new ones Picasso had made early in 1935, both sets of which made reference to his own earlier works.[34] Early in 1935, he himself had taken up the theme.[35] It did not require Picasso to direct him to do so, except perhaps to guard his own territory. What is more interesting about Picasso's early 1935 mirror-theme paintings is that they make reference to Matisse's Moroccan paintings of 1912–13 – the *Pink Nude* at its Cubist-influenced mirror stage begins to develop affinities to Matisse's own great 'Cubist' Moroccan painting, *The Moroccans* of 1915–16 (no.72). Henceforward, the figure will gradually settle itself as a bold, stately composition, whose articulation of a partly gridded ground demanded as much attention as its evocation of carnal availability. The painting finally was finished on 30 October, when both demands were satisfied as one. Thus, in the final, twenty-second state, the aforementioned effect of two overlaid planes remains, but the separation of near and far planes is now expressed only to be qualified. The far

right leg not only connects to the far right arm, but also to the near left arm, to form a big bridging shape across the composition. And the near left leg not only connects to the near left arm, but also to the far right arm, to form an echoing pair of narrow ogee arches each side of the composition. The effect is frankly bizarre, for it makes the nude seem bilaterally symmetrical along her length.[36] Matisse has not surrendered the original desire for an erotic simultaneity of aspects after all. But he offers, instead of a rotating body, a reversible body. The painting evokes not a body rolling over, but a body capable of revolving, of turning around lengthwise – pivoting on the still life, perhaps – and still occupying roughly the same position. What the body would then look like is difficult to visualise; yet the pose is imminent with change. And Matisse maintains the instability of the bodily image by making it difficult for us actually to see it. The flowers on the chair, now shaped into a seedpod parachuted over the figure, serve to attract and to dazzle vision in the flash of yellow light that they create against their vivid red ground. In the blink of distraction, it is impossible to see what position the figure might have assumed.

The *Pink Nude* has the same crucial status in Matisse's art as Picasso's 1932 Matissean paintings have in his. In both, these artists confront the memory of their recent, conservative past and push through it to the future. That past had been inimical to innovation, but, rather, sanctioned the repetition of past, classical idioms. The serial development of the *Pink Nude* reinforces how repetition itself – mutual reiteration; recurring themes; repetitions of desire – became, for both artists, the means of its own overcoming.

JE

PABLO PICASSO
118 *The Painter* 1934
Le Peintre
Oil on canvas 54 x 46 (21¼ x 18⅛)
Wadsworth Atheneum Museum of Art,
Hartford, CT. The Ella Gallup Sumner and
Mary Catlin Sumner Collection Fund

HENRI MATISSE
119 *Large Reclining Nude (The Pink Nude)* 1935
Grand Nu couché (Nu rose)
Oil on canvas 66 x 92.7 (26 x 36½)
The Baltimore Museum of Art:
The Cone Collection, formed by Dr Claribel Cone
and Miss Etta Cone

Pablo Picasso
120 *Nude in a Black Armchair* 1932
Nu au fauteuil noir
Oil on canvas 162 x 130 (63¾ x 51)
Private Collection

PABLO PICASSO
121 *Girl Before a Mirror* 1932
Jeune Fille devant un miroir
Oil on canvas 162.3 x 130.2 (64 x 51¼)
The Museum of Modern Art, New York.
Gift of Mrs Simon Guggenheim

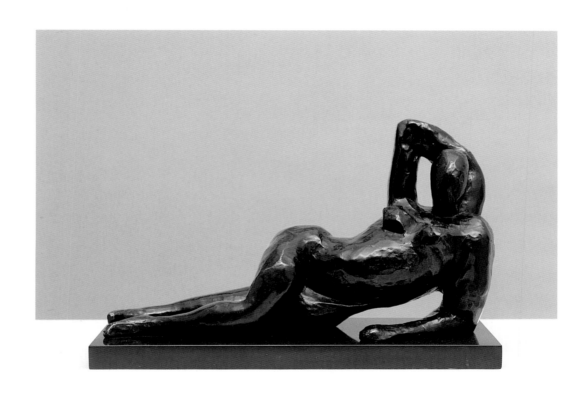

HENRI MATISSE
122 *Reclining Nude II* 1927
Nu couché II
Bronze
28.3 x 49.5 x 14.9 (11⅛ x 19½ x 5⅞)
Tate. Purchased 1953

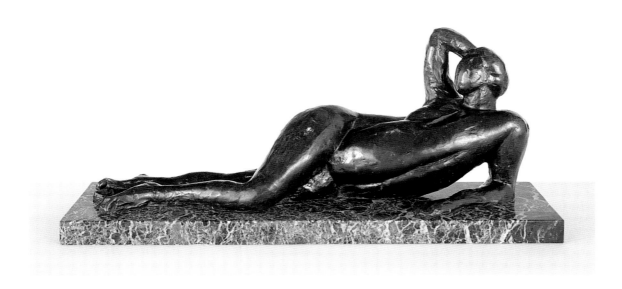

Henri Matisse
123 *Reclining Nude III* 1929
Nu couché III
Bronze 18.7 x 46.7 x 15 (7 ³/₈ x 18 ³/₈ x 5 ⁷/₈)
Hirshhorn Museum and Sculpture Garden, Smithsonian
Institution. Gift of Joseph H. Hirshhorn, 1966

25

It could be said, of course, that the most Matissean of these four paintings is Picasso's *The Dream*, what with the numerous arabesques, the vivacious areas of solid colour accurately delimited, and the 'decorative' figure all in harmonious curves on an 'ornamental'[1] background rhythmically studded with naive miniature flowers. Its theme, however – the sleeping beauty[2] – had to wait three years before Matisse could make it his own and, despite appearances of a common concern, the paintings Marie-Thérèse inspired in the spring of 1932 have little in common with the series of odalisques Matisse, over a span of twelve years, so single-mindedly produced.

It is precisely *Woman with a Veil*, painted in 1927 with Henriette, Matisse's principal model throughout the 1920s, as sitter, that closes this first Nice period of his career (1918–27). It is the last painting for which she posed, and it is indeed about leave-taking. The end of Matisse's relationship with this model coincides with the end of a long sequence of painting, quite homogenous in fact, and with respect to which *Woman with a Veil* stands out distinctly. Henriette had most often posed nude, or attired in nothing more than exotic accessories (veils, thin transparent blouses, bouffant pants or jewellery), transforming her into an odalisque. Here she is dressed from head to toe, from the pill-box hat extending into an invisible veil enclosing and splitting her face in two, to the chequered loose-fitting outfit hiding almost all of her body, leaving only the flesh of an arm bare. Matisse had generally painted her reclining, the gaze distracted or empty, the eyes depicted by two black almonds. Here she gazes intently at the artist, squarely eye to eye: her status as model has changed. By returning the gaze of him who had held her under it, the object of delight becomes once more the partner in a less strangely unilateral exchange, more balanced, but still not devoid of tension. In this respect, and in this respect only, the sleeping Marie-Thérèse paintings rehearse (almost to the point of embarrassment) the paroxysm of offered submission in some of Matisse's paintings of the 1920s.

For once, then, the face of Henriette Darricarrère – or to be more precise the motif of her face leaning on her arm – is the centre of the painting. *Woman with a Veil* is thus one of the few painted portraits of Henriette, for Matisse had also drawn her often, sometimes in close-up. Between 1925 and 1929, he also did three versions of a sculpted portrait, three heads of Henriette (see nos.145–6),[3] which are closely related to *Woman with a Veil*.

What indeed is most impressive about this painting is its sculptural quality, the insistence on the modelling of the face and arm, especially in the area where cheek and hand touch, on the shadows highlighting the huge rounded forehead, and on the roundness of the arm that seems to set off the face, supporting it as would a base, as though the *Jeannette* heads (nos.140–2), perched on top of their long necks were unconsciously coming back to haunt the pictorial process. The non-colour, an olive greyness chosen to render the flesh of the face and arm,

heightens the impression of sculptural weight. The eyes, nose and mouth are inscribed in black. It is a monochrome effect much like that in *Decorative Figure on Ornamental Background* (1925–6, no.113) which represented the first break with the series of flower-women with pearly flesh set into multi-coloured decors. From 1927, the crisis Matisse was undergoing deepened, and the movement of critical reflexion on himself became more radical: few paintings were done in 1928, even less in 1929; Matisse travelled in 1930, and his return to easel painting did not take place until 1934. It was moreover thanks to the Barnes commission – *The Dance* kept Matisse busy from 1930 to 1933 – that he would be able to re-engage actively with painting on renewed foundations. Perhaps the marks and scratchings of 1927, comparable to those of 1914–16, which occur on the surface of *Woman with a Veil* in certain zones of colour or certain parts of the body, and which visibly link this painting to the grand abstract works prior to the Nice period, can be considered the 'symptoms' of this crisis.

Yve-Alain Bois goes as far as to consider that *Woman with a Veil* 'reaches out to Cubism as efficiently as the works of the teens had engaged in a willing dialogue with it'.[4] At least two elements do, in my view, appear to reinstate the relationship with Picasso interrupted since the war,[5] or even to address themselves directly to him. First of all there is the importance given to the rendering of volume, to the work of the 'sculptor-painter',[6] with the ensuing consequences for the use of colour, less striking, less 'bouquet of anemones' than it had been during the first years of the Nice period. The second Picassian element in the painting is the criss-crossed bipartite piece of clothing, coloured half green and half red. This type of reversal is indeed rather Cubist in conception, all the more so given its reprise in the colours of the armchair, yellow on the left side and pink on the right, and especially in the face, neatly set off into two dissymmetrical zones of light and shadow. The central shadow, moreover, is so strongly highlighted that it can almost induce a simultaneous face and profile reading, following a motif often used by Picasso.

This binary arrangement can be found in the composition of *The Dream*, in the face shaped like an upturned heart, split by a black outline (extending the green plinth of the wall on the left), allowing a peaceful passage between the quiet profile and the lunar face of the sleeping woman – connected further by the small bright red spot in the shape of a leaf standing in for her mouth. A sign for the eyes, a single stroke of the brush, a sign for the lips, 'Burmese' hands:[7] this is the whole Matissean vocabulary that Picasso has made his own, radicalising it, and even anticipating it; Matisse's theory of signs would not be formalised before the 1940s.[8]

The remarkable series of works of which *The Dream* is a part (it was painted on 24 January 1932) was done between December 1931 and April 1932, that is, exactly halfway between Matisse's summer 1931 retrospective at the Georges Petit galleries, and the exhibition symmetrically previewed to honour Picasso the following summer. At that time Matisse was totally taken up with the work involved in the Barnes *Dance* commission. Although retrospectives of his work abounded (four in 1931, in Berlin, Paris, Basel, and New York),[9] he was at this time absent from the arena of painting. It is difficult to resist the conclusion that Picasso then took it upon himself to paint for two, for himself and for his main rival, which would help to explain the 'Matissean part' explicit in this moving[10] and magnificent series (which Picasso of course chose to

expose in its entirety at the Galeries Georges Petit in June 1932 – who can affirm that Picasso did not paint the series with a view to this exhibition?) The reply from Matisse to what must have appeared a message as well as a challenge would not take place before 1935, with the paintings of his new model, the blond Lydia Delectorskaya, in turn playing the role of 'sleeping beauty'.

The fact that Picasso challenged Matisse on the subject of colour and arabesque takes nothing away from their differences, from what indeed sets them in profound opposition concerning the concept of space in painting. In this respect a comparison between details of *Asia* and *The Dream* is helpful, in that two opposing systems of painting square off on the same motif. The figure in *Asia* overruns the four sides of the picture frame. The gaze of the beholder must imagine the figure stretched well beyond the limits of the rectangle that it crosses over diagonally. The figure in *The Dream* is centred, framed in the bright red solid colour of the armchair, itself proportionally fitted into the painting's rectangle. Although the lower section of her body is not depicted, she occupies a precise space: each of the elements around her, whether it be the armchair, the green wall, or the hangings, functions as a stabiliser, as though able to keep her from levitating, a counterweight to her curves too fluid to be quite tangible. Likewise for the necklaces: the one in *Asia* is painted in a series of discontinuous strokes, floating on an empty unpainted space. The necklace in *The Dream* slips little red pearls, then yellow ones, carefully set out in black contour, onto a visible wire. There is no risk of this necklace ever coming asunder. Other features distinguishing these two paintings are found in their treatment of decorative motifs. In *Asia*, the circles are traced with what one imagines a hesitant brush,[11] on a ground rubbed in red or yellow. In *The Dream*, Picasso's diamond-shaped grid encloses in a double lock each red floweret with its black centre: a single black ring around the petals, then a lozenge traced in red between two black rings. Does Picasso use the ring as compulsively as Matisse did for incision and scraping? The insistence on these black traces, often doubled up, enclosing the colours like lead outlines of stained glass windows, is more and more decisive in his work up to his late years. This type of closed-off space is the antithesis of Matisse's system of colour as exemplified in *Asia*.

If *The Dream* evokes association with Matisse's odalisques which had preceded it, *Woman in a Yellow Armchair*, painted some three months later in April 1932, challenges Matisse's achievements in a different fashion. This is the year of Marie-Thérèse's true apotheosis in Picasso's art. Virtually all the paintings that depict her are characterised by a sense of plenitude, but the impact made by *Woman in a Yellow Armchair* is of a different nature. It is one of the flattest of all the pictures of his new muse. As always, line is of importance in Picasso's work, but here it is colour that becomes the prime vehicle of expression – hence the challenge to Matisse. Yet the decorative has been suppressed. The two colours that Picasso most associated with Marie-Thérèse, the lavender he ascribed to her flesh and the corn-silk yellow of her hair are now confined to the model's head. The rest of the composition is boldly organised in areas of primary colours placed against a green ground. The red and the greens are run off the edges of the canvas in Matissean fashion. Despite the immediacy of the picture its imagery is heiractic, as if Marie-Thérèse assumes the guise of a sphinx. The lilac of her arms has been transformed into stony grey, her hands into paws, and, like Matisse's *Asia*, she takes on the air of an enigma.

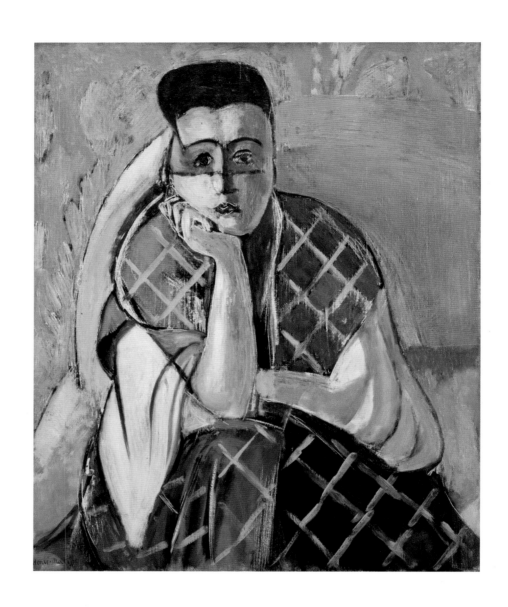

HENRI MATISSE
124 *Woman with a Veil* 1927
Femme à la voilette
Oil on canvas 61.5 x 50.2 (24¼ x 19¾)
The Museum of Modern Art, New York.
The William S. Paley Collection

PABLO PICASSO
125 *Woman in a Yellow Armchair* 1932
Femme dans un fauteuil jaune
Oil on canvas 89 x 116 (35 x 45⅝)
Private Collection

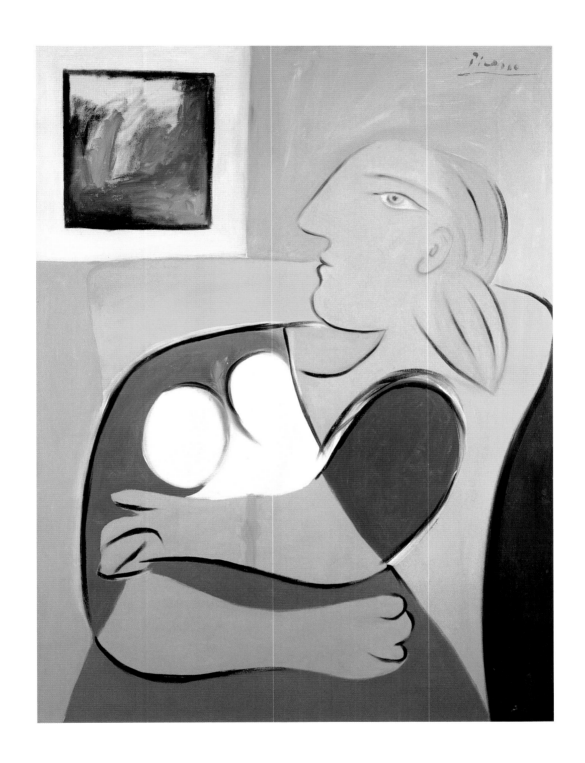

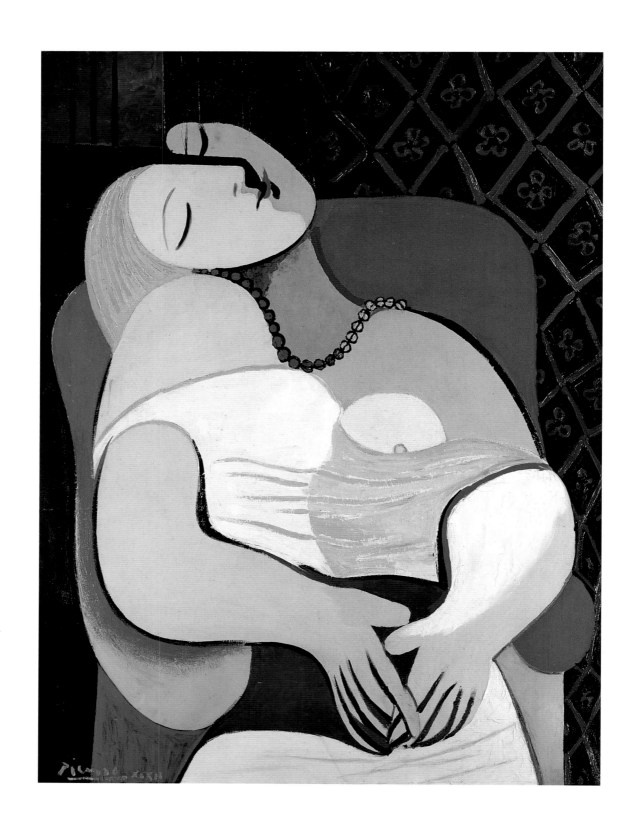

PABLO PICASSO
126 *The Dream* 1932
Le Rêve
Oil on canvas 130 x 97 (51⅛ x 38¼)
The Wynn Collection, Las Vegas,
Nevada

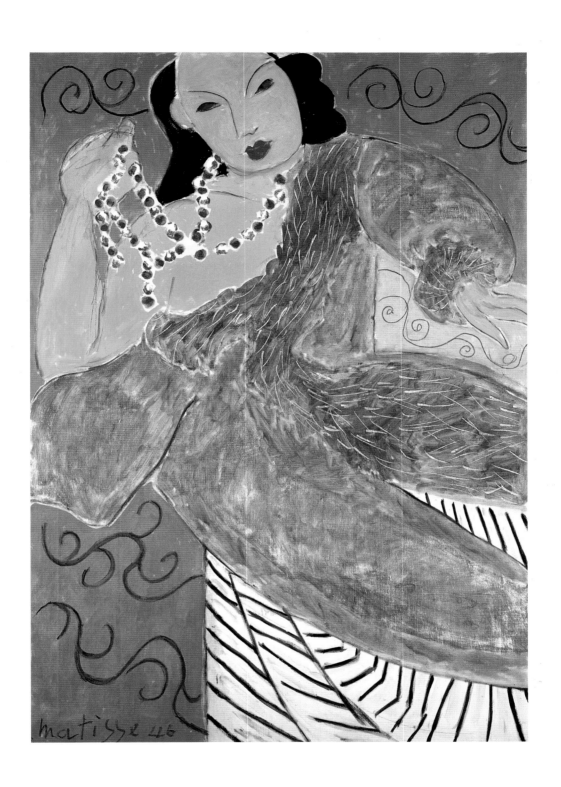

HENRI MATISSE

127 *Asia* 1946

Asie

Oil on canvas 116.2 x 81.3 (45¾ x 32)

Kimbell Art Museum, Fort Worth, Texas

26

Early in their careers, both Matisse and Picasso made pictures of the act of art making.[1] It was Matisse, though, who went on to make the studio, and what went on there, the subject of some of his most important pioneering paintings – *Carmelina* of 1903–4, *The Red Studio* of 1911, *The Painter in his Studio* (fig.79) and *The Studio, quai Saint-Michel* (no.79) of 1916–17, and so on.[2] Matisse always worked from a model; Picasso gradually stopped doing so. Matisse's studios seem to have been more places of display as well as work, and much cleaner, than Picasso's. But there is a more important reason why both the topography of the studio and the confrontation there of artist and model quickly grew in importance for Matisse. He was conscious, early on, of the studio as workplace, as offering unique insights into the artist's relation to reality, seen in terms of work and place. It was where the world as it gets into art was experienced and transformed, and the relationship of artist and model was the archetypal studio drama, encapsulating both the experience and the transformation. For Picasso, the work and the place of art-making soon became the subjects as well as the means of his art, but not privileged subjects worthy of almost devotional attention, as with Matisse. But in the second half of the 1920s, this changed.

In 1926, Picasso was commissioned by the art dealer Ambroise Vollard to illustrate an edition of Balzac's *Le Chef d'oeuvre inconnu*, the story of a painter who spends ten years on the picture of a woman, gradually covering it with scrawls and daubs until what is a masterpiece to him is meaningless to others. By then, Picasso had begun a clandestine affair with the teenage Marie-Thérèse Walter, and was soon stealthily making paintings and drawings of her or containing her profile or initials in his work, as if in a secret diary. Since early in his career, and especially in the years since 1917, he had been interested in establishing facial types, often taken from earlier art, for his portrait subjects. This new subject became the font of multiple facial types and constant transformations, to an extent unprecedented in Picasso's art.[3] His long-standing preoccupation with metamorphosis, finding its perfect, prolific vehicle, was thus realised in the familiar studio situation of an artist discovering the multiple identities of a posed model. This may well have been why Picasso was attracted to the Balzac commission. It certainly brought Picasso's practice close to Matisse's, with the exception that Picasso was not actually working from the posed model but, rather, describing imagined narratives about the relation of artist and model, and the creation of artwork from the model in the studio.[4] In any event, from 1926 through to 1933, the subject of artist and model was a critically important component of Picasso's art. And it so took root there that one of his commentators has gone so far as to say that, with so many and diverse works subsequently appearing on this subject, it acquired the status not merely of a theme but of a pictorial genre.[5]

One of the most celebrated of Picasso's Balzac illustrations shows a model sewing or knitting and an artist creating a painting that comprises a tangle of lines.[6] The model's occupation and the design of the web recapitulate those of the so-called *Milliner's Workshop*, a very large painting of January 1926, recently recognised as representing Marie-Thérèse Walter, her mother and sister, sewing at home.[7] The artist's occupation and the web design appear in the 1926 painting *Painter and Model*, almost identical in size to the *Milliner's Workshop*.[8] In this way, the relationship was forged between the depiction of Marie-Thérèse Walter and the depiction of the subject of the artist and model. Also established was the stylistic vocabulary of curving arabesques that became associated with this particular model. It has often been called Matissean although the aforementioned paintings owe much more to Joan Miró and Surrealism.[9] However, in a sudden stylistic shift, Picasso's three great succeeding paintings on the subject of artist and model, of 1927–8, display an unexpected and austere geometry.[10] It may well be that this style, not the curvilinear one, should be thought Matissean insofar as its appearance could be in part a response to a startling two-painting exhibition, held at the Paul Guillaume gallery in late 1926, containing what are arguably Matisse's grandest Cubist-inspired compositions, *The Piano Lesson* (no.71) and *Bathers by a River* (fig.12), both of 1916.[11] At least, Picasso may have been reminded that Matisse was an artist, like him, capable of working across stylistic boundaries and perhaps more deserving of attention than the Surrealists. In any event, this was precisely the period when Picasso began to pay more attention to Matisse's art than he had since these Cubist masterpieces were painted.

The contrast, in the aforementioned Balzac illustration, of figurative model and abstract pictorial counterpart is amusingly reversed in two drawings of November and December 1928 (nos.130–1) relating to the third of Picasso's geometric 1927–8 paintings, *Painter and Model* of 1928 (no.80). The model, on the left, is abstract, being most likely a female portrait-sculpture on a stand,[12] while the image on the canvas is a realistic profile of Marie-Thérèse Walter. To complicate matters, the artist, on the right, is made in the image of a sculpture by Picasso, a tripod-based, painted metal head.[13] He appears both to stand, facing the viewer, and to sit, inscribing the model with a rigidly phallic arm.

Picasso's next foray into the subject of artist and model began in 1930, when he was working on another print commission, illustrations for Ovid's *Metamorphoses*. At the beginning of November 1930, a week after he had spent an energetic month on the *Metamorphoses*,[14] he made the drawing *The Painter and his Model* (no.134), whose relief-like composition, drapery, and facial types would seem to imagine a tranquil painting session in an antique studio. Inevitably, though, it is also a self-imagination, and prominent in the drawing is Picasso's preferred form of self-representation that had emerged in the 1920s, the profile view, here juxtaposed with its frequent variant, the cast shadow.[15] A cast shadow seen detached from its source implies the absence of the source, and Picasso meditates here on his own presence with and absence from the model, explicitly recalling one myth of the invention of painting, Pliny's story of the Corinthian maiden who outlines the shadow of her lover who is about to go abroad. In contrast, an early August 1931 drawing, *The Sculptor and his Model* (no.129), recalls Ovid's story

of Pygmalion, who carves a statue of Venus from ivory and prays successfully for the statue to come to life. However, the classicism is, in this case, qualified by a strongly Rembrandtesque quality, which makes one wonder, with Dore Ashton, whether memories lingered from Picasso's sojourn with Frenhofer, whose studio Balzac described as a Rembrandt out of its frame.[16]

The shift from painter to sculptor is telling. Yve-Alain Bois thinks that it was Picasso's sight of Matisse's summer 1930 sculpture exhibition at the Galerie Pierre that turned his thoughts to modelled sculpture.[17] Another view would be that Marie-Thérèse Walter's classical profile suggested colossal Roman heads. In any event, one of the great Boisgeloup heads of Marie-Thérèse Walter, or the model herself, appears at the bottom of the August 1931 drawing. In an early December 1931 drawing (no.132), the classical sculptor unquestionably contemplates one of these works, while the model looks on. This is still in the shadow world, but a greater robustness is creeping into its representation, as befitting the sculptural subject matter, but only, it seems, to give weight to the indolence that seems to inhabit the studio. It is common, and apt, to mention the air of post-coital languor and relaxation in this and similar works in the so-called *Sculptor's Studio* engravings that followed in 1933.[18] But there is also a familial tenderness to them. The sculptor, reflecting Picasso's work on Ovid, has features that are commonly thought to be classical, as Marie-Thérèse had in reality; thus artist and lover-model are of the same family. Indeed, while Picasso's paintings of this model are vividly erotic, the drawings and engravings put the sexual component of the artist-lover/model relationship in second place.[19] The representation of the model is the focus of attention, and the model herself is not there to be looked at but to share in the looking, more studio assistant than sexual object, at least for now.

Late in February of 1933, while working on the *Sculptor's Studio* engravings, Picasso made one of his most extraordinary studio images. *The Studio* (no.136) reaches back to the late 1920s studio paintings for a contrast of classicised naturalism and non-naturalistic invention in the two representations of the model. Only now, both representations of the model are representations of representations: the one a Matissean drawing or painting on an easel; the other a surrealistic, balloon-like sculpture on a table. Between them is that over-familiar Matissean motif, the open window. Closer inspection reveals that the side of the *porte-fenêtre* behind the sculpture is open, folded into the room, whereas the side behind the drawing is spatially ambiguous. Judging from its top edge, it could be either folded into or out of the room. Judging from its top and bottom edges together, it could be either open or shut. The easel is similarly ambiguous as to whether it is open and standing or folded and shut. Beside it, a palette as thin as a decal hangs from a nail pulled from a Cubist painting.

Things appear to be more illogical on the right, but the only thing that truly is illogical, spatially, is the drawing of the table, and especially how one of its back legs is brought to the front to meet the tabletop. Just there, Picasso has drawn a tiny spatial volume, a handleless cup. The temptation must be resisted to think of this drawing as Picasso's figure contemplating a Matissean one. What we have here is a more basic *paragone*. Picasso had himself already claimed both of the depictive styles used in this drawing. He is showing, through images of his own art, how painting and sculpture differently represent the same model, the one spatially ambiguous,

tending towards flatness; the other, spatially literal, tending towards the volumetric.[20] And if there is a Matissean reference in this work, it is not simply to the image on the easel. For the whole sequence in the drawing – sleeping nude against floral ground, window, vessel on a table, and uncertain geometric form – reprises Matisse's *The Studio, quai Saint-Michel* of 1916–17.[21]

'No model, no painter', Picasso once said.[22] We have to remember, though, not only that Picasso rarely worked from the model but that his images of artists and models effectively tell stories about the artist-model relationship, musing on what emotions, associations, memories, fables or fantasies attach to the encounter. And, while much in the images relates to looking, they are not representations of the kind of looking that belongs to the literal model-artist relationship.

Matisse's are. And this is never more evident than in the case of the celebrated ink line drawings that he made on this subject in the period 1935–7.[23] Their spare but decorative style is continuous with that of the ink drawings and etchings he had been making since the later 1920s. They began to appear after, and would appear to have issued out of, his work on the *Pink Nude* (no.119). On the one hand, they continue the work of the *Pink Nude* in reinforcing Matisse's withdrawal into the world of the studio after a period of public commissions.[24] On the other, they afford a release – after the dogged erasure-and-correction process of that painting – into the more spontaneous activity of setting down the perceptual record of the model in one work after the next. Insofar as mirrors and the act of drawing play an important part in these works, they possibly respond to Matisse having seen two Matissean paintings by Picasso of February 1935, showing a girl drawing before a mirror with a sleeping female companion in the background.[25] But even more striking in Matisse's drawings is his own depicted presence in them, frequently represented as a reflection in a mirror, or as an artist in the act of drawing, and which may comprise a more telling indebtedness to Picasso than the mere iconography of mirroring and drawing. Although Matisse had used the theme of the duplicating mirror fairly frequently, only twice previously, in 1903–4 and 1924, had he represented a mirror that reflected himself.[26] These images of him thus once-removed (in actuality, twice-removed, of course) are images akin to the shadow images that Picasso had been making since the 1920s, connoting both presence and absence; in this context, both presence with and absence from the model, the controlling theme of these works.

Matisse has worked close-up to the model, and the field of paper is fully filled, in imitation of a fully filled field of vision. The paper also is filled for that perennial Matissean reason, announced in his famous *Notes of a Painter* of 1908: to make the whole surface expressive, not merely the depicted imagery.[27] But the old formula has now an added value. Consciously designing the whole sheet is a way of ensuring that the emotion called up by the depicted imagery – that of naked female bodies – 'is not apparent in the representation of their bodies, but often rather by the lines or the special values distributed over the whole canvas or paper and which form its orchestration, its architecture.'[28] Matisse wrote these words in the 1939 essay, 'Notes of a Painter on his Drawing', whose title tells that it is a conscious reprise of earlier themes, and which was written very much with these drawings in mind. While beginning to make the draw-

ings in 1935, he had written: 'The subject of a picture and its background have the same value, or, to put it more clearly, there is no principal feature.'[29] Thus, even the carefully selected and posed models were not to be principal features. But neither were they to be not principal features, because everything was interrelated and inseparable.

When Matisse spoke of 'the lines or the special values', he was referring to how he sought to generate effects of light and colour, without using shading or hatching. He did so, instead, by varying the weight of the black ink lines, the sizes of the white areas enclosed by them, and the density of the black-white patterning. (The induced and modulated movement that thus occurs optically will register as transmitted light, even producing subjective colour sensations.) This, he said, is the drawing method of colourists; hence, even the most ornamental passages were there not as evidence of technical dexterity but as 'form . . . or value accents' whose aim was to 'generate light'. And, in turn, the modulation of light was there as a correlative of the modulation of feeling. The assimilation of the figure into the decorated unity of the sheet analogises the discomforting sensation, the spatial and epistemological confusion, of a camouflaged field, with its concomitant heightening of sensation and expectation. All of this was 'perhaps sublimated sensual pleasure, which may not yet be perceived by everyone', Matisse said – guaranteeing that it would be.

'Notes of a Painter on his Drawing' was written to defend himself from critics who thought these drawings cold and the models in them no more than mere extras.[30] They continue to be considered as more about the pictorial than the human.[31] But if they do not open onto stories about the artist-model relationship as Picasso's works do, they dazzle instead with stories about pictorial representation. The most important of these pertains to duplication and displacement. The viewer's difficulty of capturing the image of the model in the camouflaged field is compounded because the model is often duplicated. The model appears to be proximate, present, and available, and never more so than when Matisse includes an image of his hand drawing the model. But that is also when the model seems most distant, absent, and unavailable, because the image of the image that he is drawing duplicates the model, producing a twice-removed image that reminds us how her supposedly proximate image is itself once-removed. (One drawing, no.135, offers a further complicating image at third remove.) A representation of an image in a mirror similarly produces an image twice removed, and with the further complication that the image will be reversed, distorted in comparison to the first-removed image, and possibly unrecognisable. And if no attempt is made to represent the surface of the mirror, and Matisse resolutely avoids doing so, then the two images will press together like a pair of Siamese twins resting in a doorway between two rooms.

Proponents of the dehumanisation theory of these drawings argue that duplication depersonalises, thereby aiding assimilation of the alien human element in the ideal decorative realm of the studio, which in turn aids depersonalisation, and so on.[32] And yet, the result is far from depersonalised. These mirrored figures are so extremely individualised as to seem uncanny – uneasily unmatched reflections who are being inspected by a serious, bearded, formally dressed man with glasses. The studio in this conception is not quite the male Arcadian fantasy

259

of duplicable female objects. It is a far more interesting place. Lascivious in quite a different way, it is where the hidden and atavistic come to light, where there is no principal feature because people are not yet marked off sharply from each other and from the external world, and where the self-regarding feeling is still in evolution.[33]

Matisse was, of course, an extremely self-regarding artist. 'The reaction of each stage is as important as the subject', he said in 1936. 'For this reaction comes from me and not from the subject'.[34] These drawings depict not the model but the effect. Therefore, it would be wrong simply to contrast Matisse's more perceptual to Picasso's more conceptual approach to the subject of artist and model. Indeed, an obvious link between the two sets of drawings is the solipsism of the two artists who made them. The strength of their commitment to individual experience caused them not merely to repudiate the traditional extroversion of visual art, but also to act as if, finally, only they and their art were real.[35] It has become customary to contrast Picasso's 'Spanish' emotionality with Matisse's 'French' coolness, yet they were exact equals in their continual, hard self-examination; the one was as systematically self-engrossed as the other. One consequence of this was their frank acceptance that the artist is the single most significant source of his art. Another was that art is a source of art and might be a subject of art, and that this subject might just as well include not only the model but also the artist.

JE

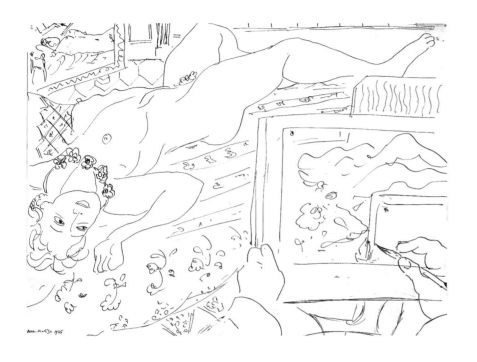

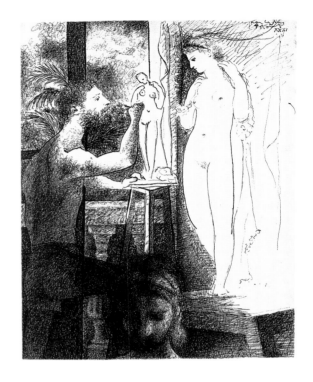

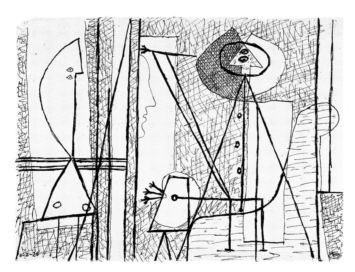

HENRI MATISSE

128 *The Artist's Studio* 1935
L'Atelier de l'artiste
Pen and ink on paper 40 x 52 (15¾ x 20½)
Private Collection

PABLO PICASSO

129 *The Sculptor and his Model* 1931
Le Sculpteur et son modèle
Ink on paper 32.4 x 25.5 (12¾ x 10⅛)
Musée Picasso, Paris MP1052

PABLO PICASSO

130 *The Painter and his Model* 1928
Le Peintre et son modèle
Ink on paper 21.1 x 27.1 (8⅛ x 10¾)
Musée Picasso, Paris MP1026

261

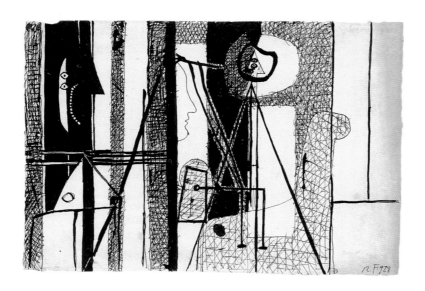

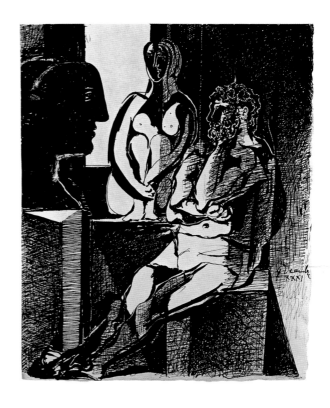

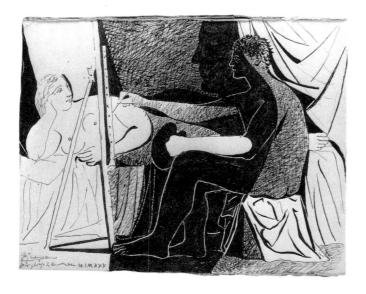

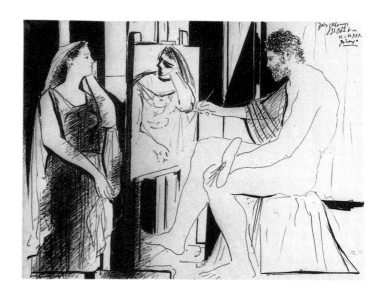

PABLO PICASSO

131 *The Painter and his Model* 1928

Le Peintre et son modèle

Ink on paper 23.6 x 34 (9¼ x 13⅜)

Musée Picasso, Paris MP1027

PABLO PICASSO

132 *The Sculptor's Studio* 1931

L'Atelier du sculpteur

Ink on paper 33 x 26 (13 x 10¼)

Musée Picasso, Paris MP1064

PABLO PICASSO

133 *The Painter and his Model* 1930

Le Peintre et son modèle

Ink on paper 23 x 29 (9⅛ x 11⅜)

Musée Picasso, Paris MP1050

PABLO PICASSO

134 *The Painter and his Model* 1930

Le Peintre et son modèle

Ink on paper 12.1 x 18.5 (9⅛ x 11⅛)

Musée Picasso, Paris MP1049

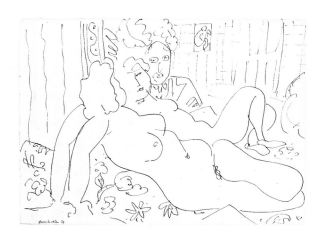

HENRI MATISSE

135 *Artist and Model Reflected in the Mirror* 1937

L'Artiste et son modèle reflétés dans un miroir

Indian ink on paper 28 x 37 (11 x 14½)

Private Collection

PABLO PICASSO

136 *The Studio* 1933

L'Atelier

Crayon on paper 26 x 34 (10¼ x 13⅜)

Musée Picasso, Paris MP1088

HENRI MATISSE

137 *Artist and Model Reflected in a Mirror* 1937

L'Artiste et son modèle reflétés dans un miroir

Pen and ink on paper 61 x 40.6 (24 x 16)

The Baltimore Museum of Art, The Cone

Collection, formed by Dr Claribel Cone and

Miss Etta Cone

HENRI MATISSE

138 *Large Nude* 1935

Grand nu

Pen and ink on paper

45.1 x 56.5 (17¾ x 22¼)

Private Collection

263

27

Sculpture is the best comment that a painter can make on a painting.[1]

<div align="right">— PABLO PICASSO</div>

I sculpted as a painter. I did not sculpt like a sculptor. Sculpture does not say what painting says. Painting does not say what sculpture says. They are parallel ways, but you can't confuse them.[2]

<div align="right">— HENRI MATISSE</div>

For Matisse as for Picasso, sculpture was mainly a specular tool to confirm and conclude in three dimensions what their painting had already accomplished. Photographs in their studios attest to the various ways the relation between painting and sculpture enabled each artist to tap new springs of energy.[3] For Matisse, a sculpture was always present in the studio[4], on hand to 'nourish'[5] the investigative work of the model. Whether in mere clay or bright plaster, sculpture, along with the tapestries, the chosen objects, the fruits, flowers and birds, was an integral part of this universe of motifs the artist jealously surveyed, waiting for the sensation that would spark a new painting. In much the same way that sculpture enabled questions posed by his painting to materialise, sculpture in turn became a subject of predilection.[6] Tossed across the floor, beneath the 'settlement of dust'[7] to which he consigned his oeuvre, Picasso's sculptures are indistinguishable from the heaps of sundry materials, discarded objects or fantastic flea market specimens which, almost by the contagion of proximity, communicate their qualities to his sculpture as primary objects of popular dreams.[8] In 1931 however, in the Boisgeloup studio, Picasso took a forthright plunge into the vertigo of monomaniacal sculpture. Here plaster in gestation would offer the means of a phenomenological conversation between the artist, the oeuvre, and the model. These are the contexts in which the intermittent dialogue between the sculpture of Matisse and Picasso must be situated, especially the obsessive litanies of heads with women's names, erected and brandished by both artists like so many blazons or trophies.

Picasso finished *Head of a Woman (Fernande)* in the autumn of 1909, a life-size plaster cast[9] with which he could appraise the recent upheavals taking place in his painting. During the summer at Horta de Ebro, Picasso had done numerous sketches and paintings carrying to its utmost limits the elementary decomposition of the figure. The architecture of *Head of a Woman (Fernande)* is similarly decomposed into triangular pieces colliding with one another to give a view of its features and planes. As Apollinaire pointed out, Picasso studies an object like a surgeon dissects a corpse.[10] The structures brought into focus here, however, are in no respect those of the physiology of muscles or entrails. They are akin rather to purely mathematical

écorchés with which to express the artist's project: the reconstruction of appearances from out of the basic geometry of a polyhedral braid.[11] Plastically and arithmetically defined, this braid effects a crystallisation in the course of which the surface loses its screen-like quality and acquires instead a transparency. In place of the Platonic entities of sphere, cylinder and cube which, in Cezanne's approach, still posited an instance of recognition of the world in terms of stasis and unity,[12] Picasso now substitutes a dissolving reading of volume. The prism, a dynamic anti-classical element, is used by Picasso to deconstruct and reconstruct all things, to penetrate beneath their surfaces, and to describe the accidents and disquieting aspects of form: gaps, folds, thicknesses, bulges, cavities. The orthodox reading of Cubism generally had it exhibiting the object from all sides at once. With Picasso, the vision of the object, remaining frontal, would continue from the surface to the inside of the object. For, 'working not after nature but before nature',[13] Picasso begins from the most common apprehension of this body facing him, whose source he wants to plumb.[14] The violently jagged surface of *Head of a Woman (Fernande)* has been interpreted as a throwback to Impressionism in sculpture, as in the work of Rodin or Medardo Rosso,[15] as though the sharp edges accentuating the modelling were seeking to compete with the most intense contrasts of light. If *Head of a Woman (Fernande)* is indeed a construction in which light plays an active essential role, then it should be seen in relation to Picasso's luminism, very Goethean in inspiration.[16] In his monochrome works, it is indeed at the point of the strongest contrast of black and white that the physiological colours, haloes, iridescences, luminescences, created by the eye and captured at the sharpest limit between sombre and clear, finally appear. In his *Theory of Colours*, Goethe was thus led to praise the plastic qualities of the polyhedron: 'In order to produce artistic effects, planar surfaces must be created, so that the sections of light and shadow may be better separated from one another. This is what the Italians call *il piazzaso* – which could translate into German as *das Fluchenhafte* (flat plane). If therefore the sphere is the perfect example of natural chiaroscuro, the polyhedron would be one of artificial chiaroscuro, wherein all categories of light, half-lights, shadows and reflections appear.'[17] In painting, and here with respect to sculpture, the Picassian geometric model would thus be designed to maximise the colour potentiality of the sequence of light and shadow. 'Colour is efficient to the extent that it makes up only one of the constructive elements of volume', as Picasso says in confirmation of this geometric model.[18] For *Head of a Woman (Fernande)*, plaster is but an intermediary stage and the artist intended bronze from the start, with its metallic quality, its lustre, its sonority. 'Sharpening'[19] the contact areas between each plane of the figure, Picasso did not intend to restore in an Impressionist vein the light originally surrounding the model, but, going beyond what Kahnweiler suggested could be called its 'objectivation',[20] Picasso managed to produce with the achromatic bronze *Head of a Woman (Fernande)* a precisely dimensioned machine for the decomposition of physical light, an object-prism capable of generating colour.

It has been pointed out that Matisse's series of heads *Jeannette I* to *V*, dating between 1910 and 1913–16,[21] can be seen to be bounded by two key Picassian works in sculpture, *Head of a Woman (Fernande)* of 1909 and *Guitare* of 1912.[22] When Matisse set out on the first two studies

Jeannette I and *II*, he wanted to delve deeper into the investigation of his model whose portrait he had just finished: *Young Girl with Tulips (Jeanne Vaderin)*.[23] Such a desire was in conformity with his often-described method: 'I changed my method, and worked in clay in order to have a rest from painting where I had done all I could for the time being . . . it was done for the purposes of organisation, to put order into my feelings . . . in view of . . . a sort of hierarchy . . . in the hope of finding an ultimate solution.'[24] In this case the project, under the direct influence of *Head of a Woman (Fernande)*, sparked work of unprecedented scope.[25] As with the small expressive heads, busts or full-length figures done previously, these heads follow the Matissean principle dictating that 'a sculpture must invite us to handle it as an object'.[26] The artist extends an invitation to touch as valid for the beholder as for the artist. Deeply committed to a pictorial experimentation in which tonal accord of colour must inform the construction of the painting, Matisse here aimed at an application in sculpture. The impact of the finger kneading the clay surface is the direct equivalent of the emotional shock produced on the artist by the model. The new interest evinced by Matisse for sculpture issuing in the *Jeannette* series was indeed contemporaneous with intense chromatic research which threw the painter into the throes of intense retinal excitation to the point that he started to worry about becoming blind.[27] Just as he would learn to play the violin in order to be sure to have an outlet for his sensitivity in case of blindness, so too he returns 'blindfolded'[28] to the model, with a hand he knows and wants to be unconscious.[29] *Head of a Woman (Fernande)* and Matisse's *Jeannette* can thus be seen, each in its own respect, as machines for the production of colour, the first by means of the artifice of chiaroscuro, and the second by means of the obscurity of the senses. For 'physiological colours' or psychic ones are both meant to relay natural vision, and to question in the universe of forms its function or its disappearance.

While the prescriptions of *Notes of a Painter* on subjects such as structure, lines of force and verticals of bodies primarily concern drawing, Matisse understood sculpture fundamentally by a surface. This surface, haptic rather than optical, enters the realm of the gaze only insofar as it is first of all in relation to a cerebral touch, a sensuousness of the eye, its aptitude to feel objects rather than to see. This erogeneity of the surface is characteristic of the art of Matisse, whether it be drawing, in which the charcoal runs between overlay and erasure, painting, in which the scumbled colour attains the status of polished surface, or sculpture, in which the surface is a palimpsest of inscribed tactile signs. Thus, the first two clay versions, *Jeannette I* and *II* are softly modelled portraits conserving the features of the subject. When making a new version in 1911[30] the goal was to transform it by placing it on a 'bust', becoming a spur in place of the bases on the edge of which he had placed the heads of *Jeannette I* and *II*.[31] With the handling of the nose in the extension of the forehead, this overhang is shaped, viewed from the side, as a structural chevron in the form of a Z, which follows alternate movement of the pressure of space on the body. *Jeannette III* instrumentalises the naturalistic and sensualist rendering of the first two versions (*I* and *II*). This one would be the squared-off version, so to speak, in the sense of stripping bark from a tree, leaving bare the heart and soul of the wood. Here would be Matisse's project to capture Jeannette's heart and soul: the taut, obtrusive presence of Jeanne Vaderin. The same

year, however, the fourth version was recast from a plaster copy of *Jeannette III,* tapered, slimmed down, as if Matisse were honing its principle. For the fifth version the same plaster copy of *Jeannette III* was used, on which Matisse grafted protuberances of clay to develop the potential of this new volume. This process remains legible in the definitive aspect of the sculpture, in which the brutal suppressions decapitating the skull can be ascertained, as well as the successive additions applied to impart rhythm to the tension of the bust and to further exalt the model's nature.[32] Matisse sets off each physiognomic aspect as if to identify the various aspects of his emotion. The 'sensation' is no longer an indistinct flux to which empathy is the response – 'It is by going into the object that one can get inside one's skin'[33] – but the sensation now issues in an articulated sequence in which hair, head, bust, sublimated into so many autonomous entities, act at once separately and globally. Cutting arbitrarily the actual architecture of the head, this work of 'condensation'[34] tends more to a definition of qualities than of a form. The influence of primitive sculpture is apparent in the eradication at work throughout the mutations of *Jeannette V.*[35] The fetish, that specular receptacle of divine presence, gives orientation to the worshipper in the labyrinth of representations, until he reaches the point of emotional coalescence with the divinity. Matisse's desire 'to make the picture'[36] in painting will be doubled in sculpture by the will to 'make the mask', yet another way of grasping the essence of beings and things. By absorbing the energy of the model through his emotional identification with her, Matisse channels, through mimetic behaviour, the properties and qualities of the object into his own body so as to reproduce them. This position whereby the artist becomes a medium is opposed to the position of Picasso, who strives toward a balanced, distanced vision and could thus say to Malraux, on the subject of the sculptures discovered in the Trocadero museum in 1907: 'All these fetishes serve the same purpose. They were weapons. So that people could escape from being haunted, so that they could become independent. Tools. By giving form to spirits, we become independent of them. Spirits, the unconscious (there was not much talk of that at the time), emotion: this is all the same thing.'[37] In fact, Picasso discovered in primitive sculpture a model of formal investigation that allowed him to fight against the overcoming of the senses by emotion.[38] Beyond all plastic analogies between their oeuvres, this is an accurate measurement of the distance between the sculptural projects of the two artists. Matisse tends to synthesise the fusional unity of painter with model, whereas Picasso sees the subject as a mere pretext for the establishment of a structural principle.

Between 1925 and 1929 Matisse returned to the practice of successive variations, in a series of heads of Henriette Darricarrère. His favourite model since 1920, she had sat for the sculpture *Large Seated Nude,* which would spark the renewal of his painting. This time, each version of the *Heads* series was done directly in clay, and Matisse confered on each one the specific features of Henriette, as if the model's multifarious identities were to be progressively established. Whereas *Jeannette V* presented the totem-like essence of Jeanne Vaderin's truth, the Henriette heads seem to display a series of parallel existences. The expansion in volume from *Henriette I* to *Henriette II* produces an effect of accomplishment, silent concord, mental transparency; Henriette is dreaming, totally there, at once rendered as a surface, and yet absent, as if appearance

were the symptom of that which totally eludes the gaze of the observer. Contrary to the active scrutiny of *Jeannette*, the *Henriette* heads are haunted by the void. In *Henriette III*, Matisse once again used the method of synthesising features, highlighting the model's psyche, revealing the arch of an inner gaze and an 'ionic' smile that led to the work's second title: *Smiling Head*.

The second version of *Henriette* has often been compared to Picasso's 1931 bronze *Head of a Woman (Marie-Thérèse)*. Both indeed have this same lunar, expansive, germinating aspect verging on the sphere. Thus expressing the self-centred involution of the subject, these softly glowing *Heads* contain the secret of the gradual accretion of each artist's feelings. In Picasso's case too, *Head of a Woman (Marie-Thérèse)* belongs to an important sequence of sculptures devoted to his young girlfriend.[39] This principle has no equivalent in his earlier sculpture, which hitherto had functioned as a marker calibrating the advance of his pictorial investigation.[40] It has nevertheless been suggested that Matisse's sculptures (of which fifteen had been exhibited at the Galerie Pierre in 1930)[41] may be the origin of the sequence of *Heads* and *Busts* done by Picasso in the winter of 1931.[42] Starting with *Fernande*, Picasso seems to have provided a reading recapping, in a deliberately non-chronological treatment, the plastic states and solutions of *Jeannette* and *Henriette*. Such an inventory and reinterpretation of the active principles of Matissean sculpture cannot be ascribed to a mere question of influence. At stake would be an actual recognition whereby Picasso could establish their common sculptural vocabulary. Matisse used the term 'fermentation'[43] to describe this process of predation and plastic assimilation Picasso experienced. One might be surprised in the 1931 series by the play back and forth between works driving abstraction to its utmost limit and others exposing the figure quite literally. Provided these movements can be considered as Picasso's theorisations of the 'Matisse/Picasso' axis, each solution will be understood in its autonomous status and as a virtuoso variation in antagonistic modes: figurative restitution, materialist deconstruction, and sign-like synthesis. Picasso did in fact refer to the absolute reversibility, indeed the versatility, of his approach. 'Starting with a portrait and aiming by progressive eliminations at the pure form, one inevitably comes up with an egg. Likewise, starting with the egg you can, by following the opposite route, arrive at the portrait.'[44] Moreover, until 1931 Picasso had been intent on encrypting the image of his new model by a wide variety of means.[45] The sequence of *Heads* inspired by Marie-Thérèse could therefore derive from a deliberate politics of *coq à l'ane*,[46] an alternating play between the concealing and the unveiling of the subject's identity. Picasso would thus on one occasion amuse himself by highlighting one of its facets, while on another occasion taking pains to hide it again, suddenly refusing to obey the dictates of veracity and realism. Roland Penrose has reported how, in his new studio set up to pursue monumental sculpture, Picasso 'working at night in the studio at Boisgeloup he had first built up a very complicated construction of wire which looked quite incomprehensible except when a light projected its shadow on the wall. At that moment the shadow became a life-like profile of Marie-Thérèse'. The artist, on seeing this 'projection', is reported to have kept adding plaster until its existence was a 'more durable and splendid version'.[47] This revelation of chance may have set off in Picasso the will to render the effigy of Marie-Thérèse in direct or indirect sculptural

forms.[48] A negative matrix, a cast shadow, obscure and transparent, of the young woman may then be seen presiding over the genesis of the series of *Heads* and *Busts*, which step by step accomplish something of a spelling out of the model's name and changing appearance.

Head of Woman (no.143), the most abstract and the most metaphoric of these works, may well have initiated the series.[49] Stylistically it belongs with the biomorphic works of the 1928–30 period. By synecdoche, this bust recaps in an optical short cut the athletic choreography of the bodies inhabiting Picasso's pictorial work at the time. The torso, the eyeball, the flare of the nose, the shaft of hair, erect their precarious architecture in an extraordinary suspension of form. Picasso returns afresh to the semantic logic initiated in 1909 by *Head of a Woman (Fernande)*. The elements of the sculpture likewise comply with a veritable montage schema, as can be seen in one of the preparatory sketches in which the corresponding volumes are numbered piece by piece.[50] This time, however, the constructive tool is not the Cubist prism but, directly taken from the rudiments of modelling, a clay scroll. Its origin would be in the isomorphic structure of bones for which Picasso admitted 'a real passion'.[51] As he said to Brassai: 'You always have the impression they come from a mould, after they were first modelled in clay . . . the fingerprints of the god who amused himself fashioning them – I see them on any bone whatsoever.'[52] Likewise, as a metaphor of the procreating finger of the artist, the clay scroll comes to prominence as the instrumental incarnation of sculpture as project and as process.

Another stage in this process of the subject's modelisation is the monumental plaster of the winter of 1931, *Head of Woman (Marie-Thérèse)* (no.144). Picasso places the pieces of the anthropomorphic puzzle into a new configuration, binding them together by deep folds, replacing the axial void of *Head of Woman* (no.143) by a gusset structure enabling the volumes to cascade freely upon one another. Although the artist keeps in part the topographical unity of forehead and nose, he creates this time a Cyclopean cheek whose incised eye is the centre of the sculpture. To this graphic inscription Picasso opposes the sensually modelled mouth opening onto an dark interior. The two modalities of sculpture, one operating by means of the sign, the other in mimetic duplication, join to impart to the work its signifying dynamic. The charcoal drawing on canvas *Sculpted Head of Marie-Thérèse*[53] witnesses this stage in the research, in which the face is consolidated and progressively becomes larger in a lateral movement, an effect also present in *Head of a Woman (Marie-Thérèse)* (no.147). The other states of the series of *Heads* and *Busts* prolong this process of 'nomination' of the model's attributes. *Head of a Woman* (fig.69), which, by the salience of the skullcap, the sharp thrust of the orbits, the prominence of the nose, the choked neck/bust, is the most evocative of *Jeannette V*, perhaps constitutes the most particular instance of the common thread whereby Picasso and Matisse encounter, each in turn, a paradigmatic configuration of the representation of the body.

In a manner similar to the cast shadow haunting this sculptural project, *Head of a Woman (Marie-Thérèse)* (no.147) could be considered as either the origin or outcome of the sequence, and as rendering the most 'figurative' transcription of the model. The illustration of the *Metamorphoses* by Ovid,[54] which Picasso had undertaken in 1931, precisely speaks of the ambiguous states that inert matter passes through on the way to anthropomorphism: 'These stones – who

could believe it without the testimony of the Ancients – lost their hardness and their rigidness grew slowly soft and, softened, assumed a shape. As they grew and felt a gentler nature's touch, a semblance seemed to appear, still indistinct, of human form, like the first rough-hewn marble of a statue, scarce modelled, or old uncouth images.'[55] Following the same movement of poetic materialisation whereby the creature and the uncreated silently dialogue in the inachievement of form, *Head of a Woman (Marie-Thérèse)* (no.147) would thus also lose the rigid appearance where the ithyphallic clay scroll savagely submerged the structural abstraction of the other *Heads*. Then the gentle curve of flesh finally reaches the idealness 'portraying its figure so beautiful'.[56]

AB

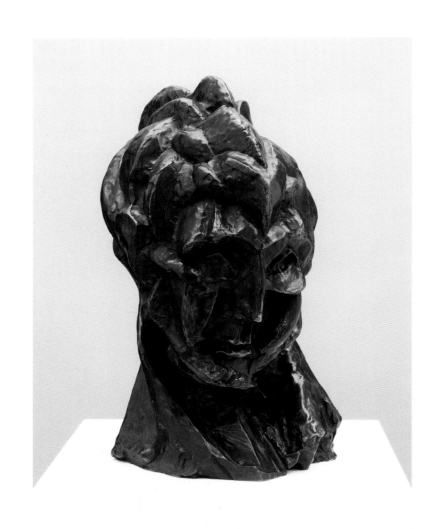

PABLO PICASSO

139 *Head of a Woman (Fernande)* 1909

Tête de femme (Fernande)

Bronze 41.3 x 24.7 x 26.6 (16¼ x 9¾ x 10½)

Musée Picasso, Paris

(shown at Tate Modern)

The Museum of Modern Art, New York. Purchase

(shown at The Museum of Modern Art)

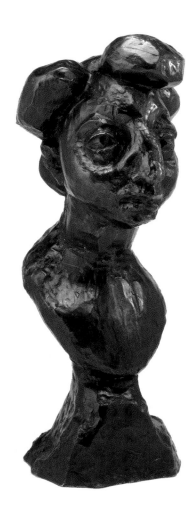

HENRI MATISSE

140 *Jeannette III* 1911

Bronze 60.3 x 26 x 28 (23¾ x 10¼ x 11)

The Museum of Modern Art, New York.

Acquired through the Lillie P. Bliss Bequest

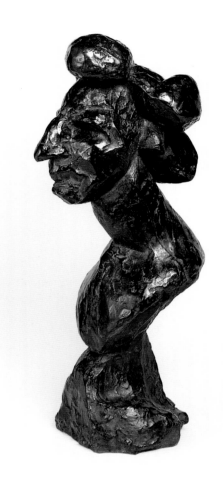

HENRI MATISSE
141 *Jeannette IV* 1913
Bronze 61.5 x 27.4 x 28.7 (24¼ x 10¾ x 11⅜)
Centre Georges Pompidou, Paris.
Musée National d'Art Moderne/Centre de
Création Industrielle. Dation en 1991
(shown at Tate Modern and the Grand Palais)
The Museum of Modern Art, New York.
Acquired through the Lillie P. Bliss Bequest
(shown at The Museum of Modern Art)

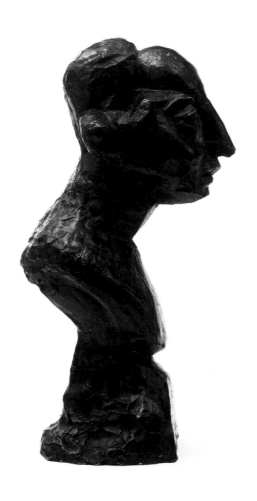

HENRI MATISSE

142 *Jeannette V* 1916

Bronze 58 x 21.3 x 27.1 (22⅞ x 8⅜ x 10⅝)

The Museum of Modern Art, New York.

Acquired through the Lillie P. Bliss Bequest

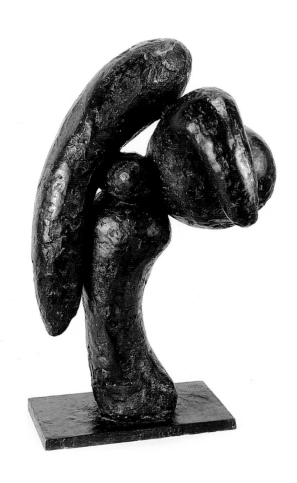

PABLO PICASSO
143 *Head of a Woman* 1931
Tête de femme
Bronze 71.5 x 41 x 33 (28⅛ x 16⅛ x 13)
Musée Picasso, Paris

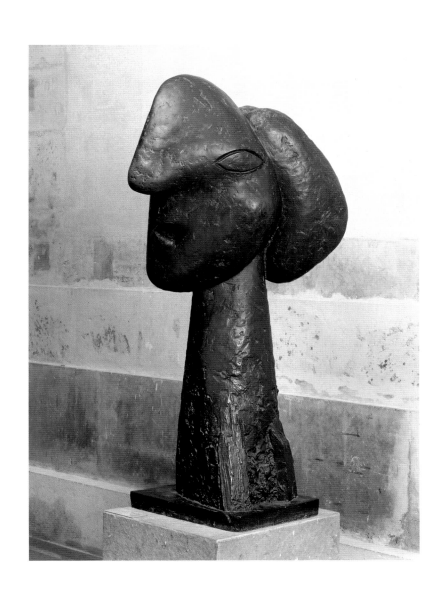

Pablo Picasso

144 *Head of a Woman (Marie-Thérèse)* 1931

Tête de femme (Marie-Thérèse)

Bronze 128.5 x 54.5 x 62.5 (50⅝ x 21½ x 24⅝)

Musée Picasso, Paris

277

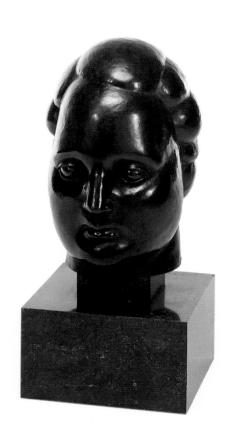

HENRI MATISSE
145 *Henriette II* 1927
Bronze 32.5 x 22.1 x 29.2 (12¾ x 8¾ x 11½)
Centre Georges Pompidou, Paris.
Musée National d'Art Moderne/
Centre de Création Industrielle.
Dation en 1991

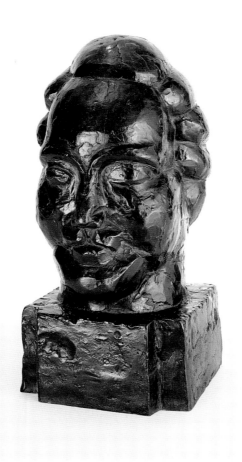

HENRI MATISSE
146 *Henriette III* 1929
Bronze 41.9 x 21.3 x 26.7 (16½ x 8⅜ x 10½)
Hirshhorn Museum and Sculpture Garden, Smithsonian
Institution. Gift of Joseph H. Hirshhorn, 1966

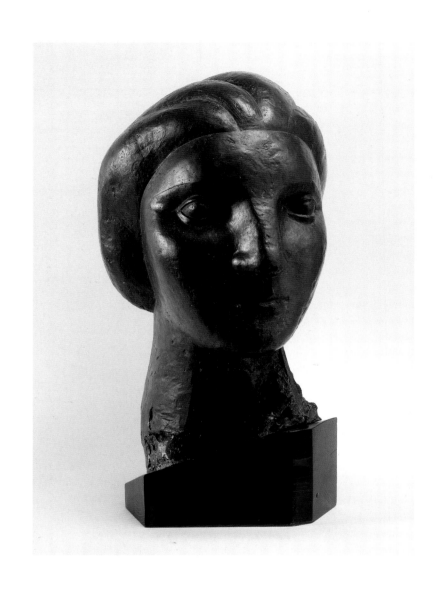

PABLO PICASSO
147 *Head of a Woman (Marie-Thérèse)* 1931
Tête de femme (Marie-Thérèse)
Bronze 50 x 31 x 27 (19⅝ x 12¼ x 10⅝)
Private Collection

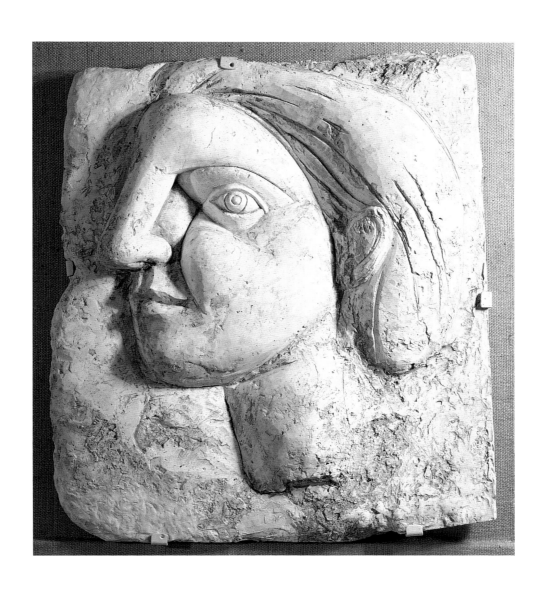

PABLO PICASSO
148 *Head of a Woman in Profile (Marie-Thérèse)* 1931
Femme de profil (Marie-Thérèse)
Plaster 60 x 60 x 10 (23⅝ x 23⅝ x 4)
Private Collection

28

Matisse's *Music* was painted in Nice in three weeks in spring 1939.[1] Before the year was over, the painting and eight in-progress documentary photographs had been published by Christian Zervos in *Cahiers d'Art,* described as the latest in a trend for modern, mural-like paintings, whose exemplars were Matisse's Barnes Foundation mural and Picasso's *Guernica.*[2] This was a topical interpretation: the City of Paris had purchased Matisse's second version of the Barnes mural in 1936, while *Guernica* had been first publicly seen in summer 1937 in the Spanish Pavilion of the Paris Exposition Internationale.[3] Before 1939 was over, *Music* was on view in the French Pavilion of the New York World's Fair, and in May of the following year was acquired by the Albright-Knox Art Gallery in Buffalo, New York. In 1941, the painting and its documentary photographs (this time, all eighteen) were published a second time, in *Art News.*[4] *Music* was again compared to *Guernica*, but not as a decorative work. Rather, *Guernica* was said to have been painted in almost as short a time and show even more alterations. 'X-rays prove that the old masters changed their minds too, but not often so materially.'[5] This was also a topical interpretation. In-progress photographs of Matisse's *Pink Nude* (no.119) had been published in 1935,[6] which may have encouraged Picasso to allow the publication, in 1937, of in-progress photographs of *Guernica*, in a special issue of *Cahiers d'Art*, whose contributors included Matisse's son-in-law Georges Duthuit.[7]

In addition to the themes of mural painting and in-progress alterations, a third theme attaches to this short history: Matisse and Picasso as very public artists, exhibiting at international exhibitions, attracting wide attention, and eliciting comparison to the old masters. This theme of the public artist readily attaches to the theme of mural painting. In-progress alterations speak of something more private, but these, too, have been introduced into the public realm – lest it be thought that fame had bred facility – to insist on the artistic difficulty of what may seem poster-like or propagandistic.

For Matisse, *Music* had an as yet private, and somewhat bitter-sweet, connotation. In the preceding winter, his nearly forty-year marriage had finally collapsed, and even as he began this painting in March 1939, his wife left Nice, which probably marks the start of their actual separation. He must have remembered that, in his earliest treatment of this musical theme, made near the beginning of his marriage, it was his wife who was playing the guitar.[8] A principal cause of the separation was Matisse's attachment to his model and secretary, Lydia Delectorskaya.[9] But it is not necessary to construct identities for the two women depicted in *Music*; the musical score and red fruit in the foreground are traditional symbols of time passing and the fealties of love.

By January 1940, the notoriously private Matisse family was finally admitting to the separa-

tion.[10] In April, Matisse was in Paris to complete the legalities, and to prepare for a month-long trip to Brazil with Lydia. But in May, leaving the travel agency, he ran into Picasso. The public world had intervened. Even as *Music* was arriving in Buffalo, German troops were crossing the Belgian border into France.[11] Talking about the catastrophe, Picasso said, 'C'est l'Ecole des Beaux-Arts!' The blame lay with the same inflexible, conservative, unimaginative aspects of French society that produced Academic art.[12] Matisse would soon decide it would be improper to leave France.[13] Two years later, in early 1942, he made his own attack on the Ecole des Beaux-Arts in a broadcast over Vichy radio. We do not know whether Picasso heard his friend railing against their common internal enemy. But we do know that Matisse and one Academician, at least, were on his mind at this time. He was making very Matissean drawings among those that prepared for a painting on a musical theme, *Serenade*, completed in Paris on 4 May 1942 – a work that recalls the Matissean motif of a reclining nude, her arms above her head, through its source in the *Odalisque with Slave* of Ingres (fig.64).[14]

In the mid 1930s, Matisse and Picasso had found common ground in Ingres's eroticism. Now, Picasso revealed the source so boldly, with life-size figures on a mural-like scale, and so disturbingly, as even to mock a hedonism now vanished in the dark days of the German Occupation. But it won't do to ascribe the painting's difficulties solely to the war,[15] for its two protagonists have plausibly been identified as representing Picasso's former and current lovers, the indolent Marie-Therèse Walter and the alert Dora Maar,[16] suggesting a domestic drama in parallel to that of Matisse's musical composition. It may be tempting to equate its visual darkness with despair, and its harshness with the 'dissonances of the world.'[17] However, a Spanish painter hardly needed a reason for using blacks or greys,[18] and an interpretation of Ingres as violent as well as voluptuous was already current in Paris, as witnessed by André Lhote's talk of how 'the Ingres-Cézanne-Cubism filiation' opened onto the 'austere violence of the new painters'.[19] Is not what Lhote calls Ingres's combination of 'voluptuous waves' with 'the constructive line' and 'mental architecture' a passable characterisation of this very painting?[20]

Also to be resisted, I think, is the idea that these two treatments of a similar theme exemplify the stereotypical Matisse-Picasso antitheses: light and dark, colour and tonality, decoration and austerity, harmony and dissonance, pleasure and unpleasure, peace and war. These are truly different, opposed works, but their principal contrast is in their pictorial space. Matisse's space is 'in preparation for something that he wants to occur . . . a space in which someone else will insinuate himself', whereas Picasso's is 'a space over which he has triumphed', being 'wrenched out of shape . . . stark and contorted, like a twisted box'.[21]

The shock of red in the Matisse holds the viewer at a distance, carefully controlling access to the pictorial space.[22] The painting has distinct parts or places, each one of a slightly different scale, to denote not its distance from the viewer but its separation from its neighbours, thus to offer a set of juxtaposed perceptual experiences, causing the viewer to look here, then there, then there. The organic upper band is one place. Another is the middle right quadrant, which holds the principal figure, but is spiky and hard to capture visually. A third is the gridded zone to the left with the diminutive figure. And the fourth is the still life zone, charged not only with

the painting's iconographic code but also with a sly reference to the still life in *Les Demoiselles d'Avignon* (no.7). Matisse said that he knew his painting was completed when he altered the direction of the legs of the woman on the left.[23] He thus opened a hidden diagonal that moves across the painting, receding in space as it rises, to overlay the push-and-pull of the four juxtaposed zones. But the other disguised stabilising device had been there virtually from the start: the vertical alignment of the sound hole of guitar and circle of the red fruit, seemingly dropped onto the coffee table beneath.[24]

The viewer of Picasso's painting is not offered the same mobility. Its space is a darkness to peer into, like searching for something under obscure circumstances in the external world. Numerous preparatory drawings asked the question, in Leo Steinberg's words, 'what sort of architecture houses (a figure that displays its) simultaneous aspects?'[25] The answer: a room that will visually transform as the figure is recognised under one interpretation then another, a room described not only by indoor space lines, which map the room, but also by lines of sight, which map its inspection, the two kinds continually criss-crossing. Hence, the room will invert, buckle, even begin to spin, when the reclining figure is seen to revolve – as if turning on an invisible spit, says Siegfried Gohr,[26] which would make a gridiron of the bed. The artist's possessive reshaping of the body reshapes her environment, once the viewer consents to search for the successive perceptual experiences that the painting provides. Straining to see, the viewer's looking is returned by a scatter of peering eyes and eye substitutes,[27] uncannily like tiny eyes in a forest. The iconography is unsettling. But it is the imagination of a complicity – the artist's and then the viewers' – in bodily and environmental control that is the more troubling. And yet, a world unmade through the exercise of power is seen to be a deconstruction not only of the made world but also of the structure of making itself – therefore capable of repair by rebuilding the structure of making. Here, the traditionally gentle, absorptive theme is the foundation on which this may begin.[28]

JE

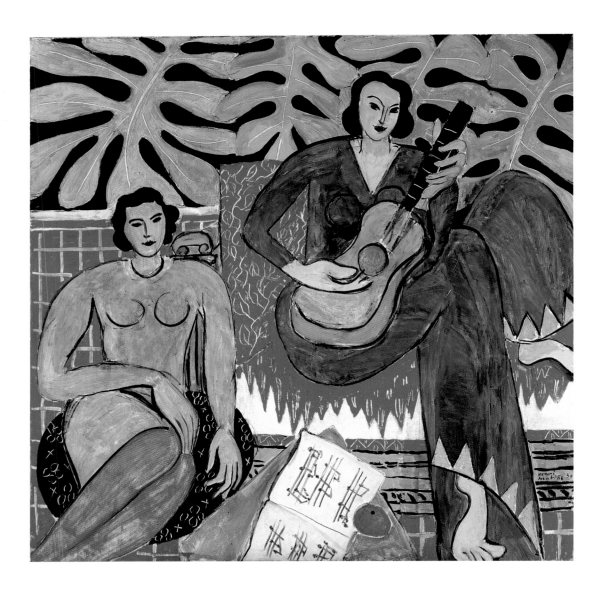

Henri Matisse

149 *Music* 1939

La Musique

Oil on canvas 115 x 115 (45¼ x 45¼)

Albright-Knox Art Gallery, Buffalo, New York.

Room of Contemporary Art Fund, 1940

Pablo Picasso

150 *Serenade* 1942

L'Aubade

Oil on canvas 195 x 265 (76¾ x 104⅜)

Centre Georges Pompidou, Paris. Musée

National d'Art Moderne/Centre de Création

Industrielle. Don de l'artiste en 1947

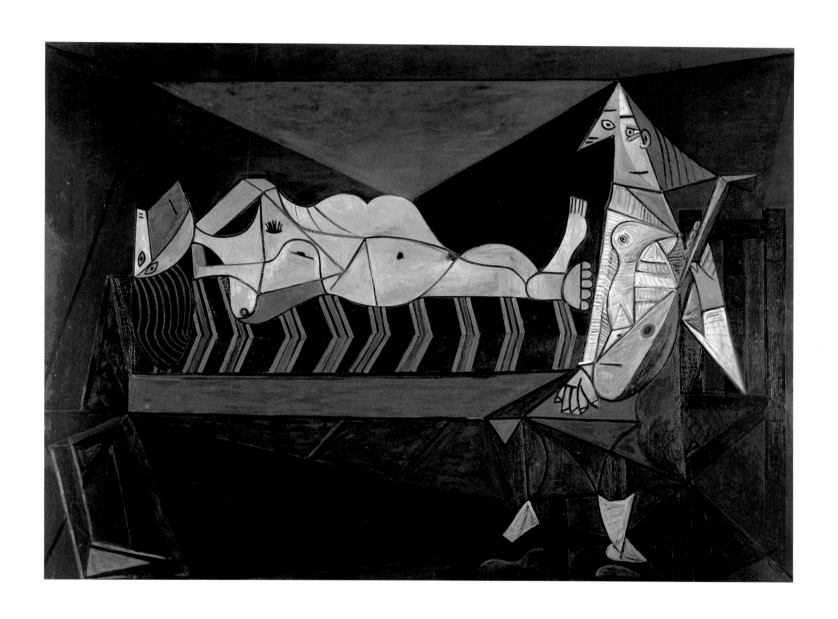

29

Although the combined effects of the Occupation and Matisse's fragile health made it impossible for them to meet, the two artists sustained a mutually supportive relationship through other means, and this formed the basis for the closer friendship of the post-war period. As we know from letters from various correspondents relaying gossip about their opinions, each derived solace from the thought that the other had remained in France instead of seeking safety in North or South America, and continued to work in his own way with unimpaired commitment. As Matisse baldly put it in a letter to his son Pierre on 1 September 1940: 'If everybody had minded his own business as Picasso and I did ours, this would not have happened.'[1]

A notoriously reluctant correspondent, Picasso did not reply directly to the handful of letters Matisse sent him from Nice during the Occupation. Or, if he did, the letters have not survived. But he did send messages via mutual friends and gave absolute proof of his admiration and solidarity by purchasing two paintings. The first, acquired from Vollard early in the summer of 1939, is a vivid proto-Fauve painting of flowers in a silver chocolate pot, datable to 1902.[2] Picasso took it with him when he settled in Royan after the declaration of war, partly no doubt in order to penetrate more fully the secrets of Matisse's genius as a colourist. A photograph shows it there hanging next to one of his latest, greatly distorted paintings of a woman in a hat.[3] The juxtaposition is like a confirmation of the distinction he drew, in conversation with Françoise Gilot, between Matisse's language of colour and what he called his 'language of construction':

The fact that in one of my paintings there is a certain spot of red isn't the essential part of the painting. The painting was done independently of that. You could take the red away and there would always be the painting; but with Matisse it is unthinkable that one could suppress a spot of red, however small, without having the painting immediately fall apart.[4]

Picasso's second, more celebrated purchase was of the sumptuous *Still Life with Basket of Oranges* (no.45) in November 1942 – an acquisition in which both artists took intense pride.

In the wake of this one-sided flurry of collecting there were two exchanges of pictures: first Matisse's fresh and charming *Seated Young Woman in a Persian Dress* of December 1942 in return for a recent, particularly grim and charmless portrait of Dora Maar – 'It's Dante confronting Hell', was Matisse's verdict; then Picasso's *Still Life with Pitcher, Glass and Orange* of 1944 in return for Matisse's *Tulips and Oysters on a Black Background* of February 1943.[5] On both occasions they apparently concurred with the judgements which had long since become a critical commonplace – Matisse the master of decorative effects and exponent of joy and serenity, Picasso the sculptural painter and exponent of passion and tragedy. The four still lifes grouped in this section spell out those differences of vision and simultaneously provide insight

into the artists' characteristic responses to what Matisse described as 'the shame of having undergone a catastrophe for which one is not responsible.'[6]

The earliest in date, *Still Life with Oysters*, was painted in November to December 1940 as a respite from the struggle Matisse was then having with the composition of another more abstracted picture, *Still Life with Shell*, which he had begun in September.[7] He reported his progress to Pierre Matisse: 'I'm painting some oysters. Quite straightforwardly, with no "arrangement". For the moment, it's somewhere between Renoir and Manet.' By 2 December significant changes had been made: 'My oysters have become captivating, like flowers . . . The painting is already a feast of colour.' In buoyant mood, he went on to describe the changes he had made to the alignment of the table in relation to the canvas stretcher, and how he had repainted the napkin 'so that it has sharp angles and corners instead of being round'.[8] These changes introduced piquant irregularities into the design, corresponding intentionally perhaps to the classic gastronomic opposition between the moist, slippery softness of oysters and the sharp tang of lemon. This feast for the stomach and the eye was no doubt also an oblique reference to the severe dietary restrictions imposed by Matisse's doctors – a subject which recurs frequently in his contemporary letters.[9] At the time, however, he had no idea how gravely ill he was; that within less than two months, like the oysters in their shells, he would be under the surgeon's knife; that the nuns nursing him in the clinic would nickname him 'Le Ressucité' (The Risen One) in recognition of how close he came to death.[10]

The contrast between Matisse's radiant and appetizing *Still Life with Oysters* and Picasso's terrifying *Still Life with a Sausage* of May 1941 could hardly be greater, and is highlighted by the remarkable coincidences in iconography, elevated viewpoint and play of shapes and forms. The traditional association of still life with a *memento mori* message predestined it as the ideal genre for Picasso during the war, and he often had recourse to familiar symbols of death and transience, particularly the skull, mirror and candle. Other paintings alluded to the severe shortages suffered in Paris by depicting delicacies, such as cherries, which had become all but impossible to get. Flayed heads of sheep, bare skulls of bulls, dead birds and ferocious knives evoke thoughts of butchery and sacrifice.

Still Life with a Sausage combines these strands of imagery, and like other masterpieces since the time of *Guernica* exploits the tragic potential of a *grisaille* palette. The makings of a hearty meal of camembert, artichokes, blood sausage and wine are laid out on a kitchen table, reputedly in the restaurant Le Savoyard,[11] which was notorious for its access to black market produce. But as the artist's daughter, Maya, has pointed out, in 1941 such a spread would have seemed hallucinatory to most Parisians – a fantasy of pre-war plenty.[12] And indeed any epicurean thoughts are instantly dispelled by the oppressively claustrophobic space, dim and ghostly lighting cast by the conical hanging lamp and, above all, by the sinister implications of the composition. Sanctioning a metaphoric reading, Picasso compared the knives and forks sticking up in the open drawer to 'souls in purgatory' and described the torture-chamber atmosphere as 'like Philip II, dark and dismal'.[13] Recent writers have pointed to the altar-like appearance of the table and the sacramental symbolism of the wine.[14] The dagger-like kitchen knife – so different

from Matisse's elegant, yellow-handled knife – has done its murderous work, slicing through the gut-like coil of sausage and the thick stems of the hand-like artichokes. There may indeed be a conscious allusion to the gruesome art of anatomy, for Picasso has closed in on the table as if he were bent over a corpse on a slab, and has disposed the interlinked objects as if they were the vital organs in an opened torso. This type of arrangement, with the neck (or head) at the top edge of the image, the genitals and upper part of the legs at the bottom, and the arms omitted, has been standard in anatomical illustration since the time of Leonardo (fig.72).[15]

Although to the casual gaze it looks spontaneous and effortless, as if painted by someone with the fresh, unsullied eye of the archetypal 'naif' or child, *Still Life with a Magnolia* required months of labour before it was completed in December 1941. When it was shown in Matisse's exhibition at the Tate Gallery in 1953 the artist lent sixty-eight preparatory studies, and several of the different states it went through are known from studio photographs, which he also made public.[16] It is tempting to see the painting as the triumphant announcement of his 'resurrection', not just because of the hallowed aspect of the pure white magnolia flower and the visionary splendour of the bright red ground – as Matisse pointed out, the real table had a green marble top[17] – but because it marks a return to the hieratic, frieze-like arrangement of *Still Life with Shell*, the very painting which had given him such difficulty exactly a year before. Unsurprisingly, some critics have felt impelled to draw analogies with sacred art: Dorival saw Christ in a mandorla surrounded by symbols of the Evangelists, as in a Romanesque tympanum,[18] Barr the Madonna flanked by four saints, as in a quattrocento altarpiece.[19]

Matisse was proud of *Still Life with a Magnolia* and gratified when it was bought for the national collection in 1945: 'For several years it has been my favourite painting', he told an interviewer. 'I believe I have given the maximum of my strength.'[20] With hindsight it can be seen as the foundation of the late Vence interiors with a saturated red ground (nos.155, 157). Picasso, however, did not like it. Françoise Gilot recalled their disagreement over its quality when they saw it in the Salon d'Automne in 1945. She was enthralled, but 'Picasso found it too decorative.' What he termed 'this juxtaposition of objects without cause-and-effect relationship' was, she adds, 'anathema to the master of Cubism. It set his teeth on edge.' But she also remembered his final, envious comment: 'Matisse is a magician, his use of colour is uncanny.'[21]

The structural differences between *Still Life with a Magnolia* and *Still Life with a Sausage* are paradigmatic of habitual differences in the artists' vision. Picasso's painting is composed theatrically in an essentially traditional Western fashion, with the table shown in raked perspective and framed to left and right, the objects modelled in three dimensions and laid out recessionally in a chain across the table-top; the composition is controlled by directional lines, with the lampshade and the top of the bottle as the apexes of two narrow, intersecting triangles. Matisse's painting, by contrast, proclaims his devotion to the flatness and all-over patterning of Islamic art, and is noticeably less Western in design than either of the still lifes by him which Picasso purchased. The photographs of earlier states indicate that, among other changes made, Matisse eliminated spatial indicators (such as the horizon line of the back edge of the table), which would have provided a rational 'explanation' of the scene. In the end he allowed the glow-

291

ing red ground to create an expansive, open space and to suggest infinity by continuing beyond the frame on all four sides. But he did not allow the objects to float free, for all except the shell overlap, or are overlapped by, the great copper cauldron which haloes the magnolia; meanwhile, the shell is pinioned by the edges of the canvas. The sensation of regular, planetary rotation is thus insinuated.

What, presumably, irritated Picasso was the creation of a complex decorative pattern through the repetition of shapes and contours – the way, for instance, the leaves of the small blue plant echo the leaves of the magnolia, the handle of the violet jug echoes the handles of the cauldron, the irregular form of the shell echoes the palmette pattern on the jar, and so on. But he was seduced by the consummate handling of colour – by the almost imperceptible shifts from indigo to black for the contours, the gentle palpitation created by the residual signs of the obliterated under-layers, and the connections (visible only at close range) set up over the entire field of the canvas through the distribution of tiny patches of the dominant hues. He, Picasso, was unable to conjure that glorious magic. But, then, Matisse could not produce apocalyptic pathos and anguish from the contents of a larder. Together, the paintings offer a vision of heaven and hell.

Contemporary with the frankly symbolic series depicting a goat skull and a burning candle, *Still Life with Flowers* is the bleakest of the still lifes with flowers Picasso constructed from found objects in Vallauris in 1951. The gaunt, spiky blooms and miserable, dried-up cakes evoke the slow attrition of starvation and the threat of physical pain. This return to the tragic mood of the Occupation is probably to be explained by Picasso's horrified reaction to the Korean war, which broke out in June 1950: *Massacre in Korea*, exhibited in the 1951 Salon de Mai, is an explicit condemnation of the war, and the *War and Peace* murals painted for a deconsecrated chapel in Vallauris the following year express his life-long pacifist convictions.[22]

Unlike Matisse, Picasso rarely painted flowers and when they do appear in his mature work it is often, as in the present sculpture, with grim irony as pathetic and broken or ugly and lethal. (In purchasing Matisse's early *Bouquet of Flowers in a Chocolate Pot* and then choosing a still life resplendent with a spray of red and white tulips, he acknowledged the fundamental differences between their tastes and gifts.) Cast in bronze, the withered flowers appear more like weapons than in their original state, where the components are easier to identify and Picasso's ingenuity steals the limelight. As a famous centre for pottery, Vallauris provided him with an endless supply of discarded pots and fire-clay kiln equipment, and he exploited the troubling associations of damage, detritus and age as well as their figurative potential. The belly of the jug in the present sculpture is a pot of the most commonplace sort; its top, neck and foot were formed from the disks and columns used in kilns to separate the wares and the cake-stand from another column and a much larger disk. (The cakes, by contrast, were modelled in plaster by hand, as if he were working pastry.) The barbed nature of the flowers is expressed physically in the objects from which Picasso fashioned them: sharp-edged metal strapping (also used for the handle of the jug), twisted wire and a handful of rusty nails embedded in plaster. The hellish devastation of war had once again provoked a supremely imaginative but also uncompromisingly materialist response.

EC

HENRI MATISSE
151 *Still Life with Oysters* 1940
Nature morte aux huîtres
Oil on canvas 65.5 x 81.5 (25¼ x 32⅛)
Offentliche Kunstsammlung Basel, Kunstmuseum

PABLO PICASSO

152 *Still Life with a Sausage* 1941

Nature morte au boudin

Oil on canvas 92.7 x 66 (36⅝ x 26)

Collection of Tony and Gail Ganz

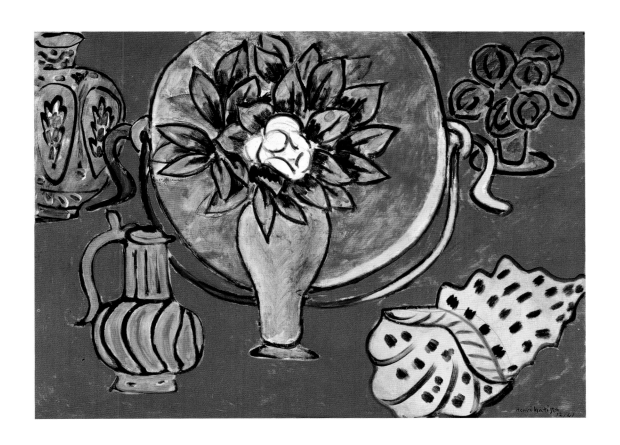

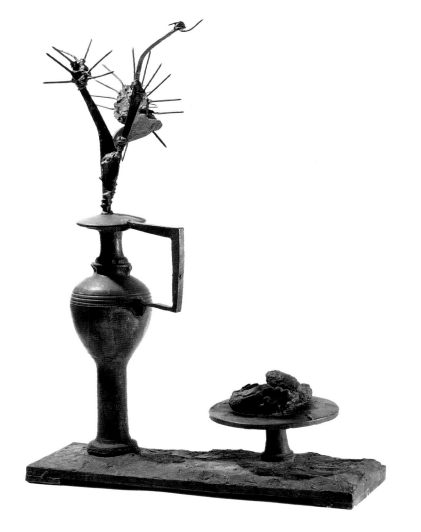

HENRI MATISSE
153 *Still Life with a Magnolia* 1941
Nature morte au magnolia
Oil on canvas 74 x 101 (29⅛ x 39¾)
Centre Georges Pompidou, Paris.
Musée National d'Art Moderne/Centre de
Création Industrielle. Achat en 1945

PABLO PICASSO
154 *Still Life with Flowers* 1953
Nature morte au bouquet de fleurs
Bronze 82 x 59 x 30 (32¼ x 23¼ x 11¾)
Private Collection

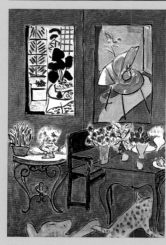

30

In 1940 Matisse's painting underwent a brief spell of crisis. In January he wrote to Bonnard, 'I am paralysed by some element of conventionality that keeps me from expressing myself as I would like to do in paint. My painting and my drawing are separating . . . my painting is hampered by new conventions of flat planes of local colour, without shading or modelling, and which must all interact to suggest light'.[1] Matisse's problems were soon resolved in works which introduced a new and final phase in his career as an easel painter.[2] *Large Red Interior* of 1948 is a work of ultimate summation; henceforth Matisse's energies were to be devoted to the Vence Chapel. The painting is also his final and definitive statement about the interrelationship between line and colour. It evokes, indeed demands, comparison with *The Red Studio* of 1911 (fig.73), the last and most daring of Matisse's great 'symphonic' interiors of that year. It depicts the studio that he had had built for himself at the bottom of the garden at the house in Issy-les-Moulineaux in 1909. From the time of Matisse's removal to Nice onwards, however, the distinction between his living quarters and his working spaces increasingly became confounded. After undergoing major surgery in 1941 he was to spend long hours of his time in bed and his bedroom, too, became a studio.

Large Red Interior shows a corner of Matisse's studio in the Villa Le Rêve in Vence, flattened out – the upright black line above the chair represents the juncture between walls but since it is discontinued in the lower half of the picture a spatial reading of the canvas is denied to us. In the culminating studio piece of 1911 the pervasive red pulses softly but insistently. In Matisse's final statement on the theme it shimmers and dazzles. The flatness of the earlier painting is subtly contradicted and informed by perspectival devices, although these are subsidiary to the overall colouristic impact. In *Large Red Interior* line and colour go hand in hand yet assert their independent existences. Perspective is implicit only in the angling of the table and seat, rendered by drawing, in black. Yet the reds soar through the furniture proclaiming the picture plane. As in the earlier picture, the reds are modulated by the freedom of the brushwork and the sensation of a subsidiary luminosity being generated from behind that has here become more insistent. Symbolically, at the top left is a bold brush drawing in black and white, while next to it hangs a brightly coloured oil, a painting within a painting.[3]

Large Red Interior is the culminating work of a group of paintings that have become known as the Vence Interiors. All of them are bold and free, seemingly effortless in their execution, but *Still Life on a Blue Table* of 1947 is one of the most daring. As in *Large Red Interior*, colour and line interact yet lead separate pictorial lives. This is also one of Matisse's last and most explicit statements on how pattern can be used decoratively, to animate the picture surface, but also by implication to suggest space and depth. To the left pattern climbs the pictorial surface steeply.

At the bottom right it zigzags backwards and after meeting the lower window edge mounts up into outer space, joining the foliage above it. In *Large Red Interior* the black outlines, rendered by brush, are tempered by paler nimbuses of pale yellow. Here the superimposed black patterning and the strips of exposed off-white act in linear partnership.

Matisse was now employing a new method of work, possibly inspired by his *Themes and Variations* drawings of 1941–2, published as a portfolio in 1943. These were executed in sets; the introductory drawing was highly worked, most often showing signs of erasure and reinstatement. The variations that followed were free-flowing and spontaneous. Some of the Vence interiors were initially blocked in as coloured studies in which compositional variants were explored. These studies were then wiped out with turpentine by assistants while the paint was still wet. Matisse would then finally repaint the canvases as freshly and directly as possible.

The Vence interiors were shown in a Matisse exhibition mounted at the Musée Nationale d'Art Moderne in June to September 1949. Picasso asked to see the exhibition just before it opened, and admired what he saw;[4] he may even have witnessed some of the works in progress. A month later, in July, an exhibition of sixty-four recent works by Picasso was staged at the Maison de la Pensée Française. At least one critic has seen some of the most recent Picassos on view as acknowledging Matisse's recent achievements.[5] Matisse himself, in his own uniquely dry and detached manner, certainly saw the Picasso exhibition as a response to his own. He wrote to his friend and confidant, Father Couturier, whom he was consulting over the Vence Chapel, 'I have read in the newspapers that Picasso is preparing an exhibition at the Pensée Française . . . In the ring we'll thus be inseparable, in Paris as well as on the Riviera. I'm awaiting his offensive.'[6]

In the years immediately following Matisse's death, Picasso produced two series of paintings concerned with studio interiors, a theme central to the evolution of Matisse's vision, and one to which Picasso turned intermittently throughout his own career. In the summer of 1955 Picasso had acquired La Californie, an ornate but not unsympathetic villa in the inland section of Cannes. La Galloise at Vallauris, which he had been occupying with Françoise Gilot and their two children, was relatively small and inadequate to his needs; after the departure of Gilot it now also had associations Picasso preferred to forget. The attractions of La Californie were threefold. It was within easy reach of Vallauris and its potteries. It was surrounded by fairly extensive grounds and had a porter's lodge, thus ensuring seclusion and privacy. Then, although La Californie was architecturally undistinguished, it had big, lofty rooms, flooded with light. The largest was to become a store room for sculpture, canvases and books still housed in the rue des Grands Augustins. As in the case of Matisse, but to a lesser extent, Picasso's domestic and working spaces tended to overlap; on the other hand, whereas Matisse's quarters were always elegant and orderly in their disposition, Picasso enjoyed a certain amount of chaos and was unconcerned with matters of good taste. At La Californie traces of previous owners' penchant for decorative flamboyance were subsumed into the house's new incarnation.

The studio paintings executed at La Californie depict in fact the withdrawing room (probably previously used for conversation, smoking and card games) off the main salon with its par-

quet floors.[7] The space was lit by three large, art nouveau windows. The first set of eleven upright pictures evolved around the theme of a plaster cast placed in front of one of these windows, and was produced within the space of eight days: 23–31 October 1955. (A twelfth horizontal picture looks forward to a second series.) The La Californie studio paintings are amongst the most overtly Matissean works that Picasso ever produced and, like the variations on Delacroix's *Women of Algiers*, can justifiably be regarded as homages to his departed friend. They are luminous but colouristically restricted; some are in virtual or inflected monochrome, relieved by small accents of colour, others are bathed in a rose light. Most are thinly painted. Picasso appears to be attempting to create an environment, a spirit to which Matisse would have responded, and this gives these pictures an elegiac cast that is rare in Picasso's work. The windows, with palm trees and foliage beyond, read like Matissean quotes. The most poignant of the first group is the one included in this exhibition. The areas of bare or lightly stained canvas on the right act as linear, structuring elements and as nimbuses of light on the left; these devices are technical acknowledgements of the admiration that Picasso felt for the Vence interiors, and here the palette sitting on the chair might belong to Matisse as much as to Picasso.

The third series of studio pictures executed at La Californie was of a very different nature. Late in the summer of 1957 Picasso moved up into the top floor of the villa, hitherto used for storage, and in great secrecy produced a series of fifty-eight paintings, forty-four of which were variations on Velázquez's *Las Meninas* (fig.74), most likely a work of 1656 and arguably the greatest and most mysterious studio picture ever to have been executed. *Las Meninas* is set in a vast chamber in the Alcázar Palace.[8] Picasso's variants on the Velázquez were spelt out by lighthearted studies of the pigeons which inhabited the dovecot outside one of the windows, and a couple of landscape or garden views. As a boy Picasso had seen *Las Meninas* on his second visit to Madrid in 1897 and had conceived a reverence for Velázquez.[9] Some forty years later he actually became custodian of *Las Meninas* when in 1936 the Spanish Republican government made him Honorary Director of the Prado at a moment when many of its treasures were being removed from the building for reasons of safety. In the autumn of 1938 Picasso undertook the journey to Geneva to see *Las Meninas*, as it happened for the last time; it was in storage there with other masterpieces from the Prado's collection.[10] It was probably after this that Picasso discussed the painting with his dealer Kahnweiler: 'What a picture! what realism! . . . What an acheivement!'[11]

Whereas the variants on *Women of Algiers* were from the start liberated and done, Picasso claimed, entirely from memory, those on *Las Meninas* were approached in a very different spirit. Hélène Parmelin, the wife of Picasso's painter friend Edouard Pignon and a frequent visitor to La Californie at this time, tells us that Picasso felt a certain anxiety and tension over this new confrontation: 'From the day the idea of *Las Meninas* raised its head, Picasso's healthy looks became ravaged . . . there was no more happiness in life, and yet complete happiness. No sooner had he left the pigeon-loft studio than he began suffering from not being in it, and the whole of life and every evening were conditioned by it. But the next day, when the time came for work, he would go up to the studio as if mounting a scaffold'.[12] Once Picasso railed against his current

mentor, 'If he were only a really intelligent painter – or even the greatest among the great.'[13] It is possible that when engaging with Velázquez at such an intensive level Picasso unconsciously resented Velázquez's supreme detachment, just as once he was at times riled by the outward serenity with which Matisse accepted life. On the visual evidence alone he must almost certainly have had a reproduction of *Las Meninas* in his hideout at La Californie.[14]

The first painting of the series, dated 17 April 1957, is the most faithful to the original, although it is horizontal rather than vertical in format. In it Velázquez himself looms large, a giant of a painter in every respect. Subsequently he appears only from time to time, and as an ordinary mortal, but most often preferring to hide behind the enormous picture on which he is at work and which we see from the back. There followed smaller variations concentrating on single figures or details; and here there are analogies with Matisse's methods in his *Themes and Variations,* although the freer canvases are interspersed with those that are more intricately worked. The work included in this exhibition comes more or less in the middle of the series and was painted on 19 September. Together with the more elaborate painting that followed on from it these two upright canvases were the second largest in the series. This particular canvas is one of the most reductive of the pictures that refer to the totality of the composition of *Las Meninas.*

It is somewhat sketchily painted and was almost certainly executed in a single day. The dominant reds and blacks relieved by yellows, blues and greens recall Matisse's palette in *Large Red Interior.* But whereas in the Matisse colour is harmonious, and despite its brilliance, serene, Picasso's colour is regal but acid, in keeping with the angular severity of the composition, and archetypally Spanish in effect. Commentators have remarked on the humorous aspect of some of the *Meninas* canvases, but the series as a whole has about it also a certain controlled ferocity, conveyed in part by spatial tensions which are absent in Picasso's *Women of Algiers,* and which are here manipulated in a latter-day variant of Cubism. The coupled figures of the tutors, male and female, beyond the Infanta and her own small court, now rendered in black and white, have been embedded into the architecture behind them and hence appear as pictures within a picture. The mirror in the Velázquez, in which we see reflections of the King and Queen, is reduced to an abstract red square. It is worth remarking that at La Californie, in what was known as 'Jacqueline's Salon', there hung a 'trick' mirror, which distorted shapes and spaces in various ways when looked into from different positions.[15] From the very beginning Picasso had substituted his daschund Lump for Velázquez's noble bloodhound. Here, in his handling, Lump bears a startling resemblance to the leopardskin rug which occupies the same pictorial position in the Matisse. Yet what is most revealing about the confrontation is that whereas Matisse is simultaneousy detached from and yet totally immersed in a domestic and studio situation that belonged only to himself and to an internalised vision of the world that he had evolved over a very long lifetime, Picasso has begun to raid the studios of the past. Henceforth, and most notably in his graphic work, his art was to become increasingly pageant-like, part of a vast, ongoing visual *theatrum mundi.*

The visual tributes Picasso paid to Matisse in his work of the second half of the 1950s are in some respects a form of mourning. Yet in a curious way Picasso also resented Matisse's death,

and this may help to account for the fact that while his own dialogue with the past was becoming ever more overt his own art was simultaneously becoming more internalised. During 1963 and 1964 he concentrated on the theme of the studio, the artist and his model, so dear to Matisse. In these works Matissean references recede and are subsumed into a sense of the totality of art which comes flooding through Picasso's vision as never before, and most markedly in his graphics. It was only in his final phase of sculptural activity that Picasso once more felt the need to interact with his departed friend.

JG

HENRI MATISSE

155 *Red Interior: Still Life on a Blue Table* 1947
Intérieur rouge: Nature morte sur table bleue
Oil on canvas 116 x 89 (45⅝ x 35)
Kunstsammlung Nordrhein-Westfalen, Düsseldorf

PABLO PICASSO
156 *The Studio at 'La Californie'* 1955
L'Atelier à 'La Californie'
Oil on canvas 116 x 89 (45⅝ x 35)
Centre Georges Pompidou, Paris. Musée National
d'Art Moderne/Centre de Création Industrielle.
Donation de Louise et Michel Leiris en 1984

HENRI MATISSE

157 *Large Red Interior* 1948

Grand intérieur rouge

Oil on canvas 146 x 97 (57½ x 38¼)

Centre Georges Pompidou, Paris. Musée National d'Art Moderne/

Centre de Création Industrielle. Achat à l'artiste en 1950.

Fonds national d'art contemporain

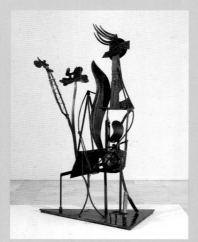
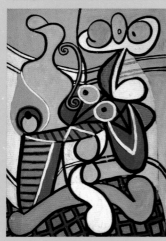
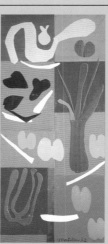

31

'It is my misfortune – and probably my delight – to use things as my passions tell me. What a miserable fate for a painter who adores blondes to have to stop himself putting them into a picture because they don't go with the basket of fruit! . . . I put all the things I like into my pictures. The things – so much the worse for them; they just have to put up with it.'[1] This statement by Picasso to Christian Zervos reveals not only his impatient will to possess everything he loves, but his *modus operandi* as well. This compulsive game comes to a paroxysmal head in *Large Still Life on a Pedestal Table*, in which the unstable collection of objects threatens both the organisation of the painting and the voluptuousness of the contemplative posture usually associated with the 'still life' genre. The springs of a helicoid dynamo spread up the central axis of the painting and, on all sides, the objects indeed must 'put up with it'. The shock wave of this 'uncontrollable biological growth'[2] hits the spheres of the composition which rebound in zig-zags off one another in the painting's angles. The 'blondes' are not forgotten for all that, since Pierre Daix reports that 'Picasso, by running his finger over the canvas and following the rhythm of the still life, could pinpoint the curves of Marie-Thérèse.'[3] Thus, with a staccato tempo, the shapes interfere with one another, becoming in turn eye, apple, breast, dish, pitcher, hip. The verticality of the painting, the elaborate column of the pedestal table, and the long neck of the pitcher, have also been interpreted as male emblems.[4] Already in the mid-1920s series of encrypted portraits of his mistress, Picasso had inscribed his own presence by a cut-out profile or by his initial P allied to the M and T of her first name.[5] This ritual acronym takes on the graphic form of the chrism, a monogram standing for the call of the gaze.[6] *Large Still Life on Pedestal Table* replaces the austere geometry of this lettering with a sinuous curvilinearity, a crypto-pictogram in which a vocabulary of forms arises out of the hidden: 'The painter must name. If I paint a nude, you must think: it's a nude.'[7] Thus, as he had done with Eva, whose pet name 'Ma Jolie' can be read in his 1912 paintings, Picasso found with Marie-Thérèse a way to 'name' where saying was impossible. It is this secret consciousness that the spectator finds so exalting: to be given by the artist, backhandedly as it were, 'the means to paint the nude with his own eyes'.[8] This double-intentioned gaze, first swept up by the subject, allowing for free associations to occur, would thus be the very gaze of the painter contemplating his object. The same gaze that Matisse 'the Professor' had staidly theorised for his students as the empathetic method, and that Picasso would make his own by painting his favourite model under all the appearances of things: 'You must not see the parts so prosaically that the resemblance of this calf to a beautiful vase-form, one line covering the other as it were, does not impress you. Nor should the fullness and olive-like quality of this extended arm escape you.'[9]

'In painting, things are signs: we used to say emblems before the First World War . . . What

would a painting be if not a sign?'[10] Picasso is opposing against the naturalistic imitation of the object a visual language that, like the word, designates rather than represents.[11] The separation between the painted thing and its referent must be maintained if painting is to occur: 'It's like the case of slang: when you say "gimmick" or "thingumajig" you break open the petrified word to give it many other poetic significations.'[12] This role as inventor of signs was quite early assigned to Picasso,[13] but the figural transparency of Matisse's work, the evident sensuousness of his pictorial means, the primacy given to colour, have all tended to disqualify the semantic import of his work. Matisse, in fact, makes the claim as staunchly as Picasso: 'The importance of an artist is to be measured by the number of new signs he has introduced into the language of art.'[14] The statement is contemporaneous with the invention of the gouache cut-outs which would enable Matisse to consider line and colour simultaneously and to embody anew a project conceived in 1909: 'It is a question of learning – and perhaps relearning – a linear script.'[15] Apollinaire had understood from the beginning that this conjunction was the motor of his art: 'Henri Matisse scaffolds his conceptions, he constructs his paintings by means of colours and lines so as to impart life to their combinations, until they become logical wholes, constitutive of a closed composition with every colour and line so essential to its unity that all other combinations would appear fortuitous.'[16] This commentary applies just as well to the large cut-outs *Zulma, Creole Dancer* or *Vegetation*. A shared visual philosophy bridges the two-decade gap between these compositions, especially *Vegetation*, and Picasso's still life. Both works are symmetrically divided vertically, and compartmentalised to enclose motifs reduced to a generic vocabulary of orbs, ova and palm-leaf shapes. Despite the optical distortion of *Large Still Life on a Pedestal Table*, the background patterning and object-outlining intertwine to mark off something like a jutting nexus: the foveal zone wherein the gaze can make out the image of Marie-Thérèse.[17] Such an attraction increasing the pressure in the centre of the painting is absent from Matisse's composition, which devotes itself totally to a subtle atonal exercise. And yet the accidents along the edges of the cut-out, imperceptibly substituting fruit for leaf or misaligning the rectangles in the background, could be seen as quivering suspensions of the line, each time in transgressive pleasure, an infringement of the colour. Matisse refers here to 'vibrant space'.[18] In *Large Still Life on a Pedestal Table,* however, the dense regular line, black or white depending on its passage from shadow to light, actually refutes all sensitive expression. It is the amorphous link that incidentally grounds 'the image in the carpet', the unconscious efflorescence of pictorial activity. This enclosed graphic style characteristic of Picasso's anthropomorphic still lifes of the 1930s,[19] had been developed before as a tool to do away with the modelling of the 'neoclassical' period of his work. Expanses of a colour more symbolic than descriptive are set off in this theoretical contour, in a black colour which will no longer be used to make the 'beholder believe that "it turns"'.[20] It is no longer black as a colour, but black as a line of a thoroughly instrumental quality, the equivalent of the body or the boldness of the typographic letter; this black is to be read from the start two-dimensionally, graphically – as a discriminating mark. Paradoxically, this over-lining questions colour in exactly the same way as the non-line in Matissean cut-outs. Matisse and Picasso experiment with a new figure/ground dialectic, totally artic-

ulated around the superimposition of flat expanses of uniformly applied colour, on their juxta-position, their harmony, their contrast. For both artists, the two pairs of complementary colours, red/green and purple/yellow, exchange places and oppose each other only to reach the critical phase of chromatic virulence. The symbolic polarities of man/woman in *Large Still Life on a Pedestal Table*, air/fire and water/earth in *Vegetation*, give still more dramatic impact to this discordance. Here and there, white fragments with geometric edges underscore the composition. The signs for objects grasp the underlying grid as would the tendrils of a vine, the serialism of the motifs and their vegetal and organic connotations meet to make these two paintings a common celebration of generative life.

At this stage, Matisse limited his work of cutting out and collage to an interior surface, equal in quality over its total expanse, quadrangularly set off from the wall and surrounding space. If in this respect these three works still align themselves with the spatial coordinates of the painting, each denotes the will to go beyond their boundaries and could indeed represent one of the stages of an emancipation of signs. 'With greater completeness and abstraction, I have attained a form filtered to its essentials and of the object which I used to present in the complexity of its space, I have preserved the sign which suffices and which is necessary to make the object exist in its own form and in the totality for which I conceived it.'[21] *Zulma* erects the grand standing figure of a nude in a dressing gown leaning on two pedestal tables, in which a simple procedural transfer of the visual universe of the large Vence studios, painted between 1943 and 1948, can be observed. '*Zulma* was done as a painting in gouache cut-outs . . . The colours of freedom come tranquilly to recline in the bed prepared by a drawing which has not given up on perspective',[22] comments Pierre Schneider, insisting on the reappearance of the 'figure of the woman' in *Zulma* and the *Creole Dancer*. The partition of shadow and light at the heart of *Zulma*'s composition will in *Vegetation* be systematised into an arbitrary chromatic grid. Doubled up by the random distribution of signs – fruit, trees, leaves – this composition achieves a perfectly decorative monumentality. *Creole Dancer* disturbs the geometric patterning, placing the representation of the figure in the sway of the rhythmic logic of the cut-out and above all opening a gape on its left side. Thereby the gouache cut-outs can henceforth 'take flight', invading the space of the wall, the bedroom, the studio, imposing themselves in the freedom of their own language: 'Space has the dimension of my imagination,' claims Matisse.[23] From the imaginary space of his paintings, punctured with windows, haunted with covers, rugs, and hangings, comes the principle of an ornamental chequerboard on which the gouache cut-outs will attain to that plastic legibility especially manifest in the sketches for *Polynesia, Sky and Sea*.[24]

Picasso's emancipation takes a different tack. In autumn 1928, Christian Zervos describes the artist 'picking up a piece of wire off the ground and bending it between his fingers, while sustaining the conversation'.[25] In the paintings of that summer, the artist had wanted to rethink the question of the sign in painting, its autonomy before the real. Sculpture in this process would become the instrumental detour. 'The most important word', says Picasso, 'is the word *tension*. A taut line should not even vibrate: should no longer be able to'[26] This structural quality of the line, blocked at its extremities by its tension, is the principle of the iron sculptures

Picasso undertakes in the company of Julio González. The latter comments: 'the essential lines, these pencil strokes on the canvas (treated as false painting, fantasy painting), purely sculptural in conception and realisation, one day Picasso replaced them with iron bars positioned to interpret the subject of one of his paintings; then he welded them, so as to obtain the maximum level of expression.'[27] The line running through the painting is, thanks to its metal analogue, the very line constructing the sculpture: 'By means of a piece of wire, he first of all makes a drawing of his sculpture, then enlarges it to take on the cast-iron slabs.'[28] Here too, as Zervos testifies, the question is one of a script that 'names' more than it represents. If in 1908, Picasso was able to say to González that his paintings 'would only have to be cut out' then to be 'assembled following the indications given by the colour' to obtain sculptures,[29] it would seem that conversely, the scriptorial potential of his painting during the period 1925–8 may have induced the need to reduce sculpture to linearity, to remove its volumetric compactness so as to call into play the very qualities of space: transparency, fluidity, reversibility. 'Then making his fondest dream come true', Picasso would have reached the point from which form 'can be seen from everywhere'.[30]

Woman in the Garden[31] is one of the major works implementing this definition of the sign by and in space. Conceived as one of the projects for a *Monument to Apollinaire*, it was, according to González, to be seen both as 'the statue of a woman' and as 'a symbol of Peace'. The erection of the sculpture took place by using a scaffold of metal bars found on a scrapheap then bolted and welded together in the laughter[32] arising out of each abrupt '*coq-à-l'âne*'.[33] Mane, flower, flame, plant life illustrate, punctuate and decorate this geometric edifice raising the triangular sign of an excavated pyramid. 'Profound sculpture made out of nothing, like poetry or glory' as Apollinaire had dreamt it.[34] Painted white by Picasso, in its original version,[35] still more matter is lost revealing the sign of its secret existence only in the fantastic shadow projected like a ghost on the wall.[36]

In addition to this procedural analogy between the cut-out sheet metal of this 'openwork sculpture'[37] and Matisse's cut-outs, the two artists share an irrepressible desire to dissolve in the same procedure the antagonism of line and form (for Picasso), line and colour (for Matisse). The solution to the antagonism is to be found in their mutual and untimely jettisoning of the major Western paradigms of the artwork: ground/figure, frame/support, reality/representation. For Picasso, the result is a three-dimensional meshed graphic system in which the eye captures the erratic arabesque of a fleeting, vacillating image. With Matisse, there are pieces of light paper, vivacious and slim like prismatic blades. 'These successive flights of pigeons, their orbs and their curves slide over me as in a huge interior space. You cannot imagine to what extent, in this period of the cut-outs, the feeling of flight which occurs within me helps to better adjust my hand as it guides the trajectory of the scissors.'[38] In both cases, the artist conquers an open, immaterial, pneumatic space in which signs light up and disappear with equal evanescence, shot through as they are by sensation only, freed from the weight of 'plastic means', free to wander in search of the grace of a gaze.

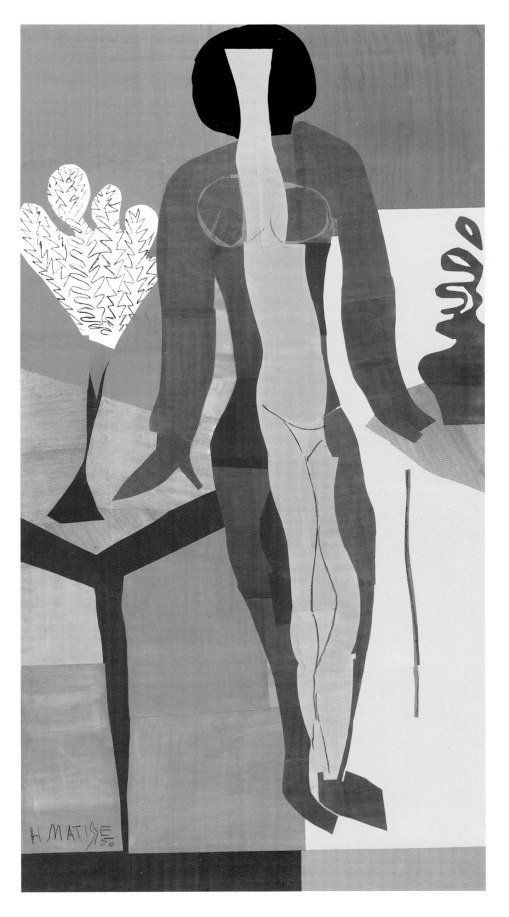

Henri Matisse
159 *Zulma* 1950
Gouache on paper, cut and pasted on
paper, and crayon 238 x 133 (93¼ x 52⅜)
Statens Museum for Kunst, Copenhagen.
Johannes Rump Collection

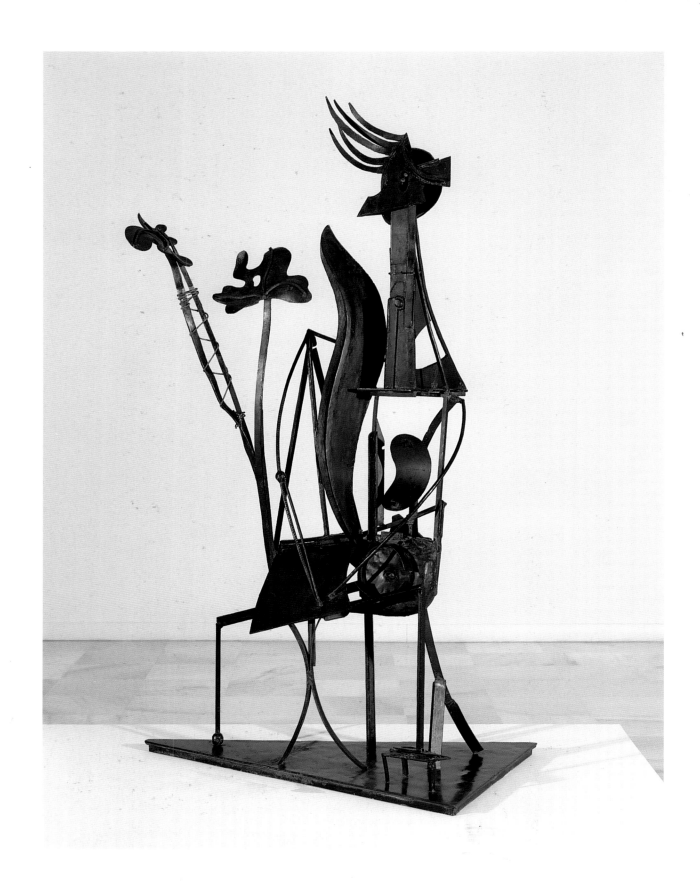

PABLO PICASSO

160 *Woman in the Garden* 1931–2

La Femme au jardin

Bronze 209.6 x 116.8 x 81.3 (82½ x 46 x 32)

Museo Nacional Centro de Arte

Reina Sofià, Madrid

HENRI MATISSE

161 *Creole Dancer* 1950

La Danseuse Créole

Gouache on paper, cut and pasted on

paper 205 x 120 (80¾ x 47¼)

Don d'Henri Matisse, Collection

Musée Matisse, Nice

PABLO PICASSO

162 *Large Still Life on a Pedestal Table* 1931

Grande Nature morte au guéridon

Oil on canvas 195 x 130 (76¼ x 51⅛)

Musée Picasso, Paris

HENRI MATISSE

163 *Vegetation c.*1951

Végétaux

Gouache on paper, cut and pasted on

paper 174.9 x 81 (68⅞ x 31⅞)

Private Collection

315

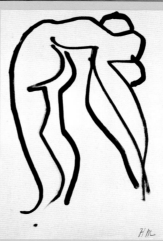

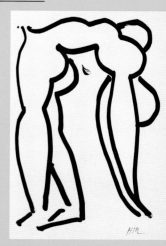

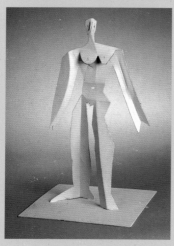

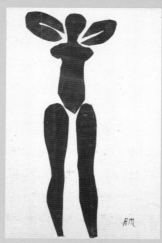

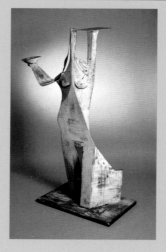

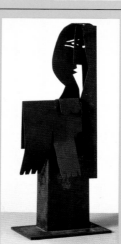

32

Between 1925 and 1932 Picasso launched his most concentrated assault on the human form, distorting it in an astonishing variety of ways. He was partaking of the Surrealist ethos which he himself had helped to create, and was experiencing stimulus from a welter of new sources. The Surrealists' enthusiasm for tribal, 'primitive' and exotic art far exceeded in its range, if not in its importance, the interest in 'art nègre' experienced by artists earlier in the century. Prehistoric and in particular Neolithic art, for example, were now experiencing a vogue. The Surrealists were fascinated by the idea of art as a sign language,[1] and to André Breton and his cohorts the systems of graphic notation evolved by Picasso in his pre-war Cubism remained a source of wonder.[2] Much of Picasso's work during the years of his association with Surrealism was profoundly, and at times even aggressively volumetric. But he was simultaneously evolving a new linear sign language with biomorphic and sexual implications.

On 1 January 1928 Picasso produced one of his most strikingly reductive images. His large *Minotaur* consists of a pair of muscular, striding legs surmounted by a bull's head, all rendered calligraphically, and overlaid on two pieces of cut and pasted paper.[3] The paler of these stands proxy for the monster's trunk, the second, jagged and blue, suggests his sexual potency. The Minotaur was to become a leitmotif in Picasso's graphic work of the 1930s, appearing often as his alter-ego. During 1929–30 Picasso produced a handful of related canvases of acrobats and swimmers (as opposed to bathers, which become legion and more often rest or disport themselves on beaches). Like their mythical antecedent, the Minotaur, they are weightless and defy gravity, and they consist almost entirely of limbs and heads, dispensing with the centrality and bulk of their bodies thus rendering them strangely – and uncharacteristically for Picasso at this time – asexual. All these images evoke comparison with Easter Island hieroglyphs (fig.75).[4] Picasso's creations are unusual in his art in the way in which they acknowledge the canvases' outer edges, at times appearing almost to touch them. Coincidentally, in 1931–2 Matisse filled a sketchbook with notations of acrobats and dancers, executed in connection with his work on the Barnes Murals.[5] But like Picasso's acrobats they are important for an understanding of the obsession which both artists in old age came to feel with the necessity of producing what Matisse designated as 'signs'.

The extreme distortions employed by Matisse in his own *Acrobats* of 1952 are rare in his art. The Matisse invites comparison, too, with Picasso's great *Minotaur* in terms of scale and colour and the use of cut and pasted paper. After major surgery undergone in 1941 Matisse had become a semi-invalid and *papier découpé* became to him an increasingly important medium that was to dominate the last ten years of his life. Assistants coloured sheets of paper for him in gouache (opaque watercolour), and he then cut into them with large, shear-like scissors. Subsequently

the assistants would place the cut-out shapes against surfaces waiting to receive them – walls or large pieces of paper attached to them – while Matisse directed operations, often from a chair or even his bed – hence the stop-watch precision of compositional arrangements. Although Matisse never ceased to find his inspiration in nature, in perceived reality, his new working methods forced him increasingly to rely on visual memory and to adopt a more conceptual approach towards his art. Matisse would now ponder upon his motif, extract from it what he felt to be its essence and then produce its 'sign'. He said, 'The cut-out is what I have now found the simplest and most direct way to express myself. One must study an object a long time to know what its sign is'.[6] Simultaneously, as he worked surrounded by fragments of cut and shaped paper he began increasingly to make use of what might be described as negative shapes, of the scissors' initial rejects. To this extent he was exploiting shapes, and with them images, arrived at fortuitously.

In his cut-outs Matisse saw himself as drawing directly into colour: 'drawing with scissors on sheets of paper coloured in advance, one movement linking line with colour, contour with surface.'[7] The later blue-and-white cut-outs introduced a further dimension into Matisse's use of the medium in that he clearly saw them also as surrogate sculptures.[8] The light backgrounds are flat and unmodulated; and while the blues in Matisse's earlier works had almost invariably been spatial they are now tangible and monolithic in feel. Most of the blue-and-whites deal with the single nude figure, sculpture's archetypal concern. *Acrobats* is amongst the most daring of all the cut-outs, but also technically one of the most revealing owing to the different handling of the two figures. The configurations of the one to the right have been reached additively, by piecing together and overlapping fragments of blue paper, a process akin to modelling, adding and removing bits of moist clay. The ghost-like traces of drawing behind indicate that Matisse had initially experimented with alternative poses or positions, working much in the way that he had on the different versions of the Barnes murals. The acrobat to the left is marginally less distorted and crackles with a different sort of vitality. Here the scissors clearly sped through the blue paper at high voltage, and the figure gives the impression of having been carved, incised. 'Cutting straight into colour reminds me of the direct carving of the sculptor', Matisse declared.[9] His dazzling folio *Jazz*, published in 1947, had contained images of circus performers and Matisse was to refer to himself on several occasions as a juggler, an acrobat and a tight-rope walker. Like Picasso's, Matisse's *Acrobats* defy gravity.

Four *Blue Nudes* preceded the *Acrobats* and initiate the blue and white *papiers découpés* which as a series belong to 1952, a prodigious year for Matisse. The *Blue Nudes* are the most truly sculptural in that the figures all sit or squat in poses that involve or imply foreshortening. They appear anchored downwards, although they have about them simultaneously a floating quality. In their distortions they evoke comparison with the sculptures produced by Matisse in the early years of the century. *Blue Nude I*[10] is the weightiest and most fully resolved of the series. Despite the whiplash vitality of the figure's contours and of the white support where it is miraculously made to read as line, defining and reinforcing the body imagery, this is the most sensuous image within the group. Of all the *Blue Nudes* she is most truly an odalisque. She is

complemented by *Flowing Hair*, a piece of visual alchemy which renders the corporeal as weightless. 'When I am doing the cut-outs', Matisse said, 'you cannot imagine to what degree the sensation of flight which comes to me helps me better to adjust my hand as it guides the path of my scissors'.[11] Matisse's most memorable image of flowing hair is perhaps to be found in his illustrations to Mallarmé; but this work also pays indirect tribute to Baudelaire, the poet with whom Picasso always associated Matisse.[12] While Matisse was at work on the *Blue Nudes*, he was also involved in one of his most rhapsodic mural projects and it has been suggested that each of the *Blue Nudes* was in turn considered for inclusion in *The Parakeet and the Mermaid* (also of 1952 and now in Stedelijk Museum, Amsterdam).[13] But in her final form the mermaid is closest in her configurations to *Flowing Hair*; the bird inhabits the air, the mermaid, by implication, the water.

Photographs show Matisse's two complementary silkscreen wall hangings, *Oceania, the Sky* and *Oceania, the Sea* of 1946, (achieved through the use of cut-outs), adorning walls of the apartment he kept in Paris, united by improvised cut-outs above the doors that separated them, an indication that Matisse was increasingly coming to see decoration as a form of total environment. With his work on the Vence Chapel behind him, his interior surroundings at the Hotel Régina in Nice became his 'gardens', a working paradise of coloured shapes and 'signs' of nature. The blue-and-whites find their ultimate expression in the two mural panels of *The Swimming Pool*, now in New York's Museum of Modern Art, latter-day aquatic counterparts to his *Dance* and *Music* murals of 1910. Over the internal doorways that separated them when installed at the Hotel Régina Matisse placed *Women and Monkeys* (Ludwig Museum, Cologne), the monkeys having been added to an earlier version of the composition in order to fit their new architectural setting.

The final phases of Picasso's activity as a sculptor relate him yet again to Matisse in that they involved the use of scissors and paper. Picasso had watched the evolution of Matisse's *découpage* with fascination. It has also been suggested that his own use of cut-outs in photographic paper, executed in 1954 in collaboration with André Villiers, may have influenced him in the creation of a new kind of planar sculpture.[14] It was also in 1954 that he created the first of his bent metal heads, executed from cardboard models by assistants in a workshop just outside Vallauris. These were returned to him for linear and sometimes colouristic embellishment.[15] A second group of heads of 1957 are raised on circular shafts or elongated angular plinths that give them a totemic appearance. The reductive boldness of the markings of eyes, mouths, nostrils and ears, which designate these 'signpost' sculptures as human heads, has an affinity with the new pictorial language that Picasso was employing in his paintings of the late 1920s and underlines his renewed compulsion to create a new, abbreviated sign language. He confided to a friend close to him at this time: 'What is necessary is to name things. They must be called by their name; I name the eye. I name the foot. I name my dog's head on someone's knees . . . To name. That's all, that's enough'.[16] Earlier, Matisse had stated to the poet Louis Aragon: 'Each thing has its own sign, the discovery of this marks the artist's progress in the knowledge and expression of the world, a saving of time, the briefest possible indication of the character of a thing'.[17]

In November 1960 Picasso visited the factory at Vallauris where his earlier sheet-metal pieces had been produced. It was now occupied by Lionel Prejger and his associates in a business venture involved in the manufacture of conical metal tubing. Picasso suggested that they work together.[18] The collaboration produced the finest of Picasso's last sculptures. The archetypal instance of Picasso's ingenuity in envisaging future sculptures in two dimensions must surely be *The Chair* of 1961. Prejger recalled that on one of his almost daily visits to Picasso he saw an odd, tentacular shape drawn in charcoal on a huge piece of wrapping paper. 'That's a chair', Picasso explained, 'and do you see its an explanation of Cubism. If you imagine a chair that's been under a steamroller it would look like that'.[19] Needless to say, cut and folded the octopus-like sketch was transposed into a convincing and totally memorable piece of furniture. In its originality and versatility *The Chair* rivals the two giant constructions of musical instruments of 1915 and 1924 (no.78), both now in the Musée Picasso in Paris.

The years 1961–2 were to be for Picasso amazingly fertile in terms of his bent and folded sculptures – some 120 were produced, mostly under the supervision of Prejger. Some of these are merely playful, but the most ambitious and fully realised evoke at a distance Matissean echoes, if only because of their apparent weightlessness, a sensation which is reinforced by the fact that mostly they were painted in pure, matt white by Prejger's workmen. *Woman with a Tray and a Bowl* calls to mind at once the serving girl in Picasso's own variants of Delacroix's *Femmes d'Alger* of 1955 (nos.178–80), in themselves tributes to Matisse.[20] *Standing Nude (Bather)* (no.171) of 1960 or 1961 finds affinity with Matisse's equally frontal *Standing Blue Nude* (no.172). In both the scissors' thrust is palpable. Matisse's *Venus* of 1952, one of the last of his blue-and-whites, is his ultimate statement of the interplay between positive and negative shapes and forms. This was an aspect of painting and sculpture that had fascinated Picasso in the early years of his Synthetic Cubism, but which had failed to interest Matisse in the succeeding years when he had recognised that he must engage with Cubism in order to further and enrich his own art. It was only in his years of *découpage* , as temporarily unwanted or negative shapes fell away from his scissors onto the floor, that he began to recognise their potential. *Venus* is present by her absence, defined by the contours of blue paper to her sides; her lower limbs flow across and up into the white background, pressing the blues back into space. This was a language which had fascinated Picasso in his sculptural career from 1912 onwards. It found one of its final and most complex and subtle expressions in the late *Heads* of 1961. And if Matisse's blue-and-white *papiers découpés* are in a very real sense surrogate sculptures, so Picasso's white bent and folded metal sculptures aspire to the condition of painting. The folded metal figures define a shallow space and do so discreetly; these are sculptures retreating towards the wall. Like Matisse's acrobats and swimmers they are levitational and bear no trace of the anguish which was to inform so many of the paintings which succeeded them.

JG

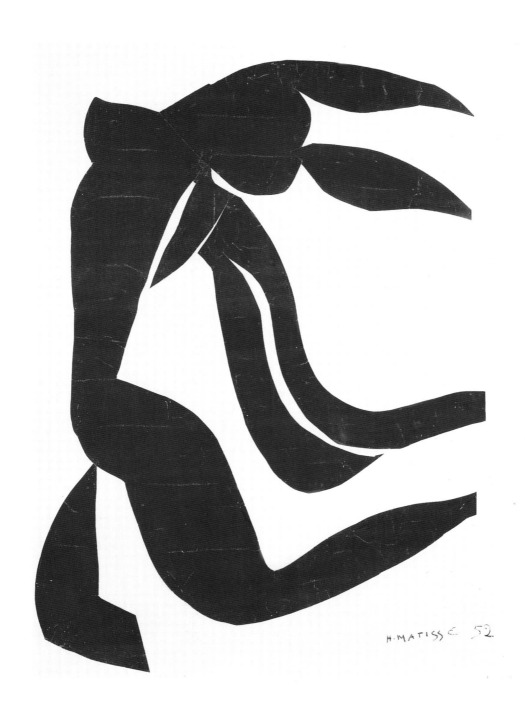

HENRI MATISSE
164 *Flowing Hair* 1952
La Chevelure
Gouache on paper, cut and pasted on paper
108 x 80 (42½ x 31½)
Private Collection

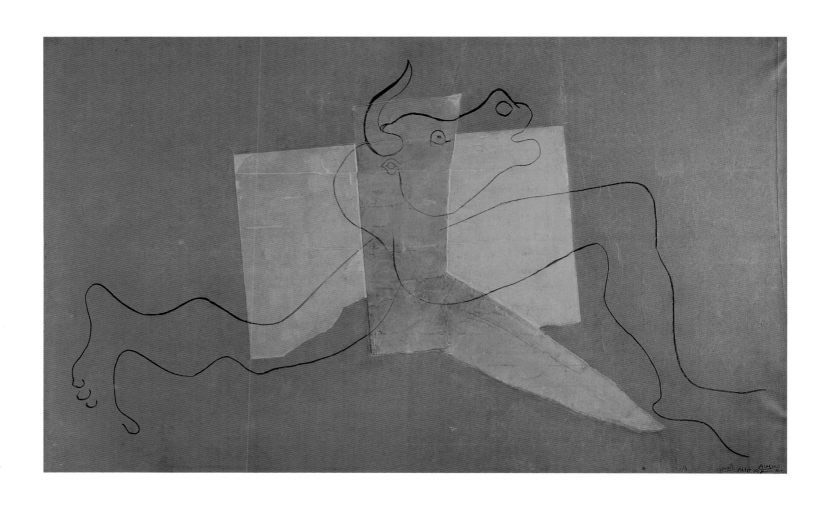

PABLO PICASSO

165 *Minotaur* 1928

Minotaure

Papier collé on canvas 142 x 232 (56 x 91³⁄₈)

Centre Georges Pompidou, Paris.

Musée National d'Art Moderne/Centre de Création Industrielle.

Donation de Marie Cuttoli (Paris) en 1963

HENRI MATISSE

166 *Acrobats* 1952

Acrobates

Gouache on paper, cut and pasted, and

charcoal on paper 215 x 210 (84 x 82³⁄₄)

Private Collection

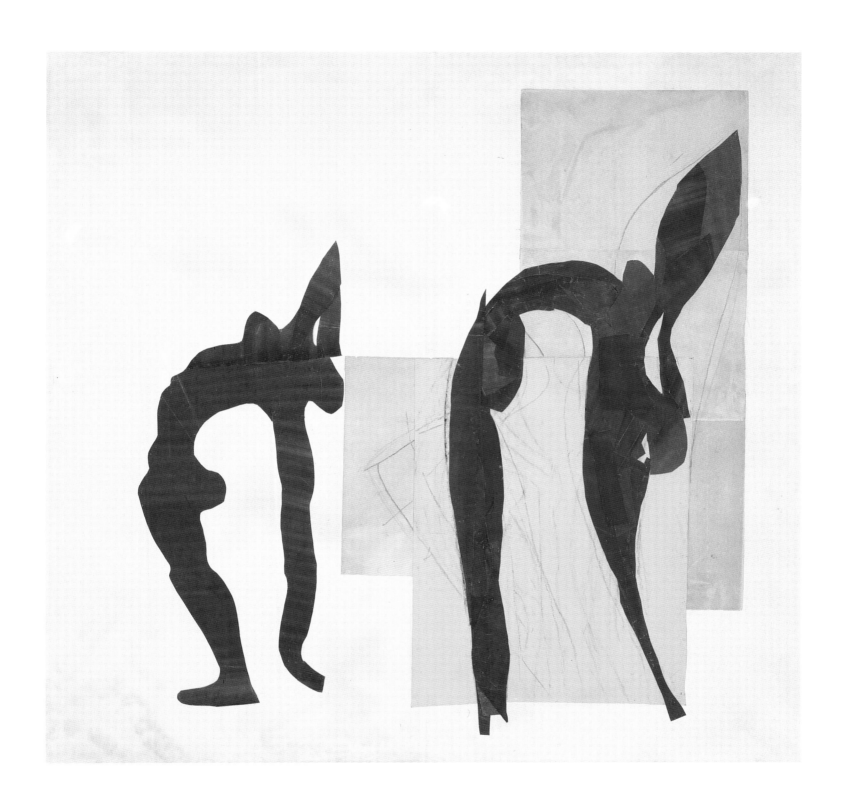

Pablo Picasso
167 *Acrobat* 1930
L'Acrobate
Oil on canvas 162 x 130 (63¾ x 51⅛)
Musée Picasso, Paris

Henri Matisse

168 *Large Acrobat* 1952

Grande Acrobate

Brush and ink on paper

105 x 75 (41³⁄₈ x 29¹⁄₂)

Direction de Musées de France,
donation Jean Matisse. Dépôt de
l'Etat au Musée Matisse de Nice

Henri Matisse

169 *Acrobat* 1952

L'Acrobate

Brush and ink on paper 105.3 x 74.5 (41¹⁄₂ x 29³⁄₈)

Centre Georges Pompidou, Paris. Musée National

d'Art Moderne/Centre de Création Industrielle.

Dation en 1991

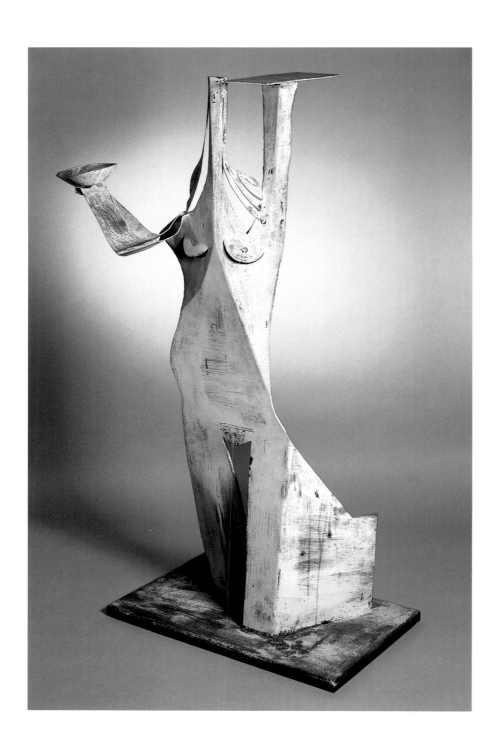

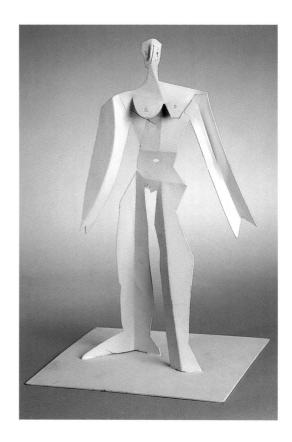

PABLO PICASSO
170 *Woman with a Tray and a Bowl* 1961
Femme au plateau et à la sébille
Painted sheet metal
114.6 x 62 x 35.5 (45⅛ x 24⅜ x 14)
Private Collection

PABLO PICASSO
171 *Standing Nude (Bather)* 1961
Baigneuse
Painted sheet metal
42 x 30 x 21 (16½ x 11¾ x 8¼)
Private Collection

HENRI MATISSE
172 *Standing Blue Nude* 1952
Nu bleu debout
Gouache on paper, cut and pasted on
paper 115.5 x 76.3 (45½ x 30)
Pierre and Maria Gaetana Matisse
Foundation Collection

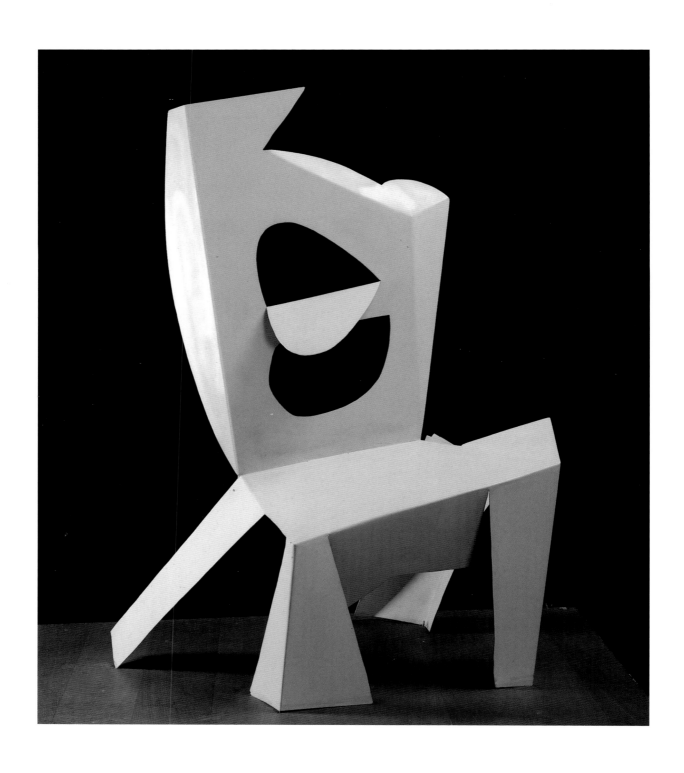

PABLO PICASSO
173 *The Chair* 1961
La Chaise
Painted sheet metal
111.5 x 114.5 x 89 (43⅞ x 45⅛ x 35)
Musée Picasso, Paris

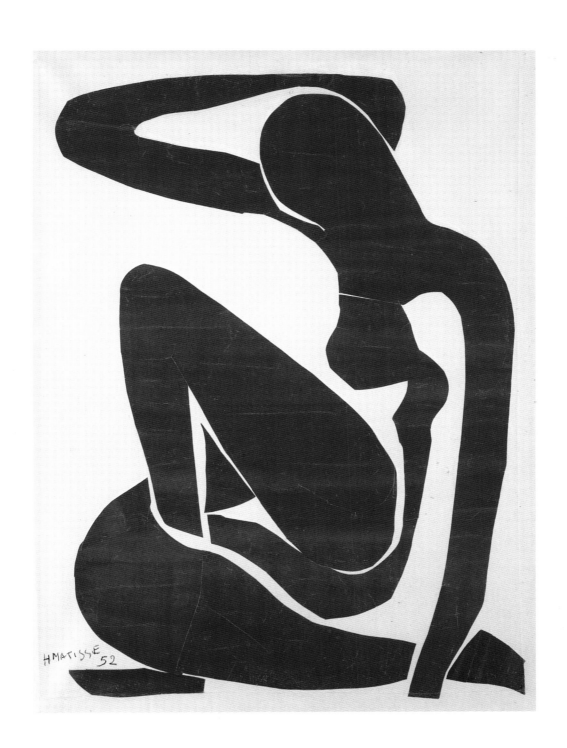

HENRI MATISSE
174 *Blue Nude I* 1952
Nu bleu I
Gouache on paper, cut and pasted
on paper 115 x 78 (45¼ x 30¾)
Private Collection, courtesy Beyeler
Foundation Riehen/Basel

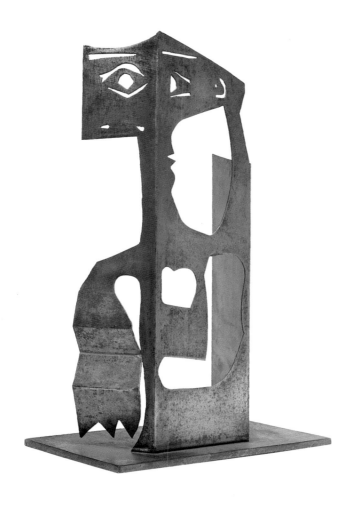

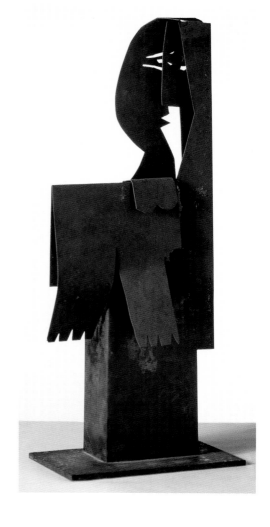

PABLO PICASSO
175 *Woman* 1961
Femme
Sheet metal 30 x 20 x 11.5 (11¾ x 7⅞ x 4½)
Private Collection

PABLO PICASSO
176 *Standing Woman* 1961
Femme debout
Sheet metal 42 x 19 x 12.5 (16½ x 7½ x 5)
Private Collection

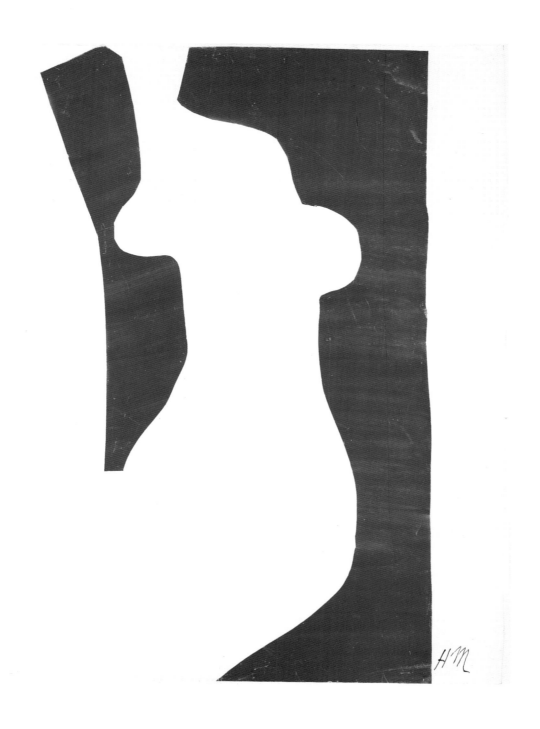

HENRI MATISSE
177 *Venus* 1952
Vénus
Gouache on paper cut and pasted on canvas
101.2 x 76.5 (39⅛ x 30⅛)
National Gallery of Art, Washington,
Ailsa Mellon Bruce Fund 1973

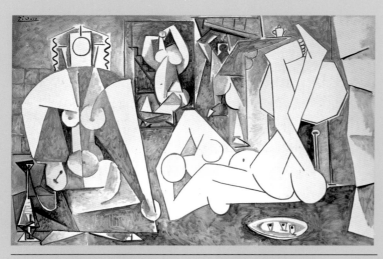

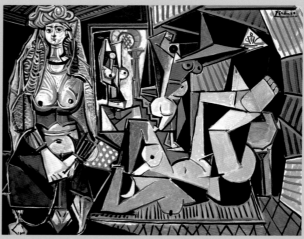

33

Within two months of Matisse and Picasso first meeting in the spring of 1906, Matisse was in Algeria, opening his art to what he would call the influence of the Orient, and Picasso was about to paint an Ingres-inspired *Harem*.[1] Within two months of Matisse's death, on 3 November 1954, Picasso began his fifteen-painting cycle of variations on Eugène Delacroix's *Women of Algiers* of 1834 (fig.75).[2] 'When Matisse died', Picasso told Roland Penrose, 'he left me his odalisques as a legacy, and this is my idea of the Orient, though I have never been there.'[3]

The claiming of this legacy is unlike any previous response by Picasso to Matisse, or vice-versa, for the obvious reason that there could be no rejoinder from the other artist. This fact adds a particular poignancy to Picasso's first major cycle of variations on the old masters – and may help to explain why there had to be not one painting, but a series. Matisse being no longer able to make a reply, Picasso had to reply for him, then to him, then for him again. Thus, the cycle may be said to contain colourful and voluptuous 'Matisse' paintings and austere, geometric 'Picasso' paintings, except that would be to prejudge what now is actually Matisse's and Picasso's own.[4] 'Oui, il est mort', Picasso said, when acknowledging Matisse's presence in his new work. 'Il est mort, et moi, je continue son travail.'[5] Every work in the cycle is for Picasso, therefore, a sort of imagined collaboration with Matisse just as much as with Delacroix; or rather, an imagined collaboration with Matisse on the subject of Delacroix.

This is true of even the most severe work of the series, the monochromatic, ante-penultimate Canvas M, painted on 11 February 1955. The odalisque framed in the doorway in the far centre had been the first inescapably Matissean quotation to appear in the series. It may not be significant that it appeared in canvas D, of New Year's Day 1955 (fig.76), on the day after what would have been Matisse's eighty-fifth birthday, but its precise derivation must be a part of the new meaning that it brought. Matisse had used this pose in the very first of his paintings purchased for the French national collections, *Odalisque with Red Culottes* of 1921,[6] and, when he refined it two years later, he named it *The Hindu Pose* (fig.77). This odalisque, Leo Steinberg writes, 'appears for the first time as a watchful presence, seeing everything we can see, but seeing it from the rear, and ineluctably associated with Matisse.'[7] Thus, she sees – through Matisse's eyes – what we logically should not be able to see, namely the reverse side of the great reclining foreground figure, the development of whose own pose was the drama of the entire series. It cannot have escaped Picasso's notice that to develop a reclining nude in a series of variations of one painting was to revisit what Matisse had done exactly twenty years earlier with his so-called *Pink Nude* (no.119). Neither could he have forgotten that Matisse's *Pink Nude* was well known as the successor to his *Blue Nude* (no.14) of 1907, which Matisse had conceived as a 'souvenir' of his visit to Algeria just after the two artists first met.

Steinberg explains the representational problem that Picasso addressed in shaping the reclining figure (which he calls the Sleeper), and solved in Canvas M, which he rightly calls the masterpiece of the series. 'The problem was to pose the Sleeper simultaneously prone and supine; put another way, to have her seen both front and back, yet . . . [unlike any Cubist solution] without physical dismemberment, without separation of facets, but as a compact, close-contoured body which denies itself neither as an object of vision nor as self-centred presence.'[8] Picasso had effectively set himself a Matissean problem – that of *Blue Nude* and *Pink Nude* – and his solution was partly Matissean: clear an open space for the figure and give to the lines describing it a more-or-less equal density, so that the signs for abutting, overlapping, and occluding edges read similarly and in plane. He would have seen a great example of this in Matisse's Hôtel Régina studio when he last visited him there, the *Nymph and Faun* (no.110),[9] and a memory of that reclining nymph surely lingers in canvas M. But the solution of Canvas M engages Matisse only to resist him. The reclining figure conflates front and back views in an impossibly folded image that alternates in our perception between indicating successive positions of one body and indicating one position seen from successive viewpoints; in either case, fitted together as snugly as the rabbet-jointed legs thrown up on the Moorish table, whose one visible kerf and hole is a nice ribald touch in an otherwise grandly serious composition.[10] This takes a greater liberty with the body than Matisse ever allowed himself, and is, more than the monochrome, how the struggle against Matisse was continued.[11]

Because this painting (and its companions) invokes the names not only of Picasso and Matisse but also of a third artist, Delacroix, it exemplifies what had been true of many previous responses by Picasso to Matisse, or vice-versa: the intimacy between the two artists was often mediated by a third artist, sometimes a contemporary but more often an earlier artist they both admired. Françoise Gilot, who witnessed the two artists talking of their heritage, has observed: 'Both wanted to verify that the very foundation of their artistic friendship was on solid ground: *a mutual understanding of the same artists and the same principles.*'[12] An artistic dialogue between Matisse and Picasso was, therefore, often a dialogue about someone in 'the great chain of artists', as they would put it, talking of how an earlier artist might remain 'alive in the mind of another artist' to maintain the continuity of the chain.[13] Speaking to Daniel-Henry Kahnweiler of his *Women of Algiers* paintings, Picasso said, 'I sometimes tell myself that perhaps this is an inheritance from Matisse. Why shouldn't we inherit from our friends, after all?'[14] The plural object of the second sentence joins Delacroix to Matisse in the chain of inheritance, now in Picasso's hands alone.

In canvas N, painted on 13 February, two days after canvas M, Picasso reintroduced colour into the series in a beautifully tinted application. The following day, he painted the final composition, canvas O. Its vivid, dense hues and profusion of decorative pattern unquestionably speak of Matisse, yet in such stern and dissonant non-Matissean terms as to seem even to do violence to the original – this may be thought of as an aggressive overcoming of Matisse.[15] Or, to alter a famous phrase, it may be thought that the tradition of the dead weighs like a nightmare on the mind of the living.

The *Women of Algiers* paintings enrol not only Delacroix but also other artists whom Matisse as well as Picasso admired. In the three final canvases, the raised legs of the reclining nude, remaining from an earlier state when the figure was upside-down, link this image to the brothel monotypes of Degas.[16] The juxtaposition of the reclining nude to the adjacent seated figure recalls Ingres's *Odalisque and Slave* (see fig.64) by way of Picasso's own *Serenade* (no.150) of 1942, which the artist had placed next to Delacroix's *Women of Algiers* when, in 1946, he had the opportunity to insert some of his own paintings in the Louvre.[17] But this canvas, and the series, had other, non-artistic associations that may well have contributed to its grave beauty, one of which is unquestionably pertinent to its dialogue with Matisse.

The series was begun after Gilot, Picasso's lover for a decade, left him in the autumn of 1953, saying, 'she did not want to spend the rest of her life with an historical monument'.[18] Picasso had taken up with Jacqueline Roque, whose resemblance to the seated woman on the right of the Louvre version of Delacroix's painting is said to have been a principal motivation for the series.[19] Ironically, Picasso's first wife, Olga Khoklova, died the very day that canvas M was painted. Three days later, in the final canvas O, the blank face of the left-hand figure was given the features of Jacqueline, his wife to be (no.180). This was a period of great personal turmoil for the artist. But it was a distant event that added an uncanny coincidence to Picasso having finally painted his idea of the Orient he had never seen.

On 1 November 1954, two days before Matisse's death, the Algerian Revolution against French rule was officially launched. The occupation of the so-called *proche Orient* that had begun in 1830, almost immediately inspiring Delacroix's great painting, had effected an extraordinary reciprocation. France reproduced itself in Algeria, administratively, economically, and politically, while Algeria reproduced itself culturally in France.[20] When Matisse and Picasso first met, it was Orientalism that was driving their attack on the norms of Western culture. It is, therefore, strangely fitting that the death of Matisse, who, more than any other modern French artist had continued what Delacroix had started, should coincide with the beginning of the end for Orientalism in France. More than a decade later, the outcome as yet undecided, a politician who would become a President could still write, 'Sans Afrique, il n'y aura pas l'histoire de France au XXIe siècle'.[21] But the memorial had already been painted as a monument to both Delacroix and Matisse.

JE

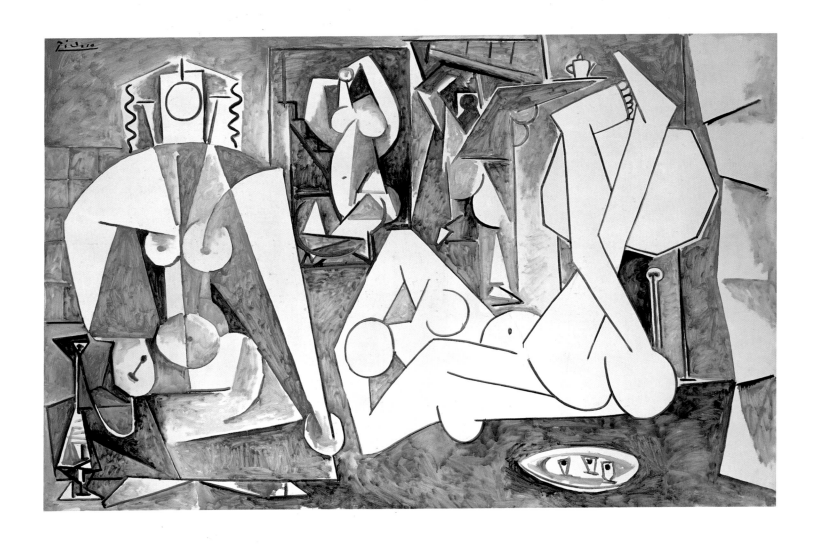

PABLO PICASSO

178 *Women of Algiers, after Delacroix (Canvas M)*

1955

Femmes d'Alger, d'après Delacroix (Toile M)

Oil on canvas 130 x 195 (51¼ x 76¾)

Lakenbleker BV

PABLO PICASSO

179 *Women of Algiers, after Delacroix (Canvas N)*

1955

Femmes d'Alger, d'après Delacroix (Toile N)

Oil on canvas 123.5 x 155.6 (44⅝ x 61¼)

Washington University Gallery of Art, St Louis, MO.

University Purchase, Steinberg Fund, 1960

PABLO PICASSO

180 *Women of Algiers, after Delacroix (Canvas O)*

1955

Femmes d'Alger, d'après Delacroix (Toile O)

Oil on canvas 114 x 146.4 (44½ x 57⅝)

Private European Collection

34

Though neither of these pictures discloses a face, both are certainly self-portrayals. In Picasso's case, we have his own affirmation. Responding to the photographer David Douglas Duncan's query about the meaning of *The Shadow*, the artist vexedly jabbed a finger toward the image and snapped that the scene was set in the bedroom he had shared with Françoise Gilot in his villa in Vallauris. 'See my shadow?', he said. 'I'd just turned from the window – *now* do you see my shadow and the sunlight falling onto the bed and across the floor? See the toy cart on the dresser, and the little vase over the fireplace? They're from Sicily and still around the house.' (Given this cue, Duncan then recognised, in the black-and-white pattern between the shadow's arms and its torso, a rug that lay on that bedroom's floor).[1] As for Matisse, there might be some logic in seeing the figure in *Violinist at the Window* as the artist's son Pierre. The boy's musical training had already been the subject of *The Piano Lesson* of 1916 (no.71), and just before the apparent date of this painting (spring 1918), Matisse made a charcoal study of him playing the violin, seen from behind (fig.78). However, much later Pierre himself – who had no memory of posing for the charcoal, either – confirmed that *Violinist at the Window* represented his father.[2] Both pictures show the painters not painting, but involved, overtly or implicitly, in separate sublimations: for Matisse, making music; for Picasso, making love.

Violinist at the Window was painted when Matisse was approaching fifty, *The Shadow* when Picasso was seventy-two. The interest in looking at them together involves not just echoes of motif and form, but deeper issues that set them apart from each man's familiar mode of self-representation. We are familiar with Picasso's practice of presenting himself, not in the first-person voice, but by projecting his identity into a character observed – the Minotaur, the harlequin, and so on. Matisse, by contrast, most typically shows himself via the mirror's reflection, and/or through the added note of self-consciousness evoked by including in the image a palette or drawing board he holds as he renders the scene. In other words, as regards viewpoint, we are used to being 'outside' Picasso and 'inside' Matisse. Here these vantages are exchanged. Formally, each picture could also be seen as borrowing from the other artist's vocabulary. Though the *Violinist* was done far from Paris (in Nice, about a year after Matisse moved there),[3] its strict gridding and the sharp austerity of the black 'brackets' at either edge clearly look back to the geometric rigours of Matisse's recent encounters with Cubism. In turn, the flattened and angular network of reserved, open-canvas lines with which Picasso structures his room borrows a technique Matisse had claimed in *The Red Studio*[4] decades before.

Central to both is the familiar Romantic motif of the window as proscenium divide between what Schiller called 'the poetry of possession' and 'the poetry of desire' – between the domain of private experience and the outer world.[5] But here the relation between interior and exterior

is made more complex, and traditional dualities of near and far collapsed. In Matisse's case, all the 'depth', in pictorial and emotive terms, is in the interior. Outside, a flattened vista fills with obscuring clouds, above which broods a sky of disquieting red (evoking not just that unusually rainy season in Nice, but also the anguish of the then-lengthening war).[6] It is only the inside of the mullions and the inward-turned shutters that offer the tender tint of bluer heavens. The mullions intersect exactly at the musician's eye level, before his face, visually pinioning (or 'crucifying') his head, and blocking his sight. Additionally, the closed grid of glass planes evokes not the standard analogy of the painting's face as a 'window onto the world', but the stretcher behind a canvas. Thus though we as viewers are behind the artist, on the outside looking in, this suggests him behind his work, on the inside looking out – perhaps an appropriate connotation for this motif of art as private solace, performed before the world but also in isolation from it.

Picasso's window on the other hand is de-materialised, a plane of daylight falling into a darkened room. The resulting play of tilted angles and overlays, opacities and transparencies, recalls earlier Cubism in a manner tellingly different from the strict and flattened lattice of *The Violinist*. This marriage chamber – *camera dei sposi* – becomes a camera in the photographic sense, receiving a projection from the world outside. The 'negative', where no light falls, is Picasso, conjuring the scene from his viewpoint, looking at his own extension, or at the black hole he causes in the world before him. If the window is a Romantic metaphor for our yearnings, the shadow is, via Plato's allegory of the cave, one of the West's oldest metaphors for the confining limits of our knowledge. Also, a Greek myth tells us that the first drawing came when a woman traced her lover's shadow before his departure for war, thus implicating the shadow as a primordial icon of physical evanescence and sublimated, surrogate possession. Both connotations, of delimitation and of loss, seem appropriate for the picture, given what we know of the circumstances of Picasso's life at the time of its making.

Thanks to the artist's precise dating, we know that the painting was made in the brief interval between Christmas and New Year's Eve, 1953. Only a few days before, Françoise, from whom Picasso had been estranged for some time, had come South to collect their children, Paloma and Claude, for the holidays.[7] The fact that Françoise made a point of not seeing Picasso on this visit seemed to put a final stone in the wall between them. Especially given this knowledge, it is irresistible to find within this scene of afternoon sexual encounter, painted by an old man left alone in a house of erotic memories, an imagery of incompletion and frustrated fantasy. In paintings of the 1920s, Picasso had often included his image as a shadow, in the form of a profile head that, detached and inviolable, oversaw the monstrous, marauding deformities he invented for his female personae.[8] Here, in more frontal encounter and with his whole body implicated, the divorce of the shadow from its surroundings takes on less confident, more poignant meaning. The intimations of failure to contact are double, if not triple. First, the elimination of the hands from the silhouette emphasises that the experience is intangible, and cannot be tactile. Then the door-knob head, at the end of its thrust inward, is enclosed by the gaping bay of the arched woman's body, but nowhere touches its perimeter. Finally, the other image of penetration, wherein the nude's pendulous buttocks serve double duty as testicles beneath the shaft-like

extension of her lower body toward the dark opening of the fireplace on the right, is severed by the cleaving edge of light. No touch, no friction, no transmission of sensation, only the awareness of the artist's own dark mass with the world of light behind him, observing, from a distant threshold, an unattainable white phantom. As Denis Hollier has pointed out, the very next day Picasso transmuted this scene of erotic shortfall into a richer, fuller image of a cluttered studio, with the nude figure – surrounded by, among other things, the same Sicilian toys – now more comfortably located as submissive to the artist's work.[9]

The Matisse painting also stems from a moment of crisis in the artist's life, albeit of a different order. His move to the South of France closed out years of strain, effort, and achievement, partly consumed by confrontations with a Cubist avant-garde that seemed alien and usurping to him, and marked by radical ambitions embodied in monumental canvases. He was on the edge of a major shift in his art, and (with important patrons swept away by the Russian revolution), uncertain how the market would respond to this change. The self-image he devised at this juncture fuses three themes that had been, and would be, recurrent in the artist's work: the window, the back view, and music. The first could be taken to stand for outward aspiration and observation, the second for concealment, interiority, and secrets held, and the last – bridging sensation and feeling – for the abstract and irresistible force of art's sway over its makers and receivers alike. As early as the first, 1909 sketch for the 1911 decoration *Music*, Matisse had cast the figure of the fiddler as surrogate for the artist (Matisse was of course himself an ardent devotee of the violin), standing solitary to the side while his tune inspires others to reverie or dance. Here the isolation and inward turn are more complete, the art more wholly self-consoling, in an image of practice not performance. The metaphor's mundane base may lie in the experience of solitude that governed Matisse's music practice at the time. After he arrived in Nice, he began, according to his wife, 'seriously studying the violin'. Insisting on an hour of practice in his daily regimen, he chose as his music 'studio' a distant bathroom of the hotel where he lived, 'so as not to plague the neighbours'. Looking back on this period, Madame Matisse recalled to Escholier that she had asked her husband why he had become so obsessed with this practice, and received a dismaying response. 'Henri told me quite simply', she recounted, '"It's a fact that I'm afraid I shall lose my sight, and not be able to paint any more. So I thought of something. A blind man must give up painting, but not music . . . So I could always play the violin in the streets. I should still be able to earn a living, yours and Margot's and mine".'[10] Just as with Picasso's domestic circumstances and *The Shadow*, it is nigh impossible not to read this memory into *The Violinist*, finding in the haunting imagination of blindness not only a synchrony with the imagery of blocked sight, and with the vacant, lumpy orb of the head, but a context for the melancholy sense of enclosure that pervades the picture. Matisse never showed the picture while he was alive, perhaps finding it not wholly finished, or too literal and sentimental in its address (in contrast to, for example, the severe and unnerving comedy of the similarly themed *Piano Lesson*), or simply too painful in its associations for him.

KV

HENRI MATISSE

181 *Violinist at the Window* 1918
Le Violoniste à la fenêtre
Oil on canvas 150 x 98 (59 x 38½)
Centre Georges Pompidou, Paris.
Musée National d'Art Moderne/Centre de
Création Industrielle. Achat en 1975

PABLO PICASSO

182 *The Shadow* 1953
L'Ombre
Oil on canvas 125.5 x 96.5 (49½ x 38)
Musée Picasso, Paris

Notes

References to the following museums have been abbreviated:
MoMA: The Museum of Modern Art, New York
MNAM: Musée National d'Art Moderne

References to the catalogues raisonnés of Matisse and Picasso have been abbreviated as follows:
Daix/DR: Pierre Daix and Joan Rosselet, *Catalogue raisonné du cubisme de Picasso, 1907–1916*, Neuchâtel 1979.
Duthuit: Claude Duthuit, ed., with Wanda de Guébriant, *Henri Matisse: Catalogue raisonné de l'oeuvre sculpté*, Paris 1997.
MP: Musée Picasso, Paris, followed by catalogue reference.
S: Werner Spies and Christine Piot, *Picasso: Das Plastische Werk*, Stuttgart 1984.
Z: Christian Zervos, *Catalogue général illustré de l'oeuvre de Picasso*, 33 vols, Paris 1932–75.

Introduction

1 Quoted in Pierre Daix, *La Vie de peintre de Pablo Picasso*, Paris 1977, p.74.
2 John Richardson, *A Life of Picasso: Volume 1, 1881–1906*, New York 1991, p.413.
3 Gertrude Stein, *The Autobiography of Alice B. Toklas*, New York 1933, p.53.
4 Fernande Olivier, *Picasso et ses amis*, Paris 1933, p.84.
5 Stein 1933, p.41.
6 See n.7.
7 Quoted in Pierre Schneider, *Matisse*, trans. Michael Taylor and Bridget Strevens Romer, New York 1984, p.733.
8 See Chronology, 1907.
9 John Richardson, *A Life of Picasso: Volume 2, 1907–1917*, New York 1996, p.90.
10 Quoted in Schneider 1984, p.734.
11 Ibid. p.352.
12 Jack Flam, *Matisse on Art*, Oxford 1973, revised ed., Berkeley and Los Angeles 1995, p.40.
13 Dominique Fourcade, ed., *Henri Matisse: Ecrits et propos sur l'art*, Paris 1972, p.203.
14 Alfred H. Barr, *Matisse: His Art and His Public*, exh. cat., MoMA, New York 1951, p.178.
15 Richardson 1 1991, p.419.
16 It was only relatively late in life that Matisse sometimes became interested in divorcing colour from line. He spoke of *The Dream* of 1940 (Private Collection) in this connection.
17 Matisse in Richardson 1 1991, p.115. Matisse is here talking specifically about his *Still Life after de Heem* of 1915 (no.75).
18 *White and Pink Head*, 1914–15 (Musée National d'Art Moderne, Paris).
19 See Chronology, 1913–14.
20 See Chronology, 1906.
21 See pp.172–7.
22 Quoted in Yve-Alain Bois, *Matisse and Picasso*, exh. cat., Kimbell Art Museum, Fort Worth 1998, p.33 (Bois is in turn quoting from Rémi Labrusse, see Bois, note 69. I am deeply indebted to Bois's book).
23 André Breton, *Le Surréalisme et la peinture*, Paris 1928, revised ed., Paris 1964, p.7.
24 See pp.172–7.
25 See Chronology, 1924–5.
26 Jean Cocteau, *Le Rappel à l'ordre*, Paris 1926, p.98.
27 See p.297.
28 Quoted in Richardson 1 1991, p.417.
29 See Chronology, 1932.
30 See Chronology, 1928–34.
31 Christian Zervos's writing in his *Cahiers d'Art*, 1926–60, was an exception in this respect.
32 See Chronology, 1921 and 1931.
33 Bois 1998, p.77.
34 Ibid. p.110.
35 This is underlined by the fact that Matisse, who disliked committing himself openly on public issues, signed two of Picasso's politically oriented proclamations. See Chronology, 1936.
36 Richardson 2 1996, p.14.
37 The reference is to the acceptance of Derain and Vlaminck to visit Germany in 1941 on a

'good will' tour.
38 In 1934 an inventory of Matisse's collection was taken. In 1936 he gave his Cézanne, *Three Bathers*, to the Musée de la ville de Paris. Degas's important *Combing the Hair*, now in the National Gallery, London (not in the inventory), was sold to his son Pierre in about 1936. Photographs taken in Matisse's apartment in Nice, Place Charles-Félix, show works by his nineteenth-century mentors hanging on the walls. At least one of the Cézannes was in his estate. But to my knowledge no photographs taken of his later interiors at Cimiez and Vence show works of his private collection on the walls, other than those by Picasso.
39 Bois 1998, p.180.
40 See Chronology, 1946–7.
41 John Russell, *Matisse, Father and Son*, New York 1999, p.246.
42 See Chronology, 1952.
43 See Chronology, 1951.
44 For a detailed description of these visits, see Bois 1998, pp.192–204.
45 See Chronology, 1948.
46 Bois 1998, p.212–15.
47 Françoise Gilot, *Matisse and Picasso: A Friendship in Art*, New York 1990, p.316.
48 Quoted in Daix 1977, p.177.
49 Roland Penrose, *Picasso, His Life and Work*, 3rd ed., Berkeley and Los Angeles 1981, p.396.
50 Françoise Gilot and Carlton Lake, *Life with Picasso*, London 1964, p.255; Gilot, *Matisse and Picasso: A Friendship in Art*, London 1990, p.316.
.

fig.15 Paul Cézanne, *Portrait of the Artist with a Palette* 1890, oil on canvas 92 x 73, Bürhle Foundation, Zurich

fig.16 Pablo Picasso, *Self-Portrait* 1907, oil on canvas 50 x 46, National Gallery, Prague

1

1 For illustrations of these works, see John Elderfield, *Henri Matisse: A Retrospective*, exh. cat., MoMA, New York 1992, pp.162, 165.
2 Gaston Diehl, *Henri Matisse*, Paris 1954, p.136: 'On a maintes fois souligné l'aspect "masque de tragédie" de cet extraordinaire portrait.' Katherine C. Bock, 'Henri Matisse's Self-Portraits: Presentation and Representation', in Mary Matthews Gedo, ed.,

Psychoanalytic Perspectives in Art, New Jersey 1988, p.245: 'the effect is highly confrontational, bold, yet diffident, forceful, yet with a youthful defiance.' John Klein, 'Matisse et l'autoportrait: démarche individuelle et relation avec le public', in *Henri Matisse Auto-portraits*, exh. cat., Musée Matisse du Cateau-Cambresis, 1988, p.14: 'Il se représente avec beaucoup d'expressivité sous les traits d'un explorateur aventureux, un marin endurci. Sa sereine confiance en lui, á la limite de l'arrogance, s'exprime dans ses yeux et sa bouche.'
3 Alfred H. Barr, *Matisse: His Art and His Public*, exh. cat., MoMA, New York 1951, p.94: 'In the *Self Portrait* . . . the artist has presented himself in a striped sailor's jersey and without spectacles. Curiously, the effect is both informal and monumental. The features are hewn in great planes and slashing black lines as if with a hatchet.' See also Jack Flam, *Matisse: The Man and His Art, 1869–1918*, Ithaca and London 1986, pp.183–4: 'There is something both romantic and appraising about the evenness of his gaze, about the firmness with which the head occupies both the framed rectangle of the canvas and the solid space behind it, which is hacked out as if with a chisel.'
4 Gertrude Stein, *The Autobiography of Alice B. Toklas*, New York 1993, p.87.
5 Georges Duthuit, *Les Fauves*, Geneva 1949, pp.216–17: '"A bas le portrait de Marguerite," criaient les camarades de Picasso dans les rues de Montmartre, à la période héroïque du té, de l'équerre, des collages et du grand sentiment.' André Salmon, *Souvenir sans fin: Première epoque 1903–1908*, Paris 1955, pp.187–8: 'Comme Matisse voulait qu'on le tînt pour un grand artiste rien que sensible à une sorte de sensualité filtrée, hors de la vie telle qu'elle nous apparaissait, et, en outre, imperméable, je ne dirai pas à l'humour, mais à la belle humeur, on lui a fait des blagues. Des blagues à distance respectueuse. Matisse fit présent à Picasso, qui l'inquiétait tellement, d'un portrait de sa fille Marguerite; une de ses moins bonnes toiles. En avait-il conscience et est-ce pour cela qu'il en faisait cadeau? Tout aussitôt nous nous sommes rendus au bazar de la rue des Abesses où, pauvres mais ne reculant devant aucun sacrifice à la joie, nous fîmes emplette d'un Tir Euréka. Et dans l'atelier les flèches à ventouse de fair merveille sur le tableau, sans l'endommager, je dois le dire. "Pan! dans l'oeil de Marguerite!" "En plein sur la joue!" On s'amusait bien, et davantage quand on apprit que Matisse déjà classé grand homme menait une discrète enquête pour savoir quelle main ou quelles mains écrivaient sur les murs et palisades de Montmartre: "Matisse rend fou!"'
6 For Picasso quote from 1962, see *Paris Match*, 9 June 1972: 'Je pensais alors que c'était un tableau clé et je le pense encore.'
7 Françoise Gilot, *Matisse and Picasso: A Friendship in Art*, New York 1990, p.62: 'Such spontaneity mesmerized Picasso. He admired the courage of the Fauvist master to show such candor. Many years later, he still regretted having allowed his friends to make fun of that painting, when he knew so well the important statement that it was making.'
. .

2

1 Gertrude and Leo Stein purchased *Boy Leading a Horse* directly from the artist soon after its completion. It can be seen in a photograph of their apartment taken in c.1907 (Baltimore Museum of Art, Cone Archives; reproduced in John Richardson, *A Life of Picasso: Volume 1, 1881–1906*, New York 1991, p.388).
2 Matisse refused to sell *Le Luxe I* to Michael and Sarah Stein, but loaned it to them from 1908 to c.1911 (see Dominique Fourcade and Isabelle Monod-Fontaine, eds., *Henri Matisse: 1904–1917*, exh. cat., Musée National d'Art Moderne, Paris 1993, cat.53).
3 Ardengo Soffici, *Ricordi di vita artistica e letteraria*, Florence 1942, pp.365–6.
4 For illustrations of the related works and

visual sources, see William Rubin and Matthew Armstrong, *The William S. Paley Collection*, exh. cat., MoMA, New York 1992, pp.98–103.

5 Paul Cézanne, *The Bather*, 1885, oil on canvas (The Museum of Modern Art, New York. The Lillie P. Bliss Collection).

6 *Le Luxe II*, 1907–?1908, casein on canvas (Statens Museum fur Kunst, Copenhagen. J. Rump Collection). There are also two small conté crayon studies and a woodcut (no.29).

7 *Le Luxe I* has sometimes been ascribed to the period after Matisse's trip to Italy, but it was sent to Paris from Collioure on 13 July 1907 (Isabelle Monod-Fontaine, with Anne Baldassari and Claude Laugier, *Matisse: Collections du musée national d'art moderne*, Paris 1989, cat.7, n.3).

8 See Robert Reiff, 'Matisse and Torrii Kiyonaga', *Arts Magazine*, Feb. 1981, pp.164–7.

9 'Moi, j'aime pas ça, no I don't care for it', Picasso told Gertrude Stein one evening after Leo had shown him 'portfolio after portfolio of japanese prints'. Gertrude, who shared his aversion, saw this as a bond between them (Gertrude Stein, *The Autobiography of Alice B. Toklas*, Harmondsworth 1966, p.52).

10 For an anthology of reviews of the 1907 Salon d'Automne, see MNAM 1993, pp.442–3.

. .

fig.17 Pablo Picasso, *Study for 'Les Demoiselles d'Avignon'* 1907, pastel 47 x 62.5, Öffentliche Kunstsammlung, Kupferstichkabinet, Basel

fig.18 Pablo Picasso, *Nude with Drapery* 1907, oil on canvas 150 x 100, The State Hermitage Museum, St Petersburg

fig.19 Pablo Picasso, *Study for 'Les Demoiselles d'Avignon'* 1907, watercolour on paper 17.4 x 22.5, Philadelphia Museum of Art: A.E. Gallatin Collection

3

1 The literature on Matisse and Picasso in these years 1906–8 is enormous, especially on *Les*

Demoiselles d'Avignon. The summary account of the development of that painting is mainly indebted to Leo Steinberg, 'The Philosophical Brothel', *October*, no.44, spring 1988, pp.7–74, then to William Rubin, 'The Genesis of *Les Demoiselles d'Avignon*', in John Elderfield, ed., *Studies in Modern Art 3: Les Demoiselles d'Avignon*, MoMA, New York 1994, pp.12–144, the most fully illustrated source, from which the dates of the studies given here derive. The account of *Bathers with a Turtle* mainly derives from John Elderfield, 'Moving Aphrodite: On the Genesis of *Bathers with a Turtle* by Henri Matisse', in *Henri Matisse: Bathers with a Turtle*, St Louis Art Museum Fall Bulletin, 1998, pp.20–49, and of *Le Bonheur de vivre* from Yve-Alain Bois, 'On Matisse: The Blinding', *October*, no.68, spring 1994, pp.60–121; John Elderfield, *Henri Matisse: A Retrospective*, exh. cat., MoMA, New York 1992, pp.13–77; and Margaret Werth, 'Engendering Imaginary Modernism: Henri Matisse's *Bonheur de vivre*', *Genders*, no.9, fall 1990, pp.49–74.

2 The emotions associable with artistic rivalry derive from Richard Wollheim, *Painting as an Art*, Princeton 1987, p.231, where such rivalry is seen to be consequent upon the historicity of art, namely, 'the authority of past art to define, or to define in part, what art is'. On Picasso's uncompleted *The Watering Place*, see John Richardson, *A Life of Picasso: Volume 1, 1881–1906*, New York 1991, pp.424–7.

3 For a listing of the retrospectives and special presentations of these artists, and of Cézanne, Courbet, Manet, Seurat, and van Gogh, see Donald E. Gordon, *Modern Art Exhibitions 1900–1916*, Munich 1974.

4 Illustrated Rubin in Elderfield 1994, p.35. See Margaret Werth, 'Representing the Body in 1906', in Marilyn McCully, *Picasso: The Early Years, 1892–1906*, exh. cat., National Gallery of Art, Washington 1997, pp.277–87 for this and other autumn 1906 works by Picasso.

5 Illustrated Rubin in Elderfield 1994, p.46 fig.30.

6 Ibid. p.50 figs.42–7.

7 See Jack Flam, 'Matisse and the Fauves', in William Rubin, ed., '*Primitivism' in Twentieth-Century Art*, exh. cat., MoMA, New York 1984, pp.216–17; ill. p.214. The head of the curtain-puller, on the left, was also, obviously, repainted at some point, although not in an 'African' way; see Rubin in Elderfield 1994, pp.92–5.

8 Although based on a photograph of two Tuareg women and owing a great deal to African sculpture (see MoMA 1984, pp.226–7), *Two Women* is a very pictorial sculpture in forming the doubled bodies into a tall rectangle.

9 See Elderfield 1998, pp.25–6.

10 See Roland Penrose, *Picasso: His Life and Work*, London 1958, p.125. Presumably, at that time Matisse probably also saw in Picasso's studio *Nude with Drapery* and an early, hatched state of *Three Women*.

11 For Matisse's statements see Jack Flam, *Matisse on Art*, Oxford 1973, revised ed., Berkeley and Los Angeles 1995, pp.27–30. See also the article by Apollinaire based on this interview, reprinted in Alfred H. Barr, *Henri Matisse: His Art and His Public*, MoMA, New York 1951, pp.101–2.

12 See Elderfield 1998, p.35.

13 See Jack Flam, *Matisse: The Man and His Art, 1869–1918*, Ithaca and London 1986, pp.202–3, 216–17.

14 See Elderfield 1998, pp.33–42, for a description and interpretation of an infra-red reflectograph examination of the painting undertaken by James Coddington, Chief Conservator, The Museum of Modern Art. The *Decorative Figure* was not completed until August 1908, as the inscription on its base indicates.

15 The immediate continuation of this process, after Matisse's *Bathers with a Turtle*, comprises his own *Games of Bowls* (see Elderfield 1998, pp.35–6) and, it is commonly assumed, Picasso's *Three Women*, in progress when Matisse saw *Les Demoiselles*, but completed, in a very different form, in late 1908. However, *Bathers*

with a Turtle was not exhibited in Paris. Matisse boycotted the Salon des Indépendants that spring, after the triumphs of the previous three years, possibly because he saw how his former Fauve colleagues, such as Georges Braque and André Derain, who intended to exhibit, were falling under Picasso's influence. According to Gertrude Stein, Matisse's jealousy of Picasso on this count created an estrangement between the two artists, so one must wonder whether Picasso ever saw *Bathers with a Turtle* in Matisse's studio before it was sent in May to its German purchaser. But Matisse supposedly took Shchukin to Picasso's studio in September, which suggests that Stein may have exaggerated, or invented, the rupture. See Chronology, p.364–5.

16 This narrative reaction and its denarrativisation are central to the account of the painting's genesis in Steinberg 1988, p.13.

17 Elizabeth Cowling pointed out, in conversation, the association of the painting with Titian's *Diana and Actaeon* at Bridgewater House in London. An all-male version of a surprised entrance that Picasso would have known is Velázquez's *The Forge of Vulcan* at the Prado.

18 Venus Anadyomene types, we should note, appear in Picasso's *The Harem* of 1906 and paintings immediately preceding *Les Demoiselles*, as well as in Matisse's *Luxe, calme et volupté* and paintings contemporaneous with *Les Demoiselles*.

19 See Wallace Martin, *Recent Theories of Narrative*, Ithaca and London 1986, p.81, referring to Gustav Freytag's pioneering work of the 1860s; Ludwig Wittgenstein, *Philosophical Investigations*, 3rd ed., trans. G.E.M. Anscombe, New York 1973, pt. 2, secn. 11.

20 Since Steinberg 1988, and most especially in Yve-Alain Bois, 'Matisse's *Bathers with a Turtle*', *St Louis Art Museum Fall Bulletin*, 1988, pp.8–19, and again in Bois 1994, recent literature has stressed the importance of all the *demoiselles* facing the viewer. However, as discussed below, the exception to this is the 'curtain-parter' at the right.

21 Michael Fried, *Absorption and Theatricality: Painting and Beholder in the Age of Diderot*, Berkeley 1980.

22 Steinberg 1988, p.13.

23 See Steinberg 1988, pp.34, 62. The formal associations of *Les Demoiselles* and *Bathers with a Turtle* are stressed by Bois 1994, p.106, and qualified by Elderfield 1998, pp.38–9.

24 Rubin in Elderfield 1994, pp.93–4, stresses the association with Matisse's *Portrait of Marguerite* (no.4).

25 Steinberg 1988, p.46.

26 The compositional association of *Les Demoiselles* and a hand is stressed by Steinberg 1988, p.46, and by John Richardson, *A Life of Picasso: Volume 2, 1907–1917*, New York 1996, p.40, who also associated the composition of the *Family of Saltimbanques* with a hand (Richardson 1 1991, p.382). Picasso was 1.58 m (5'2") tall, which means that his reach would have extended to some 2.28 m (7'6"). Since *Les Demoiselles* is 2.43 m (8') high, Picasso's hand would have reached to roughly the midpoint of the painted hand at top left.

27 A feature ring is a sequence of sensory and motor memory traces that alternatively record a feature of what is visually targeted and the eye movement required to reach the next target. See David Noton and Lawrence Stark, 'Eye Movements and Visual Perception', *Scientific American*, vol.224, no.6, June 1971, pp.38–9.

28 The transformed head has been associated with an African mask, but this is not its only 'primitive' association (see Elderfield 1998, pp.37–8).

29 The curtain-parter had been established from very early in the development of the composition, being developed from the left-hand figure of the *Two Nudes* of autumn 1906 (no.103); see Rubin in Elderfield 1994, pp.80–3. As Steinberg observes, 'Picasso knew very well that the three-quarter view in which he was casting her was fraught with significance' (Steinberg 1988, p.55). However, the famous

late stylistic transformation of this figure (and its neighbour below it) changes it from the first to the last thing in the composition. We cannot actually know whether Matisse transformed the central figure of his composition after he transformed the other two figures, but, again, stylistic anomaly is used to suggest that was the case.

30 Steinberg 1988, p.22, speaks of Picasso thus keeping the interval between the perception and the thing perceived palpably physical. Matisse, in contrast, by keeping the turtle entirely within the pictorial rectangle keeps the interval visual: the most proximate object in the pictorial rectangle, not an object forming a bridge into the pictorial rectangle.

31 Thus, the terms 'nature morte' and 'naturaleza muerta' both offer puns congruent with that of 'still life', whereas the other Spanish term for a still life, 'bodégon', is also the term for a cheap restaurant.

32 Steinberg 1988, p.64.

33 Bois 1988, p.17.

34 Elderfield 1998, pp.41–2.

. .

fig.20 Aristide Maillol, *Chained Action* 1905, bronze height 214, Maillol Museum, Paris

4

1 See Gertrude Rosenthal, 'Matisse's Reclining Figures: A Theme and its Variations', *Baltimore Museum Art News*, no.19, Feb. 1956, p.10.

2 See Jack Flam, *Matisse: The Man and His Art, 1869–1918*, Ithaca and London 1986, pp.191, 491, n.3.

3 Louis Vauxcelles, a contemporary critic, commented on this new masculinity with fervent dismay when the painting was shown at the Salon d'Automne in 1907: 'Let's speak seriously and stop in front of M. Matisse. I admit that I do not understand. An ugly nude woman lying on opaque blue grass under some palm trees. In no event would I wish to offend an artist of whose passion and conviction I am well aware; but the drawing here seems rudimentary to me, the colors cruel; the right arm of the mannish nymph is flat and weighty; the buttocks of the distorted body form an arabesque of foliage that motivates the curve of the woman. The straining of art towards the abstract here is lost on me completely.' Louis Vauxcelles, 'The Salon d'Automne', *Gil Blas*, 30 Sept. 1907, quoted in Jack Flam, *Matisse: A Retrospective*, New York 1988, p.66.

4 Matisse interviewed by Pierre Courthion in 1941, quoted in Claude Duthuit, ed., with Wanda de Guébriant, *Henri Matisse: Catalogue raisonné de l'oeuvre sculpté*, Paris 1997, p.383, n.11.

5 See John Elderfield, *Henri Matisse: A Retrospective*, exh. cat., MoMA, New York 1992, p.32, and Flam 1986, p.195.

6 For the analogy of thigh and phallus see Yve-Alain Bois, 'On Matisse: The Blinding', *October*, no.68, spring 1994, p.105.

7 For an illustration of this sculpture see Friedrich Teja Bach, ed., *Constantin Brancusi 1876–1957*, exh. cat., Philadelphia Museum of Art 1995, p.141.

8 See Tim Clark, 'Freud's Cézanne', in *Farewell*

to an Idea, New Haven and London 1999, pp.139–67 for a discussion of the insecure gender of the nine bathers in Cézanne's *Large Bathers* of 1895–1906, now at the Barnes Foundation. He especially emphasises the phallic quality of one woman's head: 'The Head is not much of a metaphor. It tries to be literal about sex, and show us the phallus once and for all—show us what the phallus is, physically, anatomically, materially' (ibid. p.147).

9 Based on Marguerite Duthuit's recollection of the wet painting hanging on the wall when she and her stepmother visited Matisse in Collioure in October or November 1906, Flam concludes that Matisse reworked the painting around the same time that he completed *Reclining Nude I* and *Blue Nude*, which would explain why it is dated 1907. See Flam 1986, p.197, p.491 n.20.

10 *Mes Modèles*, October 1906, reproduced in Isabelle Monod-Fontaine, *The Sculpture of Henri Matisse*, exh. cat., Arts Council of Great Britain, London 1984, p.13.

11 'As for belly-dancing, I didn't even bother to look for it in Algiers and I saw it by chance for a quarter of an hour in Biskra. The famous Ouled-Nails, that joke? One has seen it a hundred times better at the Exposition.' Matisse in a letter to Henri Maguin, written in June 1906, cited in Roger Benjamin, 'Orientalist Excursions: Matisse in North Africa', in R. Benjamin and Caroline Turner, eds., *Matisse*, exh. cat., Queensland Art Gallery 1993, p.73. Ibid. for a general discussion of Biskra, pp.72–4.

12 For a thorough account of the picture's creation see William Rubin, 'The Genesis of *Les Demoiselles d'Avignon*', in John Elderfield, ed., *Studies in Modern Art 3: Les Demoiselles d'Avignon*, MoMA, New York 1994, pp.12–144.

13 For a discussion of the importance of Ingres's *Grande Odalisque* for Picasso's work of that period see Michael Marrinan, 'Picasso as an "Ingres" Young Cubist', *Burlington Magazine*, vol.11a, no.896, Nov. 1977, pp.756–63. See also Susan Grace Galassi, *Picasso's Variations on the Masters*, New York 1996, pp.37–41. The most complete study of the relationship between Ingres and Picasso is Robert Rosenblum's unpublished lecture presented at the Fogg Art Museum, Harvard University, in February 1981, in conjunction with the exhibition *Master Drawings by Picasso*.

14 William Rubin quotes Lucy Lippard's observation that Picasso's borrowings from the African are 'superficial' (see 'Heroic Years from Humble Treasures: Notes on African and Modern Art', originally published in *Art International*, vol.10, no.7, Sept. 1966; reprinted in *Changing: Essays in Art Criticism*, New York 1971, p.38), but suggests replacing the adjective 'superficial' with 'indirect' and 'fragmentary' instead, as a characterisation of these borrowings (see William Rubin, 'Picasso', in Rubin, ed., '*Primitivism*' *in Twentieth-Century Art*, exh. cat., MoMA, New York 1984, pp.267–8).

15 John Elderfield, *Pleasuring Painting: Matisse's Feminine Representations*, London 1995, pp.30–2.

16 Such publications include the already cited *Mes Modèles* (n.10 above) as well as *Nu Esthétique*. Reproductions of the photograph from which *La Serpentine* was done can be found in: Albert Elsen, *The Sculpture of Henri Matisse*, New York 1972, p.93; John Elderfield, *Matisse in the Collection of the Museum of Modern Art*, New York 1978, p.190; Monod-Fontaine 1984, p.17; Michael Mezzatesta, *Henri Matisse, Sculptor/Painter: A Formal Analysis of Selected Works*, exh. cat., Kimbell Art Museum, Fort Worth 1984, p.78; Pierre Schneider, *Matisse*, trans. Michael Taylor and Bridget Strevens Romer, New York 1984, p.550; Flam 1986, p.271; Elderfield 1992, p.46; Ernst-Gerhard Güse, ed., *Henri Matisse: Drawings and Sculpture*, exh. cat., Saarland Museum, Saarbrücken 1991, p.17.

17 See Mezzatesta 1984, p.78, and Elderfield 1995, pp.32–3.

18 For a reproduction of 1909 photographs of Matisse working on the sculpture taken by Edward Steichen, showing it in an earlier, 'fatter' stage and a discussion of the sculpture's making see Queensland 1993, p.150; Flam 1986, pp.269–71; Monod-Fontaine 1984, p.17; Elsen 1972, pp.91–5; Alfred H. Barr, *Matisse: His Art and His Public*, exh. cat., MoMA, New York 1951, p.23 (for reproduction only), see also fig.86.

19 See William Rubin, *Picasso and Braque: Pioneering Cubism*, exh. cat., MoMA, New York 1996, p.111.

20 This connection with Picasso's *Nude* of 1910 in the Albright-Knox Art Gallery, Buffalo, New York was first noticed by Edward Fry (see Kirk Varnedoe, *Masterworks from the Louise Reinhardt Smith Collection*, exh. cat., MoMA, New York 1995, p.32).

21 See Marrinan 1977, pp.759–60. For a discussion of the monstrous anatomies of these figures and their erotic potential see Robert Rosenblum, 'Picasso and the Anatomy of Eroticism', in *Studies in Erotic Art*, New York and London 1970, pp.337–92.

. .

fig.21 Pablo Picasso, *Head of a Woman* 1906, woodcut 72.5 x 55.5, Musée Picasso, Paris

5

1 Picasso quoted in Brassaï, *Conversations with Picasso*, trans. Jane Marie Todd, Chicago and London 1997, p.66.

2 Picasso quoted in Geneviève Laporte, *Si tard le soir*, Paris 1973, p.77.

3 Picasso quoted in Dor de la Souchère, *Picasso à Antibes*, Paris 1960, p.3.

4 Notes by Matisse quoted by Louis Aragon in Dominique Fourcade, ed., *Matisse: Ecrits et propos sur l'art*, Paris 1972, p.160, n.4.

5 Notes by Matisse on the drawings for *Thèmes et Variations* (1942) quoted in 'La grande songerie ou le retour de Thulé (1945–6)', in Louis Aragon, *Henri Matisse: roman*, Paris 1971, vol.1, p.234.

6 Picasso quoted in Laporte 1973, p.26.

7 Matisse quoted in Aragon 1 1971, p.82.

8 Charles H. Caffin, 'Henri Matisse and Isadora Duncan', *Camera Work*, no.25, Jan. 1909.

9 Notes by Matisse on the drawings for *Thèmes et variations* quoted in Aragon 1 1971, p.234.

10 Ibid.

11 See Anne Baldassari, entry for the drawing 'Sans titre, (Nu de dos)', no.53, in Isabelle Monod-Fontaine, with Anne Baldassari and Claude Laugier, *Matisse: Collections du musée national d'art moderne*, Paris 1989.

12 This 'revelation' is recounted by Matisse in his preface to *Portraits*, Monte-Carlo 1954, republished in Jack Flam, *Matisse on Art*, Oxford 1973, revised ed., Berkeley and Los Angeles 1995, p.151.

13 The ribbon conceals the traces of the tracheotomy undergone by Matisse's daughter in 1901.

14 Gelett Burgess, 'The Wild Men of Paris', *Architectural Record*, vol.27, no.5, May 1910, p.404.

15 Picasso quoted in Brassaï 1997, p.66.

16 Ibid.

17 Picasso quoted in Hélène Parmelin, *Picasso dit . . .* , Paris 1966, p.111.

18 Leo Stein, in a letter to Picasso dated 14 April 1906 (Picasso archives), speaks of this visit which he proposes to 'postpone until the following Monday'.

19 See Monod-Fontaine et al. 1989, entries for 'Petit bois noir' (no.45) and 'Petit bois clair' (no.46).

20 Brigitte Baer, *Suites au catalogue raisonné de Bernhard Geiser: Picasso graveur*, Berne 1986, no.212.

21 This woodcut is at the Musée Picasso in Paris, and is classed among the sculptures.

22 Picasso quoted in Brassaï 1997, p.95.

23 Respectively, Z.II*.47, DR 95; Z.II*.60, DR 104; Z.II*.113, DR 133; Z.II*.108, DR 131.

24 Statement by Picasso on 9 May 1959 quoted in Daniel-Henry Kahnweiler, in *Conversations avec Picasso*, 1959, republished in Marie-Laure Bernadac and Androula Michael, eds., *Picasso: Propos sur l'art*, Paris 1998, p.97.

25 Leo Stein, *Appreciation: Painting, Poetry and Prose*, New York 1947, p.175.

26 Burgess 1910, p.403.

27 Ibid. p.401.

28 Ibid. p.403.

29 Ibid.

30 Note by Matisse, quoted in Aragon 1 1971, p.104.

31 Letter from Picasso to Kahnweiler, Céret, 12 June 1912, cited by Hélène Seckel, 'Anthology', in *Les Demoiselles d'Avignon*, Paris 1988, p.567.

32 Leo Stein 1947, pp.175–6.

33 Burgess 1910, p.403.

34 'Sarah Stein's Notes', in Flam 1995, p.43.

35 Picasso quoted by Guillaume Apollinaire, Pierre Caizergues and Hélène Seckel, eds., in *Picasso/Apollinaire: Correspondance*, Paris 1992, p.203.

.

fig.22 Henri Matisse, *The Moroccan Café* 1911–12, distemper on canvas 176 x 210, The State Hermitage Museum, St Petersburg

6

1 Theodore Reff, *Themes of Love and Death in Picasso's Early Work*, Picasso, 1881–1973, London 1973, pp.11–49. John Richardson in *A Life of Picasso: Volume 2, 1907–1917*, New York 1996, pp.86–7 follows this suggestion, and adds information about Wiegels.

2 Anatoli Podoski, *Picasso Une Quête continuelle: Oeuvres de l'artiste dans les musées soviétiques*, Leningrad 1989.

3 The two versions are in In Kunstsammlug Nordrheim-Westfalen, Düsseldorf and the Pinacoteca di Brera, Milan.

4 Jean Sutherland Boggs, *Picasso and Things*, exh. cat., Cleveland Museum of Art 1992, p.54.

5 John Richardson, *A Life of Picasso: Volume 1, 1881–1906*, New York 1991, p.518, n.22.

6 See Sutherland Boggs 1992, p.55 n.2, for an identification of the picture. But the nude might just as well be an evocation of all of those Picasso was painting early in 1908. A preparatory study on paper illustrated in ibid. p.54 fig.7, shows the frame empty.

7 Richardson 2 1996, p.87.

8 Some time around 1912 Matisse bought a Hokusai print of a carp. See R. Reif, 'Matisse and Torii Kiyonaga', *Arts*, no.55, Feb. 1981, pp.164–7.

9 Pierre Schneider, *Matisse*, trans. Michael Taylor and Bridget Strevens Romer, New York 1984, p.422.

10 Ibid.

11 Matisse, letter to Louis Aragon, 1 September 1942 in Aragon, *Henri Matisse: roman*, Paris, 1971, vol.2, p.208.

12 The commission concerned two landscape paintings and a still life, the latter to be for Madame Morosov. See John Elderfield in John Cowart and Pierre Schneider, *Matisse in Morocco: The Paintings and the Drawings, 1912–13*, National Gallery of Art, Washington 1990, appendix 2, pp.270–4. The appendix also discusses the three paintings which eventually reached the Morosovs.

13 Picasso acquired the painting from the dealer Martin Fabiani. He offered to buy it, but Fabiani preferred to accept a picture by Picasso in exchange. This was almost certainly *Gósol Landscape* of 1906 (Z.VI.732). See Martin Fabiani, *Quand j'étais marchand de tableau*, Paris, 1976, p.127.

14 Brassaï, *Conversations avec Picasso*, Paris 1986, p.63.

15 Rosamond Bernier, *Matisse, Picasso and Miró, As I knew Them*, New York 1991, p.26.

16 Hélène Parmelin, *Voyage en Picasso*, Paris 1994, p.189.

17 Quoted by Elderfield in NGA, Washington 1990, p.66 n.8.

18 André Malraux, *La Tête d'obsidienne*, Paris 1986, p.63.

19 Elderfield in NGA, Washington 1990, pp.214–15 n.17.

20 Matisse returned to Morocco in September 1912, for a further four-month period.

21 Pierre Schneider in NGA Washington 1990, p.269 n.17.

22 *Chronique d'Art*, p.430.

23 Shneider 1984, p.269.

24 Richardson 2 1996, p.281.

25 Bernier 1991, p.29.

.

fig.23 Henri Matisse, *Study of Trees* 1915–16, crayon on paper 62.1 x 47.5, Centre Georges Pompidou, Paris. Musée National d'Art Moderne/Centre de Création Industrielle.

fig.24 Pablo Picasso, *Landscape study* 1908, graphite on paper 21 x 13.5 Musée Picasso, Paris

7

1 *Young Sailor*, 1906–7 (Private Collection), illus. Dominique Fourcade and Isabelle Monod-Fontaine, eds., *Henri Matisse: 1904–1917*, exh.

fig.25 Henri Matisse, *Walk at Trivaux* 1917, oil on canvas 92 x 73, Private Collection

cat., Musée National d'Art Moderne, Paris 1993, no.45; *Young Sailor II*, 1906–7 (Metropolitan Museum of Art, New York. The Jacques and Natasha Gelman Collection).
2 *Portrait of Marguerite*, 1906–7 (Musée Picasso, Paris); *Portrait of Marguerite*, 1906–7 (Private Collection), illus. MNAM 1993, no.47.
3 *Landscape at Collioure*, 1905 (Statens Museum fur Kunst, Copenhagen. The J. Rump Collection).
4 An expression used by Charles Morice in describing *Le Bonheur de vivre*, in his article for *Mercure de France*, 15 April 1906.
5 *Le Bonheur de vivre*, autumn–winter 1905–6 (Barnes Foundation, Merion).
6 See *Henri Matisse*, exh. cat., Grand Palais, Paris 1970, in which this work is catalogued as no.88, and dated 1908.
7 See letters 68 and 69, in Philippe Dagen, ed., *André Derain: Lettres à Vlaminck*, Paris 1994.
8 Ibid. p.187.
9 Now in the fond Marc Vaux in the Documentation Section of the Musée National d'Art Moderne.
10 And as confirmed in a letter of 21 March 2001: 'The work is reproduced in an article by Louis Riotor, "Les Artistes d'Automne", in *Le dernier cahier de Mecislas Goldberg* (Paris 1908). Under the reproduction is the following caption: "Landscape by Henri Matisse (Salon d'Automne)".' My gratitude to Jack Flam for permission to publish this chronological element.
11 Four of the five exhibited paintings bear the designation 'sketch' (as well as no.759 also entitled 'Landscape').
12 Letter of Picasso to the Steins, 14 July 1907, see William Rubin and Judith Cousins, 'Documentary Chronology', in *Picasso and Braque*, exh. cat., MoMA, New York 1989, p.353.
13 Fernande Olivier, *Picasso et ses amis*, Paris 1933, p.148.
14 Ibid. p.149.
15 Picasso is said to have met Rousseau on 10 November 1908, see MoMA 1989, p.441 n.52.
16 Letter to Camoin, 19 January 1916, in Claudine Grammont, ed., *Correspondance entre Charles Camoin et Henri Matisse*, Lausanne 1997, p.95.
17 Letter to Camoin, summer 1917, ibid. p.105.
18 Private Collection, see Jack Flam, *Matisse: The Man and His Art, 1869–1918*, London 1986, p.463.
· · · · · ·

8

1 See Matisse's declaration, in a letter dated 1 September 1942 to Louis Aragon: 'I've finally begun the serious match with Painting.' Matisse was 73 years old at the time! Letter published in Dominique Fourcade, ed., *Henri Matisse: Ecrits et propos sur l'art*, Paris 1972, p.191.
2 See Pierre Daix, *Le Cubisme de Picasso*, Neuchâtel 1979, p.200.

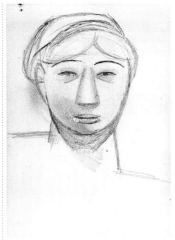

fig.26 Pablo Picasso, *Head of a Woman (study for 'Woman with a Fan')* 1908, graphite on paper 20 x 13.4, Musée Picasso, Paris

fig.27 Pablo Picasso, *Eva Gouel (Marcelle Humbert)* 1914, gelatin silver print 31.3 x 16, Musée Picasso, Paris

fig.28 Pablo Picasso, *Studies for 'Portrait of a Young Girl'* 1914, top: gouache on paper 13 x 24, bottom: oil on paper 15 x 8.5 (left), oil on paper 12 x 7.2 (centre), pencil on paper 10 x 5.8 (right), Musée Picasso, Paris

3 See the catalogue of the exhibition *De Renoir à Picasso, Masterpieces of the Musée de l'Orangerie*, Montreal Museum of the Fine Arts, 1 June–15 Oct. 2000, pp.22, 37. In both photographs, the painting is exhibited close to the paintings by Matisse belonging to the Paul Guillaume collection.
4 These two documents are reproduced in an article by Pierre Daix, 'Portraiture in Picasso's Primitivism and Cubism', in William Rubin, ed., *Picasso and Portraiture: Representation and Transformation*, exh. cat., MoMA, New York 1996, p.270.
5 Daix 144, 148, in Daix 1979, p.218.
6 *Portrait of Greta Moll* was painted during the spring and summer of 1908. According to accounts by Hans Purmann (1946) and the

fig.29 Alvin Langdon Coburn, *Matisse and Madame Matisse in the studio at Issy les Moulineaux* May 1913, photograph courtesy George Eastman House, Rochester, New York

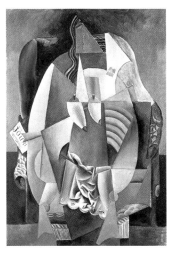

fig.30 Pablo Picasso, *Woman in an Armchair* 1913, oil on canvas 148 x 99, Private Collection

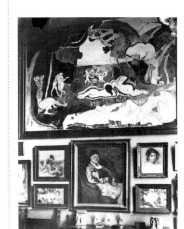

fig.31 Gertrude and Leo Stein's apartment, 27 rue de Fleurus, Paris, with Matisse's *Le Bonheur de vivre* and Cézanne's *The Artist's Wife in an Armchair* (below centre) in 1906, The Baltimore Museum of Art: Dr Claribel Cone and Miss Etta Cone Papers

model herself (1951), Matisse found inspiration in a portrait of a woman by Veronèse, in order to unify his painting in a perfectly expressive unity after the model had already sat for ten three-hour sessions (see Dominique Fourcade and Isabelle Monod-Fontaine, eds., *Henri Matisse: 1904–1917*, exh. cat., Musée National d'Art Moderne, Paris 1993, p.448).
7 Daix 258–61, in Daix 1979, p.218.
8 In the 14 November issue of *L'Intransigeant*: 'This portrait of a woman is the most voluptuous painting that has been done in a long time . . . If there is a masterpiece at the Salon d'Automne, it is there and nowhere else.' And in the 15 November issue of *Les Soirées de*

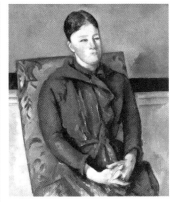

fig.32 Paul Cézanne, *Madame Cézanne in a Yellow Armchair* 1893–95, oil on canvas 80 x 67.5, Art Institute of Chicago, Wilson L. Mead Fund.

Paris: 'The figure that he exhibits, charged with voluptuousness and charm, inaugurates, so to speak, a new era in Matisse's art, and perhaps even in contemporary art.' Quoted by Jack Flam, *Matisse: The Man and His Art, 1869–1918*, London 1986, p.372.
9 André Salmon writes in *Montjoie*, nos.11–12, Nov.–Dec. 1913: 'Matisse, whose participation was decided at the last minute, has brought a portrait of a woman. It is a work that can satisfy those whom he satisfies least often. Exempt from his ordinary faults, or almost, it sums up the most beautiful qualities of this artist who is so dangerous a master.' Quoted in Flam 1986, p.372.
10 See John Elderfield, *Henri Matisse: A Retrospective*, exh. cat., MoMA, New York, 1992, p.236.
11 'By chance my painting (the portrait of my wife) has a certain success among the advanced, but it hardly satisfies me at all, it is the beginning of a very painful effort.' Matisse to Camoin in November 1913. On 4 November, Prichard announced to Isabella Stewart Gardner that Matisse 'has just finished a large portrait of his wife and two other paintings'.
12 See the letters addressed by Shchukin to Matisse on 10 October 1913: 'I hope the portrait of Madame Matisse will also be an important work', and on 18 June 1914: 'I have sent you . . . the 6,000 francs I owed you for the beautiful painting (the portrait of Madame Matisse).' It should not be necessary to point out that three of the works considered in this entry once belonged to this prodigious collector, and were hung close to each other on the walls of his home.
13 Notably *The Artist's Wife in an Armchair* (*La Femme de l'artiste au fauteuil*), also called *Woman with Fan* (*La Dame à l'éventail*), *c.*1878, reworked 1886–8 (E.G. Bürhle Foundation). This painting belonged to the Leo and Gertrude Stein collection and had been hung below *Le Bonheur de vivre* in rue de Fleurus (see fig.31). Also *Madame Cézanne au fauteuil jaune* (*Madame Cézanne in a Yellow Armchair*), 1893–5 (fig.32), which was in the Salon de Mai (1–15 May 1913). These two paintings could thus have been studied by Matisse and Picasso, conjointly.
14 See above all *Woman in an Armchair* (*Femme dans un fauteuil*), 1913 (fig.30), and all the preceding studies for it, considered by Pierre Daix as an attempt at a 'synthetic portrait' of Eva (see Daix in MoMA 1996, p.288). According to Flam, *Woman in an Armchair*, finished in the autumn of 1913, could have been painted following a visit of Picasso to Matisse (Flam 1986, p.371).
15 See in particular the elements assembled by Remi Labrusse in his doctoral thesis *Esthétique decorative et experience critique: Matisse, Byzance et la notion d'Orient*, 1996, vol.1, pp.217–25.
16 An expression used by Braque: see his 'Pensées et reflexions sur la peinture', published in *Nord-Sud*, no.10, Dec. 1917.
17 'The lines in the portrait of Miss Landsberg which you mention in your letter and lines of

construction that I put around the figure to give it more amplitude in space.' Letter of Henri Matisse to Alfred Barr, 22 June 1951, Barr Archives, MoMA, New York.

18 See Labrusse 1 1996, p.219.

19 Originally published in a special issue of the magazine *Le Point* devoted to Matisse, July 1939.

20 A photograph of Eva taken in Avignon (FPPH 48, Musée Picasso, Paris) shows that the room in which she is positioned is decked out in patterned wallpaper. See Anne Baldassari, *Picasso and Photography: The Dark Mirror*, exh. cat., Houston 1997, fig.149, p.132.

21 This visit is supposed to have occurred in June 1907, see William Rubin and Judith Cousins, 'Documentary Chronology', in *Picasso and Braque*, exh. cat., MoMA, New York 1989.

22 Daix 1979, p.200, and James Johnson Sweeney, 'Picasso and Iberian Sculptures', *Art Bulletin*, vol.23, no.3, Sept. 1941.

23 It is known that the real *papiers collés*, those that served as models (Z.II**.792–803) are conserved at the Musée Picasso.

24 The first green colour, rather clear, constituted the ground as such, including the stippled zones. Picasso then redid the whole surface (except of course for the interstitial space between the stipples) with a darker green. The particular consistency of this dense green, mixed with sand, is also noteworthy.

25 See Elizabeth Lebovici and Philippe Peltier, 'Lithophanies de Matisse', *Cahiers du musée national d'art moderne*, no.49, autumn 1994, pp.4–39. This remarkable article proposes an extensive treatment of the notion of 'scratching' in the painting of Matisse, in its formal aspects as well as its sexual connotations.

26 Lebovici and Peltier 1994, p.15: 'the scratching is probably the only process in which the painter adds a withdrawal as a supplementary stage to the process of painting, a feature at once constructive and destructive, a feature at the limit of the conceivable.'

27 Ibid. p.32, who quote here Rosalind Krauss: 'But in collage, in fact, the ground is literally masked and riven. It enters our experience not as an object of perception but as an object of discourse, of *representation* [sic].' 'In the Name of Picasso', in *The Originality of the Avant-Garde and Other Modernist Myths*, Cambridge and London 1981, p.38.

28 Sweeney 1941.

29 Jack Flam, 'Matisse and the Fauves', in William Rubin, ed., *'Primitivism' in Twentieth-Century Art*, exh. cat., MoMA, New York 1984, p.231.

30 Salmon 1913, p.4, quoted in Flam 1986, p.372.

31 According to Matisse, a hundred sittings were necessary.

32 See the description by André Breton: 'The Portrait (of Madame Matisse) exhibited in the Salon d'Automne of 1913, whose crown of black feathers, the narrow fawn-coloured fur and the emerald blouse (and wasn't the hair light brown?) I could never forget, although I haven't seen the painting since. It is a perfect example of the work-event.' 'C'est à vous de parler, jeune voyant des choses' ('You have the floor, young seer of things'), 1952; republished in *Perspective cavalière*, Paris 1970, pp.15–16.
.

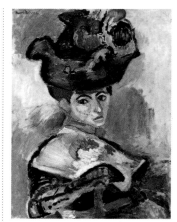

fig.33 Henri Matisse, *The Woman with the Hat* 1905, oil on canvas 80.6 x 59.7 cm, San Francisco Museum of Modern Art. Bequest of Elise S. Haas

fig.34 Jean-Auguste-Dominique Ingres, *Portrait of Louis-François Bertin* 1832, oil on canvas 116 x 95, Musée du Louvre

fig.35 Henri Matisse, *Auguste Pellerin I* 1916, oil on canvas 92.3 x 78.5, Private Collection

fig.36 Emile Bernard, *Paul Cézanne in the studio at Aix-en-Provence with 'Les Grandes Baigneuses'* 1904, Marie Louise Krumrine Collection

9

1 The only first-hand account is by Gertrude Stein (G. Stein, *The Autobiography of Alice B. Toklas*, New York 1993, pp.60–71), except that Leo Stein describes the circumstances of meeting Picasso and adds some details (L. Stein,

fig.37 Auguste Renoir, *Rapha Maitre* 1871, oil on canvas 130 x 83, Private Collection

Appreciation: Painting, Poetry and Prose, New York 1947, pp.168–70, 173–4). Important art-historical and critical accounts are: Pierre Daix, 'Picasso's Time of Decisive Encounters', *Art News*, 82, no.4, April 1987, pp.136–41; also by Daix, 'Portraiture in Picasso's Primitivism and Cubism', in William Rubin, ed., *Picasso and Portraiture: Representation and Transformation*, exh. cat., MoMA, New York 1996, pp.255–72; Leon Katz and Edward Burns, 'They Walk in the Light: Gertrude Stein and Pablo Picasso', in Burns, ed., *Gertrude Stein on Picasso*, New York 1970, pp.109–16; Robert S. Lubar, 'Unmasking Pablo's Gertrude: Queer Desire and the Subject of Portraiture', *Art Bulletin*, vol. 79, no.1, March 1997, pp.56–84; Norman Mailer, *Portrait of Picasso as a Young Man: An Interpretative Biography by Norman Mailer*, New York 1995, pp.183–233; John Richardson, *A Life of Picasso: Volume 1, 1881–1906*, New York 1991, pp.402–19; Margaret Werth, 'Representing the Body in 1906', in Marilyn McCully, ed., *Picasso: The Early Years, 1892–1906*, exh. cat., National Gallery of Art, Washington 1997, pp.277–88.

2 Lubar 1997, p.59, offers the interesting suggestion that Picasso offered to paint the portrait to ensure Leo's favour. The result, of course, was that Picasso ensured Gertrude's favour, and it would be she who shifted her allegiance from Matisse to Picasso, while Leo remained a supporter of Matisse (see Richardson 1 1991, p.419). But both artists would be baffled and annoyed when Gertrude Stein published her version of their contacts (see Richardson 1 1991, pp.405–7 for a description of Picasso's reaction and Matisse's 'Testimony Against Gertrude Stein', published in *Transition*, The Hague, July 1935, no.23, pp.3–8).

3 G. Stein 1993, p.71.

4 Roland Penrose, *Picasso: His Life and Work*, London 1991, p.116.

5 Matisse to Georges Besson, reported to Pierre Schneider, in Schneider, *Matisse*, trans. Michael Taylor and Bridget Strevens Romer, New York 1984, p.411.

6 It should be noted that, when the Stein portrait was completed and the sitter shifted her allegiance from Matisse to Picasso, her portrait by Picasso was hung directly above Matisse's *Woman with a Hat* (see 1907 photograph of the apartment at 27 rue de Fleurus in Richardson 1 1991, p.419).

7 Plausible comparisons for what the early state looked like are portraits of Leo Stein and Allan Stein; see Daix in MoMA 1996, p.258 and Richardson 1 1991, p.404.

8 The portrait of Bertin is listed as no.49 in the section *Oeuvres d'Ingres* in the catalogue of works exhibited at the 1905 Salon d'Automne.

9 See p.36.

10 Marguerite Duthuit described the encounter in an interview with Brassaï: 'Picasso . . . I remember as if it were yesterday the day the Steins took my father and me to the rue Ravignan. That's where we met him for the first time. He had a big St Bernard dog then . . .

they were amusing people, the Steins! Leo, Michael, and Gertrude. They had all had a Germanic education. The family was very rich; their father owned a street car company in San Francisco. After we left Picasso, we walked down from Montmartre to the rue de Fleurus, where the Steins lived then. We could have taken the old double-deck Batignolles-Clichy-Odéon bus, or the one that went from the Place Pigalle to the Halle-aux-Vins, but we preferred to walk. And we did not go unnoticed! On the avenue de l'Opéra, everyone turned around and stared at us. The Steins were rather oddly dressed, to say the least, especially Gertrude, who was a big woman anyway, very masculine-looking. She always wore dresses of heavy corduroy velvet and paid no attention to styles. And all three of them wore leather thong sandals on their bare feet, like the Romans, or like Isadora Duncan and her brother.' Brassaï, *Picasso and Company*, New York 1966, p.252. However, it is possible that Matisse and Picasso had met before the encounter described above. See Chronology, 1905–6.

11 See Chronology, 20 March–30 April 1906. I sympathise with Richardson 1 1991, pp.411–19, and Daix in MoMA 1996, p.262, in wanting Picasso's stopping work on the portrait to be connected with his seeing *Le Bonheur de vivre*, but I am not convinced it was: see n.16 below.

12 See Lubar 1997, p.60, n.28.

13 Richardson 1 1991, p.410. Richardson says this believing that 'Picasso's dissatisfaction with the Stein portrait coincides with his first meeting with Matisse' (ibid. p.411), implying that Picasso had seen Matisse's version of Ingres in *Le Bonheur de vivre*. But his comment remains apt even if he had not.

14 See Richardson 1 1991, pp.428, 517 n.24, who points out that the display may have been in place as early as 1905. If Picasso did not see the display until spring 1906, he may well have already ceased work on the Stein portrait, see n.16 below. This display must have also attracted Matisse's attention, judging at least from the sculptures he made that summer at Collioure, one of which is of a head that seems uncannily of the same family as those in Picasso's paintings (see Claude Duthuit, ed., with Wanda de Guébriant, *Henri Matisse: Catalogue raisonné de l'oeuvre sculpté*, Paris 1997, nos.27, 28, dated 1906–7; the view in Jack Flam, *Matisse: The Man and His Art, 1869–1918*, Ithaca and London 1986, p.183 is particularly telling). The two artists were on a very similar track. However, Matisse's principal act of masking done that summer (or, maybe, autumn) shows just how different its interpretation could be. Also in a delayed substitution, but on a different canvas, he repainted the figure of *The Young Sailor*. Matisse had just visited the so-called *proche-Orient* for the first time, and he transformed the sailorboy's face into an 'Oriental' mask (illus. John Elderfield, *Henri Matisse: A Retrospective*, exh. cat., MoMA, New York 1992, pp.164–5).

15 See Lucy Belloli, 'The Evolution of Picasso's Portrait of Gertrude Stein', *Burlington Magazine*, vol.141, no.1150, Jan. 1999, pp.12–18. However, Belloli does not address the question of the supposed ninety sittings. If there were literally that many, the suspicion has to arise that the reason was not entirely artistic, that Picasso deliberately dragged things out in order to establish a rapport with Stein, or that both artist and sitter came to enjoy their regular meetings.

16 The painting was begun in late October 1905, if it was indeed begun under the conditions described in the first paragraph of this essay. However, Richardson 1 1991, p.403, says that it was begun 'in the depths of the winter', but without documentation of this. G. Stein 1993, p.71, says that it occupied three months: 'spring was coming, and the sittings were coming to an end.' Picasso arrived in Barcelona on 21 May 1906 (see Marilyn McCully's chronology in NGA, Washington 1997, p.49) and stayed in Gósol from 2 or 3 June until 15 August (see

Robert Rosenblum, 'Picasso in Gósol: The Calm Before the Storm', in NGA, Washington 1997, p.263.) It must have been abandoned well before he left, otherwise it could not have been begun in 1905. The critical question is whether it was abandoned before March, when Picasso apparently saw the display of Iberian sculpture at the Louvre (see n.14 above), and especially before 19 and 20 March, when Matisse's Druet Gallery exhibition and the Salon des Indépendants, respectively, opened. Although Gertrude Stein does mention the Salon des Indépendants in the general context of Picasso stopping work on the portrait, he surely had to have stopped before late March; otherwise he could not have started before around Christmas, and would hardly be stopping with the advent of spring. Hence, Picasso's sight of *Le Bonheur de vivre* did not influence its abandonment, unless he was continuing to work on it in the absence of the sitter, which seems unlikely. Although it is reasonable to assume that Picasso's later sight of Matisse's new work would have increased his dissatisfaction with his present course, it is not reasonable to assume that his decision to stop working on the Stein portrait required him to have seen *Le Bonheur de vivre*. The same is true of his sight of Iberian sculpture at the Louvre in March; this, too, probably postdated the abandonment of the portrait. Lubar 1997, p.60, is correct in saying, 'The familiar art historical account of the portrait reads like an origin myth of early modernism'.

17 Stein must have known that her claim that Picasso never used models was untrue, for she would surely have known, for example, that the *Girl with a Basket of Flowers*, which her brother bought in her presence just before she met Picasso, was done from a model (see Richardson 1 1991, p.403).

18 For the Cézanne portrait, see John Rewald et al., *The Paintings of Paul Cézanne: A Catalogue Raisonné*, New York 1966, vol.1, no.811. For the Ingres, see Gary Tinterow and Philip Conisbee, eds., *Portraits by Ingres: Images of an Epoch*, exh. cat., Metropolitan Museum of Art, New York 2000, pp.300–7.

19 See Lubar 1997, pp.67–9, and passim, on Gertrude Stein's lesbianism.

20 Quoted in Dore Ashton, *A Fable of Modern Art*, London 1980, p.82, a wonderfully wide-ranging study of the Frenhofer story. Did Picasso, one wonders, then know of Cézanne's self-identification with Frenhofer (see ibid, p.9).

21 Lubar 1997, pp.70–1 asks the question vis-à-vis the robe of Rodin's *Monument to Balzac* of 1898, but misses the Frenhofer connection. Werth points to the strange emptiness of the robe, despite the apparent massiveness of the body (Werth in NGA, Washington 1997, pp.283, 287, n.30).

22 For Picasso in Gósol, see Daix in MoMA 1996, pp.255–72; Lubar 1997, pp.77–84; Rosenblum in NGA, Washington 1997, pp.263–75; Werth in NGA, Washington 1997, pp.277–88.

23 See pp.26–33.

24 Lubar 1997, p.82.

25 I here draw upon my own *The Language of the Body: Drawings by Pierre-Paul Prud'hon*, New York 1996, pp.63–4, 70–1.

26 Werth in NGA, Washington 1997, p.286, n.20.

27 Ibid. p.284. Precisely because the Stein mask blocks rather than offers any sense of psychological interiority, Elizabeth Murray, quoted in Lubar 1997, p.62, questions the suggestion raised by Adam Gopnik that it draws on a tradition of caricature (see Gopnik, 'Caricature', in *High and Low: Modern Art, Popular Culture*, exh. cat., MoMA, New York 1990, pp.128–30).

28 In the standard account of this commission by the margarine king (the fortune coming from Tip margarine), Isabelle Monod-Fontaine points out that the first painting was completed just after the portrait of Michael Stein (and probably also of Sarah as they were done at the

same time). Isabelle Monod-Fontaine with Anne Baldassari and Claude Laugier, *Matisse: Collections du musée national d'art moderne*, Paris 1989, p.58. Schneider 1984, p.417, n.64 says that Pellerin, disliking the second portrait, folded back the unpainted areas to hide them, to Matisse's discomfort. However, this was his response to the first portrait (fig.35), which presumably led Matisse to offer to make a new version. Monod-Fontaine tells me that a conservation report made on the painting when it was on loan to the Musée National d'Art Moderne, Paris in 1993 indicated that its edges had been folded.

29 Elderfield 1992, pp.268–9.

30 Schneider 1984, pp.406, 718.

31 On Matisse's relationship with his father, see Hilary Spurling, *The Unknown Matisse*, New York 1998, pp.14, 68–9.

32 Flam 1986, p.437, makes the comparison to the Bertin portrait; it is developed, and the reference to the photograph of Cézanne added, in Elderfield 1992, pp.68–9. The term 'Buddha of the bourgeoisie' was Manet's.

33 The photograph, taken in 1904 by Emile Bernard, was published in 1914. (See Ambroise Vollard, *Paul Cézanne*, Paris 1914, pl.40. Vollard erroneously lists it as taken in 1902.) On Pellerin's collection, see Monod-Fontaine et al. 1989, p.58, n.1.

34 This work was first identified in Dominique Fourcade and Isabelle Monod-Fontaine, eds., *Henri Matisse: 1904–1917*, exh. cat., Musée National d'Art Moderne, Paris 1993, p.396. It is discussed in Colin B. Bailey with the assistance of John B. Collins, *Renoir's Portraits: Impressions of an Age*, exh. cat., New Haven and Ottawa 1997, p.114. If Pellerin is an alarming paternal figure in Matisse's painting, it is tempting to think of Matisse seeing the Renoir as a pleasant, maternal one.

35 See Chronology, 6 October–15 November 1906.

36 See Julian Hochberg, 'Some of the Things That Paintings Are', in Calvin F. Nodine and Dennis F. Fisher, eds., *Perception and Pictorial Representation*, New York 1979, pp.17–41, especially pp.27–31, for a description of the perceptual mechanisms at issue. See also Michael Baxandall, 'Fixation and distraction: The Nail in Braque's *Violin and Pitcher* (1910)', in John Onians, ed., *Sight and Insight: Essays on Art and Culture in Honour of E.H.Gombrich at 85*, London 1994, pp.399–415.

37 The area of patterned floral background in the Stein portrait is exceptional in showing detail in a middle dark zone, but being in such a zone it does not attract focalisation.

38 'With the viewer's gaze directed at the focal region,' Hochberg says of a painting by Rembrandt, 'therefore, the painting can be made indistinguishable from one that is uniformly detailed, as well as from the (external) scene itself' (Hochberg 1979, p.29). Such a truly veridical effect cannot be achieved with these paintings, given the blatant abstraction of their detailed, focal areas, but something approximating it can be achieved.

39 This phenomenon was fully described in 1976; see Gaetano Kanizsa, 'Subjective Contours', in Irvin Rock, ed., *The Perceptual World*, New York 1990, pp.157–63.

40 Although it is Picasso who is especially associated with the use of black (see Richardson 1 1991, p.417), the Pellerin portrait falls within a period of Matisse's art when black is ubiquitous.

41 It is interesting that in 1916, Matisse bought the 1864 version of Courbet's *Source of the Loue*, which also shows a double movement into and out from the painting; see Michael Fried, *Courbet's Realism*, Chicago and London 1990, pp.210–17.

.

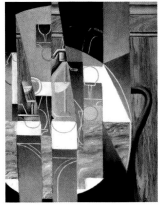

fig.38 Juan Gris, *The Siphon* 1913, oil on canvas 81.3 x 60, Rose Art Museum, Brandeis University, Waltham, Mass. Gift of Edgar Kaufman, Jr.

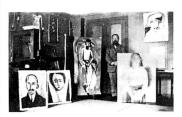

fig.39 Matisse at Quai Saint-Michel with his portrait of Greta Prozor before completion, and other works 1916, photograph courtesy The Museum of Modern Art, New York

10

1 For example, *Glass, Pipe and Playing Card*, 1914, painted wood and metal on wooden panel painted in oil (Musée Picasso, Paris; S 45), and *Bottle of Bass, Glass and Newspaper*, 1914, tinplate, cut and painted, sand, iron wire and paper (Musée Picasso, Paris; S 53).

2 Paul Cézanne, *The Card Players*, 1890–2 (Barnes Foundation, Merion, Pennsylvania). Picasso would have seen it in Ambroise Vollard's gallery before the latter sold it to Auguste Pellerin. Significantly, the two-figure version of *The Card Players*, 1893–6, now in the Musée d'Orsay, entered the Louvre with the Camondo bequest in 1911. There a bottle of wine seems to arbitrate between the two protagonists, one of whom smokes a clay pipe.

3 Andrew Steinmetz, *The Gaming Table: Its Victims and Votaries, in All Times and Countries, Especially in England and in France*, London 1870, vol.2, p.371.

4 According to Victor Crastre, Jacob did indeed 'draw up the horoscopes of the bourgeois of Céret'; *La Naissance du Cubisme (Céret 1910)*, Ophrys 1947, p.16.

5 Victor Crastre gives a vivid account of the typical clientèle of the Céret taverns: 'Many Spaniards. Muleteers, sandal-makers, cork-makers, French or Spanish peasants talk loudly and make big gestures while emptying their glasses or the "pourou"; they come here because there is elbow-room; they feel at home; they can sing at the top of their voices or make the table shake as they bang down a card, without fear of bringing down the wrath of the *patron*, who in any case joins in the feasting' (ibid, pp.43–4).

6 Cited in Etienne Sabench, 'Chronologie documentaire', *Picasso: Dessins et papiers collés – Céret 1911–1913*, exh. cat., Musée d'Art Moderne, Céret, 1997, p.358.

7 Gris and Picasso were both in Céret in mid-August 1913. In the autumn Picasso studied Gris's new work at Kahnweiler's gallery and expressed admiration (Daniel-Henry Kahnweiler, *Juan Gris: His Life and Work*, trans. D. Cooper, London 1968, p.21).

8 'I own about fifteen of your works, all very recent, which enable me sometimes to forget the horrors of the times' (letter from Léonce Rosenberg to Picasso, dated 30 October 1914, Archives Picasso, Paris). For provenance

details, see Pierre Daix and Joan Rosselet, *Picasso: The Cubist Years, 1907–1916: A Catalogue Raisonné of the Paintings and Related Works*, London 1979, cat.650.

9 *White and Pink Head*, 1914, oil on canvas (Musée National d'Art Moderne, Paris).

10 Information from Dominique Fourcade, 'Greta Prozor', *Cahiers du MNAM*, no. 11, Musée National d'Art Moderne, Paris 1983, pp.101–7, and Isabelle Monod-Fontaine, with Anne Baldassari and Claude Laugier, *Matisse: Collections du musée national d'art moderne*, Paris 1989, no.13.

11 Halvorsen organised an exhibition of modern French art at the Kunstnerforbundent in Oslo in the autumn of 1916. For the 'Dîner Braque', see Hélène Seckel, *Max Jacob et Picasso*, exh. cat., Musée Picasso, Paris 1994, pp.142, 149.

12 Fourcade 1983, p.104.

13 For the sobering influence of the war on fashion, see Harriet Worsley, *Decades of Fashion: The Hulton Getty Picture Collection*, Cologne 2000, pp.64–119. The emphasis given to the black 'choker' collar suggests some (perhaps unconscious) identification of Greta Prozor with Matisse's daughter (and often model) Marguerite (see no.4).

14 See Monod-Fontaine 1989. Matisse's admiration for the icons emerges in interviews he gave while in Russia (quoted in *Henri Matisse: 1904–1917*, exh. cat., Musée National d'Art Moderne, Paris 1993, p.99).

15 Henri Matisse, *Portraits*, Monte Carlo 1954. Cited from Jack Flam, *Matisse on Art*, Oxford 1973, p.151.

16 See also, e.g., *Olga in an Armchair*, 1919, ink on paper (Musée Picasso, Paris; Z.III.295).

. .

fig.40 Picasso's studio at 242 boulevard Raspail 1913, photograph courtesy Musée Picasso, Paris

fig.41 Henri Matisse, *French Window at Collioure* 1914, oil on canvas 116.5 x 89, Centre Georges Pompidou, Paris. Musée National d'Art Moderne/Centre de Création Industrielle.

11

1 'Sarah Stein's Notes' (1908) in Jack Flam, *Matisse on Art*, Oxford 1973, revised ed., Berkeley and Los Angeles 1995, pp.42–3.

2 Paul Cézanne, quoted by Emile Bernard, *L'Occident*, July 1904, cited in Françoise Cachin and Joseph J. Rishe, eds., *Cézanne*, exh. cat., Paris 1995, p.38. It is known that Matisse was interested in the *L'Occident* article, and that he requested a copy from Signac in a letter of the summer of 1905.

3 'Notes of a Painter' (1908) in Flam 1995, p.38.
4 Ibid, pp.35–40.
5 André Salmon, *Souvenirs sans fin*, vol. 1, Paris 1955, pp.187–8.
6 Gelett Burgess, 'The Wild Men of Paris', *Architectural Record*, vol.27, no.5, May 1910, p.404.
7 Gertrude Stein, *The Autobiography of Alice B. Toklas*, Paris 1934; London 2001, p.72.
8 According to Apollinaire in 'Les Cubistes', *Mercure de France*, 16 Oct. 1911.
9 'In the painter there are two things: the eye and the brain, both must help each other: one must assure their mutual development; the eye by vision after nature, the brain by the logic of organized sensations, which offer the means of expression.' Bernard, *L'Occident*, in *Cézanne* 1995, p.37.
10 'Matisse speaks' (1951), *Art News Annual*, no.21, 1952, republished in Flam 1995, p.134.
11 Ibid.
12 Ibid.
13 Statements by Henri Matisse quoted by Walter Pach in *Queer Thing, Painting*, New York 1938.
14 Picasso quoted by Daniel-Henry Kahnweiler, in *Conversations avec Picasso*, republished in Marie-Laure Bernadac and Androula Michael, eds., *Picasso: propos sur l'art*, Paris 1998, p.90.
15 Picasso quoted by Françoise Gilot and Carlton Lake, *Life with Picasso*, New York and London 1964, p.77.
16 Ibid.
17 We know thanks to a letter from Eva to Gertrude Stein, dated 22 July 1913 (quoted in Judith Cousins, 'Chronology', William Rubin and Cousins, *Picasso and Braque*, ex. cat., MoMA, New York 1989, p.421) that Matisse visited Picasso several times when the latter was seriously ill in his boulevard Raspail studio in the wake of his father's death. This was where, a few months earlier, he had undertaken his research into the *papiers collés*, as shown in the photographs of the period, see Anne Baldassari, *Picasso and Photography: The Dark Mirror*, exh. cat., Museum of Fine Art, Houston and Paris 1997, pp.106–17.
18 Respectively, Autumn 1912 (DR 508); Winter 1912 (Z.II**.755; DR 542); Winter 1912 (Z.II**.424; DR 543).
19 On the theoretical debate over the 'legibility' or the purely visual character of the fragments of newsprint, see the antagonistic positions of Robert Rosenblum (especially 'Picasso and the Typography of Cubism', in Roland Penrose and John Golding, eds., *Picasso in Retrospect*, New York and Washington 1973; New York 1980, pp.33–45) and Rosalind Krauss (especially 'The Motivation of the Sign', William Rubin, ed., *Picasso and Braque: a Symposium*, MoMA, New York 1992, p.88) and the more pragmatic positions of William Rubin and Leo Steinberg (ibid. p.79 and p.77 respectively). See also Anne Baldassari, *Picasso Working on Paper*, Irish Museum of Modern Art, Dublin and London 2000, p.25. The intensity of the debate has led to a situation where the same fact, that is, the frequent Cubist use of press clippings glued 'upside-down', has been interpreted in perfectly opposed ways, either as the expression of an even more radical political critique (Patricia Leighten, 'Picasso's Collages and the Threat of War', *Art Bulletin*, vol.17, no.4, Dec. 1985, p.665) or as transforming the *papiers collés* into 'unreadable printed lines' (Brigitte Léal, *Picasso: Papiers collés*, Paris 1998). As a manifestation of Picassian humour, nevertheless, the press clipping thus affixed to *Bottle and Glass* (excerpted from the *Journal*, 3 Dec. 1912, p.8) has as its central motif an advertisement for an electric light bulb, an obvious metaphor for the eye, whose slogan precisely reads as follows: 'The only one that can be placed in *any* position.'
20 Citing precisely the *papier collé Bottle and Glass* and the clipping from the *Journal*, 3 Dec. 1912, Kirk Varnedoe has pointed out that the Cubists, like Picasso, 'generally avoided the "modernized" elements of illustration and almost never extracted any of the pervasive photographic imagery. In picking advertising copy from the back sections, they consistently passed over the impressive large spreads that were then beginning to appear as banners for big-name brands, to land on cruder, unfashionable squibs for less prestigious items and enterprises.' "Words" in Kirk Varnedoe and Adam Gopnik, *High and Low: Modern Art, Popular Culture*, exh. cat., MoMA, New York 1990, pp.82–3.
21 In *Table with Bottle, Wine Glass and Newspaper*, the words 'Un Coup de Thé', an object of numerous commentaries in the debate on the 'legibility' of the *papiers collés*, comes from the headline of the *Journal*, 4 Dec. 1912, 'Un Coup de Théâtre' announcing the signature of the armistice in the Balkans war, a conflict referred to in numerous press clippings used by Picasso in the winter of 1912–13.
22 Matisse, who had a studio in 1891 at 19 quai Saint-Michel in the gables and without a view, moved to the fifth floor between 1895 and 1908, then went to the fourth floor in 1913.
23 John Elderfield, 'Describing Matisse', in *Henri Matisse: A Retrospective*, exh. cat., MoMA, New York 1992, p.66.
24 'Notes of a Painter' in Flam 1995, p.37.
25 Pablo Picasso quoted in Christian Zervos, 'Conversations avec Picasso', *Cahiers d'Art*, special issue 1935.
26 Stephane Mallarmé, 'The Impressionists and Edouard Manet', *Art Monthly Review*, 30 Sept. 1876, retranslated from the French.
27 To use an expression coined by Pierre Schneider in chap.13 of his *Matisse*, Paris 1984.
28 Pablo Picasso, quoted by Hélène Parmelin, *Picasso dit . . .*, Paris 1966, p.127.
29 Likewise, in his 1900–1 paintings entitled *Le Pont Saint-Michel* which face in the opposite direction, Matisse uses for these landscape paintings two formats which are half the size of standard French windows: 64 x 80.6 and 59 x 72.
30 This essential moment in Matissian research will reach an outermost limit in *Porte-fenêtre à Collioure*, painted several months later, which merges the beholder's point of view and the subject of the painting. In this case the question of the representation of space in perspective would seem to have been handled by obstruction. The window looking out on a blind view puts an end to the very idea of landscape and, like the half-shut blind, brings the meaning of the painting back towards the painter. See Isabelle Monod-Fontaine with Anne Baldassari and Claude Laugier, *Matisse: Collections du musée national d'art moderne*, Paris 1989, pp.41–5, no.10.
31 The colour is evocative of a Matisse painting dated 1902, *Notre-Dame, fin d'après-midi*, altogether Cézannian in inspiration, and sharing the same twilight purplish-blue atmosphere. Already here, the treatment of landscape by compact mass and chromatic blocks yielding a simplified reading can be observed. If in 1914 Matisse's vision was recentred on the cathedral, the nature of the sensation seems to be, despite the passage of time, identically strong.
32 Georges Duthuit, *Les Fauves*, Geneva 1949, quoted in Dominique Fourcade, ed., *Matisse: Ecrits et propos sur l'art*, Paris 1972, p.61 n.12.
33 Ibid.
34 As Picasso writes: 'Nature is one thing, painting another . . . the image we have of nature we owe to painters. . . . In fact, there are only signs involved in that image.' *Arts*, no.22, 29 June 1945.
.

fig.42 Henri Matisse, *Interior with a Goldfish Bowl* 1914, oil on canvas 147 x 97, Centre Georges Pompidou, Paris. Musée National d'Art Moderne/Centre de Création Industrielle.

fig.43 Henri Matisse, *Gourds* 1915–16, oil on canvas 65.1 x 80.9, The Museum of Modern Art, New York

12

1 For a full citation of the original letter from Léonce Rosenberg to Pablo Picasso, 25 November 1915, Musée Picasso Archives, Paris, see n.13 below.
2 For a chronological listing of and bibliographical reference to all six paintings on the goldfish theme, see Isabelle Monod-Fontaine with Anne Baldassari and Claude Laugier, *Matisse: Collections du musée national d'art moderne*, Paris 1989, p.40, n.4. See also Theodore Reff, 'Matisse: Meditation on a Statuette and Goldfish', *Arts Magazine*, vol.51, Nov. 1976, pp.109–15.
3 André Breton to Jacques Doucet, 6 November 1923: 'Nous arrivons donc à ce fameux *Bocal de Poisson* pour lequel vous savez, Monsieur, toute ma faiblesse. Depuis la guerre sans doute, je n'ai vu figurer dans une exposition une oeuvre picturale de cette importance. Je crois qu'il y a du *génie* de Matisse alors que partout ailleurs il n'y a que de son talent qui est immense. La *Femme sans yeux* nous parle malgré tout de ce talent. J'ai examiné ce tableau vingt fois: c'est vraiment tout à la fois d'une liberté, d'une intelligence, d'un goût et d'une audace inouïs. Déformation, pénétration intense de la vie de l'auteur dans chaque objet, magie des couleurs, tout y est. C'est sans doute une des trois ou quatre plus grandes oeuvres modernes et c'est une admirable démonstration. Je suis persuadé que nulle part Matisse n'a tant mis de lui que dans ce tableaux et que tout ce que nous verrons de lui, d'ancien ou de récent, sera pour nous le faire regretter. C'est vraiment quelque chose irremplaçable.' Cited in Dominique Fourcade and Isabelle Monod-Fontaine, eds., *Henri Matisse: 1904–1917*, exh. cat., Museé National d'Art Moderne, Paris 1993, p.502.
4 See n.13 below.
5 See entry on *Interior with Goldfish Bowl* in MNAM 1989, pp.38–40.
6 For the relationship between Matisse's *Goldfish and Palette* and Juan Gris's *Glass of Beer and Playing Cards*, 1913, and in particular his *Man in Café*, 1912, see John Elderfield, *Matisse in the Collection of the Museum of Modern Art*, New York 1978, pp.100–2; Jack Flam, *Matisse: The Man and His Art, 1869–1918*, Ithaca and London 1986, pp.397–402. For a general discussion of the Matisse-Gris relationship, see Lisa Lyons, 'Matisse: Work, 1914–1917', *Arts Magazine*, May 1975, pp.74–5.
7 Jack Flam in a discussion following Christine Poggi's presentation at the 'Picasso and Braque' symposium at MoMA on the topic of 'Braque's Early *Papiers Collés*: The Certainties of Faux Bois', reprinted in Lynn Zelevansky, ed., *Picasso and Braque: A Symposium*, New York 1992, p.153.
8 See letter from Matisse to Charles Camoin, autumn 1914, cited in n.9 below. For a discussion of the importance of the underlying colours and their atmospheric 'warming' effect see Elderfield 1978, p.102.
9 'Marquet et moi avons fini par nous remettre au travail — Je fais un tableau, c'est mon tableau des Poissons rouges que je refais avec un personnage qui a la palette à la main et qui observe (harmonie brun-rouge) . . . Je fais beaucoup d'eaux-fortes. Que veux-tu ne peut rester toute la journée à attendre les communiqués.' Cited in MNAM 1993, p.501.
10 For an illustration of the sketch see Elderfield 1978, p.205; Flam 1986, p.399. Elderfield was the first to note that the verso of the postcard shows an image of Dürer's *St Jerome in his Study, by a Window*; Elderfield 1978, p.100.
11 Elderfield writes that the angular planes and diagonal lines of the heavily reworked area towards the top of the painting are 'highly reminiscent of the stylizations of the contemporaneous *Head, White and Rose*, suggesting that they are not the arbitrary pattern they seem, but also vestiges of the seated observer Matisse abstracted and then erased'. See Elderfield 1978, p.100. Flam 1986, p.402, also emphasises the relationship to *White and Pink Head*, especially in the colour harmony and geometrical schema. See also Pierre Daix, *Picasso Matisse*, Neuchâtel 1996, p.146.
12 It was on this occasion in November 1915 that Rosenberg juxtaposed for Matisse this new picture and Picasso's *Green Still Life* of 1914, a painting whose single-hue ground many have seen as being indebted to Matisse's *Red Studio*. Note that, coincidentally, Rosenberg also acquired *Goldfish and Palette* from the Galerie Bernheim-Jeune in this same month.
13 Letter from Léonce Rosenberg to Pablo Picasso, 25 November 1915, Musée Picasso Archives, Paris. 'Cher Ami, Le maître des "poissons rouges" a été, comme moi, un peu interloqué à première vue. Votre "arlequin" est une telle révolution sur vous-mêmes [sic] que ceux qui étaient habitués à vos compositions antérieures, sont un peu dérouté [sic] en présence de "arlequin". Level était présent, mais une fois qu'il fut parti, j'ai pu obtenir de Matisse le fond de sa pensée. Après avoir vu et revu votre tableau, il a honnêtement reconnu qu'il était supérieur à tout ce que vous aviez fait et que c'était l'oeuvre qu'il préférait à toutes celles que vous aviez créées./ J'ai mis à côté de "arlequin" votre nature morte à fond vert [i.e. Daix 814]; vous ne sauriez imaginer combien ce dernier tableau, tout en conservant de magnifiques qualités de matière, paraissait petit de conception, un peu "jeu de construction" traité avec tact et sensibilité./ Dans l'arlequin Matisse a trouvé que les moyens concouraient à l'action, qu'ils étaient égaux à cette dernière, alors que dans la nature morte, il n'y avait que des *moyens*, de très belle qualité mais sans objet./ Enfin, il a exprimé le sentiment que "ses poissons rouges" vous ont conduit à l'arlequin./ Pour me résumer, quoique surpris, il n'a pu cacher que votre tableau était très beau et qu'il était obligé de l'admirer. Mon sentiment est que cette oeuvre va influencer son prochain tableau.'
14 Cited in Pierre Daix, *Picasso: Life and Art*, New York 1993, p.147. Original letter of 9 December 1915, from Picasso to Gertrude Stein in Gertrude Stein Archive, Beineke Rare Books and Manuscripts Library, Yale University.

15 See n.13 above, translation by the author.
16 Alfred H. Barr, *Picasso: Fifty Years of his Art*, New York 1946, p.93.
17 See my essay, 'Picasso's Self-Portraits', in William Rubin, ed., *Picasso and Portraiture: Representation and Transformation*. exh. cat., MoMA, New York 1996, pp.143–5; Theodore Reff, 'Saltimbanques, Clowns and Fools', *Artforum*, vol.13, no.2, Oct. 1974, pp.30–43. See also Carter Ratcliff, 'Picasso's "Harlequin"': Remarks on the Modern's "Harlequin"', *Arts Magazine*, Jan. 1977, pp.124–6, who argues that the figure brings together Pierrot and Harlequin, and thus incorporates two sides of the same manic personage.
18 John Richardson, *A Life of Picasso: Volume 2, 1907–1917*, New York 1996, p.387.
19 William Rubin argues that a reading of the unpainted buff area of the rectangular plane as a profile is unlikely and not supported by anything in the sketches or watercolours leading up to this work. See Rubin, *Picasso in the Collection of the Museum of Modern Art*, MoMA, New York 1972, p.68. However, as I have stated elsewhere, 'if this reading is correct, Picasso would have insinuated into the scene a disembodied "second self", seemingly latent or emergent in the painting process itself', Varnedoe 1996, p.145. The insertion of profile portraits became a frequently applied strategy in Picasso's subsequent work of the 1920s and 1930s, ibid. pp.146–50.
20 See Harold Bloom, *The Anxiety of Influence: A Theory of Poetry*, New York 1997.
21 See n.13 above. Cited in Michael Fitzgerald, *Making Modernism*, New York 1995, p.40.

. .

fig.44 Pablo Picasso, *Man Leaning on a Table* 1916, oil on canvas 200 x 132, Private Collection

13

1 Jack Flam, *Matisse on Art*, Berkeley and Los Angeles 1995, p.300.
2 In the text, dimensions are given rounded off to the nearest 5 cm. This is done both for the convenience of readers and because the current precise dimensions will, in the case of paintings that have been restretched (as most of those mentioned have) vary from the original dimensions (exact dimensions are given where necessary in the notes). The two other works referred to here are *The Family of Saltimbanques* of 1905, 215 x 230 cm (see E.A. Carmean, Jr., *Picasso: The Saltimbanques*, exh. cat., National Gallery of Art, Washington 1980, pl.1), and *Three Women* of 1907–8, 200 x 180 cm (see William Rubin, *Picasso and Braque: Pioneering Cubism*, exh. cat., MoMA, New York 1989, p.111).
3 The two paintings are *Still Life, Bread and Bowl of Fruit on a Table* of 1909, 165 x 133 cm (see Rubin 1989, p.115), and *Bather* of 1908–9, 130 x 97 cm (no.20).
4 The other three works are *Le Luxe* of 1907 (two versions, both 210 x 130 cm: for version 1 see no.6, for version 2 see John Elderfield,

Henri Matisse: A Retrospective, exh. cat., MoMA, New York 1992, no.177), *Harmony in Red* of 1908, 180 x 220 cm (see Elderfield 1992, no.105, p.187) and *Bathers with a Turtle* of 1908, 180 x 220 cm (see no.8).
5 See 'Appendix C: Contracts between Matisse and Bernheim-Jeune', in Alfred H. Barr, *Matisse: His Art and His Public*, exh. cat., MoMA, New York 1951, pp.553–4.
6 For details of the Shchukin commission see Jack Flam, *Matisse: The Man and his Art*, Ithaca and London 1986, pp.281–93 and Albert Kostenevich, 'Matisse and Shchukin: A Collector's Choice', *The Art Institute of Chicago Museum Studies*, vol.16, no.1, pp.27–43.
7 *The Pink Studio* of 1911, 180 x 221 cm (see Elderfield 1992, no.136, p.212); *The Painter's Family* of 1911, 143 x 19 cm (ibid. no.137, p.213); *Interior with Aubergines* of 1911, 212 x 246 cm (ibid. no.145, p.218); *The Red Studio* of 1911, 181 x 219 cm (ibid. no.146, p.219); *Nasturtiums with 'Dance' I* of 1912, 192 x 115 cm (ibid. no.149, p.222); *Nasturtiums with 'Dance' II* of 1912, 191 x 114 cm (no.81); *Corner of the Artist's Studio* of 1912, 192 x 114 cm (ibid. no.151, p.224); *Conversation* of 1912, 177 x 217 cm (ibid. no.152, p.225); *Goldfish* of 1912, 146 x 97 cm (ibid. no.155, p.227) and *Moroccan Café* of 1913, 176 x 210 cm (ibid. no.163, p.235).
8 See 'Appendix: The Library of Hamilton Easter Field', in Rubin 1989, pp.63–9, where the works are illustrated and discussed. It is worth noting that the current vogue for decorative schemes, propelled by former Nabis artists, may have also been influential in Picasso wanting to take advantage of this market (see *Beyond the Easel: Decorative Painting by Bonnard, Vuillard, Denis and Roussel 1890–1930*, exh. cat., Metropolitan Museum of Art, New York 2001). However, former Nabis were hardly competition for Picasso as was Matisse.
9 *Nude* of 1910, 187 x 61 cm, now in the National Gallery of Art, Washington (see Rubin 1989, p.65). A smaller horizontal and an additional 185 cm-tall canvas were painted, but the latter deemed unsatisfactory and reworked in 1918 (ibid.).
10 The critical reaction to the Salon d'Automne was devastating. See for example P. Strotsky's review and Matthew Stewart Prichard's letter to Isabella Stewart Gardner, both reprinted in excerpts in Jack Flam, *Matisse: A Retrospective*, New York 1988, p.126–7.
11 From a letter written by Picasso to Braque, dated 25 July 1911, reprinted in William Rubin, *Picasso and Braque: Pioneering Cubism*, exh. cat., MoMA, New York 1996, p.376. Earlier, Picasso had attempted another painting on this Cézannist subject, only to divide it into what would become *Three Women* and *Friendship*. I thank Elizabeth Cowling for this reminder.
12 See Bock 1989, pp.64, 66.
13 *Man with Guitar*, ibid. p.65.
14 Ibid. p.68.
15 On the genesis of this painting see entry on 'The Moroccans', in John Elderfield, *Matisse in the Collection of the Museum of Modern Art*, New York 1978, pp.110–13, and John Elderfield, 'An Interpretive Guide', in Jack Cowart and Pierre Schneider, *Matisse in Morocco*, exh. cat., National Gallery of Art, Washington 1990, no.24, pp.108–10.
16 Flam 1986, p.366 states this as definite, but the letter quoted on the subject is ambiguous as to which painting it refers.
17 See Elderfield 1978, pp.105–7, and n.87, p.207 for discussion, and a diagram, of the linear geometry of this work.
18 See Yves-Alain Bois, *Matisse and Picasso*, exh. cat., New York 1998, p.15 for a variant account of the problem of the imposed grid.
19 Four, if one includes the sculpture *Back III* which accompanied the final session of work on *Bathers by a River*, as *Back II* had accompanied the 1913 campaign on this painting.
20 Matisse used this term for the area of grey dress in his 1942 painting, *The Idol*. See special issue 'De la couleur', *Verve*, vol.4, no.13, 1945, p.48.

21 This painting is dated 1915–16 in the older literature and was dated to late May 1916, without explanation, in William Rubin, *Pablo Picasso: A Retrospective*, exh. cat., MoMA, New York 1980, p.196. This account of the development of the painting follows John Richardson, *A Life of Picasso: Volume 2, 1907–1917*, New York 1996, p.411–12.
22 *Man Leaning on a Table* (fig.44) self-evidently relates to *Harlequin*, and may also be thought to show a grieving harlequin insofar as it ultimately derives from Picasso's 1914 *Artist and Model* (William Rubin in *Picasso and Portraiture: Representation and Transformation*, exh. cat., MoMA, New York 1996, p.298), which shows a surrogate for Picasso leaning on the back of a chair across a table from a portrait of Eva.
23 I follow Richardson 2 1996, p.412, in assuming that this earliest documented state dates to autumn 1915. For a discussion, and larger illustrations of the documentary photographs of this painting, see Anne Baldassari, *Picasso and Photography: The Dark Mirror*, exh. cat., Museum of Fine Art, Houston and Paris 1997, pp.125–39.
24 After the autumn 1915 photograph (Baldassari 1997, fig.153), two of the remaining three photographs (ibid. figs.156, 158) were presumably taken on the same occasion, since Picasso wears the same peculiar clothes, the studio clutter seems to be identical, and the state of the painting appears to be the same, apparently completed except at the top. The third photograph (ibid. fig.155) shows Picasso wearing different clothes, an almost identical clutter on the floor to Baldassari's fig.156, and the painting in its final state, the canvas extended at the top. This suggests that it was taken very shortly after the preceding two photographs. In any event, these three photographs cannot presumably show the spring 1916 state of the painting if he worked on it after the spring, and they probably do date to autumn 1916. See also n.31, below.
25 See Chronology, 16–31 July 1916. *Les Demoiselles* can be seen hanging in Picasso's studio in a photograph that probably dates to 1915 (Baldassari 1997, fig.154) and is mentioned as hanging in the studio in spring 1916 in a report by a Danish art critic, Axel Satto (Richardson 2 1996, p.379).
26 Ibid. p.416.
27 Matisse sent fairly recent works, a *Marocaine* (most probably *La Mulatresse Fatma* of 1912; see NGA, Washington 1990, p.89), a *nature morte* and some drawings.
28 It is impossible here to offer a detailed account of these extraordinarily complex works, each one the subject of many critical and art-historical discussions. A useful introduction to *Bathers by a River* may be found in Catherine C. Bock, 'Henri Matisse's *Bathers by a River*', *Art Institute of Chicago Museum Studies*, vol.16, no.1, pp.45–55. For *The Moroccans* and *The Piano Lesson* see Elderfield 1978, pp.114–16, and for all three works see Flam 1986, pp.365–71, 408–10, 414–19 for *Bathers by a River*, pp.423–33 for *The Piano Lesson*, pp.408–14, 416 for *The Moroccans*.
29 Since painting *Le Bonheur de vivre* in 1906, Matisse had become particularly conscious of the shapes between positive objects, even to simplifying them by painting them out in solid flat colours. This painting-out technique caused the positive shapes that remained (especially if of light tonality) to seem to be, oddly, at once positive shapes pasted onto the surface and negative shapes, absences in the pictorial field. (Hence, for example, the Advent calendar look of *The Red Studio*.) Matisse had, therefore, been working in the same pictorial arena as that where the *papier collé* was invented, even to producing some works that actually seem anticipatory of that technique, most notably, *Interior with Aubergines* of 1911. By 1913–14, moreover, he was edging his paintings closer to Cubism, allowing images to seem overtly pasted onto the surface and disengaging some of his drawing from the contours of

planes to counterpoint them, rather, in the manner of a *papier collé*. And he was using blacks, together with greys and other dark colours, for painting out. He was also scratching at the surfaces of his paintings a great deal, a technique begun in 1908, both to erase areas and to create drawn lines. This technique accompanied a renewed interest in making etchings and monotypes and carving and chipping at his *Back* sculptures. All of these things made for a compatibility with the art that Cubism had become, an art not simply of flat thin planes, but of planes with emphatic materiality, of a far bolder, rougher aspect than the highly refined, hand-and-wrist painting before the invention of the *papier collé*.
30 This aspect is stressed by Pierre Schneider, *Matisse*, trans. Michael Taylor and Bridget Strevens Romer, New York 1984, pp.488–9.
31 Richardson 2 1966, p.411. Richardson, implying that the painting was completed by then, reports that Picasso needed to cancel the agreement with Rosenberg because he had agreed to give, or more likely sell, it to Madame Errazuriz. However, the precise date it entered her collection appears to be unrecorded. It was the practice of Bernheim-Jeune, Matisse's dealer, to photograph works shortly after they entered the gallery. *The Moroccans* and *Bathers by a River* missed the August 1916 photography date and were not photographed until November (see Flam 1986, p.504, n.31). However, given their size, they could only have been painted in Matisse's studio at Issy, and, therefore, had to have been completed by the autumn of 1916, when Matisse moved his activities into Paris. The *Piano Lesson*, self-evidently, was painted at Issy. If Picasso's painting was completed in September (see n.24, above), this means that he may not have seen all three Matisse paintings in their completed states. If it was not completed until after Picasso annulled its sale to Rosenberg on 22 November, Picasso could certainly have seen the three paintings, two of them at Bernheim-Jeune's. Is it possible that it was sight of Matisse's grand compositions in progress in the spring and completed in the autumn that caused Picasso twice to hold back on delivering his own grand composition? Did Matisse's great spurt of effort in the summer of 1916 owe its motivation to sight of what Picasso was doing? Was Picasso's painting not, in fact, completed in 1916, but, rather, taken up again with other large works in 1917? These are questions that, at present, seem to be unanswerable. Certainly, it seems fair to see reciprocal influences between Matisse's and Picasso's large compositions.
32 *Harlequin and Woman with Necklace*, 1917, 200 x 200 cm (Z.III.23).
33 See entry on this work in Jean Sutherland Boggs, ed., *Picasso and Things*, exh. cat., Cleveland Museum of Art 1992, no.64, pp.176–7.
34 Ibid. and Brigitte Léal, 'Picasso's Stylistic "Don Juanism": Still Life in the Dialectic between Cubism and Classicism', in Cleveland 1992, pp.30–7.
35 See Rubin 1980, p.230.
36 Theodore Reff, 'Picasso's *Three Musicians*: Maskers, Artists and Friends', *Art in America*, Dec. 1980, pp.124–42.

.

14

1 Compare, for example, Gris's *Fruit Dish and Carafe*, 1914, oil, *papier collé* and charcoal on canvas (Rijksmuseum Kröller-Müller, Otterlo).
2 Chardin's *La Brioche*, 1763, entered the Louvre in 1869 with the La Caze bequest. Crowning the brioche is a sprig of flowering orange tree, recalled in the leaf of Picasso's pear.
3 Cézanne's *Apples and Oranges* (fig.45) entered the Louvre in 1914 with the Camondo bequest.
4 The contemporary *Still Life with Cards, Glasses and Bottle of Rum*, 1914–15 (Private

fig.45 Paul Cézanne, *Apples and Oranges* c.1899, oil on canvas 74 x 93, Musée d'Orsay, Paris

fig.46 Jan Davidsz. de Heem, *La Desserte* 1640, oil on canvas 149 x 203, Musée du Louvre

fig.47 Pablo Picasso, *Study for the decor of 'La Nuit'* 1924, graphite on paper 21 x 27, Musée Picasso, Paris

Collection) contains an explicitly patriotic message, 'Vive la France'—the word 'France' being replaced by two French flags. Like *Still Life with Fruit Dish on a Table* it includes a bottle of Negrita rum (see Jean Sutherland Boggs, *Picasso and Things*, exh. cat., Cleveland Museum of Art 1992, pp.164, 169).

5 See, for example, Matisse's letters to Walter Pach on 20 November 1915 (excerpted in Dominique Fourcade and Isabelle Monod-Fontaine, eds., *Henri Matisse: 1904–1917*, exh. cat., Musée National d'Art Moderne, Paris 1993, p.503) and to André Derain in late February 1916 (cited in Raymond Escholier, *Matisse from the Life*, trans. Geraldine and H.M. Colvile, London 1960, pp.97–8).

6 E. Tériade, 'Matisse Speaks', 1951, in Jack Flam, *Matisse on Art*, Oxford 1973, p.132.

7 John Elderfield points out that De Heem's *La Desserte* (fig.46) was the inspiration behind both *The Dinner Table*, 1897 (Private Collection), and *Harmony in Red (La Desserte)*, 1908 (Hermitage State Museum, St Petersburg); in his *Matisse in the Collection of the Museum of Modern Art*, New York 1978, pp.105–7.

8 Matisse's first copy is now in the Musée Matisse, Nice-Cimiez. In making the new copy, Matisse chose a canvas close in size to, albeit larger and squarer than, De Heem's painting; in 1893 he had used a considerably smaller canvas.

9 Elderfield 1978, pp.106, 208.

10 Rosenberg paid Picasso 2,000 francs for *Still Life with Fruit Dish on a Table* at an unrecorded date. On 16 December 1920 he sold it for 25,000 francs to John Quinn. The extent of the mark-up suggests he bought it in 1915, not later. (I am very grateful to Christian Derouet for this information.)

11 Charles Sterling, *Still Life Painting from Antiquity to the Present Time*, trans. James Emmons, Paris 1959, p.111.

12 Rosenberg's first known letter to Matisse is dated 17 October 1915 (MNAM Archives) and concerns the purchase of *Goldfish and Palette*

(no.69). He subsequently returned the De Heem 'copy' to the artist. (All information from MNAM 1993, pp.116, 364.)

13 In Rosenberg's letter to Picasso of 25 November 1915 (Archives Picasso) he not only relays Matisse's observation that *Harlequin* (no.70) was indebted to *Goldfish and Palette*, but predicts *Harlequin* 'will influence his [Matisse's] next picture'.

14 *The Return from the Christening, after Le Nain*, 1917, oil on canvas (Musée Picasso, Paris).

15 For example, *Guitar and Table before a Window*, 1919, cardboard, cut and painted paper and pencil (Musée Picasso, Paris). *Fruit Dish and Guitar*, 1919 (Musée Picasso, Paris), is a larger cardboard construction of the still-life objects alone.

16 Boggs 1992, p.214.

17 'Hommage à Picasso', *Paris-Journal*, 20 June 1924. The text was countersigned by members of the fledgling Surrealist group. For a full description of the *affaire Mercure*, see Marguerite Bonnet, *André Breton: Naissance de l'aventure surréaliste*, Paris 1975, pp.325ff.

18 In October 1924 Masson was described in Breton's first Surrealist manifesto as 'so close to us', and Picasso as 'by far the purest' of the living painters who are surrealist 'some of the time' (Breton, *Manifestes du Surréalisme*, Paris 1969, p.40). Kahnweiler had begun buying Masson's work in 1922, and in February–March 1924 gave him a one-man show at the Galerie Simon.

19 Breton, 'Second Manifeste du Surréalisme', ibid. p.92.

20 For example, *Interior, Flowers and Parrots*, 1924, oil on canvas (Baltimore Museum of Art. The Cone Collection) was in Matisse's exhibition at the Galerie Bernheim Jeune in May 1924 (cat.32).

21 *Mandolin and Guitar* was shown with other similar still lifes in Picasso's exhibition at the Galerie Paul Rosenberg in June–July 1926 (cat.29), and again in June–July 1932 at his retrospective at the Galeries Georges Petit (cat.156).

.

fig.48 Henri Matisse, *Interior at Nice* 1917–18, oil on canvas 73.7 x 60.3, Philadelphia Museum of Art: The A.E. Gallatin Collection

fig.49 Pablo Picasso, *Guitar* 1912–13, sheet metal and wire 77.5 x 35 x 19.3, The Museum of Modern Art, New York

15

1 See Jack Cowart, 'The Place of Silvered Light: An Expanded, Illustrated Chronology of Matisse in the South of France', in *Henri Matisse: The Early Years in Nice 1916–1930*, National Gallery of Art, Washington and New York 1986, p.19.

2 Quoted in Kaspar Monrad, ed., *Henri Matisse: Four Great Collectors*, Statens Museum for Kunst, Copenhagen 1999, p.301.

3 Ibid. p.300. In February or March of 1918, Matisse took an empty apartment in a building next to the Beau-Rivage and the picture may have been finished there.

4 Ibid. p.300.

5 Pierre Schneider, *Matisse*, trans. Michael Taylor and Bridget Strevens Romer, New York 1984, p.339, n.37.

6 Quoted in Françoise Gilot, *Matisse and Picasso: A Friendship in Art*, London 1990, p.251. Jack Flam, *Matisse: The Man and his Art, 1869–1918*, London 1986, p.469, quotes an earlier version of the encounter. Clearly as Matisse repeated the story he enlarged upon it.

7 For the problems involved in dating this work, see Elizabeth Cowling in *Picasso: Sculptor Painter*, exh. cat., Tate Gallery, London 1994, p.258.

8 See ibid. p.258, for the ephemeral but environmental 'joke' sculpture of early 1913.

9 Elizabeth Cowling, 'The Fine Art of Cutting: Picasso's *Papier Collés* and Constructions in 1912–1914', *Apollo*, Nov. 1995, p.16.

10 Jean Sutherland Boggs, *Picasso and Things*, exh. cat., Cleveland Museum of Art 1992, p.207.

.

16

1 *The Pink Studio*, 1911, oil on canvas (Pushkin Museum, Moscow); *The Red Studio*, 1911, oil on canvas (MoMA, New York); *Interior with Aubergines*, 1911, distemper on canvas (Musée de Peinture et Sculpture, Grenoble).

2 Information from Nicholas Watkins, who visited Matisse's studio in 1976 and paced it out, Watkins, 'A History and Analysis of the Use of Colour in the Work of Matisse', M.Phil. Dissertation, Courtauld Institute of Art, University of London 1979, fig.209, pp.212-15.

3 Oil on canvas (Musée National d'Art Moderne, Paris).

4 See the essay by Kirk Varnedoe in this catalogue, pp.131–5.

5 Alfred H. Barr, in *Matisse: His Art and His Public*, exh. cat., MoMA, New York 1951, suggests that *The Studio, quai Saint-Michel* was probably 'painted late in 1916' (p.191), but reproduces it before *The Painter in his Studio* in his sequence of images. Jack Flam, *Matisse: The Man and his Art, 1869–1918*, London 1986, p.438, Pierre Schneider, *Matisse*, trans. Michael Taylor and Bridget Strevens Romer, New York 1984, p.438, and Lawrence Gowing in *Matisse*, London 1979, pp.132–3, all believe the Phillips picture followed on from the Centre Pompidou picture. Nicholas Watkins in *Matisse*, Oxford 1984, p.136, following a hint by Barr, suggests the Phillips picture may been intended as a pendant to *The Window* (Detroit Institute of Art), painted at Issy in the summer of 1916—the pictures are identical in size—therefore implying that Matisse began work on it soon after arriving in Paris that autumn. John Elderfield in his *Henri Matisse: A Retrospective*, exh. cat., MoMA, New York 1992, no.204, dates the Centre Pompidou picture 'autumn-winter 1916', and the Phillips picture 'autumn 1916 to 1917' (ibid. no.206), and Isabelle Monod-Fontaine in Dominique Fourcade and Monod-Fontaine, eds., *Henri Matisse: 1904–1917*, exh. cat., Musée National d'Art Moderne, Paris 1993, no.145, suggests for the Phillips painting a date of 'fin 1916–printemps 1917', thus reinforcing Elderfield's thesis.

6 The Italian model Lorette (or Laurette) began posing for Matisse towards the end of November 1916; Isabelle Monod-Fontaine and Claude Laugier, 'Eléments de chronologie (1904–1918)', in MNAM 1993, p.120. Lorette is

also the subject of no.101.

7 *Lorette Reclining*, 1916–17, oil on canvas (Private Collection). The looming, stretched-out figure is slightly over life-size. It is illustrated beside the Phillips painting in Elderfield 1992, p.276.

8 The phrase is from André Breton's definition of Surrealism in the first manifesto of October 1924. For further discussion of Picasso's Artist-and-Model images of the later 1920s and the 1930s, see John Elderfield's essay in the present catalogue, pp.254–63.

9 For example, *The Studio of the Artist, rue La Boétie*, 12 June 1920, pencil and charcoal on grey paper (Musée Picasso, Paris).

10 Picasso's extensive use of photographs is revealed in Anne Baldassari's *Le miroir noir: Picasso, sources photographiques 1900–1928*, exh. cat., Musée Picasso, Paris 1997. She illustrates some of his photographs of his studios in *Picasso photographe, 1901–1916*, exh. cat., Musée Picasso, Paris 1994.

11 See, for instance, Michel Leiris, 'The Artist and his Model', in Roland Penrose and John Golding, eds., *Pablo Picasso 1881–1973*, London 1988, p.249.

12 *The Studio*, 1927–8, oil on canvas (The Museum of Modern Art, New York. Gift of Walter P. Chrysler, Jr.).

13 Karen Kleinfelder has made the attractive suggestion that the curling line in *Painter and Model* describing the chair-back doubles as a monkey's tail and refers elliptically to the traditional notion of the artist as an 'ape of nature' (*The Artist, His Model, Her Image, His Gaze: Picasso's Pursuit of the Model*, Chicago 1993, p.27). Possibly Picasso intended the black and grey half-circles of the painter's head as a cryptic sign for the traditional beret (as worn, for example, by Rembrandt in several famous self-portraits). His tripod-shaped body is, surely, derived from an easel.

14 Private Collection. In a neat reversal of roles, the painter shown in *The Three O'Clock Session* is Henriette Darricarrère, Matisse's favourite model in 1920–7; for once the nude model is male (her brother).

15 Man Ray's well-known photograph of Matisse painting Henriette in the pose of the Berne Kunstmuseum's *Liseuse au guéridon* is reproduced in Elderfield 1992, p.293.

16 'Picasso Speaks', *The Arts*, New York, May 1923; in Dore Ashton, *Picasso on Art: A Selection of Views*, London 1972, p.4.

17 See Chronology, 1916–17.

18 *Oeuvres de Matisse et de Picasso*, Galerie Paul Guillaume, Paris, 23 Jan.–15 Feb. 1918, no.1.

19 *Trente ans d'art indépendant, 1884–1914: rétrospective de la Société des Artistes Indépendants*, Grand Palais, Paris, 20 Feb.–21 March 1926, no.1188.

20 'Model' should be taken in the broad, not the narrow sense: as William Rubin has pointed out, the 'model' on the left of the Janis *Painter and Model* (no.80) is a female bust on a plinth—the kind of sculpture in welded metal Picasso would soon start making with the help of Julio González (Rubin, *Picasso in the Collection of the Museum of Modern Art*, MoMA, New York 1972, p.130).

21 See, for instance, the drawings dated 4 January 1954. A drawing dated 23 December 1953 shows a fair-haired model strikingly reminiscent of Lydia Delectorskaya, who began posing for Matisse in 1935 and whom Picasso encountered on his visits to Matisse after the war. The whole series was first published as 'Suite de 180 dessins de Picasso', *Verve*, nos. 29–30, Sept. 1954. As Kleinfelder points out, Picasso would have known Brassaï's photographs of Matisse drawing a nude model in Paris in 1939 (Kleinfelder 1993, pp.134–7).

22 Oil on canvas (Private Collection).

23 *Henri-Matisse*, Galeries Georges Petit, Paris, 16 June–25 July 1931, no.36. Picasso was at the opening of the exhibition (see Chronology, 1931).

24 See n.5 above.

25 The brass charcoal burner appears in a number of Matisse's odalisque paintings of the later 1920s, for example, *Odalisque with Gray*

Culottes, 1926–7, oil on canvas (Musée de l'Orangerie, Paris; Collection Walter-Guillaume).

.

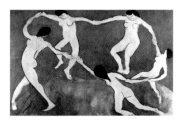

fig.50 Henri Matisse, *Dance I* 1909, oil on canvas 259.7 x 390.1, The Museum of Modern Art, New York. Gift of Nelson A. Rockefeller in honour of Alfred H. Barr, Jr.

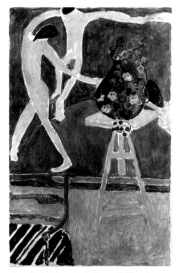

fig.51 Henri Matisse, *Nasturtiums with 'Dance' I* 1912, oil on canvas 191.8 x 115.3, The Metropolitan Museum of Art, New York, bequest of Scofield Thayer

17

1 The study for *Dance* appears in *Still Life with 'Dance'*, 1909 (Hermitage State Museum, St Petersburg), in *The Pink Studio* of 1911 (Pushkin Museum of Fine Arts, Moscow), and in the two versions of *Nasturtiums with 'Dance'* of 1912, now in the Metropolitan Museum of Art, New York (fig.51), and the painting in this exhibition. There has been a certain amount of confusion about the sequence of these. But there can be little doubt that the Russian picture, shown at the Salon d'Automne of 1912, is the second. See John Elderfield in Jack Cowart and Pierre Schneider, *Matisse in Morocco: The Paintings and Drawings 1912–13*, National Gallery of Art, Washington 1990, p.237, n.76.
2 Georges Duthuit, *Écrits sur Matisse*, Paris 1992, p.192.
3 John Richardson, *A Life of Picasso: Volume 1, 1881–1906*, New York 1991, p.419.
4 Ibid. p.319, where Richardson suggests that Picasso may have met Shchukin as early as 1906.
5 See Introduction, pp.18–20.
6 Quoted in Ronald Ally, *The Three Dancers*, Charlton Lectures on Art, Newcastle upon Tyne, 1967.
7 Infra-red photographs show that this was the only area in the painting that stayed constant and was not reworked. See Jack Flam, *Matisse: The Man and His Art, 1869–1918*, London 1986, pp.344–5.
8 A certain amount of confusion has been caused by the fact that *Capucines à la Danse*, (no.769 in the 1912 Salon d'Automne catalogue), was listed as belonging to 'M. le Dr G.' (the art historian Curt Glaser). This, and the fact that on 15 January 1913 Shchukin wrote to Matisse enquiring about his picture, has led the authors of *Henri Matisse: Four Great Collectors* (Kaspar Monran, ed., Statens

Museum fur Kunst, Copenhagen 1999) to believe that the picture now in the Metropolitan was substituted for the one now in the Pushkin (pp.232–3). The earlier version was however sent to the *Second Post-Impressionist Exhibition* in London (Grafton Galleries, 5 Oct. 1912–31 Jan. 1913) and thence to the celebrated Armory Show in New York, Chicago and Boston.
9 See Chronology, 1922.
10 *André Breton: La Beauté convulsive*, Musée National d'Art Moderne 1991, p.87. This might have been of the first version, but it is more likely to have been the second, which Breton, a gallery goer since his youth, could have seen at the 1912 Salon d'Automne.

. .

18

1 *Matisse et Picasso*, Galerie Paul Guillaume, Paris, 23 Jan.–15 Feb. 1918. See Chronology, 1918.
2 'Matisse speaks' (Interview with Tériade), 1951, in Jack Flam, *Matisse on Art*, London 1973, p.134.
3 *The Drawings of Matisse*, exh. cat., Arts Council of Great Britain 1985, p.74.
4 Felipe Cossío del Pomar, *Con las Buscadores del Camino*, Madrid 1932, cited in Dore Ashton, *Picasso on Art: A Selection of Views*, London 1972, p.98.
5 See Anne Baldassari, *Picasso and Photography: The Dark Mirror*, trans. Deke Dunisberre, Paris 1997, pp.125–87.
6 For example, *The Source*, 1921, soft crayon on canvas (Musée Picasso, Paris), and *Large Bather*, 1921, oil on canvas (Musée de l'Orangerie, Paris; Collection Jean-Walter et Paul Guillaume).
7 *Three Women at the Fountain*, 1921, sanguine on canvas (Musée Picasso, Paris).
8 *Three Musicians*, 1921, oil on canvas (Philadelphia Museum of Art).
9 For example, *Still Life with Mandolin and Compotier*, 1920, oil on canvas (Kunstmuseum, Basel).
10 Proud of his association with Picasso, Diaghilev included illustrations of his line drawings as well as his costume designs in the Company's post-war programmes.
11 Speaking to Kahnweiler in 1933 of his pure line etchings illustrating Ovid's *Metamorphoses* (Lausanne 1931), Picasso remarked: 'the line drawing has its own, innate light and does not imitate it' (Ashton 1972, p.116).
12 See Baldassari 1997, p.180, for Picasso's source.
13 Matisse's gallery, Galerie Bernheim-Jeune, held Courbet and Renoir exhibitions during the course of 1919. The Renoir show, devoted to works on paper, was held in March; he died on 3 December. Picasso's charcoal *Portrait of Renoir* (Musée Picasso, Paris) was done from a photograph and is thought to date from just after his death.
14 Raymond Escholier, *Matisse ce vivant*, Paris 1956, pp.163–4.
15 John Richardson, *The Sorcerer's Apprentice: Picasso, Provence, and Douglas Cooper*, London 1999, p.203.

.

19

1 Lorette had been recommended to Matisse by his friend Georgette Agutte Sembat, and began modelling for Matisse in late November 1916.
2 This second Renoir is RF 1973–87. On Picasso and Renoir, see the entry by Hélène Seckel in *Picasso collectionneur*, Paris 1999, pp.202–11. Paul Rosenberg attempted in vain to organise a meeting between the two painters in 1919.
3 Letter to Amélie Matisse, 5 May 1918 (Matisse Archive, Paris).
4 See the statements by Renoir as recorded by Matisse following the version given in Françoise Gilot and Carlton Lake, *Life with Picasso*, New York and London 1964, p.269: 'I should almost like to say that you're not real-

fig.52 Auguste Renoir, *Seated Bather in a Landscape* 1895–1900, oil on canvas 116 x 89, Musée Picasso, Paris

fig.53 Pablo Picasso, *Large Bather* 1921, oil on canvas 182 x 101.5, Musée de l'Orangerie, Paris

ly a good painter, or even that you're a very bad painter. But there's one thing that prevents me from telling you that. When you put on some black, it stays right there on the canvas. All my life I have been saying that one can't any longer use black without making a hole in the canvas. It's not a color. Now, you speak the language of color. Yet you put on black and you make it stick. So, even though I don't like at all what you do, and my inclination would be to tell you you're a bad painter, I suppose you are a painter, after all.'
5 'Den Franske Utstilling', Oslo, 18 Jan.– late Feb. 1918.
6 Quoted by Georges Duthuit, *Les Fauves*, Geneva 1949.
7 Letter to Alexandre Romm, October 1934, in Jack Flam, *Matisse on Art*, Oxford 1973; revised ed., Berkeley and Los Angeles 1995, p.70.
8 See *Lorette Reclining, Red Background* of late 1916–spring 1917 (Private Collection) and *Lorette with a Coffee Cup Yellow Background* of 1917 (MNAM, Paris), and also *Aïcha et Lorette* of 1917 (Private Collection) and *The Two Sisters* of 1917 (Denver Art Museum).
9 *Woman Reading* of 1920 (MNAM). See especially *Large Bather (Grande baigneuse)* of 1921, oil on canvas and *Large Bather in Drapery (Grande baigneuse à la draperie)* of 1921–3, oil on canvas, both paintings having belonged to the Paul Guillaume collection, Musée de l'Orangerie.
10 In Jean Cocteau, *Picasso*, Paris 1923.
11 These shadows literally bestow consistency upon her: the figure is painted on a grey ground and modelled classically, from dark to clear, the light tones being applied last.

. .

fig.54 Henri Matisse, *Back 0* 1909, 1st version photographed by Perret, documentation général du Centre Georges Pompidou

fig.55 Henri Matisse, *Back I* 1909, bronze 191 x 116 x 17, Centre Georges Pompidou, Paris. Musée National d'Art Moderne/Centre de Création Industrielle.

fig.56 Henri Matisse, *Back II* 1913, bronze 188 x 116 x 14, Centre Georges Pompidou, Paris. Musée National d'Art Moderne/Centre de Création Industrielle.

20

1 Pablo Picasso quoted in Claude Roy, *La Guerre et la Paix*, Paris 1954, p.26.
2 Pablo Picasso quoted in Françoise Gilot and Carlton Lake, *Life with Picasso*, New York and London 1964, pp.77, 321.
3 Ibid. p.219.
4 Daniel-Henry Kahnweiler, 'Huit entretiens avec Picasso', *Le Point*, Mulhouse, Oct. 1952.
5 Ibid.
6 8 July 1948, in Kahnweiler, 'Entretiens avec Picasso', *Quandrum*, Brussels, no.2, Nov. 1956, p.7.
7 Kahnweiler, in *Conversations avec Picasso*, 9

May 1959, republished in Marie-Laure Bernadac and Androula Michael, eds., *Picasso: Propos sur l'art*, Paris 1998, p.97.

8 Alexander Liberman, 'Picasso', in *Vogue*, New York, 1 Nov. 1956, pp.132–4.

9 William Rubin, *Picasso in the Collection of the Museum of Modern Art*, New York 1978, *Three Women at the Spring*, p.114.

10 To name or to say, in the sense of Picasso's statement: 'I wish to say the nude. I do not want to make a nude like a nude. I only want to say breast, say foot, say hand, stomach. Find the way to say it, and that's all.' Pablo Picasso quoted in Hélène Parmelin, *Picasso dit*, Paris 1966, p.111.

11 During the summer of 1921 in Fontainebleau, Picasso worked simultaneously on *Three Women at the Spring* and their red chalk variant (1921, not in Zervos; Musée Picasso, Paris, MP 74), whose rust red colour echoes the colour of the 1906 *Two Nudes*. As evidenced in photographs, the two versions of *Three Musicians* (1921, Z.IV.332, Philadelphia Museum of Art; Z.IV.331, MoMA, New York) were hung in the studio in the course of their completion (see Anne Baldassari, *Picasso and Photography: The Dark Mirror*, exh. cat., Museum of Fine Art, Houston and Paris 1997, figs.201–3, pp.174–5.) Picasso conducts, simultaneously and contradictorily, these triple masculine and feminine effigies who seem to be defying one another in an unprecedented sexual and stylistic combat. The simultaneity of the work process shows an identical strategy between the Synthetic Cubism of *Three Musicians* and the 'neoclassic' parody of *Three Women at the Spring*.

12 Concerning the photographic documentary of Picasso's visit to Pompeii in 1917 and the reference to the garden in the home of Marcus Lucretius in the neoclassic painting at the beginning of the twenties, see Anne Baldassari, '"Fantaisie pompéienne": A Photographic Source for Picasso's Neo-Classicism', in Jean Clair, ed., *Picasso 1917–1924: Le Voyage d'Italie*, Milan 1998, pp.79–86.

13 Concerning the same metaphor for sculpture as a scale model, André Salmon writes on the Cubist construction *Guitar* (1912) that Picasso told him, jokingly, that his cardboard version could have been sold as a 'layout' so that everyone could make copies. *L'Air de la Butte*, Paris 1945, p.82.

14 Julio Gonzalez, 'Picasso Sculpteur', *Cahiers d'Art*, Paris, vol.11, nos.6–7, 1936, p.18.

15 Renato Guttuso, 'Michelangelo e piu difficile' (unpublished diary) in De Micheli, *Scritti di Picasso*, Milan 1973, p.112.

16 Clara MacChesney, 'A Talk with Matisse, Leader of Post-Impressionists', *New York Times*, 9 March 1913, in Jack Flam, *Matisse on Art*, Oxford 1973; revised ed. Berkeley and Los Angeles 1995, pp.51–2.

17 Matisse did little low-relief sculpture. We might point out the wood sculpture *The Dance* (1907, Duthuit no.53) or the bronze *Standing Nude* (1908, Duthuit no. 40), done during the years following the painted wood carvings made in Gósol in the summer of 1906.

18 Reproduced in Isabelle Monod-Fontaine with Anne Baldassari and Claude Laugier, *Matisse: Collections du musée national d'art moderne*, Paris 1989, no.53, fig.b, p.160.

19 See Pierre Schneider, *Matisse*, Paris 1984, p.556 : 'We are confronted, in fact, with a double image, producing two readings reinforcing one another, and each in turn dominating the other, depending on whether low-relief is considered as (thickened) painting or as (thinned) sculpture.'

20 See the ink drawing *Study of a Nude, Standing, From the Back*, 1901–3 (Musée de Peinture et de Sculpture, Grenoble, Agutte Sembat bequest). Reproduced in Monod-Fontaine et al. 1989, no.53, fig.c, p.160.

21 'Sarah Stein's Notes' 1908, in Flam 1995, pp.43–4.

22 See especially the ink drawings *Nude Back View* (Matisse Archives), photo Druet, reproduced in Schneider 1984, p.554, and *Nude Back View* (MoMA) reproduced in Monod-Fontaine et al. 1989, no.120, fig.a, p.324.

23 Pierre Schneider proposes the following realist interpretation (Schneider 1984, p.556): 'the background is to be read as a depth: from behind a swimmer has set out—her right leg is lifted—toward an illusionist far-off place to be read as a perspective extending the water's surface in which her feet plunge: a real sculptural figure thus sinks into a fictive pictorial background.'

24 1908, St Louis City Art Museum, gift of Mr Pulitzer Jr.

25 Oil on canvas, finished in 1916 (Art Institute of Chicago, the Worcester Collection).

26 Pierre Schneider points out (Schneider 1984, p.284) this chromatic link to *Music* and *The Dance*, and in n.30 refers for this initial version of *Bathers by a Stream* to a paper by John Halmark Neef, 'Matisse and Decoration, the Shchukin Panels', *Art in America*, July–Aug. 1975, p.48, n.24.

27 *Dance II*, oil on canvas; *Music*, oil on canvas, 1910 (both Hermitage State Museum, St Petersburg).

28 1931–3 (Barnes Foundation, Merion).

29 Reproduced in Monod-Fontaine et al. 1989, no.123, fig.a, p.332.

30 'Sarah Stein's notes' in Flam 1995, p.44.

31 Henri Matisse to Georges Charbonnier, 'Interview with Charbonnier, 1951', in Flam 1995, p.141.

32 Pablo Picasso, quoted in Gilot and Lake 1964, p.118.

.

fig.57 Manet, *A Bar at the Folies-Bergère* 1881–1882, oil on canvas 96 x 130, Courtauld Institute Galleries, London

21

1 The fact has been attested by numerous witnesses and visitors, Françoise Gilot, Brassaï and André Malraux among others; see Dominique Fourcade and Isabelle Monod-Fontaine, eds., *Henri Matisse: 1904–1917*, exh. cat., Musée National d'Art Moderne, Paris 1993, pp.484–5. In addition to these exchanges of oranges, in early 1944 Picasso painted a *Still Life with Pitcher, Glass and Orange*, which he offered to Matisse in the autumn of that year. Tériade reports that 'when Matisse would send him oranges, Picasso would not eat them but set them on the mantle of the chimney, to show them to visitors, saying "Look at Matisse's oranges"' (see Pierre Schneider, *Matisse*, Paris 1984, p.269).

2 See *Manet*, exh. cat., Grand Palais, Paris 1983, pp.478–82. The painting belonged to A. Pellerin between 1897 and 1912.

3 See *Matisse: 'La révélation m'est venue de l'Orient*, exh. cat., Capitoline Museums, Rome 1997, p.176. Royall Tyler (1836–1953) had been introduced to Matisse's studio in about 1912 by Matthew Prichard. Tyler and his wife Elisina kept frequent company with Matisse throughout the First World War. They had a large collection of Byzantine art, and belonged to this Byzantophile English-American milieu which was to play such an important role for Matisse at this time. See Rémi Labrusse, 'Esthétique décorative et experience critique. Matisse/Byzance et la notion d'Orient', Doctoral thesis (unpublished), 1996, pp.299–309.

4 Schneider 1984, p.269.

5 This is nevertheless not entirely convincing: the *Bowl of Oranges* figures in a series of still lifes every bit as radical and abstract, painted in 1916, with as motif a plate of red and green or red and yellow apples.

6 Picasso's trip to Rome, and his visit to Pompeii in late March 1917 played a crucial role in his 'classic' production of the following years. See Anne Baldassari, 'Pompeian Fantasy: A Photographic Source of Picasso's Neoclassicism', in *Picasso 1917–1924*, exh. cat., Palazzo Grassi, Venice 1998.

7 See Rosalind Krauss, *The Picasso Papers*, London 1998, especially the chapter on 'Picasso/Pastiche', pp.89–212.

8 See *On Classic Ground*, exh. cat., Tate Gallery, London 1990, p.209.

.

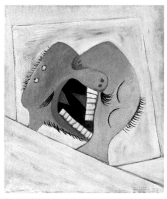

fig.58 Henri Matisse, *Nymph and Satyr* 1909, oil on canvas 89 x 117, The State Hermitage Museum, St Petersburg

fig.59 Pablo Picasso, *The Embrace* 1931, oil on canvas 61 x 50.5, Musée Picasso, Paris

22

1 Statement by Pablo Picasso quoted in Hélène Parmelin, *Picasso dit*, Paris 1966, p.77.

2 Gertrude Stein, 'From the Notebooks', in *Picasso: The Complete Writings*, intro. Leon Katz and Edward Burns, Boston 1985, p.109.

3 This artistic 'maleness' is not for Gertrude Stein the privilege of the male sex, for she adds 'Me too perhaps', ibid.

4 See Isabelle Monod-Fontaine, *Les Belles Endormies*, Paris, 1989.

5 Pablo Picasso in Roland Penrose, *Picasso*, Paris 1982, p.535.

6 Henri Matisse, 'Looking at Life with the Eyes of a Child', comments recorded by Régine Pernoud, *Le Courrier de l'UNESCO*, vol.6, no.10, Oct. 1953, republished in Jack Flam, *Matisse on Art*, Oxford 1973, revised ed., Berkeley and Los Angeles 1995, p.149.

7 Henri Matisse to Louis Aragon in 1942, quoted in Dominique Fourcade, ed., *Henri Matisse: Ecrits et propos sur l'art*, Paris 1972, p.162, n.9.

8 Triptych, ceramic, 1907–8 (Haus Hohenhof, Hagan, Westfalen).

9 Oil on canvas, c.1880. The painting belonged to Camille Pissarro and is now in a private collection; another version of the painting is in the National Gallery of Art in Washington. See *Cézanne*, exh. cat., Grand Palais, Paris 1995, no. 64 and pp.204–7.

10 Oil on canvas (Hermitage State Museum, St Petersburg). See also the study for *Nymph and Satyr* (Private Collection).

11 Charcoal on paper (Private Collection).

12 Oil on canvas, 1936–43, also referred to as *La Verdure* (Matisse Museum, Nice).

13 Triptych, oil on panel, 1944–6 (Private Collection). Charcoal studies, 1945, Matisse Archives, reproduced in Pierre Schneider, *Matisse*, trans. Michael Taylor and Bridget Strevens Romer, New York 1984, p.150.

14 Henri Matisse, statement, 1949–50, to Paule Martin in Fourcade 1972, p.322. The image was already being used by Matisse in 1908: 'In speaking of a melon one uses both hands to express it by a gesture, and so both lines defining a form must determine it.' 'Sarah Stein's Notes', 1908, Flam 1995, p.43.

15 This dialectic of dependence and distancing is set out by Matisse through the successive stages of his relation to his models: 'When I take a new model, I intuit the pose that will best suit her from her unselfconscious attitudes of repose, and then I become the slave of that pose. I often keep those girls several years, until my interest is exhausted.' 'Notes of a Painter on his Drawing', 1939, in Flam 1995, p.82.

16 Statement by Matisse in Louis Aragon, *La Grande songerie*, in Fourcade 1972, p.162, n.9.

17 Matisse to Aragon, ibid.

18 Ibid.

19 Juan-les-Pins, summer 1925, oil on canvas (Musée Picasso).

20 This painting is also entitled *The Kiss*, Paris, 12 January 1931, oil on canvas (Musée Picasso).

21 Statement by Picasso reported by Alexander Lieberman, in 'Picasso', *Vogue*, 1 November 1956.

22 'Sarah Stein's Notes', 1908, in Flam 1995, p.43.

23 Pablo Picasso in André Malraux, *La Tête d'obsidienne*, Paris 1974, p.129.

24 Pablo Picasso in Geneviève Laporte, *Si tard le soir*, Paris 1975, p.98.

25 Pablo Picasso in Malraux 1974, p.101.

26 Leo Steinberg in *Life Magazine*, 27 December 1968, reprinted in *Other Criteria*, London, Oxford and New York 1972, p.114.

27 Henri Matisse in Louis Aragon, *La Grande songerie*, in Fourcade 1972, p.162, n.9.

28 Colour pencil drawing, also entitled *The Artist Nude on the Seaside*.

29 Statement by Picasso in Laporte 1975, p.127.

. .

fig.60 Henri Matisse, *Nude with Blue Cushion beside a Fireplace* 1925, transfer lithograph 63.8 x 48, The Museum of Modern Art, New York. Gift of Abby Rockefeller (by exchange)

23

1 For a useful anthology of the early criticism, see Isabelle Monod-Fontaine, with Anne Baldassari and Claude Laugier, *Matisse: Collections du musée national d'art moderne*, Paris 1989, pp.79–82. Tériade, for example, described the painting as 'moving in its youthfulness'.

2 Jack Cowart provides a detailed description of Matisse's 'portable theater' in 'The Place of Silvered Light: An Expanded, Illustrated Chronology of Matisse in the South of France, 1916–1932', in *Henri Matisse: The Early Years in Nice 1916–1930*, exh. cat., National Gallery of

Art, Washington 1986, pp.30–2.

3 The fabric is incorrectly described as 'French Baroque wallpaper' in Alfred H. Barr, *Matisse: His Art and His Public*, exh. cat., MoMA, New York 1951, p.214. It can be glimpsed in several well-known studio photographs, including one of Henriette posing for Matisse in a harem costume, with the Venetian mirror hanging above her. This photograph is dated spring 1926 in John Elderfield, *Henri Matisse: A Retrospective*, exh. cat., MoMA, New York 1992, p.294.

4 Cowart in NGA, Washington 1986, p.31, fig.30.

5 Matisse transported the Venetian mirror to Nice from Paris: it had featured prominently in *The Painter in his Studio*, 1916, oil on canvas (fig.79).

6 See John Elderfield's essay in the present catalogue, pp.332–7.

7 Pierre Schneider, *Matisse*, trans. Michael Taylor and Bridget Strevens Romer, London 1984, pp.170, 532, 534.

8 *Seated Figure on a Decorative Background*, 1925–6, charcoal on paper (Private Collection).

9 Judith Cladel, *Aristide Maillol: Sa Vie — Son Oeuvre — Ses Idées*, Paris, 1937, p.148. *The Mediterranean* was entitled simply *Femme* when exhibited at the 1905 Salon d'Automne.

10 Matisse visited Maillol in Banyuls in summer 1905 (Hilary Spurling, *The Unknown Matisse: A Life of Henri Matisse*, vol.1, 1869–1908, London 1998, p.312). No doubt he also knew the earlier version of *The Mediterranean*, completed in 1902, in which the non-supporting arm lies horizontally across the knee, rather as in *Decorative Figure*.

11 Undated statement recorded in Raymond Escholier, *Matisse from the Life*, trans. Geraldine and H.M. Colvile, London 1960, p.141.

12 'Hommages à Maillol', *L'Art d'Aujourd'hui*, Autumn 1925, p.46. The stone version of *The Mediterranean*, which Maillol carved for Count Harry Kessler in 1905–6, is reproduced as 'Figure', pl.xlviii. No doubt Matisse knew that Maillol was currently at work on a marble replica of *The Mediterranean* for the Tuileries Gardens, where it was set up in 1927.

13 Letter to Jean Matisse, 14 February 1926, cited in Schneider 1984, p.524.

14 *Large Seated Nude* was illustrated, in two different views, in a still unfinished form in *Cahiers d'Art*, no.7, 1928, p.282. It was almost certainly present in the exhibition of Matisse's sculptures at the Galerie Pierre in June–July 1930 (see Yve-Alain Bois, *Matisse and Picasso*, Paris 1998, pp.58, 246).

15 Elderfield 1992, p.294, dates to spring 1926 the well-known photograph in which *Large Seated Nude* is silhouetted against the fabric featured in *Decorative Figure*.

16 Quoted in Cowart in NGA, Washington 1986, p.21. In the letter Matisse refers specifically to *Night* — 'I draw *The Night* and I model it' — and to the statue of Lorenzo de' Medici. Schneider 1984, p.527, associates the athleticism of *Large Seated Nude* with Matisse's prowess as an oarsman.

17 Fig.60 was one of the lithographs reproduced in Christian Zervos's 'Lithographies de Henri Matisse', published in January 1926 in the inaugural issue of *Cahiers d'Art*, 1926, p.9.

18 'Notes of a Painter' (1908), in Jack Flam, *Matisse on Art*, Oxford 1973, p.38.

19 Bois 1998, p.21, draws a telling comparison with Matisse's blazing but modestly-scaled *Odalisque with a Tambourine*, 1926, oil on canvas (The Museum of Modern Art, New York. William S. Paley Collection).

20 Michel Leiris, ed. Jean Jamin, *Journal 1922–1989*, Paris 1992, p.154. *Large Nude in a Red Armchair* is dated 5 May 1929 on the stretcher.

21 The Easter Island 'hieroglyphs' were illustrated in the reprint of Mgr Tepano Jaussen's 'L'Ile de Pâques' (originally published in 1893) in *Cahiers d'Art*, nos. 2–3, March–April 1929, pp.116–19. The Surrealists' boundless passion for Oceanic art is reflected in the fact that when Breton and Eluard auctioned their ethnographic collections in 1931, approximately half the 300+ lots were Oceanic. They owned

numerous objects from New Guinea and several wooden carvings from Easter Island (*Collection André Breton et Paul Eluard: Sculptures d'Afrique, d'Amérique, d'Océanie*, Paris, 2–3 July 1931).

22 Photographs by Régnard illustrated Breton's and Aragon's celebration of Charcot's researches into hysteria, 'La Cinquantenaire de l'hystérie', *La Révolution Surréaliste*, no. 11, 15 March 1928, pp.20–21.

23 'Notes of a Painter', Flam 1973, p.38.

24 *Metamorphosis I* and *Metamorphosis II* exist in the form of original plasters and (unique) bronze casts. The Musée Picasso, Paris, owns the bronze of the former and the plaster of the latter. They are usually dated 1928, but Peter Read argues that one was shown to the Comité Apollinaire in December 1927 (*Picasso et Apollinaire: les métamorphoses de la mémoire 1905/1973*, Paris, 1995, pp.179–81).

25 The meticulous drawings for *Seated Woman* are dated 5–8 May 1929 (Brigitte Léal, *Carnets: Catalogue des dessins*, vol.2, Musée Picasso, Paris 1996, p.112, cats. 38, 37R, 38R). Leiris mentions the drawings in his diary entry for 11 May 1929, and writes that Picasso 'is in the process of making' the sculpture (Leiris 1992, p.155).

26 See also Bois 1998, pp.58, 70–2.

..............................

fig.61 Pablo Picasso, *Nude in a Garden* 1934, oil on canvas 162 x 130, Musée Picasso, Paris

fig.62 Henri Matisse, *Apples* 1916, oil on canvas 116.8 x 88.4, The Art Institute of Chicago, Gift of Florene May Schoenborn and Samuel A. Marx

fig.63 Henri Matisse, *Reclining Nude seen from the Back* 1927, oil on canvas 66 x 92, Private Collection

fig.64 Jean-Auguste-Dominique Ingres, *Odalisque with a Slave* 1839–40, oil on canvas mounted on panel 72.1 x 100.3, Courtesy of the Fogg Museum, Harvard University Art Museums, Cambridge. Bequest of Grenville L. Winthrop.

fig.65 Photograph of Matisse's *Pink Nude (stage 1)* May 3 1935, The Baltimore Museum of Art, The Cone Archives

fig.66 Pablo Picasso, *Three Bathers* 1920, oil on wood 81 x 100, Private Collection

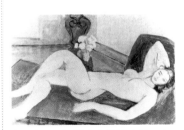
fig.67 Photograph of Matisse's *Pink Nude (stage 2)* May 10 1935, The Baltimore Museum of Art, The Cone Archives

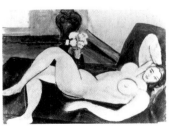
fig.68 Photograph of Matisse's *Pink Nude (stage 3)* May 16 1935, The Baltimore Museum of Art, The Cone Archives

24

1 Norman Bryson, *Tradition and Desire: From David to Delacroix*, Cambridge 1984, p.172. Jasper Johns's versions of Picasso's 1936 *Woman in a Straw Hat* almost now fall into this category.

2 The present essay derives from a study in progress that provides a detailed account of the development of Matisse's *Pink Nude* and associated works and that has been given in lecture form at the Baltimore Museum of Art in 1996 and the Kimbell Art Museum in 1999. It is indebted, as must be any account of Matisse's art in this period, to the documentation of Lydia Delectorskaya, *With Apparent Ease . . .*

Henri Matisse, Paris 1988, and now to that of Yve-Alain Bois, *Matisse and Picasso*, exh. cat., Kimbell Art Museum, Fort Worth 1998.

3 The positive critical responses to the exhibition included assertions that Matisse was biased neither to the old, like André Derain, nor to the new, like Picasso, but had achieved a perfect balance, and that there had been reciprocal influence between Matisse and the Cubists. See Christian Zervos, 'Notes on the Formation and Development of the Art of Henri Matisse', in Jack Flam, *Matisse: A Retrospective*, New York 1988, p.271; and Waldemar George, 'The Duality of Matisse', in ibid. pp.276–87. Interesting in view of what follows is that one critic mentioned how Matisse distributed colour outside the perimeters of objects (Waldemar Georges, 'Psychoananalysis of Matisse: Letter to Raymond Cogniat', in ibid. p.274). See also Bois 1998, p.64–5, for discussion of the contents of and reactions to this exhibition.

4 Bois 1998, p.102, relates this work to a motif in Matisse's *The Music Lesson*, reasonably so, since the motif is a replication of the *Blue Nude*. Apparently, Picasso's dealer refused to exhibit his *Nude in a Garden*, so it is uncertain whether Matisse saw it.

5 The reflection is reversed, side to side, thus offering a view of the figure as if seen from the back. The diamond patterning in this work not only suggests Matisse but also Picasso's own self-referential harlequin images.

6 On the antagonistic relationship of borrower to source, see Bryson 1984, pp.15–18 and passim.

7 William Rubin, ed., *Picasso and Portraiture: Representation and Transformation*, exh. cat., MoMA, New York 1996, p.66. Rubin makes reference to her presentation in *Bather with a Beachball* of 1932.

8 Henry McBride quoted in Bois 1998; p.65.

9 Picasso admitted to being influenced by Surrealism only from 1933 (see Pierre Cabanne, *Le Siècle de Picasso, L'epoque des métamorphoses*, vol.2, Paris 1979, p.190–1). However, a consensus now seems to exist that Surrealism affected him from the mid-1920s; see Pierre Daix, *La vie de peinture de Pablo Picasso*, Paris 1977, pp.198–214; John Golding, 'Picasso and Surrealism', in Roland Penrose and Golding, eds., *Picasso in Retrospect*, New York and Washington 1973, p.78; Rosalind Krauss, 'Life with Picasso', in Arnold and Marc Glimcher, eds., *Je suis le cahier: The Sketchbooks of Picasso*, exh. cat., Pace Gallery, New York 1986, p.114–15, n.9–10.

10 See Krauss 1986, p.118.

11 The critical transition is that between *Minotaur*, 1928 and *Swimmer* and *Acrobat*, both 1929.

12 On the traditional requirement that a painting deliver a commanding visual effect *au premier coup d'oeil*, see Thomas Puttfarken, *Roger de Piles' Theory of Art*, New Haven and London 1985, pp.40ff., p.55.

13 See the fine, short comparative analysis of Picasso and Matisse paintings of the mid-late 1920s in Robert Kudielka, 'Chromatic and Plastic Interaction', in *Bridget Riley: Ausgewählte Gemälde*, Ostfildern-Ruit 1999, pp.58–9.

14 See John Elderfield, *Henri Matisse: A Retrospective*, exh. cat., MoMA, New York 1992, pp.62–3; Yve-Alain Bois, 'On Matisse: The Blinding', *October*, no.68, spring 1994, pp.81–4.

15 Since the focus of this discussion is the relationship of Picasso and Matisse, I do not begin to discuss the iconography of this painting, which has provoked extensive commentary. See, for example, William Rubin, *Picasso in the Collection of the Museum of Modern Art*, MoMA, New York 1972, pp.138–41, 226–7; John Golding, 'Picasso and Surrealism', in Penrose and Golding 1973, pp.77–121, Robert Rosenblum, 'Picasso's Blond Muse: The Reign of Marie-Thérèse Walter', in MoMA 1996, pp.336–383; and Rosenblum, 'Picasso and the Anatomy of Eroticism', in *Studies in Erotic Art*,

355

New York and London 1970, pp.339–92; Rosenblum, 'Picasso as a Surrealist,' in Jean Sutherland Boggs, ed., *Picasso and Man*, exh. cat., Toronto and Montreal 1964, pp.15–17.

16 Locations of hues on the spectrum are given here to explain their connotations and not to suggest that Picasso needed to know them to code them as he did. On the iconography, but not the mechanics of colour in these works, see Linda Nochlin, 'Picasso's Color: Schemes and Gambits', in *Art in America*, Dec. 1980, pp.177–9. On their symbolism, untreated here, see the important accounts in the references given in n.15, above.

17 Hélène Parmelin, *Picasso says. . .*, London 1969, p.69. Picasso's use of black in 1932 could well have been reinforced by that year's Manet retrospective at the Musée de l'Orangerie.

18 The ur-nymph is probably Antiope in Correggio's *Jupiter and Antiope* in the Louvre. See also Isabelle Monod-Fontaine, *Matisse: Le Rêve ou les belles endormies*, Paris 1989, on the image of the sleeping nymph in this period.

19 See, for example, John Richardson, 'Picasso and Marie-Thérèse Walter', in Richardson, ed., *Through the Eye of Picasso 1928–1934: The Dinard Sketchbook and Related Paintings and Sculpture*, exh. cat. New York 1985, [n.p.], who points out that swimming was a passion of Marie-Thérèse Walter.

20 This painting forms a coda to *Still Life on a Table* of 11 March 1931 (Musée Picasso, MP 134). There, a biomorphic still life set on a pedestal adopts human forms; here a human set on a pedestal like a still life adopts biomorphic forms. It also complements the *Sleeping Woman with Mirror* of 14 January 1932 (Z.VII.360), where what in the 1934 painting seems to be a window, in the 1932 painting looks like a mirror, which reflects a coloured, inscriptive, analogical resemblance of the model. This raises the question of whether Picasso in 1934 imagined not a landscape through a window, but again a reflection of the model, only to picture it through now non-resemblant inscriptive analogy and colour. The known preparatory studies for the painting (Z.VIII.199–206) do show a window, but onto an urban scene, which includes a triangular roof shape, that will be transposed to the interior in the painting. And, finally, this painting should be seen as connecting with Picasso's other artist-and-studio representations; see pp.164–71, 254–63.

21 Penrose and Golding 1973, p.115.

22 This was noticed by Susan Grace Galassi, in a spring 2001 lecture at the Wadsworth Atheneum, Hartford. The known preparatory studies for the painting (see n.20 above) do not rehearse this writhing pose, which may be thought to confirm that it was suddenly plucked from memory. What became the image of the artist in this painting grew from studies of a classical warrior; sometimes male, sometimes female, sometimes resembling the female model.

23 It is, at present, unknown whether or not Matisse saw this particular painting.

24 See Bryson 1984, pp.28–31, on this aspect of neoclassicism. His discussions of neoclassicism, and especially of Ingres, throughout this volume are pertinent to the present subject.

25 Mary Matthews Gedo, *Picasso: Art as Autobiography*, Chicago and London 1980, p.150.

26 See Bryson 1984, pp.137–44.

27 Interview with Tériade, 15 June 1932, quoted in Bois 1998, p.74, with a different interpretation of its motivation.

28 Krauss 1986, pp.121–2, wishing to avoid a biographical reading of Picasso, speaks of the contrast of fair and dark women in his art as a semantic variant on other underlying oppositional pairs that structured his art, the most important being that of figure and ground. It is worth noticing that the development of Matisse's art in the 1920s and 1930s evidences a similar contrast. See Delectorskaya 1988, p.15. ('Je n'étais pas "son type". . . j'étais une blonde, très blonde.')

29 See Delectorskaya 1988, pp.58–67.

30 Leo Steinberg, 'The Algerian Women and Picasso at Large,' in *Other Criteria*, London, Oxford and New York 1972, pp.167, 189.

31 If Matisse had not remembered this painting from the exhibition, he would have seen it reproduced in *Documents* (no.3, 1930, p.113), in the catalogue of Picasso's retrospective at the Galeries Georges Petit (*Exposition Picasso*, Paris 1932, no.129, as *Personnages sur une plage*), and in the special issue of *Cahiers d'Art* (no.3, 1932 [n.p.]) that accompanied the exhibition.

32 See Delectorskaya 1988, p.25.

33 Steinberg 1972, p.182.

34 See Bois 1998 pp.72–5, for these works.

35 See Delectorskaya 1988, pp.36–41.

36 Once the oddity of the depicted posture is noticed, the question will arise whether, at some probably unconscious level, Matisse was recalling an early representation of a monstrous marvel of the kind that was starting to attract the attention of Rudolf Wittkower. (See especially his 1942 paper, 'Marvels of the East: a Study in the History of Monsters', in *Allegory and the Migration of Symbols*, London 1977, pp.45–74.)

.

25

1 See the painting by Matisse, *Decorative Figure on Ornamental Background*, 1925–6 (no.113).

2 On the question of this theme and its joint treatment by Picasso and Matisse, see Isabelle Monod-Fontaine, *Matisse: Le Rêve ou les belles endormies*, Paris 1989.

3 *Henriette I*, bronze 1925; *Henriette II* (the so-called 'Big head'), bronze 1927; *Henriette III*, bronze 1929.

4 Yve-Alain Bois, *Matisse and Picasso: A Gentle Rivalry*, exh. cat., Kimbell Art Museum, Fort Worth 1999. On *Woman with a Veil*, see chapter 2, pp.33–54.

5 Yve-Alain Bois, ibid. p.33, quotes Matisse in a letter to his daughter, 13 June 1926: 'I have not seen Picasso for years . . . I don't care to see him again . . . He is a bandit waiting in ambush.' (Matisse Archives, Paris).

6 To the extent that the pertinent title of the exhibition organised by Elizabeth Cowling and John Golding at the Tate Gallery in 1994, *Picasso: Sculptor-Painter*, also applies to Matisse. On their respective relations to sculpture, see Anne Baldassari, pp.264–81.

7 See the statement by Matisse (1942) as quoted by Aragon in 'Matisse-en-France': 'You know those Burmese statues with very long, flexible arms, rather like this . . . and ending in a hand that looks like a flower at the end of its stem . . . That's the Burmese sign-for-a-hand' (Jack Flam, *Matisse on Art*, Berkeley and Los Angeles 1995, p.95).

8 In the course of the same conversations with Aragon in 1942, Matisse specifies that 'the sign may have a religious, priestly, liturgical character or simply an artistic one. Each thing has its own sign. This marks the artist's progress in the knowledge and expression of the world, a saving of time, the briefest possible indication of the character of a thing . . . With signs you can compose freely and ornamentally' (ibid.).

9 Berlin, Thannhauser Gallery, 15 Feb.–19 March 1930 (265 works, including 83 paintings); Paris, Gallery Georges Petit, 16 June–25 July 1931 (141 paintings, and a choice of drawings and engravings); Bâle, Kunsthalle, 9 Aug.–15 Sept. 1931 (111 paintings, and numerous drawings, engravings and sculptures).

10 See Daniel-Henry Kahnweiler's emotional reaction on discovering several of these paintings. In a letter of 17 March 1932 to Michel Leiris, then on mission in Abyssinia, Kahnweiler writes: 'Only Picasso holds painting up, as you say, and so marvelously. Two days ago we saw two paintings he had just finished. Two nudes that are perhaps among the most accomplished, and the most moving of his works. I

said to him, "A satyr who had just killed a woman could have painted this picture". It is neither cubist, nor naturalistic, without the slightest of painters' ploys. It is lively, extremely erotic, but the eroticism is that of a giant. Picasso has accomplished nothing of the sort for years. "I would like to paint like a blind-man," he had said several days earlier, "who would grope to paint a pair of buttocks." That is exactly it. We left the studio, stunned.' The two nudes that had moved Kahnweiler are, of course, two women sleeping, two of these figures whose sleep makes them, in his view, victims already sacrificed (Kahnweiler–Leiris archives, quoted in Isabelle Monod-Fontaine 1989, p.32).

11 The slow-motion sequence of the film by François Campaux showing Matisse's brush suspended over the canvas entitled *Jeune femme en blanc, fond rouge*, hesitating on the edge of a brushstroke, is contemporaneous with *Asia*.

.

26

1 Matisse's earliest such work dates to 1895, *The Atelier of Gustave Moreau* (see John Elderfield, *Henri Matisse: A Retrospective*, exh. cat., MoMA, New York 1992, p.90); Picasso's to 1900, *Sebastian Junyent Painting* (see Michel Leiris, 'The Artist and his Model', in *Picasso in Retrospect*, New York and Washington 1973, p.243).

2 The first two works are illustrated in Elderfield 1992, p.119 no.37, p.219 no.146.

3 See Robert Rosenblum, 'Picasso's Blond Muse: The Reign of Marie-Thérèse Walter', in William Rubin, ed., *Picasso and Portraiture: Representation and Transformation*, exh. cat., MoMA, New York 1996, especially pp.340–1.

4 This is stressed by Leiris 1973, p.249 (and, following him, by other writers), who also points out that, at least in his later years, Picasso also usually painted without either a palette or an easel, but on a canvas laid flat on any convenient surface. However, it is uncertain what his practice was in the 1920s and 1930s.

5 Leiris 1973, p.244.

6 Honoré de Balzac, *Le Chef-d'oeuvre inconnu: Illustrations of Picasso*, Paris 1966, pl.4. See also Leiris 1973, p.245; Marie Laure Bernadac, 'Picasso 1953–1972: Painting as Model', in Bernadac, ed., *Late Picasso*, exh. cat., Tate Gallery, London 1988, p.77, fig.64; Kirk Varnedoe, 'Picasso's Self-Portraits', in MoMA 1996, p.153. For a complete list of all the etchings for *Le Chef-d'oeuvre inconnu* by Honoré de Balzac see also the catalogue raisonné of the commissions in Una S. Johnson, *Ambroise Vollard, Éditeur: Prints, Books, Bronzes*, exh. cat., MoMA, New York 1977, p.139–40; Georges Bloch, *Catalogue de l'oeuvre gravé et litho-graphié 1904–1969*, 2 vols., Bern 1968–71, nos.82–94; Bernhard Geiser, *Picasso: Peintre-Graveur*, 1899–1931, vol.2, Bern 1968, nos.123–35.

7 See William Rubin, 'Reflections on Picasso and Portraiture', in MoMA 1996, p.62. The identification of the subject was originally made by Herbert T. Schwarz, *Picasso and Marie-Thérèse Walter 1925–1927*, Montmagny, Quebec 1988, pp.101–5, 123–4, 152.

8 See William Rubin, *Pablo Picasso: A Retrospective*, exh. cat., MoMA, New York 1980, p.263.

9 See Rosalind Krauss, 'Life with Picasso. Sketchbook No.92, 1926', Arnold and Marc Glimcher, eds., *Je suis le cahier: The Sketchbooks of Picasso*, exh. cat., Pace Gallery, New York 1986, pp.115–16. For a further discussion of these paintings in relation to Surrealism, especially Miró and primitive art, see also John Golding, 'Picasso and Surrealism', in Roland Penrose and Golding, *Picasso in Retrospect*, London 1973, pp.89–97.

10 For illustration of these paintings see Christian Zervos, *Pablo Picasso*, vol.7, Paris 1955, p.59 pl.136; p.64 pl.142–3.

11 See Chronology, 8 October–early November 1926.

12 See William Rubin, *Picasso in the Collection of the Museum of Modern Art*, New York 1972, p.130.

13 See Rubin 1972, p.224, fig.101.

14 Yve-Alain Bois states that Picasso raced through the Ovid etchings because he wanted to finish them before Matisse would finish his Skira commissions, thereby setting the terms of a competition with Matisse. Picasso realised most of the Ovid between 13 September and 25 October 1930. A study of Picasso's forthcoming book was published by Zervos in *Cahiers d'Art*, 5, no.10, pp.511–18 with seven illustrations. See Bois, *Matisse and Picasso*, New York 1998, pp.58, 246, n.127–8.

15 For a discussion of the importance of the profile shadow in Picasso's work of the 1920s see Kirk Varnedoe in MoMA 1996, pp.146–50.

16 Dore Ashton, 'Picasso in His Studio', in Ashton and Fred Licht, eds., *Pablo Picasso L'Atelier*, exh. cat., Peggy Guggenheim Collection, Venice 1996, p.137. Ashton also offers a telling comparison with a specific Rembrandt print, pp.120–1, 137.

17 See Bois 1998, p.58.

18 See, for example, Varnedoe 1996, p.153. For a complete list of all the etchings for the *Suite Vollard*, see catalogue raisonné of the commissions in MoMA 1977, pp.140–3; Georges Bloch, *Catalogue de l'oeuvre gravé et lithographié 1904–1969*, 2 vols., Bern 1968–71, nos.134–233. For a full illustration of the *Suite Vollard* see *Pablo Picasso Suite Vollard*, exh. cat., National Gallery of Australia, Canberra 1997, as well as *Picasso Vollard Suite*, Instituto de Credito Oficial Collection, Madrid 1993; *Picasso's Vollard Suite*, London 1985; Leopold Reidemeister, *Pablo Picasso: Suite Vollard: 100 Radierungen, 1930–1937*, Hamburg 1956; Milton S. Fox, ed., *Picasso for Vollard*, New York 1956, pp.37–82.

19 See Mary Matthews Gedo, *Art as Autobiography*, Chicago and London 1980, p.221, who places the emphasis on the conflict between sexuality and creativity and its impact on the artist's self-evaluation and self-esteem. The artist is the centre of attention; the model is completely absorbed by him and his work.

20 The cup and the spatially illogical table leg are associated presumably to draw our attention to the fact that the spatial volume, the sculpture, is shown in a two-dimensional representation, and therefore is just as illogically supported as the painting is.

21 This painting was shown in Paris in 1931, and was reproduced in Florent Fels, *Henri Matisse*, Paris 1929, pl.9; Roger Eliot Fry, *Henri Matisse*, Paris and New York 1930, pl.9; Christian Zervos, *Henri Matisse*, Paris and New York 1931 [n.p.].

22 Picasso quoted in Bernadac 1988, p.76, and Frances Borel, *The Seduction of Venus, Artists and Models*, New York 1990, p.135.

23 One important reason that these drawings are celebrated is that Matisse, obviously proud of them, set out to make them known. He began to exhibit them in November 1935, at the Galerie Renou et Colle, Paris, even while he was continuing to make new works in the sequence, and did the same in January 1936, at the Leicester Gallery in London, and agreed to publish a selection in a special issue of *Cahiers d'Art*, no.3–5, October 1936.

24 See Pierre Schneider, *Matisse*, trans. Michael Taylor and Bridget Strevens Romer, New York 1984, p.440.

25 See Bois 1998, p.103, on these paintings and Matisse's response to them, but without mention of these drawings in this context.

26 The works at issue are *Carmelina* and *Interior with a Phonograph* (for illustrations see Elderfield 1992, p.119 no.37, p.332 no.258).

27 Matisse, 'Notes of a Painter, 1908' reprinted in Jack Flam, *Matisse on Art*, Berkeley and Los Angeles 1995, p.38.

28 Matisse, 'Notes of a Painter on his Drawing', reprinted in ibid. p.132.

29 Matisse, 'On Modernism and Tradition',

reprinted in ibid. p.120.

30 See ibid. pp.130–3; Matisse's essay directly addressed critics such as Claude Roger-Marx, whose 'The Drawings of Henri Matisse 1938' is reprinted in Jack Flam, ed., *Matisse: A Retrospective*, New York 1988, pp.324–7.

31 See Schneider 1984, p.411.

32 Ibid. p.426.

33 See Sigmund Freud, 'The "Uncanny"', in James Strachey, ed., *The Standard Edition of the Complete Psychological Works of Sigmund Freud*, 1953–1974, vol.17, pp.219–56.

34 Matisse, 'Statements to Tériade', in Flam 1995, p.123.

35 This characterisation is indebted to Lawrence Gowing, *Matisse*, New York 1979, pp.53–4, 106–7.

.

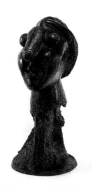

fig.69 Pablo Picasso, *Head of a Woman* 1931, bronze 86 x 32 x 48.5, Musée Picasso, Paris

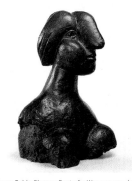

fig.70 Pablo Picasso *Bust of a Woman* 1931, bronze 77.5 x 42 x 43.5, Musée Picasso, Paris

27

1 Pablo Picasso, cited in Renato Guttuso, 'Michelangelo e piú difficile' (unpublished notebook), in De Micheli, *Scritti di Picasso*, Milan 1973.

2 Henri Matisse, in Georges Charbonnier, 'Entretiens avec Henri Matisse', in *Le Monologue du Peintre*, vol.2, Paris 1960, p.112, in Jack Flam, *Matisse on Art*, Berkeley and Los Angeles 1995, p.141.

3 See for Picasso, in particular the photos of his studio taken by the artist between 1908 and 1913, in Anne Baldassari, *Picasso and Photography: The Dark Mirror*, exh. cat., Museum of Fine Art, Houston and Paris 1997, fig.79, pp.130–2, and for Matisse, the photographs illustrating Claude Duthuit, ed., with Wanda de Guébriant, *Henri Matisse: Catalogue raisonné de l'oeuvre sculpté*, Paris 1997, pp.254–63.

4 '"What were your beginnings in sculpture?" "But I've always sculpted! I've always had one in my studio."' Henri Matisse, *Bavardages: Entretiens avec Pierre Courthion*, Paris 1941, 6th conversation, cited in Duthuit 1997, p.253.

5 'I like to model as much as to paint—I have no preference. If the search is the same when I tire of some medium, then I turn to the other— and I often make, *pour me nourrir* [as a form of nourishment], a copy of an anatomical figure in clay.' Flam 1995, pp.51–2.

6 Up until 1917, Matisse's paintings are replete with sculptural citations of his works. These paintings are studied by Isabelle Monod-Fontaine, 'The Sculptures in Matisse's Painting, 1911–1917', in *The Sculpture of Henri Matisse*, London 1984, pp.24–33, and recapitulated in Duthuit 1997, pp.265–6.

7 To use the title given by Marcel Duchamp (*Elevage de poussière*) to a photograph taken by Man Ray in 1921 of his work *Le Grand Verre* (*The Large Glass*), see Man Ray, *Self-Portrait*. Picasso informed Brassaï, on the subject of his studio on rue La Boétie, that he had 'always counted on the protection of dust'; Brassaï, *Conversations with Picasso*, trans. Jane Marie Todd, Chicago and London 1999, p.96.

8 Picasso sometimes used his sculptures for didactic demonstrations, for example, when he hung the cardboard *Guitare* (S 27A) in the midst of a series of *papiers collés* on which he was working during the winter of 1912–13. See Baldassari 1997, pp.106–23.

9 47 x 23 x 21 cm.

10 Guillaume Apollinaire, *Méditations esthé-tiques, Les peintres cubistes*, Paris 1913, republished Paris 1980, p.60.

11 This polyhedral braid appeared in Picasso's painting as early as 1907, when he embarked on the process of syntactical elaboration beginning with *Les Demoiselles d'Avignon*, *Nude in Drapery* and *Three Women*, that emerged in the radical analytical Cubist style of Horta de Ebro, in summer 1909. Picasso thus went beyond the device of a mask, used as a sign for a face, in such works as the painted *Portrait of Gertrude Stein* and the sculpted *Bust of Fontdevila*.

12 The Cézannian volumetric reduction is yet at work in the sculptures *Head* (S 25) and *Apple* (S 26), also dating from 1909.

13 Picasso cited in E. Tériade, 'En causant avec Picasso', in *L'Intransigeant*, 15 June 1932.

14 As Picasso pointed out to Roland Penrose: 'I thought that the curves you see on the surface should continue into the interior. I had the idea of doing them in wire'. Penrose, *The Sculpture of Picasso*, MoMA, New York 1967, quoted by Pepe Karmel in Kirk Varnedoe and P. Karmel, *Picasso: Masterworks from the Museum of Modern Art*, exh. cat., New York 1997, p.64.

15 See Daniel-Henry Kahnweiler, *Les Sculptures de Picasso*, photography by Brassaï, Paris 1946 (published in 1949); [n.p.]. The author adds: 'The surface is not only rough but is punctured with deep hollows, and covered with salient bumps, as if Picasso wanted to give his bronze the created light of a painting. It is no longer "as in 1900" the shape of the head that is depicted, but the objectivation of light on the head.'

16 Anne Baldassari, 'Goethe's Eye: The Role of Colour in Picasso's Graphic Work', in Roland Doschka, ed., *Picasso: Metamorphoses of the Human Form*, Munich, London and New York 2000, pp.25–35. Picasso's position seems to have borne some relation to the Goethean theory of colour which placed the beholder at the heart of a subjective experimentation of chromatic phenomena. For Picasso, the subject of modern art refounds the world on the basis of perceptive criteria and a self-referential language, each state of which must be experienced and tested before they can be organised. Penrose has offered a convincing analysis of the treatment of light in Picasso's painting of 1909, where it 'is no longer cast upon [the forms] from one given arbitrary position, but seems to radiate from beneath each surface', Penrose, *Picasso: His Life and Work*, London 1958, p.146.

17 J.W. Goethe, *Theory of Colours*, trans. Charles Lock Eastlake, London 1967.

18 Pablo Picasso, 'Letter on Art', 1926, *Ogonitok*, Moscow, no.20, 16 March 1926. Translated from the Russian.

19 Werner Spies quotes this term of Picasso's, used to describe the work of specification of the plaster piece at the foundry, Spies and Christine Piot, *Picasso Sculpteur*, Musée National d'Art Moderne, Paris 2000, p.60.

20 Kahnweiler 1949 [n.p.].

21 The plaster *Jeannette V* is dated 1910–13 by Pierre Schneider (1984, p.553) and by Margit Rowell, *Qu'est-ce que la sculpture moderne?*, Musée National d'Art Moderne, Paris 1986, p.24. Isabelle Monod-Fontaine dates it to 1913 (Monod-Fontaine 1984, no.8, p.20), as does *The Museum of Modern Art, New York: The History and the Collection*, New York 1985 (fig.47, p.71) and Claude Duthuit, ed., with Wanda de Guébriant, *Henri Matisse: Catalogue raisonné de l'oeuvre sculpté* (Paris 1997, no.33, pp.138–9). In 1984 however, Jack Flam suggested that the work should be dated 1916 ('Matisse' in William Rubin, ed., '*Primitivism' in Twentieth-Century Art*, exh. cat., MoMA, New York 1984, vol.1, p.230), referring to a conversation with Pierre Matisse (p.239 n.105). This would make *Jeannette V* the contemporary of *Back III* (see no.105). This thesis leads Jack Flam to date from 1916 the painting now in the Barnes Foundation, *Nature Morte au Buste de Plâtre*, in which there is a representation of *Jeannette V*. (The catalogue raisonné by Duthuit 1997, p.266, continues to date this painting 1913–15.) Flam's hypothesis is judged 'likely' by John Elderfield (*Henri Matisse: A Retrospective*, exh. cat., MoMA, New York 1992, pp.204, 240 fig.189). Wanda de Guébriant has informed us that the unwavering position of Marguerite Matisse was that *Jeannette V* was made in 1913.

22 This has been pointed out by Monod-Fontaine 1984, p.21.

23 1910, oil on canvas (Hermitage State Museum, St Petersburg) and *Girl with Tulips (Jeanne Vaderin)*, charcoal (MoMA, New York). Matisse exhibited only this work at the 1911 Salon des Indépendants.

24 Comment of Matisse to Pierre Courthion, cited in Jean Guichard-Meili, *Matisse son oeuvre, son univers*, Paris 1967, p.170, passage trans. by John Elderfield, *Matisse in the Collection of the Museum of Modern Art*, New York 1978, p.30.

25 Matisse uses for this series of *Heads* the principle he had previously tested in the successive versions of *Back* (nos.105–6).

26 'Sarah Stein's Notes', 1908, in Flam 1995, p.45.

27 Schneider (pp.278–9) analyses this recurrent phobia of Matisse and quotes Edward Steichen on the worry produced by the blinding light of the colours in *Danse*.

28 Referring to his beginnings in sculpture, Matisse says: 'I copied the *Tiger* by Barye, blindfolded, with my two hands like a man groping to feel a shape, my eyes closed, I performed the same operation for my work and I evaluated it.' Henri Matisse, *Bavardages*, 3rd conversation, in Duthuit 1997, p.236. The artist is in fact referring to *Jaguar Devouring a Hare* by Barye, of which Matisse made a copy in 1899–1901, Duthuit, no.4, pp.6–7.

29 The young Matisse's 'revelation' is well known; the episode which took place in a post office in Picardie, when, absent-mindedly, he drew with his pen 'going by itself' the portrait of his mother. See *Portraits*, 1954, in Flam 1995, p.151.

30 *Jeannette III*, Duthuit 1997, no.52.

31 In personal notes by Matisse published by Claude Duthuit (1997, p.260 n.21), Matisse specifies that the first two states of *Jeannette* are 'bronze casts without bases' and that the first is 'mounted on an independent cone' and the second on a 'square marble base'.

32 It should be noted that except for versions II and IV, of which there are bronze casts as early as 1910–15, that is, soon after their realisation, the various versions of *Jeannette* were presented by Matisse as plasters. Just as for the *Backs*, the bronzes are made later. A manuscript personal note by Matisse published by Claude Duthuit (1997, n.21, p.260) does however give indications on the 'bronze cast' of the '5 states of Portraits J. Vaderin'.

33 Statement to André Verdet, in Dominique Fourcade, ed., *Henri Matisse: Ecrits et propos sur l'art*, Paris 1972, p.61.

34 In the sense in which Matisse can say: 'And yet the sensations have to be condensed and the means used carried to their maximum power of expression'. 'Témoignage', in Gaston Diehl, *Peintres d'Aujourd'hui*, collection Comoedia-Charpentier, June 1943, reprinted in Fourcade 1972, p.195.

35 Jack Flam had linked *Jeannette V* to Matisse's acquisition of an 'idol of the region of Bobo-Dioulasso', of which a photograph was published in 1917 by Paul Guillaume in the album *Sculptures Nègres*, pl.5. The formal convergence of these two works lies particularly in the similar treatment of the jutting skullcap, the bridge unifying the forehead and nose, the salience of the eye pits, and the elongation of the neck. Jack Flam refers to a conversation with Pierre Matisse who told him that his father had acquired the piece 'around the beginning of World War I, *circa* 1915'. See his 'Matisse' in MoMA 1984, vol.1, n.106, p.239. This link to *Jeannette V* therefore supposes the realisation of the work from 1912 to 1916, as Flam himself proposed to date it (see n.21 above). Isabelle Monod-Fontaine, who prefers to date *Jeannette V* from 1913, places it in the context of Matisse's discovery of art nègre as early as 1906 (Monod-Fontaine 1984, p.21). Concerning 'primitivism' in the sculpture of Picasso and the formal links discovered by Daniel-Henry Kahnweiler between the 1912 *Guitare* and the structure of a Grebo mask, see William Rubin, 'Picasso', in MoMA 1984, vol.1, especially pp.304–7.

36 See Matisse quoting Cézanne—'I want to make the picture', 'Notes of a Painter', 1908, in Flam 1995, p.39, translation modified.

37 Pablo Picasso, as cited by André Malraux in *La Tête d'obsidiane*, Paris 1974, p.18.

38 See the statements quoted by André Malraux: 'I would always look at the fetishes. And I understood: me too I am against everything. Me too, I believe that everything is unknown, is the enemy. Everything! Not just details! Women, children, animals, tobacco, gambling.' Malraux 1974, p.18.

39 Besides *Head of Marie-Thérèse*, we refer to *Head of Woman*, 1931, S 110 (MP 291 plaster, MP 292 bronze); *Head of Woman*, 1931, S 133 (MP 301 plaster and wood, MP 302 bronze); *Head of Woman*, 1931, S 132 (MP 300 bronze); *Bust of Marie-Thérèse*, 1931, S 131 (MP 298 bronze, MP 299, cement).

40 Conversely, in the case of *Guitare* (1912), it is a three-dimensional work which takes on a 'generating' character (William Rubin, *Picasso and Braque: Pioneering Cubism*, exh. cat., MoMA, New York 1989, pp.31–2) for graphic works such as the series of original *papier collés*.

41 Bearing the title *Exposition de peintures et de sculptures de Henri Matisse*.

42 Yve-Alain Bois, *Matisse and Picasso*, exh. cat., Paris and Kimbell Art Museum, Fort Worth 1998, pp.66–7.

43 'I saw Picasso arrive 5 or 4 days ago with a very cute young lady. He was diabolically warm and good-humoured. He said he would return to tell me all manner of things, but he didn't. He had seen what he wanted to: my cutout papers, my new paintings . . . It will all ferment in his brain to his profit.' Henri Matisse, letter of 19 March 1946 to Pierre Matisse, Pierpont Morgan Library, Pierre Matisse Foundation.

44 Statements by Picasso quoted in E. Tériade, 'En causant avec Picasso', *L'Instransigeant*, 15 June 1932.

45 In 1931, Picasso had not yet made a painted or sculpted portrait revealing the physiognomy of his young mistress, except for a few drawings and etchings remaining of a private nature.

46 In the sense in which Picasso can affirm 'I paint with strokes of *coq-à-l'âne*? Well yes, but they follow on from one another!' cited in Malraux 1974, p.129.

47 Roland Penrose, *Picasso: His Life and Work*, London 1958, p.244. This portrait using the cast shadow of the young woman is evocative of the *Studios* of the years 1927–9, in which

357

the artist often inscribed his own presence in the form of a dark profile.

48 Picasso purchased the castle of Boigesloup in May 1931, then left Paris for Jean-les-Pins where he worked out the project of his sculptures. He set out to realise them on his return, and his efforts intensified in December.

49 As early as 11 August 1931, a sketch (MP 1056) sets out the constructive principle of the sculpture (S 110).

50 MP 1056.

51 Picasso to Brassaï in Brassaï 1999, p.100.

52 Ibid.

53 1932, in the Bayeler collection.

54 Ovide, *Les Métamorphoses*, with original engravings by Pablo Picasso, Lausanne 1931.

55 Ovid, *Metamorphoses*, trans. A.D. Melville, New York 1986, p.13.

56 Pablo Picasso, poetic text written in French ('portraiture sa figure si belle') on 15 November 1935, published in *Picasso, Ecrits*, Paris, pp.43–4.

.

28

1 It was painted in the period from 17 March to 8 April. See Lydia Delectorskaya, *With Apparent Ease . . . Henri Matisse*, Paris 1988, pp.305–7, 312–15.

2 Christian Zervos, 'Réflexions sur l'Art Mural', in *Cahier d'Art*, 5–10, 1939, pp.166–71. The article also illustrated Matisse's stylistically and thematically related overmantel decoration for Nelson A. Rockefeller, *The Song*, and some of its documented states. For this and other works related to *Music*, see Delectorskaya 1988, pp.278–87.

3 See Chronology, summer 1937.

4 'Mr. Matisse paints a picture: 3 Weeks' Work in 18 Views', *Art News*, vol.40, no.11, Sept. 1941, p.8.

5 Ibid.

6 See Roger Fry, *Henri Matisse*, New York 1935, pl.57, for the reproduction of states 1, 2, 8, 9, 11, 12, 15, 18 of the painting.

7 See *Cahiers d'Art*, 4–5, 1937. The photographs by Dora Maar are reproduced on pp.146–54.

8 Illustrated in John Elderfield, *Henri Matisse: A Retrospective*, exh. cat., MoMA, New York 1992, p.117. In 1945, Matisse fully remembered the conditions under which this work was made; see Alfred H. Barr, *Matisse: His Art and His Public*, New York 1951, p.41.

9 Lydia entered Matisse's artistic life as an assistant on the Barnes mural, and is, therefore, ineluctably associated with its new decorative style that persists in *Music*. See Delectorskaya 1988, pp.7–28. She is not represented in *Music*, however, the models being Hélène Galitzine and her cousin.

10 Letter from Pierre Matisse to Etta Cone, 11 January 1940 (Etta and Claribel Cone Archive, Archives of American Art, Smithsonian Institution): 'You have probably heard that my mother and my father are separating. It is a great blow to us all but after many efforts we are forced to realize it is the best alternative for the time being. Mother is in Paris with Marguerite and father is in Nice where he is working. I never thought anything like this could happen in our family.'

11 Matisse's hometown was thus overrun for the third time in his lifetime. Prussian Troops invaded Bohain on New Year's Day 1871 during the Franco-Prussian War and then again during the First World War (the neighbouring St Quentin was completely destroyed in March 1917). Hilary Spurling has pointed out that, while Picasso rather than Matisse is popularly associated with images of war, he had no first-hand experience of it, whereas Matisse knew it from the first year of his life, then from the sufferings of his family during the two World Wars. See Spurling, *The Unknown Matisse*, New York 1998, p.9.

12 See Barr 1951, p.255. Repeating the story later, Matisse added: 'If everybody had minded his own business as Picasso and I did ours,

this would not have happened' (ibid. p.256).

13 'It seemed to me as if I would be deserting. If everyone who has any value leaves France, what remains of France?' (ibid.).

14 Matisse's admiration of Ingres as an artist was tempered by his influence as an Academician, as he had explained in an article of December 1937. See Dominique Fourcade, ed., *Henri Matisse: Ecrits et propos sur l'art*, Paris 1972, pp.157–8; trans. Jack Flam, *Matisse on Art*, Berkeley and Los Angeles 1995, pp.125–7. Picasso's reversal of the pose of Ingres in *Serenade* was anticipated in a lithograph by Matisse of *c*.1931 (Claude Duthuit with Françoise Garnaud, eds., *Henri Matisse: Catalogue raisonné de l'oeuvre gravé*, Paris 1983, no.525.) See Yve-Alain Bois, *Matisse and Picasso*, New York 1998, pp.162–9, for a thorough, well-illustrated account of the development of *Serenade*, including its Matissean elements. Other art-historical sources for the painting include Giorgione's and Titian's *Concert Champêtre* (Musée du Louvre), Velázquez's *Venus with a Mirror* (Prado, Madrid); Edouard Manet's *Olympia* (Musée d'Orsay, Paris); and Rousseau's *The Dream* (MoMA, New York).

15 It is interesting, of course, that it reprises a motif announced in Avignon just prior to the First World War. See Alfred H. Barr, *Picasso: Fifty Years of his Art*, New York 1974, p.89.

16 Werner Spies, *Picasso: Die Zeit nach Guernica, 1937–1973*, exh. cat., Berlin 1993, p.35: 'Man kann hinter der Gegenüberstellung der zwei Frauen im privaten Harem den autobiographischen Bezug ahnen: Sie inszeniert den Kontrast Marie-Thérèse Walter und Dora Maar, wie immer den der passiven, indolenten und der kritischen, wachen Natur.'

17 Ludwig Ullman, *Picasso und der Krieg*, Bielefeld 1993, p.336: 'Auch damals [März 1939] wählte er [Picasso] eine Frau mit Mandoline als Bildthema, um durch extreme Verunstaltungen eine traditionellen Metapher harmonischen Einklangs, Ungehaltenheit und Zorn über die "Dissonanzen der Welt" zu artikulieren.' The most hyperbolic association of the painting with catastrophe is Lydia Gasman, *Mystery, Magic and Love in Picasso, 1925–1938*, London 1981, p.1125–7.

18 Bois 1998, p.116, associates the flat blacks of Picasso's early war-years canvases with 1939 paintings by Matisse that he did see. Another association would be that of Miró's recent paintings, which might have infiltrated the caricatural drawing of *Serenade*. An interesting stylistic comparison with Kandinsky's contemporary paintings is made in *Paris–Paris, 1937–1957: Créations en France*, exh. cat., Musée National d'Art Moderne, Paris 1981, p.105. But Picasso's painting requires none of these antecedents.

19 André Lhote, *La Peinture, Le Coeur et L'Esprit*, Paris 1993, being a collection of essays originally published between 1919 and 1922. Quoted and translated in Carol Ockman, *Ingres's Eroticized Bodies: Retracing the Serpentine Line*, New Haven and London 1995, p.112.

20 Ibid. p.113.

21 These two characterisations are, in fact, of Manet (Matisse) and Ingres (Picasso) in Richard Wollheim, *Painting as an Art*, Princeton 1987, p.275, whose analysis therefore raises fascinating implications for consideration of the lineage of our two artists.

22 This account is indebted to the fine analysis of Matisse's *Harmony in Yellow* of 1928 by Bridget Riley, 'Painting Now,' in Robert Kudielka, ed., *The Eye's Mind: Bridget Riley: Collected Writings, 1965–1999*, London 1999, pp.207–9.

23 See Delectorskaya 1988, p.314.

24 The motif appears in the first, 18 March 1939, state, but the vertical alignment is not established until the 25 March 1939 state; see ibid. p.307.

25 Leo Steinberg, 'The Algerian Women and Picasso At Large', in *Other Criteria*, London, Oxford and New York 1972, pp.217–22; p.217

for the quotation.

26 Siegfried Gohr, *Picasso im Zweiten Weltkrieg, 1939 bis 1945*, exh. cat., Museum Ludwig, Cologne 1988, p.35.

27 Ibid. p.33.

28 I refer here to Elaine Scary's extraordinary *The Body in Pain: The Making and Unmaking of the World*, New York and Oxford 1985, p.279 and passim. It is more than appropriate, then, that *Serenade* was so prominently featured at the Salon de Liberation of 1944; see Chronology, 6 October–5 November 1944.

. .

fig.71 Leonardo da Vinci, *Anatomical Studies of the Principal Organs and Arterial System of a Female Torso c*.1510, pen with brown ink and chalk 47 x 32.8, The Royal Collection

29

1 Alfred H. Barr, *Matisse: His Art and his Public*, exh. cat., MoMA, New York 1951, p.256. Letters in which Matisse hotly defends Picasso against malignant gossip are quoted in the Chronology, 1942.

2 *Bouquet of Flowers in a Chocolate Pot*, 1902, oil on canvas (Musée Picasso, Paris). See Hélène Seckel-Klein, *Picasso collectionneur*, exh. cat., Paris 1998, pp.166, 168. See also Chronology, 1939–40.

3 Photograph given to the Archives Picasso by Roland Penrose. Reproduced in *Picasso and the War Years, 1937–1945*, Fine Arts Museums of San Francisco 1998, p.213.

4 Françoise Gilot and Carlton Lake, *Life with Picasso*, Harmondsworth 1966, p.263.

5 See Seckel-Klein, pp.170–3, and Yve-Alain Bois, *Matisse and Picasso*, Paris 1998, pp.133–6. Bois quotes more fully Matisse's comments on *Portrait of Dora Maar*, 1942, oil on canvas (Private Collection). Picasso gave it to him in June 1942.

6 Barr 1951, p.256, quoting Matisse's letter to Pierre Matisse of 1 September 1940.

7 *Still Life with Shell*, 1940, oil on canvas (Pushkin State Museum of Fine Arts, Moscow).

8 Letters extracted in John Russell, *Matisse: Father and Son*, New York 1999, pp.199–200.

9 Matisse's model and companion, Lydia Delectorskaya, stresses the importance the artist attached to creating a mouth-watering effect: 'When he painted a still life with oysters, he needed to have them fresh every third day, lest they lose their allure. He himself never ate them, probably so that he would not be less attracted to them.' (trans. Olga Tourkoff, *With Apparent Ease . . . Henri Matisse: Paintings from 1935–1939*, Paris 1988, p.25).

10 Recounted in a letter from Matisse to Simon Bussy, 13 April 1941, quoted in Pierre Schneider, *Matisse*, trans. Michael Taylor and Bridget Strevens Romer, London 1984, p.738. It is indicative of the bond between the two men that Picasso was one of the people to whom Matisse wrote in January 1941 to announce his impending operation.

11 Jean Sutherland Boggs, *Picasso and Things*, exh. cat., Cleveland Museum of Art 1992, p.268.

12 Conversation with Maya Widmaier-Picasso, November 2000. She spent the Occupation in Paris with her mother and saw her father regularly. She has also pointed out that, since the Germans confiscated cutlery, the array of cutlery alludes to its increasing rarity (Boggs 1992, p.268). Pierre Loeb describes meeting Picasso in 1941 and how food, not painting, was the main topic of their conversations (*Voyages à travers la peinture*, Paris 1946, p.63). The obsession with food and hunger also emerges in Picasso's play *Le Désir attrapé par la queue*, which was composed in Paris between 14 and 17 January 1941.

13 Cited in Boggs 1992, p.268.

14 Steven Nash in *Picasso and the War Years*, p.31. See also Brigitte Baer, 'Where Do They Come From – Those Superb Paintings and Horrid Women of "Picasso's War"?', ibid. pp.96–7, who provides a psychoanalytic reading.

15 For some later examples, see K.B. Roberts and J.D.W. Tomlinson, *The Fabric of the Body: European Traditions of Anatomical Illustration*, Oxford 1992, pp.189, 395, 459, 573.

16 Isabelle Monod-Fontaine, with Anne Baldassari and Claude Laugier, *Matisse: Collections du musée national d'art moderne*, Paris 1989, pp.104–7. Monod-Fontaine reproduces, on p.107, Matisse's sketch itemising all the colours he used. Some of the much more naturalistic pen-and-ink studies of the various objects, dated 12–13 September 1941, plus related compositional studies included in *Thèmes et variations* as Série G, are reproduced in Lydia Delectorskaya, *Henri Matisse, Contre vents et marées: Peinture et livres illustrés de 1939 à 1943*, Paris 1996, pp.166, 170–3.

17 Henri Matisse, 'Looking at Life with the Eyes of a Child', 1953, in Jack Flam, *Matisse on Art*, Oxford 1973, p.149.

18 Bernard Dorival, 'Musée d'art moderne — Peintures de maîtres contemporains', *Bulletin des Musées de France*, no.2, 1946, p.17.

19 Barr 1951, p.268.

20 Cited in Monod-Fontaine et al., 1989, p.107. Matisse's comment was recorded in François Campaux's documentary film, *Matisse*, 1946.

21 Françoise Gilot, *Matisse and Picasso: A Friendship in Art*, London 1990, pp.12, 14.

22 *Massacre in Korea*, 1951, oil on plywood (Musée Picasso, Paris). The *War and Peace* murals, painted in oil on fibreboard, are in place in the Musée National Picasso *La Guerre et la Paix*, Vallauris. For the relationship of these works to Picasso's membership of the Communist Party, see Gertje Utley, *Picasso: the Communist Years*, London and New Haven 2000, esp. chapter 9.

.

fig.72 Henri Matisse, *The Red Studio* 1911, oil on canvas 181 x 219.1, The Museum of Modern Art, New York. Mrs Simon Guggenheim Fund

30

1 Dominique Fourcade, ed., *Henri Matisse: Ecrits et propos sur l'art*, Paris 1972, p.182.

2 Matisse felt that *Le Rêve* (Private Collection), finished in September 1940, and on which he had laboured long, was a 'breakthrough' picture in his attempt to handle colour and line in a new way.

3 The brush drawing *The Black Fern* of 1948 also exists as an oil painting (Beyler Collection, Basel). The painting *Pineapple* of 1948 in turn

fig.73 Diego Velázquez, *Las Meninas* 1656, oil on canvas 318 x 276, Museo del Prado, Madrid

exists as a work in brush and ink (Private Collection).

4 See Chronology, 1949.

5 Yve-Alain Bois, *Matisse and Picasso*, Paris 1998, p.206.

6 See Chronology, 1949.

7 For a vivid description of the working spaces at La Californie, see Antonina Vallentin, *Pablo Picasso*, Paris 1957, pp.434–6. See also John Richardson, 'Picasso's Ateliers and Other Recent Works', *Burlington Magazine*, June 1957, pp.183–93. Bois 1998, pp.231–9, writes emotively on the Californie studio pictures as homages to Matisse.

8 Jonathan Brown, *Velázquez: Painter and Courtier*, New Haven and London 1986, p.256. This space was set aside for the Court Painter after the death of Prince Baltasar Carlos in 1646.

9 That winter he produced a copy of one of Velázquez's portraits of Philip IV, now in the Museo Picasso, Barcelona.

10 The Prado pictures were first of all moved to Valencia. When Picasso heard that *Las Meninas* had been unrolled for inspection he exclaimed, 'comme j'aurais aimé cela!'. Quoted in Vallentin 1957, p.316.

11 Quoted in Roland Penrose, *Picasso: His Life and Work*, 3rd ed., California 1981, p.420. Penrose also tells us (p.422) that Michel Leiris and Edouard Pignon were the only people, other than Jacqueline, who were allowed to see the *Meninas* series before it was finished.

12 Hélène Parmelin, *Picasso Plain*, trans. Humphrey Hare, London, 1963, pp.229–31.

13 Ibid. p.232.

14 This is largely confirmed by a conversation that took place between Picasso and Roland Penrose at the time concerning the spatial ambiguities of *Las Meninas*. Penrose, *Picasso: His Life and Work*, London 1958, p.371.

15 Jean Sutherland Boggs, 'The Last Thirty Years', in Roland Penrose and John Golding, eds., *Picasso, 1881–1973*, London 1973, p.225.

· ·

31

1 Pablo Picasso, in Christian Zervos, 'Conversation avec Picasso', *Cahier d'Art*, special issue 1935, pp.173–8.

2 Robert Rosenblum, 'Large Still Life on a Pedestal Table', *Picasso from the Musée Picasso*, exh. cat., Walker Art Center, Minneapolis 1980, p.66.

3 Pierre Daix, *Picasso créateur, la vie intime et l'oeuvre*, Paris 1987, p.229.

4 See especially Robert Rosenblum, 'Picasso's Blond Muse: The Reign of Marie-Thérèse Walter', in William Rubin, ed., *Picasso and Portraiture: Representation and Transformation*, exh. cat., MoMA, New York 1996, p.362.

5 See *Guitar and Profile*, 1927, oil on canvas (Chicago, Collection Alsdorf). With a comparable procedure, the artist in 1916 calligraphed his name 'Picasso' intertwined with the surname 'Gaby' (Lespinasse), see watercolour and ink on paper, MP, 1996—1.

6 Composed of the Greek characters 'chi' and 'rho', superimposed, the chrism is thus named

from the Greek *khrésimos* (that which is useful or profitable) and was used to indicate the salient passages of a manuscript. In its liturgical use, this monogram refers to Christ, using the first two letters of his name in Greek. From 1935, Picasso began to mark the envelopes he used for the conservation of letters or photographs with a chrism of his own, the written word *ojo*, meaning 'eye' in Spanish. Often traced in colour or accompanied by written works or paragraphs, sometimes writing *ojo ph* to designate photographs, the monogram, although indicating that attention must be paid to the manuscript, also allows variations on this simplified autoportrait, *ojo*: the left eye, the nose, the right eye. See on this subject, Anne Baldassari, *Picasso photographe, 1901–1916*, Paris 1994, p.13 and fig.1.

7 Pablo Picasso cited in André Malraux, *La Tête d'obsidienne*, Paris 1974, p.110.

8 Pablo Picasso cited in Hélène Parmelin, *Picasso dit. . . .*, Paris 1966, p.111.

9 Henri Matisse, as reported by Sarah Stein in 'A Great Artist Speaks to his Students', in Alfred H. Barr, *Matisse: His Art and His Public*, exh. cat., MoMA, New York 1951, quoted in Jack Flam, *Matisse on Art*, Berkeley and Los Angeles 1995, p.43.

10 Pablo Picasso as reported by Malraux 1974, p.110.

11 The original meaning of 'emblem' was that of a symbolic figure underscored by a caption, and it can be remarked that such a meaning can be quite literally applied to Cubist paintings with their combinations of visual signs, words, letterings and titles.

12 Pablo Picasso, in Anatole Jakovski, 'Midis avec Picasso', *Arts de France*, Paris, no.6, 1946, pp.3–12, 57.

13 Starting with Daniel-Henry Kahnweiler in his work of 1920, *Der Weg zu Kubismus*.

14 Henri Matisse as reported by Louis Aragon, 'Matisse-en-France' (1942), in *Henri Matisse: roman*, Paris 1971, quoted in Flam 1995, p.95.

15 Henri Matisse as reported by Estienne, 'Des tendances de la peinture moderne', *Les Nouvelles*, 12 April 1909, republished in Flam 1995, p.48.

16 Guillaume Apollinaire, in 'Henri Matisse', *La Phalange*, no.2, 15–18 December 1907, republished in Dominique Fourcade, ed., *Henri Matisse: Ecrits et propos sur l'art*, Paris 1972, p.56.

17 In notebook 34 (Dec. 1926–May 1927), the genesis of *Woman Seated in Armchair* is not that different from *Large Still Life on Pedestal Table*. The contour of the feminine body is broken and assimilated to the space of the work, whereas the graphism of her sex and breasts, condensed into a diagram progressively substitutes its mask for the model's face. See sheets 4, 5, 8, 9, 10, in Carnets, Musée Picasso, vol.1, pp.66–7.

18 Henri Matisse as reported by André Verdet, 'Les Heures azuréeennes', *XXième siècle*, special issue devoted to Matisse 1970, republished in Dominique Fourcade, ed., *Henri Matisse: Ecrits et propos sur l'art*, Paris 1972, p.251.

19 See *Picasso et les choses*, notices 91, 92, pp.230–3.

20 Pablo Picasso (2 October 1933), as reported by Daniel-Henry Kahnweiler, 'Huit entretiens avec Picasso', *Le Point*, Mulhouse, Oct. 1952, republished in Marie-Laure Bernadac and Androula Michael, eds., *Picasso: Propos sur l'art*, Paris 1998, p.60.

21 Flam 1995, p.49.

22 Pierre Schneider, *Matisse*, Paris 1984, p.697.

23 Statement by Henri Matisse, as reported by Gaston Diehl (1949), republished in Fourcade 1972, p.244.

24 *Papiers collés*, 1946, entry nos. 148, 149, in Isabelle Monod-Fontaine with Anne Baldassari and Claude Laugier, *Matisse: Collections du musée national d'art moderne*, Paris 1989, pp.372–5.

25 Christian Zervos, 'Picasso à Dinard, été 1928', *Cahiers d'Art*, vol.4, no.1, 1929, pp.5–20.

26 Statement by Picasso in André Malraux 1974, p.129.

27 Julio Gonzalez, 'Picasso sculpteur', *Cahiers*

d'Art, vol.11, nos.6–7, pp.189–91.

28 Christian Zervos, 'Picasso à Dinard', *Cahiers d'Art*, no.1, 1929, p.11.

29 *Gonzalez Picasso Dialogue*, Musée National d'Art Moderne, Paris 1999, p.125.

30 Ibid.

31 1929, notice in Werner Spies and Christine Piot, *Picasso Sculpteur*, Musée National d'Art Moderne, Paris 2000, pp.137–43.

32 See the statement by André Salmon: 'I saw Picasso rummaging in a scrap heap to complete his monument, in the hearth of Plaisance in which the forge was aflame, where pacifist torpedos were throwing up their gases. He was laughing!' in 'Vingt-cinq ans d'art vivant', pt. 2, *La Revue de France*, 1 March 1931.

33 In the sense in which Picasso could say: 'I paint with strokes of *coq-à-l'âne*? Well yes, but they follow on from one another!' cited in André Malraux in *La Tête d'obsidienne*, Paris 1974, p.129. The expression means, literally, 'from the rooster to the donkey' in a conversation, but its use by Picasso gives it more profound and critical connotations.

34 Guillaume Apollinaire, *Le Poète assasiné*, 1916, Paris 1979, p.301.

35 Musée Picasso, Paris.

36 This effect is suggested by the photograph of *Woman in Garden* published in *Hommage à Picasso*, exh. cat., Petit Palais, Paris 1966, no.228.

37 Daniel-Henry Kahnweiler, *Les Sculptures de Picasso*, photographs by Brassaï, Paris 1948, pub. 1949 [n.p.].

38 Statements by Matisse in André Verdet, 'Les Heures azuréeennes', *XXIème siècle*, special issue devoted to Matisse, 1970, reprinted in Dominique Fourcade, ed., *Matisse: Ecrits et propos sur l'art*, Paris 1972, pp.250–1.

· ·

32

1 The editor Tériade, who was steeped in the movement's aesthetic, wrote: 'D'autre part, elle (l'écriture) relie l'aesthétique surréaliste au langage primitif, à ce langage par signes dont on connait de si étttonants schématisations', *Cahiers d'Art*, no.2, Paris 1930, p.74.

2 Despite their domination of ballet as a frivolous form of bourgeois entertainment, the Surrealists were forced to revise their opinion when confronted with Picasso's contribution to *Mercure*, mounted in the summer of 1924 by Count Etienne de Beaumont's *Soirées de Paris*, with music by Eric Satie and choreography by Léonid Massine. It was the quasi-automatic linear economy of Picasso's designs that the Surrealists admired. Gertrude Stein wrote: 'Calligraphy as I understand it in him had perhaps its most intense moment in the décor of *Mercure*. That was written, so simply written, no painting, pure calligraphy'. Stein, *Picasso*, Paris 1938, p.37.

3 *Minotaur* was transformed into a Gobelins tapestry some nine years later.

4 Charts of Easter Island hieroglyphs were printed in *Cahiers d'Art*, nos. 2–3, 1929. Zervos, the editor, was a friend of Picasso and of the Surrealists, and when articles and reproductions of different art forms appeared in his periodical it was often as a result of the artists' enthusiasm for them.

5 Some of these are reproduced in Yves-Alain Bois, *Matisse and Picasso*, New York 1998, pp.84–7.

6 Maria Luz, 'Témoinages: Henri Matisse', *XXIème siècle*, n.s 2, Jan. 1952, pp.55–7, trans. as 'Testimonial, 1951', in Jack Flam, *Matisse on Art*, Oxford 1973, pp.136–8.

7 André Verdet, 'Entretiens avec Henri Matisse', in *Prestiges de Matisse*, Paris 1952, pp.37–76; trans. Flam 1973, p.147.

8 John Hallmark Neff, 'Matisse: His Cut-Outs and the Ultimate Method', in Jack Cowart, *Henri Matisse: Paper Cut-Outs*, exh. cat., Washington University Gallery of Art, St Louis, Detroit 1977, p.27, n.8.

9 Matisse in his text to *Jazz*. The images for

fig.74 Chart of Easter Island hieroglyphs, as printed in *Cahiers d'Art*, 1929, nos. 2–3

Jazz were executed in 1943–4. They were published as a folio in 1947, accompanied by the artist's text.

10 *Blue Nude IV* was in fact almost certainly the first to be begun. See Washington University Gallery of Art 1977, p.21, n.8.

11 Interview with Verdet 1952, in Dominique Fourcade, ed., *Henri Matisse: Ecrits et propos sur l'art*, Paris 1972, pp.250–1.

12 *La Chevelure* appears in *Les Fleurs du Mal*, which Matisse had known since his youth. His own illustrations to Baudelaire were published in a limited edition by La Bibliothèque Française in 1947.

13 Cowart 1977, p.211, n.8.

14 Werner Spies, *Picasso: The Sculptures. Catalogue Raisonné of the Sculptures in Collaboration with Christine Piot*, Paris 2000, p.291.

15 Some of the black linear elements on the heads were rendered in raised metal and later in wire mesh in the factory.

16 Hélène Parmelin, *Picasso's Women*, London 1961, p.45.

17 Louis Aragon, *Henri Matisse: roman*, Paris 1971, p.153. Matisse's conversation with Aragon concerning signs had first been published in 1943. See Flam 1973, p.95.

18 Lionel Prejer, 'Picasso's Sheet-Metal Sculpture', in Elizabeth Cowling and John Golding, *Picasso: Sculptor Painter*, exh. cat., Tate Gallery, London 1994, p.242.

19 Lionel Prejer, 'Picasso découpe le Fer', *L'Oeil*, no.82, Oct. 1961, pp.28–32.

20 See in particular the version now in the Washington University Gallery of Art, St Louis.

· ·

fig.75 Eugène Delacroix, *Women of Algiers* 1834, oil on canvas 180 x 229, Musée du Louvre

33

1 For Picasso in Gósol and the importance of *The Harem*, see William Rubin, 'The Genesis of

fig.76 Pablo Picasso, *Women of Algiers after Delacroix (Canvas D)* 1955, oil on canvas 46 x 55, Private Collection

fig.77 Henri Matisse, *The Hindu Pose* 1923, oil on canvas 83 x 60, Private Collection

Les Demoiselles d'Avignon', in John Elderfield, ed., *Studies in Modern Art 3: Les Demoiselles d'Avignon*, MoMA, New York 1994, pp.35–42. For Matisse in Algeria, see John Cowart and Pierre Schneider, *Matisse in Morocco: The Paintings and the Drawings, 1912–13*, exh. cat., National Gallery of Art, Washington 1990. For Matisse's statements about the influence of the Orient, see 'Orient' in the index of Dominique Fourcade, ed., *Henri Matisse: Ecrits et propos sur l'art*, Paris 1972, p.356. The year 1906 was important politically for French colonialism, the Algericas Conference giving France and Spain joint control of Morocco.

2 See Christian Zervos, *Pablo Picasso: Oeuvres de 1953 à 1955*, vol.16, Paris 1965, nos.342, 343, 345–9, 352–7, 359, 360. The fullest, most influential analysis of the series is Leo Steinberg, 'The Algerian Women and Picasso at Large', in *Other Criteria*, London, Oxford and New York 1972, pp.125–34. A fine new account is in Susan Grace Galassi, *Picasso's Variations on the Masters: Confrontations with the Past*, New York 1996, pp.127–47, which includes useful information on Delacroix's modernist reputation and on the circumstances of the creation of Picasso's variations, and makes reference to the 1849 version of Delacroix's painting at Montpelier as well as to the Louvre version. I am deeply indebted to both of these sources. A good, recent account of the Delacroix itself in the context of Orientalism appears in Todd Porterfield, *The Allure of the Empire: Art in the Service of French Imperialism 1798–1836*, Princeton 1998, pp.117–42. Unlike Picasso, Matisse did not make any paintings after the old masters in his maturity, with the single exception of his copy after De Heem (see pp.150–7), but he did make an early drawn copy after the Louvre version of Delacroix's *The Abduction of Rebecca* (see Roger Benjamin, 'Recovering Authors: The Modern Copy, Copy Exhibitions and Matisse', *Art History*, vol.12, no.2, June 1989, pp.187–8).

3 Roland Penrose, *Picasso: His Life and Work*, London 1958, p.396.

4 For prejudicial stereotypes of Matisse and Picasso, see John Elderfield, *Henri Matisse: A Retrospective*, exh. cat., MoMA, New York 1992, pp.20–2. However, the works in the series may have been originally received in such terms; see n.11 below. Picasso's first approach to the *Women of Algiers*, leaving aside its influence on his earlier paintings,

including *Les Demoiselles d'Avignon* (no.7), comprise four drawings in a Royan sketchbook of 1940 (see Galassi 1996, p.134), which prepare for the biomorphic, painterly approach of the early, densely patterned 'Matissean' works in the series. The more severe works are Canvases K, L and M, which appeared after an eleven-day break in the series. After Canvas M, Picasso reintroduced colour, leading up to the most decoratively colourful final Canvas O, which has been thought to be a consummate Picasso-Matisse alliance (Galassi 1996, pp.146–7) and an anti-Matissean return to mesmerising aggressiveness akin to that of *Les Demoiselles d'Avignon* (Yve-Alain Bois, *Matisse and Picasso*, New York 1998, p.231). The present account addresses mainly Canvas M, and that only from the point of view of its relationship to Matisse.

5 Quoted by Steinberg 1972, p.136.

6 For an illustration of this work, see Elderfield 1992, p.337.

7 Steinberg 1972, p.133, noting the reference to *The Hindu Pose*.

8 Steinberg 1972, pp.141–3, including an explanation of Picasso's solution, as summarised in my essay, below.

9 This work appears in photographs of Matisse's studio from 1940 (see Elderfield 1992, pp.364–5) to 1952 (see Jack Cowart, *Henri Matisse: Paper Cut-Outs*, exh. cat., Washington University Gallery of Art, St Louis, Detroit 1977, p.250).

10 The Moorish table is itself another synecdoche of Matisse, and appears in numerous of his paintings and prints of the Nice period, most tellingly in lithographs of a 'Hindu' model (e.g. Claude Duthuit with Françoise Garnaud, eds., *Henri Matisse: Catalogue raisonné de l'oeuvre gravé*, Paris 1983, no.510).

11 Kahnweiler said that the work he saw on 7 February 1955 (presumably Canvas K, painted the previous day) was, 'instead of being brightly colored . . . in black and white . . . entirely a matter of drawing . . . I would call it cubist.' The works he had seen previously he had acknowledged to be Matissean. (Daniel-Henry Kahnweiler, 'Conversations about the *Femmes d'Alger*', in Marilyn McCully, ed., *A Picasso Anthology: Documents, Criticism, Reminiscences*, Arts Council of Great Britain, London 1982, p.253). Thus, the use of monochrome was understood to be non-Matissean if not anti-Matissean. Interestingly, Kahnweiler quotes Picasso as saying, after speaking of Matisse's influence on the paintings, that 'the bright colors get buried beneath others' (ibid.); given the occasion, an unfortunate, possibly telling metaphor.

12 Françoise Gilot, *Matisse and Picasso: A Friendship in Art*, New York 1990, p.95.

13 Ibid. p.90.

14 McCully 1982, p.252.

15 See Bois 1998, p.231.

16 Galassi 1996, p.139 relates this image, which appeared first in drawings made on Christmas Day 1954, to Matisse's 1929 lithograph of an upsidedown nude with brazier (Duthuit 1983, no.500), but this clearly shows a foreshortened figure seen from above. There are a number of strikingly similar poses in the brothel monotypes (see Jean Adhémar and Françoise Cachin, *Degas: The Complete Etchings, Lithographs, and Monotypes*, New York 1975, nos.97, 98, 111, 112, 121). Picasso would not acquire a considerable number of the brothel monotypes until 1958, and none of the works with such poses (see Eugenia Parry Janis, *Degas Monotypes*, exh. cat., Fogg Art Museum, Cambridge, Mass. 1968, nos.62ff.), but it seems very likely that he must have been aware of such prints, especially since Vollard published some of them, and given the fact that, in the Bateau-Lavoir, 'doing a Degas' was shorthand for making a lascivious drawing (see Richard Kendall, *Degas: Beyond Impressionism*, exh. cat., London, Chicago and New Haven 1996, p.171). These monotypes presumably show women having orgasms after masturbation (Eunice Lipton, *Looking into Degas: Uneasy Images of*

Women and Modern Life, Berkeley 1987, pp.177–8), and may be indebted to Paul Richter's contemporaneous drawings of hysterical distortions, published in book form in 1881, one of which shows the extended cross-legged pose of Canvas M (see Richard Thomson, *Degas: The Nudes*, London 1988, p.102). Squirming in erotic excitement might well be the narrative to associate Steinberg's contrary readings of this figure.

17 See Christian Geelhaar, *Picasso: Wegbereiter und Förderer seines Aufstiegs 1899–1939*, Zurich 1993, pp.229–30 and Dore Ashton, 'Picasso in His Studio', in Ashton and Fred Licht, eds., *Pablo Picasso L'Atelier*, exh. cat., Peggy Guggenheim Collection, Venice 1996, p.140. The conflation of Delacroix and Ingres thus achieved is, of course, entirely appropriate to a work that also conflates Matisse and Picasso. An additional artist, Velázquez, is invoked in Canvas E (see Steinberg 1972, p.136), but the reference had been overlaid and transformed by the time that Canvas M was made. The disappearance of this reference is interesting insofar as Matisse claimed to dislike Velázquez's work (Fourcade 1972, pp.89, 96), whereas, of course, Degas, Ingres and Delacroix were in his 'great chain'.

18 Penrose 1958, p.344.

19 Ibid. p.350.

20 My use of the term 'reproduction' derives from David Prochaska, *Making Algeria French: Colonialism in Bône*, Cambridge 1990, pp.141–2, as discussed in Edward W. Said, *Culture and Imperialism*, New York 1994, p.171.

21 François Mitterrand, *Presence française et abondon*, 1957, quoted in Said 1994, p.178. Liberation came in 1963.

.

fig.78 Henri Matisse, *The Violinist* 1917, charcoal on canvas 194 x 114, Musée Matisse, Le Cateau-Cambrésis

34

1 David Douglas Duncan, *Picasso's Picassos*, New York 1961, p.183.

2 Isabelle Monod-Fontaine with Anne Baldassari and Claude Laugier, *Matisse: Collections du musée national d'art moderne*, Paris 1989, p.64, and Jack Flam, *Matisse: The Man and His Art, 1869–1918*, Ithaca and London 1986, p.506, n.29, are referring to and quoting Pierre Matisse's statement that he did not pose for the drawing or the painting.

3 See Monod-Fontaine et al. 1989, ibid. and Flam 1986, ibid. for a discussion of the painting's date, begun in April 1918 and completed at an uncertain date sometime thereafter.

4 For an illustration of this work, see John Elderfield, *Henri Matisse: A Retrospective*, exh. cat., MoMA, New York 1992, p.219; see also fig.72.

5 See Lorenz Eitner, 'The Open Window and the Storm-Tossed Boat', in *Art Bulletin*, vol.37,

no.4, Dec. 1955, pp.281–90.

6 According to Matisse it never stopped raining (quoted in Flam 1986, p.463). Flam describes the weather as depressing, and the view depicted in the painting as desolate and of uncommon coloration: 'gray sea and clouds and tile-red sky' (ibid.). In an earlier essay, Flam suggests that the image reflects the artist's reaction to the end of an Epoch of European culture as well as his own artistic crisis (see Flam, 'Some Observations on Matisse's Self-Portraits', *Arts Magazine*, vol.49, no.9, May 1975, pp.51–2).

7 Francoise Gilot and Carlton Lake, *Life With Picasso*, New York 1964, p.358.

8 See Kirk Varnedoe, 'Picasso's Self-Portraits', in William Rubin, ed., *Picasso and Portraiture: Representation and Transformation*, exh. cat., MoMA, New York 1996, pp.146–50.

9 Denis Hollier, 'Portrait de l'artiste en son absence', in *Les Cahiers du musée national d'art moderne*, no.30, winter 1989, pp.12,14.

10 Raymond Escholier, *Matisse, from the life*, trans. Geraldine and H. M. Colvile, London 1960, p.102.

fig.79 Henri Matisse, *The Painter in his Studio* 1916, oil on canvas 146.5 x 97, Centre Georges Pompidou, Paris. Musée National d'Art Moderne/Centre de Création Industrielle.

fig.80 Pablo Picasso, *Nude in the Studio* 1953, oil on canvas 89 x 116.2, Private Collection

fig.80a Pablo Picasso, *The Mirror* 1932, oil on canvas 130.7 x 97, Private Collection

Chronology

Anne Baldassari, Elizabeth Cowling,
Claude Laugier and Isabelle
Monod-Fontaine

This chronology is not a comprehensive summary of the lives and careers of the two artists. Instead, it has two main priorities. First to document the relationship, artistic and personal, of Matisse and Picasso from the time of their first meetings until Matisse's death, evoking briefly the general historical and cultural context, and citing in full their surviving correspondence. Secondly to give a sense of the evolving critical view of that relationship through a small, representative selection of quotations from contemporary sources, derived in particular from the collections of press cuttings in the archives of both artists.

The chronology has been composed as follows: 1900–23 by Anne Baldassari; 1924–39 by Elizabeth Cowling; 1940–54 by Isabelle Monod-Fontaine and Claude Laugier. The authors are particularly indebted to the research and friendly support of Wanda de Guébriant, Isabelle Alonso, Georges Matisse and Claude Duthuit of the Archives Matisse, and to Christine Pinault, Sylvie Vautier and Claude Ruiz-Picasso of the Picasso Administration. Hitherto unpublished information presented here is largely the result of the extensive primary research conducted by Ivan Conquéré de Monbrison, Emma Laurent and Colette Haufrecht in the Musée Picasso (Library and Archives), Bibliothèque de l'Arsenal and Bibliothèque Nationale de France. The authors wish to thank warmly for their important contributions the staff of the Centres de Documentation of the Musée Picasso and the Musée National d'Art Moderne, Centre Georges Pompidou: Véronique Balu, Laurence Camous, Pierrot Eugène, Sylvie Fresnault, Laurence Madeline, Paule Mazouet, Mélanie Petetin, Christiane Rojouan, Dominique Rossi, Jeanne Sudour, Vérane Tasseau and Brigitte Vincens. Staff in the libraries and archives of The Museum of Modern Art, Tate Modern and the Victoria and Albert Museum have also been very helpful, and the authors are extremely grateful to Sophie Clark of Tate Modern and to Claudia Schmuckli of The Museum of Modern Art for their invaluable contribution in assembling British and American material. They are also grateful to Gavin Parkinson for research assistance, and to Pierre Daix, Josep Palau i Fabre, Hélène Seckel-Klein, Brigitte Léal, Marilyn McCully, John Richardson and Hilary Spurling for information.

Finally the authors particularly wish to thank Elaine Rosenberg and Paul Matisse, and Christine Nelson and Robert Parks of the Pierpont Morgan Library, New York, for exceptionally permitting access to the collections of documents of the Galerie Paul Rosenberg and the Pierre Matisse Gallery, and for granting access to the private correspondence of Pierre and Henri Matisse.

Abbreviations

AK-L Archives Kahnweiler-Leiris, Paris

AM Archives Matisse, Paris

AP Archives Picasso, Musée Picasso, Paris

Apollinaire 1972 Guillaume Apollinaire, *Apollinaire on Art: Essays and Reviews 1902–1918*, ed. L.C. Bruenig, trans. S. Suleiman, London 1972

BL Beinecke Library of Rare Books and Manuscripts, Yale University

Bois 1998 Yve-Alain Bois, *Matisse and Picasso*, Paris 1998

CC/M Claudine Grammont (ed.), *Correspondance entre Charles Camoin et Henri Matisse*, Lausanne 1997

Gilot 1965 Françoise Gilot and Carlton Lake, *Life with Picasso*, London 1965

Gilot 1990 Françoise Gilot, *Matisse and Picasso: A Friendship in Art*, London 1990

Matisse 1941 *Bavardages*, Matisse in Conversation with Pierre Courthion, 1941, unpublished
MS, AM

Matisse 1999 Henri Matisse, M.-A. Couturier, L.-B. Rayssiguier, *The Vence Chapel: The Archive of a Creation*, ed. M. Billot, trans. M. Taylor, Milan 1999

MNAM Fonds du Musée National d'Art Moderne, Paris

Olivier 1933 Fernande Olivier, *Picasso and his Friends*, London 1964, trans. by Jane Miller of *Picasso et ses Amis*, Paris 1933

PMA Pierre Matisse Archives, Pierpont Morgan Library, New York

Russell 1999 John Russell, *Matisse: Father and Son*, New York 1999

fig.81 Matisse, Emile Jean and Jean Petit in the studio of Adolphe-William Bouguereau, Paris 1891–2. Archives Matisse

Introduction

1900 – The *Exposition Universelle* opens in Paris in April 1900. The young Pablo Ruiz Picasso (born Málaga 1881), making his first visit to the city, shows a large painting entitled *Last Moments* in the Spanish section of the *Décennale* fine arts exhibition mounted at the Grand Palais. Matisse's picture *Woman Reading* is rejected by the jury of the French section. Plagued by financial difficulties, Matisse (born Le Cateau-Cambrésis 1869) is reduced to providing 'decoration by the kilometre' for the Grand Palais building. As a result of the experiences of the two artists, both in terms of new contacts (the art dealers Ambroise Vollard, Berthe Weill and Pedro Mañach) and artistic discoveries (Pierre Puvis de Chavannes, Auguste Rodin, Eugène Carrière and the Post-Impressionists), the Exposition Universelle has a lasting impact on their later work and sets the scene for a drama in which the paths of Matisse and Picasso are destined to cross in a long series of encounters.

1901 – During the course of the year the works of Matisse and Picasso are exhibited for the first time in Paris. In April/May Matisse exhibits twelve works in the Salon des Indépendants, including *Model with Rose Slippers (Study)* and probably *Blue Nude*. Given the historical role of the Salon des Indépendants (originally the Salon des Refusés) in challenging the academic establishment, it is likely that Picasso, who returned to Paris from Barcelona in May, would have seen these works by Matisse. On this assumption Alfred H. Barr argued that Picasso's subsequent Blue Period was due to the influence of Matisse. However, the first signs of his use of a monochrome palette were already evident in *Lady in Blue*, which was shown at the National Exhibition of Fine Arts in Madrid before he left Barcelona. The innovative use of monochrome, which the two artists embarked upon simultaneously, may also be attributed to the influence of Carrière and to the emblematic use of the colour blue, as applied by the Impressionists and Post-Impressionists. At that time, however, it was the two artists' use of pure colour that caught the attention of critics. Gustave Coquiot, for instance, announcing Picasso's exhibition at the Galerie Vollard in *Le Journal* on 17 June, stressed this quality in his work, describing him as the 'new harmonist of bright tonalities, with dazzling tones of red, yellow, green and blue'. Since it has now been established that Matisse was in Paris at the beginning of July – greatly distressed by the condition of his daughter Marguerite, on whom a tracheotomy had

fig.82 Picasso, Mañach and Fuster in Picasso's studio at Boulevard de Clichy, 1901. Photograph by Torres Fuentes. Archives Picasso

been performed in dramatic circumstances – he might have seen the Picasso exhibition at the Galerie Vollard, which also featured Francisco Iturrino, a former pupil (like Matisse himself) of Gustave Moreau. A similarity in the use of green shadows has been noted in *Portrait of Mme Matisse (The Green Line)* (1905) and *Self-Portrait 'Yo Picasso'* shown in Vollard's exhibition. There are also remarkable analogies between *Portrait of Marguerite* (no.4), painted by Matisse in 1906–7 and offered to Picasso, and Picasso's *Portrait of Mañach*, also shown in Vollard's exhibition – notably the large expanses of solid colour separated by thick black lines, the hieratic figure standing out against a uniform background of cadmium yellow, and the name of the model written in stick-like capital letters at the top left-hand side of the composition. Might Marguerite's black ribbon echo Mañach's red tie? Might the coincidence of the discovery by Matisse of Picasso's painting – which has been classified as proto-Fauvist – and the injury sustained by Marguerite have formed the traumatic, stylistic and chromatic nexus of a meeting whose shock waves would continue to reverberate throughout their relationship?

1902 – The year is marked by successive exhibitions of works by Matisse and Picasso at the gallery recently opened by Berthe Weill, who in February devotes her third group exhibition to former pupils of Gustave Moreau, including Matisse. At the beginning of April, at Mañach's suggestion, Weill mounts an exhibition of works by Louis Bernard-Lemaire and Picasso; in June 1902 she also organises an exhibition 'recapitulating the six previous exhibitions'. This 'mixture of drawings, watercolours and paintings' must therefore have been the first occasion on which works by Matisse and Picasso were exhibited together. Picasso, cloistered in Barcelona since the previous winter, is unable to see this exhibition, as he does not return to Paris until the end of October 1902; it is likely, however, that Matisse visits it. After mid-November, Berthe Weill shows in a group exhibition the most recent works by Picasso in which the principles of the Blue Period are fully in evidence. After a few grim months spent with the

poet Max Jacob, whom he had met the previous year, poverty forces Picasso to return to Barcelona in January 1903.

1903 – This year also sees the departure from Paris of Matisse, who returns to Bohain, but not before exhibiting in the Salon des Indépendants and the first Salon d'Automne, instituted by Frantz Jourdain.

1904 – Picasso settles in Paris, rejoining the Spanish colony in the Bateau-Lavoir tenement in rue Ravignan. He meets the poets Guillaume Apollinaire and André Salmon, who are also critics. Clovis Sagot, who opens a gallery at 46 rue Laffitte, becomes Picasso's main dealer. The 'Peau de l'Ours' association buys several works by Matisse and Picasso. In April Picasso may have seen the exhibition at the Galerie Berthe Weill of the work of Moreau's former pupils, among whom Matisse is pre-eminent. In June Vollard's first exhibition dedicated to Matisse features works from 1897 to 1903. In July the review *L'Occident* publishes an article on Cézanne by Jacques-Emile Blanche ahead of the Cézanne retrospective at the Salon d'Automne, to which Matisse lends his *Three Bathers*. Cézanne becomes a common point of reference for the two artists: Matisse would later claim that 'Cézanne is the master for all of us' while Picasso, using similar language, would declare 'Cézanne! He was my one and only master! ... He was like the father of us all.'

The paintings chosen to open the Salon d'Automne include fourteen canvases and two sculptures (*The Serf* and *Madeleine*) by Matisse. At the end of October Picasso, alongside Raoul Dufy and Francis Picabia amongst others, takes part in a group exhibition of watercolours, pastels and drawings at Berthe Weill's gallery.

1905–6 – Despite the many occasions on which their paths have crossed from 1900 onwards, several years pass before Matisse and Picasso actually meet. It is acknowledged that their meeting took place with the Steins acting as intermediaries (see frontispiece). According to the respective memoirs of Gertrude and Leo Stein (*Autobiography of Alice B. Toklas* by Gertrude Stein, 1933, and *Appreciation: Painting, Poetry and Prose* by Leo Stein, 1947), the basic sequence of events is as follows: they purchase Matisse's *Woman with the Hat* (fig.33) at the 1905 Salon d'Automne and subsequently meet Matisse; they purchase Picasso's *Acrobat's Family with a Monkey* from Sagot and then his *Girl with a Basket of Flowers*, and subsequently meet Picasso; finally there is a meeting between Matisse and Picasso at their home. This series of events takes place between the autumn of 1905 and the spring of 1906.

However, some aspects of this story need to be adjusted when other facts are taken into account. Leo Stein says he discovered Picasso's work at an exhibition recommended to him by Sagot. The only exhibition of Picasso's work in 1905 was held at the beginning of the year, from 24 February to 6 March, at the Galeries Serrurier. Gertrude Stein describes the venue as 'a little furniture store where there were some paintings being shown by Picasso'. Although Serrurier's premises could hardly be considered a 'little store', they were devoted to 'furnishings and artistic decoration'. Having made an offer for a painting from this establishment, which remained unanswered, Leo Stein acquired the *The Acrobat's Family with a Monkey* from Sagot. This work was probably shown at Serrurier's, since in his

poetic account of the exhibition (*La Plume*, May 1905) Apollinaire refers to 'the future acrobats among the familiar monkeys, white horses and dogs resembling bears'. Leo and Gertrude Stein concur that Henri-Pierre Roché set up the meeting with Picasso. A letter from Roché in the Picasso Archives bears them out: 'I shall bring the American of whom I spoke to see you at your house tomorrow, Wednesday morning, at 10.00 a.m.' The postmark on this letter, however, is either 8 March, or more probably 8 May, i.e. it dates from the period following the Serrurier exhibition. If this meeting did in fact take place, Leo and Gertrude Stein would have visited the Bateau-Lavoir in late spring rather than in the autumn of 1905.

As far as the meeting between Matisse and Picasso is concerned, Fernande Olivier believes that it took place at one of the dinners given for artists on Saturday evenings at the Steins' apartment in rue de Fleurus. In a conversation with Brassaï, however, Matisse's daughter, Marguerite Duthuit, was equally convinced that it took place at the Bateau-Lavoir in rue Ravignan. According to Gertrude Stein, the first meeting was in the spring of 1906, shortly before the departure of the Steins for Fiesole and Picasso for Gósol; however, her account is not completely trustworthy because she confuses, for instance, the trips made by the Matisses to Collioure and to Italy during the years 1905, 1906 and 1907. For his part, Leo Stein refers to a discussion between Matisse and Picasso that supposedly took place during an exhibition devoted to Odilon Redon and Edouard Manet. This exhibition, however, was held at the Durand-Ruel gallery in late February 1906, and Matisse and Picasso would not have entered into such a discussion had they not met beforehand. Furthermore, on 8 May 1906 Leo Stein wrote a brief note to Matisse informing him of Vollard's acquisition of a number of pictures by Picasso. The style of this communication suggests that Matisse already knew Picasso sufficiently well to take a particular interest in his financial situation, which was extremely difficult at that time.

These facts suggest that the meeting between Matisse and Picasso may have taken place several weeks, or indeed several months, before the Salon des Indépendants in 1906, which is when Picasso himself later said they had first met, and that Leo Stein's first visit to Picasso's studio may have taken place before the summer of 1905. Such a change in the chronology would lend greater authenticity to the 'ninety or so' sittings said by Gertrude Stein to have taken place from the time when Picasso first started painting her portrait (no.58) to March 1906 when the artist temporarily abandoned it. The portrait would therefore probably have been underway in the autumn of 1905 when the Steins bought Matisse's *Woman with the Hat* (fig.33). In any event, it is reasonable to assume that the Steins acquired their first Picassos between the Serrurier exhibition and the summer of 1905 rather than after the 1905 Salon d'Automne, and this purchase would therefore have been made before, rather than just after, the purchase of their first Matisse.

1905

25 February–6 March: Leo Stein discovers the work of Picasso at the Galeries Serrurier and buys *Acrobat's Family with a Monkey* from Clovis Sagot.

Spring: Picasso attends the soirées of the review *Vers et Prose* at the Closerie des Lilas. Matisse is one of the first subscribers to this review.

24 March–30 April: Salon des Indépendants. Matisse exhibits *Luxe, calme et volupté*. In *Gil Blas* (23 March) Louis Vauxcelles writes: 'This young painter – yet another dissident from the Moreau studio who has risen freely towards the summits of Cézanne – is assuming, willingly or not, the position of leader of a school.'

6–29 April: Matisse is included in a group exhibition at the Galerie Berthe Weill.

8 [May?]: Henri-Pierre Roché, at the request of Leo Stein, writes to Picasso: 'I shall bring the American of whom I spoke to see you at your house tomorrow, Wednesday morning, at 10.00 a.m.' (AP)

15 May: Apollinaire publishes an article on Picasso in *La Plume*.

18 October–25 November: Salon d'Automne: Matisse exhibits alongside André Derain, Albert Marquet, Maurice de Vlaminck, Charles Camoin and Henri Manguin. Vauxcelles christens this group of artists the 'Fauves' (wild beasts) (*Gil Blas*, 17 October). Leo and Gertrude Stein acquire *The Woman with the Hat* (fig.33) at the Salon. *The Turkish Bath*, shown at the Salon's Ingres retrospective, has a profound impact on Matisse and Picasso.

Fernande Olivier writes: 'As small-scale patrons of those extraordinary days, the Steins did a great deal to make modern artists popular ... Matisse was far older than Picasso, and a serious and cautious man. He never saw eye-to-eye with the younger painter. As different as the North Pole is from the South Pole, he would say, when talking about the two of them ... Matisse shone and impressed people. They were the two painters of whom most was expected.' (Olivier 1933, pp.84, 88.)

Matisse comments: 'The originality of the Stein family, as art lovers, lay in the fact that they declared at once what they had bought and displayed the pictures quite simply on their walls. Leo and Gertrude Stein also bought Picassos. Picasso's painting interested me greatly.' (Matisse 1941.) At that time the Steins' collection of Picassos, in addition to *Acrobat's Family with a Monkey*, included *Girl with a Basket of Flowers* and *Two Women at a Bar*.

21 October–21 November: Exhibition of the 'Fauves' at the Galerie Berthe Weill. She writes in her memoirs: 'The Fauves are beginning to tame the art lovers. Apollinaire, a regular visitor to my gallery, and an equally revolutionary poet, is particularly interested in the work of these revolutionary artists. How boisterous these young artists are! Matisse, the eldest, however, remains very reserved; Picasso and Apollinaire, who have become very friendly, arouse his suspicion ... why? Quickly reassured, he becomes one of the clan.' (Weill, *Pan! dans l'oeil!*, Paris 1933, pp.118–21.)

1906

Mid-January: Claribel and Etta Cone, from Baltimore, begin buying works by Matisse and Picasso. Matisse sees Gustave Fayet's collection of works by Gauguin. Influenced by these works, he produces a series of three woodcuts (nos.21–2, 30).

28 February–15 March: The Manet and Redon exhibitions at the Durand-Ruel gallery are the backdrop for an exchange between Matisse and Picasso, reported by Leo Stein: 'At Durand-Ruel's there were at one time two exhibitions on, one of Odilon Redon, and one of Manet. Matisse was at this time specially interested in Redon. When I happened in he was there, and spoke at length of Redon and Manet, with emphasis on the superior merits of the lesser man ... He told me he had seen Picasso earlier, and Picasso had agreed with him ... Later on that same day Picasso came to the house and I told him what Matisse had said about Redon and Manet. Picasso burst out almost angrily, "But that is nonsense. Redon is an interesting painter, certainly, but Manet, Manet is a giant". I answered, "Matisse told me you agreed with him". Picasso, more angrily: "Of course I agreed with him. Matisse talks and talks. I can't talk, so I just said *oui oui oui*. But it's damned nonsense all the same".' (Leo Stein, *Appreciation: Painting, Poetry and Prose*, New York 1947, p.171.)

19 March–7 April: Matisse retrospective (1897–1906) at the Galerie Druet.

20 March–30 April: Salon des Indépendants: Matisse exhibits *Le Bonheur de vivre* (fig.2). In *Le Mercure de France* (15 April), Charles Morice writes: 'Henri Matisse, feverishly synthesising and simplifying extravagance, rationalises and gives us, in the guise of pictorial art, pure "theoretical figures".' Leo Stein buys *Le Bonheur de vivre*, regarding it as 'the most important work of our time'.

Mid-April: Picasso sees Fayet's Gauguin collection, and this influence is apparent in his woodcuts *Head of a Woman* (fig.21), his high reliefs and the canvases painted during the summer in Gósol and in Paris during the autumn (see no.103). He paints *Woman Combing her Hair*, in reference to Puvis de Chavannes.

24 April: Vollard buys 2,200 francs' worth of works by Matisse (twenty paintings and studies).

Early May: Vollard buys 2,000 francs' worth of pictures by Picasso. Matisse visits the Colonial Exhibition at Marseilles.

8 May: Leo Stein writes to Matisse: 'I am sure that you will be pleased to know that Picasso has done business with Vollard. He has not sold everything but he has sold enough to give him peace of mind during the summer and perhaps longer. Vollard has taken 27 pictures, mostly old ones, a few of the more recent ones, but nothing major. Picasso was very happy with the price.' (AM)

Gertrude Stein recalls: 'It had been a fruitful winter. In the long struggle with the portrait of Gertrude Stein, Picasso passed from the Harlequin, the charming early italian period to the intensive struggle which was to end in cubism ... Matisse had painted the Bonheur de vivre and had created the new school of colour which was soon to leave its mark on everything. And everybody went away.' (*The Autobiography of Alice B. Toklas*, London 1933, p.58.)

10–26 May: Matisse is in Algeria (visiting Algiers and Biskra).

21 May–late July: Picasso travels to Barcelona, then Gósol.

[?Late May]: Matisse meets the Russian collector, Sergei Shchukin, for the first time, in Paris.

June–October: Matisse is in Collioure.

End of July: Picasso returns to Paris and completes the *Portrait of Gertrude Stein* (no.58).

6 October–15 November: Matisse returns to Paris and exhibits in the Salon d'Automne. In *Gil Blas* (5 October) Vauxcelles writes: 'M. Matisse. Well, he has gotten a grip on himself ... No more abstraction, no more painting "in itself", in the absolute, or "noumenon pictures".' While in Paris, Matisse purchases a nineteenth-century Vili statuette (from the Congo). He recalls: 'In rue de Rennes, I frequently passed a shop called "Le Père Sauvage" belonging to a dealer in exotic curios. And late one afternoon, I went in to buy a seated figure, a little man sticking out his tongue. Then I went to Gertrude Stein's in rue de Fleurus. Picasso arrived as I was showing her the statue. We chatted about it. It was then that Picasso noticed the Negro sculpture.' (Matisse 1941.)

Winter: Matisse returns to Collioure where he finishes *Standing Nude* (no.17) and, working from the photographic albums *Mes Modèles* and *L'Humanité Féminine*, he produces the sculpture *Reclining Nude I* (no.15) and the canvas *Blue Nude: Memory of Biskra* (no.14). In a parallel development Picasso uses photographs or postcards of 'African types' as sources for his proto-Cubist works.

1907

February: Picasso begins work on *Les Demoiselles d'Avignon* (no.7).

Early March: Matisse returns to Paris.

20 March–30 April: Salon des Indépendants: Matisse exhibits *Blue Nude: Memory of Biskra*

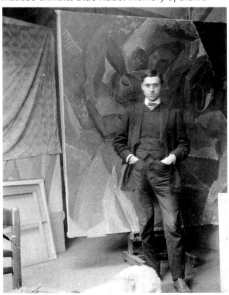

fig.83 André Salmon in Picasso's studio in the Bateau-Lavoir, in front of *Three Women* (unfinished) with *Les Demoiselles d'Avignon* (no.7) half hidden to the left. The studio appears in the state in which Matisse saw it when he and Picasso exchanged pictures in the autumn on 1907. Photograph by Picasso. Archives Picasso

(no.14) which is bought by Leo and Gertrude Stein. Walter Pach exchanges a few words with Picasso while standing in front of the painting: '"Does that interest you?" asked Picasso. "In a way, yes ... it interests me like a blow between the eyes. I don't understand what he is thinking". "Neither do I", said Picasso. "If he wants to make a woman, let him make a woman. If he wants to make a design, let him make a design. This is between the two."' (Walter Pach, *Queer Thing, Painting*, New York and London 1938, p.125.)

30 March–15 April: Matisse and others exhibit work at the Galerie Berthe Weill.

Spring: Picasso visits the Musée d'Ethnographie du Trocadéro for the first time, and as a result makes changes to *Les Demoiselles d'Avignon*.

21 April: Matisse leaves for Collioure.

27 April: Picasso writes to Leo Stein on the back of a postcard: 'My dear friends / would you like to come tomorrow (Sunday) to see / the picture / Picasso.' The picture in question could be *Les Demoiselles d'Avignon* (no.7) (in its first state). Thus at the time of the Salon des Indépendants, Apollinaire, Fénéon, Vollard, Uhde, Derain and Braque, all of whom were close to Matisse, had already had an opportunity to view *Les Demoiselles*, which Matisse himself is generally believed to have seen on his return to Paris in the autumn.

14 July–14 August: Matisse travels in Italy.

14 August: Matisse returns to Collioure. He accepts Mécislas Golberg's proposal to write about his painting. Golberg is planning for the same issue of *Les Cahiers de Mécislas Golberg* an article entitled 'Quelques Uns' about Matisse, Picasso and Derain.

1 September: Matisse returns to Paris.

10 September: Matisse submits the manuscript for his 'Notes d'un peintre' (Notes of a Painter) to Golberg, but the project does not come to fruition owing to Golberg's death on 28 December. The jury of the Salon d'Automne rejects *The Coiffure*, painted by Matisse in response to Picasso's version of 1906.

1–22 October: Salon d'Automne: Matisse exhibits *Le Luxe I* (no.6). In *Gil Blas* (30 September), Vauxcelles writes: 'We will begin with the unsettling work of Matisse ... I am, of course, well aware of the decorative merits that Matisse exhibits in his stunning panel of nudes, even in his almost caricatural effigy of a woman ... Why this hateful contempt for form?'

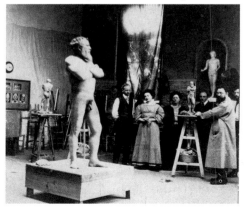

fig.84 Life class in the sculpture studio of L'Academie Matisse at the Hôtel Biron (Couvant du Sacré-Coeur), Paris c.1909. Archives Matisse

Autumn: Picasso and Matisse exchange recent canvases, *Pitcher, Bowl and Lemon* (no.3) and *Portrait of Marguerite* (no.4). Salmon recalls the mood at the dinner during which the paintings were exchanged:

'What a day! Picasso, who was to say nothing, received his guests, or to be more precise resigned himself to having so many guests at his house. Max Jacob, Guillaume Apollinaire, Vlaminck, Matisse and Maurice Princet, the actuary who was to become the legendary "mathematician of Cubism" were there; Georges Braque, still a Fauve ... Matisse only ever approached his juniors with a great deal of unease, even when they were barely younger than him ... A pure spirit? Why not? As Matisse was worthy of being regarded a great artist, susceptible only to a kind of filtered sensuality, removed from life as we knew it, and in my opinion moreover impervious, not to humour as such, but to light-heartedness, we played jokes on him. Jokes at a respectful distance. Matisse presented Picasso, who disquieted him considerably, with a portrait of his daughter, Marguerite. Was he aware of this, and is this why he gave it away? We went directly to the bazaar in the rue des Abbesses where, poor but not afraid to make sacrifices in the interests of pleasure, we bought a set of toy arrows tipped with suction pads, which I have to say were wonderful fun back in the studio as we could shoot at the painting without damaging it. "A hit! One in the eye for Marguerite!" "Another hit on the cheek!" We enjoyed ourselves immensely. More so, when we learned that Matisse, already regarded as a great man, was conducting discreet enquiries about the person or persons responsible for writing on the walls and fences of Montmartre, "Matisse induces madness!", "Matisse is more dangerous than alcohol", "Matisse has done more harm than war!" This despite the fact that our experience of war was confined to notions of going to war gleaned from the chronicles of 1870. (André Salmon, *Souvenirs sans fin. Première époque (1903–1908)*, Paris 1955, pp.187–8; see fig.83.)

15 November: The review *La Phalange* publishes 'Les Fauves', by Michel Puy.

Early December: Matisse sets up his studio in the Couvent des Oiseaux, Paris.

15 December: *La Phalange* (no.18) publishes an interview with Matisse by Apollinaire, which had initially been published in *Les Cahiers de Mécislas Golberg*.

10–30 December: Matisse and Picasso each show two pictures in a group exhibition at Galerie Eugène Blot.

1908

Early January: The 'Matisse Academy' opens at the Couvent des Oiseaux as a result of an initiative by Sarah Stein and Hans Purrmann.

24 January: André Level buys Picasso's *Family of Saltimbanques* for the 'Peau de l'Ours' association. Shchukin introduces the collector Ivan Morosov to Matisse. In a letter of 12 June 1912 Picasso describes to the dealer Daniel-Henry Kahnweiler a scene that took place at this time: 'You tell me that you very much like the picture [*Three Women*] in Shchukin's style [probable reference to *Friendship*].

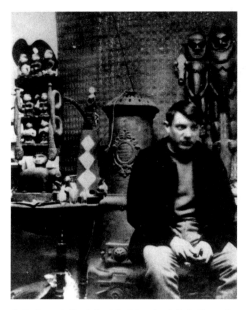

fig.85 Picasso in his studio at the Bateau-Lavoir, Paris, May 1908. Photograph by Gelett Burgess. Archives Picasso

I remember that one day while I was painting it, Matisse and Stein came and quite openly joked in front of me. Stein said to me (I was telling him something to try and explain to him) "but that's the fourth dimension" and then started laughing.' (AK-L)

March: Shchukin commissions several large decorative canvases by Matisse for his Moscow residence.

20 March–20 April: Salon des Indépendants. Gertrude Stein recalls: 'The feeling between the Picassoites and the Matisseites became bitter. And this, you see, brings me to the independent where ... two pictures ... showed that Derain and Braque had become Picassoites and were definitely not Matisseites ... Matisse showed in every autumn salon and every independent. He was beginning to have a considerable following. Picasso, on the contrary, never in all his life had shown in any salon. His pictures at that time could really only be seen at 27 rue de Fleurus. The first time as one might say that he had ever shown at a public show was when Derain and Braque, completely influenced by his recent work, showed theirs. After that he too had many followers.' (*The Autobiography of Alice B. Toklas*, London 1933, p.69.)

Spring: Matisse moves his studio to the Hôtel Biron (Couvent du Sacré-Coeur).

20–29 April: The American journalist and writer Gelett Burgess writes an article on the artistic scene in Paris. He visits Matisse on 20 April, and Picasso at the Bateau-Lavoir on 29 April (fig.85).

14 June: Picasso writes to the Steins at Fiesole: 'All the Indépendant painters [Matisse, Braque, Derain] left for the south [of France] and we are alone, Fernande and I. We see only painters from the Champs-de-Mars.' (BL)

Mid-June: Matisse returns to Paris.

August–September: Picasso holidays in La-Rue-des-Bois, on the edge of the Forest of Halatte.

September: Shchukin meets Picasso: 'One day Matisse brought an important collector from Moscow to see him. Chukin [Shchukin] was a Russian Jew,

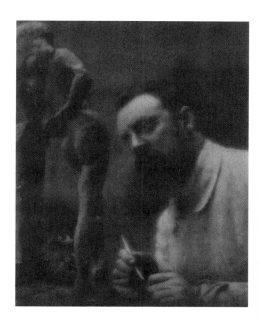

fig.86 Matisse working on *La Serpentine* (no.18), Paris, autumn 1909. Photograph by Edward Steichen. Platinum print 29.6 x 23.4cm. The Museum of Modern Art, New York. Gift of the Photographer

very rich and a lover of modern art ... He bought – and paid a lot of money by the standards of those days – two canvases. One of them, the *Femme à l'éventail* [*Woman with a Fan*; no.53] is very beautiful. From that moment the Russian was a partisan of Picasso.' (Olivier 1933, p.118–19.)

According to Matisse, on his return to Paris he 'looked in at Picasso's studio, where Picasso was discussing with friends the first Cubist picture. Braque had come back from the south of France with a landscape of a village by the sea, viewed from above, *The Bay at L'Estaque*.' He also mentioned 'having seen the *Large Nude* in Braque's studio, influenced by *Three Women* and *Nude with Drapery* [fig.18] by Picasso as well as his *Blue Nude* [no.14].' (Henri Matisse in *Transition*, no.23, 1934–5.)

20 September: Matisse leaves for Spain.

1 October–8 November: Salon d'Automne: Matisse is represented by thirty works. The 'acting jury' of the Salon, of which Matisse is a member, rejects paintings by Braque. (Braque exhibits them at the Galerie Kahnweiler instead, 9–28 November.) Vauxcelles recalls Matisse's remark that 'Braque has just sent a painting made of small cubes'. 'In order to make himself better understood (for I was dumbfounded), he [Matisse] took a piece of paper and in three seconds he drew two ascending converging lines between which the small cubes were set, depicting an Estaque landscape of Georges Braque.'

Fernande Olivier states: 'Picasso and Matisse, who were quite friendly with one another, clashed over the birth of Cubism; a subject which managed to startle Matisse out of his normal calm. He lost his temper and talked of getting even with Picasso, of making him beg for mercy. None of this prevented him, some months later, when the new developments in the Spanish painter's work began to bear fruit, from attempting to see some similarity in their artistic ideas.' (Olivier 1933, p.88.)

Leo and Gertrude Stein let Sarah and Michael Stein have most of their Matisse collection, Gertrude having decided to devote herself exclusively to collecting Picasso's work. 'Two worlds are being created in the Paris art world,' writes Harriet Levy.

Autumn–Winter: Picasso completes *Three Women*, which is added to the collection of Leo and Gertrude Stein (see fig.83).

11–31 December: Matisse is included in a group exhibition at the Galerie Berthe Weill.

21 December–15 January: Picasso is included in a group exhibition at the Galerie Notre-Dame-des-Champs.

25 December: Matisse's 'Notes of a Painter' is published in *La Grande Revue* with a preface by Georges Desvallières.

1909

7 February–early March: Matisse is in Cassis.

25 March–2 May: Salon des Indépendants: Matisse exhibits four works including *The Girl with Green Eyes*. In his review in *Mercure de France* (16 April 1909) Charles Morice writes: 'One wonders, with curiosity but also with unease, where the dangerous and divergent path [chosen by Henri Matisse] might lead. This is perhaps why the intransigents and absolutists who quite recently accepted his tyranny have disowned him.'

12 April: Charles Estienne publishes an interview with Matisse in *Les Nouvelles*.

12 May–September: Picasso goes first to Barcelona, then to Horta de Ebro. He paints his first Cubist landscapes and portraits.

15 May–mid-August: Matisse is in Cavalière.

Mid-August: Matisse moves into the house he has rented at Issy-les-Moulineaux.

11 September: Picasso returns to Paris.

13 September: Picasso writes to the Steins to invite them to see the works painted in Horta. 'It was in Aragon, in a little village called Horta near Saragossa, that Picasso's Cubist formula was defined and established; or rather on his return from a trip there. He brought back several canvases, the two best of which were bought by the Steins.' (Olivier 1933, p.96.)

Picasso works on the sculpture *Head of a Woman* (no.139).

18 September: Matisse signs a three-year contract with Galerie Bernheim-Jeune, subsequently renewed until 1921.

Late September: Picasso moves to 11 boulevard de Clichy.

1 October–8 November: Salon d'Automne: Matisse exhibits two still lifes.

1910

14 February–5 March: Matisse has a retrospective (1895–1910) at the Galerie Bernheim-Jeune.

27 February–29 March: An exhibition devoted to Matisse's drawings is held at Alfred Stieglitz's '291' gallery in New York.

18 March–1 May: Salon des Indépendants: Matisse shows *Girl with Tulips (Portrait of Jeanne Vaderin)*.

Apollinaire writes in *L'Intransigeant* of 19 March: 'Let us first talk first about Henri Matisse, one of today's most disparaged painters. Have we not seen the Paris press (including this very newspaper) recently attack him with unusual violence? No man is a prophet in his own country, and while the foreigners who acclaim him are at the same time acclaiming France, France is preparing to stone to death one of the most captivating practitioners of the plastic arts today.' (Apollinaire 1972, pp.65–6.)

May: Picasso contributes to a group exhibition at the Galerie Notre-Dame-des-Champs. In June Léon Werth writes in *La Phalange*: 'From these agreeable and ingenious works, M. Picasso proceeds to this fruit bowl and this glass which reveal their structure and their hyperstructure.'

May: The article written by Gelett Burgess in 1908, 'The Wild Men of Paris', is published in the *Architectural Record*, accompanied by illustrations (fig.85).

19 June: Picasso writes to Leo Stein: 'The American review in New York that publishes portraits of Fauves is called "The-Architectural-Record" ... it will give you a good laugh.' (BL)

1 July–5 September: Picasso is in Cadaquès.

16 July–9 October: Matisse and Picasso are represented in the exhibition *Ausstellung des Sonderbundes Westdeutscher Kunstfreunde und Künstler* in Düsseldorf.

1 October–8 November: Salon d'Automne: Matisse shows *Dance II* and *Music*, which spark off a violent debate. Apollinaire defends Matisse in *L'Intransigeant* (1 October): 'The two decorative panels by M. Henri Matisse produce a powerful impression. The richness of colour, the sober perfection of the line are undeniable this time, and it is probable that the French public will not continue to ignore one of the most significant painters of our time.' (Apollinaire 1972, p.110.)

8 November–15 January 1911: Matisse and Picasso take part in the exhibition *Manet and the Post-Impressionists* organised by Roger Fry at the Grafton Galleries, London. Picasso is represented by nine works and Matisse by twenty-three.

16 November–17 January 1911: Matisse travels extensively in Spain. He writes to Camoin from Seville: 'I am basking with the sun on my belly, my dear friend. Why not come here instead of staying there on the Butte [in Montmartre] and being at the butt-end of all the trouble? I am leaving tomorrow for Granada.' (CC/M)

Before 22 December–February 1911: Picasso has a retrospective at the Galerie Vollard.

1911

17 January: Matisse returns to France.

28 March–25 April: Picasso has an exhibition of drawings and watercolours at the '291' Gallery in New York. *Camera Work* publishes an interview with Picasso by Marius de Zayas.

16 April: Apollinaire writes in the *Le Mercure de France*: 'On the contrary, Picasso, who is a Spaniard, takes delight in cultivating the disarray in his studio,

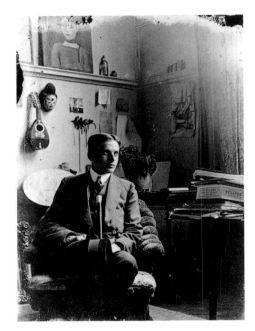

fig.87 Portrait of Frank-Burty Haviland in Picasso's studio at Boulevard de Clichy with Matisse's *Portrait de Marguerite*, (no.4) Paris, 1911. Photograph by Picasso. Archives Picasso

where you see a jumble of Oceanian and African idols, anatomical pieces and a great deal of dust. The painter works there slowly, barefoot, and smoking a clay pipe. At one time he used to paint during the night ... The erudite Henri Matisse paints with gravity and solemnity, as if hundreds of Russians and Berliners were watching him. He works on one canvas for a quarter of an hour and then moves on to another. If anyone is in his studio, he indoctrinates them and quotes Nietzsche and Claudel, mentioning Duccio, Cézanne and the New Zealanders as well.' Apollinaire sends this review to Picasso on 30 April.

21 April–15 June: Salon des Indépendants: Matisse exhibits *Mme Matisse in the Manilla Shawl* but after the private view replaces it with *The Pink Studio*, which according to Roger Allard writing in *La Rue* on 5 May was 'still quite damp, so that visitors on the Sunday were brushing against the wet paint'. The critics stress 'the taming of the wild beast Matisse', said to be 'drawing in his claws and fangs' (*Fantasio*, 1 May). The Cubist room at the Salon causes a scandal. Vauxcelles, writing in *Le Petit Parisien* (23 April), asks: 'What is a Cubist? It is a painter from the Braque-Picasso school'. Apollinaire writes in *L'Intransigeant* (21 April): 'The Fauves of the past. They have assembled in Room 27, very far from their young rivals [the Cubists]. There is some coquettishness on their part in making themselves seem so old. Never has Henri Matisse's talent been younger.' (Apollinaire 1972, p.153.)

10 August–4 September: Picasso is in Céret.

29 August–8 September: *Paris-Journal* (29 August) publishes a statement by the self-styled 'thief' of the *Mona Lisa* (Géry Pieret), recounting how in March 1907 he had stolen two Iberian sculptures from the Louvre and sold them to an art lover. Picasso is immediately aware of the gravity of these revelations, for he recognises himself as the art lover in question. On 6 September Picasso and Apollinaire return the two sculptures bought from Géry Pieret. On 8 September Apollinaire alone is charged with complicity and receiving stolen goods, and spends six days in the Santé prison before he is vindicated.

Early September–13 October: Matisse is in Collioure.

September–October: Salmon published two pen-portraits of Picasso and Matisse in the *Paris-Journal*:
'Pablo Picasso. He has left his sapper's lodgings perched on the Butte for a more academic studio. Affable and sly, Picasso, dressed as an aviator, equally untouched by praise or criticism, finally shows the canvases that collectors are looking for, which he has the slyness not to exhibit in any Salon.' (21 September.)
'Henri Matisse has retired to Issy-les-Moulineaux, abandoning his academy and his pupils. At dawn, Henri Matisse mounts his horse, rides around the forest and returns to his studio at a gallop. He is no longer equal to his commissions, and no doubt this is why he does not finish any canvases.' (1 October.)

Mid-September/early October: Alfred Stieglitz meets Picasso and Matisse.

1 October–8 November: Salon d'Automne: Matisse shows *View of Collioure* and *Still Life with Aubergines*. The Cubist works shown in the Salon (none of them by Picasso or Braque) arouse controversy. An anonymous article in *Paris-Midi* (30 September) declares: 'The Cubists are these young jokers, followers of Picasso who was a very gifted colourist and is now an equally gifted humorist. They construct geometric, pyramidal, rhombohedral nudes. They are reacting, they say, against the "coloured debauchery" of Matisse.'
Apollinaire writes in *L'Intransigeant* (12 October): 'A very good likeness of *Henri Matisse* by Mme Meerson [Merson] makes this group serve as an homage to the master of powerful and pleasant colours.' (Apollinaire 1972, p.186.)
Apollinaire writes in *Le Mercure de France* (16 October): 'The Cubists, who are so unjustly mocked, are painters who try to give their works the greatest possible degree of plasticity, and who are aware that while colours are symbols, light is reality. The name Cubism was coined by the painter Henri Matisse, who used it to describe a picture by Picasso.'
Vauxcelles writes in *L'Art Décoratif* (5 November): ' ... these fugitives, these "survivors" have not departed to the rue Bonaparte, but to Montparnasse, Montrouge and Vaugirard, to libertarian studios and anti-establishment academies where the gospel according to Henri Matisse is preached. Derain, and the enigmatic Picasso attempted to react.'

1 December: Apollinaire writes in *L'Intransigeant* under the title 'Le Kub': 'These days, it is easy to joke about works of art when they are new. This releases one from the obligation to understand them. Today, we mock the Cubists; yesterday, we mocked the great painter Henri Matisse, who himself has succumbed to this modern failing: it is said that he does not care for Cubism; it was he who gave it its name. Imagine his discomfiture, this summer, arriving at Collioure where he spends the summer months, to read the word "Kub" on his house in enormous letters. The outside of one of the walls of his house is leased to an advertising company which put up an advertisement for a fashionable food product [a stock cube] there, thus playing a trick on the master of powerful and mellow colours that spoiled his holidays.'

1912

January: Matisse and Picasso are represented in the *Jack of Diamonds* exhibition in Moscow.

27 January–mid-April: Matisse is in Morocco.

4 March–6 April: Exhibition of sculptures by Matisse at the '291' Gallery in New York.

20 March–16 May: Salon des Indépendants: Juan Gris shows his *Homage to Pablo Picasso*. This tribute echoes the *Portrait of Henri Matisse* by Olga Merson shown at the previous year's Salon d'Automne in the Fauves room. The following appears in *L'Occident* (March): 'Time moves on. It is three or four years since Matisse was prince of the Fauves. Where he trod, the grass of the academic establishment grew no more. Alas, the wheel of fortune has turned. At the 1912 Salon des Indépendants there are no pupils of Matisse, or at least very few. Cubism is in favour ... the master has been abandoned; his painting is doubly deserted. It is a fall from grace. Oh Matisse, such a fall!' Des Gaschons writes in *Je sais tout* (15 April): 'In recent times, Paris has seen several manifestations of art: Futurists, Cubists, followers of Picasso, whom *Je sais tout* has been unable to ignore.' Still lifes by Braque and Picasso and a detail of *Music* by Matisse are reproduced, although Matisse is not mentioned.

14 April: Matisse returns to Paris.

18 May: Picasso leaves for Céret.

25 May–30 September: At the *Internationale Kunst-Ausstellung des Sonderbundes Westdeutscher Kunstfreunde und Künstler zu Köln* (Cologne) Picasso is represented by sixteen works (1903–11) and Matisse by five including the *Portrait of Marguerite* (no.4), loaned by Picasso.

Spring–Summer: Matisse spends the summer at Issy-les-Moulineaux.

Late June–23 September: Picasso is in Sorgues, near Avignon.

15 July: Picasso writes to Kahnweiler: 'Why have these people at the Sonderbund reproduced my paintings with Haviland's at the front instead of a better, more recent one? And in the catalogue they might have said that the painting by Matisse (Marguerite) belongs to Monsieur Picasso.' (AK-L)

August: An issue of *Camera Work* is devoted to Matisse and Picasso with two 'word-portraits' by Gertrude Stein as well as portfolios of illustrations.

18 September: Picasso writes to Gertrude Stein: 'My dear Gertrude, I've received your book [*Camera Work*] ... The reproductions are very beautiful. I thank you for all that, and for your dedication.' (BL)

23 September: Picasso moves into 242 boulevard Raspail, Paris.

30 September–mid-February 1913: Matisse is in Tangier.

30 September: Apollinaire writes in *L'Intransigeant*: 'The opening of the Salon d'Automne will take place tomorrow, Monday. This year's Salon does not have the battle-scarred look it had in 1907, 1908 and last year. Henri Matisse, Van Dongen and Friesz,

accepted by the public, occupy the places of honour in their respective rooms ... The Cubists, grouped together in a dark room at the far end of the retrospective exhibit of portraits, are no longer ridiculed the way they were last year. Now the feeling they arouse is hatred.' (Apollinaire 1972, p.247.)

1 October–8 November: Salon d'Automne: Matisse shows *Nasturtiums with Dance II* (no.81).

5 October–31 December: At Roger Fry's Second Post-Impressionist Exhibition at the Grafton Galleries in London, Matisse is represented by twenty-seven paintings and sculptures and many drawings and prints, and Picasso by sixteen works. In his catalogue essay Fry presents Matisse and Picasso as the leaders of the avant-garde in France, who represent 'two extremes' between which 'we may find ranged almost all the remaining artists': while Picasso in his recent Cubist work is poised 'to create a purely abstract language of form – a visual music ... Matisse aims at convincing us of the reality of his forms by the continuity and flow of his rhythmic line, by the logic of his space relations, and above all by an entirely new use of colour' (p.15). Reviewers, many of them hostile, stress the Matisse-Picasso polarity: a review in *The Times* (4 October 1912) is headlined 'A Post-Impressionist Exhibition, Matisse and Picasso'.

6 October–7 November: Matisse and Picasso are represented in an exhibition at the Modern Kunst Kring, Stedelijk Museum, Amsterdam.

21 October: André Salmon publishes *La Jeune Peinture française* which is disparaging about Matisse and insists on the importance of Picasso. About this book, Vauxcelles writes in *Gil Blas* (21 October): 'The fact that there might be a few too many Germans and Spaniards in the Fauve and Cubist business and that Matisse has become naturalised as a Berliner or that Pablo is from Barcelona, is of itself scarcely important.'

23 October: Vauxcelles writes in *Paris-Journal*: 'The word "Cubism", invented by Matisse and originally intended as an insult, is meaningless when used to describe a school: there is no Cubist school.'

November–December: Picasso creates a series of *papiers collés* and photographs them hanging in the boulevard Raspail studio.

3 December: The Socialist deputy Jules-Louis Breton makes a speech denouncing Cubism in the French parliament, the Chambre des Députés: 'Gentlemen, it is inadmissible that our national galleries should be used for displays of such a radically anti-artistic and anti-national character.' Marcel Sembat, a deputy and an important collector of the work of Matisse, replies: 'My dear sir, when a picture displeases you, you have one undeniable right: and that is not to look at it, and go and look at others. But you don't call out the police.' (*Journal Officiel.*)

18 December: Picasso signs a three-year contract with Kahnweiler.

23 December–mid-January 1913: Picasso spends time in Céret and Barcelona.

1913

January–February: Matisse and Picasso are represented in an exhibition in Vienna (Miethke Gallery) and Munich (Neue Kunstsalon).

17 February–15 March: At the *International Exhibition of Modern Art*, known as the Armory Show, in New York, Picasso is represented by eight works, Matisse by twelve. The exhibition subsequently travels to Boston and Chicago, where students burn effigies of Matisse's *Blue Nude: Memory of Biskra* (no.14) and *Le Luxe II* to the accompaniment of 'Cubo-futurist' music.

24 February: Matisse and Picasso feature in a retrospective exhibition at the Galerie Berthe Weill.

Late February: A Picasso retrospective (1901–12) is held at the Tannhauser Gallery in Munich.

March: Apollinaire publishes *Méditations Esthétiques: Les Peintres cubistes*: 'The new school of painting is known as Cubism, a name first applied to it in the fall of 1908 in a spirit of derision by Henri Matisse ... Instinctive Cubism is an important movement ... encompassing numerous artists such as Henri Matisse, Rouault, André Derain.'

Around 10 March: Picasso leaves for Céret.

12 March: Picasso sends a postcard representing a group of three Catalans to Gertrude Stein: 'Je vous envoi le portrait de Matisse en Catalan.' (BL)

14 March: Apollinaire publishes an article entitled 'Pablo Picasso' in *Montjoie!*

18 March: Salon des Indépendants. Report in *L'Intransigeant*, 19 March: 'From ten in the morning, the Salon des Indépendants was full. Matisse's name was heard. There was talk of Cubism, of pointillism, of discipline.'

14–19 April: Matisse has an exhibition at the Galerie Bernheim-Jeune. Sembat publishes an essay on him in *Cahiers d'Aujourd'hui.*

20–22 June: Picasso contracts typhoid on his return to Paris.

22 July: Eva Gouel writes to Gertrude Stein: 'Pablo is almost entirely well. He gets up every day in the afternoon. Mr Matisse has come often to ask for news about him. And today he has brought Pablo some flowers and spent practically the afternoon with us. He is very agreeable.' (BL)

9–19 August: Picasso is in Céret. On 19 August, on returning to Paris, he moves into 5bis rue Schoelcher.

Late August: Picasso writes to Gertrude Stein (29 August): 'We take horseback rides with Matisse through the forest of Clamart.' (BL) Matisse writes to Gertrude Stein: 'Picasso is a cavalier. We are cavaliers together. This astonishes a lot of people.' (BL) Later, Matisse was to say of this period: 'Shortly before the war, in 1912 or 1913, our differences of opinion were amicable. At times we were strangely in agreement ... Picasso and I were at ease with one another. We gave each other a great deal in our exchanges. We were passionately interested in our respective technical problems. We undoubtedly benefited from one another. I think that ultimately there was mutual interpenetration of our individual approaches. This, it should be emphasised, was the time when discoveries by one or other of us were offered generously to all, a time of artistic brother-

fig.88 Matisse working on *Bathers by a River* (fig.12) at his studio in Issy-les-Moulineaux, Paris 1913. Photograph by Alvin Langdon Coburn. George Eastman House, New York

hood. Indeed, when I think of Cubism, I see the two faces of Braque and Picasso together with their works ... I was very fond of Picasso on those occasions when, appearing to play the devil's advocate, he persistently tried to combat in me something that deep down he liked, something that aroused his curiosity. Then he would suddenly start to laugh at the trap that he had set me so maliciously! Ultimately, you know, I was very close to the Cubists, since Juan Gris, one of the most rigorous of their number, had also become a great friend of mine. We spent summer holidays together at Collioure.' (André Verdet (1952), in *Entretiens, notes et écrits sur la peinture: Braque, Léger, Matisse, Picasso*, Paris 1978, p.127.)

The following anecdote, related by Matisse to Pierre Courthion, perhaps belongs to the same period: 'One day, meeting Max Jacob on one of the boulevards, I said to him, "If I weren't doing what I am doing, I'd like to paint like Picasso". "Well", said Max, "that's very funny! Do you know that Picasso made the same remark to me about you?"' (Matisse 1941.)

Late October: Matisse and Picasso return to Paris.

15 November–5 January 1914: Salon d'Automne: Matisse shows the *Portrait of Mme Matisse* (no.52). Apollinaire writes in *Les Soirées de Paris* (15 November): 'Henri Matisse's portrait of a woman is the best thing in the Salon, which is more than weak this year. In my opinion, this portrait, along with *The Woman with the Hat* (fig.33) in the Stein collection, ranks as the artist's masterpiece ... Henri Matisse has always had a hedonistic conception of art, but at the same time he has profited greatly from Gauguin's teachings ... His art is all sensibility. He has always been a voluptuous painter ... The portrait he is exhibiting here, full of voluptuousness and charm, marks, in a sense, a new period in Matisse's art, and perhaps in contemporary art as a whole: until now voluptuousness had almost completely disappeared from contemporary art, and was to be found almost nowhere except in the magnificent sensual paintings of the aged Renoir.' (Apollinaire 1932, pp.330–1.)

Five Cubist constructions by Picasso are reproduced opposite this text, resulting in the cancellation of most of the subscriptions to the review.

December: Matisse again rents a studio at 19 boulevard Saint-Michel, Paris.

1914

January: Matisse and Picasso are represented in an exhibition in the Flechtheim Gallery in Düsseldorf.

10 January: Robert Rey writes an account of a visit to Matisse in *L'Opinion*.

29 January: In *Le Journal des Débats* Gaston Migeon describes Shchukin's collection of works by Matisse and Picasso.

2 February: In New York *The Sun* announces: 'One of the world's finest collections of four living French masters, Cézanne, Picasso, Matisse and Renoir, will be disintegrated with the departure from Paris of Leo Stein.' Gertrude remains at rue de Fleurus while Leo goes, in April 1914, to live in Settignano. They divide their collection.

2 March: The collection of the 'Peau de l'Ours' association, including ten paintings by Matisse and twelve by Picasso, is auctioned at the Hôtel Drouot. Picasso's *Family of Saltimbanques* sells for the record price of 11,500 francs to the dealer Thannhauser. Matisse's *Compotier of Apples and Oranges* sells for 5,000 francs. Apollinaire writes in *Le Mercure de France* (16 March): 'Works by this generation – Henri Matisse, Pablo Picasso – were on display alongside works by artists of earlier generations. This was the first time that works by the new painters, Fauves or Cubists, had come up for auction.'

15 May: Apollinaire reproduces seven canvases by Matisse in *Les Soirées de Paris*.

25 May: Ardengo Soffici writes to Giuseppe Prezzolini that he has lunched with Picasso at rue Schoelcher, and that Matisse was also present (Soffici, *Ricordi di vita artistica e litteraria, Opere*, VI, 1968, p.212).

6 June: Gustave Coquiot publishes *Cubistes, Futuristes, Passéistes, essai sur la jeune peinture et la jeune sculpture* (Cubists, Futurists, Traditionalists: an essay on the new painting and the new sculpture) in Paris: 'Not only does M. Henri Matisse paint ... he evangelises! With considerable success, moreover. He has withdrawn to Issy-les-Moulineaux, to a luxurious villa, the better to think! There in this aeronautical centre, he is like some kind of aviator of painting. He is still intoxicated by the unknown; he is attracted by exploits!

'Pablo Picasso ... the leader of the Cubists ... He has an extraordinary virtuosity. He feels nothing and assimilates everything, but retains nothing inside him. Nor do I need to comment on the triumph of Cubism, which is now familiar to everyone. It even has a band of followers now who form Picasso's entourage. Also, the latter is now dreaming of a complete transformation of Cubism, a process which has already begun with the collage of actual fragments of objects – newspaper, fabric, hair, nail clippings ... in the art, in a word, of displaying "paraphernalia".'

Mid-June: Picasso leaves for Avignon.

Summer: Matisse and Picasso are represented in the Sommerschau exhibition in Munich.

fig.89 Picasso's self–portrait whilst working on *Man Leaning on a Table* (fig.44) at his studio in rue Schoelcher, Paris 1915–16. Archives Picasso

2 August: War is declared. Gertrude Stein is in England at the time and Kahnweiler in Rome. Apollinaire applies for French citizenship in order to join the army. Picasso accompanies Braque and Derain, who have been called up, to the station at Avignon. Matisse is in Paris; at the age of forty-four, he tries without success to enlist and joins the reserves. André Level writes: 'Then it was late July, the war, the first days in August. I remember a luncheon at my house, the day after Charleroi, with Matisse and Apollinaire, who is waiting to be called up before he enlists.' (André Level, *Souvenirs d'un Collectionneur*, Paris 1959, p.38.)

10 September–23 October: Matisse is in Collioure. He then returns to Paris.

Late October: Picasso returns to Paris.

1915

24 April: Picasso writes to Guillaume Apollinaire: 'Derain was in Paris, he went to see Matisse but did not come to see me.' (*Apollinaire/Picasso Correspondence*, ed. P. Caizergues and H. Seckel, Paris 1992, no.105.)

17 October: Léonce Rosenberg writes to Matisse that he is interested in buying his canvas *Goldfish and Palette* (no.69). (AM)

3 November: Léonce Rosenberg writes to Picasso: 'Dear friend, for the sake of good form, I have pleasure in confirming my purchase today of your two large paintings *Harlequin* [no.70] and *Man Seated in Shrubbery* [i.e. *Man Leaning on a Table* (fig.44)].' (AP)

November: Matisse sells *Still Life after Jan Davidsz. de Heem's 'La Desserte'* (no.75) to Léonce Rosenberg. Rosenberg shows him Picasso's *Harlequin* (no.70).

25 November: Rosenberg writes to Picasso: 'Like me, the master of the "goldfish" was a bit non-plussed at first: for your *Harlequin* [no.70] is such a revolution that even those who know your previous work were a little disconcerted ... After looking at your painting again and again, [Matisse] honestly recognised that it was superior to anything you had done so far, and that it was the work he preferred to all others. Next to the *Harlequin* I placed your still life with a green background; you cannot imagine how this other work, while keeping all its splendid textural qualities, looked small in conception ... In your *Harlequin*, Matisse finds that the means contribute to the action, that they are equal to it, while in the still life there are only means, very beautiful but without object. Finally, he expresses the feeling that his own "goldfish" [no.69] may have led you to your *Harlequin* ... In short then, although surprised, he was unable to conceal the fact that he considered your picture very fine and that he could not but admire it. My feeling is that this work will influence his next picture.' (AP)

An anecdote recounted by André Salmon featuring Picasso, Rosenberg and himself relates to this same period: 'In the midst of war, an illustrious Andalusian and a poet on leave visit a dealer in uniform, who takes them into a back-room behind his gallery, the dealer's no-man's land. They view a Matisse. The dealer says, "Hmm. But is it decorative enough?" And the Andalusian says to the poet, "After all we have done to try and make sure nothing is ever decorative again!"' (*Der Querschnitt*, no.2–3, May 1921.)

1–6 December: Matisse travels to Marseilles and L'Estaque.

9 December: Picasso writes to Gertrude Stein: 'I have painted a picture of a harlequin [no.70] which I and several other people believe is the best thing I have done.' (BL)

Late 1915: In *Souvenirs d'un Collectionneur* André Level evokes the resumption of artistic activity. In the 'boutique' in rue de Penthièvre, Germaine Bongard, sister of the couturier Paul Poiret, is hanging canvases by Matisse and Picasso alongside those of Léger, Derain and Modigliani. (André Level, *Souvenirs d'un Collectionneur*, Paris 1959, p.57.)

28 December–6 January 1916: Matisse and Picasso donate works to an art tombola organised by the Galerie Bernheim-Jeune for the benefit of Polish artists who have become victims of war.

1916

Early January: Matisse is in Martigues.

Late February: Matisse writes to Derain: 'I have sold my picture in the style of Davidsz de Heem [no.75] to Rosenberg. At his place I saw a new Picasso, a harlequin [no.70] in a new style, no collage, just painting, perhaps you know it?' (Archives Taillade-Derain, Collection Georges Taillade)

2 March–15 April: Matisse exhibits at the *Triennale de l'art français* at the Jeu de Paume. Léonce Rosenberg writes to Picasso (2 March): 'Saw the "Triennale" yesterday! Alas! Or rather so much the better! Disgust descends sooner than you would believe possible! This is Boche art!! All Philistines are Boches! Apart from Matisse and a picture by

Degas, what is there is enough to make you fall asleep on your feet!' (AP)

17 March: Apollinaire is wounded.

May: Jean Cocteau introduces Sergei Diaghilev to Picasso.

10 May–1 June: Matisse and Picasso donate works to the sale organised by the Galerie Georges Bernheim for the benefit of the Association for Blind Soldiers.

15 May: Erik Satie writes to Misia Edwards: 'Matisse, Picasso and other *Bons Messieurs* are giving a "Granados-Satie" concert on 30 May at Bongard's.' (Satie, *Correspondance presque complète*, ed. Ornella Volta, Paris 2000, p.242.)

16 May: Erik Satie writes to Léon-Paul Farge: 'Send me – immediately – something *very* short and *terribly* cynical. It's for the Matisse-Picasso-Bongard soirée.' (Satie, *Correspondance presque complète*, ed. Ornella Volta, Paris 2000, p.242.)

20 May: The sculptor Jacques Lipchitz writes to Léonce Rosenberg: 'A few days ago I had an unexpected visit from a whole band of people – Picasso, Matisse, Rivera, Ortiz and Brenner, and they saw the sculpture that you have just bought from me. Matisse was very interested in what I was doing, so much so (according to Rivera) that he annoyed Picasso.' (Correspondance Rosenberg/Lipchitz, MNAM.)

13–30 June: Matisse and Picasso are represented in a group exhibition at the Galerie des Indépendants.

15 June: In a letter to Léonce Rosenberg on the subject of 'exhibitions organised by couturiers', Juan Gris writes: 'I myself made clear to Picasso my astonishment at the way he has chosen to exhibit. He replied that during the war he had not turned down any French art shows in case people thought badly of him. For him, as for Matisse, given their celebrity, this is a plausible enough reason. To refuse to take part in shows here after having sold so many pictures abroad would look odd.' (Correspondance Rosenberg/Juan Gris, MNAM.)

19–30 June: Matisse's *White and Pink Head* is included in an exhibition at the Galerie Bernheim-Jeune.

16–31 July: Matisse and Picasso exhibit at the *L'Art moderne en France* show (known as *Le Salon d'Antin*) organised by Salmon at the Galerie Barbazanges. The catalogue mentions 'Henri Matisse (French), painting: *Moroccan Woman, Still Life* and drawings; Picasso (Spanish), *Les Demoiselles d'Avignon*.' This is the first public showing of *Les Demoiselles* (no.7). The following appears in *L'Intransigeant* (16 June): 'This man Picasso! – You perhaps prefer these harlequins? – Yes, but I am drawn to this large canvas; it overwhelms me, you might say. And Matisse? He is seductive. How could anyone have said of art such as this that it is not French?'

30 July: The *Cri de Paris* publishes the following anonymously:
'A young Cubist was looking at an odalisque with an apple-green face, no nose, no mouth, and with hands like rakes, a daring masterpiece by the famous Matisse, the leader, the prince of the Fauves. "Good God! How pretentious!" murmured the Cubist in disgust. The Fauves and the Cubists are protesting vigorously, having been reproached

for exploiting artistic formulae held in esteem by the Boches. We are sorry if the Boches did not invent Cubism. All we know is that a number of them have collected works from our new school of art. But it has not been proved that they were driven by passion to do so. They were perhaps driven by a Machiavellian ulterior motive. Shortly before the war, the curator of the Pinakothek in Munich entered the premises of an art dealer in rue Laffitte:
"I would like", he said, "some pictures by Fauves and Cubists".
"I do not stock such things", replied the dealer. "How could the horrors of our inebriate daubers possibly be to your taste?"
To which the curator, adjusting his gold-rimmed spectacles, replied: "Listen carefully! In about ten years' time I intend to open a highly educational room in the Pinakothek in Munich. On the door, I shall write the words *French decadence*".'

Summer: Matisse goes to Marseilles and Nice.

19 November–5 December: Matisse and Picasso take part in the *Lyre et Palette* exhibition organised at the Salle Huygens by Cocteau.

18 November–10 December: Matisse and Picasso take part in the exhibition of French art at the Kunstnerforbundet, Oslo.

4 December: Lipchitz writes to Léonce Rosenberg: 'One feels greatly in need of an artistic life, and even a more or less unattractive exhibition like the one in Montparnasse at the moment is excessively popular. *L'Elan* has just reappeared and contains drawings by Picasso and Matisse, poetry by Max Jacob, Georges [Guillaume] Apollinaire, Reverdy, etc ... and an immensely obtuse article on Cubism by Mr. Onzenfant [Ozenfant] in which the poor gentleman is at pains to show that anything that is not by him, Picasso or Braque is worthless.' (Correspondance Rosenberg/Lipchitz, MNAM.)

31 December–1 January 1917: Publication of the *Poète assassiné* by Apollinaire (31 December). A banquet is organised in his honour by Matisse, Picasso and Gris among others. Gris writes to Rosenberg: 'The dinner for Apollinaire was held yesterday. It was a great success, with over 100 people there. Some very important people came to demonstrate their sympathy for Apollinaire. At the same time, there were some minor incidents, which only served to add a flavour of the avant-garde to the banquet.' (Correspondance Rosenberg/Gris, MNAM.)

1917

14 January: Matisse and Picasso are members of the committee organising the 'Braque dinner' in the studio of Marie Vassilieff (Braque had been seriously wounded in spring 1915). (See fig.90.)

16 January–late March: Picasso goes to Barcelona on 16 January. On 17 February he leaves for Rome to join the Ballets Russes troupe and design the sets and costumes for *Parade*.

15 March: Pierre Reverdy's essay 'Sur le Cubisme' is published in *Nord-Sud*.

May: The review *SIC* publishes a text by Apollinaire on Picasso.

1–11 May: Matisse's *The Italian Woman* (no.55) is

fig.90 Puppets of Picasso and Matisse by Marie Vassilief, Paris 1917. Archives Picasso

included in the *Exposition de peintres, série D* at the Galerie Bernheim-Jeune.

18 May: Première of *Parade* (libretto by Cocteau, music by Satie, choreography by Léonide Massine, curtain, sets and costumes by Picasso) at the Théâtre du Châtelet, with Ernest Ansermet as musical director. Programme notes by Apollinaire. The première is the scene of violent demonstrations. Picasso, fleeing his box to escape a particularly vindictive audience chanting 'Picasso! Picasso!', bumps into Matisse, telling him 'Ah! How happy I am to meet a real friend in such circumstances.' (Pierre Schneider, *Matisse*, trans. M. Taylor and B. Strevens Romer, London 1984, p.735.)

27 May: Lipchitz writes to Léonce Rosenberg: 'Paris will soon have two Cubist exhibitions, one at Mme Bongard's and one at Chéron's, rue La Boétie, with Picasso, Matisse etc.' (Correspondance Rosenberg/Lipchitz, MNAM.)

Spring–summer: Matisse works at Issy-les-Moulineaux.

Early June: Picasso accompanies the Ballets Russes to Madrid and Barcelona.

24 June: Apollinaire's *Les Mamelles de Tirésias*, a 'sur-realist drama in two acts with a monologue', is performed during the 'Manifestation *SIC*'. Victor Basch writes in *Le Pays* (15 July): 'Before the curtain rose, there was a feeling that the SIC show – as advertised in the programme adorned with a suggestive drawing by Picasso and a powerful woodcut by Henri Matisse – would be youthful, turbulent and as stormy as one could wish.'

Late October–early November: Matisse is in Marseilles.

November: Matisse and Picasso are included in *Noir et blanc* exhibition at the Galerie Berthe Weill.

Late November: Picasso returns to Paris (Montrouge).

15 December: *L'Eventail* announces: 'M. Paul Guillaume ... invites us to consider some admirable portraits signed by Matisse. Every work by Matisse

appears to be numbered.'

20 December: Matisse settles in Nice.

1918

January: Paul Guillaume, who is planning the first ever Matisse-Picasso exhibition, writes to Picasso (12 January): 'The exhibition will open on the 23rd. Do you think that among the kind people you know there might be someone willing to lend us some of your good or important works?' (AP)

Guillaume writes to Matisse on 14 January: 'On the 23rd of this month, an exhibition of your work and that of PICASSO is to open at my premises. I am keen to show some excellent exhibits and I have taken some of the necessary steps. PICASSO is lending me one or two things in addition to the works I have obtained from sources elsewhere.' (AM) He writes again to Matisse on 16 January: 'You will be aware that I own a number of your important works. I thought you would not be displeased to see them on display, not in a special exhibition which could look as if it had been organised by you and might therefore appear to be a show that you have mounted personally – which no doubt you do not care to do during time of war – but by contrast alongside a number of works by Picasso. I do not believe that this juxtaposition contains any elements which you would find disagreeable. I have obtained Picasso's consent. All that remains is for me to obtain yours, which I now request. I might add that, should you give your permission, I have been promised some very fine works of yours, in particular by Monsieur Hesse. Profits from the sale of the programme will benefit crippled servicemen. We are anticipating substantial takings and we are certain that you would not want to diminish them by withholding the simple authorisation which I am requesting.' (AM)

Guillaume writes to Picasso on 18 January: 'I shall have a sufficient number of important works by Matisse and am keen that you should be equally well represented.' (AP)

23 January–15 February: Matisse-Picasso exhibition at the Galerie Paul Guillaume (see fig.91). Matisse is represented by twelve canvases including *Bowl of Oranges* (no.107) and *The Studio, quai Saint-Michel* (no.79). There are sixteen canvases by Picasso including *Portrait of a Young Girl* (no.57). The catalogue contains parallel texts on the two artists by Apollinaire: 'If one were to compare Henri Matisse's work to something, it would have to be an orange'; 'Picasso ... Is his not the greatest aesthetic effort we have ever witnessed?' (Apollinaire 1972, pp.457–8.)

Vauxcelles writes in *Le Pays*: 'For twenty years, Picasso and Matisse have been feverishly searching, undergoing frequent metamorphoses, like all those tormented by anxiety.'

Bissière writes in *L'Opinion*: 'Messrs. Matisse and Picasso have until now been regarded as the leaders of contemporary youth, those who best represent the two faces of avant-garde painting. All that is left is abstraction, theory and technique.'

18 March: Charles Camoin writes to Matisse in Nice: 'Dufy has asked me to do all I can to persuade you to send something for the Manzi exhibition, where they were counting on you. I have a few good friends there who are going to take part; you would

fig.91 Catalogue of *Matisse-Picasso* exhibition at the Galerie Paul Guillaume (with a preface by Guillaume Apollinaire), Paris, 1918. Bibliothèque Musée Picasso, Paris

be wrong to think that this is another trap like Guillaume's [Matisse-Picasso exhibition]. I have the impression that it is rather the opposite, and that it is rather more in the "anti-foreigners" [*anti-métèques*] style than anything.' (CC/M)

May–early June: Matisse moves to Mont-Boron, returning to Paris in early July.

2 May: Apollinaire and Jacqueline Kolb are married. Picasso and Vollard act as witnesses.

Early July: Matisse returns to Paris.

9 July: Picasso is at Montrouge. Matisse withdraws to Maintenon with his family.

12 July: Picasso marries Olga Koklova at the Russian church in rue Daru. They depart immediately for Biarritz to stay at the home of Eugenia Errazuriz, the villa La Mimoseraie, where they meet Paul Rosenberg.

9 September: Léonide Massine, in London, writes to Picasso: 'We have offered Matisse the opportunity to put on *Schéhérazade* or *Rossignol*; he has accepted both, which we are delighted about – at last we shall see Matisse in the theatre. We are still working on the ballet of *Pulcinella* and I hope that you are still thinking about this character too.' (AP)

Late September: Picasso returns to Paris. Paul Rosenberg becomes his dealer.

November or December: Matisse returns to Nice.

9 November: Death of Apollinaire.

11 November: Armistice.

Late November: Picasso moves to 23bis rue La Boétie.

1919

February: Cocteau publishes *Ode à Picasso* (Bernouard, Paris).

2–16 May: Matisse has a one-man exhibition at the Galerie Bernheim-Jeune (works of 1914–19). Cocteau writes: 'Here the wild beast who basked in sunshine has turned into one of Bonnard's kittens.

Freely, joyously and bravely he once painted pictures that give one a taste for living. What is happening to him?' ('Déformation Professionnelle', *Paris-Midi*, 12 May 1919.)

Early May–July: Picasso is in London to design the sets and costumes for the Ballets Russes production of *Le Tricorne (The Three-Cornered Hat)*.

22 July: Première of *Le Tricorne* (based on the novel by Pedro de Alarcon, choreography by Massine, sets and curtain by Picasso, music by Manuel de Falla) at the Alhambra Theatre in London.

Summer: Matisse is in Issy-les-Moulineaux. Stravinsky and Diaghilev visit him to discuss his involvement in the ballet *Le Chant du Rossignol*.

August: Picasso is in Saint-Raphaël.

September: Matisse is in Nice.

20 October–15 November: Exhibition of drawings and watercolours (167 works) by Picasso at the Galerie Paul Rosenberg.

Autumn: Picasso agrees to collaborate on *Pulcinella* for the Ballets Russes. Diaghilev writes to him from London (12 October): 'Just a few words to tell you that *Le Tricorne* is continuing its triumphant career and that *Parade* will be opening in two weeks' time. This evening we are expecting Matisse who is coming for a few days. For our part, it is the Parisian air that we are missing so much here.' (AP)

Matisse writes to Amélie Matisse from London on 17 October: 'I believe the ballet [*Le Chant du Rossignol*] will be good, as good I hope as Derain's [*La Boutique fantasque*], which is really good and is a great success here, as it surely will be in Paris. Picasso's ballet [*Le Tricorne*], although more refined, is less well put together, a lot less successful as an ensemble.' (AM)

Massine writes to Picasso from London on 24 October: 'I am beginning with rehearsals for *Parade* which will open at the beginning of November. Matisse is absorbed with the Polunins [Diaghilev's scene painters] and is in a light-hearted phase. I have received a postcard from Stravinsky saying that he is working enthusiastically [on *Pulcinella*] and has fallen in love with Pergolesi.' (AP)

Matisse writes to Amélie Matisse from London on 21 November: 'I'm watching the Ballets here. It's doomed because deep down it's sickening, and the Cubists, Picasso and Derain, will have done nothing to make it last, on the contrary. The success of *Parade*, which was not very real because there was a lot of partisan support, is beginning to fall off. The English aren't protesting but they say nothing and don't come. The theatre is emptier at every performance.' (Rémi Labrusse, *Matisse: La Condition de l'image*, 1999, p.134.)

1 November–10 December: The Salon d'Automne, suspended during the war, reopens. Matisse shows seven works; Georges Ribemont-Dessaignes writes disparagingly about them in the Dadaist review *391*.

November: Exhibition of drawings and watercolours

by Picasso, Gris and Henri Laurens at Galerie Paul Rosenberg. Exhibition of works by Matisse, Dufy and Luc-Albert Moreau at Galerie Berthe Weill.

1920

January: Marcel Sembat publishes the first monograph devoted to Matisse, illustrated with works from 1897 to 1919 (*Henri Matisse*, Editions de la Nouvelle Revue française, Paris).

27 January: Paul Rosenberg writes postcards to Picasso from Nice: 'Such a success, so many curtain calls [*Le Tricorne*] … Why don't you come here and recuperate after your success. It must have been tiring for you. I have seen Matisse here, he has painted some fine things. He is going to come back. Come before he has painted everything. The year 1919–1920 will turn out to have been the year of the window! Windows by Picasso, a window by Matisse.' (AP)

28 January–12 February: A mixed exhibition at the Galerie Devambez, Paris, includes works by Matisse and Picasso. Vanderpyl writes in *Le Petit Parisien* (22 February) about the exhibition of *Peinture Moderne* at the gallery: 'Apart from Matisse, who is represented mainly by several bronzes and straddles two eras, the new is most visible there in the work of Picasso, who is already famous.'

February–June: Matisse returns to Paris.

2 February: Première of *Le Chant du Rossignol* (music by Stravinsky, choreography by Massine, curtain and sets by Matisse) at the Paris Opéra. Matisse attends the performance.

3 February: Michel Georges-Michel writes in *L'Intransigeant*: 'A few words on … three Fauves. The three great wild beasts of painting have entered the cage of the Opéra. But it is the cages which appear larger as a result. For not one of the Fauves wanted to trim his claws or lower his head. Picasso kept his pipe in his mouth. Derain wore his felt hat and Henri Matisse failed to put on a black suit. You know very well what I mean – the Napoleon III gilding did not impress these republicans of art. Picasso remained jovial, ironic and bold while painting the sets of *Le Tricorne* … And the harmonies created by Henri Matisse, without so much as a smile, are such that the ancient and pompous edifice will appear more fragile than its canvas sets. For here we have three honest people, three free men. Honest towards their art and their times, with freedom of conscience.'

10 and 16 February: *Le Chant du Rossignol*, *Le Tricorne* and Derain's *La Boutique fantasque* are presented in a triple bill by the Ballet Russes at the Paris Opéra.

22 February: Kahnweiler returns to France following his enforced exile during the war years. During the year he publishes *Der Weg zum Kubismus* (Munich).

16 March–3 April: Matisse and Picasso exhibit work at a show devoted to the nude at the Editions Crès gallery.

April: A survey of 'Opinions on Negro Art' is published in *Action* by Florent Fels, with an introduction by Apollinaire. Picasso's responds:

'Negro art? Don't know of any!'

11 April: 'Pinturrichio' (Vauxcelles's pseudonym) writes in *Le Carnet de la Semaine*: 'I have just received the *Album* by M. Georges de Zayas inscribed "The victims of Marius de Zayas are Messrs. Matisse, Picasso, Metzinger, Marcel Duchamp, Erik Satie and various others who are less well known or unknown".'

20 April–8 May: Exhibition of portraits at the Editions Crès gallery. Matisse and Picasso show *Woman with the Feathered Hat* and *Portrait of Gertrude Stein* (no.58) respectively.

20 April: Matisse and Picasso are represented in the *Salon d'Art Moderne*, Maison Watteau, Paris.

28 April–8 May: Group exhibition at the Galerie des Feuillets d'Art includes works by Matisse and Picasso.

May: The *Bulletin de la Vie Artistique* publishes an interview (signed F.F.) with Ivan Morosov about the circumstances surrounding the nationalisation of his and Shchukin's art collections. Among the illustrations in the article are Picasso's *Two Saltimbanques* and *Still Life* by Matisse.

8 May–13 October: At the twelfth Biennale in Venice Matisse shows two canvases, *Carmelina* and *Tea in the Garden*.

15 May: Première of *Pulcinella* at the Paris Opéra (choreography by Massine, music by Stravinsky after Pergolesi, sets and costumes by Picasso). The sets show Cubist tendencies, while the costumes are closer to the tradition of the Commedia dell'Arte. Picasso attends the performance.

June–July: Matisse is in Etretat.

Mid-June–July: Picasso is first in Saint-Raphaël, then Juan-les-Pins.

Late July: Publication of *L'Art vivant* by André Salmon (Editions Crès, Paris) in which the author moderates the criticisms he levelled at Matisse in *La Jeune Peinture française* in 1912.

2 August–11 September: Works by Matisse and Picasso appear in an exhibition at the galleries of the Société Anonyme in New York (and again from 15 December 1920–1 February 1921).

September: Matisse is in Paris. The Galerie Bernheim-Jeune publishes the album of drawings *Cinquante dessins par Henri Matisse*, with a preface by Charles Vildrac, and *Henri Matisse*, an illustrated book containing essays by Elie Faure, Jules Romains, Vildrac and Léon Werth.

Late September: Picasso returns to Paris.

15 October: In an essay on Picasso in *L'Esprit Nouveau* Salmon writes: 'Picasso is not static. He is all movement, more so than the Fauves, threatened on the very day of the first triumph by apathy, which his art has been condemning, attacking and striking at from 1906 onwards. As regards the venture by the three of them, the peripatetic Matisse emerges as the glorious victor in the tradition of painting at its most painterly, the studio tradition, glorious but forsaken to the point of injustice. And here, at last, are Picasso and Derain, face to face.'

15 October–6 November: Matisse has an exhibition of recent work (1919–20) at the Galerie Bernheim-Jeune. Charles Vildrac writes the catalogue preface.

23 October: Sale of Impressionist paintings and drawings at Hôtel Drouot. According to the *Gazette de l'Hôtel Drouot*, the highest price (1,200 francs) is paid for a pastel by Matisse of the *Pont Saint-Michel*. A drawing by Picasso, *Harlequin*, is auctioned for 380 francs.

November: Clive Bell publishes a sustained comparison between the two artists entitled 'Matisse and Picasso' in *Art and Decoration*.

1921

2–21 January: The *Exposition Internationale d'Art Moderne*, Geneva, includes works by Matisse and Picasso.

15 January: *Le Mercure de France* announces: 'A committee has just been formed to erect a monument by Pablo Picasso on the tomb of Guillaume Apollinaire at Père Lachaise Cemetery.'

4 February: A son (Paulo) is born to Picasso and Olga.

21 February: The hundreth exhibition at the Galerie Berthe Weill includes works by Matisse and Picasso.

27 March–25 April: An exhibition of modern French art at the Brooklyn Museum includes works by Cézanne, Matisse and Picasso.

April: The first monograph on Picasso, written by Maurice Raynal and containing 100 illustrations, is published in Munich (Delphin): 'Two general tendencies can be identified, often simultaneously, in the history of painting – the cult of colour, and the cult of line. It may even be observed that these two phenomena are related to ethnographic factors. Colour and line are the North and the South. The North, which lacks colour, likes it more than the South, which has too much. One might include Rubens in one of these categories and El Greco in the other; similarly Rembrandt and Raphael; in more recent times Delacroix and Ingres; and finally Matisse and Picasso.' (Maurice Raynal, *Picasso*, French edition, Paris 1922, p.70.)

3–21 May: An exhibition of sixty *Nus* at the Galerie Bernheim-Jeune includes works by Matisse and Picasso.

3 May–5 September: Matisse and Picasso are represented in the *Loan Exhibition of Impressionist and Post-Impressionist Paintings* at The Metropolitan Museum of Art, New York.

23 May–11 June: A Picasso exhibition (thirty-nine works) is held at the Galerie Paul Rosenberg. Rosenberg publishes a portfolio of Picasso's designs for *Le Tricorne*.

22 May: First performance of *Cuadro Flamenco* at the Théâtre de la Gaîté-Lyrique in Paris, with traditional Spanish folk music adapted by Manuel de Falla, choreography by Massine, sets and costumes by Picasso.

30 May: The collection of Wilhelm Uhde (sixteen works by Picasso), sequestered in 1914, is auctioned at the Hôtel Drouot with Bareiller-Fouché and Léonce Rosenberg as experts. The proceeds of the

sale total 247,000 francs, three times the amount anticipated. On the day of the sale, in a room in the Hôtel Drouot, Braque and Rosenberg clash violently. Gertrude Stein witnesses the fight, as does Matisse. When told of the reasons for the quarrel, Matisse delivers his judgement: 'Braque is right, this man has robbed France, and we know very well what it means to rob France.' (Pierre Assouline, *L'Homme de l'Art: D. H. Kahnweiler – 1884–1979*, Paris 1988, p.224.)

13–14 June: The first of the Galerie Kahnweiler sequestration sales (thirty-six works by Picasso) is held at the Hôtel Drouot with G. Zapp and Rosenberg as experts. The second sale (fifty works by Picasso) is held there on 17–18 November.

July–September: Picasso and Olga are in Fontainebleau with their infant son. Picasso paints great neo-classical (*Three Women at the Spring*, no.104) and decorative Cubist (*Three Musicians*, no.73) compositions.

1–25 July: Exhibition at Léonce Rosenberg's Galerie de L'Effort Moderne of post-war works by pre-war Cubist painters including Picasso.

Early September: Matisse is in Nice. Publication, several days before the closure of the *Loan Exhibition of Impressionist and Post-Impressionist Paintings* in New York, of a pamphlet signed by a committee of citizens and supporters of the museum entitled 'Protest against the Present Exhibition of Degenerate "Modernistic" Works in the Metropolitan Museum of Art'. This pamphlet is intended as a denunciation of 'the Bolshevik philosophy and the cult of "Satanism" evident in this exhibition, in which the human body is deliberately mutilated'. This sparks off a debate on the subject in the press. John Quinn, one of the organisers of the exhibition, responds: 'This is Ku Klux Art Criticism. One does not argue with degenerates who see nothing but degeneracy around them.'

December: Matisse exhibits *Portrait against a Red Background* in the Carnegie International Exhibition at Pittsburgh.

7 December: Elie Faure writes to Matisse: 'We have withdrawn the Iturrino tombola. I am certain that your gesture and that of Picasso will be enough to shame the other exhibitors.' (AM)

12 December–7 January 1922: *Retrospective 1900–1921* at the Galerie Berthe Weill includes works by Matisse and Picasso.

1922

23 February–15 March: Matisse has a one-man exhibition at the Galerie Bernheim-Jeune (thirty-nine works painted in 1921). An album of photographs is published with a text by Charles Vildrac. Matisse is regularly represented in mixed exhibitions at the gallery during the 1920s.

March: The Musée du Luxembourg acquires Matisse's *Odalisque with Red Culottes*.

Mid-June: Matisse is in Aix-les-Bains, returning to Paris in late June.

4 July: Third Kahnweiler sequestration sale (ten works by Picasso) at the Hôtel Drouot.

14–15 July: Picasso draws a portrait of one of the Cone sisters, then leaves for Dinard.

Summer: Claribel and Etta Cone acquire four bronzes and six paintings by Matisse from the Galerie Bernheim-Jeune.

August: Matisse goes to Nice.

1 September: André Breton writes in *Littérature*: 'Whether we like it or not, he [Matisse] is one of those men who shared in this anguish to some degree. Their major concern today is to reveal nothing of this; if one is to believe them, they have always treated art simply as a job. Several days ago I met M. Henri Matisse at the house of a friend of mine, a photographer [Man Ray]. No painter is more concerned about his reputation for having taken liberties with nature. His early works? Mere experiments, with the sole merit, in his eyes, of having made his present works possible. Today there are about a dozen such men – the Valérys, the Derains, the Marinettis – whose chickens may yet come home to roost, who joke when you present them with a list of grievances and leave at once, having curtly granted you an appointment in ten years' time.'

Late September: Picasso returns to Paris.

17 November: In a lecture given in Barcelona, Breton says, 'Let us not forget that the principle of this more or less lyrical distortion that Matisse and Derain inherited, I believe, from the Negroes was a long way from liberating painting from the conventions of representation, which Picasso was not afraid to be the first to break.' (*Les Pas Perdus*, Paris 1924, p.192–3.)

December: Picasso designs the sets for Cocteau's adaptation of *Antigone* at the Théâtre de l'Atelier, Paris.

Publication in 1922 of Roland Schacht's *Henri Matisse* (Dresden, Rudolf Kaemmerer).

1923

Early 1923: In *L'Esprit Nouveau* (no.22) Ozenfant and Jeanneret [Le Corbusier] write: 'The penultimate liberator ... Matisse felt that lyricism was not entirely lost; he was able to take the necessary step that no one had dared to do. He was a great liberator. One glimpsed the moment at which Cubism would become possible, liberating us from the last constraint, that of the subject itself, which in Matisse's work remains only as a trace and which Picasso and Braque will deliberately eliminate. But without Matisse, one must allow that Cubism would not have become what it has.'

January–February: The works by Matisse purchased by Albert C. Barnes are exhibited at the Galerie Paul Guillaume before being shipped to America.

18 March: Picasso and Matisse donate works to the sale organised for the benefit of needy Russian artists.

16–30 April: Matisse has a one-man exhibition at the Galerie Bernheim-Jeune.

6 May: *Paris-Journal* reports: 'M. Ambroise Vollard

therefore wished painters to be appointed who would in turn award a prize for writers. *L'Excelsior* has already published the names of the artists who have agreed to be members of the jury: Messrs. Picasso and Henri Matisse.'

7–8 May: Fourth and final sale of Kahnweiler's sequestered stock. Receipts from the four Kahnweiler sales total 47,819 francs.

19 May: An interview with Picasso by Marius de Zayas is published with illustrations in *The Arts* (New York) as 'Picasso Speaks. A Statement by the Artist'.

19–31 May: A group exhibition of paintings, water-colours, gouache and drawings at Léonce Rosenberg's Galerie de L'Effort Moderne includes works by Picasso.

14–30 June: Matisse and Picasso are included in the exhibition *Etudes et Portraits de Femmes* (Studies and Portraits of Women) at the Galerie Marcel Bernheim.

July–September: Picasso is first in Royan, then at Cap d'Antibes.

Autumn: Matisse is in Nice.

8 October: The following note appears in *Les Arts à Paris*: 'The State of Pennsylvania has given the Barnes Foundation a Charter conferring recognition as an educational institution. Of the contemporary French painters, we must mention Picasso who is represented by 22 canvases and Matisse who is represented by 12 canvases.'

20–31 October: An exhibition of prints by Matisse is held at the Galerie Bernheim-Jeune.

November: Jacques Doucet, on the advice of André Breton, purchases Matisse's *Goldfish and Palette* (no.69). (See fig.94.)

17 November: The exhibition *Picasso – Recent Work*, organised by Paul Rosenberg, opens at the Wildenstein Gallery in New York.

18 December–21 January 1924: Picasso has a one-man exhibition at the Chicago Art Institute, with a catalogue introduction by Clive Bell.

1924

Spring: The recent work of Matisse and Picasso is on show in two one-man exhibitions: March–17 April, *Exposition d'oeuvres nouvelles (peintures et dessins) de Picasso*, Galerie Paul Rosenberg, (twelve oils and thirty-six drawings); 6–20 May: *Exposition Henri-Matisse*, Galerie Bernheim-Jeune, (thirty-nine oils, plus drawings).

May–June: Picasso's success as a designer is underlined. During the season of the Ballets Russes de Monte Carlo at the Théâtre des Champs-Elysées, Paris, there are acclaimed revivals of *Parade* and *Pulcinella*; the curtain (executed by Prince Schervachidze) is based on Picasso's gouache *The Race*, 1922, and is used as 'un prélude figuré' to all performances (see Louis Laloy, 'La Saison des Ballets russes', *Le Figaro*, 16 May 1924). On 15 June *Mercure*, with curtain, sets and costumes by Picasso, music by Erik Satie and choreography by Massine, is premièred at the Théâtre de la Cigale, as part of Comte Etienne de Beaumont's 'Soirées de Paris'. Despite the Surrealists' theoretical

disapproval of the ballet, they laud Picasso's designs publicly in a 'Hommage' in *Le Journal littéraire*, 21 June 1924. By contrast, Matisse refuses Massine's invitation to collaborate on the 'Soirées de Paris' programme, alleging that it would distract him from his painting. Similarly, in 1928 he refuses Diaghilev's invitation to design sets and costumes for a new production of *Schéhérazade*. (AM)

21 June: Works of art donated to finance a monument, to be designed by Picasso, for Guillaume Apollinaire's grave in Père Lachaise cemetery are auctioned at Hôtel Drouot, Paris. A landscape donated by Matisse sells for 3,000 francs and a nude by Picasso for 4,600 francs (the highest price realised). Picasso works intensively on the commission in 1927–32, with Julio González acting as his assistant on the welded metal sculptures. Unable to satisfy the Comité Apollinaire, he finally abandons the project in November 1934.

28 July: Death of the American collector John Quinn. His will provides for the liquidation of his entire collection. On 18 October 1924 Jeanne Robert Foster, Quinn's companion, writes to Thomas Curtin, one of his executors, warning against flooding the market by hasty sales: 'Who will at the present time buy twenty Picassos … in *this* country? Who will buy fifteen Matisses?' (Judith Zilcer, '*The Noble Buyer': John Quinn, Patron of the Avant-Garde*, Hirshhorn Museum and Sculpture Garden, Washington, 1978, pp.58–61). In January 1926 Paul Rosenberg purchases some fifty paintings by Picasso directly from the Quinn estate. On 28 October 1926, *Blue Nude: Memory of Biskra* (no.14) is one of two paintings by Matisse to be auctioned at the Quinn sale, Hôtel Drouot, Paris (lot 61). It is bought by Dr Claribel Cone for 101,000 francs, the third highest price paid.

15 October: Publication of André Breton's *Manifeste du surréalisme* (Editions Sagittaire chez Kra). In a footnote Breton lists painters who 'are not full-time Surrealists', but are 'Surrealist in this or that aspect', including Matisse in '*La Musique* for instance', and Picasso 'by far the purest'. (*Les Manifestes du Surréalisme, suivi de Prolégomènes à un troisième manifeste du Surréalisme ou non*, Paris 1946, pp.47–8.)

December: Picasso's association with the Surrealists is reflected in the first issue of *La Révolution surréaliste* (1 December). He appears in Man Ray's montage of photo-portraits of the group members (p.17), and *Guitar* (no.78) is reproduced within a poetic text by Pierre Reverdy (p.19). On 2 December Breton writes to congratulate Jacques Doucet on the purchase (brokered by Breton) of *Les Demoiselles d'Avignon* (no.7) from Picasso: 'It is never realised sufficiently that Picasso is the only authentic genius of our times, an artist such as never existed before, unless perhaps in Antiquity.' (Bibliothèque Littéraire Jacques Doucet, B-IV-6, 7210-59.) (See fig.93.)

1–20 December: Matisse and Picasso are represented by four works each in *Quelques peintres du XXème siècle*, Galerie Paul Rosenberg. This is probably the first exhibition mounted by Rosenberg to include paintings by Matisse (who is under contract to the Galerie Bernheim-Jeune). Rosenberg mounts similar mixed exhibitions, including paintings by both Matisse and Picasso, in June–July 1927, April–May 1929 and January–February 1931.

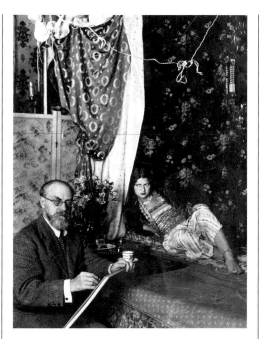

fig.92 Matisse drawing a model at no.1, place Charles Félix, Nice, c.1927–8

1925

June: During the Ballets Russes season at the Théâtre de la Gaité Lyrique, Paris, *Pulcinella* is performed with Massine's original choreography, and *Le Chant du Rossignol* is presented with Matisse's original sets and costumes, but with new choreography by Georges Balanchine.

10 July: Matisse is elected Chevalier de la Légion d'honneur.

15 July: Picasso is hailed as 'a powerful searchlight' and claimed as 'one of us' in the first instalment of André Breton's 'Le Surréalisme et la peinture', *La Révolution surréaliste*, no.4 (pp.26–30). Five of his paintings are reproduced, including *Les Demoiselles d'Avignon* (no.7) and *The Three Dancers* (no.82). In the second instalment of Breton's essay, published 1 March 1926, a further tribute to the 'genius' of Picasso precedes a denunciation of the recent work of Matisse and Derain: 'Two of these disheartened and disheartening old lions are named Matisse and Derain. Leaving behind them the forest and the desert, which they do not even remember with nostalgia, they have entered the tiny arena of gratitude towards those who have broken them in and throw them their food. What surer testimony than a Derain *Nude* or yet another Matisse *Window* to the truth of Lautréamont's dictum that "not all the water in the ocean would suffice to wash out one drop of intellectual blood"?' (André Breton, *Surrealism and Painting*, trans. Simon Watson Taylor, London 1972, pp.5, 7, 9.)

19 July: Francis Poulenc writes to Picasso, then in Juan-les-Pins: 'The new version of the *Nightingale* has barely made it. Situation between Igor [Stravinsky] and Serge [Diaghilev] quite tense, though of course they don't show it in public.' (Francis Poulenc, *Correspondance 1910–63*, ed. Myriam Chimènes, Paris 1994, p.259.)

25 July: On Matisse's instigation, Christian Zervos writes – to no avail – to Picasso to invite him to contribute a text to the 'Hommages à Maillol' to be published in the forthcoming issue of *L'Art d'Aujourd'hui* (AP). In his own brief 'homage', Matisse describes Aristide Maillol as 'our greatest sculptor' (p.46).

13 November: Picasso is represented in the first exhibition of Surrealist painting at the Galerie Pierre, Paris.

13–28 November: An exhibition of Matisse's drawings is held at the Galerie des Quatre Chemins to coincide with the publication of Waldemar George, *Henri-Matisse: dessins* (Editions des Quatre-Chemins, Paris). The companion volume *Picasso: dessins*, also by Waldemar George, is published on 1 June 1926. Each book is illustrated with sixty-four plates.

1926

January: Foundation of *Cahiers d'Art*, edited by Christian Zervos. Although known particularly for his promotion of Picasso's work, Zervos actively supports Matisse throughout the lifetime of the periodical. The fifth issue (May 1926) contains Zervos's 'Oeuvres récentes de Picasso', and the seventh (September 1926) Georges Duthuit's 'Oeuvres récentes de Henri-Matisse'.

May–June: Matisse exhibits *Decorative Figure on an Ornamental Background* (no.113) at the Salon des Tuileries (no.2178). The painting arouses controversy and is widely recognised as, for better or worse, a watershed in Matisse's career.

May: Publication of Adolphe Basler, *La Peinture … Religion nouvelle* (Bibliothèque des Marges, Paris). The author reports a recent conversation in Galerie Bernheim-Jeune in which Picasso is scathing about the paintings on display by Courbet, Renoir, Cézanne, Utrillo, Modigliani, Bonnard and Braque: 'Only Matisse is lucky enough to win Picasso's approval. "Here's someone at least with some talent; the rest are nothing beside him".' (pp.11–12.)

13 June: Matisse writes to his daughter, Marguerite Duthuit, from Nice: 'I saw [Walther] Halvorsen … During our conversation, he told me that it seems you and Picasso fell into each others' arms. I replied that I had not seen Picasso for years, nor had I written to him, and I regret now having got into the habit of not going out, with results which aren't immediately foreseeable.' (AM)

15 June–10 July: *Exposition d'oeuvres récentes de Picasso*, Galerie Paul Rosenberg, Paris (fifty-eight works dating from 1918, including *The Three Dancers* [no.82], loaned by Picasso). In 'Lendemain d'une exposition' Zervos summarises the hostile reaction to the eclecticism of Picasso's work, adding: 'Having run out of arguments against Picasso's work, the Judges and his so-called friends are reproaching him for his Spanish passport, accusing him of losing sight of the French notion of moderation which he had managed to grasp with such difficulty. They resent him for having revealed a strength which is beyond the rest of us, for his astonishing passion, and for his joy in constantly dashing to the edge of the abyss, where he pulls up short and takes himself in hand again. Society doesn't like people who frighten it without getting hurt.' (*Cahiers d'Art*, no.6, July 1926, pp.119–21.)

8 October–early November: Paul Guillaume provokes comment by exhibiting Matisse's *The Piano Lesson*, 1916 (no.71), and *Bathers by a River*, 1916 (fig.12), neither of which has hitherto been seen in public and which he has recently purchased from the artist. In a review Sylvain Bonmariage recalls that in *c.*1909 Matisse, standing before a painting by Picasso, described Cubism as 'an enormous step towards pure technique', and added: 'We'll all get there eventually.' Bonmariage comments: 'The battle honours went to Picasso. Yet it is undeniable ... that Matisse, already an artist of stature in 1909, deserves credit for being the first to understand Picasso's intentions.' ('Henri Matisse et la peinture pure', *Cahiers d'Art*, I, no.9, November 1926, pp.239–40.) Georges Duthuit notes the following reference to Picasso made by Matisse during the late 1920s: 'Once over the first surprise, the spectator flees. He can feel no delight if he tries to analyse his emotions. Moreover, surprise doesn't last: Picasso's faceless models quickly become familiar to us, simply more intelligent and more direct than figures made of wax.' (*Ecrits sur Matisse*, Paris 1992, pp.291, 295.)

1927

January: Traditional date of Picasso's first meeting with Marie-Thérèse Walter. Her pregnancy leads to his separation from Olga in June 1935. Their daughter Maya is born 5 September 1935.

3–31 January 1927: *Retrospective Exhibition of Henri Matisse, the first painting 1890, the latest painting 1926*, organised by Pierre Matisse at Valentine Dudensing Gallery, New York. Forbes Watson uses the occasion to pit Picasso against Matisse:

'Unless the artist gives this particular special public [who appreciate modern art] something new, in the sense of something not already understood, some unexpected idea to struggle over, it is quite capable of becoming cool towards the artist. This danger point in the appreciation of the contemporary artist's highly specialised public furnishes him with the supreme test of his character as a painter. Picasso has not been able to face it calmly; he has watched for the signal which would indicate that his public was saying: "Oh, we know all that!". Imagining that he hears the signal, he jumps this way and that, changing his art again and again until it has lost logical sequence. Matisse, threatened with the same signal, has calmly gone ahead in his own logical manner, intensifying his pattern, painting with purer and purer color, when color was going out of fashion, holding to the thing that he himself wanted to do and doing it steadily better.' ('Henri Matisse', *The Arts*, January 1927.)

13 October–4 December: *Twenty-Sixth International Exhibition of Painting*, Carnegie Institute, Pittsburgh. Matisse, represented by five recent pictures all lent by Bernheim-Jeune, is awarded the 1,500-dollar first prize for *Fruit and Flowers*, 1924. The award is widely reported in the press and enhances his growing fame in the United States.

1928

September: In 'Sculptures des peintres d'aujourd'hui' (*Cahiers d'Art*, III, no.7, pp.277–89) Christian Zervos pays particular attention to Matisse's sculpture. He also illustrates several sculptures by

fig.93 Interior of Jacques Doucet's Neuilly apartment with Picasso's *Les Demoiselles d'Avignon* (no.7), *c.*1928–9. Daniel Wolf Inc., New York

Picasso, including *Metamorphosis*, a grotesque female bather modelled in plaster, which is probably the artist's first maquette for the monument to Apollinaire.

15 October: Publication of Wilhelm Uhde's *Picasso et la Tradition française: Notes sur la Peinture actuelle* (Editions des Quatre-Chemins, Paris), in which Matisse and Picasso are associated with, respectively, 'purely intellectual passion', and 'life' and 'love'. Uhde comments: 'For Picasso, love had a different scope to Henri Matisse's intelligence. It is, in fact, an inexhaustible wellspring, whereas the permutations of intelligence are limited' (pp.21–4).

4 November–16 December: Matisse exhibits the Cézannesque *Still Life on a Green Sideboard* at the Salon d'Automne. Early in 1929 he sells it for one franc to the Association des Amis des Artistes vivants to ensure that it be given to the Musée du Luxembourg.

1929

April: Publication of Carl Einstein's 'Pablo Picasso: quelques tableaux de 1928' in the first issue of *Documents: Doctrines, Archéologie, Beaux-Arts, Ethnographie*, the review of the dissident Surrealists edited by Georges Bataille (pp.35–47). Picasso is often featured in the magazine, Matisse never. The March 1930 issue is composed of

fig.94 Interior of Jacques Doucet's apartment in Neuilly, with Matisse's *Goldfish and Palette* (no.69), *c.*1928–9. Daniel Wolf Inc., New York

'Hommages à Picasso', but none of the contributors draws the comparisons with Matisse which are the norm in contemporary journalistic criticism.

25 May–7 June: *Exposition de la Collection Paul Guillaume*, Galerie Bernheim-Jeune, Paris. Adolphe Basler detects a battle for supremacy between the artists represented:

'It was a bad day for this Iberian genius [Picasso], the private view of the exhibition. The unanimous opinion of the visitors condemned out of hand the metamorphoses of such a prolific form of aestheticism. The pictures of the Spanish prodigy shrank back into the walls. Picasso's disaster was worsened by the siting of Derain's work opposite and by the Matisses scattered in the vicinity. In reality, the contest was between the latter two artists. Picasso had been knocked out. "Victory for the French!", cried artists and critics to their hearts' content. It was the Derain section which was most impressive for its consistency, its artistic sense, its size and scale, its force and sensuality, but also for that offhand and casual air which imparts savour to the traditionalism of the painter's craft. In vain did this juggernaut roll over Matisse, who fought back with the freshness of his sensations, with the subtle mobility of his art. The style is perhaps more pedestrian, the substance thinner; yet the effect is full of voluptuousness and sensory charm. In short, as regards Matisse and Derain, it was a draw.' ('M. Paul Guillaume et sa collection de tableaux', *L'Amour de l'Art*, July 1929, pp.255–6.)

1 June: In his diary the dealer René Gimpel summarises a conversation with Jacques Mauny, artist and French agent of the American collector A.E. Gallatin: 'He has been to Doucet's and seen his new modern setting, done entirely by Legrain the bookbinder ... He is equally impressed by the Doucet Collection. No one knew how to select the way he did ... The Louvre has turned down his Picasso, which must be the most beautiful in the world [i.e. no.7]. At the Louvre, at the Luxembourg, no one in the official world wants to understand Picasso. He is a marked man. A new group, a society, has been formed to get the moderns into the Louvre and not repeat the errors of yesteryear, but the first purchases have been deplorable, except for the Matisse, which the artist donated himself [i.e. *Still Life on a Green Sideboard*]. Mauny swears only by Picasso, one of the greatest masters, he says, that the world has seen. The Spaniard may do three pictures in a day. Mauny must be exaggerating. At all events, his work is prodigious, and goes on by night with electric reflectors. Mauny spent two hours in Nice with Matisse, whom he ranks very high. Matisse, whose canvases appear to be only rapid sketches, works on them for days without any let-up. Just now he is absorbed in sculpture. Mauny had seen him mould clay and swears that he is the greatest modern sculptor. He gets up very early and models until eleven; then practices sports, then lunches; and in the afternoon he paints. He surrounds himself with antique and modern fabrics, will put a Coptic fragment beside one of his canvases and derive inspiration from its colour harmonies. His love of colour is consuming. He draws and paints from a model. His eternal odalisque of these recent years is a Basque woman.' (*Diary of an Art Dealer*, trans. John Rosenberg, London 1992, pp.363–4.) (See figs. 93, 94.)

7–25 November: *Exposition des peintures et dessins de Matisse*, Galerie du Portique, Paris. This coincides with the publication of Florent Fels's *Henri-Matisse* (Editions des 'Chroniques du Jour', Paris). In 1930 the illustrations in Fels's book accompany Roger Fry's text (*Henri-Matisse*, A. Zwemmer, London, and 'Chroniques du Jour', Paris). The companion volume on Picasso by Eugenio d'Ors is published in December 1930.

1930

19 January–16 February: *Painting in Paris from American Collections*, The Museum of Modern Art, New York, includes eleven paintings by Matisse and fourteen by Picasso. Inaugurated on 7 November 1929 under the directorship of Alfred H. Barr, The Museum of Modern Art actively promotes the work of both artists by means of major exhibitions and its acquisition policy.

27 February: Matisse sails for New York, en route for Papeete. On 15 June he leaves Tahiti, and via Martinique, Panama and Guadeloupe reaches Marseille on 31 July. His voyage is widely reported in the French press. Asked by Albert Junyent whether he enjoys travelling, Picasso replies: 'It seems to me it must be very galling to travel to the other side of the world, as Matisse did in Gauguin's footsteps, only to discover that, after all, the light over there and the essential elements of the landscape that attract the painter's eye are little different to those he could find on the banks of the Marne or the plain of the Ampurdán. ('Una vista a Picasso, senyor feudal', *Mirador* (Barcelona), 16 August 1934; quoted in *Picasso: propos sur l'art*, ed. Marie-Laure Bernadac and Androula Michael, Paris, 1998, p.31.) Picasso's reply suggests familiarity with Matisse's account of his voyage to Tahiti in 'Entretien avec Tériade', *L'Intransigeant*, 20 and 27 October 1930.

March: Publication of Louis Aragon's *La Peinture au défi*, to coincide with an exhibition of collages at the Galerie Goemans, Paris. Picasso is represented by six works, and hailed in Aragon's essay as the instigator of the revolt against traditional artistic techniques. Evoking Picasso's reliefs of 1926 made with discarded scraps of fabric, Aragon writes: 'Then I heard him grumbling because everyone who came to see him ... thought they were being helpful by bringing him pieces of splendid material *for his work*. He didn't want it; he wanted the real detritus of human life, something poor, something considered useless' (p.26). The reference to 'pictures' composed with 'magnificent materials' is probably a covert allusion to Matisse's work.

5 March: In an account of a recent visit to André Derain's studio, Paul Morand reports the latter's opinion on his two main rivals: 'Picasso? He is a demon of pride. He is a haughty Spaniard. He never tries to do a thing well; he tries to do it better than others. Matisse? He paints well; yet he does not paint the intimate structure of things, but their exterior. In this, however, he is a master; he has multiplied our visual approaches immeasurably.' ('The Truth about Modern Painters', *Vogue*, London, 5 March 1930, p.59.)

April: Matisse signs a contract with Albert Skira for a new illustrated edition of La Fontaine's *Amours de Psyché*. Mallarmé's *Poésies* is substituted later.

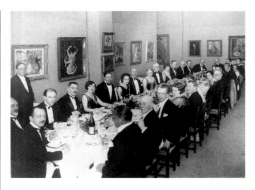

fig.95 The banquet held at the Matisse retrospective of 1931 at Galeries Georges Petit, Paris. Archives Matisse

Skira has already secured Picasso's promise to illustrate Ovid's *Metamorphoses*. *Les Métamorphoses d'Ovide*, with thirty etchings by Picasso, is published on 25 October 1931, and *Poésies de Stéphane Mallarmé*, with twenty-nine etchings by Matisse, exactly one year later.

12 June–late July: *Sculptures de Matisse*, Galerie Pierre, Paris. Hoping to secure an exclusive contract for Matisse's sculpture, Pierre Loeb organises the exhibition with the artist's daughter, Marguerite Duthuit. Picasso almost certainly visits the exhibition. Zervos comments on their similar attitude to sculpting: 'Matisse and Picasso attach considerable importance to sculpture. With them, it is no mere pastime. It is even more than a sort of effective way of disciplining the mind, encouraging or checking spontaneous impulses. It allows artists to achieve what the limitations of painting prevent. Every now and again, Matisse devotes the best part of his time to sculpture. And lately I saw Picasso in a state of extraordinary excitement because he had just begun to realise his new sculptural vision. "Since the *Demoiselles d'Avignon*" [no.7], he confided, "I have never been so thrilled as I am with my new sculptures".' ('Sculptures de Matisse (Galerie Pierre)', *Cahiers d'Art*, 1930, no.5, p.275.)

14 September–mid October: Matisse is in the United States. He accepts a commission from Albert Barnes for murals for his Foundation in Merion, Pennsylvania (fig.11). In Pittsburgh he serves on the jury of the Carnegie Institute Prize. The 1,500-dollar first prize is awarded to Picasso for *Portrait of Madame Picasso*, 1923. In an interview with Tériade serialised in *L'Intransigeant* in late October 1930, Matisse remarks that since the jury is composed 'by artists of such irredeemably different tendencies', the result 'has no significance'. (*Ecrits et propos sur l'art*, ed. D. Fourcade, p.112.) Despite the sober, classical character of the prize-winning portrait, most American critics are astounded at Picasso's triumph. Henry McBride argues that Matisse's success in 1927 was a necessary intermediate step: 'The winning of that prize, after the furore had subsided, made it possible to invite Matisse to come to this country as a juror. That was done – and he came this year. With Matisse on the jury how natural and simple it becomes to give the prize this year to Picasso! Do you see, now, how it works? There is no sense of shock, whatever, it is a natural sequence, and leads on to – what? Well, I make no pretentions to the gift of prophecy but it would not surprise me much to see the great Pablo himself coming to Pittsburgh as a juror in a year or two, and once Picasso strides into that jury-room what might not

happen in the way of prize awards?' ('The palette knife', *Creative Art*, November 1930, p.78.)

2 November: In a review of the Salon d'Automne in *Le Carnet de la Semaine* Louis Vauxcelles summarises the generally devastating effect on the art market of the Wall Street Crash of 29 October 1929: 'There is a crisis, and a really worrying one. Luxury industries are paralysed; painters are out of work and suffering. The picture galleries can sell a Manet or a Renoir all right, but not the work of young artists ... The things told me in confidence about this are heartbreaking ... Only people like Matisse, Derain or Picasso are still making a lot of money, as their works are an excuse for speculation.'

December 1930–3 January 1931: Matisse makes a third trip to the United States, visiting Merion to make preparatory studies for the Barnes Foundation mural, *Dance*. His departure and the prestigious commission are widely reported in French newspapers. On his return to France he devotes himself to the project, to the exclusion of painting, developing the composition by means of paper cut-outs. The second completed version of the mural is installed in Merion, under his supervision, in May 1933 (fig.11).

1931

April: Publication of 'Pour ou Contre Henri-Matisse: Enquête, Opinions, Documents', edited by Raymond Cogniat (*Chroniques du Jour*, no.9), in anticipation of Matisse's forthcoming retrospective at Galeries Georges Petit. A similar *cahier* devoted to Derain has already appeared. A *cahier* devoted to Picasso is planned, but never published.

June: Elie Faure uses Matisse and Picasso as prime cases in a pessimistic summary of the moral crisis supposedly afflicting contemporary culture:

'Only Picasso on the one hand and Matisse on the other represented the two extremes of conflicting aesthetic theories, one seeking in sensations of

En haut : Une des toiles du peintre Henri Matisse (collection de Miss Etta Cone) exposée à Paris, et M. Henri Matisse. — En bas : Une des dernières œuvres de M. Pablo Picasso : Les trois musiciens ; à droite : La célèbre danseuse Argentina.

fig.96 Montage from *Le Mois*, 1 July 1931. Henri Matisse top right beside one of his paintings, Picasso's *Three Musicians* (no.73) bottom left, and the dancer Argentina at bottom right. Archives Matisse

colour a sort of concrete alchemy capable of extracting from form the totality of chromatic richness it contains, the other demanding that his linear arabesques lead him to abstract constructions – which he called poetry, and which, indeed, are poetry – whose prime consideration was no longer to be indebted for anything to 'Nature' but to derive all things from the mind, henceforth the sole master of invention, of construction, of giving birth to ideas. On the one hand a Westerner arrived at the very end of Europe's centuries-old search. On the other, an Oriental desensualised by the genius of Semitic culture and standing on the farther shores of an Asiatic dreamscape ... It is pointless to ponder here what will remain of these masters, including their errors and their most extreme experiments, or to try and estimate the disasters they have brought upon painting itself, or the pathways they have opened up in the mind no longer concerned with goals. They both seem to have reached the end of the road they embarked upon, and which perhaps leads nowhere after all, as happens every time the hand becomes the servant of too much theory.' ('L'Agonie de la peinture', *L'Amour de l'Art*, 1 June 1931, pp.235–6.)

16 June–25 July: *Henri-Matisse*, Galeries Georges Petit, Paris, exhibition organised by Josse and Gaston Bernheim-Jeune and Etienne Bignou 'in aid of orphans of the arts'. Matisse shows 141 paintings, one sculpture, a selection of prints and about 100 drawings, the majority of the works dating from his move to Nice. Christian Zervos devotes a special number of *Cahiers d'Art* to Matisse (nos.3–5). The glittering preview is the subject of much press comment and several journalists, including Helen Appleton Read, note Picasso's presence: 'Matisse refused to be lionised and slipped away early in the evening, preferring that his pictures speak for him. But Picasso, who, with Matisse, shares the distinction of being leader of twentieth-century painting, was much in evidence.' ('Matisse, accepted at last', *Brooklyn Eagle Magazine*, 26–31 July, 1931.) (See fig.95.) It is likely that direct contact between Matisse and Picasso resumes at this period. A reduced version of the exhibition is held in the Basel Kunsthalle (9 August–15 September).

23 June–11 July: *Exposition d'oeuvres de Picasso: peintures, gouaches, pastels, dessins, d'époques diverses*, Galerie Percier, Paris. The timing of this exhibition, and of a mixed exhibition at the Galerie Paul Rosenberg (1–21 July) in which an entire room is dedicated to Picasso, prompts further bouts of comparison with Matisse (see fig.96). Waldemar George, formerly a keen supporter, now associates Picasso with 'a modern form of neurosis, a yearning for the mysterious, a peculiar love of escapism typical of godless eras,' adding: 'These are not the dominant features of the age or the constants of European art, through which the white race has assured its survival and identity throughout history.' ('Les cinquante ans de Picasso et la mort de la nature-morte', *Formes*, no.14, avril 1931, p.56.) By contrast, he hails Matisse as the 'jewel in the crown of French painting', and continues: 'Matisse has accomplished his work of redemption on the frontiers of contemporary art. A picture by Matisse is never a problem posed and resolved. It is not a whim translated into plastic figures.' ('Dualité de Matisse', *Formes*, no.16, June 1931, p.94.) The notion that the artists' rivalry does not preclude

fig.97 The Picasso exhibition at Galeries Georges Petit, Paris, 1932 with annotations by Margaret Scolari Barr and Alfred H. Barr. The Museum of Modern Art Archives, New York

mutual influence becomes more common from this time onwards. Thus Pierre de Colombier suggests that 'in these last few years' Matisse 'has – like Picasso, whom he is always watching out of the corner of his eye – multiplied the number of his pen-and-ink drawings, purely linear in nature.' But whereas Picasso's line drawings appear 'cold' in their 'concerted exaltation of form', Matisse 'effortlessly gives free rein to his taste for the voluptuous and his passion for filling the paper with elegant lines'. ('Henri Matisse', *Candide*, 9 July 1931.) The society portraitist Jacques Emile Blanche pokes fun at the 'pensive passion' of each artist's 'fanatical devotees', and remarks: 'That the fresh sketches of the magician-colourist should touch a public with very little technical knowledge is only justice ... At his best, Matisse is all charm, joy and lightness. One could think of few more delightful canvases than his Nice interiors with figures, or even better, without ... But Picasso's abstract work is at the opposite extreme to Matisse's sensual, aphrodisiac painting. How many people will come to a relevant conclusion about the sense of metaphysical disquiet discernible in his latest productions? This versatile Catalan virtuoso is one of those who travel to the very edge of what lies beyond their capabilities.' ('La peinture et la canicule', *Le Figaro*, 17 July 1931.)

25 October: The opening of the Pierre Matisse Gallery in New York is announced in *The Art News*. The gallery becomes one of the principal outlets for Matisse's work in the United States. The first exhibition (15 November–5 December) includes paintings by Braque, Derain, Dufy, Lurçat, Rouault and Rousseau, as well as Matisse and Picasso. During the 1930s Pierre Matisse organises similar mixed exhibitions, including works by both his father and Picasso, in March 1933, January 1937, January 1938 and January 1939.

3 November–6 December: *Henri-Matisse: Retrospective Exhibition*, The Museum of Modern Art, New York. Organised by Alfred H. Barr, it displays seventy-eight paintings, eleven sculptures, and numerous drawings and prints, the emphasis being on Matisse's work before 1918. Henry McBride applauds this reorientation: 'In Paris there was a slight chill in the enthusiasm of those who had previously been very enthusiastic. It seemed to them

that the Matisse reputation had been hurt. Now, suddenly, there is another exhibition, and behold, Matisse is again the important painter that he really is.' ('The Museum of Modern Art gives a Matisse exhibition with special success', *New York City Sun*, 7 November 1931.)

Barr's plan to stage an equally important Picasso retrospective at The Museum of Modern Art during the autumn of 1931 is thwarted when Picasso withdraws his agreement to cooperate in June (see Michael FitzGerald, *Making Modernism*, New York 1995, pp.204–13). Barr's Picasso retrospective eventually takes place in 1939–40.

1932

June: Tériade quotes Picasso on Matisse: 'In the end, everything depends on one's self. It's a sun in the belly with a thousand rays. The rest is nothing. It's the only reason why, for example, Matisse is Matisse. For he's got the sun in his belly. That is also why, from time to time, we create something. The work one does is a way of keeping one's diary.' ('En causant avec Picasso', *L'Intransigeant*, 15 June 1932.)

16 June–30 July: *Exposition Picasso*, Galeries Georges Petit, Paris. On display are 225 paintings (including a series of large nudes completed shortly before the opening), seven sculptures and six illustrated books (fig.97). Pierre Matisse is among those thanked for their cooperation. An enlarged version travels to the Kunsthaus, Zurich (11 September–30 October). Matisse is certain to have seen the retrospective in Paris, and in a letter dated 10 August 1933 to Pierre Matisse remarks: 'I do not have to respond to Picasso's exhibition since it has been made in response to mine.' (Bois 1998, p.248.) The French critics – many are hostile – tend to focus on the stylistic variety of Picasso's oeuvre, his debt to other artists and the monstrousness of his recent representations of the figure. Louis Mouilleseaux writes: 'There are at least three styles inside this strange master. The first, the Blue, as it is called, is in the mainstream. Divine art equalling the very greatest. The second, Cubism, follows a side-channel; a genial affair, an unrepeatable experiment in rhythm and in meticulously unravelling the secrets and synthesis of form, quite simple and natural, though people think, wrongly, it is something spiritualistic and transcendental. But Picasso has a third style. The master, in fact, would have given us a different opinion of himself, the man, by choosing at least to pop behind a bush before relieving himself of this style. It is sort of very bad sub-Matisse, very bad, false Diego-Rivera, monumental vulgarity. A whole room, the biggest too, at Petit's, is packed with these ... errors.' ('Expositions: Manet–Picasso', *Le Cahier*, June–July 1932, pp.44, 46.)

In a largely favourable review, André Lhote argues that Picasso's work, unlike Matisse's, aptly reflects the 'disquiet' of the age: 'Picasso's big still lifes [of the mid-1920s] (ten or so are truly first-

class) are … with Matisse's major works – I'm thinking of the magnificent *The Moroccans* (no.72) – the last word in modern art, whose effects, according to Matisse, should be like those of a comfortable armchair. This concept, it is true, dates from the first thirty years of a century which has proved so fertile in extraordinary events. I would be highly astonished if the worries of today – tomorrow's revolutions – did not soon incite the public to clamour for works of art which administer more than just a "little shock".' (André Lhote, 'Chronique des arts', *Nouvelle Revue française*, 1 August 1932, p.288.)

As he had done for Matisse in 1931, Christian Zervos devotes a special number of *Cahiers d'Art* to Picasso (VII, nos.3–5). In June 1932 Zervos also publishes the first volume of his complete catalogue of Picasso's work, *Pablo Picasso: Oeuvres de 1895 à 1906* (Editions des 'Cahiers d'Art', Paris).

7 August: Matisse writes to Pierre Matisse describing a recent meeting with Albert Barnes: '[Barnes] also told me that he had finished his book [see under 1933] on my work, and was very pleased with it and would give it to his publisher the moment he reached New York. He went on to say that, both in his book and in a lecture, he had said that Picasso had no sense of colour at all. [Georges] Keller [the dealer] had brought for Barnes an invitation from Picasso to come to lunch at his house in the country. Barnes had refused. Picasso apparently was bitterly hurt that Barnes did not like his work. Bignou wanted Barnes to buy a big early (Blue Period) Picasso of a man and a pregnant woman – *La Vie*, it is called. Barnes told me he had got about ten Picassos already and that was quite enough.' (Russell 1999, p.67.)

In an undated letter of 1932 Matisse writes to Barnes: 'The little collection of photos taken during the painting of the mural [fig.11], and which I gave you, will be of great interest from an instructional point of view, showing as it does how a work of the imagination was created. I have just read an article by Picasso in which he says he is busy preparing a copper-plate engraving, and is printing off copies as things proceed, so that once it is finished, he will have a whole series charting the birth of his work. That's what I have been doing for two years with my frescoes. I hope Picasso hasn't heard what I'm up to, and that it is by a happy coincidence that we have both had the same idea.' (AM)

September: During Picasso's exhibition at the Zurich Kunsthaus Gotthard Jedlicka gives a lecture in which he attempts to define the artistic relationship of Matisse and Picasso: 'The exhibition has demonstrated that the painting of Picasso constitutes the most dangerous attack on French painting: one cannot emphasise this enough. It is in every respect the invasion of a barbaric force into a secure world, with all the power and danger that entails. Already today it has initiated a revolution, with serious consequences, that has spread over the entire world. Matisse's painting is the dam that French painting has built, or tried to build, against this invasion. The two artistic forces embodied in these two artists are locked in a passionate battle. I am under the impression that Matisse and Picasso are well aware of this, and that their differences in personality, which are manifold, combine with their differences as artists … But these two artists are not only leaders – they are also seducers. In one, the Frenchman, it is the clarity that is seductive. In

the other, the Spaniard, it is the mystery … The work of Matisse seems to be a victory of pure reason; the work of Picasso the game of a demon. Matisse is a classic – to date, the last classic of French painting. And like many classics before him he is also a constructor. But Picasso is a romantic, the most restless and fascinating romantic that painting has ever produced. One is primarily a painter, the other an artist of ideas … Matisse always strives for objectivity, as the classical French masters did. He works from the object and creates the subject in a visually ordered form. Even in the blue, almost abstract still lifes [e.g. no.47], which seem so far removed from reality, he represents a factual experience in an almost dogmatic fashion … Picasso, however, has always worked from a mood. He is the perfect example of the ego-centric artist. He seeks, in all his undertakings, the realisation of a sensation independent from the object that triggered it. He does not search for the quality of the object, but for the quality of the sensation. He searches with ever increasing determination. Even figures that are seemingly based on real models are born out of a mood and removed from reality. In the end, the whole world for him is nothing but the sum of different stimuli.' (Gotthard Jedlicka, *Picasso*, Zurich 1934, pp.46–55.)

In an exchange of letters, Francis Picabia and Léonce Rosenberg comment on the effect of the Depression on market values. On 24 September Picabia writes to Rosenberg: 'I feel sure that with Matisse and Picasso things are never going to look up; it's more difficult than to paint; it's not like a game of BACCARAT.' (*Francis Picabia: Lettres à Léonce Rosenberg 1929–40*, ed. Christian Derouet, Les Cahiers du MNAM, Paris, 2000, p.92.) On 27 September Rosenberg writes to Picabia: 'Bignou confided to me the other day that, three years ago, he had sold an American a big Matisse for 600,000 francs! And that in a forthcoming sale, we would see that artist's canvases having trouble reaching twenty-five per cent of their old values. What a nice surprise for people when they find their paintings are only worth twenty-five per cent of what they paid for them! I don't think Picassos are going down to the same extent, as he's extremely popular, except for those over 100,000 francs; all the same, I think they'll lose a lot, say 50%. A Picasso worth 50,000 francs before will, with time, make around 20,000.' (ibid.)

1933

May: Jean Cassou, who will later publish monographs on both artists, sustains the prevalent view of Matisse as the moderate, rational Frenchman, Picasso as the excessive Spaniard:

'Those two great lyric poets of painting, Matisse and Picasso, have looked each other in the eye. But Matisse leaves within reach, without touching them, the dread potions and charms of the speculative. "*We are seeking the same goal*", he is supposed to

fig.98 Picasso, maquette for the cover of *Minotaure*, May 1933. Mixed media, 48.5 x 41cm. The Museum of Modern Art New York. Gift of Mr and Mrs Alexandre P Rosenberg

have said to Picasso, "*but by different means*". And these means, through which, in his own way, he pursues the liberation of the mind, he has long been the master of. Variations of method are not in his temperament. He has, then, only to persevere along his chosen path. However spare the figures with which he ends up, they could never topple over the edge into abstractions. His decorative genius safeguards him from this extreme. And also, no doubt, the taste for the *naturel* which is a quintessential facet of French culture. Picasso, the paradoxical and heroic Spaniard, is dragging painting into bizarre experiments and forced attitudes, towards the monstrous, in fact. As for Matisse, if he strips his work to the bone, it is never because he has given up, but for economy's sake. Having reached the threshold of obscurity, he turns back. His goal never lay that way. Provoking people or upsetting them is not part of his game; but then, it is not a game at all for him. What he really … has been aiming at is comfort, pleasantness and charm. Grace and elegance. And here it is that his decorative art rescues him from the abstract. The abstract, with Picasso, always appears as a proposition, a hypothesis, a magic formula, or a demand, a violent protestation, a battle cry. Never, or virtually never, does he spread his wings in decorative devices.' ('L'Histoire de l'art contemporain: Matisse', *L'Amour de l'Art*, vol. XIV, no.5, May 1933, pp.108–10.)

Early summer: Publication of Albert C. Barnes and Violette de Mazia, *The Art of Henri-Matisse* (New York and London). Although stating that 'by centering his interest upon decoration he misses the supreme values of painting', the authors describe Matisse's works as 'unequalled by those of any other painter of his generation' (pp.210–11). Cubism is defined as a disaster 'for all subsequent painting', and Picasso's post-war Cubist paintings as failures because they combine 'patterns more or

less cubistic with bright and exotic colors which were clearly imitative of Matisse's. The result is a travesty of both his own form and Matisse's' (pp.215–16).

June: The inaugural issue of the luxurious review *Minotaure*, published by Albert Skira, is largely devoted to the work of Picasso, who designs the cover (fig.98). It includes André Breton's essay on his sculpture, 'Picasso dans son élément', illustrated with Brassaï's photographs.

August: Despite Picasso's strenuous efforts to obtain an injunction, Fernande Olivier's intimate memoir of her love affair with him is published in Paris by Librairie Stock as *Picasso et ses amis*. (Extracts have already appeared in *Le Soir* in September 1930 and in *Mercure de France* in May–July 1931.) The book touches on the personal relationship of Matisse and Picasso in 1906–11 (see above pp.363, 365).

30 August: Publication of Bernhard Geiser, *Picasso: Peintre-Graveur. Catalogue illustré de l'oeuvre gravé et lithographié 1899–1931*, Imprimerie Union, Berne. This complements Zervos's complete catalogue of Picasso's paintings and drawings. No comparable *oeuvre-catalogue* of Matisse appears during his lifetime.

In 1933 Madame Coquiot donates Picasso's *Portrait of Gustave Coquiot*, 1901, to the Musée du Jeu de Paume – the first work by Picasso to enter a public collection in Paris.

1934

February–March: George Macy commissions Picasso to illustrate Aristophanes's *Lysistrata* and Matisse to illustrate James Joyce's *Ulysses* for the Limited Editions Club, New York. *Lysistrata* is published in the autumn of 1934 (six etchings and thirty-four lithographs), *Ulysses* in 1935 (six etchings on copper with *vernis mou*).

Publication of Gertrude Stein's memoirs, *Autobiographie d'Alice Toklas*, Paris (translated by Bernard Faÿ from *The Autobiography of Alice B. Toklas*, London 1933; see above pp.363–4.). Matisse is among those to respond angrily in *Testimony against Gertrude Stein* (*Transition*, Pamphlet no.1, February 1935). He objects strongly to the '*sans-gêne* and irresponsibility' (p.7) of the account and refutes in detail specific passages, including the statement that Picasso 'created cubism': 'According to my recollection it was Braque who made the first cubist painting' (p.6). He explains Stein's bias towards Picasso's work and against his own: 'Gertrude Stein had a sentimental attachment for Picasso. With regard to myself, she has satisfied in her book an old rancour which had its origin in the fact that having promised me she would help Juan Gris, who had been caught by the war in Collioure where he was obliged to stay, she did not keep her word, and it was for this reason that I stopped seeing her' (pp.6–7).

Picasso, who continues to see Gertrude Stein periodically, makes no public statement. However, in a letter to Simon Bussy of 23 September 1934 Matisse reports: 'Picasso is cross with her.' (Bibliothèque du Louvre). On 2 November Albert Barnes writes to Leo Stein: 'Picasso and Matisse each told me what a damned liar she [Gertrude Stein] is, and I also put her down the same way for

what she said about me in the book. Your explanation is better than theirs or mine – she's so far away from reality that she doesn't know romance from history. She is meat for the newspapers here and nearly always with ridicule played to the limit. Of course she's too good a showman and exhibitionist to let anything get through her crust of conceit. As I read her book I recalled often your reply, way back in 1913 or 14, to my question – "Why are you leaving Paris to live in Italy?" You said – in effect – "Gertrude is crazy. I can't stand her any more".' (BL) According to Zervos, asked whether he had read Stein's memoirs Picasso replied: 'No; if what she says is true, I already know it. If it isn't, there's no way she can make me interested.' (Letter to Matisse, 8 March 1935; AM.)

1 October: Death of Paul Guillaume. On 4 December Matisse writes to Pierre Matisse: 'Waldemar George is forming a sort of club from the friends of ... P. Guillaume! Picasso, Derain, Max Jacob, Vollard, etc. I find myself caught up in it – unwillingly, of course.' He goes on to describe a visit to Paul Rosenberg, which has made him white-hot with excitement ('chauffé à blanc'): Rosenberg's staircase is hung 'from top to bottom with big Picassos and Braques; with plenty of light, it looks really good.' (PMA)

1935

Cahiers d'Art is in deep financial crisis. On 23 January Zervos writes to Matisse requesting the gift of a painting, to be sold in the United States, 'so we can still carry on this year'. Picasso heads his list of artists who have already donated a canvas. On 28 February Matisse replies: 'We'll let you have the canvas you want before the end of the week.' (AM)

March–April: *Les Créateurs du cubisme*, Galerie des Beaux-Arts, Paris. Organised by Raymond Cogniat, it includes thirty-eight works by Picasso. On 22 March Matisse writes to Pierre Matisse from Nice: 'I'll be going to Paris in two weeks for the big Cubist exhibition. There are two really special Picassos, which people say are dynamite.' (PMA) On 26 April he writes again: 'The Cubist exhibition feels lacklustre and long in the tooth. That's the opinion of people I met, and it reflects the views in knowledgeable circles. Picasso is said to be in a furious temper. Apart from his being disagreeable, I was dismayed to see so little happiness in this exhibition. I saw Picasso at Lacourière's place [Roger Lacourière, the master-printer]; he told me bitterly that the Braque exhibition was reckoned to be the best.' (PMA)

Picasso's disgust emerges in a conversation with Kahnweiler on 9 March 1935: 'None of that is Cubism. The whole show makes me sick, my own stuff most of all.' (Kahnweiler, 'Entretiens avec Picasso', *Quadrum*, no.2, November 1956, p.74.)

July: In her campaign to revive the French tapestry industry, Marie Cuttoli commissions Matisse to design a tapestry cartoon. He responds with the oil painting *Window at Tahiti I*. Picasso's first cartoon for Mme Cuttoli, *Confidences*, is realised in 1934 in a collage technique. Both tapestries, woven in 1935–6, are exhibited in the Bignou Gallery, New York, in April 1936 (*Modern French Tapestries from the collection of Madame Paul Cuttoli*, nos.8–9).

12–30 November: *Henri Matisse: Dessins*, Galerie Renou et Colle, Paris. The exhibition also includes

sculptures by Matisse. The parallel exhibition, *Picasso: Dessins*, is mounted in the same gallery, 14 February–11 March 1936.

December: Publication of 'Picasso 1930–1935', *Cahiers d'Art*, X, nos.7–10. Zervos reports the following remarks by Picasso: 'It would be very interesting to preserve photographically, not the stages, but the metamorphoses of a picture. Possibly one might then discover the path followed by the brain in materialising a dream. But there is one very odd thing – to notice that basically a picture doesn't change, that the first 'vision' remains almost intact, in spite of appearances.' ('Conversation avec Picasso', pp.173–8.) This suggests knowledge of Matisse's practice of recording photographically the gradual evolution, or 'states', of his paintings. (Eight of the twenty states of *The Pink Nude* (no.119) are reproduced in the second edition of Roger Fry's *Henri-Matisse*, London, New York, Paris 1935, pl.57.)

Alexander Romm interprets the principal differences between the two artists' work in Marxist terms: 'Considered in relation to the development of an art style of the modern bourgeoisie, the sum of Matisse's many years of work is not very great when compared to the great role played by Cubism. For however we may evaluate Cubism, one thing is certain – it is a particular style that harmonises with contemporary capitalist reality, it is a style as dynamic, unbalanced and disharmonious as decaying capitalism itself. Thus Cubism reflects the complex reality of the imperialist stage of capitalism. Matisse's harmonious decorativeness does not express these strong tendencies. Picasso sees into the depth of the phenomena, identifies himself with the tempestuous rhythms and dissonances of the epoch, with its cacophony of ugliness; Matisse glides over the surface. Enjoying great popularity, he does not create a unified school – he is one of the individualist Fauves – people of a past epoch for whom the highest good is an abstract freedom, understood as an extreme assertion of the ego.' (*Henri Matisse*, Moscow 1935. English translation by Chen I-Wan, Moscow 1937, pp.69–70.)

1936

The Japanese artist Riichiro Kawashima recalls former meetings with Matisse and Picasso: 'At one time, I wanted to ask what they thought about each other's work. It was quite a long time ago, when Picasso lived in a fashionable studio overlooking the Montparnasse cemetery [i.e. 1913–16]. One day I visited him and chatted with him in a room decorated with many black African sculptures. I asked him, "Do you like Matisse?" He widened his big, bright eyes and said, "Well, Matisse paints beautiful and elegant pictures. He is understanding". He would not say more. When I visited Matisse in Nice four years ago, I asked him, "What do you think about Picasso?" After a moment's silence, he said, "He is capricious and unpredictable. But he understands things".' (*Matisse*, Tokyo 1936, pp.8–9).

March: Matisse and Picasso are among the artists, writers and critics to sign an open letter (published in *Le Petit Démocrate*, 22 March 1936) protesting against the demolition of the old Palais du Trocadéro to make way for the new Musée d'Art Moderne, for the forthcoming *Exposition Internationale*. The protest is unsuccessful. Neither

Matisse nor Picasso receives a commission from the French State for the *Exposition*.

Spring: Paul Rosenberg mounts successive one-man exhibitions of the two artists' latest work: 3–31 March, *Exposition d'oeuvres récentes de Picasso*; 2–20 May, *Exposition d'oeuvres récentes d'Henri Matisse* (Matisse's first solo exhibition at the gallery). Critics are divided over the audacity of Matisse's new, abstracted style. Claude Roger-Marx detects the damaging influence of Picasso: 'Is the Galerie Rosenberg still flooded with the latest Picassos? Picasso it is who comes to mind as soon as we set eyes on the twenty-seven canvases meant to relaunch Matisse's work after his two-year break. In an attempt to convey the sense of unease I feel when confronted by Picasso's monstrous and fantastic mythology, those satanic inventions of his, I have spoken of "an atmosphere of crime". And now we're being presented with another criminal outrage: the outrage of an artist against himself. We tolerate from Picasso, a specifically Spanish painter, an attitude we have trouble accepting from a French artist, from one of the twentieth-century masters, to whom we remain loyal, if I may say so, despite himself. Matisse has long been itching to do battle among the avant-garde, doing violence to his true nature, and, while producing the odd exquisite work, destroys his own pleasure, or at least ours, with *coups de force* and adventures where a certain vanity – let's not mince words – seems to dominate his inspiration.' ('Oeuvres récentes d'Henri Matisse', *Le Jour*, 9 May 1936.)

On 16 July Matisse signs a three-year contract with Paul Rosenberg, stipulating 30,000 francs for a standard '50-paysage' (116 x 89cm) canvas.

17 June: Preliminary meeting of *Union pour l'Art* at the Grand Palais, Paris. According to André Bloc in his opening address, the primary purpose of the association is to facilitate a mutually beneficial collaboration between the best architects, painters, sculptors and decorators, not to provide support for unemployed artists. Matisse and Picasso are named among the founder-members. Matisse attends the meeting and, with Maillol and Le Corbusier, is elected vice-president; Auguste Perret is elected president. Picasso does not attend the meeting. (The initiative comes to nothing.)

July: The first version of Matisse's *Dance* mural, 1931–3, is purchased by the city of Paris. Matisse is promoted to the rank of Officier de la Légion d'Honneur. Following the electoral victory of the Popular Front led by Léon Blum on 5 June 1936, Matisse and Picasso participate in an exhibition organised under the auspices of the Maison de la Culture (Secretary General: Louis Aragon) in the Alhambra Theatre, Paris. Matisse lends *The Moroccans* (no.72). The exhibition coincides with the performance, on Bastille Day, of Romain Rolland's anti-fascist play, *Le 14 Juillet*, with a curtain designed by Picasso. The Russian painter Boris Taslitzky recalls:

'We had set up a big exhibition in the foyer of the theatre, with canvases by Matisse, Léger, Picasso, Lurçat, Lipchitz, Goerg, Gromaire and Lhote. Pignon, Amblard and I did the hanging. We found ourselves in a real quandary; should we mix the work of the older painters with that of the younger men? We were continually putting things up and taking them down when Matisse and Picasso arrived. Matisse hesitated about what to do. Picasso declared that he liked 'charcuterie' and we ought to mix everything up. It was a funny sort of exhibition, with everything higgledy-piggledy, no individual display panels, with prominence given to everything and nothing. Certainly, no art dealer and no hanging committee had a hand in it. Romain Rolland's play was a triumph, the audience gave Picasso's curtain a huge ovation, and everybody went frantic with delight when the dancers left the stage and led a farandole round the aisles, to a sudden outburst of the *Marseillaise*.' (*La Nouvelle Critique*, December 1955.)

15 August: Following the outbreak of the Spanish Civil War on 18 July, Matisse and Picasso are among numerous signatories of a telegram, emanating from the Maison de la Culture, to Luis Companys, President of the Catalan government, and to the Casa del Pueblo in Madrid: 'Salute our heroic brothers fighting for liberty of Spain. Firmly expect final victory of Spanish people over criminal attempts of adventurers. Long live Spain, guardian of culture and traditions with which indestructible bond unites us.' On 19 September Picasso is appointed Director of the Prado, Madrid. Although he supports the Republic's efforts to protect Spain's artistic heritage, he does not return to Spain.

October: Matisse designs the cover for *Minotaure* no.9, which includes many reproductions of his work and Tériade's essay, 'Constance du Fauvisme'. He also designs the cover for the inaugural issue of Tériade's sumptuously illustrated periodical *Verve*, published December 1937 (fig.99).

1937

20 April: Publication of Raymond Escholier's first monograph on Matisse in the 'Anciens et Modernes' series, Librairie Floury, Paris. The companion volume on Picasso, by Gertrude Stein, appears in 1938 (see below).

May: As an emissary of the London-based Artists' International Association, Quentin Bell obtains Picasso's signature on a petition to raise money for Spanish Republican refugees. He anticipates difficulty in obtaining Matisse's signature because the latter 'could be trusted to shy away from anything which was suspected of being inspired by the communists'. Matisse is reluctant initially: 'In vain I pointed out that the children whom we were trying to help were far too young to have political opinions, in vain I protested that I was not a communist and that the proposed Albert Hall meeting would be a non-party affair. He was adamant. Finally, when I had lost all hope of moving him, I revealed that Picasso had signed. He started, stared, pulled out his pen

fig.99 Matisse, cover for *Verve* no.1, 1937

and added his name.' (Quentin Bell, *Elders and Betters*, London 1997, pp.17–18.)

Summer: Matisse's diary (AM) provides evidence of regular contact between the two artists. On 27 May 'P.P' (Picasso) visits Matisse. On 1 June (day of the opening of *Oeuvres récentes de Henri-Matisse*, Galerie Paul Rosenberg, Paris) Matisse visits Picasso in his studio at 7 rue des Grands-Augustins, where the latter is at work on the mural inspired by the Nazi bombing raid on the historic Basque town Guernica and commissioned for the Spanish Pavilion at the *Exposition Internationale*. Matisse visits Picasso again on 25 June and 3 July. On 9 August he goes to see *Guernica* in the Spanish Pavilion.

17 June–10 November: *Les Maîtres de l'art indépendant 1895–1937*, Petit Palais, Paris. In this immense exhibition, curated by Raymond Escholier, Matisse and Picasso are each given galleries to themselves, and the opportunity to choose and install their works. The catalogue lists sixty-one paintings by Matisse, and thirty paintings and two sculptures by Picasso. Both also show numerous uncatalogued drawings and prints. The exhibition generates heated controversy, especially over the definition of 'art indépendant', the mixture of French and non-French artists from the 'Ecole de Paris', the role of dealers and the state of contemporary art at this period of high political tension and economic uncertainty. In a two-part review Louis Gillet, of the Académie Française, defines what he considers to be the emotional limitations of Matisse's 'irresistible' art and the baneful character of Picasso's 'genius':

'M. Henri Matisse appears to be the first to represent art as something where tomorrow is independent of today, and to have taken to heart

Zarathustra's advice about taking risks and living dangerously ... No doubt, we have here [in the exhibition] only the half as yet of this great master, a Matisse stripped of his decorative work and the grandest and noblest fruits of his method. Obviously there are grounds to regret certain limitations of his system, the convictions which prevent him from attempting not merely the dramatic and the narrative, but the portrayal even of emotion, tenderness and human sympathy. With Matisse, pathos is reduced to the personal drama of the artist, to his problems as he struggles with his art ... In vain we wonder if the painter is not doing himself a disfavour by limiting himself to battling with the charm of a piece of porcelain, the beauty of a carpet. What does it matter! Whatever he does, M. Henri Matisse, the magician, is always irresistible.' ('Trente ans de Peinture au Petit Palais', *Revue des Deux Mondes*, part I, 15 July 1937, pp.331–2, 336.)

'His [Picasso's] father was a Catalan, his mother Italian. She herself was of Jewish descent; this eastern coast of the Iberian Peninsula between Valencia and Málaga has been home to peoples of mixed race since time immemorial ... M. Picasso appears to have made a point of overturning all our ideas. He rejects any kind of laws. He is bound, he says, by no necessity. For our old-fashioned conception of the artist – a man of the soil, a sort of market-gardener, humble, attached to a locality, clinging to it like an espalier to a wall – he has substituted the figure of an adventurer ... Then, in his latest works, the storm breaks loose: all that remains are tortured caricatures – wild and outrageous – acts of derision, insults to the human form, far exceeding Goya's hallucinatory scenes and grotesques in the Quinta del Sordo ... In all of this there stands revealed a kind of despair, a curse as it were, of a sort which never befell an artist before, and properly belonging to the torments of Hell: the wretchedness of not loving, of painting without love. M. Picasso's tragedy is that in him are thrown together a plastic genius of the first order, unheard-of virtuoso talent – and absolute nihilism. This unparalleled mixture of conflicting talents and faculties, of passion and frigidity, of creative force and destructive power, explains clearly enough the extraordinary prestige surrounding him, the fascination he exerts, and his formidable halo of good or bad angel. It is very hard to say how he will be ranked by future generations, any more than we can say whether we love or hate him. Hesitation seizes us, faced with this monster of egotism, pride, and impersonality.' (ibid., part II, 1 August 1937, pp.564, 577–8.)

18 July: Hitler delivers a speech attacking *entartete Kunst* (degenerate art) at the opening of the *Grosse deutsche Kunstausstellung*, Haus der deutschen Kunst, Munich. During the course of the summer, 'degenerate' paintings by Matisse and Picasso are among those confiscated from German museums and stored in Berlin.

30 July–31 October: *Origines et développement de l'art international indépendant*, Jeu de Paume, Paris. Curated by Christian Zervos, this represents an alternative to Escholier's *Les Maîtres de l'art indépendant*. Artists from thirty-six different countries are represented, including Africa and Polynesia. Matisse and Picasso are members of the honorary committee, the former showing six paintings (1905–16) and the latter eleven paintings (1908–25) and one sculpture. Matisse also lends some of his African sculptures.

1938

11 January: *Matisse, Picasso, Braque, Laurens* opens in Kunstnernes Hus, Oslo. The exhibition, organised by Matisse's former student Walther Halvorsen, subsequently travels to the Statens Museum fur Kunst, Copenhagen, the Liljevalchs Konsthall, Stockholm, and the Konsthallen, Göteborg, where it closes in April 1938. Matisse shows thirty-one works dating from 1896–1937, Picasso thirty-three works from 1908–37, including *Guernica*. The exhibition generates extensive press coverage at every point on the tour, the Scandanavian critics paying substantially more attention to Matisse and Picasso than to Braque or Laurens. *Guernica* is the subject of intense interest, and as usual the stylistic variety of Picasso's work arouses controversy. Matisse's work is praised for its abstract painterly qualities, but described as largely empty of meaning.

10 February: In his only known letter to Matisse (fig.100), Picasso writes: 'My dear Mattisse [*sic*], Please be the first to put your name on the list of painters anxious to create a real museum for the people of Spain, and donate us a major canvas. We're all ready to follow your lead and give our best work to this cause. Yours in all friendship, Picasso. Greetings.'

fig.100 Picasso's letter to Matisse of 10 February 1938. Archives Matisse

Matisse receives the letter only on his return to Paris on 16 June 1938. On 17 June he goes to Picasso's studio (agenda, AM) and, finding him absent, leaves a hurried note: 'My dear friend, As soon as I got to Paris I called to answer your letter, which touched me very deeply. I'll tell you why I couldn't do it before my return to Paris. Yours, Henri Matisse.'

Matisse donates a picture, as do Picasso and ninety-eight other artists. The works are exhibited in Galerie Jeanne Bucher, *c.*10–16 July, and sold in aid of Spanish children (see *Ce Soir*, 13 July 1938).

12 March: Publication of Gertrude Stein, *Picasso*, Paris and London: 'One day they asked Matisse if, when he ate a tomato, he saw it as he painted it. No, said Matisse, when I eat it I see it as everybody sees it ... But Picasso was not like that, when he ate a tomato the tomato was not everybody's tomato, not at all and his effort was not to express in his way the things seen as every one sees them, but to express the thing as he was seeing it ... Matisse and all the others saw the twentieth century with their eyes but they saw the reality of the nineteenth century, Picasso was the only one in painting who saw the twentieth century with his eyes and saw its reality and consequently his struggle was terrifying' (pp.17, 22).

In a later passage Stein associates a supposedly uncharacteristic, Matissean phase in Picasso's painting with a personal crisis: 'Between 1927 and 1935 Picasso had a tendency to console himself with Matisse's conception of color, this was when he was most despairful that this commenced, and ended when he ceased to paint in 1935' (ibid., p.45).

19 October–11 November: *Picasso, Henri-Matisse*, The Boston Museum of Modern Art. In this, the first Matisse-Picasso exhibition since 1918, Matisse is represented by fifteen paintings (1906–37) and Picasso by twenty-three paintings and one papier collé (1901–37). All the works are loaned from American sources. A parallel exhibition of works on paper is held in the Grace Horne Gallery, Boston. The local press coverage tends to focus on the evolution of individual compositions by Matisse and the stylistic variety of Picasso's work.

Autumn: Matisse has consecutive one-man shows of works executed since 1917 in the Galerie Paul Rosenberg, Paris (24 October–12 November), and the Pierre Matisse Gallery, New York (15 November–10 December). The French and American critics assess his achievement in similar terms, maintaining the tradition of seeing the volatile Picasso as his natural opposite. Louis Cheronnet defines Matisse, especially in his odalisque paintings, as 'at once an inheritor of French tradition and a prince of liberty and individualism', and praises him for avoiding 'anarchy', 'illogicality' and 'effects' ('Leçon de Matisse', *Marianne*, 9 November 1938).

Emily Genauer admires him for 'not making pointless detours', and continues: 'You may not like that Omar Khayyam kind of world, where all ideas and reality are repudiated, where hedonism is the order of all days. But even if you chose a world of thought, created by painters like Picasso, or dozens of our provocative socially-conscious Americans, you must recognise that it is the mastery of many lessons taught by Matisse himself, his intense, expressive color, his superbly rhythmic form, his sense of pictorial unity, which has made the thoughtful painters articulate.' ('Matisse paintings at son's gallery', *The New York World-Telegram*, 19 November 1938.)

1939

January: Foundation of the Académie française du Film, modelled on the Motion Picture Academy of America. Matisse and Picasso are elected to a jury composed of celebrated writers, artists and intellectuals, whose job is to assess French movies (report in *Gazette de Lausanne*, 15 January 1939).

17 January–18 February: *Exposition Picasso (Oeuvres récentes)*, Galerie Paul Rosenberg, Paris, the parallel to Matisse's one-man show in the same gallery the previous autumn.

Spring: Picasso purchases Matisse's *Bouquet of Flowers in a Chocolate Pot*, c.1902, from Ambroise Vollard (now Musée Picasso, Paris).

11 May: Première of *Rouge et Noir* (formerly entitled *L'Etrange farandole*) in Monte Carlo, with choreography by Massine, music from Shostakovich's First Symphony, and sets and costumes by Matisse. Matisse's designs, adapted from his *Dance* mural (fig.11), date from February to April 1938. On 5 June 1939 *Rouge et Noir* is performed in Paris at the Théâtre National du Palais de Chaillot. Matisse and Massine plan a second ballet on the theme of *Diane Chasseresse*, with music by Luigi Dallapiccola and libretto by Matisse himself, but the war puts paid to the project (Matisse 1941). On several occasions during the 1930s Massine has attempted, unsuccessfully, to persuade Picasso to design a new ballet for him, most recently, in 1937, a ballet on the life of St Francis of Assisi. (AP)

30 June: Theodor Fischer, of Galerie Fischer, Lucerne, auctions 125 of the most valuable 'degenerate' paintings and sculptures confiscated from German museums by the Nazis. Four works by Matisse are auctioned, including *Bathers with a Turtle* (no.8) and a terracotta cast of *Reclining Nude I* (no.15), and four paintings by Picasso. The auction and the prices realised generate intense interest in the international press. Raymond Escholier comments ironically: 'Picasso and Matisse turned into cannon balls: that must be the oddest transformation of all time!' (*Le Journal*, 19 June 1939.)

14 July: Ram Gopal, 'a sacred dancer of the Hindu Temples', and other Indian and Javanese dancers perform at the Salle Pleyel, Paris. According to Michel Georges-Michel, Matisse and Picasso attend, along with 'le tout Paris'. ('Au Balcon du Club', *Cri de Paris*, 16 July 1939.)

28 July: Picasso attends the funeral of Ambroise Vollard in Paris and visits Matisse in the studio at Villa Alésia, rue de Plantes, which the latter has occupied since May 1939. (Matisse's agenda, AM)

3 September: France and Great Britain declare war on Germany. Picasso leaves Paris and settles in Royan with his lover, Dora Maar. Matisse leaves Paris for Rochefort-en-Yvelines, near Rambouillet. Having stored all his work in the Banque de France, he returns to Nice-Cimiez in October.

15 November: *Picasso: Forty Years of His Art* opens at the Museum of Modern Art, New York. Organised by Alfred Barr, the exhibition catalogue lists 360 works dating from 1898 to March 1939 but, as the foreword explains, the war prevents major works from leaving Europe. The show is a joint undertaking with the Chicago Art Institute, where it travels on the second leg of a long tour throughout the United States (Saint Louis, Boston, Cincinnati, Cleveland, New Orleans, Minneapolis and Pittsburgh). It attracts enormous crowds in New York: on 5 December, Barr cables Picasso 'Colossal success 60,000 visitors surpassing Van Gogh exhibition [1935]'. (AP) Although much of the press coverage focuses on the exhibition as a social event, for some critics, including George L.K. Morris, it estab-lishes Picasso as the greatest living artist: 'Perhaps the painter before us today is the only one alive who can survive a test that has diminished so many reputations. It can be recalled how no less an artist than Henri-Matisse became the victim of his limitations when his works were assembled into a comprehensive one-man show [in 1931].'

However, Morris is critical of Picasso's work since 1931: 'His succeeding works were modelled upon – of all people – those of Henri-Matisse. Whatever the paintings of Matisse may say to the observer, their expression is always marvelously unified, and to achieve this very direct expression he had made his long effort to 'think himself back to five years old.' The flat patterns derived from the Persian miniatures are exactly right for odalisques, for flowers, for Riviera window-views. Picasso started with similar subjects and there was a long succession of ladies with mirrors and flowers. His lines now ceased their angularity; broad swinging curves enclosed bright garish areas, flat in color. There were no longer the delicate impressionist halftones, everything has become full-spoken and direct; the tactile sense has diminished and with it the mysterious Picasso quality.' ('Picasso: 4000 [sic] Years of his Art', *Partisan Review*, January–February 1940.)

Matisse takes a keen interest in the exhibition, writing to Pierre Matisse on 17 December: 'I know that art in New York is flourishing: more people attended the Picasso exhibition than the Van Gogh one, which had 232,000 visitors'. (PMA)

1940

5–29 February: Picasso is in Paris. He returns from Royan to Paris in mid-March and stays till 17 May.

End of April: Matisse is back in Paris.

2 May: Matisse plans to go to Brazil at the start of June. Leaving the Office du Brésil, he meets Picasso in rue La Boétie; this at a time when the Germans are advancing and the fall of France seems imminent. A few days later he relates his conversation with Picasso, which has affected him deeply, to his son Pierre. 'I met Pablo in rue La Boétie. He shrugged his shoulders and said, "It's the Ecole des Beaux-Arts, then!". He's at Royan now.' (Henri Matisse to Pierre Matisse, Ciboure, mid-June 1940, PMA.)

20 May: Matisse leaves Paris with Lydia Delectorskaya. He only returns to Nice at the end of August. He has abandoned the idea of going to Brazil; he will also refuse invitations (relayed by Pierre Matisse) from the USA.

14 June: The Germans enter Paris.

14 July: Matisse writes to Picasso (still at Royan) from Saint-Gaudens: 'Amongst other things, it's just occurred to me that when you recently said you'd bought one of my still lifes from Vollard's [*Bouquet of Flowers in a Chocolate Pot*], I got it completely mixed up with a painting which is in Moscow. Paul [Rosenberg] mentioned it when I met him in Bordeaux, and I made the same mistake then. Where is the picture? As you found it interesting, I would very much like to know which it is. Would it be too much to ask you to make me a sketch so I can work it out, and send it with all your news?' (AP)

25 August: Matisse is back in his Nice studio, at the Hôtel Régina. Picasso returns definitively to Paris.

1 September: Long letter from Matisse to Pierre Matisse: he writes of 'the uncertainty in which we're living, and the shame – the shame of suffering a catastrophe which we're not responsible for. As Pablo said to me: "It's the Ecole des Beaux-Arts". If everybody had minded his own business as Picasso and I did ours, this would not have happened.' (PMA)

22 September: Publication of vol.2 (Part 1) of the complete catalogue of Picasso's works (*Oeuvres de 1906 à 1912*) by Christian Zervos.

Autumn: During the autumn, Picasso is summoned to make the inventory of his safe deposit. Matisse appears to have requested Picasso to represent him when his own was checked, at the Banque de France. (Alfred H. Barr, *Matisse: His Art and his Public*, New York 1951, p.256; and letter to Pierre Matisse of 5 June 1941: 'You probably know I am free to visit them [the safes] whenever I want. I made Pablo my proxy; he arranged it with one of his friends. It was the same story for him.' [PMA])

10 November: Matisse writes to Pierre Matisse: 'I find it amusing that everyone can think of reasons to stay in France. When I heard for a moment that Pablo was in Mexico, it really upset me. I felt that France was the poorer for it.' (PMA)

28 November: Matisse to Pierre Matisse: 'I hear that he [Picasso] gave Max Pellequer a photograph of a painting of mine that Picasso had bought a few months ago (or maybe a year) from Vollard. He even made a sketch of it with some indications of colour, and asked that it should be sent to me. It seems that Picasso is just as he always was – a true Bohemian, taking his meals here, there, and everywhere. But it seems that Dora Maar is no longer with him. He is still worried that our national misfortunes will make the public turn away from Cubism. I forgot to ask what kind of pictures he was painting. It exasperated him that he could no longer go to his strong room at the bank. But that has now been settled and he can go and see the pictures that he has there.' (Russell 1999, p.199.)

10 December: Matisse writes to Picasso, on an inter-zone postcard: 'Thanks a million [for securing Matisse's right of access to his deposits?]. I hear you have a big exhibition at Cleveland where Paul [Rosenberg] has been lecturing. French painting doing well.' (AP)

1941

7 or 8 January: Matisse leaves Nice to undergo cancer surgery at Lyon. (Date given as 7 in letter to Camoin of 6 January (CC/M, p.142); 8 in letter to Marquet of 22 May 1941.)

14 January: Matisse communicates with Picasso on an inter-zone card: 'Saw Max [Pellequer]. Thanks very much. Am at Lyon clinic about to have minor operation: no danger.' (AP)

16 January: Matisse undergoes an operation at the Clinique du Parc, where he remains until 31 March. He continues his convalescence at the Grand Nouvel Hôtel up to the end of May.

23 May: Matisse is back in Nice at the Hôtel Régina.

August: Matisse is back at work on two projects simultaneously: Henry de Montherlant's *Pasiphaé* and a series of preparatory drawings for *Still Life with a Magnolia* (no.153), completed in October. One of these studies will eventually be dedicated to Picasso (Bois 1998, no.123, p.134). In a letter to Camoin of August 1941, Matisse recalls an old anecdote (which came to mind during his conversations with Courthion). 'Jean Puy told me that during the 1914 war, in the two camouflage sections – Segonzac was in charge of one ... who was the other officer? Anyway, each had a rabbit as a mascot, one called Picasso, the other Matisse. The men discussed the respective merits of both animals, but it wasn't a question of "rabbits" any more; they used to say: "Our Picasso is a finer fellow than your Matisse!" Who was it now who was in charge of the other section?'

On 17 August Camoin replies, in a different tone, but one which is grimly evocative of the atmosphere of the period: 'Myself, I know another story: about a lecture given by M. on behalf of the *directeur* of the Beaux-Arts, and I heard this Jew say that Picasso was "the greatest French painter of our times". "French", he added, "because he did us the honour of coming to work in France". I was coward enough not to walk out of the room at once in protest, though I didn't stay right to the end. This is another proof of the hold the Jews have got over our times; that's what started all this dago Jew style which Picasso is behind. Now it's all known as the "Ecole de Paris". How ironical.' (CC/M, pp.161, 163.)

At the request of Varian Fry, Matisse joins the French section of the Emergency Reserve Committee.

10–30 November: Exhibition of Matisse's recent drawings at the Galerie Louis Carré in Paris. Picasso attends the exhibition and signs the visitors' book. (AM) Following the exhibition, two drawings are purchased by the French state.

12 November: Arno Breker organises a visit to Germany by a group of sculptors (Despiau, Belmondo, Bouchard, Maillol, etc.) and painters (Legueult, Oudot, Dunoyer de Segonzac, Friesz, Van Dongen, Derain, Vlaminck, etc.).

1942

11 March: Henri Matisse informs Pierre Matisse that Louis Aragon has prepared a 'damn good introduction' ('Matisse-en-France') for a series of drawings entitled *Thèmes et variations*, about to be published by Martin Fabiani. He adds that his agreement with Fabiani – former lawyer to Ambroise Vollard's nephew, who has bought up the latter's share of Vollard stock and consequently disposes of large financial means – 'will run out at the end of September'. (PMA) Martin Fabiani is destined to play an important part, both as art dealer and publisher, during the war years, and in this dual role becomes a principal correspondent of both Matisse and Picasso throughout the period.

4 May: Publication by Martin Fabiani of an edition of the eighteenth-century reference book, *Histoire naturelle*, by the comte de Buffon, illustrated with thirty-one aquatints, etchings and drypoint engravings by Picasso. Matisse acquires a copy.

6 June: Appearance of a venomous article by Vlaminck in *Comoedia* ('Opinions libres ... sur la

peinture'), with a violent attack on both Picasso's character and work. The same day (a coincidence?), Matisse replies to Pierre Matisse: 'It's disgusting, that rumour. It must have been started by the enemies of Picasso's paintings. The same rumour was launched about twenty years ago ... Picasso pays dearly for his exceptional qualities. But he leads a dignified life in Paris. He works, he doesn't want to sell, and he makes no demands. He still has the human dignity that his colleagues have abandoned to an unbelievable degree.' (PMA)

16 June: *Le Pilori* runs a violent attack (signed R.M. Fechy) on 'decadent art' under the guise of a critique of John Henning Fry's *Decadent Art under Democracy and Communism*. Reproduced side by side are Matisse's *La Serpentine* (no.18) and one of Picasso's female heads (*Head of a Woman*, captioned 'a woman we'd loathe on sight'). The article is entitled 'La Cacade à l'honneur' ('Crap takes centre-stage') (fig.101).

15 July: In *Présent* (a newspaper published in Lyon, in the Unoccupied Zone) a paragraph appears on the 'Vlaminck–Picasso Affair': 'The outrageous attacks by Vlaminck on Picasso have caused astonishment everywhere. Matisse has informed the committee of the Salon des Tuileries that he would refuse to exhibit alongside the painter of *The Road That Leads Nowhere*. The younger generation of artists have voiced their protest in a manifesto. Picasso is maintaining a very dignified silence.'

6 August: Opening of the Musée National d'Art Moderne: 650 works by 327 artists on show. Matisse is represented (two canvases), but not Picasso, although since 1933 the museum has owned the *Portrait of Gustave Coquiot* (1901) – a further proof of the veto imposed on Picasso's work by the occupying Germans.

11 November: The so-called Unoccupied Zone is now also occupied.

12 November: Through an exchange with Martin Fabiani Picasso acquires a very important work by Matisse: *Still Life with Basket of Oranges* (1912; no.45). This canvas previously belonged to the collection of Carl and Thea Sternheim (at least until 1937) and later came into the hands of Vollard. Matisse is immediately informed of the event, and writes to his daughter Marguerite on 15 November: 'Pablo has been to Fabiani and swapped the Moroccan s[till] l[ife] [that used to belong to] Mme Sterner [*sic*] – Fabiani turned down huge sums for it – for a big painting of the Blue or Rose Periods.' (See Hélène Seckel-Klein, *Picasso collectionneur*, Paris 1998, pp.166–70.)

1943

May: First visit of Françoise Gilot to Picasso's studio, where she sees Matisse's *Still Life with Basket of Oranges* (no.45) placed in a conspicuous position (fig.102).

June: Publication of *Henri Matisse: Dessins: Thèmes et variations* (Editions Martin Fabiani) with Aragon's 'Matisse-en-France' introduction. Picasso selects a painting by Matisse, *Seated Girl in a Persian Dress* (1942) in exchange for the work offered to Matisse the year before (*Portrait of Dora Maar*).

Late June/early July: With Nice threatened by Allied bombing, Matisse installs himself at Vence in the Villa Le Rêve.

27 July: First letter from Marcelo Fernandez Enchorena, an Argentinian diplomat, to Matisse, concerning a commission for a door. (AM)

July–August: Matisse is at work on Montherlant's *Pasiphaé: Chant de Minos*. His design requires black, white and red, which Picasso will use a few years later for his illustrations to Pierre Reverdy's *Le Chant des morts*.

September–October: Brassaï often visits Picasso to photograph his sculptures. He also comments on Matisse's *Still Life with Basket of Oranges* (no.45) ('the first painting one notices is a Matisse') and reports a number of Picasso's remarks about his fellow artist: 'Matisse does a drawing, then he recopies it. He recopies it five times, ten times, each time with cleaner lines. He is persuaded that the last one, the most spare, is the best, the purest, the definitive one; and yet, usually it's the first. When it comes to drawing, nothing is better than the first sketch.' (Brassaï, *Conversations with Picasso*, trans. Jane Marie Todd, Chicago and London 1999, p.66.)

23 September–31 October: Salon d'Automne. Braque is honoured with a large gallery in which he shows twenty recent paintings. Matisse exhibits four or five paintings, including *Tulips and Oysters on a Black Background*, executed in February 1943 (and remarked on by Picasso).

November: Matisse writes to Picasso (13 November), suggesting another exchange: 'My dear Picasso, I have left with Fabiani the painting you liked [*Tulips and Oysters on a Black Background*]. It was in the Salon d'A. Do you still like it? If so, it's yours, and Fabiani can hand it over. On the other hand, I'm waiting for what Pellequer offered me for his first trip to Nice. I hope you're keeping well and working hard. By the way, I am not set on having a cockerel: I mentioned that because I've seen the ones you did and I assumed it was your favourite subject at the moment. I want a beautiful Picasso. All best wishes. H. Matisse.' (AM)

Matisse now begins his initial researches for *Jazz* by making cut-outs from paper coloured in advance with gouache.

The album *Matisse, Seize Peintures, 1933–1943*, with a preface by A. Lejard, is published by Editions du Chêne. It contains a reproduction of *Seated Girl in a Persian Dress*, which Picasso selected in June. Editions du Chêne issues a parallel work in December: *Picasso, Seize Peintures 1939–1943*, with a preface by Robert Desnos.

1944

7 February: After a walk Matisse records in his diary: 'Villa Céleste a robust olive tree – old, with its main branches much cut down – has young branches that dance and express the promise of a new life. I pass by it every day and often think of a painting by Picasso, representing a Provençal town or the outskirts of such a town. In the foreground a large tree, an olive tree it seems to me, also quite heavily pruned. The gap between the young shoots and the important trunk had struck me and had always seemed unlikely to me. Now I see what enticed him to represent such a thing.' (AM. Quoted in Bois 1998, p.130.) These remarks also shed light on Matisse's fascination in 1951 with Picasso's *Winter Landscape* with its contorted tree-trunks; Picasso would eventually lend it to him for a few weeks. (See fig.111.)

20 May: Editions Martin Fabiani publishes Montherlant's *Pasiphaé: Chant de Minos*, illustrated with linocuts (eighteen plates, dropped initials and *bandeaux*) by Matisse. In Picasso's library there is an example, no.95, on vellum.

12 June: Matisse writes to Picasso, concerning an exchange of works: 'You may not know it, but there's a still life waiting for you in Martin Fabiani's safe. It was shown at the last Salon d'Automne and reproduced by Lejard [i.e. in the album published by Editions du Chêne] where you chose it (or was it at his printer's?).

'It shows some oysters and flowers on a brown table, against a black tiled background [*Tulips and Oysters on a Black Background*, February 1943]. It ought to be exchanged for one of your canvases. I told Pellequer that I would like a good cockerel, but then I thought that if you hadn't already done one, you wouldn't be able to do it for me. Any picture you like will do. I already have a very beautiful, if

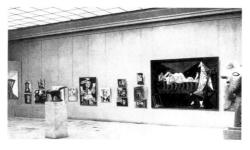

fig.103 Picasso's exhibition at the 1944 Salon d'Automne, 'Salon de la Libération'. Photograph by Marc Vaux

austere, painting which still intrigues me [*Portrait of Dora Maar*]. This time, I'd be quite satisfied with a brightly coloured canvas of your choice. In any case, you can pick up my painting.

'How are you managing to put up with Paris at the moment? I don't expect you to answer that, knowing how much you hate writing. All the same, have someone write back for you if you get this letter.' (AP)

3 October: Meeting of the Comité Directeur du Front National des Arts (a Communist body) with Picasso in the chair. The committee demands the arrest and trial of certain artists who collaborated with the Germans: in the main, those who took part in the 1941 trip to Germany organised by Breker. Yet Picasso seems to have distanced himself very quickly from these first initiatives (see Laurence Bertrand-Dorléac, *L'Art et la défaite, 1940–1944*, Paris 1993, p.292).

5 October: Front-page headlines in *L'Humanité* proclaim that Picasso has joined the Communist Party.

6 October–5 November: Salon d'Automne, known as the Salon de la Libération. A large room is set aside for Picasso, with seventy-four paintings and five sculptures, mostly executed after 1939 (fig.103). The exhibition provokes a passionate debate, and there are even threats against the exhibits; they have to be guarded by a force of young artists. Picasso also lends his Matisse *Still Life with Basket of Oranges* (no.45); it is shown, contrary to legend, in a different room (cf. the article by André Lhote, 'Cette vertu oubliée: la subtilité', in *Les Lettres françaises*, 18 November 1944: 'Matisse's still life, hung so unfortunately as it is in this room, where Marquet, Braque and Dufy languish as well'). The Salon d'Automne also includes an important section of illustrated books featuring Picasso's and Matisse's latest work: Buffon's *Histoire Naturelle* and *Dessins: Thèmes et variations* respectively.

24 October: Picasso discusses his commitment to Communism in the American Marxist magazine *New Masses*, statements reiterated in *L'Humanité* of 29 October. Doubtless soon afterwards, Marquet writes to Matisse from Algiers: 'I've just read – and you probably have as well – Picasso's political statement. Times are awful enough, but one can still have a laugh.' (AM)

16 November: Matisse writes to Camoin: 'Did you see the Picasso room [at the Salon d'Automne]? People speak a lot about it, there were demonstrations against it in the street. What a success!' In the same letter he refers to the 'purges': 'Basically, I feel it's wrong to persecute those with different views to one's own. But that's what they call

Freedom nowadays.' (CC/M, p.211.)

6 December: Revival of the correspondence between Matisse and his son Pierre. The latter mentions the albums of colour reproductions published in late 1943 by Editions du Chêne, now the subject of an exhibition at The Museum of Modern Art, New York.

23 December: The April 1945 issue of *Cahiers d'art, 1940–1944*, appears, marking the resumption of publication. It contains two features, one on Matisse (thirty-one reproductions, 1940–4) and another on Picasso (sixty reproductions, 1940–2).

28 December: Still on the subject of purges, Matisse writes Picasso a letter throwing considerable light on his position:

'My dear Picasso, People have told me how you have read political intentions into the petition for a statue of Maillol [died 16 September 1944]. It was I who started the petition. When you attributed such intentions to me, you didn't take into account that I am too old and in too poor health to play any part whatsoever in the politics of my country. The only homage I can pay to events is through acts of charity. All the same, knowing through experience what a struggle the life of an artist is – didn't you say to me in 1914: "Matisse, we've already been in the trenches for ages"? – and with this single purpose in mind, I wanted to take advantage of the opportunity to pay tribute to an artist who worked like a Trojan, as we have, all his life. I wanted to relate it to something I saw him working on – in fact we worked together on the casting – during those days when we struggled at Collioure. Because the whole thing is getting so complicated and I need what remains of my energy for my daily work, I am abandoning the project, into which I also dragged Bonnard, who had the same reasons as I for agreeing. What will be will be. I hope after you read this you will acknowledge that my gesture was made in all innocence. Finally, my dear Picasso, all my very best wishes for 1945. Yours affectionately, etc.' (AP)

1945

15 January: Marcelo Enchorena writes to Matisse, concerning the door on which Matisse is still working: 'A few days ago Picasso brought his friends to dinner; he no sooner entered the house than he said, "I want to see Matisse's door". All Paris is holding its breath!' (AM)

12 February: In a long and moving letter from Vence to his son Pierre, Matisse sums up his life and work between 1943 and 1944, years when their correspondence was interrupted: 'I've got through an enormous amount of work since my operation – you will be astonished. I feel this work is absolutely essential ... Picasso has bought a major Tangier still life [no.45]; it belonged to Mme Sternheim, a German woman. He is very proud of it. As he has just packed a room at the Salon d'Automne from top to bottom, so they say, with unframed work, he was in a great position to show this still life.' (PMA)

21 April: Matisse meets Picasso during a brief stay in Paris. (Agenda, AM)

7 May: Germany surrenders to the Allies.

12 May: Matisse is concerned with standardising

the framing of his and Picasso's canvases, due to be shown jointly in London: 'Vence, 12 May 1945. Dear Picasso, I hear that M. Erlanger from the management of the Beaux-Arts has invited just the two of us to exhibit in London – a propaganda show! Please could you write me or let me know somehow if you are going to accept – I am. If so, what sort of frames are you thinking of using, so yours and mine will match. For myself, the simplest will do fine: plain lattice strips, for instance. Will you be lending that big 1912 still life [*Still Life with Basket of Oranges*; no.45] or the two you had lately: the still life [*Tulips and Oysters on a Black Background*, 1943] and the seated female figure [*Seated Girl in Persian Dress*]? See you soon; I'll be back in Paris before long. Very best wishes, H. Matisse.' (AM)

The exhibition referred to is the *Matisse-Picasso Exhibition* at the Victoria and Albert Museum, London, which opens in December 1945. Note the concern for framing, or rather for 'non-framing', which Matisse shows from around this time, perhaps as a result of the 1944 Salon d'Automne, where Picasso had shown his canvases unframed.

20 June–13 July: An exhibition entitled *Picasso: Peintures récentes* organised in aid of charity work by the Comité France-Espagne is held at Galerie Louis Carré. Twenty-one canvases (1940–5) are on display. The catalogue for the exhibition is called *Picasso Libre* ('Picasso Liberated'), after the title of Eluard's poem which serves as an introduction.

1 July–mid-November: Matisse is in Paris (cf. letter to Pierre Matisse dated 7/45 on Hôtel Lutétia notepaper), in his apartment on boulevard Montparnasse. He undoubtedly meets Picasso several times during the autumn.

July: Picasso stays with the Cuttolis, at Cap d'Antibes.

4 August: On the subject of their forthcoming joint exhibition, and arranging a meeting with Picasso for August 5th, Matisse notes: 'Tomorrow Sunday, at 4 o'clock, visit from Picasso. As I'm expecting to see him tomorrow, my mind is at work. I'm doing this propaganda show in London with him. I can imagine the room with my pictures on one side, and his on the other. It's as if I were going to cohabit with an epileptic. How quiet I will look (even a bit old hat for some) next to his pyrotechnics, as Rodin used to call my works! I still go for it head on, I never recoiled from a heavy or embarrassing neighbour. Justice will prevail, I always thought. But then, what if he was right? People are so nuts!' (AM; quoted in Bois 1998, p.180). His misgivings prove perfectly justified.

22 September: Martin Fabiani is charged with handling stolen goods and imprisoned on information given by the Committee for the Recovery of Works of Art. The names of Picasso and Matisse are mentioned in the press in connection with the affair; Fabiani is released on bail (10 November 1945) after a heavy fine and the confiscation of his 'illicit profits'.

25 September–29 October: Salon d'Automne. The tribute paid to Picasso the previous year is echoed in a homage to Matisse: the same room is used to hang thirty-seven of Matisse's works dating from 1890 to 1944. It is not, however, a retrospective, with only seven canvases pre-dating 1937. The press naturally seizes on the similarities and differences between the two special events, contrasting

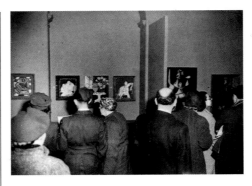

fig.104 Visitors to the *Matisse-Picasso* exhibition at the Victoria and Albert Museum, London, which opened in December 1945

the 'forty or so dazzling works' by Matisse with the 'maniacal Picasso' of the year before (*Nouvelles du Matin*, 27 September 1945) or Picasso's 'tormented violence and eternal dissatisfaction' with the 'soothing assurance' of Matisse (Gaston Diehl, *Le XXè Siècle*, Brussels, 11 October 1945).

8 November: Publication of issue no.13 of *Verve*, devoted to Matisse and entitled 'De la Couleur', with text by André Rouveyre and nineteen colour reproductions of works from 1941 to 1944.

5 December–15 January 1946: A joint Picasso-Matisse exhibition is held at the Victoria and Albert Museum, London or rather, two parallel exhibitions with two catalogues (for Matisse, preface by Jean Cassou, recently appointed Director of the Musée National d'Art Moderne; for Picasso, preface by Christian Zervos). The exhibition, in somewhat modified form, transfers to Manchester in May 1946, then to Glasgow, Amsterdam and Brussels. (See figs.104–6.)

On display are twenty-four works (1896–1944: a mini-retrospective) by Matisse, as well as a series of photographs illustrating the different stages of five recent pictures, and twenty-seven recent works (1939–45) by Picasso, plus a collection of sixty-three photos forming a retrospective, with works dated 1895 to 1939. In London, the exhibition attracts some 160,000 visitors in five weeks, causing 'an enormous stir' among the British public and generating hundreds of articles (Philip James, 'Picasso and Matisse in London', *Psyché*, no.1, 1946). These violent, emotional reactions are aroused primarily by Picasso's canvases: 'all painted in Paris, and most of them in the shadow of enemy occupation', continues the same critic, whilst in the 'dazzling Mediterranean atmosphere' of the latest Matisses he discerns 'something a bit too facile'; in his opinion, 'Matisse is verging on the purely decorative'. An article by Eric Newton, 'Storm over Picasso', in the *Manchester Guardian* of 22 December 1945, is illustrated with side-by-side reproductions of Picasso's *Serenade* (no.150) and Matisse's *Decorative Figure* (no.113). Adopting a similar tone, it reveals the strength of critical reaction to Picasso in contrast to Matisse, the opposite of what had happened in the exhibition organised in London by Roger Fry in 1912:

'Poor Matisse has been ignored or treated as no more than a chocolate-box painter in this storm in the British Council's teacup. Picasso is the villain. It is he who has debased the coinage of art and produced an "insidious growth that will sap the roots of all that is fine in painting", a "crazy guying of the human kind" from which our school children must be protected.'

Brassaï reports the reaction of Matisse, who is not deceived by the mildness of his reviews: 'I remember last year, at their joint exhibition in London at the Victoria and Albert Museum: Matisse showed me a voluminous packet of English reviews and articles devoted to the event, and told me with some sadness and bitterness: "He's the one who's getting most of the insults, not me ... They're courteous toward me ... Obviously, next to him, I always look like a little girl".' (Brassaï, *Conversations with Picasso*, trans. Jane Marie Todd, Chicago and London 1999, p.293.)

5 December–11 January 1946: Picasso produces the eleven successive stages or 'states' of his lithograph *The Bull*, which are not unlike the stage-by-stage photos of Matisse canvases shown simultaneously in London and Paris.

7 December–29 December: Inaugural exhibition (*Henri Matisse: peintures, dessins, sculptures*) of the Galerie Maeght (13 rue de Téheran, Paris). According to Camoin (letter of 20 December to Matisse), Picasso visits the exhibition: 'I haven't yet seen your exhibition; Marquet told me about it – he met there with Picasso.' Five paintings are on show, accompanied by photos of their various 'states'. (CC/M, p.219.) Matisse is very concerned with the didactic aspect of this exhibition.

1946

January: An exhibition entitled *Sur quatre murs* at the Galerie Maeght includes monumental works such as Matisse's *The Moroccans* (1915–16; no.72), a canvas still in his possession, and *Seated Man with Glass* (1913–14) by Picasso.

Early February: Françoise Gilot leaves for Golfe-Juan on the Riviera. In the weeks to follow (early March) she will visit Matisse at Vence, with Picasso. Matisse is now busy with *Asia* (no.127), and starting on the series of Vence interiors.

10 March: In a letter to Pierre Matisse his father describes the recent transfer of 'the didactic exhibition at the Maeght' to Nice (at the Casino de la Méditerranée): 'Students and painters in Nice protested: a repeat of what happened in Paris when Picasso staged his exhibition [Salon d'Automne, 1944]. There are lots of visitors and a great deal of real interest.' (PMA)

19 March: Matisse continues his epistolary chronicle, addressed to Pierre Matisse: 'Three or four days ago, Picasso came to see me with a very pretty young woman [Françoise Gilot]. He could not have been more friendly, and he said he would come back and have a lot of things to tell me. He hasn't come back. He saw what he wanted to see – my works in cut paper, my new paintings, the painted door, etc. That's all that he wanted. He will put it all to good use in time.' (PMA; Russell 1999, p.245.)

fig.105 Catalogue cover for the *Matisse-Picasso* exhibition, held in 1946 at the Stedelijk Museum, Amsterdam. Archives Picasso

fig.106 Catalogue cover for the exhibition *Matisse et Picasso*, held in May 1946 at the Palais des Beaux-Arts, Brussels. Bibliothèque Musée Picasso, Paris

April: François Campaux makes a film about Matisse. It includes a famous slow-motion sequence showing Matisse at work on *Young Woman in White, Red Background* (MNAM). (See fig.107.)

Late April: Picasso and Françoise Gilot return to Paris from Golfe-Juan. Françoise moves in with Picasso at rue des Grands-Augustins.

1 May: In a letter to her sister Elsa Triolet, Lili Brik expresses a deeply felt wish: 'How I'd love Matisse or Picasso to paint us together – *The Two Sisters*! – while we're all of us still alive.' (*Lili Brik Elsa Triolet: Correspondance 1921–1970*, ed. Léon Robel, Paris 2000.)

5 May: Picasso paints *The Woman-Flower*, a portrait of Françoise Gilot, visibly influenced by Matisse, according to Françoise herself: 'He began to simplify my figure by making it longer. Suddenly he remembered that Matisse had spoken of doing my portrait with green hair and he fell in with that suggestion. "Matisse isn't the only one who can paint you with green hair", he said. From that point the hair developed into a leaf form.' (Françoise Gilot and Carlton Lake, *Life With Picasso*, London 1965, p.111.)

Early June: Matisse leaves Vence for Paris, remaining there until April 1947.

14 June–14 July: Picasso has an exhibition at Galerie Louis Carré (*Dix-neuf Peintures*) covering the period 1939–46 and featuring *The Woman-Flower* of May 1946 – an exhibition which Matisse must no doubt have had the curiosity to see.

Early July: Picasso and Françoise leave for the south of France (Ménerbes, then Cap d'Antibes and Golfe-Juan). During the summer Picasso visits the Madoura Pottery at Vallauris (run by Georges Ramié) and immediately tries his hand at this new activity.

Late July: Death of Gertrude Stein.

August: Publication of an important monograph by Alfred H. Barr: *Picasso: Fifty Years of his Art* (The Museum of Modern Art, New York).

8 September: Romuald Dor de la Souchère, Curator of the Château d'Antibes, offers to place a large room at Picasso's disposal. From October to late November, Picasso uses it to create a score of works on fibrocement panels, using marine paint; some of these panels are still *in situ* (including fig.13).

15 September: *Paris-Presse* publishes an interview with Giorgio de Chirico. Despite his scorn for contemporary art in general ('It's time to do away with all this tomfoolery'), he concedes that 'the only one with any talent is Picasso. He at least knows what he's doing. He knows how to draw and paint.' On the other hand, he has nothing but contempt for Matisse: 'He does absolutely nothing at all. He just sleeps and sells things.'

19 September: Pierre Matisse passes on to his father certain questions from Alfred Barr (in connection with a monograph he is working on, which will appear in 1951). Two of these refer to Picasso:

'Was *Nude Man (The Serf)* painted in 1899 or 1900? Can we find out what canvases were sent to the Salon des Surindépendants in 1901? Were there any of his *académies bleues* there? This is important, as the *académies bleues* appear to be at the source of Picasso's Blue Period starting at the end of 1901. It's possible Picasso saw them at the Surindépendants, or at Berthe Weill's. Did Berthe Weill have these blue studies in her gallery?

'Did Picasso come across *La Joie de vivre* [*Le Bonheur de Vivre*; fig.2] in your studio before seeing it at the Indépendants?

'Barr thinks that Picasso's *Demoiselles d'Avignon* [no.7] arose from his desire to paint a picture which would eclipse *La Joie de vivre*. He asks if *La Joie de vivre* is the exact title.' (PMA)

24 November: Matisse informs his son Pierre of his plans to compile a complete catalogue of his work to be published by Skira. (PMA) The project (clearly connected to Zervos's catalogue of Picasso) was abortive.

Late November: Picasso is back in Paris.

20 December: Brassaï meets Matisse at La Coupole, then accompanies him to boulevard Montparnasse, where he discovers the designs for *Océanie*, *La Mer* and *Le Ciel*: small pieces of *découpage* are pinned to the wall. They resume their conversation about Picasso: 'But Matisse, always so eager for news, is trembling with impatience to ask me what Picasso has been up to recently. For forty years, he has been his pal and his rival, his *bête noire* and his comrade-in-arms. So he questions me: "How is he? What is he doing? How are his love affairs going?" The most insignificant gesture, the slightest joke that has fallen from his lips, the most minor events in his life interest him, excite him. In Vence, he told me: "Every year, I send a crate of oranges to Picasso. He displays them in his studio and tells every visitor: 'Look and admire, these are Matisse's oranges'. No-one dares to touch them, no one dares eat them ... By the way, have you seen my film? ... I was over-whelmed by the slow motion. What a strange thing! Suddenly, you see the completely instinctive work of the hand, captured by the movie camera and decomposed [fig.107]. That sequence left me dumbfounded ... Usually, when I start a drawing, I get stage fright, if not panic. But I've never been so scared as when I saw my poor hand in slow motion going its own way, as if I had drawn with my eyes shut".' (Brassaï, *Conversations with Picasso*, trans. Jane Marie Todd, Chicago and London 1999, pp.293–5).

According to Roland Penrose, Picasso, watching Campaux's film about Matisse, exclaimed: 'Never will you make an ape of me like that', and declared nothing would make him take part in such a film. (*Picasso: His Life and Work*, Harmondsworth 1971, p.418) And yet, in 1956, Picasso allows Henri-Georges Clouzot to make *Le Mystère Picasso*, showing him at work, too, for the occasion.

fig.107 Still of Matisse painting from François Campaux's film *Matisse*, made in 1946

1947

c.25 April: Matisse is back in Vence. Besides his *découpages*, he continues work on his series of *Vence Interiors* (see no.155) and also draws with brush and Indian ink.

1 May: Yvonne Zervos writes to Matisse to discuss further the project for an important summer exhibition in the chapel of the Palais des Papes, Avignon.

15 May: Birth of Claude Picasso.

19 May: Yvonne Zervos contacts Matisse again: 'When I saw you last, I told you I would show twelve pictures of yours and twelve by Picasso.' (AM)

6 June: *Arts* reports the comments of Jean Cassou, Director of the Musée National d'Art Moderne, in praise of Picasso's generosity towards his museum, under the heading 'Picasso offers ten paintings to the Musée d'art moderne'. This collection, an extraordinary one indeed, includes *The Milliner's Workshop* (1926), *The Muse* (1935), *The Serenade* (1942; no.150) and *The Enamel Saucepan* (1945).

9 June: The Musée National d'Art Moderne is inaugurated thanks to Picasso's and other donations and a purchasing budget specially granted by the Direction des Arts et Lettres. Seven canvases by Matisse, including *Le Luxe I* (1907; no.6), *The Painter in his Studio* (1916–17) and *Still Life with a Magnolia* (1941; no.153) have been bought directly from the artist in 1945. In some fifty rooms an unparalleled panorama of twentieth-century art unfolds. The press enthusiastically welcomes these

first steps. Matisse and Picasso each have a room to themselves (XI and XIX respectively). Some of the essential stages in their development remain unrepresented – no Cubist work by Picasso, nothing from Matisse's Fauve period – but at least the collection reflects the 'official' recognition now accorded the two artists by French institutions. All the same, French museums are considerably behind the Americans in this respect.

Mid-June: Picasso, Françoise and their baby Claude arrive at Golfe-Juan. They will stay in the South for almost a year until June 1948. Matisse comes to visit Picasso on 12 June. (Agenda, AM)

27 June–30 September: Opening of the *Exposition de peintures et de sculptures contemporaines* at the Palais des Papes, Avignon, under the direction of Yvonne Zervos. There are 150 works, including twelve, both early and recent, by Matisse and eleven recent canvases by Picasso (1941–7). In *Arts* (11 July) Albert La Bastie's report on 'Picasso and Matisse at the Palais des Papes' is illustrated with a photo of the installation.

29 July: Death of Leo Stein.

August onwards: Picasso is at work daily with Ramié at the Madoura Pottery, Vallauris. He decorates hundreds of pieces, progressively producing more and more of the artefacts himself.

11 August: *Pravda* (Moscow) prints a violent attack on the 'demoralising' effect of modern Western art, citing both Picasso (though a Communist Party member) and Matisse by name: 'It is intolerable that, side by side with our healthy Soviet Realism, there can exist in our country a movement represented by lovers of decadent bourgeois art who consider the French formalists Picasso and Matisse their spiritual masters.' (Reported in *France Dimanche*, 31 August 1947.) An intense polemic develops immediately in the press, particularly around the role of Aragon, who is in a difficult position through his closeness to both artists, and who is editor-in-chief of *Les Lettres françaises*, the cultural organ of the French Communist Party.

16 August: Picasso, Françoise and Claude visit Matisse in Vence.

17 August: Matisse writes to Picasso: 'My dear Picasso, It was very kind, what you suggested yesterday, to bring me some plates to decorate. I shan't have time before I leave on 5 September, and as you said, we would need to do a certain number, and then there are the designs. So I think the best thing is if I go to the pottery when I get back, if you'll give me the address, and then I can do as much as I want, as long as I'm allowed to smash the rotten ones. But promise all the same you'll come over one evening before I leave; but don't wait until everything's packed up. All my affection to you both – or rather all three of you. You seemed in wonderful condition yesterday – in all respects, physically and mentally. Your friend, H. Matisse.' (AP)

7 September: Picasso visits Matisse in Vence.

8 September: Matisse sends an urgent message to Picasso: 'My dear friend, I have persuaded myself tonight that Picasso ought to do a proper fresco at the Musée d'Antibes. We'll find a mason who knows how to prepare the plaster. In any case Italy – real

fresco country – isn't far away. I'm convinced you'd make a stunning job of it, and without any trouble. I'd love you to do this work, as it is impossible for me, and I know you'd do it better than I. It's important for everyone. Please forgive my insistence, but I feel it's my duty. Thanks for your visit yesterday. All the best, H. Matisse. (AP)

30 September: Publication by Tériade of Matisse's *Jazz* (Editions Verve). The twenty plates printed by pochoir (stencil) are produced from arrangements of paper cut-outs pre-coloured with gouache and dating from 1943 and 1944. The facsimile hand-written text dates from the summer of 1946. In Picasso's library there is a signed copy, no.256.

19 November: In a letter to Pierre Matisse, Matisse describes a fresh visit by Picasso: 'Picasso is still at Golfe-Juan, working at his ceramics. He came to visit me a few days back with Françoise, Tériade, Prévert and Adam. He has decorated 501 or 502 plates, and he's still not finished. A wonderful afternoon.' (PMA) Is it during one of these visits – surely more frequent than the letters suggest – that Matisse offers Pablo and Françoise two collages, one of which, pink and black on a green background, recalls certain plates in *Jazz*? (See its description and the conversation on this subject, dated by François Gilot to 7 December 1947, related in full in Gilot 1990, pp.71–6.) Picasso for his part has presented Matisse with a symbolic shard: a piece of tile covered with blue pigment, signed on the back 'P to M 47' (Musée Matisse, Nice).

4 December: First visit of Brother Rayssiguier to Vence, and initial discussions concerning the construction of the Dominican chapel in Vence. This is to occupy most of Matisse's time until 1951.

1948

9 March: Following the visit by Teeny Duchamp, his ex-daughter-in-law, Matisse writes to his son Pierre: 'She saw the 600 plates decorated by Picasso (only a part). I saw them too and I have to tell you it's absolutely extraordinary. He's been hard at it every afternoon for seven months.' (Russell 1999, p.302.)

5 April: André Breton, who has been staying for two months with Marie Cuttoli at Cap d'Antibes, is asked by Tériade to write an article on Matisse for the magazine *Verve*. Matisse explains to his son Pierre: 'It has been agreed with Tériade that he [Breton] will do quite a big article on me for the next issue of *Verve*. All these Surrealists are in a funny mood at the moment: they're cold-shouldering Breton, even Picasso.' (PMA)

'I spent this afternoon with Breton. I'm wondering what he'll write about me. I'm so different to Matta. They're so intelligent I look like a clodhopping peasant beside them. Picasso once said: "In art, intelligence means damn all ... " I said a few words [to Breton], intimating that Tériade doesn't want anything controversial. Especially he doesn't want him [Breton] laying into Picasso.' (Russell 1999, pp.307–8.)

14 April: Matisse writes to his son Pierre: 'Breton has left Antibes. He claims I'm to blame for the Surrealists. What does he make of Picasso? I saw the museum at Antibes. There are some quite amazing Picassos there ... Picasso is going to show his latest work and a selection of decorated plates at

the *Biennale* in Venice ... Picasso still goes to Vallauris; he's going to buy a small house there. At the moment he's working on some large heads.' (Russell 1999, p.309.)

15 April: *Verve* nos.19–20, entirely devoted to Picasso, is entitled 'Couleur de Picasso, peintures et dessins de Picasso', with the sub-title 'Antipolis [the Greek name for Antibes] 1946'.

22 April: Following a recent exchange of drawings between Matisse and Françoise Gilot, Matisse writes to her from Vence: 'I believed that I would see you a few days later – either here where you and Picasso are always welcome or in Vallauris – and that I would speak of your generosity. As it happened, Picasso had to enquire yesterday about the drawing and ask if it had arrived ... I did not tell Picasso that a week ago I went to the museum and spent an hour and a half in front of his works, so deeply was I enthralled by them.' (Gilot 1990, p.105.)

29 April: Matisse writes to his son: 'Picasso has just purchased a house at Vallauris, on the high ground, with 10,000 [square] metres of garden, but no trees. It's the spitting image of Issy. He's still carried away with his ceramics. He's been working on statues incorporating large, odd-shaped pots for a long while now. He sticks his hand inside where he wants the hollows. It's original, but I don't altogether go along with it. When you think of his panels at the museum with their very anaemic and pale colours. They're very intriguing, but he's going through a sort of stage similar to the Blue or Rose periods. This time it's grey. With glazed colours, the designs come to life automatically [in the firing]. After moulding his plates he always decorates them with kinds of pictures. Why use plates instead of panels ... ? I've been twice to the Musée d'Antibes without him. I set off with my pencil this morning to make some quick sketches of what he's done. There's a reclining woman, which I call the *faux col* [detachable collar]; that's what it looks like at first sight. I spent half an hour drawing it; then I returned to take another look and it still resembled a detachable collar. Actually, Picasso is a sort of superior clown like [Charles] Grock – I don't mean to insult the man.' (PMA)

Matisse in fact executes several sketches from the fibrecement panels, particularly *Reclining Nude on Blue Bed* (November 1946) on plywood.

Tériade works with Picasso on Pierre Reverdy's *Le Chant des morts*, illustrated with 125 red lithographs by Picasso, which he publishes at the end of September.

3 April–9 May: Matisse retrospective in Philadelphia organised in collaboration with the artist: ninety-three paintings, nineteen sculptures, eighty-six drawings and eleven illustrated books. In *France Amérique* (2 May) Ozenfant publishes an open letter to Matisse following a visit to the exhibition: 'Today everyone who has visited your show in Philadelphia considers you the greatest living painter. Your message to society is of particular importance in this day and age; there are too many who believe, and keep on repeating ... that work which is profound or carries a social message must be sad and ugly ... Picasso paints spider-women, and you, Matisse, think that what people call ugly-beautiful is never as beautiful as the beautiful-beautiful.'

May: Picasso and Françoise Gilot settle into the Villa La Galloise in Vallauris. Before Matisse leaves for Paris, Picasso visits him and promises to look after the white pigeons he can neither leave at the Hôtel Régina nor take with him to the capital.

Summer: At the request of Matisse, who is working on his project for the stained glass windows of the Dominican Chapel of the Rosary at Vence, Picasso views the first maquette. Picasso realises that this is to be a full-scale architectural project and not a mere decoration. 'Picasso was furious that I'm doing a church,' Matisse confides to Father Couturier. '"Why don't you do a covered market instead? You could paint fruit, vegetables". But I don't give a damn about fruit and vegetables: my greens are greener than pears and my oranges more orange than pumpkins. What would be the point? He was furious.' (Father Couturier's diary, 9 August 1948, in Matisse 1999, p.82.) According to Gilot, Picasso 'was amazed at Matisse's decision, and rather upset ... Pablo asked Matisse if he had become a believer. Matisse answered that the chapel was giving him the opportunity to work on all the different aspects of a complete environment and that for him it was an artistic project.' (Gilot 1990, p.194.)

1 October: Publication of *Verve* nos.21–2, devoted to 'Matisse: Vence 1944–1948', with cover illustration from the artist's cut-outs, and including twenty-four works from the *Vence Interiors* series, alternating with drawings of fruit and foliage.

9 October: Following his visit to Matisse, Father Couturier notes in his diary: 'I tell him Picasso feels warmly towards him, that he was very moved to see his photo tacked to the revolving bookshelves by his bed.' (Matisse 1999, p.86.)

17 November: Matisse, anxious about the ceramics for the projected chapel, writes to Father Couturier: 'The immediate problem is to find a ceramist to do the ceramic tiles. There's Vallauris. There's Biot, as well ... The man who works for Picasso will *not* be available if Picasso continues to do his ceramics. Who can advise us? Who can tell us that? Does Picasso himself know? Where is Picasso? ... I think Picasso's ceramists, Mme and M. Ramié, are what we need, provided our Picasso doesn't involve himself in ceramics for a while ... If you happen to see Picasso, he may – if you put the question to him firmly – give you a reply he might feel somewhat obliged to commit himself to, don't you think?' (Matisse 1999, p.107.)

24 November: In his diary Brother Rayssiguier records Matisse's remarks on Picasso: '"His periods of serenity are easy to spot; having made two thousand plates, he felt like smashing them all because they no longer seemed to make any sense. He's a pure draughtsman. Some time ago, I found him doing paintings with squares in different colours. He told me he was trying to find his palette; I had one, there were Matisse blues, even though I use the same blues as everyone else ... His work with ceramics was a response to this weakness."' Rayssiguier continues: 'He [Matisse] cites one of Picasso's ripostes [to a person who criticised a picture]: "It isn't true; Matisse never made an ugly picture". Picasso is a worrier, very concerned about what people, say about him. "He's incapable of ful-fulling himself. He wants to be first. I prefer being

second."' (Matisse 1999, p.116.)

26 November: Opening of an exhibition of 149 ceramics out of the 2,000 Picasso has done in a year, plus his sculpture *Man with a Sheep*, at the Maison de la Pensée française in Paris,

December: Picasso completes the twenty-seven lith-ographic 'states' of *Woman in an Armchair* repre-senting Françoise Gilot wearing an embroidered coat, which he has brought back from a visit to Poland to attend a Congress for the Defence of Peace at the end of August. The motif is similar to Matisse's *The Romanian Blouse*, 1939–40. An exhibi-tion at Achille Weber's gallery from 7 to 31 December – *Vingt ans d'activité des éditions Albert Skira* – includes Pierre de Ronsard's *Florilège des amours*, illustrated by Matisse and with a text by the editor, and *Premières reproductions en couleurs des céramiques de Picasso*, with a text by Suzanne and Georges Ramié.

1949

16 January: In his diary Brother Rayssiguier notes Matisse's observation: 'I too said, if one was happy, one wouldn't paint. I agree with Picasso there. A painter has to be perched on a volcano. Picasso gets into terrible cold sweats: he wanted to smash everything at Vallauris. I used to tell him that I'm not a believer, but when things are going badly, I say my childhood, my first communion, prayers over again, and this brings me back to a world where things are better ... Picasso's a Spaniard, you know. He says he's chucked all that out, but ... ' (Matisse 1999, p.134.)

21 February: From Nice Matisse writes to Father Couturier: 'I was told that someone saw a terracotta slab of the same size as my compartments for the big double window, which worries me. Is our Pablo [Picasso] getting ready to build a Babylonian wall? I feel slightly reassured about the ceramists, who are probably no longer under the spell of our Malaguenian *enfant terrible*, for the newspapers have mentioned he was present at Christian Bérard's funeral.' (Matisse 1999, p.156.)

11 March: Matisse shows Brother Rayssiguier his copy of *Le Chant des morts* illustrated by Picasso. 'A response to *Jazz*?' Rayssiguier asks, to which Matisse replies: 'I've been through the book three times, and the more I look at it, the more I see how remarkably well composed it is and how everything has its place, how well balanced the pages are. Only Picasso could have done it, just as I am the only one who could have done those [pointing to the windows opposite his bed]. Picasso sees every-thing.' (Matisse 1999, p.160.)

21 March: From Paris Father Couturier writes to Matisse: 'I saw Picasso twice. I'll tell you about it in detail: he always speaks of you in the most affec-tionate terms!' (Matisse 1999, p.164.)

April: According to Françoise Gilot, Matisse is at work on the *Stations of the Cross* for the Chapelle de Vence and returns on the 29th to the Château d'Antibes to see Picasso's paintings. Picasso later admits that it is the *Stations of the Cross*, as well as the chasubles, that he likes most about the Vence chapel. Matisse hangs Picasso's *Portrait of Dora Maar* beside his bed.

fig.108 Matisse's apartment at the Hotel Régina, Nice, 1949. On the wall hangs Picasso's *Portrait of Dora Maar*, above an owl-shaped vase also by Picasso

19 May: Matisse writes to Françoise Gilot after the birth of Paloma: 'All my congratulations, which I want you to share with Picasso, on the undoubtedly most charming dove [Paloma means 'dove' in Spanish], who must be making herself audible by now. How strange things are sometimes. For the last few weeks I have been working at representing a young mother and the child that she holds on her knees since she is seated; and despite being seat-ed, she measures ten feet high [3.5 metres].' (Gilot 1990, p.200.)

9 June–25 September: In close collaboration with the artist, Jean Cassou, director of the Musée National d'Art Moderne, marks Matisse's eightieth birthday with an exhibition entitled *Henri Matisse: oeuvres récentes 1947–1949*, presenting thirteen paintings from the *Vence Interiors* series, twenty-one paper cut-outs, twenty-two pen-and-ink draw-ings, two tapestries (*Polynesia: Sky and Sea*) and a number of illustrated books, including *Jazz*.

22 June: Brother Rayssiguier reports in his diary entry after visiting Matisse at the Hôtel Régina: 'Picasso is supposed to come and see him to con-tinue his conversation of last year. ([He will say] Matisse shouldn't be doing the Chapel probably.)' (Matisse 1999, p.207.) (See fig.108.)

23 June: Matisse writes to Father Couturier: 'I read in the papers that Picasso is going to have a big exhibition of large-scale canvases at the [Maison de la] Pensée française. Is it going to be a summer exhibition, like the one at the Musée Moderne? So we're going to be inseparable in the ring, in Paris and on the Côte d'Azur. I have been told in several quarters that he's organising an offensive, and I'm waiting to see it. Except for Mme Lydia, some peo-ple are worried for my sake. I'll let you know how the prizefight turns out.' (Matisse 1999, pp.208.)

Early July–30 September: The Maison de la Pensée française (a cultural organ of the Communist Party) stages an exhibition of sixty-four recent canvases and one sculpture by Picasso. Allusions to Matisse are noticed in some works. Christian Zervos, in a commentary published in *Cahiers d'art* (1949, no.2), hastens to Picasso's defence: 'It is wrong to say that Picasso has copied Matisse ... It is no less erro-neous to claim that Picasso thinks it's his mission and his right to rectify Matisse's weakness or fail-ings. He has never contemplated outclassing Matisse ... For Picasso the essential ... is to verify his own aesthetic experiments with the help of Matisse's, attempting to shed his own light on them, to submit them to his own acid test, to turn them

over and over and, as it were, recast them in his own mould in search of inspiration to further his talent.'

20 July: Matisse is having problems with his first experiments with the ceramics for the chapel, necessitating frequent trips to the Ramiés' workshop in Vallauris. He writes to Picasso: 'Jacqueline [Pierre Matisse's daughter] – you met her at the Ramié *vernissage* – told me you were upset because I haven't been coming to see you even though I've sometimes been so close by when I come to Vallauris. I should explain that it's a very big effort to get to Vallauris, and after spending the minimum time with the Ramiés, I get back to Nice absolutely drained. Don't forget I'm in my eightieth year and also infirm; that is enough on its own. So please don't think it's because I'm very *vieille France* [old-fashioned], as someone told you who doesn't know the meaning of the expression. I don't know what I'm going to do – things are really getting me down. My dear Picasso, come and bawl me out if that helps – between old friends like us what does it matter, we know each other so well. All my best love to your family – how lucky you are in them – and to yourself. H. Matisse.' (AP)

21 July: For the decoration of the chapel, Matisse decides to keep to ceramics rather than use fibrocement as Picasso had at Antibes. (Matisse 1999, p.221.)

31 July: Picasso, Françoise and Jaime Sabartés visit Matisse at Cimiez. (Ibid., p.219)

August: Another visit (on the 17th) by Picasso, Françoise and the Ramiés to Matisse. Matisse is trying to find a way to paint in pure black on the large white-enamelled terracotta panels. In his diary for 30 August Brother Rayssiguier notes: 'Picasso brought him an earthenware jug the other day, "holding it by the belly." Looking at it, he [Matisse] says Picasso "breaks up forms," whereas he is "their servant".' (Matisse 1999, p.232)

12 December: Laying of the first stone of the future Chapelle du Rosaire at Vence by Monseigneur Rémond, Bishop of Nice. Matisse is not present. The same day, *Life* magazine publishes photos by Gjon Mili, illustrating the article 'The Old Men of Modern Art'. On 12 January Matisse writes to Father Couturier on the subject: 'You saw *Life* – about French painters. It's really wretched.' (Matisse 1999, p.283)

THE OLD MEN OF MODERN ART

Their passing will mean the end of a memorable era

fig.110 'The Old Men of Modern Art', article in *Life* magazine, 12 December 1949, with photographs of Matisse and Picasso by Gjon Mili. Archives Picasso

1950

February: Les Ateliers Mourlot print the *Poèmes de Charles d'Orléans*, hand-copied and illustrated by Henri Matisse, for the publisher Tériade; the preparation of the book dates back to 1943.

14 February: Picasso visits Matisse accompanied by Solange Morin, a lawyer and the director of the Maison de la Pensée française: 'Big news: Picasso came by yesterday afternoon with an unknown lady in tow. The lady is connected with the Pensée française and wanted to ask me if I agreed to having a show of my paintings, drawings and bronzes at the Pensée française.'

Matisse also wants to show his work from the chapel, but '*it is out of the question that the show should consist entirely of my work on the Chapel. They want the exhibition to centre on my work in general and view the chapel as an important work, but untypical. They don't want to create the impression that it's an exhibition of religious art. They want it to be a MATISSE exhibition. I agreed in principle – the date remains to be set ... Picasso told me he had been asked to speak to me about it long ago ... He was unhappy because there wasn't a spot for him to look at in my studio that wasn't connected with the Chapel.*' (Matisse 1999, p.293.)

15 June: Matisse writes to Picasso, who doubtless has failed to respond to Solange Morin's request for the loan of pictures: 'My dear Picasso, I know that the Maison de la Pensée française has written to you, or is about to write, requesting the loan of some of my pictures in your possession. I'm asking you as well. I hope you'll make an exception to your flattering habit of never separating yourself from my canvases for a moment. All my best wishes; I hope you're all well – I picture you like a Triton spitting out the waves you've swallowed as you swim along. Love to you all, H. Matisse.' (AP)

Pablo Picasso, 68

5 July–24 September: Exhibition at the Maison de la Pensée française: *Henri Matisse: chapelle, peintures, dessins, sculptures*, displaying fifty-one sculptures, twenty-seven paintings, thirty-two drawings, three gouache cut-outs, and only two maquettes for the Chapelle de Vence. Picasso lends two canvases: *Still Life with Basket of Oranges* (no.45) and *Still Life with Tulips and Oysters* (1943). Catalogue preface by Aragon.

6 August: Official unveiling, in the presence of Paul Eluard, Jean Cocteau and Laurent Casanova (representing the Communist Party), of *Man with a Sheep*, 1943, in the market square, Vallauris. The bronze, donated to the town by Picasso, has hitherto been sited in the choir of the deconsecrated chapel near the castle. The artist receives the freedom of Vallauris, and is invited to decorate the chapel with paintings celebrating Peace. Initially, Picasso hopes to use ceramics, the dominant material in the Chapelle du Rosaire in Vence, but the curvature of the walls renders this impossible. He then considers frescoes or painting on fibrocement, as in the Château d'Antibes. Finally, in 1952, he decides to use fibreboard.

29 November: At the Maison de la Pensée française, opening of the exhibition *Picasso: sculptures, dessins*, with forty-three sculptures and an equal number of drawings executed between 1914 and 1950, again with catalogue preface by Aragon.

December: On the occasion of a visit by Picasso and Françoise Gilot to the Hôtel Régina – which Lydia Delectorskaya places in late 1950 or early 1951 – Matisse tries to present him with a collector's piece from Oceania: a ceremonial Vanuatuan headdress. 'Pablo's eyes darkened by the minute, and when we left he apologised for not taking it with us, saying that it was too large for our car,' relates Françoise Gilot. According to her he exclaims: 'that New Guinea thing [*sic*] frightens me. I think it probably frightens Matisse too, and that's why he's so eager to get rid of it.' (Gilot 1990, p.257; Gilot 1965, p.257.) (See fig.112.)

Nonetheless, Picasso will reclaim the object after Matisse's death, Pierre Matisse bringing it to him in the summer of 1957 at La Californie. (Letter of Pierre

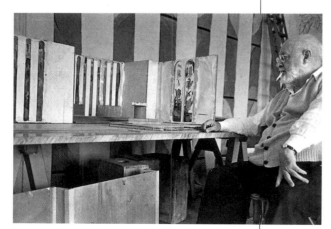

fig.109 Matisse in his studio at the Hotel Régina, Nice, with a model of the Vence Chapel, August 1949. In the background is the cutout *The Tree of Life*, a maquette for the nave window of the Chapel. Photograph by Robert Capa

Matisse to Picasso, 13 May 1957, AP.) It is now preserved in the Musée Picasso, Paris.

1951

February: Picasso is staying in Paris, where he meets Tériade to discuss an issue of *Verve* featuring his work at Vallauris between 1949 and 1951.

25 June: Consecration of the Chapelle du Rosaire at Vence; Matisse is represented by his son Pierre. For the occasion a small book is published, with an introduction by Matisse presenting the chapel as the culmination of his life's work, since the Fauve period. In his diary entry for 23 June Father Couturier notes: 'He [Matisse] tells me Picasso came to see him last week with Françoise. He brought ten large landscapes he wanted to show to Matisse and asked him what he thought of them. "Ten landscapes! He must have really been in an agony of worrying …" He showed them amid the large colour maquettes for the chasubles, which he thought were very beautiful.' (Matisse 1999, p.386.)

Françoise Gilot relates: 'When we reached Matisse's apartment with the paintings and the portfolios … Pablo put *Winter Landscape* on the mantelpiece of the fireplace, so that Matisse could see it well from his bed. Matisse was struck as if by lightning. He fell in love with that painting. He looked at the other things we had brought along and we discussed them too, but I could not concentrate on what was being said. He also tried to participate, but he could not keep his eyes away from the *Winter Landscape* … Since this work of art beguiled him so thoroughly, he asked Pablo to leave it with him for a few weeks so he could look at it in leisure. Pablo was quite gratified by Matisse's enthusiasm, and he agreed to leave his newborn creation in the hands of his friend.' (Gilot 1990, p.233.) (See fig.111.)

On Picasso's next visit to Cimiez, Matisse proposes exchanging *Winter Landscape*, still on the mantelpiece, with one of his own canvases. The painting only returns to Picasso at the end of the summer.

27 June: Jean Cocteau writes to Matisse, from Saint Jean Cap Ferrat: 'I'm very sorry to hear that the celebrations for the Chapel are over. Is it possible to take a look round without troubling anyone? Picasso tells me he brought you his landscapes. Have you still got them? If so, what an assortment of beauties you must have in your bedroom!' (AM)

18 August: Father Couturier informs Matisse that Picasso is expected soon. 'Yes,' replies Matisse, 'but he never turns up. One day he said to me: "We need to see each other often; when one of us dies, there will be things the other can't tell anyone any more". But he just doesn't come.' (Matisse 1990, p.390.)

13 November: Opening of the *Henri Matisse* retrospective at The Museum of Modern Art, New York, comprising 144 works: seventy-three paintings, thirty-one sculptures, plus drawings and prints. A section devoted to the chapel at Vence is added a month after the exhibition opens. The artist produces designs for the catalogue cover and for the jacket of a monograph by Alfred Barr published simultaneously: *Matisse: His Art and His Public*. The exhibition, widely reported in the American press, is

a great success, with 125,000 visitors before its closure on 13 January. The names of Picasso and Matisse are frequently linked, and the art critic A.L. Chanin presents a series of four lectures – 12, 19, 26 November at the Steinway Hall, and 3 December at the MOMA – under the title 'Two Masters of Modern Art: Matisse and Picasso'.

1952

February: The Matisse retrospective transfers to the Cleveland Museum of Art. Early in the month Dr Thomas Munro lectures on 'Matisse and Picasso in Recent Years'. On 29 February the British art critic Clive Bell presents 'Picasso, Matisse and their Contemporaries'.

March: In the course of January, an offer for *The Moroccans* (no.72) has been made to Matisse by the collector Samuel A. Marx through Alfred Barr. On 26 March Barr writes again to Matisse: 'Please, I must ask you urgently to let me know your decision about *The Moroccans*. We have just acquired a large and very important canvas by Picasso, *Night Fishing at Antibes*, so more than ever we need a major Matisse for our collection.' Agreement is reached the following month. (AM)

April: After abandoning the idea of using ceramics for the deconsecrated chapel in Vallauris, as Matisse had at Vence, Picasso decides to cover the walls with 'frescoes', and begins the first sketches of *War and Peace*. During April and May, André Verdet visits Matisse several times at Cimiez while working on his book *Prestiges de Matisse*, to be published in Paris by Editions Emile-Paul at the end of the year, in parallel with *Faunes et nymphes de Pablo Picasso*, the latter published by Editions Pierre Cailler, Geneva.

19 September: Jean Cocteau writes to Matisse: 'I had lunch yesterday with Picasso. "If I was at Nice", he explained, "I'd go and see [Matisse] every morning. I don't go to Nice because of these 100 square metres of frescoes. Please explain to him why I've not seen him for a year". Then he talked about you for a long time with affection and respect. When I told him I was sure you'd love to see him, he said, "Are you sure about that?"'

fig.111 Matisse's room at Hotel Régina, Nice, c.1952. On the wall above the mantelpiece is Picasso's *Winter Landscape* of 1950. Also visible are Matisse's last two paintings: above the door left is *Woman in a Blue Gandanoura Robe*, and on the floor to right of the mantelpiece is *Katia* of 1951

As a postscript, Cocteau reports: 'He [Picasso] has covered the [rue du Fournas] studio with hardboard and is painting by neon lighting, using a wheeled platform he made himself. No-one's allowed in, not even Françoise.' (AM)

Each of the two 'frescoes' for the Vallauris chapel has to cover an area 10 metres wide by 4.7 metres high (32 ft 10 in x 15ft 5 in) – a similar scale to that which confronted Matisse. The sections deal respectively with the themes of War and Peace; certain portions are reminiscent of motifs used by Matisse, such as the flute-player of the *Peace* fresco.

December: Picasso, back in Vallauris, completes the two *War and Peace* murals. Matisse will never see them: they are not installed until 1954.

1953

5 May–5 July: An important Picasso retrospective is held at the Galleria Nazionale d'Arte Moderna, Rome: it transfers in augmented form to Milan in September. Some two hundred works on show, comprising paintings, sculptures, drawings and ceramics from 1920 to 1953 and including the two panels of *War and Peace* for the Vallauris chapel.

June–September: For a Picasso retrospective at the Musée de Lyon (180 works), Matisse lends his *Portrait of Dora Maar* executed in 1942. At the end of September, Françoise Gilot leaves Picasso and takes up residence in Paris with their children Claude and Paloma.

November: Matisse is officially invited to design a monument to Apollinaire, to be sited at the corner of rue de l'Abbaye and the place Saint Germain des Prés. (Having failed to satisfy the Comité Apollinaire with any of his designs for the monument, Picasso had withdrawn from the commission in 1934.). In a letter of 2 November 1948 Jacqueline Apollinaire asked Picasso again about the Saint Germain des Prés site. Following a visit to Matisse, M. Goudal, head of the Bureau des Travaux d'Art, writes on 16 December 1953 to André Billy: 'Matisse has two designs in mind. One is a large ceramic panel in the little garden next to the boulevard Saint Germain, instead of the big Sèvres panel already there, which everyone agrees ought to go. The other is a ceramic fountain for the garden area of the place Saint Germain des Prés.' (Peter Read, *Picasso et Apollinaire*, Paris 1995, p.264.)

André Salmon, a member of the Comité Apollinaire, does not approve of the choice of Matisse, and writes to Billy telling him so. The 14 November issue of *Le Figaro littéraire* carries an article, possibly by Billy himself: 'The monument to the poet was also discussed. As Picasso has withdrawn, Henri Matisse promised to make a model of the design. It hasn't arrived.' (Judith Cousins, *Matisse Chronology*, New York 1992;

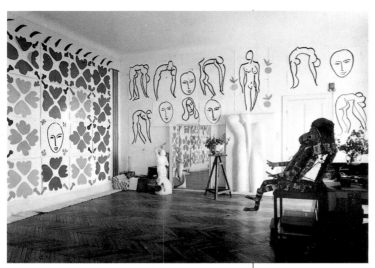

fig.112 Matisse's studio at Hotel Régina, Nice, c.1953.
In the right hand foreground is a New Hebrides head-dress, which Matisse subsequently gave to Picasso

unpublished.) The Curator of the Musée de Nice, Mme Guynet, informs M. Goudal: 'I saw Matisse after he got back from Nice ... I also saw his ceramic panel, which would go very well in the site I mentioned to you. There would be no problem adapting it as a commemorative monument; there is an allegorical medallion which we could replace with a profile of Apollinaire, and a feature underneath which could easily become a fountain. All the same ... the Master wants to have a photo taken of the site ... as he hasn't completely abandoned the idea of a circular fountain.' (Peter Read, op. cit., p.265.)

Matisse finally refuses the invitation for 'a composition in ceramics on a stone base' on the grounds of ill health. ('Echo', *Le Figaro littéraire*, February 1954.)

1954

27 February: Matisse explains to André Rouveyre: 'The "Echo" article is both right and wrong. True: I accepted the commission for the Apollinaire monument. False: I was already working on it and my present state of health forced me to stop. It was simply that, on reflection, I realised I was getting involved in something too big for someone of 84, and I thought it best to refuse before I started.' (*Correspondance Matisse–Rouveyre*, Hanne Finson (ed.), Paris 2001, p.646.)

On their return from Italy, the two Picasso panels (*War and Peace*) are installed in the entrance to the Vallauris chapel. Picasso declares at the time: 'There's not much light in this chapel, and I don't want it lit. Let the visitors take a candle and walk round the walls as if they were in prehistoric caves, picking out the figures, with the light flickering over my paintings, just a tiny candle flame.' (Claude Roy, *La Guerre et la Paix*, Paris 1954, p.21.) This is a very different approach to that of Matisse with the chapel at Vence, where sunlight plays an essential part.

July: At the Maison de la Pensée française, an exhibition entitled *Picasso, deux périodes, 1900–1914, 1950–1954*, displays canvases from the Schukin and Morosov collections. Picasso makes his first sheet metal sculptures.

September: Death of an artist close to both Matisse and Picasso: André Derain is knocked down, 8 September, at Chambourcy. Roland Penrose, staying, with Picasso, at the home of Jacques and Paule de Lazerme in Perpignan, notes on 18 September: 'He [Picasso] showed us a drawing for a proposed Temple of Peace to be built on top of a mountain overlooking Spain and the sea. Sketches had not gone far, but showed general idea of heavy irregular marble columns holding a heavy flat roof on which would stand a large dove-like creature ... Idea was still nebulous but an ambition which is close to his heart. He has never yet had a serious architectural project; he would like to make a non-Christian temple and is always talking of the mystery of the Matisse Chapel, the Braque windows at Varengeville, etc. *L'art religieux* is to him an absurdity, as he says how can you make religious art one day and another kind of art the next.' (Roland Penrose Archives, Edinburgh.)

Autumn: Publication of *Verve* (nos.29–30) devoted entirely to the 'Suite de cent quatre-vingt dessins de Picasso', with layout by Tériade and text by Michel Leiris ('Picasso et la Comédie humaine'). *Verve* no.35–36 (summer 1958) presents 'Les Dernières Oeuvres de Matisse 1950–1954', with text by Pierre Reverdy.

3 November: Matisse dies at Nice. He is buried at Cimiez. At the funeral service on 8 November, Jean Cocteau, Edouard Pignon and Jean Cassou, representing the government, pay tribute to the artist. Marguerite Duthuit, Matisse's daughter, tells Brassaï on 22 September 1960: 'When Matisse died, we informed him [Picasso] immediately. They were very friendly, intimate. You would have thought he'd come to the phone to tell us how this sad news affected him. After a long wait, we were told, "M. Picasso is having lunch, he cannot be disturbed." We were expecting a telegram, a phone call. Nothing. Thinking no-one had given him the message, we called back. It was the same thing. And when we tried to speak to him a third time, we were told: "M. Picasso has nothing to say about Matisse, since he is dead." Could he really have said that? Or could someone have replied unbeknownst to him, to spare him intense emotion?' (Brassaï, *Conversations with Picasso*, trans. Jane Marie Todd, Chicago and London 1999, p.333.)

'Often Picasso said, "There are a number of things I shall no longer be able to talk about with anyone after Matisse's death ... Everything considered, there's only Matisse." Matisse's death, though not unexpected, was quite a shock for his old friend and rival.' (Gilot 1990, p.316.) The *Times* of London devotes a long critical study to Matisse's work. 'Matisse painted the pleasures of life, rather than its pains. He was French, a moderate, not Spanish and an extremist like Picasso.' The *New York Herald Tribune* declares that the oeuvre of Matisse 'more than that of any other of his contemporaries – with the exception of Picasso – has changed the whole of contemporary art. He was in the tradition of masters like Rembrandt, Titian and Renoir.'

21 November: Ronald Penrose notes after a visit to Picasso: 'He [Picasso] was sad, looked smaller, more wrinkled and paler than a week ago. Not forthcoming in conversation. Talked of Matisse, whose death he certainly feels heavily. He denied that Matisse was deeply Catholic, as the press tried to make out. Matisse thought of the project [the chapel at Vence] as a means to make more paintings, etc. Picasso said he had often reproached Matisse for his religious tendencies [*sic*] but apart from that, he said, "Il a fait des Matisses, et ça, c'est important". ["He painted Matisses, and that's the main thing".] Picasso is obviously in fear of death, since this year so many of his generation have died: Derain, Matisse, Maurice Raynal, Sabartés' wife.' (Roland Penrose Archives, Edinburgh.)

1 December: 'Later in the day, I visited Picasso. He was playing with his two small children ... The talk came round naturally to Matisse. Picasso looked out of the window and said pensively: "Il est mort, il est mort ... " ["He is dead, he is dead ... "] Matisse, to Picasso's way of thinking, was the most fulfilled artist of his time ... On the Thursday he died, some of the cafés, where his drawings hung on the walls in the company of lesser artists, closed for the day ... Matisse was the pure inheritor of the French strain like Ingres, Manet and Renoir.' (Joseph Kissel Foster, 'Matisse: an Informal Note; Reflections of Picasso and Others ...', *Art Digest*, 1 December 1954.)

December: From 13 December, Picasso begins a series of variations on Delacroix's *Women of Algiers* (nos.178–80), 'one of the masterpieces that had been a well-loved favourite of Matisse as well as himself,' writes Françoise Gilot. 'Between 13 December 1954 and 14 February 1955, Picasso finished fifteen oil paintings and two lithographs, all free interpretations of *The Women of Algiers*. Such was Picasso's participation in Matisse's funeral cortege. Irrationally, he experienced his friend's death as a kind of betrayal. As he felt abandoned, he somehow has to exact revenge for his own sadness, selecting Delacroix's masterpiece as a scapegoat.' (Gilot 1990, p.331.)

Roland Penrose adds, in connection with *The Women of Algiers*: 'What I saw of the Moorish interiors and the provocative poses of the naked women reminded me immediately of Matisse's odalisques. "You're right", said Picasso, laughing, "when Matisse died, he left his odalisques to me as a legacy, and this is my idea of the Orient though I have never been there".' (*Picasso: His Life and Work*, Harmondsworth 1971, p.406.)

Texts by Anne Baldassari and Isabelle Monod-Fontaine translated from the French by Judith Phillips and Ian West in association with First Edition Translations Ltd, Cambridge, England. Unless otherwise stated, extracts from manuscripts and previously published texts translated from the French by Elizabeth Cowling, and from the German by Claudia Schmuckli.

Lenders

Works Not Exhibited

This list is a record of the presentations in London and New York.
The presentation in Paris will be slightly different and these differences will be recorded in the French edition of the catalogue.

The information is correct on going to press but may be subject to change during the course of the exhibition.

Works not exhibited at
Tate Modern, London
7–11, 24–31, 33, 35–6, 38, 40–2,
44–5, 51, 65, 81, 83–7, 90, 93–6,
98, 112, 115, 120, 126, 130, 132–3, 136,
147–8, 161, 165–6, 171, 178–9

Works not exhibited at
The Museum of Modern Art,
New York
9–11, 16, 24, 26, 28–30, 33–9,
41–5, 58, 64, 90, 92–3, 95–9, 109,
115, 125, 129, 131, 134–5, 147,
165, 168–9, 171, 178, 180

Private Collections

Carol A. Cowan 42
Collection of Tony and Gail Ganz 152
Collection Jan and Marie-Anne Krugier-Poniatowski 44
Lakenbleker BV 178
Pierre and Maria Gaetana Matisse Foundation Collection 35, 98, 172
Marina Picasso Collection 96
The Solinger Collection 112
The Wynn Collection, Las Vegas, Nevada 126
Private Collections 3, 16, 24, 32, 39, 43, 48, 50–1, 83, 86–8, 93, 95, 107, 109, 120, 125, 128, 135, 138, 147–8, 154, 163–4, 166, 170–1, 174–6, 178, 180

Public Collections

Baltimore, The Baltimore Museum of Art 14, 40, 119, 137
Barcelona, Museu Picasso 158
Basel, Öffentliche Kunstsammlung Basel, Kunstmuseum 151
Berlin, Staatliche Museen zu Berlin, Nationalgalerie. Sammlung Berggruen 99
Buffalo, Albright-Knox Art Gallery 149
Chicago, The Art Institute of Chicago 84–5
Columbus, Columbus Museum of Art 74
Copenhagen, Statens Museum for Kunst 2, 19, 77, 159
Düsseldorf, Kunstsammlung Nordrhein-Westfalen 155
Fort Worth, Kimbell Art Museum 127
Hamburg, Collection Hegewisch at Hamburger Kunsthalle 100
Hartford, Wadsworth Atheneum Museum of Art 118
Houston, The Menil Collection 65
London, The British Museum 37
London, Tate 17, 68, 82, 104–5, 122
London, The Victoria and Albert Museum 21
Madrid, Museo Nacional Centro de Arte Reinà Sofia 160
Moscow, The Pushkin State Museum of Fine Arts 54, 81
New York, The Metropolitan Museum of Art 49, 58, 101

New York, The Museum of Modern Art 5, 7, 18, 20–23, 31, 47, 60, 63, 67, 69–73, 75, 80, 89, 103–6, 116, 121, 124, 139–142
New York, Solomon R. Guggenheim Museum 55, 76
Nice, Musée Matisse 161, 168
Norwich, Robert and Lisa Sainsbury Collection, University of East Anglia 34
Paris, Bibliothèque d'Art et d'Archéologie Jacques Doucet 21–3
Paris, Bibliothèque Nationale de France 97
Paris, Centre Georges Pompidou. Musée National d'Art Moderne/Centre de Création Industrielle 6, 12, 15, 57, 59, 61–2, 92, 94, 104–5, 110, 113, 141, 145, 150, 153, 156–7, 165, 169, 181
Paris, Musée Picasso 4, 9–11, 25–30, 33, 38, 41, 45, 78, 90, 102, 108, 111, 114–15, 117, 129–134, 136, 139, 143-4, 162, 167, 173, 182
Perth, Kerry Stokes Collection 64
Philadelphia, Philadelphia Museum of Art 1, 56
Saint Louis, The Saint Louis Art Museum 8
Saint Louis, Washington University Gallery of Art 179
St Petersburg, The State Hermitage Museum 46, 52-3, 66
Santa Barbara, Santa Barbara Museum of Art 91
Washington DC, Hirshhorn Museum and Sculpture Garden, Smithsonian Institution 13, 123, 146
Washington DC, National Gallery of Art 177
Washington DC, The Phillips Collection 36, 79

Index

Supporting TATE

Tate relies on a large number of supporters—individuals, foundations, companies and public sector sources—to enable it to deliver its programme of activities, both on and off its gallery sites. This support is essential in order to acquire works of art for the Collection, run education, outreach and exhibition programmes, care for the Collection in storage and enable art to be displayed, both digitally and physically, inside and outside Tate. Your donation will make a real difference and enable others to enjoy Tate and its Collections both now and in the future. There are a variety of ways in which you can help support the Tate and also benefit as a UK or US taxpayer. Please contact us at:

The Development Office
Tate, Millbank,London SWIP 4RG
Tel: 020 7887 8942
Fax: 020 7887 8738

Tate American Fund
1285 Avenue of the Americas (35th fl)
New York, NY 10019
Tel: 001 212 713 8497
Fax: 001 212 713 8655

Donations

Donations, of whatever size, from individuals, companies and trusts are welcome, either to support particular areas of interest, or to contribute to general running costs.

Gifts of Shares

Since April 2000, we can accept gifts of quoted shares and securities. These are not subject to capital gains tax. For higher rate taxpayers, a gift of shares saves income tax as well as capital gains tax. For further information please contact the Campaigns Section of the Development Office.

Tate Annual Fund

A donation to the Annual Fund at Tate benefits a variety of projects throughout the organisation, from the development of new conservation techniques to education programmes for people of all ages.

Gift Aid

Through Gift Aid, you can provide significant additional revenue to Tate. Gift Aid applies to gifts of any size, whether regular or one-off, since we can claim back the tax on your charitable donation. Higher rate taxpayers are also able to claim additional personal tax relief. Contact us for further information and a Gift-Aid Declaration.

Legacies

A legacy to Tate may take the form of a residual share of an estate, a specific cash sum or item of property such as a work of art. Legacies to Tate are free of Inheritance Tax.

Offers in Lieu of Tax

Inheritance Tax can be satisfied by transferring to the Government a work of art of outstanding importance. In this case the rate of tax is reduced and it can be made a condition of the offer that the work of art is allocated to Tate. Please contact us for details.

Tate American Fund and Tate American Patrons

The American Fund for the Tate Gallery was formed in 1986 to facilitate gifts of works of art, donations and bequests to Tate from United States residents. United States taxpayers who wish to support Tate on an annual basis can join the American Patrons of the Tate Gallery and enjoy membership benefits and events in the United States and United Kingdom (single membership $1000 and double $1500). Both organisations receive full tax exempt status from the IRS. Please contact the Tate American Fund for further details.

Membership Programmes

Tate Members enjoy unlimited free admission throughout the year to all exhibitions at Tate Britain, Tate Liverpool, Tate Modern and Tate St Ives, as well as a number of other benefits such as exclusive use of our Members' Rooms and a free annual subscription to *Tate: The Art Magazine*.

Whilst enjoying the exclusive privileges of membership, you are also helping secure Tate's position at the very heart of British and modern art. Your support actively contributes to new purchases of important art, ensuring that the Tate's Collection continues to be relevant and comprehensive, as well as funding projects in London, Liverpool and St Ives that increase access and understanding for everyone.

Patrons

Tate Patrons are people who share a keen interest in art and are committed to giving significant financial support to the Tate on an annual basis, specifically to support acquisitions. There are four levels of Patron, including Associate Patron (£250), Patrons of New Art (£500), Patrons of British Art (£500) and Patrons Circle (£1000). Benefits include opportunities to sit on acquisition committees, special access to the Collection and entry with a family member to all Tate exhibitions.

Corporate Membership

Corporate Membership at Tate Liverpool and Tate Britain, and support for the Business Circle at Tate St Ives, offer companies opportunities for corporate entertaining and the chance for a wide variety of employee benefits. These include special private views, special access to paying exhibitions, out-of-hours visits and tours, invitations to VIP events and talks at members' offices.

Founding Corporate Partners

Companies are also able to join the special Founding Corporate Partnership scheme which offers access to corporate entertaining and benefits at Tate Modern and Tate Britain in London, until the end of March 2003. Further details are available on request.

Corporate Investment

Tate has developed a range of imaginative partnerships with the corporate sector, ranging from international interpretation and exhibition programmes to local outreach and staff development programmes. We are particularly known for high-profile business to business marketing initiatives and employee benefit packages. Please contact the Corporate Fundraising team for further details.

Charity Details

The Tate Gallery is an exempt charity; the Museums & Galleries Act 1992 added the Tate Gallery to the list of exempt charities defined in the 1960 Charities Act. The Friends of the Tate Gallery is a registered charity (number 313021). Tate Foundation is a registered charity (number 1085314).

TATE MODERN

Donors to the Capital Campaign by category in alphabetical order

Founders
The Arts Council of England
English Partnerships
The Millennium Commission

Founding Benefactors
Mr and Mrs James Brice
The Clore Duffield Foundation
Gilbert de Botton
Richard B. and Jeanne Donovan Fisher
Noam and Gerald Gottesman
Anthony and Evelyn Jacobs
The Kresge Foundation
The Frank Lloyd Family Trusts
Ronald and Rita McAulay
The Monument Trust
Mori Building Co,. Ltd
Mr and Mrs MD Moross
Peter and Eileen Norton, The Peter Norton Family Foundation
Maja Oeri and Hans Bodenmann
The Dr Mortimer and Theresa Sackler Foundation
Stephan Schmidheiny
Mr and Mrs Charles Schwab
Peter Simon
London Borough of Southwark
The Starr Foundation
John Studzinski
The Weston Family
Poju and Anita Zabludowicz

Benefactors
Frances and John Bowes
Donald L Bryant Jr Family
Sir Harry and Lady Djanogly
Donald and Doris Fisher
The Government Office for London
Mimi and Peter Haas
The Headley Trust
Mr and Mrs André Hoffmann
Pamela and C. Richard Kramlich

Major Donors
The Annenberg Foundation
The Baring Foundation
Ron Beller and Jennifer Moses
Alex and Angela Bernstein
Mr and Mrs Pontus Bonnier
Lauren and Mark Booth
Ivor Braka
The British Land Company PLC
Meva Bucksbaum
Edwin C. Cohen
Carole and Neville Conrad
Michel and Helene David-Weill
English Heritage
Esmée Fairbairn Charitable Trust
Tate Friends
Bob and Kate Gavron
Giancarlo Giammetti
The Horace W. Goldsmith Foundation
Lydia and Manfred Gorvy
The Government of Switzerland
Mr and Mrs Karpidas
Peter and Maria Kellner
Mr and Mrs Henry R Kravis
Irene and Hyman Kreitman
Catherine and Pierre Lagrange
Edward and Agnes Lee
Ruth and Stuart Lipton
James Mayor
The Mercers' Company
The Meyer Foundation
Guy and Marion Naggar
William A. Palmer
The Nyda and Oliver Prenn Foundation
The Rayne Foundation
John and Jill Ritblat
Barrie and Emmanuel Roman
Lord and Lady Rothschild
Belle Shenkman Estate
Hugh and Catherine Stevenson
Charlotte Stevenson
David and Linda Supino
David and Emma Verey
Clodagh and Leslie Waddington
Robert and Felicity Waley-Cohen

Donors
The Asprey Family Charitable Foundation
Lord and Lady Attenborough
David and Janice Blackburn
Mr and Mrs Anthony Bloom

Mr and Mrs John Botts
Cazenove & Co.
The John S. Cohen Foundation
Ronald and Sharon Cohen
Sadie Coles
Giles and Sonia Coode-Adams
Alan Cristea
Thomas Dane
Judy and Kenneth Dayton
Pauline Denyer-Smith and Paul Smith
The Fishmongers' Company
The Foundation for Sport and the Arts
Alan Gibbs
Mr and Mrs Edward Gilhuly
Helyn and Ralph Goldenberg
The Worship Company of Goldsmiths
Pehr and Christina Gyllenhammar
Richard and Odile Grogan
The Worship Company of
Haberdashers
Hanover Acceptances Limited
Jay Jopling
Howard and Lynda Karshan
Lady Kleinwort
Brian and Lesley Knox
The Lauder Foundation—Leonard
 and Evelyn Lauder Fund
Ronald and Jo Carole Lauder
Leathersellers' Company Charitable
 Fund
Lex Service Plc
Mr and Mrs Ulf G. Linden
Anders and Ulla Ljungh
Mr and Mrs George Loudon
David and Pauline Mann-Vogelpoel
Nick and Annette Mason
Viviane and James Mayor
Anthony and Deidre Montague
Sir Peter and Lady Osborne
Maureen Paley
Mr Frederik Paulsen
The Pet Shop Boys
David and Sophie Shalit
William Sieghart
Mr and Mrs Sven Skarendahl
Mr and Mrs Nicholas Stanley
The Jack Steinberg Charitable Trust
Carter and Mary Thacher
Insinger Townsley
The 29th May 1961 Charitable Trust
Dinah Verey
The Vintners' Company
Gordon D. Watson
Mr and Mrs Stephen Wilberding
Michael S. Wilson

*and those donors who wish
to remain anonymous*

TATE COLLECTION

Founders
Sir Henry Tate
Sir Joseph Duveen
Lord Duveen
The Clore Duffield Foundation
Heritage Lottery Fund
National Art Collections Fund

Founding Benefactors
Sir Edwin and Lady Manton
The Kreitman Foundation
The American Fund for the Tate Gallery
The Nomura Securities Co Ltd

Benefactors
Gilbert and Janet de Botton
The Deborah Loeb Brice Foundation
Tate Members
National Heritage Memorial Fund
Patrons of British Art
Patrons of New Art
Dr Mortimer and Theresa Sackler
 Foundation

Major Donors
Edwin C Cohen
Hartley Neel
Richard Neel

Donors
Howard and Roberta Ahmanson
Lord and Lady Attenborough
The Charlotte Bonham-Carter
 Charitable Trust
Mrs John Chandris
Brooke Hayward Duchin
GABO TRUST for Sculpture
 Conservation
The Gapper Charitable Trust
The Getty Grant Program
Calouste Gulbenkian Foundation
HSBC Artscard
The Samuel H Kress Foundation
Leche Trust
Robert Lehman Foundation
The Leverhulme Trust
William Louis-Dreyfus
The Henry Moore Foundation
Friends of the Newfoundland Dog
 and Members of the Newfoundland
 Dog Club of America
Peter and Eileen Norton, The Peter
 Norton Family Foundation
New Opportunites Fund
The Radcliffe Trust
The Rayne Foundation
Mr Simon Robertson
Lord and Lady Rothschild
Mrs Jean Sainsbury
The Foundation for Sports and
 the Arts
Stanley Foundation Limited
Mr and Mrs A Alfred Taubman

*and those donors who wish
to remain anonymous*

Tate Collectors Forum
Lord Attenborough Kt CBE
Ricki Gail Conway
Madeleine, Lady Kleinwort
George Loudon
Anders and Ulla Ljungh
Jonathan Marland
Keir McGuinness
Tineke Pugh
Roland and Sophie Rudd
Andrew and Belinda Scott
Dennis and Charlotte Stevenson
Mr and Mrs John L Thornton

*and those donors who wish
to remain anonymous*

Tate Collection Sponsor
Carillion plc
 Painting Conservation (1995–2000)

TATE MODERN DONORS

Founding Benefactor
The Paul Hamlyn Foundation

Major Donor
The Deborah Loeb Brice Foundation
The Henry Luce Foundation

Donors
The Annenberg Foundation
Arts and Culture Foundation of North
 Rhine Westfalia
Donald L Bryant
Edwin C Cohen
Judith and Kenneth Dayton
ICAP plc
Institute for Foreign Cultural Relations
 Stuttgart
The Italian Ministry of Foreign Affairs
 and the Italian Cultural Insitute in
 London
John Lyon's Charity
London Arts
The Henry Moore Foundation
Maurice S. Kanbar and the Murray
 and Isabella Rayburn Foundation
The Judith Rothschild Foundation
Thames and Hudson

*and those donors who wish
to remain anonymous*

TATE FOUNDING
CORPORATE PARTNERS

AMP
Avaya UK
BNP Paribas
CGNU plc
Clifford Chance
Dresdner Kleinwort Wasserstein
Energis plc
Freshfields Bruckhaus Deringer
GLG Partners
Goldman Sachs International
J Sainsbury plc
Lazard
Lehman Brothers
London & Cambridge Properties Ltd
London Electricity Group plc and EDF
Group
Mayer, Brown, Rowe and Maw
Pearson
Prudential
Railtrack PLC
Reuters
Rolls-Royce plc
Schroders
UBS PaineWebber Inc.
UBS Warburg
Whitehead Mann

TATE MODERN SPONSORS

Founding Sponsors
Bloomberg
 Tate Audio, Reading Points, Audio
 Points (2000–2003)
BT
 Tate Modern: Collection (2000–2003)
 Tate Online (2001–2003)

Ernst & Young
 Tate Modern Visitor Centre
 (1997–2000)
 Matisse Picasso (2002)
Unilever
 The Unilever Series (2000–2004)

Benefactor Sponsors
Morgan Stanley
 Surrealism: Desire Unbound (2001)
Tate & Lyle PLC
 Tate Members (1991–2000)

Major Sponsors
CGNU plc
 *Century City: Art and Culture in the
 Modern Metropolis* (2001)
The Guardian/The Observer
 Media Sponsor for the Tate 2000
 Launch (2000)
 Media Partner for *Century City:
 Art and Culture in the Modern
 Metropolis* (2001)
 Media Partner for *Warhol* (2002)
UBS PaineWebber Inc.
 Office for the Tate American Fund
 (1999–2)
UBS Warburg
 Warhol (2002)

Sponsors
Deutsche Bank
 Herzog & de Meuron: 11 Stations
 (2000)
Lloyds of London
 Community Partnership Programme
 (2001–2004)